TRISTAN AND ISOLDE

ARTHURIAN CHARACTERS AND THEMES
Norris J. Lacy, *Series Editor*

King Arthur
A Casebook
Edited by Edward Donald Kennedy

Lancelot and Guinevere
A Casebook
Edited by Lori J. Walters

Tristan and Isolde
A Casebook
Edited by Joan Tasker Grimbert

Arthurian Women
A Casebook
Edited by Thelma S. Fenster

The Grail
A Casebook
Edited by Dhira B. Mahoney

Perceval/Parzival
A Casebook
Edited by Arthur Groos and Norris Lacy

TRISTAN AND ISOLDE
A Casebook

EDITED WITH AN INTRODUCTION BY
JOAN TASKER GRIMBERT

Routledge
New York and London

Published in 2002 by
Routledge
29 West 35th Street
New York, NY 10001

Published in Great Britain by
Routledge
11 New Fetter Lane
London EC4P 4EE

Routledge is an imprint of the Taylor & Francis Group.

Printed in the United States of America on acid-free paer.

10 9 8 7 6 5 4 3 2 1

Library of Congress Cataloging–in–Publication Data

Tristan and Isolde : a casebook / edited by Joan Tasker Grimbert.
 p. cm.—(Arthurian characters and themes ; vol. 2)
 (Garland reference library of the humanities ; vol. 1514)
 Includes bibliograhical references.
 ISBN 0–8153–0654–7 (acid-free paper)
 1. Tristan (Legendary character) in the arts. 2. Iseult (Legendary character) in the arts. I. Grimbert, Joan T. II. Series. III. Series: Garland reference library of the humanities ; vol. 1514.
NX652.T75T75 1995
700—dc20 94–25538
 CIP

ISBN 0–415–93910–0

For Bob

Contents

(1949) included 226 items (books, articles, and reviews). That number has increased regularly until, in the most recent volumes, some 700 items are listed per year. Given this increase, which shows no sign of abating, it is next to impossible for readers, even for scholars, to keep up; furthermore, the major contributions to Arthurian scholarship are often dispersed widely through books and journals published through North America, Europe, and elsewhere.

That proliferation makes it very difficult even for the professional medievalist to keep abreast of Arthurian scholarship, and it would be very nearly impossible for the non-scholar with serious Arthurian interests to select and locate fifteen or twenty of the major scholarly contributions devoted to a particular character or theme. These difficulties clearly dramatize the value of this series, but they also remain an insistent reminder that even the most informed selection of about twenty major essays requires us to omit many dozens of studies that may be equally instructive and engaging. Editors have attempted to remedy this situation insofar as possible by providing introductions that present other writers and texts, as well as bibliographies that document a good many important studies that could find no room in these volumes. In addition, many of the contributions that are included here will provide discussions of, or references to, other treatments that will be of interest to readers.

This volume, edited by Joan Tasker Grimbert, provides a very full and detailed introduction surveying the Tristan and Isolde legend—that is to say, both the development of the lovers as fictional characters and their tragic love as a universal theme—from its origins to its most recent incarnation in a 1994 novel by John Updike. Following that introduction and a thorough bibliography, the editor offers nineteen essays on subjects as diverse as Celtic material, Thomas of England, Gottfried von Strassburg, the Prose *Tristan*, the *Tavola ritonda*, Malory, Tennyson, Bédier, and Swinburne; in addition, the interdisciplinary character of the volume, and of the legend itself, is indicated by the inclusion of essays on Wagner's opera, on Cocteau's film, and on the treatment of Tristan and Isolde in art.

The contributions by Professors Hoffman, Maddux, Poulson, and Walworth are original essays prepared for this volume; the others have been previously published. In the latter cases, permissions from copyright holders sometimes prohibited us from modifying the texts in any way, and thus the decision was made to present all of them in their original form, with changes generally limited to the correction of typographical errors. However, in some cases authors have, with permission, chosen to update, expand, or rework their contributions. All such treatments, as well as the translation of some articles into English, are documented at the beginning of the previously published essays. (In the introduction and bibliography, an asterisk beside a title or an author's name identifies studies that are included in this book.)

The necessity to reproduce many essays in the exact form of their original publication yields results that, although inevitable, may perturb some editorial sensibilities. First, there are a few instances in which a reprinted book chapter refers to a passage that is not to be found in this volume. Second, note form will vary from one to another. Finally, style, usage, and even spelling (British vs. American) vary as well. Offsetting these inconsistencies is the advantage of having in one's hand a substantial selection of the finest available studies, new as well as previously published, of Arthurian characters and themes.

Herewith, then, a score of contributions to our understanding of one of the most famous love stories in history and of the processes by which it took shape and survived over a period of many centuries.

Such a volume could not be produced without the generosity of museum officials and editors of presses and journals, who kindly gave permission for us to reproduce illustrations and articles. We are pleased to express our gratitude to all of them. Reproduction credits accompany essays and plates.

Introduction

Joan Tasker Grimbert

Gaston Paris called it the incomparable love epic, and for Jean-Charles Payen it was the most beautiful love story of all time: Tristan and Isolde bound by the singular power of an exclusive passion that forces them to violate the most sacred social and religious ties. As one of the founding myths of Western culture, it has been told and retold from the Middle Ages to the present day. It flourished first in the British Isles, France, and Germany, countries where its appeal has remained most enduring, then quickly spread to Italy, the Iberian Peninsula, Scandinavia, and well beyond, for there are even early versions in Czech and Byelorussian. Transmitted originally, no doubt, in the form of short oral tales, it was cast in verse romances by French and German poets in the late twelfth and early thirteenth centuries. The subversive nature of the passion informing the tale also exercised a powerful attraction on lyric poets and artists, for whom the lovers epitomized ardor, ingenuity, and beauty. Stressing either the celebratory or the cautionary aspect of the legend, they encapsulated it, seeking to portray its essence in one or two emblematic phrases or images. Others expanded it: as Tristan was increasingly drawn into the Arthurian orbit, gaining eventually a seat at the celebrated Round Table, the legend was incorporated into the large prose cycles that recounted, starting in the thirteenth century, the adventures of Arthur's knights. In these romances (mostly French, English, Italian, and Spanish), where the focus was usually on chivalric exploits, the love story was at times eclipsed, although the parallel established with

Lancelot and Guenevere gave it new significance. It remained squarely in the forefront of later German and Scandinavian romances, but the subversive impact was blunted by other means.

The legend went into virtual eclipse after the medieval period, only to be resurrected several centuries later when Romantic poets and artists, troubled by the excesses of absolutist regimes and by the social changes wrought by the Industrial Age, embraced the Middle Ages as an idyllic time when people had lived—or so they imagined—happily in harmony with each other, and with nature and the universe. The masterpieces of that "golden age," preserved in manuscripts or early printed editions but maligned and disdained by Humanist scholars and their Classicist successors, had been gathering dust in libraries and secondhand bookstores. Brought suddenly to light by philologists and other scholars, who published editions, summaries, and modern translations of them, the earliest versions of the Tristan legend became increasingly available to all those for whom the Middle Ages held a special attraction. The patient work of scholars and the impatient aspirations of Romantic and Victorian writers and artists conspired to bring about an important revival of the legend, in England most notably by Arnold, Tennyson, and Swinburne, who profoundly influenced British and American art and literature. Wagner's opera was to have an exceptional impact, disseminating not just in Germany but throughout the Western world a singularly Romantic version of the legend. As if to counteract that effect, the eminent medievalist Joseph Bédier sought to turn attention back to the legend's roots, reconstructing what he believed to be the "original" text and producing for the general public a graceful version in modern French that was widely translated. The extraordinary conjunction of these influences stimulated a new wave of retellings that was to peak in the early decades of this century. Although the legend has continued in the late twentieth century to inspire new and often highly creative retellings, it bears the scars of a difficult passage into an age that is at once more tolerant of adultery and less sanguine about the prospects for undying love. Indeed, it is not uncommon nowadays to see the venerable old story pressed into service to

pen its own critique or, more accurately, to condemn the kind of romantic fantasy it has come to represent for those who are unaware of the beauty and complexity of its earliest incarnations.

The foregoing summary, designed to give a broad overview of the legend's prodigious fortunes, purposely blurs the particularities of its evolution in each of the major countries where it first flourished and was rediscovered. Yet one of the most fascinating aspects of the legend is how it took root and thrived in the British Isles, France, Germany, and Norway, then branched out in varied and distinctive ways as it spread throughout Europe, Scandinavia, and, in this century, to the United States. In the more detailed discussion below, we shall see the various metamorphoses it underwent.[1]

The Origins of the Legend and the Earliest Extant Versions

[Note: Items with asterisks are represented in this volume]

The origins of the legend remain obscure, despite numerous efforts to pinpoint them.[2] While the oldest extant versions are fragments dating from the late twelfth century, there are manuscripts preserving traces of earlier states, tales transmitted orally, no doubt, that constitute analogues if not actual sources but that may in fact have been influenced by early French and German versions. These are Celtic, for the most part, but certain motifs were evidently borrowed from Hellenic, Persian, and

1. When speaking of the legend generally, I refer to the major characters as "Tristan," "Isolde," "Mark," "Brangane," and "Kaherdin," but in discussing a particular version I use the form of each name favored in that work.

2. See McCann.* Early surveys were done by Eisner, Newstead, Schoepperle, Schröder, and Zenker. More recent studies include those of Bromwich, Carney, and Padel for the Celtic sources/analogues, and Gallais and Polack for the nonCeltic ones.

impossible to know what elements of these earliest extant versions were included in the "archetype"—if indeed a single one ever existed—the following rough outline of the legend is intended simply as a frame of reference to facilitate discussion and comparison of the individual versions.

Born to King Rivalin of Lyonesse and Blancheflor, sister of King Mark of Cornwall, Tristan loses his mother at birth, and in most versions his father dies in battle before or just afterward. His education is entrusted to his tutor, Governal, who will become his trusted companion. He shows great promise, not only in all martial skills taught to young nobles, but also in more courtly ones, especially music. He arrives incognito in Cornwall, where his skills in harping and hunting win his uncle's heart. When the Irish champion Morholt (the Irish queen's brother) arrives to demand the annual tribute, Tristan defeats him, inflicting a fatal blow to the head, where a piece of his sword lodges and will later identify him as the slayer. Tristan himself receives a poisonous wound in that combat and eventually, believing he is doomed, has himself set adrift in an open boat along with his harp. He arrives by chance in Ireland, where, disguised as a minstrel named Tantris, he is cured by the Queen and her daughter, Isolde, and then returns to Cornwall, where his uncle's affection for him and the determination to make him his heir cause the jealous barons to urge Mark to marry. Tristan is entrusted with.the bridequest, which takes him back to Ireland, where in some versions he goes deliberately in search of Isolde, while in others a storm lands him there after he has set out blindly on a quest Mark hopes is impossible: to find the woman from whose head came the golden strand of hair brought to him by two swallows. In Ireland, Tristan slays the dragon that has been ravaging the land but faints from the poisonous flames emanating from its mouth. When Isolde learns that her father's steward, a known coward, intends to claim the prize (her hand in marriage), she seeks out the real hero, finds Tristan, and nurses him back to health. Although outraged to discover the notch in his sword identifying him as her uncle's murderer, she is persuaded not to kill him in order to avoid being married to the steward. Tristan obtains the king's permission to take her

back to Cornwall for Mark, and the two set out with Isolde's servant and confidante, Brangane, to whom the Queen entrusts a love potion for the bridal couple.

On board the ship to Cornwall, Tristan and Isolde drink the potion by mistake and consummate the love that will give them no rest until they die. Isolde persuades Brangane to replace her in her nuptial bed (but later, fearing betrayal, she tries unsuccessfully to have her murdered). In Cornwall, the lovers lead a double life, meeting secretly while trying to thwart attempts by the evil dwarf Frocin and the felonious barons to prove their treachery to Mark, whose affection for the couple makes him reluctant to doubt their professed loyalty. In one famous episode, Frocin persuades Mark to spy on them by hiding in the tree in the orchard where they often meet, but the lovers see his reflection in the water below and engage in an exchange that dispels his doubts, causing him to invite Tristan to sleep again in the royal chamber. One night when Mark is supposedly away, the dwarf sprinkles flour on the floor between the lovers' beds and, although Tristan avoids it by jumping from his bed to Isolde's, blood from a reopened wound leaves telltale stains on the bedsheets. The lovers are condemned to death, but Tristan escapes by leaping from the window of a cliff-side chapel he entered for last-minute prayer and lands miraculously unhurt on the rocky coast below. Meanwhile, Mark has been persuaded to assure Isolde a shameful death by turning her over to the local leper colony. Tristan rescues her, and they flee to the Morois forest, where they lead an existence whose harshness is mitigated only by their ardent love for each other. At length, Mark learns of their whereabouts and goes there intending to kill them, but after finding them sleeping fully clothed in their hut, with Tristan's sword between them, he again persuades himself of their innocence and retreats, leaving signs to indicate his change of heart. Not long after, the lovers, anxious to reclaim their rightful roles in society, decide to return to court, a desire that in some versions is caused by the abatement of the potion's effects after three or four years. While Mark agrees to take back his wife, he is persuaded to exile Tristan and eventually to make Isolde swear an oath of innocence, an ordeal from which she emerges unscathed.

Tristan's travels lead him at last to Brittany, where he enters the service of Duke Hoël, whose son, Kaherdin, becomes his companion. He eventually marries Hoël's daughter, Isolde of the White Hands, but, realizing on his wedding night that he was temporarily bewitched by her name and beauty, he is unable to consummate the union. He returns periodically to see the Queen in Cornwall, variously disguised as leper, pilgrim, and fool. Back in Brittany while helping Kaherdin engineer a meeting with his lover, he is fatally wounded by a poisoned spear. All remedies failing, he sends for the Queen, instructing the messenger to hoist, on the return trip, a white sail if she is aboard, a black sail if she is not. His wife, apprised at last of his relationship and also of this code, informs Tristan that the white sail she sees on the returning ship is black. Tristan, believing that his lover has ceased to care for him, expires on the spot, as does the Queen when she arrives and finds him dead. Having learned the secret of the potion, a repentant Mark buries them side by side in Tintagel. From their tombs spring two vines that intertwine.

Béroul's poem, composed perhaps as early as 1150, but more likely closer to 1190, is a 4,485-line fragment that takes up the story at the point of the famous tryst under the pine (which establishes the lovers' unrepentant talent for verbal duplicity and Marc's touching gullibility) and recounts all events up through Yseut's return to court and Tristran's banishment. One of the most famous episodes is both highly comical and deeply disturbing: when Yseut is forced to swear her innocence at a ceremony presided over by King Arthur near the Mal Pas swamp, she arranges to have Tristran, disguised as a leper, carry her across the swamp on his shoulders so that she can swear honestly that she has never had any man between her thighs except her lord Marc . . . and the leper. That she is successful here seems to suggest either that God is satisfied with literal truth or that He deems her innocent because she has been driven to this sinful love against her will.

Béroul attributes to the abatement of the potion's effects (limited to three years) the lovers' decision to leave the forest, but they apparently remain bound by their passion, for they are

in the midst of still another secret rendezvous when the fragment breaks off. Comparing Béroul's poem with Thomas's, one is struck by the upbeat tone that stems partly from the lovers' mischievous delight in their ability to exploit language to achieve their subversive ends and partly from the narrator's overt espousal of their cause, a sympathetic attitude shared by all of Marc's subjects except Frocin and the felonious barons, who claim to have their lord's interests at heart. But the situation is not as clear-cut as it may at first seem. While Tristran's enemies (who, motivated by envy and spite, are clearly evil) manage occasionally to awaken a cruel streak in the King, Marc is actually portrayed with some sympathy, as he wavers between his love for his wife and nephew and his appreciation of the barons' position. As for the lovers, it is hard to believe that Béroul approves of their attitude of total self-absorption, evidenced by the delight with which they engage in their duplicitous schemes and their apparent lack of feeling toward Marc while the potion is in full force, and, when its effects abate, their refusal to repent of their behavior even as they seek to regain what they believe to be their rightful places in a society whose laws they continue blithely to disregard.

Thomas's poem, which was probably composed around 1170–75 and quite possibly for the court of Henry II of England and Eleanor of Aquitaine, is preserved in eight separate fragments from five different manuscripts (over 3,082 lines in all) representing probably only about one sixth of his original poem. Judging from the outlines provided by Róbert and Gottfried, it is Thomas who expanded the love story of Rivalin and Blancheflor in a way that anticipates Tristran's own story: their love is a passion that erupts suddenly and ends in sorrow. (Tristran is conceived illegitimately and born an orphan; he is raised by his father's trusted vassal, Rual.) The extant portions of the poem begin with the lovers' adieu and pledge of loyalty preceding Tristran's self-exile in Brittany and recount their respective attempts to deal with the separation and their eventual death. But Thomas emphasizes the bitter toll the lovers' estrangement takes on each of them and includes episodes that show their increasing disarray and that of their entourage. Following Tristran's abortive attempt to replace Ysolt by marrying her

Breton counterpart, he arranges to transform a nearby cave into a beautiful hall in which are placed stunningly lifelike statues of his lover and her confidante. When an angry Kaerdin discovers by chance that his sister has remained a virgin, Tristran tries to justify himself by bringing him to the hall, where Kaerdin promptly falls in love with "Brengvein" and requests that they travel to Cornwall so that he can meet her. A rendezvous pleasing to all four ends in disaster when Kariado, an ardent suitor of Ysolt's, manages to convince Brengvein that her lover is a coward. Upon returning to Brittany, Tristran is persuaded by a dwarf (also named Tristran) to help him recover his lady, who has been abducted, and it is thus that he receives the poisonous wound that will prove fatal, although the circumstances in which he incurs it suggest that it is a double for Love's wound.[4]

By substituting these episodes for the ones found in the *version commune*, Thomas concentrates on the pain endured by the lovers and their loving but unloved spouses (and by the lovers' loyal confidants, Brengvein and Kaerdin). He is clearly interested in the psychology of this antisocial passion, the self-delusion it fosters, and the alienating effects it has not only on the lovers but on all those drawn into their orbit. The focus here is very much more on the pain—*dulur*—the lovers now endure than on the joy they have previously known, and although the extant fragments depict what is admittedly the "down side" of the legend (separation and eventual death), both protagonists evoke the pain they have endured for each other throughout lives characterized by isolation from family and, in the case of Tristran, outright exile. Moreover, the conclusion lacks the "compensating" effects found in other versions: there is no posthumous "reconciliation" with a repentant Marke, nor is

4. Because Tristran's wound is in the loins and is incurred in the service of an amorous "double," it evokes indirectly the Ovidian love wound, the usual metaphor in medieval literature for depicting the abrupt onset of passion. Thus, while the legend initially uses the love potion to fulfill this function, it eventually incorporates the more familiar metaphor of the dart at the point that the potion is about to fulfill the promise of death to which the dying hero refers when he states that its consumption proved fatal.

there the assurance of their own eternal union symbolized elsewhere by the intertwining vines.[5]

Eilhart's 9,446-line *Tristrant*, composed between 1170 and 1190, was long considered a clumsy translation of a French source, but recent research has challenged that view, seeing it more as a courtly adaptation.[6] What is certain is that it is linked to the so-called *version commune*, of which it provides the earliest complete outline. It includes episodes found in the extant fragments of twelfth- and thirteenth-century French works, as well as episodes not preserved elsewhere. Eilhart's choice of episodes and the tone of his work seem to stem from two very different impulses. It may well be that his interest in showing the inexorable effects of fate reflects an earlier state of the legend, while his desire to present Tristrant as a man of action is dictated by his own tastes. In the first part of the poem, the sea is presented as a powerful instrument of fate. The hero is actually born at sea and is torn from his dead mother's womb, a sign of impending misfortune. He is twice carried to Ireland by the sea, the second time on the bridequest version involving the strand of golden hair. Finally, the drinking of the potion takes place when the boat puts into port temporarily in response to Isalde's complaint of seasickness.[7] Although Tristrant and Isalde are shown anguishing at length over the feelings awakened by the potion, after they arrive in Cornwall they conduct their affair with a minimum of verbalization (unlike in Béroul), and their

5. However, Blakeslee speculates that it was a part of the original poem but was omitted in the extant manuscript to avoid the appearance of blasphemy.

6. This theory has been developed by Danielle Buschinger, who has also provided a modern edition of this romance, of which the earliest manuscripts (latter twelfth or early thirteenth century) contain only about one-tenth of the work, with the rest supplied by three later manuscripts, a Czech translation, and a chapbook, all from the fourteenth and fifteenth centuries.

7. On these intrusions of an irrational power, see J.W. Thomas, tr., *Eilhart von Oberge's "Tristrant"* (Lincoln: University of Nebraska Press, 1978), introduction, pp. 4–10.

of the late twelfth century.[10] A well-educated and highly accomplished poet, Gottfried incorporated into the Celtic legend numerous elements borrowed from classical and Christian thought. Given his background, it is not surprising that he was drawn to Thomas's depiction of a hero so unlike those portrayed in the romances of Chrétien de Troyes, where a knight cannot gain or preserve a woman's love without furnishing proof of his prowess. Except for the trials inherent to the legend (combat with the Morholt and the dragon), chivalric exploits—especially knight-errantry and tournaments—play a decidedly minor role in a work that stresses much more than Eilhart's version Tristan's courtly accomplishments. (On the significance of these changes, see Jackson* and McDonald.*) Gottfried, who in his prologue addresses himself explicitly to an elite audience of *edele herzen* ("noble hearts"), lavishes much attention on the episodes in which the lovers indulge their passion, but the figure of Tristan is clearly the focus since the consumption of the potion does not occur before what would presumably have been the midpoint of the completed romance.

If Tristan represents a model knight-courtier, the lovers' efforts to lead the double life required by their determination to pursue their clandestine affair without relinquishing their place in society serve nevertheless to underscore the negative elements of court life—a world of intrigue where men vie for the favor of the king. It is thus with some relief that Tristan and Isold abandon the court momentarily to enjoy their love freely—not in a primitive branch hut, however, but in the splendid "cave of lovers" which represents one of Gottfried's most stunning innovations. A detailed allegorical description of this idyllic refuge seems designed to celebrate the transcendent heights to which the pure love nourished in the lovers' noble hearts has raised them. The allusions to Christian tradition in this episode (among others) are unmistakable, and the spiritualized conception that Gottfried presents of what is essentially an anti-social passion is difficult to reconcile with orthodox beliefs.

10. Jaeger, *Medieval Humanism*. On this and other aspects of this point, see Jaeger's excellent entry on Gottfried in *New Arthurian Encyclopedia*, ed. Lacy, pp. 206–11.

Gottfried's successors, apparently imbued with a keener appreciation of conservative Christian ethics, would have to grapple with the same problem, and with mixed results, as we shall see.

The distinction between the *version commune* and the *version courtoise* has become a commonplace of Tristan criticism, particularly in discussing these five early versions; it cannot be ignored, therefore, despite various attempts to challenge both its value and its validity.[11] If Thomas's and Gottfried's poems are considered "courtly," it is because the authors seem to have eliminated some of the cruder elements of earlier states and rationalized or adapted certain archaic elements—traces of a pre-Christian culture. For example, it is often said that while in the Béroul-Eilhart tradition the potion preserves its magical force (despite its limitation in time), it is thought to be little more than a symbol for Gottfried—and Thomas too, presumably—where the focus is on the force of this passionate, illegitimate love and its psychological effects on the lovers and their entourage. But the extant portions of both of these poems reveal that the "courtly" tradition is not purely a refined one in which love is seen only as an ennobling force. Gottfried retains a few jarring instances of Isold's cruelty toward Brangain and of Mark's cruelty toward the lovers, and Thomas's account of the pain, frustration, and outright anger experienced by six alienated individuals—the lovers, their spouses, and their confidants—is definitely composed in a minor key. One danger in applying the epithet "courtly" to the early Tristan poems is the problematic association it appears to make with "courtly love." Since Gaston Paris introduced the term *amour courtois* in 1883, a whole century of criticism has proven how ill-defined, elusive, and ultimately

11. Jonin, *Personnages féminins*, was the first to challenge it, drawing an impassioned defense of the distinction from Frappier, "Structure and Sens." In "Significance of Thomas's *Tristan*," Hunt summarizes the debate and supports Jonin, as does Grimbert, "*Voleir* v. *Poeir*." Rather than taking sides, Bruckner* attempts to account for the multiplicity of interpretations evoked by this poem.

undefinable it is.[12] No matter how many poets may have nonchalantly compared themselves to Tristan, it is misguided to see what Germanists call Tristan-love as just one more example of a broader phenomenon that is said to "celebrate" adulterous love or even of the more refined *fine amor* associated with the troubadours. The love binding Tristan and Isolde is fated and reciprocal, dooming them to a premature death which they forestall as long as possible. If the lovers embrace their fate willingly, it is because they cannot do otherwise, but they realize how incompatible their passion is with their normal social obligations, which they nevertheless obstinately attempt to fulfill as best they can.

No doubt the best justification of the term "courtly" in reference to the Thomas/Gottfried tradition is the two poets' sophisticated treatment of the scenes in which the narrator or the protagonists characterize their love by using many of the rhetorical figures found in the works of French and German court poets. This is particularly true of Gottfried's poem, which reflects the humanist ideal of the twelfth-century renaissance and offers a stark contrast with Eilhart's version. But the distinction works better for the Germans than it does for the French: to say that Thomas's art is more sophisticated than Béroul's is to ignore the complexity of the playful discourse in which Béroul's story is embedded (see Burns*), where the incessant play on the opposition between illusion and reality is surely as reminiscent of the art of Chrétien de Troyes as is Thomas's love of rhetoric and dialectic. Indeed, it is quite likely that Béroul's poem, which elsewhere displays certain traits associated with epic—its episodic character and the narrator's appeals to his audience—represents a deliberate attempt at an archaic style.

12. See Roger Boase, *The Origin and Meaning of Courtly Love: A Critical Study of European Scholarship* (Manchester: Manchester University Press, 1977), and Edmund Reiss, "*Fin'amors*: Its History and Meaning in Medieval Literature," *Medieval and Renaissance Studies*, 8 (1979), 74–99. For a concise statement of this complex issue, see Norris J. Lacy, "Courtly Love," in *New Arthurian Encyclopedia*, ed. Lacy, pp. 101–02.

The Legend as Exemplum, Emblem, and Lyric

Before examining how these early versions were amplified in the great prose romances of the following centuries, we must consider various manifestations of the opposite impulse: compression of the legend into a single episode that somehow epitomizes it. For example, the anonymous *Donnei des Amants* ("Lovers' Courtship," late twelfth or early thirteenth century) contains in lines 453–683 what is virtually a lay, known as "Tristan Rossignol" ("Tristan the Nightingale"), which a man recounts to his lady as an example of how much one might be willing to risk for one's lover. He tells how Ysoud dared to elude her guards to escape into the garden for a clandestine meeting with her banished lover, after hearing him summon her by imitating the song of the nightingale and other birds. The lady, in turn, praises the sincerity of Tristran's love, demonstrated by his willingness to incur ridicule by disguising himself as various marginal figures in order to see Ysoud. The allusion demonstrates how well known the lovers were by the time the *Donnei* was composed and their reputation for self-sacrifice and inventiveness in their secret rendezvous.

The earliest lyric poets made abundant allusions to the legend. For them, the lovers were emblematic not only of unsurpassed beauty and great ingenuity, but also and especially of an ardent and enduring passion involving intense pain as well as great joy. Small wonder, then, that Tristan and Isolde became rapidly enshrined in the pantheon of passionate but hapless lovers with the likes of Antony and Cleopatra, Paris and Helen, Dido, and Pyramus and Thisbe, many of whom were later to be found languishing with the "lustful" in the second circle of Dante's *Inferno*, along with Paolo and Francesca, whose "Galeotto" (go-between[13]) was none other than the romance of Lancelot and Guenevere. The earliest extant reference to Tristan

13. Because it was Galehaut who facilitated the first secret rendezvous between Lancelot and Guenevere in the thirteenth-century Prose *Lancelot* (and later texts), the Italian equivalent, "Galeotto," came to mean an intermediary for would-be lovers.

and Isolde in the lyric poetry of medieval France is to be found in the work of the troubadour Cercamon (fl. 1137–48). Allusions proliferate from 1150 on,[14] proving that the legend was well known on the Continent prior to Béroul and Thomas, no doubt in the form of lays or short narratives that were either recited or sung. Both Béroul and Thomas claim to have heard differing accounts of it from various minstrels, of whom the most famous and "trustworthy" appears to have been a certain Bréri.

One can imagine these early narratives thanks in part to Marie de France, a contemporary of Béroul and Thomas, who defines the subject of her *Lai de Chevrefueil* ("Lay of the Honeysuckle") as follows: "De Tristram e de la reïne, / De lur amur qui tant fu fine, / Dunt il eurent meinte dolur, / Puis en mururent en un jur" ("About Tristan and the Queen / and their love which was so tender / from which they had much grief / then died both on the same day"—ll. 7–10). The lay records a meeting that the banished Tristram engineers when he learns that the Queen plans to travel to Tintagel for Pentecost. To attract her attention, he throws in her path a hazel branch engraved with his name (or a message), signifying that their situation is analogous to that of the honeysuckle entwining the hazel: for while they can live a long time together, separated they cannot endure. "Bele amie, si est de nus: / Ne vuz sanz mei, ne jeo sanz vus" ("My beloved, it is thus with us: / neither you without me, nor I without you"—ll. 77–78).[15]

Marie claims to have heard *Chevrefueil* recounted many times and even to have seen it in writing, and while it is not known whether she ever heard it sung, music and minstrels undoubtedly played a decisive role in the transmission of the legend, a tradition renewed many centuries later by Wagner, whose influence was both widespread and profound. Music is also an integral part of the legend itself. Tristan is the first romance hero whose skills as a musician are almost as celebrated

14. See Nathaniel Smith, "Troubadours," in *New Arthurian Encyclopedia*, ed. Lacy, pp. 475–76. Many of the earliest allusions to the legend are recorded by Sudre.

15. A Norwegian prose version, *Geitarlauf*, dates from the first half of the thirteenth century.

as his prowess in combat, and when, mortally wounded by the Morholt, he is set adrift in a rudderless, oarless boat, he takes along only his harp: music is to be his sole consolation. Music will also be his salvation when he resorts to a minstrel disguise upon finding himself in the land of his enemies. Isolde first meets Tristan as the wounded minstrel who, in some versions, teaches her how to play and sing. (On the importance of music for the lovers' relationship in Gottfried, see Jackson.*) Thus it is that music presides over the first period of their acquaintance, but following Tristan's banishment it is their separation that makes them turn to song. Thomas depicts the Queen as singing the *Lai de Guiron* ("Guiron's Lay"), which recounts a tragic love story linked to the *cœur mangé* ("eaten heart") tradition, aspects of which no doubt strike a responsive chord in her,[16] and the Prose *Tristan* (discussed below) contains a number of lays composed and sung by the lovers and others seeking consolation from the pangs of a frustrated love. (See Baumgartner.*) During periods of imposed separation, then, songs, lays, or other types of performances are used either to signal one's presence, as in the case of Tristan's bird calls, or to seek consolation or establish some kind of spiritual communion by commemorating one's love or that of other tragic couples. These two purposes are served in two short twelfth-century narrative poems, both known as the *Folie Tristan* ("Tristan's Madness") but differentiated by the location of the two manuscripts—one (572 lines) in Berne and the other (998 lines) in Oxford. In both versions Tristan appears at Mark's court disguised as a fool and recounts distorted versions of his story in order to signal his presence to Isolde, but the *Folie de Berne* appears to be related to the *version commune*, whereas the *Folie d'Oxford* is associated with the *version courtoise*.[17] Tristan also appears disguised in a 1,524-line text inserted into the Fourth Continuation of *Perceval* and

16. In stories containing this motif, the jealous husband kills the lover and has the heart prepared and served as a delicacy to his unsuspecting wife.

17. The main differences between the two are summarized by Baumgartner, *Tristan et Iseut*, pp. 116–21. Payen* analyzes the *Folie Tristan d'Oxford*.

known as *Tristan Menestrel* ("Tristan the Minstrel") because after drawing Arthur and his knights to Mark's court, he uses a minstrel disguise to win a night of love with the Queen.

Just as the lyric lays in the Prose *Tristan* are intimately tied to love intrigues elaborated in the work as a whole, allusions to the legend in romances about other couples are often used to compare—or indeed contrast—their behavior with that of the celebrated lovers. Jean Renart's romance *L'Escoufle* ("The Kite," ca. 1200) contains not only a lengthy description of a cup engraved with several scenes from the Tristan legend but also a whole network of allusions to the lovers that invite the reader to note significant parallels.[18] We owe the most sustained comparison of this type to Chrétien de Troyes, who, after claiming in the prologue of *Cligés* to have once composed a version of the legend, proceeds to recount a mock-Tristan. In this most curious version the heroine (Fénice), citing Ysolt's sexual double-dealing as a negative example, swears that she will never give her body to any man other than the one who has her heart. That Chrétien views her self-righteousness as a delusion and is having fun at her expense seems clear from the way he shows her engaged in conduct as duplicitous as Ysolt's and in no way more meritorious. If she does not end up like the woman she has no wish to imitate, it is because she is luckier: her confidante provides her with one potion to keep her husband from ever touching her and another potion to enable her to feign death, and the Emperor conveniently dies off at the end of the romance, thus allowing the lovers to inherit the throne and live happily ever after.[19] *Le Roman de la Poire* ("Romance of the Pear," ca.

18. This may in turn have inspired a feature in the play *Tristan et Iseut* (1929), by Joseph Bédier and Louis Artus. The character (Prinis) who hands the protagonists the love potion points out that the scenes engraved on the silver flask show famous lovers: Lancelot crossing the Sword Bridge to reach Guinevere; Thisbe's mulberry bush.

19. The closing verses of the romance recount the crowning irony as Fénice also ends up as a negative exemplum: remembering her deceit involving the two potions, future emperors kept their wives closely guarded, allowing no man alone with her unless he be a eunuch from birth. On Fénice's double-dealing, see Peter Haidu, *Aesthetic Distance in Chrétien de Troyes: Irony and Comedy in "Cligés" and "Perceval"* (Geneva:

1250) by Tibaut is a particularly interesting case in that the narrative, in which the poet-lover becomes smitten with his Lady after biting into a pear that she offers him, is preceded by a kind of prologue composed of successive speeches by Love, Fortune, and four sets of famous lovers (Cligés and Fénice, Tristan and Isolde, Pyramus and Thisbe, Paris and Helen) and accompanied on each facing page by appropriate miniatures.

It is, no doubt, the exemplary nature of the legend that explains its great appeal for medieval artists. The cup described in *L'Escoufle* demonstrates how various artists seized upon certain episodes that for them epitomized the legend, such as the lovers' consumption of the potion at sea, their orchard tryst, and their death. The earliest manuscripts illustrating the legend date from the middle of the thirteenth century. Key scenes from the legend also adorned the walls of secular and religious buildings and were used in the paving tiles of at least one monastery (Chertsey Abbey). They were stitched onto silk or linen embroideries, woven into tapestries, and sculpted onto ivory and wooden boxes—even onto misericords preserved in two English cathedrals. As was the case in literature, the lovers, while generally depicted in a positive light, were sometimes presented as a negative exemplum. The orchard rendezvous—the overwhelming favorite among artists—had an iconography similar to that of depictions of Adam and Eve partaking of the forbidden fruit in the Garden of Eden under God's watchful, disapproving eye. The lovers were shown standing on either side of a tree where one could observe the stern visage of King Mark, his crowned head reminding the viewer of the law transgressed by the sinful lovers.[20]

Droz, 1968), pp. 104–06. Allusions to the legend abound in Chrétien's romances. Karl D. Uitti has detected a particularly well-sustained network in *Yvain* (see his "Intertextuality in the *Chevalier au lion*," *Dalhousie French Studies*, 2 [1980], 3–13).

20. On Tristan and Isolde in medieval art, see Walworth,* Loomis, Frühmorgen-Voss, Ott, and Whitaker. On the various interpretations of the orchard tryst in medieval art, see Michael Curschmann, "Images of Tristan," in *Gottfried von Strassburg and the Medieval Tristan Legend*, ed. Stevens and Wisbey, pp. 1–17, and Doris Fouquet, "Die

The Legend in France, Italy, Spain, and England
Through the Sixteenth Century

From an examination of the various compressed forms of the legend attesting to its renown as a tale of exemplary value, we turn now to an opposing phenomenon that also demonstrates the legend's enduring popularity: its expansion—and dilution—in the long prose reworkings that began in the thirteenth century and continued up to the end of the Middle Ages in France, Italy, Spain, and Britain. The legend's development in these countries differs considerably from that seen in Germany and Scandinavia, as the lovers are drawn decisively into the Arthurian orbit, with Tristan eventually becoming a knight of the Round Table. In the earliest French and German verse redactions, Arthur and his knights either constitute a minimal presence (as in Béroul and Eilhart) or are wholly absent (as in Thomas and Gottfried).[21] The dominance of the *version courtoise* in Germany and Scandinavia accounts for the legend's development as separate from the Arthurian one, whereas in the other countries of Western Europe the two traditions merged beginning with the long, highly influential romance known as the Prose *Tristan*.

The Prose *Tristan* (which may or may not have been begun by Luces de Gat and completed by Hélie de Boron) dates from the second and third quarters of the thirteenth century and is preserved in two basic traditions, one of which is only about three-quarters the length of the "long version."[22] Composed after

Baumgartenszene des *Tristan* in der mittelalterlichen Kunst und Literatur," *Zeitschrift für deutsche Philologie*, 92 (1973), 360–70.

21. Since Arthurian romance was very popular both in France and Germany at the time that the *Tristan* verse redactions were composed, the physical absence of Arthur in a poem like Gottfried's does not preclude his "presence" as an invisible force or influence. (See McDonald.*)

22. The short version is often identified with B.N. MS 103; the long version is also known as the "cyclical version" because certain manuscripts include a portion of the *Queste del Saint Graal* ("Quest of the Holy Grail"). See Baumgartner's critique of Vinaver's theory about the

the enormous Vulgate Cycle of five French Arthurian romances (ca. 1215–35) and decisively influenced by it, this extraordinarily popular romance underscores the connection between love and prowess first explored by Chrétien and further elaborated in the French Prose *Lancelot*. Tristan's story, which is eventually woven into the Arthurian tapestry, is preceded not just by that of his father, but by a whole "genealogy" that traces the hero's (and Marc's) lineage back to Sadoc, the only one of Joseph of Arimathea's sons who defies his father by choosing his own wife, setting off a series of family episodes involving violent, often lethal, passion that prefigure later ones (see Traxler). As in the verse redactions, Tristan is orphaned at an early age and threatened before and after his arrival at Marc's court by enemies bent on depriving him of his rightful heritage. Among these is his stepmother, who twice tries to poison him. But his eventual banishment from Cornwall is no longer a lonely exile spent pining away for his beloved and living only for the rare meetings he can engineer. Rather, it sets off an interminable series of *aventures* interspersed with tournaments in which Tristan measures himself against Artus's best knights and is seen very early to be on a par with Lancelot. He eventually gains admittance to the Round Table, where he takes the seat formerly occupied by his old rival Morholt, and he even participates in the Grail Quest. The emphasis on prowess is such that, as Merlin explains, Tristan is destined to rank with Galahot and Lancelot as one of the best, most celebrated knights in the world. Marc's jealousy is aroused not just by his nephew's amorous exploits but also by his chivalric ones, as Tristan becomes progressively more integrated into the Arthurian world. There emerges very early a striking opposition between Cornwall, with its cowardly barons and the increasingly unscrupulous Marc, and Camelot, with its valiant knights presided over by the illustrious Artus.

With the introduction into the legend of numerous chivalric encounters (some appearing as long digressions involving knights other than Tristan), the love intrigue is necessarily relegated to the background for long stretches.

two versions and her plot summary of the romance in her *"Tristan" en prose.*

recognized by Mark and the Cornish—as the perfect knight and lover" (Seidenspinner-Núñez, 36).

It may seem surprising that a work that spends so much time detailing chivalric exploits and recounting the joy and pain of passionate love to what was clearly the great delight of myriad readers should actually wish to question the value of such activities. But the romance does incorporate a critique of the twin ideals espoused by Tristan, a critique that becomes increasingly explicit as the romance progresses, particularly with the introduction of Dinadan, who points out the pain of loving and the folly of jousting with any knight who challenges him. Although criticism of the lack of moderation in matters both of love and chivalry dates back at least to Chrétien, who also anticipates the move to transcend the concern for worldly love and glory represented by the Grail Quest, the explicit character of the critique found in the Prose *Tristan* is striking, and it is a feature that will be echoed in later versions of the Tristan legend—especially those that exploit the lovers' passion to questionable ends, i.e., to highlight the solid middle-class virtues they either refuse steadfastly to exemplify or are eventually persuaded to embrace.

The Prose *Tristan* may well have been the most popular prose romance of the Middle Ages, judging not only from the unusually large number of manuscripts preserved (seventy-five) but also from the frequency with which it was reprinted: eight editions were published in the fifteenth and sixteenth centuries.[23] It was also widely translated and imitated, spawning romances in Italian, Spanish, English, Danish, Russian, and Polish, as well as later French versions. All of these subsequent retellings of the legend distinguish themselves in part by the weight they accord chivalry, on the one hand, and love, on the other, and in the

23. See the discussion in Baumgartner, *"Tristan" en prose*, and in Renée Curtis's introduction to her (Curtis's) edition, *Le Roman de Tristan en prose*, vol. 1 (Munich: Hueber, 1963). Besides the versions in French, Spanish, Italian, and English discussed below, a Russian/Serbo-Croatian *Tristan* has been preserved in a Russian manuscript of the late sixteenth century. See Zora Kipel, tr., *The Byelorussion "Tristan"* (New York and London: Garland, 1988).

treatment of the parallel between Tristan and Lancelot as famous knights and lovers.

In France, the popularity of the Prose *Tristan* generated interest in other Arthurian figures associated with Tristan, including his father (Meliadus) and his son. *Palamedes*, which actually predates the cyclical version of the Prose *Tristan*, is a collection of tales about Meliadus's generation, including the fathers of Palamedes, Arthur, and Erec. It comprises two parts that were often considered as independent texts and, indeed, were published separately in the sixteenth century: *Meliadus de Leonnoys* ("Meliadus of Lyonesse," seven editions between 1528 and 1584) and *Guiron* (or *Gyron*) *le Courtois* ("Guiron the Courteous," three editions between 1501 and 1509). The earliest version of *Palamedes* is preserved as part of a compilation by Rusticiano da Pisa called *Le Roman de Roi Artus* ("The Romance of King Artus") or *Compilation* (ca. 1272) and is included in the Arthurian compilations made by Jehan Vaillant de Poitiers (ca. 1391) and Michot Gonnot (1470). The Prose *Tristan* also produced, in the late fourteenth or early fifteenth century, *Ysaïe le Triste* ("Ysaïe the Sorrowful"), published in 1522 as *L'Histoire d'Isaie le Triste* ("The Story of Ysaïe the Sorrowful"). It was conceived as a "dynastic continuation" of the earlier romance in that it recounts the seriocomic adventures of the Cornish lovers' son, Ysaïe, and his own son, Marc, who, appalled by the anarchy into which Arthur's realm has fallen since his death, struggle to restore its harmony by eliminating the evil forces and customs. Besides these editions of medieval Tristan romances, sixteenth-century France also produced two new prose romances. Written for François Ier, Pierre Sala's *Tristan* (1525–29), considered his best work, draws on material from various sources (the Prose *Tristan*, the Prose *Lancelot*, the *Tavola Ritonda* ["Round Table"], and the *Dame de la Licorne* ["Lady of the Unicorn"]) to tell "a new and joyous tale of adventures" that may well be a critique of Arthurian ideals. In 1554 appeared Jean Maugin's *Premier Livre du nouveau Tristan de Leonnois, chevalier de la Table Ronde et d'Yseulte Princesse d'Yrlande, Royne de Cornouaille* ("The First Book of the New Tristan, Prince of Leonnois, Knight of the Round Table and of Yseulte, Princess of Ireland, Queen of Cornwall"), known as the *Nouveau Tristan*. It was reprinted three times

between 1567 and 1586, but the promised second book never materialized. After the sixteenth century, interest in the legend faded, although it can be argued that it contributed indirectly to the depiction of fatal love in various plays and novels of the seventeenth and eighteenth centuries.[24]

In Italy, the Tristan legend was echoed throughout the Middle Ages in lyrical poetry, figuring even in Dante's *Inferno*.[25] The lyrical tradition intersects with the prose tradition in several *cantari*, or "songs" (preserved in fourteenth- and fifteenth-century manuscripts) that recount various episodes of the Prose *Tristan*. In the early sixteenth century, a further generic blending (with Carolingian epic) occurred in Matteo Maria Boiardo's *Orlando Innamorato* and Ludovico Ariosto's continuation, *Orlando Furioso*. The Prose *Tristan* was also the source of several extant Italian prose romances. Four of these are fragments, of which the earliest (late thirteenth century) and longest, *Tristano Riccardiano*, strays the farthest from its source, actually exaggerating the preference for chivalric adventures over love.[26]

The most innovative of the Italian prose versions is the *Tavola Ritonda* (second quarter of the fourteenth century), which draws on a variety of sources besides the Prose *Tristan* and may well have been inspired by aspects of the lyrical tradition, for it puts the love intrigue squarely back into the foreground,

24. See Jean Frappier, "Les Romans de la Table Ronde et les lettres en France au XVIe siècle," in his *Amour courtois et Table Ronde* (Geneva: Droz, 1973), pp. 263–81. See also the entries in *New Arthurian Encyclopedia*, ed. Lacy, by Jane H.M. Taylor on *Ysaïe le Triste*, p. 530, and by Norris J. Lacy on Sala, p. 395, and Maugin, p. 316, and his article "The Arthurian Ideal in Pierre Sala's *Tristan*," *Arthurian Interpretations*, 1.2 (1987), 1–9.

25. The legend is also represented in *Il Novellino* (ca. 1300), a collection of tales by an anonymous Florentine author. No. 65 recounts the orchard tryst.

26. The *Tristano Riccardiano* lacks only the conclusion of the romance; its modern editor has provided the one found in the *Tristano Panciaticchiano*. On these romances and the other fragments (the *Tristano Veneto* and the *Tristano Corsiano*), see the entries on them by Donald L. Hoffman in *New Arthurian Encyclopedia*, ed. Lacy, pp. 473–74, as well as Branca's introduction.

idealizing it in an original and somewhat disturbing way (Hoffman,* Grimbert, "Translating Tristan-love"). In exalting Tristano's and Isotta's love, the anonymous author places it at the summit of a secular hierarchy parallel to that of Christian love. As in the French Prose *Tristan*, Tristano, Galeotto, and Lancilotto are destined to become the three best knights in the world, but the *Tavola Ritonda* departs from the French tradition in making it clear that Tristano surpasses Lancilotto in the areas both of love and chivalry. Tristano was the best knight in the world but also the most "unfortunate," in that he would have reached the High Table if fate had not willed that he drink the potion. Although Lancilotto and Ginevara are also seen as victims of inordinate love, their succumbing to a sudden passion conceived on their very first meeting is seen as a bond inferior to that shared by Tristano and Isotta, who loved with a "loyal" love (based on reciprocal service) even before the effects of the potion subjected their reason to the desire for carnal pleasure. Tristano and Isotta, though they consummate their love, are considered "chaste" in that they are faithful to each other (and because their passion was forced on them). One of the most innovative aspects of this romance is the decision to invest the potion with a force equal—indeed superior—to that seen in Béroul. (On the drink's powerful effects, see Hoffman.*) In the comparison of Tristano with Galasso (Galahad), of the former's fatal love with the latter's Christian love, the mysterious potion takes on religious overtones, particularly with the lovers' death.[27]

The Tristan legend filtered into Iberia in the twelfth century, arriving first in Catalonia. The Catalan troubadour Guiraut de Cabrera alluded to it around 1170. The popularity of the legend was particularly discernible in lyric poetry and romance in the fourteenth and fifteenth centuries, owing to the influence of the Prose *Tristan*. A ballad, "Herido está don

27. "The allegorization of the grape vines growing out of the lovers' tomb invites an ecstatic exegesis that blends Dionysian celebration with eucharistic devotion, recreating Tristan as the patron of a new communion of lovers who will drink the wine transubstantiated from his body and blood" (Hoffman, "Arthurian Tradition in Italy," p. 177).

Tristán" ("Wounded Is Sir Tristan"), recounting Tristan's death,
is preserved in over ten texts. All of the Spanish prose versions
of the legend appear to have descended from the same (lost)
version of the Prose *Tristan* that served as the basis for the Italian
versions, although the intermediary may well have been
Catalan.[28] The only complete Spanish version is the *Libro del
esforçado cauallero don Tristán de Leonís y de sus grandes fechos en
armas* ("The Story of the Valiant Knight Sir Tristan of Leonis and
of His Great Feats of Arms"), published in Valladolid in 1501
with subsequent imprints in 1511, 1525, and 1528. It contains
several interpolations from Juan de Flores's sentimental novel
Grimalte y Gradissa. A comparison of this version and two earlier
fragments with the Prose *Tristan* and the Italian versions
suggests that the version of the legend that circulated in Spain in
the fourteenth and fifteenth centuries followed the Italians in
their move toward greater narrative economy—concentration on
Tristan's amorous and chivalric activities at the expense of those
of his fellow knights—and their effort to equalize the emphasis
on love and chivalry. The 1501 imprint, on the other hand,
influenced no doubt by the vogue for the sentimental novel,
reorients the legend toward the love tragedy, replacing the
statues adorning the lovers' sepulcher with the image of "the
boat of love on the sea of vain hope" (Seidenspinner-Nuñez, 38).
In 1534 appeared *Corónica nueuamente emendata y añadida del buen
cavallero don Tristán de Leonís y del rey don Tristán de Leonís el joven
su hijo* ("Newly Revised and Expanded Chronicle of the Great
Knight Sir Tristan of Leonis and His Son, King Tristan of Leonis,
the Younger"), a reworking of the *Libro*, followed by a sequel
recounting the adventures of the lovers' children, Tristán and
Yseo.[29]

 In England, the reception of the Tristan legend was totally
different than in Italy and Spain. The earliest known version is
the alliterative Middle English romance *Sir Tristrem* (late

28. On this theory and on the medieval Spanish *Tristans*, see
Harvey L. Sharrer, *A Critical Bibliography of Hispanic Arthurian Material*
(London: Grant & Cutler, 1977), Vol. 1: *Texts: The Prose Romance Cycles*.

29. It was translated into Italian as *I due Tristani* ("The Two
Tristans") and published in 1555 in Venice.

thirteenth century), attributed—no doubt erroneously—to Thomas of Erceldoune by its first editor, Sir Walter Scott. The (unfinished) 3,344-line poem follows closely the plot of Thomas's version but alters considerably its spirit, presenting the story from a more rationalizing and moralizing viewpoint. Little interested in courtly love psychology, the author condenses those passages and develops the references to hunting, fighting, and gaming, topics that presumably appealed both to him and to his audience. (On this work, see Rumble, "The Middle English *Sir Tristrem*," and Pickford.)

The most important and influential English version of the legend is *The Book of Sir Tristram de Lyones*, which Sir Thomas Malory placed in the middle of his *Morte Darthur* ("Death of Arthur"), published by Caxton in 1495.[30] Based on several sources, but mainly on the Prose *Tristan*, the *Tristram* reflects the tastes of Malory's fifteenth-century English audience and also draws on the conventions of English romance.[31] The focus is much less on Trystram's reputation as a great lover than as a celebrated knight. The hero seems preoccupied mainly with obtaining "worship" and enjoying the bonds forged in the fellowship of Arthur's knights. The main theme is thus *chevalerie* rather than *courtoisie*, but *chevalarie* in a heroic context. Indeed, Malory's refusal to focus on adulterous love is clear from his treatment of the Launcelot/Gwenyver/Arthur triangle. While Gwenyver states in the last book of the *Morte Darthur* that hers and Launcelot's sinful love brought Arthur down, her lover never does so; rather, the disintegration of the Round Table is blamed by both Launcelot and Gawayne on their own pride, the epic sin *par excellence*, for Arthur himself states that he would have been willing to forgive the couple if only he could have

30. Malory called it *The Hoole Book of Kyng Arthur and His Noble Knyghts of the Round Table*, but it has been known as the *Le Morte Darthur* since Caxton mistook the title of the last tale for that of the whole work. On the interesting history of the various editions, see Peter J.C. Field, "Sir Thomas Malory," in *New Arthurian Encyclopedia*, ed. Lacy, pp. 294–97.

31. See Mahoney,* who nuances the interpretation in Benson, *Malory's "Morte Darthur."*

enjoyed anew the company not so much of his queen as of his best knight. (He even states that one can have many queens, but only one such company of knights!)

Since adultery is much less of an issue for Malory than is faithful chivalric service, comparatively little space is devoted to Trystram's and La Beale Isode's numerous attempts to elude discovery by Marke either before or after Trystram's banishment; indeed, the lovers spend a good part of their time living in "comfortable domesticity" at Joyus Gard (Mahoney,* p. 238). Like Launcelot and Gwenyver, they feel no compunction about their behavior, and Marke's character is blackened so much that he elicits no sympathy whatsoever. In any case, Trystram believes (like Launcelot) that his lord's first consideration should be the great service he has rendered to him. The other kings he serves—the Irish king, the Breton king Howell, and Arthur— cherish him well, in marked contrast to his own uncle. When his Irish hosts discover that it was he who killed Marhalte, he ably defends his actions by claiming to have done battle for the love of his uncle and his country and to increase his honor, for he had just that day been knighted. He also points out that Marhalte left the field alive, his shield and sword behind him. It is an explanation that the king willingly accepts, in part because he recognizes Trystram's worth and is grateful for his service, even though he is obligated to banish him to preserve harmony within the kingdom. The comparison between Arthur and Marke, though always implicit, becomes explicit when Launcelot, despairing of being able to work the reconciliation with his lord that Bors foresees, evokes the treacherous slaying of Trystram after he had been invited to return to Cornwayle. Bors points out that Arthur, unlike Marke, has always been one to keep his word. No doubt the clearest evidence of Malory's lack of interest in Trystram as a lover is the fact that the book devoted to him does not recount his death, but rather ends on a joyful note of epic celebration: the baptism and induction into the Round Table of Palomydes (Mahoney,* p. 245). Only much later does the narrator mention Trystram's sad fate, as he evokes knights of valor who have perished. The manner of death is first described in the context of the treacherous slaying of noble knights, and, as noted, Launcelot and Bors also have occasion to evoke the event.

Malory's influence was enormous, especially in the modern period. Many of the numerous British and American versions can be traced back to him, but few authors were content to leave the love intrigue in the background, though for widely divergent reasons. Tennyson, writing in Victorian England, was not willing to overlook the adultery issue, especially as it concerned the Cornish lovers, while Swinburne, like Wagner, was eager to celebrate its transcendent nature.

The Legend in Germany and Scandinavia from the Mid-Thirteenth Century Through the Eighteenth Century

Gottfried's unfinished poem inspired two continuations for which the authors, Ulrich von Türheim and Heinrich von Freiburg, drew heavily on the latter part of Eilhart's version.[32] Ulrich's *Tristan* (1235) begins with the hero's decision to marry the second Ŷsôt and borrows from Eilhart the magic-pillow episode and the hero's stay at Mark's court disguised as a fool, but the 3,731-line poem does not draw the tale to a conclusion. Heinrich's own attempt (*Tristan*, 1285–90) appears to be more successful in every way. In a style that is closer than Ulrich's to that of Gottfried, he begins his 6,890-line poem with Tristan's marriage (attributing the hero's failure to consummate it to a vow he made to the Virgin Mary to abstain for a year) and follows Eilhart's outline right up to the end, where he inverts the intertwining-vine motif, placing the rose over Tristan's head and the grapevine over Îsôt's. Both poets refer to Gottfried in their prologues, presenting themselves humbly as comparatively untalented successors to a great master. Heinrich's use of a common modesty topos unwittingly sets the tone for future assessments of their work and, indeed, of all subsequent versions in German up to Wagner, since critics have been unable

32. See the entries on these authors by Marianne E. Kalinke in *New Arthurian Encyclopedia*, ed. Lacy, and the chapters devoted to their works in McDonald, *Tristan Story in German Literature*.

generally to resist the temptation to measure these works against Gottfried's, rather than judging them on their own terms.[33] Heinrich espouses Ulrich's revisionist view that reflects bourgeois morality, presenting the lovers' adulterous passion as reprehensible behavior that will deliver them into the hands of the Devil. Tristan's disdain for the conjugal bliss offered by his excellent wife can only be explained by the force of the potion and the astrological configuration that determined the lovers' destiny. Heinrich contrasts the sinful and ultimately ephemeral delights of Tristan-love with the love of God and the promise of eternal joy. Unrelated to either of these versions (or indeed to Gottfried or Eilhart) is a shorter verse romance (2,705 lines), *Tristan als Mönch* ("Tristan as Monk"), which dates from the first half of the thirteenth century and may depend on a French source. It recounts Tristan's successful attempt to visit Ysot by posing as "Brother Wit," a chaplain who accompanies a funeral procession to Cornwall. When Ysot feigns sickness, he takes the disguise of a physician and remains at her side long enough to "cure" what ails them both.

In the later Middle Ages, Eilhart's version of the legend overtook Gottfried's in popularity. A relatively faithful prose redaction, to which has been added some didactic material (reflecting the attitude taken by Ulrich and Heinrich), is preserved in a 1484 incunabulum, *Ein wunderbarlich vnd fast lustige Historij von Herr Tristrand vnd der schönen Isalden* ("A Marvelous and Quite Pleasing Tale of Sir Tristrant and the Beautiful Isalde"). The chapbook was reprinted every ten or twenty years up to 1664, fifteen times in all, followed by seven modern printings or editions. It was the source for the play written in 1553 by Hans Sachs, the prolific shoemaker of Nürnberg, who also celebrated scenes from the legend in six of his *Meisterlieder* (1551–53). In his seven-act play of 1553, *Tragedia von der strengen Lieb, Herr Tristrant mit der schönen Königin Isalden* ("Tragedy of the Strong Love of Sir Tristrant and the Beautiful Queen Isalde"), Sachs recounts the legend from the cautionary perspective of a middle-class German Protestant, appending an

33. In *Tristan Story in German Literature*, McDonald makes a conscious attempt to avoid this pitfall.

epilogue in which the audience is urged to eschew illegitimate passion and opt instead for love sanctioned by marriage.

The Tristan legend was very popular in Scandinavia from the thirteenth century on, owing primarily to the influence of Róbert's *Tristrams saga*, which inspired several reworkings. The most important of these is the fourteenth-century Icelandic *Saga af Tristram ok Ísodd*, known also as *Tristrams saga ok Ísoddar* ("Saga of Tristram and Isolt"), once harshly judged as a "boorish account" but now thought to be a parody of the legend and indeed of Arthurian romance generally.[34] Various motifs of the Tristan legend took on a life of their own as they were either incorporated into indigenous works or became the subject of ballads and folktales. Of the ballads preserved in Icelandic, Danish, and Faroese, the most beautiful is the Icelandic ballad "Tristrams kvæ i" ("Poem of Tristram," ca. 1400), which recounts Tristram's wounding and death and distinguishes between the "fair" Ísodd and the "dark" one. In three of the four redactions, each strophe ends with the haunting refrain: "For them, it was fated only to part." While this ballad is clearly related to the Icelandic saga, the Danish ballads, "Tistram og Jomfru Isolt" ("Tristram and Maid Isolt") and "Tistram og Isold" ("Tristram and Isold"), and the Faroese "Tístrams táttur" ("Tale of Tristram") depart significantly from the traditional plot. In the Icelandic folktale *Tistram og Ísól* ("Tristram and Isolt"), Isolt the Dark is both Isolt's wicked stepsister and Tristram's (unchaste) wife, whom Isolt replaces on her wedding night, revealing her identity to her lover through a song that alludes to their past.[35]

34. The earlier assessment was made by Leach in his chapter "Tristan in the North." Paul Schach, *"Tristrams Saga ok Ýsoddar* as Burlesque," *Scandinavian Studies*, 59 (1987), 86–100, claims that it is a burlesque parody of the legend, and Kalinke, *King Arthur, North-by-Northwest*, suggests that the burlesque intention extended to Arthurian legend in general. On Róbert's influence, see Schach, "Some Observations on the Influence of *Tristrams saga ok Ísöndar* on Old Icelandic Literature."

35. On these works and others, see Schach, "Tristan and Isolde in Scandinavian Ballad and Folktale."

Much innovation can be seen as well in the popular Danish chapbook *En tragoedisk Historie om den œdle og tappre Tistrand, Hertugens Søn af Burgundien, og den skiønne Indiana, den store Mogul Kejserens Daatter af Indien* ("A Tragic Story of the Noble and Courageous Tistrand, Son of the Duke of Burgundy, and Indiana, the Daughter of the Ruler of India"), preserved in four editions (1775, 1785, 1792, 1800) and purporting to be translated from a fifteenth-century German chapbook. While it preserves the basic outline of Róbert's redaction, the spirit of the romance is altered considerably to suit the taste of the time, with the "lovers" enjoying a chaste, though passionate, friendship. It is presumably their suffering and virtuous denial, even as they fulfill their obligations to their respective spouses, that leads to their canonization. As Tistrand is bringing Indiana from India to marry his uncle, Alfonsus of Spain, the inadvertent drinking of the potion leads Tistrand to kiss Indiana's hand, the chaste gesture to which this and all subsequent sexual encounters are reduced. Persecuted at court by his jealous cousin (Røderich), Tistrand eventually returns to France and marries Innanda, with whom he has children. Following his death, as Indiana prepares to follow him, she seeks consolation in two highly symbolic unions to which her husband agrees: her burial with Tistrand in the same coffin and the marital union of the "lovers'" children by each of their marriages. Having learned about the potion from Indiana's handmaiden, an aggrieved Alfonsus arranges a royal burial in a monastery for the pair, who are then canonized. Lilies sprout from their breasts and intertwine: this is said to be the source of the fleur-de-lis on the French coat of arms. This popular version was translated into Icelandic as *Tistrans saga ok Indiönu* ("Saga of Tistrand and Indiana"), which inspired two nineteenth-century rímur, by Sigur ur Brei fjör and Níels Jónsson, respectively.[36]

36. On the Scandinavian versions, see Kalinke, *King Arthur, North-by-Northwest*, and her "Arthurian Literature in Scandinavia," in *King Arthur Through the Ages*, ed. Lagorio and Day, I, pp. 128–51, and Paul Schach, "Tristan in Scandinavia," in *New Arthurian Encyclopedia*, ed. Lacy, pp. 469–71.

The Legend in the Modern World

After the Middle Ages, the story of Tristan and Isolde, like Arthurian legend generally, suffered a decline owing largely to the reputation that romance had developed among Renaissance neoclassical theorists as a degenerate or popular form of literature. Although Boiardo and Ariosto managed to incorporate romance characters into their great epics, many authors considered such figures unworthy of their attention.[37] Interest in the Tristan legend was not revived until the late eighteenth and early nineteenth centuries, when the Romantics revolted against the tyranny of neoclassical rules concerning subject matter and form. It enjoyed a glorious and distinctive resurrection in each of the major countries where it had originally flourished—France, Germany, and England, from which it travelled across the ocean to the United States. The legend reemerged in other countries as well (e.g., Spain and Italy), but for some reason its impact was much less dramatic in southern Europe than in northern. Consequently, in describing the legend's rebirth in modern times, this survey will focus on the versions in English, French, and German. Given the nexus of interdisciplinary influences at work in the history of the legend in the modern period, it has seemed sensible to integrate into this overview, devoted primarily to literature, some discussion of the most important interpretations of the legend in music and film; however, it has not been feasible, unfortunately, to interweave a running account of the legend as represented in the visual arts of the nineteenth and twentieth centuries.[38]

37. The most impressive Arthurian interpretation in the sixteenth century was in fact Miguel de Cervantes's celebrated parody of romance ideals, *Don Quijote*, a work seen by many as situated midway between romance and novel. On this transition, see Edwin Williamson, *The Half-Way House of Fiction: "Don Quixote" and Arthurian Romance* (Oxford: Clarendon, 1984).

38. Fortunately, the most prolific period, nineteenth- and early twentieth-century British art, is treated by Poulson.*

The Legend in the English Romantic Revival
of the Nineteenth Century

In the early nineteenth century, British scholars made available to the public several medieval versions of the Tristan legend, either as printed editions or summaries. Sir Walter Scott published the incomplete thirteenth-century *Sir Tristrem* in 1804, adding an ending of his own invention based on Malory; John Dunlop's *History of Prose Fiction* (1814) included a summary of one version of the Prose *Tristan*; and there were several successive editions of Malory, the most notable being a deluxe Caxton-based edition by the poet-laureate Robert Southey (1817). But two cheaper versions based on the corrupt Stansby text of 1634 were to influence the Romantic Revival decisively before a second Caxton edition, by Sir Edward Strachey, appeared in 1868. Summaries of the Tristan legend and other Arthurian legends published in various scholarly journals added to the rich fund of material that inspired poets and artists to revive the legend in a guise that would appeal to contemporary audiences. The tales of Arthur's knights fighting for great and honorable ideals while experiencing passionate love fired the imagination of the Romantics in search of an antidote to an increasingly industrialized society, dominated by the homely, materialistic values of an upwardly mobile bourgeoisie. But the revival in the Victorian age of legends that appeared to celebrate adulterous love posed the problem of how to reconcile this love with the moral ideals of the age. Medieval poets had been faced with a similar dilemma when portraying a love inimical to the Church, but they had also been concerned with the betrayal of feudal and kinship bonds. For the Victorians, it was the tantalizing issue of "free love" that inspired feelings both of revulsion and fascination, which explains the ambivalence one detects in many Romantic retellings.

Matthew Arnold (*Tristram and Iseult*, 1852) was the first modern English poet to treat the Tristan legend, which he found

summarized in a French journal.[39] Although the story remains strongly anchored in the medieval tradition, Arnold transposes it to the realm of ordinary experience by emphasizing the element of human psychology. The three-part poem is devoted successively to Tristram's musings on his deathbed, to a last reunion that the poet accords Iseult of Ireland, and to a totally new episode: Iseult of Brittany's attempts a year after Tristram's death to cope with her fate by telling her two children the tale of Vivian's beguiling of Merlin, which offers an obvious parallel to that of the Tristan story. If Arnold focuses on the lovers' death, parts of the legend are retold in flashback or dream sequences, while others are encapsulated in various details. He uses a complicated system of narrative devices, which, in stark contrast to the suffering imposed on all three protagonists by the fatal passion, offer a more positive view of that love as it is transposed into the realm of dream, memory, and fable—virtually metamorphosed by art. Consequently, although earlier critics interpreted his sympathetic presentation of the legitimate spouse and his portrayal of the suffering caused by the adulterous passion as an indictment of it, Arnold was apparently aware of the insufficiencies of both unbridled passion and the placid joys of domestic life, and he tried to show how one can use art and fantasy to compensate for the barrenness of modern life.[40]

Alfred, Lord Tennyson displays in his *Idylls of the King* an attitude that is ambivalent only in that he appears to have a certain sympathy for Lancelot and Guenevere, despite the fact that he (unlike Malory) identifies their sinful love as the cause of the destruction of Arthur's realm. But his heartless portrayal of

39. His sources were Théodore de la Villemarqué, "Les Poèmes gallois et les romans de la Table Ronde," *Revue de Paris*, 3rd series, 24 (1841), 274–75, and "Visite au Tombeau de Merlin," *Revue de Paris*, 2nd series, 41 (1837), 45–62. He read Dunlop only after being advised to use it as a preface to his poem in order to compensate for his oblique mode of storytelling.

40. Taylor and Brewer, pp. 79–85. Leavy has suggested that the inclusion of the story of Merlin and Vivian shows the forbidden attraction that passionate women like Iseult of Ireland and Vivian held for Victorian men like Arnold.

the parallel love of Tristram and Isolt in "The Last Tournament" (1871) seems calculated to show the extreme degradation of that form of love (which in this version no potion excuses). This idyll, which springs almost purely from the poet's imagination, features little action: at what is fated to be the last Arthurian tournament (presided over by Lancelot), Tristram wins the prize—a ruby necklace donated by Guinevere (for whom it symbolizes the innocent death of a foundling she had adopted)—and takes it back to Isolt in Tintagel, where, as he sits harping to her, he is brutally slain by Mark. The bulk of the episode is devoted to dialogues engaging Tristram first with Dagonet the Fool and then with Isolt. Tennyson situates the lovers' story in one of the last of the *Idylls* (in a depressing autumnal setting), just before Guinevere's retreat to the convent, and utterly transforms Malory's most courteous of knights into a crude, haughty, and self-indulgent rebel who sings the praises of free love while cynically debunking the vows that Arthur's knights used to respect. His celebrated harping skills are seen by Dagonet as making "broken music," a disharmonious cacophony that contrasts with the "harmony" of Arthurian ideals. Tristram appears just as unprincipled in his love relationships, blithely breaking vows to both Isolts. (See Taylor and Brewer, 117–20.)

Considerably more positive in conception is *Tristram of Lyonesse* (1882), Algernon Charles Swinburne's exuberant paean to the lovers, which may have been influenced by Wagner and was written in reaction to his English predecessors' innovative— and, in the case of Tennyson, degrading—treatment of "the dear old story" he remembered so fondly from his youth.[41] Following the "Prelude," an extremely lyrical celebration of Love where Iseult, a veritable Pre-Raphaelite beauty, appears as the April star along with other great female lovers from Helen (January) to Guenevere (December), Swinburne presents in nine cantos a series of tableaux comprising the decisive moments of the story, from the drinking of the potion through the lovers' sojourns before and after Tristram's hapless marriage and their eventual death. We are witness to Tristram's battles with the giant Urgan

41. *The Swinburne Letters*, ed. Cecil Y. Lang, 6 vols. (New Haven: Yale University Press, 1959–62), IV, 260.

(an episode drawn from the Thomas-Gottfried tradition) and
with the double for whose sake he is mortally wounded, and
other Arthurian material is introduced in the lovers'
conversations, which focus on the loves of Lancelot and
Guenevere and of Merlin and Nimue. As in Arnold's poem,
Iseult of Brittany plays a sizable role, particularly in her waiting
mode, which echoes the lovers' various vigils and parallels their
stay at Joyous Gard. Although she is presented positively at first
(with Tristram musing sadly that she will never know the joys of
motherhood), bitter jealousy eventually transforms her gentle
radiance into the dark instrument of Fate, striking Tristram dead
with the false report of the black sail. Because the lovers are
under the sway of Love and Fate, they are victims of "sinless
sin," a fact to which they allude only occasionally, so aware are
they of loving each other more than God. Swinburne wanted the
story to have the scope of a classical tragedy, and, while the
potion can hardly be considered a tragic flaw, the treatment is
both epic and lyrical. Tristram and Iseult seem born of the sun
and immersed in nature, with which they are in communion
throughout their lives and after death. As in Tennyson, the
change of seasons from spring to winter serves to mark the
progression of their lives, but the daily succession of glorious
dawns constantly renews them. The sea, which plays such a
prominent part in the legend, not only conveys the protagonists
between Ireland, Cornwall, Camelot, and Brittany, but also
provides the backdrop for their vigils on the strand and
eventually engulfs their tomb, taking the lovers to its bosom.
Swinburne's sensuous natural imagery heightens the intensity of
the lovers' frustrated desire and places his provocative version in
a universalizing context so as to render it more morally
acceptable and justify the blend of medieval motifs with modern
psychological expression.[42]

42. See Taylor and Brewer, pp. 149–59, and Harrison.* In
Swinburne's Medievalism, Harrison also discusses Swinburne's earlier
treatment of the Tristan material in *Queen Yseult*, a long unfinished
poem (only six of the ten planned cantos) following Tristram from his
birth to his marriage, and "Joyeuse Garde," which may have been a
continuation.

The Legend in Germany in the Nineteenth and Twentieth Centuries

In the English and Romance prose versions of the Middle Ages, Tristan was eventually inducted into the Round Table, but he remained aloof from the Arthurian realm in the German and Scandinavian versions, as previously noted. Thus, the legend was revived in Germany as an independent story rather than as one of a series of Arthurian tales. This revival was due, as in Britain, to the fascination that the Middle Ages held for the Romantics and to the prodigious work of medievalists imbued with a desire to rediscover and make accessible the masterpieces of Germany's past. In the period from Eberhardt von Groote's 1821 edition to Friedrich Ranke's in 1930, at least ten editors tackled the *Tristan* poems, mostly those of Gottfried and his immediate successors; in the same period, there appeared, starting with Hermann Kurz's 1847 modern German rendering of Gottfried, four translations and two prose adaptations.[43] The abortive retellings by Romantic poets (Schlegel, Platen, and Rückert) testify to the difficulty of reconciling the adulterous, worldly love depicted by Gottfried with the Romantic conception of love as a semireligious, otherworldly phenomenon. A significant plot alteration seen in Karl Immermann's more successful (but also incomplete) verse romance (*Tristan und Isolde*, 1841) reveals the dilemma faced by many German poets and dramatists, namely, how to portray the divine quality of passion while upholding the "sanctity of the moral code" (Batts,* p. 512). In the first part of the poem, the lovers are prepared to atone for their sin by devoting themselves to the cause of the Church, and Isolde, after emerging unscathed from her ordeal, determines to adhere to public morality, thus refusing to see Tristan again until the moment of his death.

It was, of course, Richard Wagner's celebrated "music-drama" *Tristan und Isolde* (published in 1859, first performed in 1865) that was to revive the legend most decisively not only in

43. See Adams for the nineteenth- and early twentieth-century German editions and translations of the medieval Tristan texts.

Germany but all over Europe. Indeed, it is to Wagner that most nonspecialists today owe their knowledge of the Tristan legend. This is in some ways unfortunate, for his opera, which concentrates on pivotal moments of great emotion that lend themselves particularly well to musical expression, offers not only a drastic simplification of the legendary plot and cast of characters but also a radical transformation of the meaning of Tristan-love, a change that would have a profound effect on the way the legend was viewed, both as it was reinterpreted by modern adaptors and also—more problematically—as early critics sought to elucidate the meaning of the medieval texts.[44]

Because the movement of the opera is essentially psychological (internal), there is very little action. Background material is furnished by the lovers in their reminiscences as "incidents remembered in, and blindingly illuminated by, emotion."[45] Thus, the plot, adapted from Gottfried and doubtless influenced by Immermann, is easily summarized. Act I takes place on board the ship bearing the lovers to Cornwall. Isolde is beset by strong conflicting emotions: although she already loves Tristan, her resentment of his willingness to relinquish her to Mark and her desire to avenge the death of Morholt (here, her fiancé) lead her to propose to Tristan that they consume what they think is poison. Unaware that Brangaene has substituted the love potion, they feel free to express openly a strong mutual passion that reaches a high pitch just as the crew prepares for landing. For Act II, Wagner condensed into a single moment of tryst and betrayal all the lovers' secret meetings and their enemies' attempts to catch them. The extraordinarily protracted moment known as the "love duet" is an outpouring of the ecstasy experienced by the lovers in an intense spiritual union fostered by Night, which frees them momentarily from the

44. It influenced not only a whole generation of early medievalists, but also Denis de Rougement's controversial—and highly influential— interpretation of the medieval legend, which betrayed little understanding of Gottfried. (See n. 76 below.)

45. Newman, p. 204. For a comparison of Wagner and Gottfried, see Curtis, "Wagner's *Tristan und Isolde,*" and Frederick L. Toner's entry on Wagner in *New Arthurian Encyclopedia*, ed. Lacy, pp. 502–05.

clashing, embracing and well-nigh engulfing one another."[49] The ceaseless modulation increases the tension until, at the end of the "Liebestod," the long-awaited B major chord finally provides resolution.

The association of love with death has always been a part of the Tristan legend, but the "Liebestod" had a very different meaning for the earliest medieval poets. In Thomas's version, the dying Tristran tells Kaerdin to remind Ysolt of all they have suffered since they "drank their death," but if separation from each other has caused them great suffering, so has their effective alienation from a society of which they would have preferred to be a part. The major conflict posed is between the desire to enjoy fully their deep passion and the wish to be wholly integrated into society.[50] Although death proves to be the only way out ultimately, they do not yearn for death (or even transfiguration), unlike Wagner's lovers, who seem to welcome the prospect from the very beginning. Nor does their union go unconsummated as it apparently does in the opera, where the death wish is a craving for physical as well as spiritual union. In the medieval versions, the lovers consummate their love soon after drinking the potion and renew their physical relationship as often as they can in future meetings. This cyclical movement gives way in Wagner to a linear one in which the lovers' passion is prolonged in an agonizing anticipation of final fulfillment that can only be in death. Wagner's *Tristan* "apotheosizes the unhealthiest Eros— the boundless desire for a suicidal union with the Infinite, objectified in a human love impossible of fulfillment" (Zuckerman, 24).

The effect of Wagner's *Tristan* was immediate and enduring. It exercised a prodigious influence generally on the music, art, and literature of the late nineteenth and early twentieth centuries throughout the West and its impact on the

49. Richard Wagner, "Ludwig Schnorr von Carolsfeld," *Sämtliche Schriften und Dichtungen,* 12 vols. (Leipzig: Breitkopf & Härtel, 1911), VIII, 186; cited by Zuckerman, p. 19.

50. See Curtis, "Wagner's *Tristan und Isolde,*" and Grimbert, "Love, Honor, and Alienation."

history of the legend's interpretation is incalculable.[51] As in the case of the English Romantics, it sparked a renewed interest in the medieval Tristan, encouraging scholars like Jessie Weston and Adolf Bonilla y San Martín to make available to the public the medieval sources in English and Spanish literature, respectively, of "Wagner's legends." The opera stimulated an enormous wave of new retellings, especially in dramatic form, but it also influenced literary technique generally, most notably in the use of the musical leitmotif to convey a particular recurrent feeling. Marcel Proust, for example, in his monumental *A la recherche du temps perdu* ("In Search of Lost Time," published in English as *Remembrance of Things Past*), uses the "petite phrase" from Vinteuil's sonata as a central motif whose evocative power is explicitly related to Wagner's *Tristan*. (Swann thinks of it as the national anthem of his love for Odette.) The technique of the leitmotif, transposed to literature in the form of a phrase, symbol, image, or allusion, was to be used increasingly in the modern novel, whose various parts tended to be related in a spatial rather than linear pattern.[52]

Wagner was also responsible for another, more flamboyant—Nietzsche was to call it "dangerous"—effect, giving rise to the phenomenon of "Tristanism," which affected poets, novelists, and composers who appeared to be overwhelmed by or totally infatuated with the music (Zuckerman, 30–31). Indeed, the opera spawned a number of works in which the musical score plays a prominent catalytic role, kindling the flame of passion in the hearts of those who hear it, much as the romance of Lancelot and Guenevere had served as the Galeotto for Dante's Francesca and Paolo. For some, as in the case of the protagonists of Thomas Mann's novel

51. Wagner's influence and that of English Romantic poets on British art are examined by Poulson.* For his influence on literature generally and the resulting transformation of the legend, see Furness, *Wagner and Literature*.

52. On this technique generally, see Furness, *Wagner and Literature*, pp. 7–19; on Mann's use of the technique with specific reference to Wagner, see Frank W. Young, *Montage and Motif in Thomas Mann's "Tristan"* (Bonn: Grundmann, 1975).

Buddenbrooks (1900) and novella *Tristan* (1902), the effect of the music is not simply overpowering, it is unwholesome. This is particularly true in cases where the "Liebestod" is used to convey the notion that the ultimate consummation is death at the moment of sexual climax.[53]

Both Immermann and Wagner influenced the German writers who in the last half of the nineteenth century recast the legend in dramatic form, usually in blank verse.[54] These include Josef Weilen's *Tristan* (1860), Ludwig Schneegan's *Tristan* (1865), Albert Gerhrke's *Isolde* (1869), and Adolf Bessel's *Tristan und Isolde* (1895).[55] Invariably labeled tragedies (*Tragödie* or *Trauerspiel*), they betray the playwrights' desire to downplay the elements of the traditional plot that are driven by magic (potions and poisons) and to highlight instead the sad fate of the lovers, portrayed as relatively innocent, whose passion brings them into conflict with a rigid and soulless society that sanctions marriage without love. The potion, if present, generally serves only to reinforce the love that already binds Tristan and Isolde, who attempt to suppress or renounce it, an impulse seen as misguided, despite the difficulty of defying an unyielding and unfair moral code.

Drama also dominated the first decades of the twentieth century, which saw Albert Geiger's *Tristan* (1906), Ernst Hardt's *Tantris der Narr* ("Tantris the Fool," 1909; translated into English as *Tristram the Jester*, 1913), Emil Ludwig's *Tristan und Isolde* (1909), George Kaiser's *König Hahnrei* ("King Cuckold," 1910), Eduard Stucken's *Tristram und Yseult* (1916), Maja Loehr's

53. See Furness,* who focuses on this (decadent) aspect of Wagner's influence in the novels of Mann, George Moore, Maurice Barrès, and Gabriele d'Annunzio, among others. See also Zuckerman, pp. 136–44.

54. The following survey of modern German versions of the legend owes much to three articles: Batts* and, in *New Arthurian Encyclopedia*, ed. Lacy: Batts, "Tristan in Modern German Versions," pp. 465–69, and Richard W. Kimpel, "German Arthurian Literature (Modern)," pp. 188–94.

55. For plot summaries of these plays, see Batts, "Tristan in Modern German Versions," pp. 466–67.

Tristans Tod ("Tristan's Death," 1919), Robert Prechtl's *Trilogie der Leidenschaft: Ysot, Marke, Tristan* ("Trilogy of Passion," 1922), and Joseph-Herter Ammann's *Tristan und Isolde* (1928).[56] While most of these continued the dominant trend of the earlier plays in the attempt to recount in five acts the entire legend from the shipboard scene to the lovers' death, some tried to limit the scope to a few episodes or to the emotions felt by two or three of the main characters. Geiger's two-part play focuses on "Blanscheflur" and "Isolde," while Loehr uses five acts to explore the sense of betrayal felt by the two Isoldes, and Ammann uses two dramatic tableaux to finesse the difficulties of portraying the countless episodes of deception in Cornwall by limiting the first part to the episodes leading up to the potion's consumption and having the second part span the events from Tristan's arrival in Brittany to his death.

Of all of these, only Hardt's retelling of the legend is truly successful, partly because it tries to distill the essence of the legend into the events of a single day set in motion by Tristram's covert return to court following his exile (ten years before) and his marriage. Denovalin, the jealous baron who had first denounced the lovers, claims to have glimpsed Tristram in the woods, and Mark, convinced at last that he has been ensnared by Iseult's lies, determines to hand her over the next day to the lepers. But Tristram, disguised as a leper, disperses the group, kills Denovalin, and leaps from the castle walls, thus convincing the Cornish that God has reiterated his belief in the lovers' innocence. That night, Tristram reappears in court as a jester named Tantris and reveals such intimate knowledge of Iseult that she retires in dread. Unable to convince her of his true identity during a last interview at dawn, he tries at least to defend his "friend" Tristram as Iseult exhales her bitter feelings of betrayal. In a desperate gesture, she sends him off to see his dog, Husdent, which has gone mad with rage since his departure, then learns too late the jester's true identity upon seeing him head into the woods with his joyful canine

56. For plot summaries of these plays, see Batts, "Tristan in Modern German Versions," pp. 467–68. Discussion of the plays by Hardt and Kaiser is also included in Batts.*

companion. This moving rendition draws its power from the portrayal of the complex emotions aroused in the three protagonists, all of whom earn our compassion.

Despite Kaiser's importance for German Expressionist drama, his *Tristan* drama is disappointing, although it is certainly worthy of note as one of the more bizarre subversions of the legend. It explores the potential for perverse pleasure in the love triangle, since the aging king, disturbed by his inability to possess Isolde, is acutely aware of the sexual currents passing between her and others, including the one he imagines between her and her little brother. Though jealous, he is a most unusual cuckold in that he derives a vicarious thrill from the affair between his wife and nephew, which he purposely prolongs. Similarly, the source of the lovers' passion stems from their knowledge that it is illicit. Consequently, their death, and that of their love, occurs when Mark reveals his voyeuristic desire: revolted by his command to embrace openly before him, they refuse and are summarily put to death by him.

Interest in the Tristan story declined in Germany during the National Socialist period but was revived in the late 1960s. Of the few works produced during the period of relative eclipse, three are noteworthy for their attempt to subvert the legend. The Austrian known as Wilhelm Kubie wrote a novel *Mummenschanz auf Tintagel* ("Masquerade at Tintagel," 1937, 1946), in which Bedivir, taking Mark's side, narrates the lovers' story as a farce. Denounced as a delusion are not only their love but also Arthurian ideals as a whole. The two other works are both attempts at contemporary versions of the legend. In Karl Albrecht Bernouilli's *Tristans Ehe* ("Tristan's Marriage," 1926), Marke appears as an American millionaire whose wife becomes unbalanced following Tristan's disappearance. The novel focuses on her psychiatric treatment, which ensures the "happy" ending in which the lovers are reunited with their spouses. Hans Erich Nossack's *Spätestens im November* ("November at the Latest," 1955; published in English in 1982 as *Wait for November*) is not immediately recognizable as a retelling of the legend. Set in postwar Germany, it focuses on the affair between a writer and a rich industrialist's wife, who, finding their love diminished by society's tolerance of it and bored with their life together, seek

transcendence in death. Because the traditional conflict with society becomes one that divides the lovers against themselves, the novel seems to question the legend's ability to live on productively into the modern age.[57]

The revival in the late 1960s of the Tristan legend, and indeed of Arthurian legend in general, was partly in response to the desire of both the German Democratic Republic and the Federal Republic of Germany to define their respective national identities by emphasizing their cultural heritage (Kimpel, 190). In this latter part of the twentieth century, prose fiction has been the dominant genre, ranging from Ruth Schirmer-Imhoff's fairly traditional retelling, *Der Roman von Tristan und Isolde* ("The Romance of Tristan and Isolde," 1969), to more politically motivated celebrations of the legend as an important part of German culture, such as Günter de Bruyn's idealizing *Tristan und Isolde* (1975). Bruno Gloger's *Dieterich: Vermutungen um Gottfried von Strassburg* ("Dieterich: Speculations About Gottfried von Strassburg," 1976) features a pseudo-biography of the medieval poet—about whom nothing is really known—used as a frame for Gottfried's *Tristan*.

The modern period has also been characterized by a desire to combine the medieval text with images and music and thus to interpret the legend simultaneously in several media. The movement is in some sense anticipated by two attempts to marry text and image: Leo Stettner's *Tristan und Isôt: Ein Spiel nach einem alten Wandteppich* ("A Play Based on an Old Tapestry," 1964), in which the characters emerge from a tapestry to perform their story, and Lawrence Lacina's *Tristan und Isolde: 21 Kaltnadel-Radierungen von Salvador Dali* ("21 Drypoint Etchings by Salvador Dali," 1969), featuring a greatly abbreviated text. Hans Werner Henze's orchestral work *Tristan, Prelude für Klavier, Tonbänder und Orchester* ("Prelude for Piano, Tape Recorder, and Orchestra") combines medieval music (*Lamento di Tristano*— "Tristan's Lament"]) and the music of Wagner's *Tristan* and the

57. Batts* discusses Nossack at length. For Bernouilli, see Batts, "Tristan in Modern German Versions," p. 467, and for Kubie, see his entry by Siegrid Schmidt and William C. McDonald in *New Arthurian Encyclopedia*, ed. Lacy, p. 264.

Wesendonck song (*"Im Treibhaus"*—"In the Conservatory"), as well as passages from Brahms and Chopin, with verses from Thomas describing Isolde's death; the legend is used here to depict "the total misery of humanity."[58]

Text, music, and image are also combined in three films made in the 1980s in Germany and Scandinavia. The most recent are Hrafn Gunnlaugsson's *I skugga Hrafsina* ("In the Shadow of the Raven," 1988), an Icelandic-Swedish film, and Jytte Rex's *Isolde* (1989), a Danish film that transposes the legend to modern times. In *Feuer und Schwert* ("Fire and Sword," 1980), Veith von Fürstenberg focuses on political interests he imagines in the relations between Ireland and Cornwall, and consequently in Marke's relations with his wife, nephew, and Andret, who eventually betrays him by allying himself with Ireland to obliterate Cornwall. The film shows the effect of the forces of economic determinism, which individuals cannot oppose without destroying both the social order and themselves. "Fire and sword" eventually reduce this world to "fire and ashes" (the original title) in an apocalyptic vision in which Marke's Cornwall perishes, followed by the lovers, whose death—loosely patterned after Thomas's version—occurs in Brittany, presumably, where Tristan has been wounded rescuing a woman he dubs "Isolde" from the ravages of marauders. In the closing shot, Governal builds a pyre on the edge of a cliff, where the lovers' bodies, consumed by flames, are reduced to ashes and scattered to the winds. Noteworthy in this idiosyncratic interpretation is the dominant role played by Isolde, who prepares the potion specifically to conquer her lover's resistance to her idea that they refuse to sacrifice their love to their country's political ends and who engineers the lovers' return from the forest in response to Dinas's urging (which, paradoxically, awakens her political conscience).[59]

58. In *New Arthurian Encyclopedia*, ed. Lacy, see the entries by Siegrid Schmidt and Peter Meister on Stettner, p. 432, and Lacina, p. 267, and by Ulrich Müller and Wayne Stith on Henze, p. 230.

59. All three films are discussed briefly by Aubrey E. Galyon and Kevin J. Harty, "Films," in *New Arthurian Encyclopedia*, ed. Lacy, pp. 154–55. My discussion of *Feuer und Schwert* owes much to Alain

The Legend in France in the Nineteenth and Twentieth Centuries

Although Tristan was among the Arthurian knights held up as examples of chivalric nobility by French authors in the seventeenth and eighteenth centuries, the legend as love story produced no works of compelling interest in that period, partly, no doubt, because the Prose *Tristan* was the only Old French version known. In the Comte de Tressan's abridged retelling of that work, *L'Histoire de Tristan de Léonois* ("The Story of Tristan of Lyonesse," 1781), the lovers' passion takes the diluted form of a pastoral. The legend was not really revived in a form anywhere near its early grandeur until the discovery by Francisque Michel of the Old French Tristan poems by Béroul and Thomas. Michel published them in 1835–39, adding a long introduction in which he detailed the appearance of the legend in the literature of various countries and discussed Tristan's historical connections. The publication by scholarly journals of summaries of the Prose *Tristan* and other Arthurian works also helped make the legend known throughout Europe, but it was really Wagner who initially served as the catalyst for artists and writers, exercising a profound influence on Charles Baudelaire, Stéphane Mallarmé, Paul Verlaine, and their symbolist successors in their quest for a new language that would evoke the artist's aspiration to escape from the material world toward the spiritual realm.[60] The combined influence of Wagner and these poets no doubt accounts for the tendency of many modern French authors to spiritualize the legend, to see the lover's inexorable itinerary in life toward death principally as a quest for transcendence.

Kerdelhue, "*Feuer und Schwert*; Lecture matérielle du mythe: Un Film de Veith von Fürstenberg (1980)," in *Tristan et Iseut: mythe européen et mondial*, ed. Buschinger, pp. 181–98.

60. The *Revue Wagnérienne* was founded in 1885. On the impact of Wagner on French poetry, see Furness* and the chapter in Furness's book called "Symbolism and Modernism." See also Linden's study on the reception of the legend in France from the end of the eighteenth to the beginning of the twentieth century.

While Wagner's impact on modern French literature generally has been enduring, the single most influential force shaping the Tristan legend in the twentieth century has been the distinguished medievalist Joseph Bédier, whose celebrated retelling appeared in 1900 and was an immediate and lasting success. His *Roman de Tristan et Iseut* ("Romance of Tristan and Iseut") was an attempt to reconstruct for the general public a version of the legend that would approximate the archetype (*estoire*); consequently, he used primarily Béroul and Eilhart, although he incorporated elements of other medieval versions as well.[61] His flair for prose enabled him to combine characteristics of Béroul's style with modern "novelistic" elements in order to tell a story that would at once seem remote in time and be comprehensible to modern readers.[62] But as his successors were to observe, in the effort to create a seamless narrative and coherently motivated characters, he attenuated much of the force of the medieval versions he claimed to celebrate. Tristan, Iseut, and Marc are depicted with great sympathy and imbued with the noblest and tenderest of feelings, which are only occasionally overridden by a surge of paranoia, jealousy, or anger easily imputable to their impossible situation. In such a context, it would have been unseemly to preserve the comic tone of Béroul's text that characterizes the Orchard Tryst and the Mal Pas episodes. Bédier uses these moments more to demonstrate God's sympathy for the lovers' plight than to showcase their extraordinary talent for deception and their delight therein.

61. He had studied all of the known medieval poems and romances, identifying the common elements that related various versions in an effort to reconstitute the two major traditions, those of Béroul and Thomas. His reconstruction of the latter tradition, *Le Roman de Tristan par Thomas*, published in 1902, was accompanied by a volume of notes and commentary in which he also pieced together the *version commune*.

62. Although Bédier claimed in a note added to Gaston Paris's preface to his romance that he had tried to avoid mixing our modern conceptions with the old forms of thought and feeling, he admitted that it was a somewhat fanciful ambition. On Bédier's transformation of the legend, see Gallagher* and Gunnlaugsdóttir.

Bédier's romance was reprinted hundreds of times and translated into numerous languages (into English by none other than Hilaire Belloc). His influence was both prodigious and wide-ranging, but, oddly enough, it was not of the kind to inspire a large wave of creative retellings among his compatriots. Indeed, it may well be his tremendous authority and prestige that account for the relative paucity of twentieth-century French versions, especially compared with the enormous Anglo-Saxon production.[63] The weight of his influence is, of course, particularly clear in the case of his direct successors, medievalists who applied themselves to the very task he had set for himself: to combine the medieval sources in a modern prose retelling that would faithfully reflect, if not the letter, at least the spirit, of the earliest texts. The first to follow in his footsteps was André Mary, who published his *Tristan* in 1937, accompanied by a section of explanatory notes on medieval life.[64] Following an elaborate preamble of his own invention imitating prologues from other medieval texts, Mary's version features a surprisingly literal rendering of the extant portions of the twelfth-century texts, but the rest of the narrative follows Bédier's principle of weaving elements from various sources into a somewhat romanticized whole.

Following Bédier's death in 1938, several more medievalists attempted retellings. While Pierre Champion worked with a different source for his *Roman de Tristan et Yseut:*

63. In his 1931 study on the legend in Anglo-American literature of the nineteenth and twentieth centuries, Halperin had noted with some surprise the apparent reluctance of major French authors to treat the legend.

64. For the 1941 edition, he expanded the title to include a telling capsule description: *La Merveilleuse Histoire de Tristan et Iseut et de leurs folles amours et de leur fin tragique, avec toutes les aventures s'y rapportant, restituée en son ensemble et nouvellement écrite dans l'esprit des grands conteurs d'autrefois"* ("The Wonderful Story of Tristan and Iseut and of Their Mad Loves and Tragic End, with All the Related Adventures, Reconstructed in Its Entirely and Newly Told in the Spirit of the Great Storytellers of Old"). Mary's version has been reprinted several times. The 1946 edition features a preface by Jean Giono; the 1973 one, a preface by Denis de Rougement.

traduction du roman en prose du quinzième siècle ("Romance of Tristan and Iseut: A Translation of the Fifteenth-Century Prose Romance," 1947),[65] Robert Bossuat, Pierre d'Espezel, and René Louis all took up the challenge of working with the same sources as Bédier. They were clearly at pains to pay homage to their illustrious predecessor while asserting the need to remove the Romantic veneer that in his version obscured the lively spirit of the Celtic sources. Justification for such an enterprise could be found in the research of students of Celtic culture and mythology, such as Henri Hubert, Jean Marx, and Jean Markale.[66] In his *Tristan et Iseut, conte du XIIᵉ siècle* ("Tristan and Iseut, a Story from the Twelfth Century," 1951), Bossuat touts Béroul's version as being closest to the hypothetical *estoire*, with characters that reflect the primitive, irrational impulses of Irish and Welsh heroes. D'Espezel, on the contrary, deliberately eschewing the notion of an archetype, makes it clear in his title, *Tristan et Iseut renouvelé d'après les manuscrits de Thomas, des deux Béroul et de la Folie Tristan de Berne* ("[The Romance of] Tristan and Iseut, Reconstructed from the Manuscript of Thomas, the Two Bérouls, and the Berne Version of 'Tristan's Madness,'" 1956), that he is drawing on several extant texts for specific elements that demonstrate how the legend "sprang from Celtic and pagan sources, from a world where . . . love is a force of fate stronger than social bonds, where . . . the lives of all are subject to magic."[67] Both render Béroul faithfully and provide an abbreviated version of Thomas, but d'Espezel eliminates those scenes from the Thomas tradition that he sees as later additions, even substituting for Thomas's ending the one preserved in the

65. Champion explains that he carved his Tristan out of the version of the Prose *Tristan* (contained in B.N. MS 103) that derives most directly from Thomas's poem (p. 33). A recent edition of Champion's retelling contains a preface by Michel Tournier.

66. The most elaborate example of the process of homage and justification can be found in d'Espezel's introduction to his version and in Jean Marx's preface.

67. Here and throughout this section on modern French versions, I have translated into English all quotations cited from the various prefaces and texts.

Prose *Tristan* (although the poisoned lance that Marc uses to kill Tristan comes not from Morgan the Fay, but rather from Duke Morgan, Rivalen's murderer!). To an even greater degree than Bossuat and d'Espezel, René Louis (*Tristan et Iseult*, 1972) seems determined to underscore the "primitive or barbaric traits" and to "eliminate as much as possible the chivalric and courtly backdrop" (preface) that he sees as a betrayal of the original story. However, he embeds the featured traits in so much explanatory material of his own invention that the desired effect is lost. His most daring innovation vis-à-vis his French sources is his handling of the potion scene: Brangien, seeing that Iseult is in love with Tristan and would welcome the chance to thwart his plan to marry her to Marc, offers the cup to her mistress, who, fully aware of its contents, drinks it and passes it to the unsuspecting Tristan. Thus, whereas the heroine is portrayed in most versions as a victim of fate, here she takes her destiny into her own hands.

The most recent retelling by a scholar is *Tristan et Iseut* (1985) by Michel Cazenave, with a preface by Jean Marx. Cazenave's stated ambition is to return the legend to its roots in Celtic and pre-Celtic mythology by removing two layers of artistic interpretation that he believes have obscured the myth's original meaning. Rejecting both Wagner's Romantic vision of a transcendent end for the lovers and the tragic overtones imposed by a Christian feudal perspective in the twelfth-century continental versions, Cazenave seeks to show how Iseut and Tristan, creatures of the sun and moon, respectively, participate in a common network that links all living creatures in a universe presided over by a pre-Christian God of love. While his adherence to the general plot outlined in the extant medieval texts tends to obscure this optimistic vision, the addition of certain significant details does underscore the lovers' privileged situation within the universe: Tristan spends seven years (the moon's cycle) under the protection of women; the love potion is consumed at high noon on the eve of the Feast of Saint John (summer solstice); the potion's effects wear off exactly three years later; and the lovers die at midnight on the eve of the winter solstice. After recounting the traditional epilogue, the narrator substitutes another: Brangien and Kaherdin put the

lovers side by side in an open boat and push it out to sea, watching it head "toward Ireland or the Blessed Isles, where love is bound by no laws other than those of the sun's light, the harp's sweet sound, and the heart of a woman in love."

Unlike the retellings produced by scholars, those undertaken by nonmedievalists generally offer a simplified version of Bédier (in editions adorned with illustrations[68]) or bend the legend unapologetically to their own or to popular tastes. Marcelle Vioux's *Tristan et Yseult, amants éternels* ("Tristan and Yseult, Eternal Lovers," 1946), appearing in a collection called "Les Destinées romantiques" ("Romantic Destinies"), alludes to a bond that linked the lovers in another existence before they were reunited on earth. Vioux recounts the legend like a novel, describing at length the lovers' feelings, which, like Marc's, are generally honorable, and supplying modern psychological motivation for most of their decisions. They feel guilty about deceiving Marc by their deceptive exchange in the orchard (and, thankfully, do not have to execute the traditional farce at Mal Pas). The mercy Marc shows them by sparing them in the Morois—more intolerable to them than his hatred—is a factor in their decision to leave, as is their guilt about depriving each other of the life each deserves. Initially, Tristan actually considers returning home to Léonnois ("in Brittany") with Yseult in tow, but his people make it clear that they will not accept her. (Much earlier, Yseult had shown a similar desire to defy society in a peculiarly modern way by suggesting—after drinking the potion—that they return to Ireland rather than going on to Cornwall.) While medieval and modern elements generally exist side by side—Marc throws dances as well as tournaments to celebrate an earlier return to court by Tristan—Vioux clearly finds it necessary to rationalize certain motifs. The "dragon" that

68. E.g., Blaise Gautier, *Tristan et Iseut* (1958) with illustrations by Jean Garcia; and Michel Manoll, *Tristan et Yseult*, with illustrations by Gilles Valdès (1959), rpt. 1971, 1981 with illustrations by Michel Gourlier. A recent trend has been to publish illustrated manuscripts of the Prose *Tristan*, such as Codex 2537 housed in the Vienna National Library, e.g., Gabriel Bise, *Tristan et Iseut* (1978), and Cazenave's edition (cited in n. 72).

Tristan slays is actually the leader of a band of Nordic pirates who terrorizes the Irish coast by donning a dragon head and covering his body with seal skins.

In the hands of modern poets like Yves Viollier and Pierre Dalle Nogare, the legend is totally transformed. For his *Un Tristan pour Iseut* ("A Tristan for Iseut," 1972) Viollier, a Breton poet who as a youth was "initiated into the secrets of plants" (according to the jacket blurb), imagines the story set in a small village in contemporary Vendée, where Tristan attends a dance and gets into a fight with a local youth, Morhout, whom he kills after receiving a wound that only Morhout's father can heal. At the farm where he goes for successive herbal treatments, he sees Iseut, and, although the two are aware of a mutual attraction (especially after Tristan, now cured, is offered a sweet wine that tastes like nectar), they renounce any thought of marrying, since Tristan is responsible for the death of Iseut's cousin Morhout. But during a final meeting in the fields on the eve of Iseut's wedding to "Monsieur Marc," they conceive an uncontrollable passion for each other after tasting an aphrodisiac mint. It is the subsequent separation from Iseut that causes Tristan to languish and to come under the influence of Iseut aux Blanches Mains, who proves to be death.

The lovers share a similarly intimate bond with nature in Nogare's poetic rendering, *Tristan et Iseut* (1977), but the tone is much more contemplative. Presenting his story as a "long chant full of dreams and fatality," Nogare traces the lovers' itinerary through the events of the traditional legend, which they experience in a somnambulic daze. Nothing appears to be premeditated, whether it is Tristan's combat with the dragon or Iseut's ambiguous oath: what the two do and say is seen and heard by them as impressions that appear on the margins of their consciousness like the flickering light in the sky and on the sea, to which they are extremely sensitive. Their passivity stems in part from their knowledge that they are following a destined path. This veritable prose poem begins with a languishing Tristan drifting in his boat (toward Ireland) in hope of finding that mythical magic island where he will be cured. The sea imagery is echoed at the end as Iseut arrives in Brittany by boat and, finding her lover dead, stretches out over him and loses

herself in him, thus recalling the opening lines of the prologue—
"It can happen that love and death are a single word for two
people: thus it was for Tristan and Iseut, who came into this
world to recognize and name each other and to lose themselves
in each other."[69]

Although Bédier has dominated the prose retellings,
Wagner's influence is also evident, particularly in
"metaphysical" renderings like Nogare's, but his greatest impact
has naturally been in the area of drama. Because the majority of
versions written in the first half of this century were in dramatic
form, they came under the sway of both men. Bédier himself
wrote a play with Louis Artus (*Tristan et Yseult*, 1929), featuring
music by Paul Ladmirault.[70] Other plays include Armand
Silvestre's *Tristan de Leónis*, performed at the Comédie Française
in 1897); Saint-Georges de Bouhélier's *Tragédie de Tristan et Iseult*,
performed in Paris in 1923; Ernst Moerman's *Tristan et Yseult*,
first performed in Brussels in 1936; and Lucien Fabre's *Tristan et
Yseult*, 1945. There was even an oratorio by the Swiss composer
Frank Martin, *Le Vin herbé* ("The Potion," completed in 1940),
which followed Bédier, and an opera by Sylvain Arlanc (and
Paul Gautier?), *Tristan et Yseut: version nouvelle d'après la légende
des trouvères* ("New Version Based on the Legend of the
Trouvères," 1943).

The most innovative French play inspired by the legend
was Paul Claudel's *Partage de Midi* ("Break of Noon," 1948; first
performed in 1949, but a confidential edition of an earlier draft
appeared in 1906). It borrows elements from the legend to
present the conflict inherent in the love of a man and a woman
between the appeal of the flesh and that of the spirit. Claudel

69. Nogare's adaptation, originally illustrated with lithographs by
Peverelli, was republished in 1991 by Michel Cazenave, whose
commentary describes the legend; it is lavishly illustrated with
miniatures from a manuscript of the Prose *Tristan* (Codex 2537, Vienna
National Library) described by Edmond Pognon.

70. The three acts, which span the events from the barons'
attempts to vilify Tristan to the lovers' death, highlight even more
strikingly than Bédier's original prose romance the Romantic aspects of
his interpretation that his successors have criticized.

patterns the three acts of his play after Wagner, the better to oppose the ethos celebrated in the opera. In a boat headed for the Far East, a young man, Mesa, whose attempt to devote himself to the religious life has recently been "rejected" by God, and a married woman, Ysé, conceive a powerful mutual attraction that they attempt in vain to resist. For the second act, Claudel uses a scene that at once inverts the image of the traditional garden refuge of the lovers and recalls the Fall. He situates the lovers' rendezvous in a Hong Kong cemetery, where they consummate their forbidden love as the black flame of passion reflected in their eyes signifies the rending of their souls. Ysé recognizes it as a travesty of marriage—not a union, but a rupture—and sees herself surrendering to her love a "dowry" composed of her name and her honor, her husband's name and joy, and her children. In the final act, the rather convoluted plot leads at last to the lovers' death, where, freed of the call of the flesh, they are finally united in spirit at the point that separates Time and Eternity. But Ysé's embrace here is redemptive, and the light of divine grace shines through as they reach the point of ultimate light and clarity.[71]

One of France's best-known and most fascinating retellings is Jean Delannoy's film *L'Éternel Retour* ("The Eternal Return," 1943), with music by Georges Auric, whose music also accompanied Georges Beaume's 1951 radio adaptation. Jean Cocteau wrote the screenplay, situating the legend in modern times. Although forced to consolidate certain episodes, his adherence to the legendary plot is remarkable, and many of his transpositions are ingenious—and not without humor.[72] Patrice (Tristan) rescues Nathalie (Iseut)[73] in a bar where she is being bullied by her ardent suitor, Morholt, who stabs him in the thigh. Restored to health by Nathalie and her foster mother, Anne, Patrice persuades the young woman to marry his widowed

71. See Furness, *Wagner and Literature*, pp. 87–88, and Brunel.

72. For a detailed summary of Cocteau's changes and an episode-by-episode comparison of his screenplay with Bédier's romance, see Maddux.*

73. The last syllable of each of the names chosen by Cocteau echoes the first syllable of each of the traditional names.

uncle, Marc. He takes her to the chateau where he and Marc live with the Frossins, his deceased aunt's and mother's family, whose malevolence is particularly well distilled in their dwarf son, Achille. Hoping to do away with Patrice and Nathalie, Achille pours into their drinks the contents of a vial marked "Poison"—the love potion concocted by Anne and still unused— which he finds in Nathalie's medicine cabinet. The already close friendship between Patrice and Nathalie becomes passionate (although they apparently stop short of consummating their love), and when the Frossins and Marc surprise them in a compromising situation, they are banished and flee for a short time, only to be discovered by Marc, who takes back Nathalie. Feeling abandoned, Patrice eventually finds work in a garage run by his old friend Lionel (Kaherdin), whose beautiful sister, Nathalie, he proposes to marry on the very island from which he had rescued his first love. But when the two discover his allegiance to the first Nathalie, Patrice decides to return to his uncle's chateau to ascertain whether or not she has truly abandoned him. While there, he is wounded by Achille, and, after returning to the island, he sends Lionel to fetch the one woman who can cure him. Informed by his fiancée that the ship bringing Lionel, Nathalie, and Marc sports as its pennant a black scarf, he dies of despair, as does his love promptly upon arriving.

Cocteau is at considerable pains to rationalize the tale in order to make it believable in a modern setting, but in so doing he risks banalizing the legend, a risk that is compounded by his efforts to eliminate any suggestion of wrongdoing on the part of Patrice and Nathalie.[74] His treatment of the couple's passion offers a clear illustration of the problem. Although the magic potion is retained, it is not consumed until well after Nathalie marries Marc. The young people are drawn together, then, by the force of mutual attraction, and their friendship is reinforced by the natural camaraderie they cannot help sharing in the presence of the aging chatelain and the odious Frossin trio. On the night they consume the potion, their delight at having been left alone in the chateau is such that the effects of the drink might

74. In this, he was clearly influenced by Bédier.

be likened to those of champagne on young people unaccustomed to alcohol. Another of Cocteau's innovations also diminishes the force of the medieval legend: from the moment of her marriage, Nathalie contracts a debilitating illness that, besides its symbolic import, has the merit of freeing its victim from the necessity of ever consummating her marriage to Marc or, indeed, her love for Patrice. Just as Nathalie is allowed to remain pure, so too is Patrice, who incurs his fatal wound in time to prevent him from actually going through with his proposed marriage, let alone its consummation. And given the state of the lovers' health at the end of the film, their death seems more like the logical result of illness than of grief.[75]

In the past fifty years, France has produced a number of innovative versions of the legend that are much less dependent on Bédier or Wagner, or indeed on any particular version; rather, they reflect in vastly different ways the recognition that the romance of Tristan and Isolde is one of the great founding myths of Western civilization, an awareness fostered largely by *L'Amour et l'Occident*, Denis de Rougement's celebrated study of the legend's impact on Western culture.[76] The idiosyncratic but highly influential Romantic interpretations by Wagner and de Rougemont, which gloss over many crucial details that made the various medieval versions of the legend meaningful within the context of feudal times, contributed greatly to the trends toward mystification and demystification that characterize these later interpretations, some of which, however, present themselves as reactions precisely against both modern Romantic and medieval romance influences. There is a desire to reinforce the legend's mythic status either by reducing it to—and, consequently, highlighting—its most universal components in a way that links

75. Starting from his own sense of disappointment with the film, Maddux* analyzes it as it relates to Cocteau's entire cinematic *œuvre*.

76. De Rougement's knowledge of the legend was apparently based primarily on Béroul as presented by Bédier; his knowledge of Gottfried's version was filtered through Wagner. (See Rocher.) For a summary and critique of de Rougement's interpretation, see Rabine* and John Updike's review of de Rougement's *Love Declared* (1963) in his *Assorted Prose* (New York: Knopf, 1965), pp. 283–300.

it to other great Western or Eastern myths, or by accentuating its specific roots in Celtic culture and mythology. While these processes of universalization and particularization are contradictory impulses, both nevertheless challenge to some extent the appropriation of the legend by a patriarchal society as early as the twelfth century.

We have seen traces of this universalizing trend in discussing above the evolution of prose retellings from Bédier to Cazenave, but it is even more obvious in the less traditional treatments of the legend. André Swoboda's poetic film *Noces de sable* ("Wedding in the Dunes," 1949), shot in Morocco, is a retelling of an Islamic legend using texts written by Cocteau, who perceived analogies with the *Tristan*. Mas-Felipe (or Max-Philippe) Delavouët's 500-line poem in Provençal, "Ço que Tristan se disiè sus la mar" ("What Tristan Said While on the Sea," 1971), focuses on the episode where the ailing hero is set adrift in his boat, but it departs dramatically from the tradition. In his monologue, Tristan invokes his "older brother" Ulysses, expressing thereby the desire to rediscover not only his beloved but also his homeland and its concrete realities.[77] Pierre Garnier's *Tristan et Iseult* (1981) is a "spatial poem" in which the legend is reduced to key components (Tristan, Iseult, life, death), natural elements (sun, sea, sky, water), seascape images (rock, sand, wind, sea gull, wave, sail), and so forth, all arranged on the page with symbols to indicate the tensions between these forces in action. As Ilse Garnier explains in the preface, "The lovers form their own constellation among the elements of space and time" While Don Juan represents an open love, Tristan et Iseult represent a love that encloses them in their own time and space. They reject society as it rejects them and retreat into the unity of nature, where they experience the harmony of the inner

77. Claude Mauron, "Un 'Tristan' en provençal moderne: *Ço que Tristan se disiè sus la mar*, de Max-Philippe Delavouët," *Revue des Langues Romanes*, 83 (1977), 181–93.

and outer world combined. Their love is not eliminated by their death, but rather accomplished in eternity.[78]

One of the most stunning representatives of the universalizing trend is Yvan Lagrange's film *Tristan et Iseult* (1972). The opening scene signifies the filmmaker's intention of situating the myth at the intersection of the four main elements, and the interpretation is, according to one critic (Paquette), fundamentally "anthropological" in the sense that it explores the two primordial instincts of the human race: the instinct for individual survival and the reproductive instinct. The numerous combat scenes constitute a ritual "celebration" of war (whose carnage is associated with alimentary needs), and indeed Tristan is depicted essentially as Iseult's breadwinner, intent on that role alone and seemingly oblivious to his lover's other needs. Lagrange, who claims to have read two or three versions of the legend and "forgotten" them, dispenses with specific spatiotemporal links in his "visual opera," presenting an odd juxtaposition of sometimes stunning, often jarring, images that transport the viewer from Iceland to Morocco. His desire to detach the myth from its textual tradition and inscribe it in a timeless framework is conveyed by the musical soundtrack (from the rock group Magma) featuring "lyrics" in a nonexistent phonetic language. Impressionistic and contemplative, the film invites the viewer to react individually with rapture or revulsion, claims Lagrange, whose demystifying intention is nonetheless manifest, especially in the final scene, which returns the protagonists to the primordial chaos. They lie as though in an embryo within the bloody cadaver of a bull (symbol of carnivorous feeding), clenching in their teeth a white rose, once the symbol of anti-Nazi students in Munich. It is a death that shows the incompatibility of our basic instincts: before we can love, we must nourish ourselves—a task that cannot be accomplished without combat (Paquette, 325).[79]

78. See also Ernstpeter Ruhe, "Tristan et Iseut dans l'espace: à propos d'un poème de Pierre Garnier," in *Tristan et Iseut, mythe européen et mondial*, ed. Buschinger, pp. 352–77.

79. Lagrange comments on his method and intention in "Yvan Lagrange: Impressions of a Filmmaker," *Tristania*, 4.2 (May 1979), 44–50.

A wholly different form of demystification is at work in the modern versions of the legend that challenge the dominance of cultural values seen as imposed or superimposed by the continental poets who first appropriated the Celtic legend, and then reinforced down through the ages by successive storytellers and early medievalist scholars. Verlet's *Yseult et Tristan* (1978) is a feminist play that, as the inversion in the title indicates, accords primary importance to Yseult in recognition of the more important role played by women in Celtic culture and in the Irish analogues of the legend. The mysterious and magical Yseult, the earthly image of the Great Sun Goddess of the ancient Celts, is the opposite of the "romantic" heroine. As Jean Markale explains in his preface to Verlet's play, Yseult "represents all women who have yearned to free themselves from the masculine yoke, be it paternal or conjugal," whereas Tristan, "insignificant and weak, like all men," represents, in his attempt to hand Yseult over to Marc, the laws of patriarchal society, which would have women submit to the Father. Unable to accept the overwhelming passion that Yseult proposes to him, Tristan dies from his refusal to relinquish the traditional image of women that he cherishes.[80] Verlet's unusual retelling is also innovative theater: the action takes place on a circular "stage" that actually surrounds the audience and comprises various locales, such as the Morois forest and Marc's castle. It is designed to replicate the repetitive and fluid rhythms of the ancient storytellers.

The formidable power of the Irish princess is also acknowledged in two other recent works, but through a specific focus on the plight of Tristan's wife, seen as a calm refuge from the stormy passion of his lover: *An Isild a-heul* or *Yseult seconde* ("The Second Yseult," 1964), a three-act tragedy with epilogue composed in Breton by Per-Jakez (or Pierre-Jakez) Hélias (with

In the same issue, Jean-Charles Payen reviews the film and notes that Lagrange is of the generation formed by the Events of May 1968, he interprets the film as a subversion of traditional eroticism, which is openly denounced as poetic mystification (52–56).

80. Préface, 6–7. On this issue, see Rabine.*

facing translation in modern French),[81] and *Yseut aux Blanches Mains, tapisserie d'un long hiver* ("Yseult of the White Hands, Tapestry of a Long Winter," 1975), a dramatic prose poem in six "chants" by Elyane Gastaud. Both works take place in Carhaix and recount the legend through the eyes of Tristan's wife from the moment she meets Tristan up to his death. In both, her calm, patient, realistic love and her modest hopes contrast sharply with the lovers' passion, which she is inclined at times to see as an illusory dream, the image of an impossible love. In Héliaz's play, she reproaches Tristan bitterly for his attitude, claiming that he invented his vocation as poet when he drank the potion; but eventually she draws strength and even pride from the realization that an "impossible love" has also linked Tristan and her, since he has never touched her. Gastaud's more poetic version offers a rather phantasmagoric vision featuring a figure identified in the cast of characters as "La Guenilleuse (Mari-Morgan ou Iseult-la-Blonde)," a veritable fury who sings the praises alternately of passionate love and of order and progress but, by her desire to wield power over the protagonists, seems to represent fate and death.[82]

81. It was broadcast on France-Culture in 1965. Another modern Breton storyteller is Xavier de Langlais (or Langleiz) who has rendered into modern Breton both the Tristan legend (*Tristan hag Izold* ["Tristan and Isold"], 1958) and the "Arthurian cycle" (*Roman ar roue Arzhur* ["Romance of King Arthur"], 1975). The latter, in five volumes based on the Vulgate and other Arthurian sources (Chrétien, Béroul, Wolfram von Eschenbach), appeared in modern French in 1980 as the *Roman du roi Arthur*. Presented as a freer adaptation than that of Jacques Boulenger (*Les Romans de la Table ronde* ["Romances of the Round Table"], 1922), it seeks to "restore unity" to the cycle. The Tristan legend plays a very minor part: vol. 2 (*Lancelot*) includes the Béroul-Bédier version of Izeult's trial, parts of which are reworked considerably in order to summarize the love story.

82. As an adjective "guenilleuse" means "ragged" or "tattered," and this "tattered woman" is both Iseult the Fair and a siren or mermaid who lures men to their death (when the Dahud Queen of Is became Queen of the Drowned City, she also became the siren/mermaid known as Marie-Morgane).

Twentieth-Century English-Language
Versions of the Legend

The great number and variety of versions produced in Great Britain and the United States in this century defy summary in any comprehensive manner. These works include approximately fifty narrative and lyric poems or sequences, twenty plays, twenty-five prose retellings or novels (some using the legend merely as a frame of reference), ten short stories, and two operas—totals that do not include the numerous works depicting Tristan's adventures within the more general context of Arthur's Round Table.[83] Given the heterogenous nature of the Tristan versions, the following survey will be limited to a discussion of the major trends as illustrated by some of the most significant representatives, along with a few of the more curious ones. It will also serve as a summary of the types and processes of transformation that characterize modern retellings generally and, as such, will conclude this brief history of the legend's evolution.

Three fundamental decisions faced by modern redactors involve the choice of sources (usually reflected in the spelling of the characters' names), the degree and type of updating to which the legend is to be subjected, and the approach to the traditional characters. English-language authors, more eclectic by and large

83. These accounts of the entire Arthurian legend will not be considered here, but the best known and most influential is T.H. White's *Once and Future King* (1958), the novel that formed the basis for the Broadway play and film *Camelot*. It was followed by Parke Godwin's *Firelord* (1980). Recently, Alan Lupack has treated the legend in a cycle of twenty-seven poems, *The Dream of Camelot* (1990). Special mention should be made of Thomas Berger's *Arthur Rex* (1978), which Raymond H. Thompson calls "the finest ironic fantasy on the Arthurian legend written in the twentieth century" (see his entry on Berger in *New Arthurian Encyclopedia*, ed. Lacy, p. 35). Taylor and Brewer, p. 300, cite as an example of Berger's inimitable comic touches the moment when Tristram, anxious to prove to Kaherdin the power of his lover's beauty, takes him to Cornwall and "finds a haggard, aged creature with 'white hair and yellowed skin', but loves her more than ever."

than their French and German counterparts, express varying attitudes toward their sources, with some intent on reworking modern versions, while others pointedly return to Malory or to the legend's roots in the earliest continental versions or in Irish, Scottish, and Welsh analogues. In an implicit recognition of the story's timeless appeal, it is often updated by developing the characters in a manner typical of the traditional novel or play (and eliminating all traces of magic, such as the potion) while preserving the medieval historical backdrop or, more radically, by transposing the legend to a modern setting. In a variation on this last case, the events of the legend are lived out by modern analogues (with different names), who usually have an obscure impression of *déjà vu* or whose story is narrated with a fearful sense of impending doom by a relative or interested witness cognizant of the parallels with the celebrated lovers. Depending on an author's particular interest and the sources used, a single character may be chosen to dominate the work either by becoming the main protagonist or by recounting events from his or her point of view (or both). In several versions, Isolde occupies center stage, sometimes with Guinevere, whose conduct in an analogous situation affords a contrast that is usually unfavorable to the latter, generally because Arthur is noble, whereas Mark often is not. In another popular variation the plight of the legitimate spouses, Mark and Isolde of the White Hands (the lovers' antagonists in medieval versions), elicits particular sympathy. Even secondary characters are occasionally elevated to the status of hero: Brangane and Palamede, who do not always feel that their devotion to Isolde is adequately rewarded, receive their due in a couple of works where they are squarely in the forefront.

As in France and Germany, the first major wave of English-language retellings in this century was a series of plays that betrayed a desire either to adapt Wagner or to reject him.[84] The first of these was Louis K. Anspacher's *Tristan and Isolde*

84. In considering the various plays, I have consulted especially Taylor and Brewer, Halperin, and Alan Lupack's introduction to his anthology of Arthurian plays, *Arthurian Drama: An Anthology* (New York and London: Garland, 1991).

(1904). A verse play in five acts, it bears Wagner's stamp, albeit with greater appreciation of the tragic role incarnated by Mark, portrayed as a reasonable man, imbued with admirable and noble instincts. For her three-act play *Tristram and Isoult* (1905), Martha W. Austin deliberately used British sources, primarily Malory, but also Arnold, Tennyson, and Swinburne. The focus is on Isoult, who in Act I recounts to Guinevere the lovers' entire history from Tristram's victory over Morholt to his marriage. Tristram arrives to present her with the ruby necklace (bereft here of the pejorative sense it has in Tennyson) and, following a love scene, goes off to defend Cornwall. In Act II, Isoult confesses her love for Tristram to Mark, who promptly banishes his nephew, then stabs him after the lovers have bid adieu to each other. Act III finds the wounded hero in Brittany awaiting the arrival of Isoult, who, before expiring with her lover, is greeted sympathetically by his wife. For this highly original blend of sources, Austin not only uses Malory's Arthurian frame and the parallel with Lancelot and Guinevere but also weaves in references to the Grail legend: Tristram compares the Grail cup to the one that held the love potion and speaks of Isoult as the "angel of the Grail."

J.W. Comyns Carr's *Tristram and Iseult* (1906), a four-act drama in Shakespearian verse, infuses elements of Malory, Gottfried, and Swinburne with a Wagnerian spirit. In the first act ("The Poisoned Spear"), Tristram arrives in Ireland on the bridequest, badly wounded from his combat with Moraunt; in the second ("The Hands That Heal"), he is cured by Iseult, whom he then wins by defeating Palamide. The third act ("The Love Draught") shows the protagonists consuming what they believe is poison, which leads in the final act ("The Wound Incurable") to a rapturous rendezvous, in which they evoke the fatal implications of the potion and seem actually—as in Wagner—to will the arrival of Mark and Andred, who kills Tristram, thus provoking Iseult's death. In this piece dominated by the oppositions life/death and wounding/healing, Tristram's wife appears as a spectral figure who predicts the lovers' death and then reappears at the end as a healing image of death to stretch her white hands over the lovers in a gesture that delivers them at last into a state of supreme happiness. Less successful is Thomas

Herbert Lee's *Marriage of Iseult* (1909), which compresses the legend into two scenes to underscore the unacceptability of the lovers' situation. For Iseult believes that a woman who does not love her husband is a "strumpet" and actually accuses Tristram of rape for arranging her marriage. She attempts to serve them both poison (as in Wagner, where her anger has a different source), but Brangane substitutes the love potion, which leads to the second scene, in which they do indeed manage to drink their death (Taylor and Brewer, 215–16).

Two of the best Tristan plays are verse dramas by Martha Kinross (*Tristram and Isoult*, 1913) and Arthur Symons (*Tristan and Iseult*, 1917). In Kinross's remarkably feminist version, Isoult appears (in contrast to Guinevere) as a strong, independent, courageous, and forthright figure who, armed with a dagger, openly confronts Mark and reveals her love for Tristram, which began when she healed him. Her refusal to respect conventional moral standards and her desire to determine her own life and death can be seen as well in her decision at the end of the play to drink a cup of poison, which she refers to as "the Grail upraised." Isoult of Brittany is also portrayed with much sympathy, and Queen Isoult is seen regretting the pain she has caused her. Mark is depicted as jealous and ungrateful for all Tristram has done to defend Cornwall. He attempts to kill Isoult at one point and later inflicts Tristram's fatal wound.

Symons's compelling four-act symbolist drama refocuses attention on the timeless conflict between love and honor. The couple feels a mutual attraction in Ireland, but Tristan is intent on serving with honor both Mark and Iseult, while Iseult strongly resents being turned over to the aging king for political reasons. Although the potion ensures love's victory and banishes the conflict in Iseult's heart, Tristan continues to feel guilt, which deepens to shame when Mark reproaches him. Love and honor dwell together also in the heart of Meriodoc: having long loved Iseult and desired to avenge the death of his father, Morold, he eventually inflicts the wound that kills Tristan, who is the victim as well of the report of the black sail by Iseult of Brittany, a lie for which she feels immediate remorse. Mark, when apprised of the truth by Brangaene, begs the lovers' pardon. The emphasis on

these conflicts makes the characters more complex and their respective plights more compelling.

Both Thomas Hardy and John Masefield try in different ways to replicate the primitive rhythms of the medieval versions. In Thomas Hardy's one-act verse play for mummers, *The Famous Tragedy of the Queen of Cornwall at Tintagel in Lyonnesse* (1923), the action unfolds in the kind of fatalistic atmosphere that pervades Hardy's novels and is reinforced by the decision to incorporate conventions of classical Greek drama (the three unities, a chorus). A prologue recited by Merlin and several scenes featuring chanters (the Shades of Dead Cornishmen and Dead Cornishwomen) summarize the events leading up to the climactic death scene at Tintagel, where Tristram, the two Iseults, Brangwain, Mark, and Andret have all converged. In order to explore more fully the lovers' sad fate and how it encompasses Tristram's wife as well, Hardy combines the death scenes found in both Thomas and Malory: Iseult, having gone to Brittany to heal Tristram, has returned to Cornwall after being met by his wife on the beach and told that he is dead. But Tristram, who only fainted upon hearing that the sail was black, has returned to Cornwall in disguise, followed by Iseult Whitehanded, who has come to win him back and vainly confronts the lovers. Her arrival confirms Andret's suspicions that Tristram has returned; he alerts Mark, and while Tristram sings to Iseult, his uncle stabs him and is slain in turn by Iseult, who plunges off the cliff, leaving Iseult Whitehanded to mourn her husband and lament the inexorable force of destiny, a theme that Merlin reiterates in his epilogue.[85]

Fate also figures prominently in John Masefield's verse play *Tristan and Isolt* (1927), loudly proclaiming its power in

85. This work, written when Hardy was eighty-three for performance by amateur players, has received little attention from Hardy scholars. Even Clark and Wasserman, in a book devoted to Hardy's use of the legend, have less to say about his play than about his novels, especially *Tess of the d'Urbervilles* (1891), which they see as a retelling of Gottfried. The play has fared better with Arthurian critics. See Taylor and Brewer, pp. 232–34, and Halperin, pp. 98–106; also Lance St. John Butler, "Hardy's 'Tragedy of the Queen of Cornwall,'" *Cahiers victoriens et édouardiens*, 12 (1980), 211–18.

speeches framing the play's action. Masefield's desire to return the legend to the rude, barbarous setting from which it sprang causes him to draw on the Welsh Triads as a primary source, identifying Tristan as a Pictish prince and devoting a portion of the play to reenacting the farcical swineherd episode. Marc is a thoroughly good and honorable character: his generous reaction upon finding the sleeping lovers in the forest virtually obliges Isolt to abandon Tristan, who eventually goes mad. (No mention is made of a Breton exile or marriage.) After Marc is killed fighting the heathen at Badon, Brangwen, who has long loved him in secret, pronounces his eulogy. (Unlike other playwrights, Masefield does not shy away from depicting Isolt's successful attempt to persuade her confidante to replace her in the nuptial bed: Tristan suggests they add a sleeping potion to the love drink, Brangwen partakes of it and becomes bound to Marc but then drops the cup, leaving for him only the drug added by Tristan.) Once released from the duty to stand by her husband, Isolt eventually seeks out her lover; they are briefly reunited just before he expires, after which she stabs herself.

In this century as in the previous one, poetry has been a popular medium because of its potential for developing selected scenes told from the perspective of one or more characters, using a variety of tones, from the most lyrical or contemplative to the most burlesque or even cruel. Dramatists have also recognized this potential, as we have seen, and An Philibin (John Hackett Pollock) calls his *Tristram and Iseult* (1924) a "dramatic poem." Both a short play and a poem, it depicts the change that comes over the protagonists after they have drunk the potion: seeing how the becalmed sea is churned up by a sudden storm symbolizing the impending tragedy, the two, conscious that their love will triumph, accept their fate and their place in the cosmic scene. Frank Kendon's *Tristram* (1934), a narrative poem in nine sections linked with songs sung by Tristram, tells the hero's story from his bridequest to his death. Edna St. Vincent Millay's "Tristan" (in *Mine the Harvest*, 1954) is a four-part poem that evokes Tristan's memories of three moments connected with Isolde, ending with his thoughts as he contemplates his death. While most poets adopt a single approach to the legend, Norman Talbot, for his part, seems intent on viewing it from as many

perspectives as possible—from the most lyrical to the most violent—in the various Tristan poems contained in his *Poems for a Female Universe* (1968) and *Son of a Female Universe* (1971).[86]

Of the many narrative poems produced, Edwin Arlington Robinson's *Tristram* (1927), the first such Tristan poem by an American, stands out as the best and most celebrated, winning the Pulitzer Prize in 1927. Third in Robinson's Arthurian trilogy, which also includes poems on Merlin and Lancelot, it is an internal drama that explores in blank verse the moral tensions created by the lovers' situation in their own hearts and in that of Isolt of Brittany, through whom the theme of loss at the hands of Time and Destiny is underscored with great pathos. Robinson omits the potion, which he judged totally superfluous. Following Swinburne, but in a more contemplative mood, he evokes ten "moments" in which the main characters analyze their feelings in extended dialogues and monologues broken occasionally by vigorous action. The story is recounted in three principal scenes, all of them encounters by the lovers that are brutally cut short by their adversaries: a conversation on Isolt's wedding night in which Tristram betrays his passion and is banished by Mark; an idyllic summer stay at Joyous Garde that ends with Isolt's abduction by Mark; and the lovers' death, which features an unusual reversal (with Isolt languishing on her deathbed, Mark allows a final visit to Tristram, who is, however subsequently slain by Andred). The tripartite structure is underscored by Isolt of the White Hands's patient watch on the Breton coast. When the poem begins, she is expecting Tristram to return and fulfill his promise to marry her; later, she is seen awaiting his return from Joyous Garde; and at the end, her gaze is still fixed on the sea, watching and waiting even after his death. All four of the spouses experience acute deprivation, and although the lovers manage to transcend time through love, Mark and especially Isolt of the White Hands provide an important lesson—that

86. See, in *New Arthurian Encyclopedia*, ed. Lacy, the entries by Raymond H. Thompson on Kendon, p. 326, by Amelia Rutledge on Millay, pp. 323–24, and by Daniel Nastali on Talbot, p. 441. On Philibin, see Lupack, who calls the work "a masterpiece of mood" (p. xxiii).

suffering can be borne and loss overcome with a fortitude and self-control that are ennobling and enriching.[87]

Although lyric poetry has continued to be a popular medium for treating the legend, the novel has figured most prominently in recent decades.[88] Among the many novels that have appeared, some have attempted to retell the legend in its entirety, albeit with numerous modifications; others have relegated the lovers to the background, where their unscrupulous behavior provides a sharp contrast to the less selfish forms of love embraced by secondary characters; and still others have used the legend as a frame of reference to illuminate a story set in modern times. One of the best works in the first category is the historical novel *Tristan* (1940) by Hannah Closs, who tries to "tell the story as it crystallized in [her] imagination," filtering the events of the legend through the minds of the protagonists by means of a stream of consciousness technique that moves the story beyond the bounds of material reality into the eternal realm of Platonic reality, where all passions are experienced with greater intensity. Tristan is at once warrior and minstrel-poet (dreamer), trying both to fulfill his social obligations and to discover the unity of life that he intuits in his dream world. The lure of that world is seen in the titles of the various parts of the novel (Prelude, Dawn, Quest, Dream and Awakening, Semblance, Vision, Confluence). The middle section is devoted to Tristan's time with Iseult, and once awakened from this dream, he tries to find a "life that might bear fruit." But his marriage is an illusion, and his disappointed wife, an avid reader of Arthurian romance who "lives only in tales and semblances," acknowledges to herself the folly of having seen Tristan as a composite of Lancelot, Ivein, and Lohengrin, and of having "woven a tale transcending all heroic lore, a tale that she had realized gradually was but an empty fallacy." It is only in death

87. See Taylor and Brewer, pp. 188–92, Starr, pp. 72–84, and Amelia Rutledge's entry on Robinson in *New Arthurian Encyclopedia*, ed. Lacy, pp. 387–88. Carpenter* examines the poem in the context of the trilogy and its connection with Emerson's transcendentalism.

88. My discussion of the novels owes much to Taylor and Brewer and to Thompson.

Everybody), a middle-aged pub owner whose lack of desire for
his wife is worked out in a dream involving an incestuous
passion for his daughter Issy (Iseult, Isolde, Isabelle, etc.). The
fantasy begins after HCE consumes the dregs of his patrons'
drinks and passes out on the floor . . . as a ship passes out to sea.
The four Old Men who are the "evangelists" of this story, which
spans human history from Adam's fall from Paradise through
Finnegan's fall from the ladder (in the popular song) to HCE's
fall from some unspecified indiscretion in a park, spy on the love
ship of Tristram and Iseult and comment on the lovers' sexual
union as HCE and his wife, Ann, are settling into bed. In his
dream, HCE sees himself as the young hero, Tristram, making
love to his Iseult, who is his daughter, but perhaps also a young
version of his wife (also identified with Eve and Isis). Tristram is
both a reflection of HCE's adolescent self and his son, Shem, and
the involvement of the two generations and the blending of past
and present show the sexual impulse as a means of constant
renewal, symbolized as well by the many references to drink, the
river, and the sea. Indeed, as the morning dawns, a new cycle
begins: HCE makes love to his wife, who gives her final
soliloquy as she goes out to sea. But the situation emblematized
by the Cornish lovers is a romantic delusion: while the settings
chosen for the sequences in which they appear are edenic, the
watching eye is always present to dissolve the illusion. Passion
and yearning are constantly distorted (Taylor and Brewer, 272–
77).[92]

92. Structurally, the allusions to the Tristan legend constitute a
subplot that contributes to the novel's formal unity (there are about 250
references to the legend's three principals in various guises).
Thematically, according to David Hayman, they denounce as romantic
illusion the young adults' attempt to prolong the pre-responsible period
in which desire is restrained by parental force. Joyce, who by then had
rejected *fin de siècle* aestheticism (which the *Tristan* had come to
exemplify for him, thanks to Wagner), had developed the same theme in
a Wagnerian pastiche "Tristan and Isolde" (1923) and in his play *Exiles*
(1913–15). Hayman, using the hundred-odd notes on the legend found
in Joyce's *Scribbledehobble* notebooks, traces the evolution of this theme
in Joyce's mind over time. See also his *A Wake in Transit* (Cornell:

Three novels in which the correspondence between a modern love story and the legend is both systematic and highly elaborate are Maria Kuncewiczowa's *Tristan 1946* (first published in Polish in 1967, then in English in 1974 as *Tristan* under the name Kuncewicz[93]), Arthur Quiller-Couch's *Castel Dor* (1961: completed from his notes by Daphne du Maurier after his death), and Jean MacVean's *The Intermediaries* (1965). *Castel Dor*, set in the nineteenth century near the historical site of Mark's fortress, revolves around a Breton fisherman (Amyot Trestane), an aging innkeeper (Mark Lewarne), and his beautiful young wife (Linnet), whose faithful maid is Deborah Brangwyn. The Breton king is incarnated by a descendant of Hoel (Farmer Bosanko), who takes Amyot in when he is "banished"; his children play the roles of the second Isolde and her brother. The tale is narrated by Dr. Carfax, who has researched the legend and, conscious of the uncanny power of the site, makes a desperate attempt to prevent its being played out again—in vain. Indeed, it is he who, though a generally faithful Dinas-figure, unwittingly inflicts the wound that kills Amyot. The appeal of this particular transposition depends not only on the clever interweaving of countless motifs from the traditional story but also on the evocative sense of place created by the compassionate narrator.

The peculiar tonality of Kuncewiczowa's novel owes much, as the original title suggests, to the sense of alienation and disillusionment that characterized the postwar period. The main narrator is Wanda Gaszynski, a Polish refugee and war widow. Her son Michael, who was tortured by the Nazis, joins her in Cornwall in 1946 after being nursed back to health in London by Kathleen McDougall, an Irish student of psychophysiology. Clinging to a vanishing idealism, Michael "saves" Kathleen from her abusive father by finding her a position as a live-in secretary in Truro with the distinguished Professor Bradley, who

Cornell University Press, 1990) and John Harty, III, ed., *Finnegans Wake: A Casebook* (New York and London: Garland, 1991).

93. Although this novel is not technically an English-language version, I include it here both because it is available in English and because it represents a significant trend in the treatment of the legend in modern fiction.

gratefully offers to pay for Michael's architecture studies. After Kathleen and Bradley marry (much to Michael's dismay), the two young people see their mutual attraction transformed into uncontrollable passion one night after consuming sherry while listening to a recording of César Franck's symphony sent by Kathleen's mother. Wanda, who has served up this potent mixture, watches with helpless fascination as their story unfolds, explaining both how it corresponds to the legend and how details become "muddled up." Many elements of the medieval legend are indeed present, some bizarrely transformed, particularly in Part II, where the love story rapidly unravels as the lovers attempt life in the urban "jungle" of London in a particularly degenerate bohemian setting that only increases Michael's lack of faith in the future. The two grow increasingly apart, and in Part III Kathleen returns to Bradley to wait for Michael to make his fortune in the New World, where he is helped by an American acquaintance, Kate Walker. A failure in communication between the lovers (a pervasive theme) induces Michael eventually to marry Kate and to accept a position in the Walkers' shipbuilding business. Severely beaten when he resists a Mafia takeover attempt, Michael dispatches his brother-in-law to fetch Kathleen, instructing him to cable "white" if she is coming and "black" if she is not. Despite Kate's treacherous report of the cable's message, the only death that occurs is Michael's love for Kathleen, who, having lost all self-esteem through this rejection, stays on in New York and becomes a great actress, content to experience the joys and pains of other women. Michael continues life with Kate, apparently enjoying a rather exclusive relationship with one of her young daughters. This is only the last of multiple instances of sexual ambiguity that convey the notion of a world in grave moral crisis, an idea reinforced by the subversion of the legendary ending such that we witness the demise not of the lovers *per se*, but of their love, revealed to be as illusory as the roles incarnated on stage by Kathleen.

Kuncewiczowa's novel exemplifies the difficult passage of the legend into an age whose sensibilities are poorly attuned to the notion of an everlasting, all-encompassing romantic love. Since adultery has become so commonplace in our times, it no

longer functions as a powerful taboo; if it is to retain its shock value, it must be replaced or attended by more unusual sexual practices involving the principal characters[94] or by homosexual undercurrents in members of their entourage, as in Kuncewiczowa's *Tristan* and MacVean's *The Intermediaries*. In MacVean's novel, which transposes the story to London of the 1960s, all the characters are bound by strong love-hate relationships that are threatened by the sudden decision of a successful middle-aged businessman (Mark) to marry a young Irish woman (Isobel). The change upsets Mark's rigidly ordered existence and affects his relations with his adopted nephew, Charles, who has long chafed under his uncle's yoke. The situation worsens when Charles, instinctively drawn to the Irish beauty, falls in love with her after the two partake of an Irish liqueur brought over by Isobel's cousin Blanche as a gift for the newlyweds one evening when Mark is away on business. It is a well-wrought tale infused with modern psychological realism, but it would no doubt seem banal if Blanche and Charles's friend Chalmers, the "confidants"—in whom the lovers do *not* confide—did not feel profoundly betrayed by the love affair. The role of the spying villain is given to Rankin, one of Mark's employees, who both admires and hates him, but his denunciation of the lovers is motivated as well by his feelings of rejection by a young male painter who has taken up with a young French woman. In addition, his story is actually corroborated by Chalmers, who feels both jealousy and betrayal.

The current failure of adultery as an effective taboo explains in part the unsatisfactory nature of many of the versions of the legend produced by European and American writers who attempt a serious transposition to modern times without introducing details that clearly signal a subversive intent. In today's atmosphere, the ironic perspective is often more successful, and indeed there are several short stories and

94. De Rougement, in his "New Metamorphoses of Tristan," cites as modern transpositions of the legend Vladimir Nabokov's *Lolita* (1955), Robert Musil's *The Man Without Qualities* (1953), and Boris Pasternak's *Doctor Zhivago* (1958)—works describing sexual passions that are still taboo, such as incest and nymphet love. (See Batts.*)

novelettes that poke fun at the legend or otherwise attempt to demystify it. An early example is the epistolary short story "Mark vs. Tristram," written in 1947 by C.S. Lewis and Owen Barfield, who take the roles of solicitors representing the two protagonists in a lawsuit brought by Mark. In a similar vein, John Updike's "Four Sides of One Story" (1965) is a series of four letters written by each of the four main protagonists from their respective points of view and showing an utter failure of communication. Harder to categorize is Updike's newest novel, *Brazil* (1994), where the legend (in only its broadest outlines) is used to explore current issues of sexual and racial prejudice, as well as the author's perennial obsessions, for the protagonists, a poor (ebony) black boy, and an upper-class ("pale") white girl take inordinate delight in coupling in every conceivable way with each other and countless others. Tristão and Isabel fall in love on Copacabana beach in the 1960s, then, having failed to gain either family's blessing, begin a flight that takes them to São Paulo, Brazília, a gold mining camp on the edge of the Mato Grosso, then into the wilderness increasingly westward and even back in time, where in a scene tinged with magic realism a shaman reorders nature, making Isabel black and Tristão white. This change enables them to experience sex in new racial (though annoyingly stereotypical) roles; it also allows their return to "civilization" as a more socially acceptable mixed couple and their rapid insertion into São Paulo's bourgeoisie. But eventually, sensing the threat represented by the Latin version of the American middle-class suburbia of which Updike has written so eloquently, they are drawn by nostalgia and fate back full circle to Rio and Copacabana, where Tristão is stabbed to death by thieving black boys who, though so like his former self, see in him only "white" and "rich." When Isabel finds his corpse on the beach, she stretches out on top of it and, remembering the end of the legend, tries to will her own death—in vain: having absorbed the "desolating truth" that matter is stronger than spirit, she reluctantly abandons what her abashed uncle sees as a "vulgar display of Brazilian romanticism" and lets him lead her home. In interviews, Updike has said that he considers this novel "hopeful," for the lovers are color-blind and, though hardly "faithful," steadfastly loyal. But their graphic sex scenes add a

dimension totally alien to the legend that conspires with the ironic twist at the end to encourage us to see their entire story as Isabel's uncle sees its conclusion.

Poised now on the threshold of the twenty-first century, we may wonder if it is still possible to produce a serious, original treatment of the legend. It would seem so, especially if one adopts the kind of multilayered, self-conscious treatment of the *matière de Bretagne* that A.S. Byatt and Paul Griffiths have used in two recent works, with approaches that seem eminently well suited to the postmodern age.[95] The links between Byatt's *Possession: A Romance* (1990) and the Tristan legend are admittedly tenuous, but Byatt has much to say about the prospects for romance in the modern world, and about romance both as a literary genre and a life force. Roland Mitchell and Maud Bailey, specialists in the works of two Victorian poets, Randolph Henry Ash and Christabel LaMotte, respectively, discover letters documenting a secret romance between the two poets, thus changing forever established views that each poet enjoyed a life of domestic tranquility—Ash with his wife, and LaMotte with a lesbian companion. The flame of the poets' passion is kindled in part by their interest in poetry and myth. Roland and Maud share a similar Galeotto, drawn together by their literary interest in Ash and LaMotte, whose romantic itinerary they passionately retrace. For the greater part of this double romance, the actual burden of the Tristan legend—or at least of "Romance"—appears wisely to be consigned to the poet-lovers, whose epoch and rapturous natures we imagine to be

95. A serious, straightforward treatment of the legend can, of course, still appeal to an unjaded audience, and Rosemary Sutcliff (*Tristan and Iseult*, 1971) has had considerable success adapting Arthurian legend for young readers. Sounding for all the world like a Thomas choosing from among the various versions he knows the one he deems the most authentic, Sutcliff invokes her license as a storyteller to justify the changes she makes, such as the elimination of the potion, stating her firm belief that it was not a part of the "original" legend. Her lovely, poetic rendering simplifies, while preserving much of what makes the medieval versions so appealing. It is reassuring to think that it is she who is guiding future generations on their forays into the magical world of the legendary lovers.

better attuned to it, whereas the two academics, necessarily suspicious of coherence and closure and fearful of defining their relationship, nurture a warm intimacy. Their postmodernist perspective on their own and the more remote love story allows Byatt's treatment to be both ironic and serious. But as our understanding of the four protagonists evolves, with pieces of the puzzle supplied by disparate sources, we learn that the two couples actually share unexpected points of convergence. Both couples are hampered not only by the intervention of possessive secondary characters (LaMotte's female companion, Ash's wife, Roland's girlfriend, Maud's former lover, as well as assorted specialists in Ash's and LaMotte's respective *œuvres*), but also by the various scruples and "motte-and-bailey" defenses that characterize all four protagonists, who, conscious of being victims of demonic possession, nevertheless guard jealously their solitude and self-possession. This is true particularly of the aptly named female protagonists. LaMotte does not immediately surrender herself to her nascent passion, and the portrait of a fiercely independent yet vulnerable woman may owe something to feminist readings of the Tristan legend. After her flight with Ash, which wreaks havoc with her quiet life, she seeks sanctuary with relatives on the Breton coast, where she is immersed in Breton folklore and myth—especially tales involving strong women, including the siren/mermaid Marie-Morgane (see n. 82 above). For LaMotte, who leans towards Spiritualism and has written a poem on the Drowned City of Is and and an epic called *The Fairy Melusina*, is attracted by beings who pass with ease between different realms and who tap into (or actually create, as Ash recognizes) the underlying harmony of the universe. Significantly, Maud's main academic interest is in liminality, and we learn that the two women share an even greater bond, when all is revealed—and closure miraculously achieved—at the end of what is, after all, a Romance.

Varying perspectives, doubling, and mistrust of closure also characterize *The Lay of Sir Tristram* (1991), in which music critic Paul Griffiths retells the legend, interspersing parallel sequences that illustrate the universal tendency to identify with the lovers. Frequent reference is made to Wagner, seen composing his opera while nurturing his passion for Mathilde

Wesendonck. Moreover, the narrator ("I") interjects his own story, recounting over and over to his beloved ("you") "how it began"—or rather "how it *begins*," since they "write" their own love story as past events are perpetually transmuted by memory. This "lay" is a polyphonic litany. For each episode, the narrator conjures up visually scenes and portraits from the multiple versions he knows or can imagine and watches with us as they merge and coalesce. With its stress on re-creation in different media—literature, music, painting, tapestry, film—and in its attempt to encompass the legend's history and significance, Griffiths's *Lay* provides an excellent, open-ended conclusion to our survey. This richly meditative piece is a *Tristan*-in-process, showing the legend in constant flux through time. The initial emphasis is on construction and integration; then, as the narrator and his inscribed audience ("we") become increasingly intrusive, there is a movement toward deconstruction and disintegration. But if Tristram and Yseult are exposed as mere puppets, figments of their creators' imagination, the force of the legend is such that it transforms our "reality," recreating our past and causing us to attach to otherwise insignificant events "feelings learned from old myths." And there is constant renewal, owing to the interpretive power of the artist and audience, for the lovers' death is described as a coalescence of "I" and "you" into a single androgynous being, disintegrating into "blankness, stillness and silence" . . . but soon to begin the story anew. Indeed, poets like Byatt's Ash and LaMotte, so conscious of reworking old myths, might say (if asked) that we need only an inspired storyteller and a receptive reader, listener, or spectator for Tristan and Isolde to rise again phoenix-like from their ashes in all their radiant beauty.

The Contents of This Volume

The enduring popularity of the Tristan legend, which accounts for so many and such varied re-creations, has given rise to an impressive body of scholarship. Besides the many editions and translations, there are numerous studies devoted to the origins and development of the legend over a specific time period or in a

particular geographical area and countless others concentrating
on one or more versions. Several bibliographies enumerating this
scholarship have also appeared. Although the bibliography
appended to this introduction must regrettably leave aside the
patient work of editors and translators, it does list important
reference works regarding the legend, as well as many of the
most noteworthy secondary studies that have been produced in
the past century.

The quality and breadth of this scholarship are reflected in
the essays contained in this volume, which have been chosen not
only for their intrinsic interest but also because they represent as
a group approaches that are at once diverse and complemen-
tary.[96] Mindful of the focus of the series in which this volume
appears, I have privileged studies that deal either with the
legend's major characters or its predominant themes, arranging
the essays roughly in chronological order, the better to illustrate
the evolution from the Middle Ages through the twentieth
century. The majority of the essays analyze a single, important,
and particularly influential version of the celebrated love story,
but several offer a valuable survey tracking the legend over time.
An important factor in the selection of essays has been the desire
to underscore the powerful interdisciplinary appeal of the
legend and to illustrate the complex network of influences that
make up its colorful history. Thus, although the predominant
focus of the volume is clearly literary, several essays treat the
appearance of Tristan and Isolde in works of music, art, and
cinema, while others explore the interrelation of two or more
areas of the literary and visual arts.

The first two essays probe the origins of the legend and its
early history. In his comprehensive survey of the potential
"sources" or analogues of the legend, W.J. McCann (University
of Southampton, England) presents the major findings of the
past few decades regarding the Celtic material and evaluates in
detail the evidence offered by proponents of the Oriental
hypothesis of origins. Leslie W. Rabine (University of California-

96. This is not to say that the contributors do not reveal points of
disagreement among themselves and with respect to certain views
presented in this introduction.

Irvine) takes as her starting point the matrilineal social structure of the Celts to describe an important aspect of the legend's transformation in the hands of the continental authors of the earliest extant versions, who reinforced the patriarchal structures prescribed by the Church and the sociopolitical system emerging in the twelfth century.

The subversive nature of the lovers' illicit passion and its unusually complex representation in the earliest French and German verse redactions is the focus of the next five essays. E. Jane Burns (University of North Carolina-Chapel Hill) shows how Béroul uses the lovers' extraordinary talent for dissembling their adulterous liaison to establish a new kind of legal truth based on visual evidence, a truth supported by fictive discourse. In an attempt to account for the wealth of contradictory interpretations elicited by Thomas's poem, Matilda Tomaryn Bruckner (Boston College) uses the final scene to demonstrate how the poet encourages us both to identify empathetically with the lovers and to maintain the critical distance espoused by the narrator. The late Jean-Charles Payen analyzes Tristan's "glass palace" reverie in the *Folie d'Oxford* as a projection of the impossible desire to live openly a passion that was roundly condemned by twelfth-century society. In the first of several essays in this volume on the importance of music in the legend and its history, the late W.T.H. Jackson focuses on Gottfried's description of Tristan's training in the arts and the couple's particular devotion to music to show how the poet conceived of their love as resting on the harmony attained only through the arts. In a complementary essay on the German poet, which also anticipates in a curious way Tristan's entry into the Arthurian orbit, William C. McDonald (University of Virginia) shows how Gottfried's portrayal of the lovers as imbued with an unusually refined sensibility functions in part as an implicit critique of the chivalric society depicted in the Arthurian verse romances.

The next three essays examine aspects of the legend's transformation in the French, Italian, and English prose romances starting in the thirteenth century, as Tristan's association with the Round Table lends increased importance to his chivalric exploits. Emmanuèle Baumgartner (University of Paris-III) and Donald L. Hoffman (Northeastern Illinois

University, Chicago) both focus on the lyrical dimension of the prose tradition. Baumgartner analyzes the various types of amorous discourse found in the Prose *Tristan*, showing how the theme of inordinate passion at the core of the Tristan legend is preserved and developed, even in a romance that devotes a disproportionate amount of space to chivalric adventures. Hoffman explores the manner in which the *Tavola Ritonda* draws on the Italian lyrical tradition to exalt the lovers' passion in an original way that effectively reverses the preference seen in most prose romances for chivalric themes. Malory's preoccupation with Tristram in his *Morte Darthur*, on the contrary, deals primarily with his reputation as a great knight, an interest that he develops by drawing on the English alliterative tradition, as Dhira B. Mahoney (Arizona State University) demonstrates in her essay on the "Tale of Sir Tristram."

The last of the essays devoted to the medieval period is by Julia Walworth (Special Collections, University of London Library), who describes the major contributions of art historians regarding the representation of the legend in medieval art. Given its focus on art history, it cannot be grouped with any of the preceding essays, but it is related to nearly all of them in that it examines the correlation between each work of art discussed and its "sources," which are both literary and iconographical.

The first four essays on the Tristan story in modern times deal in different ways with the vision of some of the most influential figures in modern music, letters, and art and their role in the legend's transformation in the nineteenth and early twentieth centuries. Antony H. Harrison (North Carolina State University) demonstrates how Swinburne, offended by Tennyson's disparaging treatment of the lovers, was inspired to create a new form in his treatment of the legend, fusing epic and lyrical elements into a "visionary and courtly epic" that was to be highly influential. Wagner's impact was even greater, and Joseph Kerman (University of California-Berkeley), in a detailed analysis of the final act of *Tristan und Isolde*, describes Wagner's conception of a powerful operatic form to convey his own "unequivocal, intense mystic view" of the legend. The legend also inspired such British artists as Dyce, Morris, Burne-Jones, Rossetti, and Beardsley, all of whom are included in the survey

of the legend in British art of the nineteenth and early twentieth centuries by Christine Poulson (Homerton College, Cambridge), who shows how the depiction of the lovers evolved as Tennyson's disapproving view was eclipsed by Wagner's more exalted vision. Exalted to the point of decadence is the Wagnerian tendency explored by Raymond Furness (University of St. Andrew's, Scotland) in his study of the influence of *Tannhäuser, Tristan und Isolde, Die Walküre,* and *Parzival* on turn-of-the-century European poets, novelists, and artists who found morbid inspiration in the theme of the "Liebestod."

Three of the most important twentieth-century treatments of the legend in France and the United States are the subject of the trio of essays that follow. Edward J. Gallagher (Wheaton College, Newton, Massachusetts) offers a balanced critique of Bédier's celebrated retelling, exploring the most significant changes that the distinguished medievalist brought to the legend, even as he sought to return it to its medieval roots. Frederick Yves Carpenter studies Edwin Arlington Robinson's acclaimed narrative poem in the context of the poet's entire Arthurian trilogy and shows how the lovers are made to epitomize the ideals of Emerson's transcendentalism. Cocteau's famous screenplay for the most celebrated film of the legend is the focus of the essay by Stephen Maddux (University of Dallas), who analyzes it as it relates both to its apparent source (Bédier's version) and to other works in the filmmaker's *œuvre.*

The last essay in the volume is by Michael S. Batts (University of British Columbia), who surveys the radical changes of perspective seen in the major German versions of the legend from Gottfried up to the present time, focusing particularly on Nossack's novel to illustrate the difficulties encountered in the attempt to adapt the legend to modern sensibilities. The unusually wide scope of this final essay serves both to bring us up to the present and to remind us of the long, circuitous route that Tristan and Isolde have traveled since the Middle Ages and of the many and varied ways in which they have loved and perished, only to be reborn again and again.

Acknowledgments

Many have shared in the production of this book. I wish to thank first of all the nineteen scholars who contributed essays, especially those who provided new or revised ones specifically for this volume. I am deeply grateful to Norris J. Lacy for his confidence and support, for his numerous editorial suggestions, and for his prompt and courteous response to a stream of disparate queries extending over four years. Debra N. Mancoff, William C. McDonald, Arthur Groos, and Thelma Fenster made invaluable suggestions regarding potential contributors, essays, and bibliographical items. Special thanks go to Garland, particularly to Gary Kuris both for his meticulous copy editing and his enthusiastic support of this volume and of the entire series. I am grateful to my home institution, Catholic University of America, for the generous financial support it has provided for this project in the form of two consecutive Faculty Research Grants-in-Aid. Finally, I would like to thank my friends and colleagues Nancy L. Green, Chad C. Wright, Hanna Marks, and Patricia Hannon, who have provided advice, support, and camaraderie throughout, as has my husband, Robert Smarz, who has the added distinction of having braved with good humor the onslaught of countless versions of the Tristan legend. This book is dedicated to him.

J.T.G.

Tristania. *A Journal Devoted to Tristan Studies*, ed. Lewis A.M. Sumberg. Vol. 1–12, Chattanooga: University of Tennessee; vol. 13–, Lewiston, N.Y.: Mellen.

II. Critical Studies

Barteau, Françoise. *Les Romans de Tristan et Iseut: introduction à une lecture plurielle*. Paris: Larousse, 1972.

Batts, Michael S. *Gottfried von Strassburg*. New York: Twayne, 1971.

*————. "Tristan and Isolde in Modern Literature: L'éternel retour." *Seminar*, 5 (1969), 79–91.

Baumgartner, Emmanuèle. *La Harpe et l'épée. Tradition et renouvellement dans le "Tristan" en Prose*. Paris: SEDES, 1990. *English translation of "La Parole amoureuse," pp. 107–31.

————. *Le "Tristan" en prose: Essai d'interprétation d'un roman médiéval*. Geneva: Droz, 1975.

————. *Tristan et Iseut. De la légende aux récits en vers*. Paris: Presses Universitaires de France, 1987.

Bédier, Joseph. "The Legend of Tristan and Isolt." Tr. Susan Hilles Taber. *International Quarterly*, 9 (1904), 103–28.

————. *Le Roman de Tristan par Thomas*. 2 vols. Paris: Firmin Didot, 1902–05.

Bekker, Hugo. *Gottfried von Strassburg's "Tristan": Journey Through the Realm of Eros*. Columbia, S.C.: Camden, 1987.

Benson, Larry D. *Malory's "Morte Darthur."* Cambridge, Mass., and London: Harvard University Press, 1976.

Bijvoet, Maya C. *Liebestod: The Function and Meaning of the Double Love-Death*. New York: Garland, 1988.

Blakeslee, Merritt R. *Love's Masks: Identity, Intertextuality, and Meaning in the Old French Tristan Poems*. Cambridge: Brewer, 1989.

Bloch, R. Howard. "Tristan, the Myth of the State and the Language of the Self." *Yale French Studies*, 51 (1974), 61–81.

Branca, Daniela [Delcorno]. *I Romanzi italiani di Tristano e la "Tavola Ritonda."* Florence: Olschki, 1968.

Bromily, Geoffrey N. *Thomas's "Tristan" and the "Folie Tristan d'Oxford."* London: Grant & Cutler, 1986.

Bromwich, Rachel. "Some Remarks on the Celtic Sources of 'Tristan.'" *Transactions of the Honourable Society of Cymmrodorian*, Session 1953 (1955), 32–60.

*Bruckner, Matilda Tomaryn. "The Representation of the Lovers' Death: Thomas' *Tristan* as Open Text." *Tristania*, 9 (Autumn 1983–Spring 1984), 49–61.

Brunel, Pierre. "Claudel and the Tristan Myth." *Tristania*, 11 (Autumn 1986–Spring 1987), 31–45.

———. "*Partage de Midi* et le mythe de Tristan." *Revue des Lettres modernes*, 747–52 (1985), 192–222.

*Burns, E. Jane. "How Lovers Lie Together: Infidelity and Fictive Discourse in the *Roman de Tristan*." *Tristania*, 8.2 (Spring 1983), 15–30.

———. "Why Beauty Laughs: Iseut's Enormous Thighs," Ch. 5 in *Bodytalk: When Women Speak in Old French Romance*. Philadelphia: University of Pennsylvania Press, 1993, pp. 203–40.

Buschinger, Danielle, ed. *La Légende de Tristan au moyen âge. Actes du Colloque des 16 et 17 janvier, 1982 du Centre d'Etudes Médiévales de l'Université de Picardie*. Göppingen: Kümmerle, 1982.

———. "Tristan et Iseut aux Blanches Mains dans la Tradition de *Tristan* en France et en Allemagne au Moyen Age." In *Actes du XIVᵉ Congrès international arthurien*, eds. Charles Foulon et al. 2 vols. Rennes, 1985, I, 142–57.

———. *Tristan et Iseut; mythe européen et mondial. Actes du Colloque des 10, 11 et 12 janvier, 1986*. Göppingen: Kümmerle, 1987.

———. *Le Tristrant d'Eilhart von Oberg*. 2 vols. Paris: Champion, 1975.

Cahné, C. *Le Philtre et le vénin dans "Tristan et Iseut."* Paris: Nizet, 1975.

Carney, James. "The Irish Affinities of Tristan." In *Studies in Irish Literature and History*. Dublin: Institute for Advanced Studies, 1955, pp. 189–242.

*Carpenter, Frederic Yves. "Tristram the Transcendent." *New England Quarterly*, 11 (1938): 501–23. Rpt. in *Appreciation of Edwin Arlington Robinson. 28 Interpretive Essays*, ed. Richard Cary. Waterville, Maine: Colby College Press, 1969, pp. 75–90.

Cazenave, Michel. *Le Philtre et l'amour: la légende de Tristan et Iseut*. Paris: Corti, 1969.

———. *La Subversion de l'âme: mythanalyse de l'histoire de Tristan et Iseut*. Paris: Seghers, 1981.

Chênerie, Marie-Luce. *Le Chevalier errant dans les romans arthuriens en vers des XII^e et XIII^e siècles*. Geneva: Droz, 1986.

Clark, Susan L., and Julian N. Wasserman. *Thomas Hardy and the Tristan Legend*. Heidelberg: Winter, 1983.

Cochran, Rebecca. "Swinburne's Fated Lovers in *Tristram of Lyonesse*." *Tristania*, 13 (Autumn 1987–Spring 1988), 53–61.

Curtis, Renée L. "The Character of Iseut in the Prose Tristan (Parts I and II)." In *Mélanges de Littérature du moyen âge au XX^e siècle offerts à Jeanne Lods*. Paris: Ecole Normale Supérieure de Jeunes Filles, 1978, pp. 173–82.

———. "The Humble and the Cruel Tristan: A New Look at the Two Poems of the *Folie Tristan*." *Tristania*, 2.1 (November 1976), 3–11.

———. *Tristan Studies*. Munich: Fink, 1969.

———. "Wagner's *Tristan und Isolde*: The Transformation of a Medieval Legend." *Tristania*, 8.2 (Spring 1983), 3–14.

Dannenbaum [Crane], Susan. "Doubling and *Fine Amor* in Thomas' *Tristan*." *Tristania*, 5.1 (Autumn 1979), 3–14.

Dayan, Joan C. "The Figure of Isolde in Gottfried's *Tristan*: Toward a Paradigm of *Minne*." *Tristania*, 6.2 (Spring 1981), 23–36.

Delbouille, Maurice, Eugène Vinaver, and Denis de Rougement. "Tristan et Iseut à travers le temps." *Bulletin de l'Académie royale de langue et litterature françaises de Belgique*, 39 (1961), 187–221.

Dick, Ernst S. "Gottfried's Isolde: *Coincidentia Oppositorum*?" *Tristania*, 12 (Autumn 1986–Spring 1987), 15–24.

Dubuis, Roger. "Plaidoyer pour une lecture globale du lai du *Chèvrefeuille*." *Le Moyen âge*, 87 (1981), 341–71.

Eisner, Sigmund. *The Tristan Legend: A Study in Sources*. Evanston, Ill.: Northwestern University Press, 1969.

Entwistle, W.J. *The Arthurian Legend in the Literatures of the Spanish Peninsula*. London: Dent, 1925.

Ertzdorff, Xenja von. "Tristan und Lanzelot. Zur Problematik des Liebe in den höfischen Romanen des 12. und frühen 13. Jahrhunderts." *Germanisch-romanische Monatsschrift*, 33 (1983), 21–52.

Fedrick, Alan. "The Love Potion in the French Prose *Tristan*." *Romance Philology*, 21 (1967–68), 23–34.

Ferrante, Joan M. *The Conflict of Love and Honor. The Medieval Tristan Legend in France, Germany and Italy*. The Hague and Paris: Mouton, 1973.

Fisher, John H. "Tristan and Courtly Adultery." *Comparative Literature*, 9 (1957), 150–64.

Fourrier, Anthime. "Le *Tristan* de Thomas d'Angleterre." In his *Le Courant réaliste dans le roman courtois en France au moyen âge*. Paris: Nizet, 1960, pp. 19–109.

Frappier, Jean. "La Reine Iseut dans le *Tristan* de Béroul." *Romance Philology*, 26 (1972–73), 215–28.

———. "Structure et sens du *Tristan*: version commune, version courtoise." *Cahiers de civilisation médiévale*, 6 (1963), 255–80, 441–54.

Fries, Maureen. "Indiscreet Objects of Desire: Malory's 'Tristram' and the Necessity of Deceit." In *Studies in Malory*, ed. James W. Spisak. Kalamazoo: Medieval Institute Publications, 1985, pp. 87–108.

Frühmorgen-Voss, Hella. *Text und Illustration im Mittelalter. Aufsatze zu den Wechselbeziehungen zwischen Literatur und bildender Kunst*, ed. Norbert H. Ott. Munich: Beck, 1975.

———. "Tristan und Isolde in mittelalterlichen Bildzeugnissen." *Deutsche Vierteljahrsschrift für Literaturwissenschaft und Geistesgeschichte*, 47 (1973), 645–63.

Furness, Raymond. *Wagner and Literature*. Manchester: Manchester University Press; New York: St. Martin's Press, 1982. *"Wagner and Decadence," pp. 31–68.

*Gallagher, Edward J. "Une Reconstitution à la Viollet-le-Duc: More on Bédier's *Roman de Tristan et Iseut*." *Tristania*, 8.1 (Autumn 1982), 18–28. [Gallagher's essay in the present volume represents a fusion of this article with the following one.]

*———. "*Le Roman de Tristan et Iseut*: Joseph Bédier, *rénovateur* of Béroul and Thomas," *Tristania*, 5.2 (Spring 1980), 3–15.

Gallais, Pierre. *Genèse du roman occidental. Essais sur Tristan et Iseut et son modèle persan*. Paris: Tête de feuilles et Éditions Sirac, 1974.

Gardner, Edmund G. *The Arthurian Legend in Italian Literature from 1200 to 1500*. London: Dent; New York: Dutton, 1930.

Golther, Wolfgang. *Tristan und Isolde in den Dichtungen des Mittelalters und der neuen Zeit*. Leipzig: Hirzel, 1907; rev. ed. Berlin: Gruyter, 1929.

Gravdal, Kathryn. "Fragmentation and Imagination in the Old French *Tristan*: Marie de France's *Lai du chievrefoil*," *Tristania*, 12 (Autumn 1986–Spring 1987), 69–78.

Grimbert, Joan Tasker. "Love, Honor, and Alienation in Thomas's *Roman de Tristan*." *Arthurian Yearbook*, 2 (1992), 77–98.

——. "Translating Tristan-love from the *Prose Tristan* to the *Tavola Ritonda*." *Romance Languages Annual*, 6 (1994), forthcoming.

——. "*Voleir* v. *Poeir*: Frustrated Desire in Thomas's *Roman de Tristan*." *Philological Quarterly*, 69 (1990), 153–65.

Groos, Arthur. "Appropriation in Wagner's *Tristan* Libretto." In *Reading Opera*, ed. Arthur Groos and Roger Parker. Princeton: Princeton University Press, 1988, pp. 12–33.

——. "Wagner's 'Tristan und Isolde': In Defence of the Libretto." *Music and Letters*, 69 (1988), 465–81.

Gruentner, Rainer. "Der Favorit: Das Motiv der höfischen Intrigue in Gottfrieds *Tristan und Isold*." *Euphorion*, 55 (1961), 1–15.

Gunnlaugsdóttir, Álfrún. *Tristán en el norte*. Reykjavík: Magnússonar, 1978.

Halperin, Maurice. *Le Roman de Tristan et Iseut dans la littérature anglo-américaine au XIX^e et au XX^e siècles*. Paris: Jouve, 1931.

Harrison, Antony H. *Swinburne's Medievalism: A Study in Victorian Love Poetry*. Baton Rouge and London: Louisiana State University Press, 1988.

*——. "Swinburne's *Tristram of Lyonesse*: Visionary and Courtly Epic." *Modern Language Quarterly*, 37 (1976), 370–89. Rpt. in his *Swinburne's Medievalism*.

Hayman, David. "Tristan and Isolde in *Finnegans Wake*: A Study of the Sources and Evolution of a Theme." *Comparative Literature Studies*, 1 (1964), 93–112.

Hoffman, Donald L. "The Arthurian Tradition in Italy." In *King Arthur Through the Ages*, ed. Lagorio and Day, I, 170–88.

——. "Cult and Culture: 'Courtly Love' in the Cave and the Forest." *Tristania*, 4.1 (November 1978), 15–34.

Huby, Michel. *Prolegomena zu einer Untersuchung von Gottfrieds "Tristan."* 2 vols. Göppingen: Kümmerle, 1984.

Huchet, Jean-Charles. *Tristan et le sang de l'écriture*. Paris: Presses Universitaires de France. 1990.

Hunt, Tony. "Abelardian Ethics and Béroul's *Tristan*." *Romania*, 98 (1977), 501–40.

——. "The Significance of Thomas's *Tristan*." *Reading Medieval Studies*, 7 (1981), 41–61.

Jackson, W.T.H. *The Anatomy of Love: The "Tristan" of Gottfried von Strassburg*. New York: Columbia University Press, 1971.

*————. "Tristan the Artist in Gottfried's Poem." *PMLA*, 77 (1962), 364–72.

Jaeger, C. Stephen. "Mark and Tristan: The Love of Medieval Kings and Their Courts." In *In hôhem prîse: a Festschrift in Honor of Ernst S. Dick*, ed. Winder McConnell. Göppingen: Kümmerle, 1989, pp. 183–97.

————. *Medieval Humanism in Gottfried von Strassburg's Tristan und Isolde*. Heidelberg: Winter, 1977.

Jonin, Pierre. "L'esprit celtique dans le roman de Béroul." In *Mélanges de langue et de littérature médiévales offerts à Pierre Le Gentil*. Paris: SEDES et CDU Réunis, 1973, pp. 409–20.

————. *Les Personnages féminins dans les romans français de Tristan au XII^e siècle*. Aix-en-Provence: Ophrys, 1958.

Kalinke, Marianne E. *King Arthur, North-by-Northwest: the "Matière de Bretagne" in Old Norse-Icelandic Romances*. Copenhagen: Reitzel, 1981.

Kennedy, Beverly. *Knighthood in the Morte Darthur*. Woodbridge, Suffolk: Brewer, 1985.

Kennedy, Edward D. "Malory's King Mark and King Arthur." *Mediaeval Studies*, 37 (1975), 190–234.

*Kerman, Joseph. "Opera as Symphonic Poem." In his *Opera as Drama*. New York: Knopf, 1956; rev. ed. Berkeley and Los Angeles: University of California Press, 1988, pp. 158–77.

Kjær, Jonna. "Théorie du mythe et les romans de *Tristan et Iseult*. Présentation d'un projet de recherches." *Revue romane*, 15.2 (1980), 221–33.

————. "*Tristrams saga ok Ísöndar*—une version christianisée de la branche dite courtoise du 'Tristan.'" In *Courtly Literature: Culture and Context*, ed. Keith Busby and Erik Kooper. Amsterdam and Philadelphia: Benjamins, 1990, pp. 367–77.

Kleinhenz, Christopher. "Tristan in Italy: The Death or Rebirth of a Legend." *Studies in Medieval Culture*, 5 (1975), 145–58.

Konecny, Silveria. "Die Eheformen in den Tristanromanen des Mittelalters." *Pauls und Braunes Beiträge zur Geschichte der deutschen Sprache und Literatur* (Halle), 99 (1978), 182–215.

Konecny, Silvia. "Tristan und Marke bei Gottfried von Strassburg." *Leuvense Bijdragen*, 66 (1977), 43–60.

Krohn, Rüdiger. "Erotik und Tabu in Gottfrieds *Tristan.*" In *Stauferzeit. Geschichte, Literatur, Kunst*, ed. Krohn, et al. Stuttgart: Klett-Cotta, 1978, pp. 362–76.

Kunstmann, Pierre. "Symbole et interprétation: le message de Tristan dans le *Chèvrefeuille.*" *Tristania*, 13 (Autumn 1987–Spring 1988), 35–52.

Kunzer, Ruth Goldschmidt. *The "Tristan" of Gottfried von Strassburg—An Ironic Perspective.* Berkeley: University of California Press, 1973.

Leach, Henry Goddard. "Tristan in the North." In his *Angevin Britain and Scandinavia.* Cambridge, 1921. Rpt. Millwood, N.Y.: Kraus Reprint Co., 1975, pp. 169–98.

Leavy, Barbara Fass. "Iseut of Brittany: A New Interpretation of Matthew Arnold's *Tristram and Iseult.*" *Victorian Poetry*, 18 (1980), 1–22.

Le Gentil. P[ierre]. "La Légende de Tristan vue par Béroul et Thomas. Essai d'interprétation." *Romance Philology*, 7 (1953–54), 111–29.

Linden, Brigitte. *Die Rezeption des Tristanstoffs in Frankreich vom Ende des 18. bis zum Beginn des 20. Jahrhunderts.* Bern, Frankfurt/M., New York, Paris: P. Lang, 1988.

Loomis, Roger Sherman, and Laura Hibbard Loomis. *Arthurian Legends in Medieval Art.* London: Oxford University Press, 1938.

Magee, Bryan. "Schopenhauer and Wagner." In his *The Philosophy of Schopenhauer.* Oxford: Clarendon; New York: Oxford University Press, 1983, pp. 326–78.

*Mahoney, Dhira B. "Malory's 'Tale of Sir Tristram': Source and Setting Reconsidered." *Medievalia et Humanistica*, n.s. 9 (1979), 175–98.

Mancoff, Debra N. *The Arthurian Revival in Victorian Art.* New York and London: Garland, 1990.

Marchello-Nizia, Christiane. "Amour courtois, société masculine et figures du pouvoir." *Annales*, 36.6 (nov.–déc. 1981), 969–82.

Markale, Jean. *L'amour courtois ou le couple infernal.* Paris: Imago, 1987.

*McCann, W.J. "Tristan: The Celtic Material Re-examined." In *Gottfried von Strassburg and the Medieval Tristan Legend*, eds. Stevens and Wisbey, Cambridge: Brewer, 1990, pp. 19–28. [*Expanded in the present volume to include a discussion of the theories regarding possible Oriental analogues and sources.]

McDonald, William C. *Arthur and Tristan: On the Intersection of Legends in German Literature.* Lewiston, N.Y.: Mellen, 1990.

————. "Character Portrayal in Eilhart's *Tristrant*." *Tristania*, 9 (Autumn 1983–Spring 1984), 25–39.

*————. "Gottfried von Strassburg: *Tristan* and the Arthurian Tradition." In *In hôhem prîse: a Festschrift in Honor of Ernst S. Dick*, ed. Winder McConnell. Göppingen: Kümmerle, 1989, pp. 243–66.

————. *The Tristan Story in German Literature of the Late Middle Ages and Early Renaissance: Tradition and Innovation*. Lewiston, N.Y.: Mellen, 1990.

Mergell, Bodo. *Tristan und Isolde: Ursprung und Entwicklung der Tristansage des Mittelalters*. Mainz: Kirchheim, 1949.

Mohr, Wolfgang. "Tristan und Isolde als Künstlerroman." *Euphorion*, 53 (1959), 153–74.

Newman, Ernest. "Tristan and Isolde." In his *The Wagner Operas*. New York: Knopf, 1949, pp. 160–278.

Newstead, Helaine. "The Origin and Growth of the Tristan Legend." In *Arthurian Literature in the Middle Ages*, ed. Roger Sherman Loomis, pp. 122–33.

Noble, Peter S. *Béroul's "Tristan" and the "Folie Tristan de Berne."* London: Grant & Cutler, 1982.

Okken, Lambertus. *Kommentar zum Tristan-Roman Gottfrieds von Strassburg*. 2 vols. Amsterdam: Rodopi, 1984–85.

Ollier, Marie-Louise. "Le Statut de la vérité et du mensonge dans le 'Tristan' de Béroul." In *Tristan et Iseut, mythe européen et mondial*, ed. Buschinger, pp. 298–318.

Østergaard Kristensen, Vibeke. "L'amour de Tristan et Iseut dans *Le Roman de Tristan en prose*. Amour fatal ou amour chevaleresque?" *Revue Romane*, 20.2 (1985), 243–58.

Ott, Norbert H. "Katalog der Tristan-Bildzeugnisse." In *Frühmorgen-Voss, Text und Illustration im Mittelalter*, pp. 140–71.

Padel, O[liver] J. "The Cornish Background of the Tristan Stories." *Cambridge Medieval Celtic Studies*, 1 (1981), 53–81.

Panvini, Bruno. *La leggenda di Tristano e Isotta*. Florence: Olschki, 1951.

Paquette, Jean-Marcel. "La Dernière Métamorphose de Tristan: Yvan Lagrange (1972)." In *Tristan et Iseut, mythe européen et mondial*, ed. Buschinger, pp. 319–25.

Paris, Gaston. "Tristan et Iseut." *Revue de Paris* (15 avril 1894), 138–79. Rpt. in his *Poèmes et Légendes du moyen âge*. Paris: Baranger, 1900, pp. 113–80.

Payen, Jean-Charles. "Lancelot contre Tristan: la conjuration d'un mythe subversif (Réflexions sur l'idéologie romanesque au moyen âge)." In *Mélanges de langue et de littérature médiévales offerts à Pierre Le Gentil*. Paris: SEDES et CDU Réunis, 1973, pp. 617–32.

*———. "Le Palais de verre dans la *Folie d'Oxford*: De la folie métaphorique à la folie vécue, ou: le rêve de l'île déserte à l'heure de l'exil: Notes sur l'érotique des *Tristan*." *Tristania*, 5.2 (Spring 1980), 17–27. [In English translation in the present volume.]

Pickford, Cedric E. "*Sir Tristrem*, Sir Walter Scott and Thomas," *Studies in Medieval Literature and Languages in Memory of Frederick Whitehead*, ed. W. Rothwell et al. (Manchester University Press, 1973), pp. 219–28.

Piquet, Félix. "Le problème Eilhart-Gottfried." *Revue Germanique*, 20 (1929), 119–32, 242–54.

Polack, L[ucie]. "Tristan and *Vis and Ramin*." *Romania*, 95 (1974), 216–34.

Poletti, Elena. *Love, Honour and Artifice. Attitudes to the Tristan Material in the Medieval Epic Poems and in Selected Plays from 1853–1919*. Göppingen: Kümmerle, 1989.

Poulson, Christine. "Arthurian Legend in Fine and Applied Art of the 19th and Early 20th Centuries: A Catalogue of Artists." *Arthurian Literature*, 9 (1989), 81–142.

*Rabine, Leslie W. "Love and the New Patriarchy: *Tristan and Isolde*." In her *Reading the Romantic Heroine. Text, History, Ideology*. Ann Arbor: University of Michigan Press, 1985, pp. 20–49.

Reed, John R. "Swinburne's *Tristram of Lyonnesse*: The Poet-Lover's Song of Love." *Victorian Poetry*, 4 (1966), 99–120.

Ribard, Jacques. *Du Philtre au Graal. Pour une interprétation théologique du "Roman de Tristan" et du "Conte du Graal."* Paris: Champion, 1989.

Rocher, Daniel. "Denis de Rougemont, la 'légende' et le Roman de Gottfried von Strassburg." In *La Légende de Tristan au moyen âge*, ed. Buschinger, pp. 139–50.

Rosenbrand, Doris. *Das Liebemotiv in Gottfrieds "Tristan" und Wagners "Tristan und Isolde."* Göppingen: Kümmerle, 1973.

Rougemont, Denis de. *L'Amour et l'Occident*. 1939; éd. définitive, Paris: Plon, 1972. *Love in the Western World*. Tr. Montgomery Belgion. 1940; Princeton: Princeton University Press, 1983.

———. "New Metamorphoses of Tristan." In his *Love Declared: Essays on the Myths of Love*. Tr. Richard Howard. New York Pantheon, 1963, pp. 39–76. Orig. pub. *Comme Toi-Même*. Paris: A. Michel, 1961.

Rumble, Thomas C. "The Middle English *Sir Tristrem*: Towards a Reappraisal." *Comparative Literature*, 11 (1959), 221–28.

———. "'The Tale of Tristram': Development by Analogy." In *Malory's Originality: A Critical Study of "Le Morte Darthur,"* ed. R.M. Lumiansky. Baltimore: Johns Hopkins University Press, 1964, pp. 118–83.

Savage, Edward B. *The Rose and the Vine. A Study of the Evolution of the Tristan and Isolt Tale in Drama.* Cairo: American University at Cairo Press, 1961.

Schach, Paul. "Some Observations on the Influence of *Tristrams saga ok Ísöndar* on Old Icelandic Literature." In *Old Norse Literature and Mythology: A Symposium*, ed. Edgar C. Polomé. Austin and London: University of Texas Press, 1969, pp. 81–129.

———. "The Style and Structure of *Tristrams Saga.*" In *Scandinavian Studies. Essays Presented to Dr. Henry Goddard Leach*, ed. Carl F. Bayerschmidt and Erik J. Friis. Seattle: University of Washington Press, 1965, pp. 63–86.

———. "Tristan and Isolde in Scandinavian Ballad and Folktale." *Scandinavian Studies* 36 (1964), 281–97.

Schindele, Gerhard. *Tristan: Metamorphose und Tradition.* Stuttgart: Kohlhammer, 1971.

Schmolke-Hasselmann, Beate. "Tristan als Dicter. Ein Beitrag zur Erforschung des lai lyrique breton," *Romanische Forschungen*, 94 (1986), 258–76.

Schnell, Rüdiger. *Causa Amoris, Liebeskonzeption und Liebesdarstellung in der mittelalterlichen Literatur.* Bern: Francke, 1985.

Schoepperle [Loomis], Gertrude. *Tristan and Isolt. A Study of the Sources of the Romance.* Frankfurt and London, 1913. 2nd ed., Roger Sherman Loomis. New York: Franklin, 1959.

Schröder, Franz Rolf. "Die Tristansage und das Persische Epos 'Wis und Ramin,'" *Germanisch-Romanische Monatsschrift*, 42 (1961), 1–44.

Schueler, Donald G. "The Tristram Section of Malory's *Morte Darthur.*" *Studies in Philology*, 65 (1968), 51–66.

Schwartz, Alexander. *Sprechaktgeschichte: Studien zu den Liebeserklärungen in mittelhochdeutschen und modernen Tristandichtungen.* Göppingen: Kümmerle, 1984.

Seidenspinner-Núñez, Dayle. "The Sense of an Ending: The Tristán Romance in Spain." *Tristania*, 7 (Autumn 1981–Spring 1982), 27–46.

Shaver, Anne. "The Italian Round Table and the Arthurian Tradition." In *Courtly Romance: A Collection of Essays*, ed. Guy Mermier and Edelgard E. Du Bruck. Detroit: Fifteenth-Century Studies, 1984, pp. 203–22.

Spitzer, Leo. "La 'Lettre sur la baguette de coudrier' dans le lai de *Chievrefeuil*." *Romania*, 69 (1946–47), 80–90.

Staines, David. *Tennyson's Camelot: The "Idylls of the King" and Its Medieval Sources*. Waterloo, Ont.: Wilfrid Laurier University Press, 1982.

Starr, Nathan Comfort. *King Arthur Today: the Arthurian Legend in English and American Literature, 1901–1953*. Gainesville: University of Florida Press, 1954.

Stein, Jack M. "Tristan and Isolde as 'Music of the Future,'" *Criticism*, 2 (1960), 1–22. Rpt. in his *Richard Wagner and the Synthesis of the Arts*. Detroit: Wayne State University Press, 1960; Westport, Conn.: Greenwood Press, 1973, ch. 13 and 14.

Stein, Peter K. "Tristan." In *Die epischen Stoffe des Mittelalters*. Stuttgart: Kröner, 1984, pp. 365–94.

Stevens, Adrian, and Roy Wisbey, eds. *Gottfried von Strassburg and the Medieval Tristan Legend. Papers from an Anglo-North American Symposium*. Cambridge: Brewer, 1990.

Sudre, Léopold. "Les Allusions à la Légende de Tristan dans la littérature du moyen âge." *Romania*, 15 (1886), 534–57.

Surles, Robert L. "Mark of Cornwall: Noble, Ignoble, Ignored." *Arthurian Interpretations*, 3.2 (Spring 1989), 60–75.

Tax, Petrus W. *Wort, Sinnbild, Zahl im Tristanroman. Studien zum Denken und Werten Gottfrieds von Strassburg*. Berlin: Schmidt, 1961; 2nd ed. 1971.

Taylor, Beverly, and Elizabeth Brewer. *The Return of King Arthur: British and American Arthurian Literature Since 1800*. Woodbridge, Suffolk: Brewer, 1983.

Thomas, Neil. "The *Minnegrotte*: Shrine of Love or Fools' Paradise? Thomas, Gottfried and the European Development of the Tristan Legend." *Trivium*, 23 (1988), 89–106.

Thomas, M.F. "The Briar and the Vine: Tristan Goes North." *Arthurian Literature*, 3 (1983), 53–90.

Thompson, Raymond H. *The Return from Avalon: A Study of the Arthurian Legend in Modern Fiction*. Westport, Conn. and London: Greenwood Press, 1985.

Tomasek, Tomas. *Die Utopie im "Tristan" Gotfrids von Strassburg.* Tübingen: Niemeyer, 1985.

Traxler, Janina P. "Observations on the Importance of Prehistory in the *Tristan en prose.*" *Romania*, 108 (1987), 539–48.

Unterreitmeier, Hans. *Tristan als Retter.* Perugia: Benucci, 1984.

Van Coolput, Colette-Anne. *Aventures quérant et le sens du monde. Aspects de la réception productive des premiers romans du Graal cycliques dans le "Tristan en prose."* Leuven: Leuven University Press, 1986.

Várvaro, Alberto. *Il "Roman de Tristan" de Béroul.* Turin: Bottega d'Erasmo, 1963. *Béroul's "Romance of Tristan."* Tr. John C. Barnes. Manchester: Manchester University Press; New York: Barnes and Noble, 1972.

———. "La teoria dell'archetipo tristaniano." *Romania*, 88 (1967), 13–58.

Vinaver, Eugène. *Etudes sur le Tristan en prose.* Paris: Champion, 1925.

———. *Le Roman de Tristan et Iseut dans l'œuvre de Thomas Malory.* Paris: Champion, 1925.

Wagner, Wieland, ed. *Hundert Jahre Tristan. Neunzehn Essays.* Emsdetten: Lechte, 1965.

Walter, Philippe. *Le Gant de verre: le mythe de Tristan et Yseut.* Paris: Artus, 1990.

Wapnewski, Peter. *Tristan Der Held Richard Wagners.* Berlin: Severin und Siedler, 1981.

Weber, Gottfried. *Gottfrieds von Strassburg Tristan und die Krise des hochmittelalterlichen Weltbildes um 1200.* 2 vols. Stuttgart: Metzler, 1953.

Weber, Gottfried, and Werner Hoffmann. *Gottfried von Strassburg.* Stuttgart: Metzler, 1962.

Whitaker, Muriel. *The Legends of King Arthur in Art.* Woodbridge, Suffolk; Rochester, N.Y.: Brewer, 1990.

Wiesmann-Wiedemann, Frederike. "From Victim to Villain: King Mark." In *The Expansion and Transformation of Courtly Literature,* ed. Nathanial Smith and Joseph T. Snow. Athens: University of Georgia Press, 1980, pp. 49–68.

Wolf, Alois. *Gottfried von Strassburg und die Mythe von Tristan und Isolde.* Darmstadt: Wissenschaftliche, 1989.

Wynn, Marianne. "Gottfried's Heroine." In *Gottfried von Strassburg and the Medieval Tristan Legend,* ed. Stevens and Wisbey, pp. 127–41.

Zenker, Rudolf. "Die Tristansage und das persische Epos von Wîs und Râmîn." *Romanische Forschungen*, 29 (1911), 321–69.

Zuckerman, Elliott. *The First Hundred Years of Wagner's Tristan*. New York and London: Columbia University Press, 1964.

Tristan and Isolde

Tristan: The Celtic and Oriental Material Re-examined[1]

W.J. McCann

The purpose of this essay is to examine and evaluate as objectively as possible the most recent research by scholars in the fields of Celtic and Oriental Studies, in order to pose the most important questions about the origins of the Tristan legend. It will become obvious by the end of this enquiry that, in the state of our present knowledge, some of the questions raised are in themselves unanswerable and that the individual solutions to the problem so far offered each leave *different* questions unanswered. The nature of the relationship between Celtic and continental sources in the field of the Arthurian Romance and the Tristan legend (and, in the case of the latter, the relationship with oriental sources as well) is a problem which has given rise

Revised and expanded by the author, with permission, from "Tristan: The Celtic Material Re-examined," in *Gottfried von Strassburg and the Medieval Tristan Legend*, ed. Adrian Stevens and Roy Wisbey (Cambridge: Brewer, 1990), pp. 19–28.

1. The second part of this article is a reworking of material presented in my paper "Tristan: the Celtic Material Re-examined," in *Gottfried von Strassburg and the Medieval Tristan Legend*, ed. Adrian Stevens and Roy Wisbey (Cambridge: Brewer, 1990), pp. 19–28. I am grateful to Boydell and Brewer for permission to re-use this material. I would also like to thank the Inter-Library Loan staff at Southampton University Library for their more than usual helpfulness in obtaining material for the Persian part of this article.

to fierce controversy, with some scholars both modern and not
so modern adopting extreme positions on both sides.[2] I hope that
this study, by eschewing these extremes, will achieve that *mâze*
which is the aim of so many medieval authors.

One is supported in this sensible approach by Bruford in
his work on Gaelic folktales and medieval romances:

> It is dangerous to be too dogmatic about the sources of
> episodes in mediaeval romances: so much of the relevant
> material must have been lost . . . that the mere fact of a
> motif first appearing in a French MS dated, say, about
> 1250, and then in an Irish one of the fifteenth century,
> cannot be taken as conclusive proof that the motif is of
> French origin or even was known in France before it was
> known in Ireland. . . . The fact that motifs found in
> continental lays and romances also appear in Irish tales
> which, on linguistic grounds, can be dated earlier, often
> centuries earlier, has led to a situation where some
> Arthurian scholars seem to describe any motif whose
> source is unknown as "Celtic," and may even treat
> nineteenth-century Irish folk-tales as accurate
> representatives of the source drawn on by a twelfth-
> century lai.[3]

As we shall see, this last remark is particularly pertinent
when we come to look at some of the Irish (and *mutatis mutandis*
the oriental) "sources" of the Tristan material. One major
problem in this respect is the extremely positivistic approach of
many scholars, particularly earlier this century: it is
automatically assumed that if a motif or narrative occurs in two
places, then one must be the source of the other, no matter how
banal the content, even, say, an adulterous relationship between
the young wife of an older man and her husband's younger

2. The old battles of the *Mabinogionfrage*, fought out in the early
years of this century, are typical of the passions aroused in this context.
See, for example, the references in Roger Sherman Loomis, ed.,
Arthurian Literature in the Middle Ages (Oxford: Oxford University Press,
1959) (hereafter *ALMA*), p. 53.

3. Alan Bruford, *Gaelic Folk-Tales and Mediaeval Romances: a Study
of the Early Modern Irish "Romantic Tales" and their Oral Derivatives*
(Dublin: The Folklore of Ireland Society, 1969), p. 12.

relative. Also, there is a tendency to treat the history of a narrative like the history of a written text, with assumptions about archetypes, originals, intermediate stages, etc., often involving the creation of imaginary versions, which are then treated without any justification by subsequent generations of scholars as entities which actually exist.[4]

A major methodological problem is also the question of what is to be defined as the *Tristan* for which the Celtic or oriental material is the source: are we looking at the extant texts, or an amalgam of them; or are we looking at a hypothetical *estoire* or *Ur-Tristan*? Each scholar differs, as can be seen by perusal of the material, in what s/he considers to be the essence of the Tristan legend, so that motifs which do not fit into a particular conception of the essential Tristan can be discarded as unimportant, or as later accretions, or both. This process is further complicated by the fact that the extant versions themselves divide into two broad groups, the "uncourtly" (Béroul/Eilhart) and the "courtly" (Thomas and his adaptors), with the former usually being regarded, not entirely justifiably, as closer to the original because of their more "primitive" nature. As we will also see later, many of the elements that are assumed to be analogous can only be so by a very broad stretch of the imagination, so that in some cases one is irresistibly reminded of Fluellen equating Macedon with Monmouth in *Henry V*, Act IV, scene 7:

> There is a river in Macedon; and there is also moreover a river at Monmouth; it is call'd Wye at Monmouth, but it is out of my prains what is the name of the other river; but 'tis all one, 'tis alike as my fingers is to my fingers, and there is salmons in both.

4. See, for example, the invention of a combination of the Persian *Vīs-u Rāmīn*, and the story of *Qays and Lubnā* which was supposed to have been transmitted from the Orient and then translated into (or at least summarised in) Latin "am ehesten in Italien ... etwa um die Wende des 11. und 12. Jahrhunderts" in Franz Rolf Schröder, "Die Tristansage und das Persische Epos 'Wis und Ramin,'" *Germanisch-Romanische Monatsschrift*, 42 (1961), 1–44, here 31 and 36.

In my survey of the material that has been suggested as possible sources of the Tristan legend, I will first deal with the Persian and Arabic material which has been mentioned by some scholars, particularly in Germany,[5] as one possibility. I will then examine the actual material concerning Tristan in the medieval Celtic languages (which basically means in Welsh) and consider the Celtic nature of the story itself.

It was in 1869 that Graf[6] first suggested that there were analogies between the Persian *Vīs and Rāmīn*, composed by Gurgāni in the 11th century,[7] and the Tristan legend. This was later taken up by Zenker in 1911, though his work had the misfortune to appear almost simultaneously with Gertrude Schoepperle's,[8] and was for the most part rejected by the then prevalent Celtic school of Tristan scholars,[9] although many people were prepared to agree that a number of motifs, particularly the episodes dealing with Isolde of the White Hands, must be of oriental origin.[10] It was not until Schröder's work in 1961 that the theory of a Persian source for the Tristan

5. Rudolf Zenker, "Die Tristansage und das persische Epos von Wîs und Râmîn," *Romanische Forschungen*, 29 (1911), 321–69; Schröder, art. cit.; Walter Haug, "Die Tristansage und das persische Epos *Wîs und Râmin*," *Germanisch-Romanische Monatsschrift*, 54 (1973), 404–23; and L. Polak, "*Tristan* and *Vis and Ramin*," *Romania*, 95 (1974), 216–34.

6. Karl Heinrich Graf, "Wis und Ramin," *Zeitschrift der Deutschen Morgenländischen Gesellschaft*, 23 (1869), 375–433. Throughout the present essay, material quoted from French and German sources has been translated by the author.

7. Translated into French: Gorgâni, *Le Roman de Wîs et Râmîn*, tr. Henri Massé (Paris: Les Belles Lettres, 1959); and English: *Vīs and Rāmīn*, Translated from the Persian of Fakhr ud-Dīn Gurgānī by George Morrison (New York and London: Columbia University Press, 1972).

8. *Tristan and Isolde, a Study of the Sources of the Romance*, 1913; 2nd edition (New York: Knopf, 1960).

9. See the references in Schröder (15) and W. Ann Trindade, "Tristan and Wis and Ramin: the Last Word?" *Parergon*, 5 (1987), 19–28, here 21.

10. E.g., Helaine Newstead, "The Origin and Growth of the Tristan Legend," *ALMA*, pp. 123–33.

legend once again entered the field, and it has since found support from Haug, Polak, and Gallais.[11]

Since so many scholars have in their work presented differing versions of the narrative of *Vīs and Rāmīn*, either because (1) they have relied on synopses rather than translations; or (2) because they have used the Georgian rather than the Persian version; or (3) because they have left out material they deemed irrelevant, I feel it would be useful to include at this point a rather fuller synopsis of the text than any yet found in the critics. Since it is itself based on the translations by Henri Massé and George Morrison, it obviously lays itself open to similar criticism; nonetheless it does bring to light some interesting information. The division into sections and their numbering is arbitrary, and used only for ease of reference.[12] Since there are a number of systems of transliteration from the Persian, I have chosen to follow that used by Minorsky,[13] except in direct quotations from authors who have used different systems.

1. King Mōbad entertains a large number of personages at a feast (including, apparently, his brother Rāmīn, who according to the later narrative should not have been born at this time). He falls in love with Queen Shahrō who, however, rejects his advances. They agree that should she ever have a daughter, the latter will be betrothed to Mōbad (19–25).

2. Late in life Shahrō gives birth to a daughter, Vīs, who is put to nurse at Khūzān, with the same wet nurse who is looking after Mōbad's younger brother, Rāmīn. They grow up together for ten years, until Vīs is recalled to her mother (25–29).

11. Pierre Gallais, *Genèse du roman occidental. Essais sur Tristan et Iseut et son modèle persan* (Paris: Tête de Feuilles, 1974).

12. Page numbers in the summary that follow are taken from Morrison's translation, for ease of reference for English-speaking readers.

13. Vladimir Minorsky, "Vīs-u Rāmīn. A Parthian Romance," *Bulletin of the School of Oriental and African Studies*, 11 (1943–46), 741–63; 12 (1947–48), 20–35; 16 (1954), 91–92; 25 (1962), 275–86.

3. Vīs is betrothed and married to her brother, Virō (We later learn, p. 50, that the marriage remains unconsummated because Vīs begins to menstruate, which makes her unapproachable.) During the celebrations, Zard, Mōbad's other brother, arrives and claims Vīs's hand for Mōbad. Vīs defiantly rejects his suit, pointing out that she is already married (29–36).

4. Mōbad, enraged by the news, declares war on Māh-ābād. In the ensuing battle, Vīs's father, Qārin, is killed, but her brother, Virō, ultimately defeats Mōbad (36–45).

5. Mōbad, though defeated, takes his army to Gūrāb, where Vīs is awaiting the outcome of the battle. He sends a messenger to her, offering her various privileges in return for marrying him. She replies proudly and indignantly in the negative (45–51).

6. Mōbad takes advice from his two brothers, Rāmīn and Zard, about what he should do in this situation. We learn, p. 51, that Rāmīn is already in love with Vīs. He attempts to dissuade Mōbad from trying to win Vīs, but Zard advises bribing Shahrō—as a way of influencing her daughter (51–53).

7. Mōbad writes to Shahrō and bribes her to gain entry into the castle. He takes Vīs away, much to the chagrin of her brother/husband, Virō (53–59).

8. On the journey back to Marv, Rāmīn catches sight of Vīs and is immediately consumed with love for her, so much so that he falls off his horse in a faint. Vīs is installed in Mōbad's harem and showered with gifts (60–64).

9. Vīs's nurse follows her to Marv and attempts to persuade her to behave practically, accept Mōbad, and forget Virō. Vīs is not prepared to take this course of action at first but eventually resigns herself to her fate (64–70).

10. Vīs refuses to give herself to Mōbad for a year, during which she will mourn the death of her father. The nurse agrees to help her by fashioning a talisman which will magically render him impotent, but only for a month. The talisman is buried beside a river, as contact with the

damp and cold of the earth produces the magic that will affect Mōbad. Unfortunately, a storm causes the river to overflow its banks, washing the talisman away: Mōbad is now "bound" forever by the talisman's power, and Vīs once again remains a virgin (70–73).

11. Rāmīn laments his love for Vīs. Meeting the nurse in the garden, he tells her of his state. She at first tries to dissuade him but eventually agrees to help him with his suit to Vīs. He is so overjoyed that he actually makes love to the nurse; the text suggests that this is one way of influencing women to act in one's interests (73–85).

12. The nurse uses all her wiles to try and persuade Vīs to take Rāmīn as her lover. Vīs refuses angrily, but the devil is on the nurse's side (p. 98), and Vīs is eventually persuaded by the nurse's argument that she will be condemned to a life of distress if she is deprived of the pleasures of physical love forever. However, she dissembles and pretends still to be determined to reject Rāmīn. Eventually, the thought of Rāmīn and his love overcomes her nonetheless (85–102).

13. Vīs sees Rāmīn at a feast, and this confirms her love for him. However, thoughts of morality and salvation lead her to continue to reject his attentions at first. Ultimately, it appears that her concerns are more practical than moral: her main fear is that of being found out (102–07).

14. In the absence of Mōbad, Vīs meets Rāmīn (who, feigning illness, has been left behind as regent), and although she attempts to dissuade him from continuing, they eventually swear an oath of mutual and eternal fidelity, and the relationship is consummated (107–11).

15. Vīs and Rāmīn are called to join Mōbad. They are unable to meet because of the circumstances, and one day Mōbad overhears the nurse talking to Vīs about her lover. He is enraged, but Vīs refuses to deny her love either to him or to her brother Virō, claiming that she would give up paradise for Rāmīn (111–17).

16. In the face of Vīs's continued refusal to renounce her love for Rāmīn, Mōbad exiles her. Desolated, Rāmīn tries

to follow her under the pretext of a hunting trip. Mōbad is not deceived and exiles him as well. In spite of denying that he will do so, Rāmīn goes to join Vīs (117–25).

17. Mōbad is informed that they are together. Enraged, he threatens to kill them both, but his mother advises him that he needs his brother's support and that he can find a thousand wives like Vīs. He deflects his rage to Virō and declares war on him. However, Virō's noble reply assuages his anger, they are reconciled, and Vīs is returned to Mōbad (125–32).

18. Mōbad accuses Vīs of having had an affair with Rāmīn, which she denies. Mōbad requires her to take an oath of purity and to pass through the sacred fire, which will not harm her if she is innocent. Knowing her guilt, she persuades Rāmīn to escape with her, and they go to Rayy, where they are concealed by a friend, Bihrōz, in whose home they live in delight (132–39).

19. Mōbad searches the world for Vīs and Rāmīn, undergoing extreme hardship, and returns unsuccessful to Marv after more than six months of suffering (139–41).

20. Rāmīn writes to his mother to reassure her that he is still alive. After getting Mōbad to swear an oath that he will not harm Vīs and Rāmīn, the mother reveals their whereabouts to him, and they are recalled to Marv, where harmony is restored (141–45).

21. At a feast, Vīs and Rāmīn talk of their love and are overheard by the king. When they retire for the night, Mōbad reproaches Vīs, who feels a rush of sympathy for her husband and assures him of her love. This does not prevent her from joining Rāmīn later in the night, when she hears him lamenting on the terrace outside, and leaving the nurse in her place at Mōbad's side. When the king awakes, he is aware that something is wrong, and calls for lights, but before they come, Vīs returns and is thus able to make Mōbad think that he was in the wrong to suspect her (146–56).

22. Mōbad departs on a campaign against the Greek emperor, leaving Vīs locked up in a castle in the charge of Zard. Rāmīn becomes ill in her absence and is left behind when the army departs. Rāmīn then joins Vīs by climbing over the castle walls (thus avoiding the locks and the guards), and they spend nine months together in bliss. No one knows what is happening except the sorceress, Zarrēn-Gēs (156–74).

23. Mōbad returns victorious but is furious when Zarrēn-Gēs tells him of the lovers. Rāmīn escapes at his approach, but he demotes Zard and whips Vīs and the nurse almost to death (175–82).

24. At the pleading of Shahrō and Zard, Mōbad pardons Vīs and Rāmīn yet again, entrusting Vīs to the nurse. Since the nurse determines to behave honourably, Vīs joins Rāmīn by leaping down into the garden from the harem wall (182–95).

25. Mōbad comes to the garden. Rāmīn escapes before being found, but the king draws his sword to kill Vīs. Once again Zard's pleading prevents this; the king believes Vīs's lies and is reconciled with her again. At a feast, a minstrel sings a song referring to the love of Vīs and Rāmīn. The king, enraged, tries to kill Rāmīn, but the latter is too strong for him (195–204).

26. A wise man advises Rāmīn that his love for Vīs is endangering his soul. Rāmīn is convinced, and the lovers part from each other with protestations of eternal loyalty (204–18).

27. In Gūrāb Rāmīn falls in love with Gul (Rose) whom he marries. She becomes angered when he compares her to Vīs, and in order to prove his love for Gul, Rāmīn sends a letter of rejection to Vīs, who is devastated and sends the nurse to reproach him (218–35).

28. Rāmīn insults the nurse, sending her back to Vīs with a message of rejection. Vīs becomes ill and sends a series of ten letters to Rāmīn (235–68).

29. In the meanwhile, Rāmīn has begun to tire of Gul and to regret having been unfaithful to Vīs. This is discovered

by Gul's father and reported to her. Vīs's messenger
arrives, and Rāmīn is overjoyed at the letter (268–79).

30. Rāmīn replies to the letter and follows the messenger to
 Marv. On his arrival, Vīs asks the nurse to make the king
 fall into an enchanted sleep, which she does. However,
 Vīs does not immediately accept Rāmīn: on the contrary,
 she reproaches him bitterly and will not accept his
 excuses, finally sending him away and locking the door
 (279–308).

31. She repents of her cruelty, sends the nurse after Rāmīn,
 and follows her. They argue, Vīs leaves Rāmīn yet again,
 but they are eventually reunited (in Mōbad's palace,
 although he is unaware of this) (308–21).

32. Rāmīn reveals his presence to Mōbad and is welcomed
 back. He continues his affair with Vīs in secret. The king
 takes Rāmīn hunting with him, much to Vīs's chagrin;
 she decides that the time has come to put an end to their
 difficulties by disposing of Mōbad. She sends a letter to
 this effect, and Rāmīn is persuaded by her arguments
 (322–35).

33. Rāmīn and forty warriors, disguised as women, enter the
 castle, kill Zard and the guards and escape, taking with
 them Vīs together with Mōbad's treasure (335–41).

34. Mōbad collects his forces to take revenge but is killed by
 a wild boar before setting forth (341–44).

35. Rāmīn becomes king and reigns for eighty-three years.
 Vīs dies before him, and he abdicates in favour of his
 son, spending the rest of his life in the Temple of Fire.
 On his death, his soul rejoins that of Vīs (344–52).

The happy ending to this text does not sort very well with
the tragic ending of the Tristan story, and another oriental
analogue which is much closer to the ending of the narrative as
we have it is to be found in the romance concerning the poet
Qays ibn Ḍarih (died 687) and his wife Lubnā, first mentioned in

this context by Singer.[14] This has almost universally been accepted as the source of the last part of the Tristan story, namely, Tristan's relationship with Isolde of the White Hands, and the final death of the lovers. However one might, as devil's advocate, ask what the source of this romance was: i.e., was it based on historical fact, or was it another "floating" narrative motif that was attached to this poet?

Qays, who in most versions is called Kais ibn Doreidsch (although Kunitsch suggests they are wrongly following Singer here[15]), was married to Lubnā, but because the marriage remained childless he was forced by his father to repudiate her. He fell sick because of the loss of his love and was advised to take another wife. He met another beautiful woman and, on discovering that her name was also Lubnā, fell unconscious. Though he did not form a relationship with her at that time, he became friends with her brother, who eventually persuaded him to marry her. However, he did not consummate the marriage until forced to as a result of her family's complaints to the Khalif. Both he and the first Lubnā (who had also remarried) made a pilgrimage to Mecca, but as they did not meet, he fell ill and lamented her indifference in verse. Finally, Lubnā did visit him and, after this brief reunion, they both died.

This narrative does seem to contain a number of features that are extremely close to the story of Tristan and Isolde of the White Hands—the similarity of the two wives' names, the failure to consummate the marriage, the involvement of the second wife's brother—and is, in fact, the most convincing parallel evinced by those who favour the thesis of oriental origin, though Kunitsch (82) casts some doubt even on this (see below).

Schröder, and also Gallais, proposed that what eventually reached the West was an amalgam of the two Eastern texts, where the tragic ending of Qays and Lubnā was tacked on to the story of Vīs and Rāmīn, thus creating yet another hypothetical

14. S. Singer, "Arabische und europäische Literatur im Mittelalter," *Abhandlungen der Preußischen Akademie der Wissenschaften*, Phil.-hist. Kl. 13 (1918).

15. Paul Kunitsch, "Are there Oriental Elements in the Tristan Story?" *Vox Romanica*, 39 (1980), 73–85, here 81.

text. He also suggests an as yet undiscovered Latin text as the ultimate source of Tristan. Without accepting or denying this idea, since in the absence of any concrete evidence it cannot be proved either way, perhaps one should proceed to an examination of the points of similarity between the oriental and Western material. Here we follow Schröder's argumentation, since he subsumes Zenker's work into his and uses a methodology that can be taken as typical. Schröder lists twelve points of similarity between *Tristan* and *Vīs-u Rāmīn*, which can be analyzed as follows:

1. "The aged and powerful Iranian King Mobad forcibly captures Wis, the daughter of a neighbouring ruler, in order to marry her—just like the equally aged King Mark with Isolde." Though he does mention in a footnote the fact that Vīs is already married (cf. Morrison 3 above), he fails to mention the major differences with the Tristan narrative: namely, that it is *not* Mark who wins Isolde, and that Vīs is betrothed to Mōbad before her birth (Morrison, p. 25, translates: "See into what tribulation they fell from giving away an unborn child as a bride.") Here one is struck more by the similarity with the Irish story of Deirdre,[16] where the heroine is betrothed to King Conchobar of Ulster while still in her mother's womb and, like Vīs, betrays him with a younger man.

2. "Wis is accompanied on her journey from her father's house to her new home by Ramin. . . . When a sudden gust of wind blows the curtain of her litter aside, he catches sight of Wis, whom he has not seen since childhood, and is overcome with passionate love for her." This is then compared with Tristan's bringing Isolde home to Mark, though it is admitted that love in the latter case is brought about by the potion. The fact that Mōbad and the whole court are also there is ignored, as is the fact that Rāmīn is already in love with

16. *Longes Mac n-Uislenn: The Exile of the Sons of Uisliu*, ed. Vernam · Hull (New York: Modern Language Association of America, 1949).

Vīs ("From childhood, Rāmīn's heart had kept the secret of desire for Vīseh; he ever treasured love for Vīs in his soul, but kept his feelings hidden from others. . . . Hope for Vīs revivified his love; the old desire in his soul became young again" [Morrison, p. 51]). Since this is not an example of falling suddenly in love, this comparison seems a little over-stretched.

3. More sensibly, the nurse's devotion to Vīs is compared to Brangaene's devotion to Isolde, though one wonders how unusual an element this is. For example, Deirdre, too, has a confidante, Leborcham the satirist (*Longes Mac N-Uislenn*, 45).

4. "At Wis's request, the nurse prepares a talisman by which Mōbad's virility is (by an unfortunate accident permanently) 'bound.' In Tristan the love potion binds the lovers." Apart from the use of magic in both cases, and the ingenious (or disingenuous) use of the verb "to bind" to suggest a closer parallel than in fact exists, there is little to support this comparison.

5. "Both Wis and Isolde carry on an adulterous liaison from the time of their marriage, and since Ramin, and like him Tristan, live at the king's court in permanent close proximity with the married couple, they have the easiest opportunity for ever renewed secret rendez-vous." True, but banal, in regard to the second part; and the first part overlooks the fact that Tristan and Isolde consummate their relationship before the marriage and that Vīs, instead of being struck by love for Rāmīn in a way even vaguely similar to Isolde, is actually rather sordidly seduced by him with the help and prompting of the nurse. This last fact also slightly calls into question point 3 above: to whom is the nurse loyal? (Cf. also the fact that she actually has intercourse with Rāmīn [Morrison 11].)

6. Here the similarity between the roles and characters of Mark and Mōbad is mentioned. This is said to explain the apparent discrepancies in Mark's character (the oscillation between the violent rage and hatred he feels

towards the lovers, and the following reconciliation, forgiveness, and affection) which had led at least one critic[17] to believe that this must be a combination of two originally separate versions of his character. This might be an acceptable point, were it not for the fact that Mark's variations of behaviour are motivated by his uncertainty—there is nearly always apparent evidence for the innocence of the lovers, e.g., the sword in the bed, the ambiguous oath taken by Isolde—whereas Môbad is the one whose behaviour seems totally arbitrary, since he is constantly forgiving the lovers while aware of their guilt. In fact, one might well say that Mark's behaviour is more likely to be the basis of Môbad's vacillation rather than the reverse.

7. Both heroines are replaced in the marriage bed by their confidantes. Obviously the circumstances are different, since Mark is not impotent and will notice the fact that Isolde is no longer a virgin, but this does seem to be a reasonably close parallel (although Schröder himself draws attention to "the widespread motif of the substituted bride," before going on to say: "but in spite of this difference one must place the two narratives, the French and the Persian, in parallel and in relationship with each other" [Schröder, 20]).

8. Both heroines are required by their husbands to swear an oath to prove their fidelity and to undergo an ordeal as well. Vīs escapes in order to avoid the ordeal, Isolde survives it, thanks to her ambiguous oath, which Schröder himself here points out is a known oriental motif in other sources (20) and thus not necessarily derived from *Vīs-u Rāmīn*.

9. Schröder claims that Vīs and Rāmīn escape "into the desert," where their love makes deprivation seem paradise. This he compares with Gottfried's *minnegrotte*. Though this desert life is certainly one of hardship in the

17. Jakob Kelemina, *Geschichte der Tristansage nach den Dichtungen des Mittelalters* (Wien: Hölzel, 1923), p. 17.

Georgian translation he quotes, Morrison 18 has them living in luxury with a friend, and Morrison 19 has *Mōbad* suffering the pains of life in the desert. One might also question whether this section is an important point of contact, since the escaping lovers would have to live somewhere; cf. what is said about the Deirdre story below.

10. The scene where Rāmīn is advised by the wise man to give up Vīs for his salvation's sake does seem to have a good deal in common with the scenes with the hermit Ogrin/Ugrim in the Béroul/Eilhart versions.

11. Both Rāmīn and Tristan meet and marry another woman during their separation from their first loves. Though she is not called Vīs in the Persian text, Rāmīn does anger her by comparing her to Vīs (Morrison 27), a fact that was either unnoticed by Schröder, or not present in the text he was using. This second liaison in the Tristan legend is, however, much closer to the story of Qays and Lubnā mentioned above, as Schröder agrees.

12. "Both poems end with the death of the lovers: admittedly the conclusion is very different"(!), since the death of Tristan and Isolde is tragic, that of Vīs and Rāmīn a relatively happy one after a long life together (Schröder, 21). Of course, the unhappy ending of Qays and Lubnā is much closer, which is why even some scholars who deny the influence of Vīs and Rāmīn are prepared to accept the former as an ultimate source.

Schröder mentions other parallels, such as Tristan's and Rāmīn's artistic abilities, but feels that they are less strong and convincing. However, he passes over a point which, precisely because it is an apparently trivial detail, might be held to be evidence for his case: this is the fact that Mōbad is killed by a wild boar. Zenker had already compared this with the dream of Marjodo in Gottfried where a wild boar enters Mark's bedroom and attacks him, soiling the sheets with blood. As will be seen below, the wild boar plays an important part in both the Tristan texts and in a number of others which have been connected with Tristan (e.g., Diarmaid is also killed during a boar hunt): might

this not then be another point of connexion? Schröder rejects this because "as the boar hunt—often not without its dangers—was popular in real life, so the boar and the boar hunt are also found too frequently as a literary motif in the Old French epic for this trait, which is identical or at least comparable, seriously to come into question" (22). Surely the same might be said of many of the parallels which he does not reject, particularly when their similarity is not so obvious to the unbiased reader? One explanation given by Schröder is that "on its wanderings, which we can no longer trace with any certainty, one thing or another may well already have become displaced" (22), a statement which seems to allow him a great deal of latitude.

Part of Schröder's text is also devoted to criticism of the evidence presented by Celticists in favour of a Celtic origin of the material. While he admits that many things may derive from "one of the many, as it were, 'free floating' Celtic motifs"—and might not one here make the rejoinder that much of the oriental material might likewise derive from such motifs?—he devotes a good deal of time to demolishing arguments whose invalidity even Celticists today would admit. It should be emphasised that he is in no way to blame for this, as the material presented by Schoepperle and, following her, Ranke, was the latest state of Celtic scholarship at the time, with the exception of Rachel Bromwich's article,[18] of which Schröder seems to have been unaware. However, as will be seen below, the plethora of differing strata of the story and the detail of some of the motifs (e.g., Grainne's use of a *geis* or Diarmaid's "love spot") are no longer part of the "pro-Celtic" argument, and one can quite willingly concur in Schröder's demolition of them.

While Gallais has a number of very interesting and critically sensitive things to say about the *nature* of the Tristan legend, his arguments about its origins are to a large extent of a rather more nebulous nature, being based on *ex cathedra* statements about the differing nature of European and oriental society, such as: "It is a basic truth that the Occidentals are more active and the Orientals more contemplative. . . . To burn up his

18. "Some Remarks on the Celtic Sources of 'Tristan,'" *Transactions of the Honourable Society of Cymmrodorion*, Session 1953 (1955), 32–60.

life in action, that was the ideal of many an Occidental; to
consume it in contemplation, that is the ideal of the majority of
the philosophico-mystical systems of the Orient" (13). "The
spontaneous generation of *Tristan* in the Occident of the twelfth
century is inconceivable" (32). His main type of argument is that
those who do not agree with him are too insensitive to
appreciate the subtleties of his approach. He also, as Trindade
points out in an article somewhat optimistically entitled "Wis
and Ramin, the Last Word?," treats the Celtic evidence in a very
cavalier fashion. For example, he misquotes Bromwich when it
serves his purpose (Trindade, 23, referring to Gallais, 88), and
tries to bluff his way when all else fails: "I would like to see
someone quote four verses where, before 1150, the Irish, the
Scots or the Welsh sang about the sea" (one has only to look at
some of the examples quoted in the section on the Celtic material
below!). Moreover he uses Arbois de Jubainville in a way that
seems totally shameless. To give just one example, he cites the
following:

> I would like someone to find that mad depiction of love
> for me in the literature of the Celts before the XIIth
> century. The oldest Irish literature shows us the fiancée
> faithful to her fiancé, the wife faithful to her husband, the
> wife who misses him and remains faithful to him, while as
> well as the model daughter and wife there are many
> others of less strict morals. But the type of illegitimate
> love, all-powerful, such as we find in the romance of
> Tristan and Iseut, is a French creation of the XIIth
> century. [19]

Having quoted this in support of his thesis, Gallais himself refers
later on to Deirdre.

Interestingly enough, the orientalists who have studied the
material are far less convinced of the connexion between at least
Vīs-u Rāmīn and the Tristan story. Minorsky simply states,
referring to an article by O.M. Friedenberg:[20]

19. Henri d'Arbois de Jubainville, in the "Chronique" of the *Revue
Celtique*, 15 (1894), 407, quoted in Gallais, 76.

20. "Tristan i Isolda," *Troodi Institoota Yezika i Mishleniya*, 2 (1932),
15.

In addition to the basic, and very general, likeness in the
romantic situation, I have found in Dr. Friedenberg's
longish record only two points of similarity with Vīs-u
Rāmīn: the episode of a maid (in our case the nurse) depu-
tizing for her mistress on the marital couch, and the
episode of the hero temporarily forgetting the heroine.
Tristan's retirement to the forest might perhaps be
compared to Rāmīn's retirement to Daylam [Morrison 33].
The results of the comparison look somewhat meagre.
Isolated details can certainly belong to the common stock
of human fantasy, which is not unlimited as regards
situations in a three-cornered love. The general
atmosphere of the two poems is very different. Apart from
the talisman . . . , Vīs-u Rāmīn is devoid of magic or sym-
bolic elements which abound in the Celtic legend
(Minorsky, 1954, 91–92).

and Massé writes :

Without doubt, from a general point of view, the two
works exalt fatal love. But what makes for the superiority
of the poem of Tristan, is that if two beings are eternally
bound to one another, it is by a magic process. . . . This
mysterious force gives the poem of Tristan its marvellous
poetic appeal. Now this force plays no part in the passion
which unites Vīs to Rāmīn; the cause of their love is more
simple and more natural: it is a sentiment which was
formed without their being aware of it while they were
being nursed together, and which awakens with full force
when they rediscover one another in their youth—a
situation of interest to the psychologist, but one which
does not contain the dramatic motivation of
Tristan. . . . Finally, the dénouement of Vīs and
Rāmīn . . . appears more realistic, but without the tragic
grandeur of Tristan (11–12).

Morrison refers first of all to "the legend of Tristan and
Isolde, to which the Persian story bears a resemblance" (xii), and
then a few pages later lists the similarities between the stories,
without actually coming to any conclusion. The fact that he lists
some of the similarities, however, might be taken as implying
that he believes there to be a link, though without being too sure
exactly what that link might be, apart from a reference to the
orally communicated view of Professor Mujtabā Mīnovī "that the

Persian romance may have been transmitted to the West through minstrels who had free access to both Crusader and Saracen camps in the Holy Land" (xvi–ix).

The fullest recent account by an orientalist is that of Kunitsch, and though we should definitely heed Trindade's *caveat* that "by totally excluding the question of oral transmission he leaves room for the possibility of a rejoinder on the part of those scholars he is criticising" (20), some of his arguments seem *a priori* to be convincing (particularly as some of those criticised refer precisely to *written* texts, e.g., Schröder [cf. note 4 above]). He points out, for example, that though Western authors have a "real predilection" for introducing exotic names and places into their texts, there are only two names in the Tristan material (apart from the birthplace of Isolde's father in Gottfried; see note 25 below) which might enter this category: Kaedin (Kaherdin etc.) and Marjodo(c). The only oriental parallel he finds for the first could not have been known in the West before 1191; and he finds no serious parallel for the second, pointing out that both have perfectly respectable Celtic etymologies anyway (74–76). He then looks at routes of transmission, indicating first of all that such works as we know to have been translated from Eastern into Western languages (and among them there was not a single Persian or Turkish text) were, with the exception of Petrus Alfonsi's *Disciplina Clericalis*, "scientific texts in medicine, astronomy and astrology, mathematics, philosophy and similar theoretical texts" (77). He claims, too, that *Vīs-u Rāmīn* was *not* widely known in the Arabic world (there is only one mention, and that by a poet with a Persian mother), which would have precluded its translation anyway, as Arabic and Hebrew were the only Eastern languages translated at this time. He similarly throws doubt on the possibility that the story of Qays and Lubnā could have been translated *before* the first surviving Tristan texts were written down. He accepts the possibility that captured minstrels and musicians may have sung to their captors, but doubts whether their texts would have been understood: in fact, the *locus classicus* for this, cited by Gallais (137) is the capture of Barbastro in 1064, and the taking of muslim prisoners, here a female singer: "She began to sing, reports the Jew, some verses

which I could not understand and which, consequently, *the Christian understood even less"* [my emphasis]. He concludes:

> Having denied . . . that the Persian epic of Vīs-*u* Rāmīn
> could have reached Europe in the Persian language—
> which, by the way, nobody in Europe would have been
> able to understand at that epoch—, having also denied
> that Vīs-*u* Rāmīn had been done into Arabic, and reached
> Europe in an Arabicized form, and having denied, thirdly,
> that the Arabic story of Qays and Lubnā might have been
> translated into a European language in due time to be
> ready for the composition of the Tristan story, we have
> finally to deny the most improbable of these theories, that
> is that both Vīs-*u* Rāmīn and the story of Qays and Lubnā
> had been amalgamated somewhere in the Arabic region
> and had been passed over, in this amalgamated form, to
> the Europeans (82).

To sum up, the evidence for oriental origin of the Tristan legend as a whole is totally circumstantial, although there remains the possibility that certain motifs which are found in the legend are derived from a common stock of material (what Schröder might describe as "free-floating motifs"). A large number of the so-called "similarities" do seem to be somewhat far-fetched, but there is the counter-argument that, while individual elements may well each be trivial or banal, there are too large a number of them to be ascribed to mere coincidence. There is also the question, raised by Kunitsch in particular, of routes of transmission: one might ask, applying Ockam's razor, why one needs to postulate all the steps of transmission and translation necessary to bring Gurgāni to Cornwall, when there is a possible source so close at hand in the Celtic world. Ultimately, the most favourable verdict one could bring in would be the Scottish one of "Not Proven."

We will now turn to the Celtic material, which divides into actual texts concerning a character named Trystan/Drystan in Middle Welsh, and analogues (or supposed analogues) in Old Irish. Since the majority of the material in Welsh is later than the period to which the origin of the legend is ascribed, we will start with the second question first.

Two studies that are of immense use in this respect are those of Rachel Bromwich ("Remarks") and Oliver J. Padel,[21] which in themselves represent both original ideas and excellent syntheses of the available material. A good deal of the evidence for the supposed Celtic origin of the material is derived from similarities, or supposed similarities, to episodes and motifs found in Old Irish literature: what, then, are these, and how valid are they?

It would be difficult to deny that there are certain types of narrative as listed in the Old Irish tale-lists[22] that do seem to be very close to the major elements of the Tristan legend, particularly the *aitheda* (elopements), *tochmarca* (wooings), and possibly (for Tristan's voyages to Ireland or to Cornwall) the *immrama* (sea voyages). Also, given the consistently Celtic background and location of the legend, it might seem strange to posit any other than a Celtic origin for the stories concerning Tristan. The main question is, however, which branch of the Celtic tradition is at the root of what we have today? Is it Irish, North British, Pictish, Cornish, even Breton? Some confusion obviously arises from the habit mentioned above of assuming that any two texts dealing with a similar subject must be in some way related, as if we were dealing with textual criticism based on a presumed authorial archetype, so that if there is an Irish *aithed* with a similar narrative pattern to that of Tristan, then there must be some kind of direct connexion between them. This may be so, but it seems far more likely that both are versions of common Celtic analogues, since so much material has been lost in languages other than Irish (MacCana, for example, sees the *aitheda* and *tochmarca* as "the diversified reflex of myths, which are as old, and older, than the Celts" [75]). As will be seen below, we know of Tristan material in Welsh from the Triads which

21. Oliver J. Padel, "The Cornish Background of the Tristan Stories," *Cambridge Medieval Celtic Studies*, 1 (1981), 53–81.

22. The Old Irish Tale-Lists, their content, date and provenance are discussed in great detail in Proinsias MacCana, *The Learned Tales of Medieval Ireland* (Dublin: Dublin Institute for Advanced Studies, 1980); and Rudolf Thurneysen, *Die irischen Helden- und Königsage bis zum siebzehnten Jahrhundert* (Halle: Niemeyer, 1921), pp. 21–24.

does not exist in any surviving narrative. The Irish texts, then, may be useful less as source material than as analogues of the kind of narrative pattern which could lie at the base of the Tristan legend. Their usefulness does, however, depend on their presenting this material in an unadulterated form, and this is where the major problem lies for those attempting to analyse both them and the Tristan material.

The first text to concern us is The Wooing of Emer (*Tochmarc Emire*). One episode in this text, which is dated by Thurneysen to the eighth century *in its earliest form* (though he states that the composite form which we have at present dates from soon after the first half of the twelfth century [382]), concerns an exploit of CuChulainn at the court of the "King of the Islands." As is well known,[23] this is a version of the Andromeda story, but it has links with the Tristan legend because it contains, firstly, the recognition motif, where Cuchulainn is recognised because he has been bandaged with a piece of the princess's shift; secondly, a possible connexion with the name *Mor*holt, since the oppressors who are demanding the maiden as tribute are the Fo*mori* (Bromwich, "Remarks," 39–40); and also a character, otherwise inactive, named Drust mac Seirb. It has been suggested that this indicates that Drust was the original protagonist of this exploit who has been displaced by CuChulainn, and further, that this indicates a Pictish origin for the story, since, as Thurneysen says, "*Drostan* is frequently found as a Pictish name in Irish literature" (392, n. 2). Carney sees these elements as an indication that "the Irish story is obviously borrowed through the medium of the primitive British Tristan" which he earlier suggests "was composed and written in N. Britain sometime before the year 800" (197). We will return to the question of the Pictish name below, though in view of the prevalence of the name Drostan in Irish literature, it could just be that this was the closest approximation to the name Trystan/Drystan available, and therefore not admissible as evidence of Pictish origins. While one might be prepared to see

23. See James Carney, "The Irish Affinities of Tristan," in *Studies in Irish Literature and History* (Dublin: Dublin Institute for Advanced Studies, 1979), 189–242, here 241; and Bromwich, "Remarks," 38–42.

the influence as actually being that of "Britain" (and here one must ask oneself whether it is North or South Britain, Pictish or Brittonic speakers who are being referred to) on Ireland, the late dating of the version of *Tochmarc Emire* concerned (and Padel [56] suggests that as a digression this episode may well be as late as the twelfth century) brings us no closer to a version of Tristan that predates the earliest continental versions.

The story of Deirdre (found in the Irish text *Longes mac n-Uislenn*, dated "sometime before A.D. 1000—probably in the ninth, possibly even in the eighth century" [*Longes Mac n-Uislenn*, 32]), has affinities with Tristan because of the elements of fatal love and of the life of the lovers in the wilderness. (However, one could ask oneself here if all tales of adultery between the young wife or betrothed of an older man and a more attractive young hero need to be traced to literary antecedents; and the fact that people who act in this way are forced to live outside normal society also seems relatively logical.) Nevertheless, in spite of its early dating compared with the earliest extant Tristan material, even this is relegated to a secondary status by Carney: "I now, however, regard *Deirdre* as the earliest Irish borrowing of the British Tristan" (190, n. 1). Whether one agrees with his detailed reasoning or not, this does cast some doubt on the question of primacy in the relationship between the texts, even for those who assume that similarity means derivation.

Toruigheacht Dhiarmada agus Ghrainne (The Pursuit of Diarmaid and Grainne)[24] is the Irish narrative that has been, possibly rightly, seen as being the closest analogue to the Tristan legend. While the main lines of the narrative have been widely discussed in the literature, it is worth pointing out that two elements in the Tristan tradition, the Separating Sword motif and that of the Bold Water are found in connexion with Diarmaid and Grainne, and in contexts which make reasonable sense, particularly in the case of the former, since Diarmaid is reluctant to consummate his relationship with Grainne (Ni Sheaghda, xxviii, 33). However, in terms of the power of the symbolism of

24. *Toruigheacht Dhiarmada Agus Ghrainne. The Pursuit of Diarmaid and Grainne*, ed. Nessa Ni Sheaghda (Dublin: Irish Texts Society, 1967).

the sword in the Tristan story, one is for once tempted to agree with Gallais: "In a single word, I believe that the only correct interpretation of this episode consists . . . in not interpreting it" (49).

What is important about the *Pursuit* is how much this can be taken to represent a "purely Celtic" version of the theme, and here again the question of dating comes into play. There can be no doubt that some narrative dealing with the love between Diarmaid, one of Finn's warriors, and Grainne, Finn's betrothed, existed by the tenth century. Mention of an *Aithed Grainne ingine Corbmaic le Diarmaid ua nDuibne* occurs in the tale-lists, and there is a poem, dated by Gerard Murphy to the ninth or tenth century, telling of Grainne's love: "There is one / on whom I would gladly gaze / for whom I would give the whole world / all of it, all of it, though it be an unequal bargain."[25] There are other mentions and fragments, listed in Ni Sheaghda's introduction, but the main text occurs in Early Modern Irish manuscripts, the oldest of which dates from 1651 (Ni Sheaghda, xiv). This gap between earliest mention of the tale and earliest manuscript need not necessarily mean that the version we have is unreliable, the tenacity of oral folk tradition being what it is (or is supposed to be), but both Padel and Carney cast doubt on the virginal purity of this narrative. The latter, for example, points out that the use of *gessa* by Grainne to compel Diarmaid to run away with her, far from being the sign of antiquity which Schoepperle considers it to be (402; she also claims here that Deirdre's treatment of Noisiu in compelling him to go with her is a *geis*, though the text does not mention the word at this point) is in fact a corruption of the original meaning of the *geis* and thus "nothing more than an author's lazy method of motivating action . . . artistically, but hardly anthropologically, primitive" (193). The same could be said of the "love-spot" of which Schoepperle also makes so much (401–03). Padel points out that the "horse's ears" episode (which makes sense in the Tristan legend, since the name March means "horse" in the Brittonic languages) found in the *Toruigheacht* is likely to be derived from

25. *Early Irish Lyrics, Eighth to Twelfth Century* (Oxford: Oxford University Press, 1956), p. 160.

the Tristan legend, so that the tale *as we have it* may well be influenced by the Tristan tradition and therefore cannot be used as evidence of possible source material. He concludes: "One can only say that ultimately there may be some unknown early Irish *aithed* behind the Tristan stories, but that there need not be" (57). A far more sensible way of proceeding might be to assume with MacCana [75] that these narrative patterns derive from a common Celtic fund of tradition, and could possibly even be pre-Celtic, though that would be incapable of proof. This latter theory could, however, provide another point of contact with the Persians, themselves an Indo-European people, obviating the need to find routes of narrative transmission in the historical period. This would mean that, as suggested above, the Irish material would constitute not sources for, but analogues to, the narrative patterns which may be at the base of the lost Tristan material mentioned in, for example, the Welsh Triads.[26]

One is thus thrown back to the evidence, such as it is, for the existence of *Tristan* that exists in Celtic sources outside Ireland. The first category to be considered is that of the personal names. The material is discussed in detail by Padel and can be summarised thus:

> a) Though there are occurrences of a Pictish DRUST, DROSTEN, etc., the name DRYSTAN "is a perfectly good Brittonic name, and its earliest occurrence is not in Pictland but on a Dark Age inscribed stone in Cornwall" (55). He points to the similarity between the patronymic TALLWCH found in Welsh and TALARGAN found in Pictish, but finally dismisses it as interesting, but hardly constituting "evidence for the origin of the Tristan legend" (55). This similarity, though, does seem, as he himself admits, to be more than coincidence. Unfortunately, in the present state of the argument and the evidence, it has to remain as one of those awkward and inexplicable things which bedevil just this subject.

26. Rachel Bromwich, *Trioedd Ynys Prydein, The Welsh Triads, Edited with Introduction, Translation and Commentary* (Cardiff: University of Wales Press, 1961).

b) the name ESELT (the Cornish form of the name found as ESSYLLT in Welsh, probably the origin of the name Isolt/Yseult) is found in an Anglo-Saxon charter-boundary dated A.D. 967, in the form *hryt eselt* (Isolt's ford). The stream concerned is on the Lizard peninsula (66). One might interject here that, even if the name Isolt were of Germanic origin, as others have suggested (e.g., Schröder, 3), then the fact that she is a princess from Ireland in most versions of the legend might well explain this fact, in view of the Norse settlements in Ireland.[27]

c) The name MARCH (though difficult to distinguish in placenames from the common noun *march* 'horse') is also found traditionally as that of an early king of Cornwall (72–73).

Other evidence about personal names is discussed in Dr. Bromwich's edition of the Welsh "Tristan" poems,[28] which will be mentioned below. The gist of this is that the names Tristan, March, and Kyheic (a character in the poems) are found in early Wales only in witness lists in the Llandaf charters (a fact which may point to the popularity of the literary material in South Wales) and in Wendy Davies's work on the charters, some of the ones containing precisely these names are dated to the late eighth and early tenth century.[29]

27. One should note that the name of her father as given in Gottfried is "Gurmun" (l. 5886), which could be compared with the French "Gormont," known as the name of a Viking leader; see Italo Siciliano, *Les Origines des Chansons de Geste: théories et discussions* (Paris: Picard, 1951), 101–08. He is also said in Gottfried to have been born in Africa, one of the few exotic place references in the text.

28. "The 'Tristan' Poem in the Black Book of Carmarthen," *Studia Celtica*, 14/15 (1979–80), 54–65.

29. Wendy Davies, *The Llandaff Charters* (Aberystwyth: National Library of Wales, 1979):

> MARCH, f. Pepiau . . . 235a; *c*.900 (179)
> MARCH, . . . 224; *c*.935 (ibid.)
> CEHEIC, . . . 206, 211b (Coheic); *c*.775 (153).

Another example from a charter in the Book of Llandaf not used in Prof. Davies's collection is: Auel mab TRISTAN, in *The Text of the Book of Llan Dâv Reproduced from the Gwysaney Manuscript* by J. Gwenogvryn

Placenames are also discussed by Padel, who describes in great detail the way in which Béroul's use of Cornish place-names fits the geography of the county quite accurately. He also shows how even if one assumes that the place name *Lohnois* (sometimes mentioned as Tristan's homeland) is Lothian in Scotland, this does not support the hypothesis of Pictish origin, as "Lothian was never a part of Pictland" (56). All in all, his conclusion is that "a case can be made out, though only a very tentative one, for the Tristan stories having originated in Cornwall" (80).

Finally, we come to the actual literary material in Celtic, or rather in Welsh. The only even vaguely complete text is the tale, of which the earliest manuscripts are sixteenth-century, told in a mixture of prose and *englynion*, of how Trystan and Essyllt outwit March: given the choice by Arthur between having Essyllt when the leaves are on the trees or when the trees are bare, March chooses the time when they are bare (presumably thinking of the long winter nights). To this Essyllt's reply is: "There are three trees that are good of their kind, holly, ivy and yew, which keep their leaves as long as they live. I am Trystan's as long as he lives."[30] Here Trystan and Essyllt are set in the context of the "classical" Arthurian court, where the main hero is Gwalchmai (Gawain), which would point to a date later in the evolution of the Arthurian legend in Wales than at least one of the Triads discussed below. Ceridwen Lloyd-Morgan in a recent article about this text suggests that there may well be moral reasons for the lack of Tristan material in the main Welsh *literary* tradition. After talking about the avoidance of adultery in the majority of the Welsh texts that have survived (admittedly not a very large corpus), she continues:

> In view of the tendency of Welsh authors or translators to prefer military prowess to tenderness and love, we could well ask ourselves if the legend of Tristan, as it evolved in

Evans. . . . with the co-operation of John Rhys (Oxford: Evans, 1893), p. 279, l. 26.

30. Robert L. Thomson, "The Welsh Fragment of Tristan (Trystan ac Esyllt)," in *The Tristan Legend*, ed. Joyce Hill (Leeds: Leeds University Press, 1977), pp. 1–5, gives a convenient version for non-Welsh readers.

France, did not seem too "romantic" to them, and lacking
in the heroism they found indispensable.... As regards its
evolution and transmission, it therefore seems to us as if
the legend of Tristan was never accepted in the purely
literary tradition. Other Arthurian personages, like
Peredur or Owein, could pass back and forth between the
French and Welsh traditions without any trouble, whereas
Tristan, even if his name and adventures were of Celtic
origin, never took his place beside them in the written
literature. His story, it seems, was banished from the
court, to be preserved mainly in popular tradition, where
it survived ... until modern times.[31]

Another source in *englyn* form, which may again link a
character from the Tristan legend with the Arthurian legend is
the *Englynion y Beddau* (Stanzas of the Graves) from the Black
Book of Carmarthen. Though the manuscript itself dates from
the thirteenth century, Thomas Jones suggests that various
criteria "point to their composition in a period considerably
earlier than even the Black Book ... probably as early as the
ninth or tenth century."[32] Here "March" (though one cannot be
absolutely certain that it is the Mark of the Tristan legend) is
mentioned in the same stanza as the famous one that describes
Arthur's grave as *anoeth bit* (the world's wonder, or mystery)
(Jones, 127). Unfortunately, no geographical location is given for
March's grave, as is done for some of the other heroes mentioned
in the stanzas, so this source is not very helpful in any origin
study.

The Triads are similar to the Irish tale-lists, in that they
provide a catalogue of the narrative material available, this time
to the Welsh story-teller. These can be found in Dr. Bromwich's
masterly edition, *Trioedd Ynys Prydain*, which also acts as an
index nominorum to a great deal of Welsh literature. Those
wishing to investigate the use made of the characters of Tristan,
Isolde and Mark by the Welsh poets of the Middle Ages—
unfortunately at a time when the influence of the continental

31. Ceridwen Lloyd-Morgan, "Tristan et Iseut au Pays de Galles,"
PRIS-MA (Poitiers) 7.2 (1991), 89–98, here 92.

32. Thomas Jones, "The Black Book of Carmarthen 'Stanzas of the
Graves,'" *Proceedings of the British Academy*, 53 (1967), 100.

material cannot be discounted—have only to consult this work. The earliest manuscript of the Triads, Peniarth 16, dates from the third quarter of the thirteenth century, but linguistic features suggest an earlier dating (Bromwich, *Trioedd*, xviii). In them, Tristan is mentioned a number of times: he is one of the three Enemy-Subduers of the Island of Britain, one of the three Battle-Diademed Men, one of the three Lovers, one of the three Stubborn Men, and finally one of the three Powerful Swineherds. This last Triad contains an interesting narrative element:

> Drystan son of Tallwch, who guarded the swine of March son of Meirchiawn while the swineherd went to ask Essyllt to come to a meeting with him. And Arthur was seeking to obtain one pig from among them, either by deceit or by force, but he did not get it (Variant: Arthur and March and Cai and Bedwyr were [there] all four, but they did not succeed in getting so much as one pigling—neither by force, nor by deception, nor by stealth [46ff.]).

Here the warriors of Arthur's whom we meet are Cai and Bedwyr, who belong to the earliest stratum of the Welsh Arthurian legend, and the spirit of the Triad does seem comparable to that of the earliest Welsh Arthurian prose narrative, *Culhwch ac Olwen*. This would seem to suggest two things: firstly, that there was an early Tristan narrative in Welsh which predates the texts we know to have been influenced by continental sources (e.g., *Geraint, Iarlles Y Ffynnawn, Peredur*), and secondly, that like many other originally independent heroes Tristan was drawn into the Arthurian orbit—again, however, at a relatively early stage (*Culhwch ac Olwen* has been dated to "the last decades of the eleventh century, perhaps the turn of the century, c.1100"[33]). Fascinating, too, is the mention of pigs: apart from the fact that we seem to have here an example of Tristan visiting Isolde in disguise, the coat of arms of Gottfried's Tristan is a boar, and Diarmaid dies as result of hunting a boar whose life is magically linked with his. This complex of ideas led Edward Davies in his *The Mythology and Rites of the British Druids*

33. *Culhwch and Olwen: an Edition and Study of the Oldest Arthurian Tale*, ed. Rachel Bromwich and D. Simon Evans (Cardiff: University of Wales Press, 1992), p. lxxxi.

to suggest "that the legend allegorized that period of British history when the Phoenician rites of the sow were being introduced into Cornish religions."[34] Such amusing speculation aside (and one cannot help wondering what the rites of the sow actually were!), there may be something more to this. Apart from the obvious symbolism of the boar as an emblem of courage and virility, there may be an association with Cornwall: Arthur himself is called *aper Cornubiae* in the *Prophecies of Merlin*, and the story of his hunting the Twrch Trwyth is also linked to Cornwall.[35] One might tentatively suggest, then, that there is some emblematic connexion between Cornwall and boars—a further aid to one's attempts to locate the origins of the Tristan legend (and, of course, there is the link with the death of King Mōbad mentioned above).

The final text is one that has been recently re-edited by Dr. Bromwich, though it has been known for some time. This is the series of stanzas, again in the Black Book of Carmarthen, which are associated with the Tristan legend by the fact that the name *Diristan* (a form of Drystan) appears in the last of them. They actually seem from their metrical structure to belong to two separate poems, but these poems are further linked by the fact that the unusual name *Kyheic* (which, apart from the Book of Llandaf charters, is not found elsewhere in Welsh tradition, see above) occurs in both. It may even be that this occurrence of an unusual name is what caused the juxtaposition of the stanzas in the manuscript in the first place. Fragmentary as they are, it seems clear that they belong, as Dr. Bromwich says, "to speech-poems of a passionate and highly dramatic character" ("Tristan" Poem 54).

The texts are dated by the editor "before 1100" (55), and a version of her suggested translation follows (with some possible emendations, where the context is not clear enough to indicate which of two homonyms is to be understood):

34. Quoted in Rosemary Picozzi, *A History of Tristan Scholarship* (Berne: P. Lang, 1971), p. 19.

35. Oliver J. Padel, "Geoffrey of Monmouth and Cornwall," *Cambridge Medieval Celtic Studies*, 8 (1984), 13.

I. 1. Though I love the sea-shore, I hate the sea
 That [or: why] the wave should cover the hero's
 rock.
 Brave constant courteous generous ?strong branch?
 Mounting block of the poets of the world, a
 victorious protector
 The cup-bearer of fame has done a disastrous
 favour.
 Till Judgement will last its/his ?lamentation?

 2. Though I love the sea-shore, I hate the wave
 The violence of the wave has made a cold
 separation between us.
 I shall lament as long as I live because of this,
 A ?nimble? deed washing on my breast[s],
 Though it fills the thoughts it does not heat the
 heart
 And ?after?/[in the track/?manner?/of] Kyheic,
 reconciliation between us.

 3. I regret his expedition
 When the strong man rushed far to death.
 A strong constant company were we two
 In the place where the water carries the leaves.

II. 1. Drystan is enraged [?flees?] at your coming
 [destruction, leaving]
 I will not accept from you my ?dismissal?
 For my part I betrayed March [or: sold a horse!] for
 your sake.

 2. Vengeance on/for Kyheic would be my wish
 Because of his sweet speech [or: for his wealth, for
 his court].
 Alas, dwarf, your anger was hostile to me.

A number of elements important to the Tristan legend, and
also typical of the Celtic tradition, are present in these intriguing
fragments: the betrayal of Mark, the hostile dwarf, the water
carrying the leaves are all found elsewhere. The importance of
the sea, which is also a factor in the Tristan legend, is found both
in Old Irish elegy, often in poems attributed to women
lamenting their lovers' deaths (Murphy, poems 36 and 39) and in

early Welsh poetry.[36] In view of this tradition, and particularly of the existence in Welsh of a number of poems attributed to female personae, many in *englyn* metre as is the second of these poems,[37] it is tempting to speculate that the character speaking here may be Isolde (or Essyllt as she would more properly be in Welsh). Unfortunately, there is no evidence from the texts themselves to suggest even the sex of the speaker, let alone his/her identity. One possible clue in the word *dwyvron* (dual of *bron*, "breast") is shown to be invalid, in that early examples in *Geiriadur Prifysgol Cymru* (the University of Wales Dictionary) refer to both male and female.

In conclusion, then, it seems possible to say that there are a number of connexions, which seem both strong and valid, between the Tristan legend and the Celtic literary and historical traditions. The main problem is that texts which have earlier been seen as sources (or perhaps more correctly analogues) of the Tristan material may actually have been influenced by that very material, and so become inadmissible as evidence for the provenance of any particular detail, motif or narrative sequence. The question of the geographical or linguistic provenance of the insular form of the legend, too, is one that is still undecided (if such a decision is ever possible). The long accepted Pictish hypothesis seems to have been called very much into question, if not entirely demolished—and there is the unsolved mystery of the *Tallwch* patronymic in the Welsh tradition—by Oliver Padel's detailed researches (including the wading of the *gué aventuros* in Cornwall, though without carrying a young woman for total verisimilitude). The pendulum has swung back towards a Brittonic origin for the Celtic Tristan material, at least in its present form.

Overall, it is clear that, when investigating the early stages of the Tristan legend, the majority of the evidence is totally circumstantial, and that what seems conclusive proof to one scholar is regarded as idle speculation by another. The story of

36. E.g., Hywel ap Owein Gwynedd, "Tonn wenn orewyn," in *The Myvyrian Archaiology of Wales* (Denbigh: T. Gee, 1870), p. 198.

37. E.g., Heledd in the Cynddylan saga found in *Canu Llywarch Hen*, ed. Ifor Williams (Cardiff: University of Wales Press, 1935).

Qays and Lubnā, for example, does provide very close parallels with the concluding part of the traditional Tristan story—but an orientalist says that it is extremely unlikely to have been able to reach Western Europe by any known channel of transmission. Perhaps ultimately the most sensible approach is that adopted by Peter Dronke in his work on the medieval lyric, where he discusses parallels and comparisons between the productions of various poets in various periods and cultures without implying any causative or derivative relationship between them. He even mentions *Vīs-u Rāmīn* in a context which compares it with *Tristan*, but in a critical and creative rather than a positivistic way:

> Between the greatest Tristan romance [Gottfried] and *Wis and Rāmīn* there is this profounder resemblance on which no one has yet commented, a resemblance which underlies all the similarities of plot and characterization and gives these a deeper significance. Here in two major works a story of unique love, love that resists all obstacles and all other loyalties, is given a philosophical dimension: each aspect of the story illuminates the fact that it is not because of these circumstances or these that love's joy and sorrow are inseparable, but because this is of the very nature of an absolute love. Any future comparison of the two stories must, I am convinced, take this extraordinary achievement, the complete poetic fusion of a love-story with a metaphysic of love, into account.[38]

38. Peter Dronke, *Medieval Latin and the Rise of European Love-Lyric*, 1965; 2nd edition (Oxford: Oxford University Press, 1968), p. 25.

Love and the New Patriarchy:
*Tristan and Isolde**

Leslie W. Rabine

The fascination of romantic love narrative for contemporary feminine readers sinks its roots into a long history. The first women in Western culture to enjoy it belonged to the aristocratic and royal courts of late-twelfth-century Europe. One of their favorite romances, judging by the number of different manuscript versions which have come down to us, was *Tristan and Isolde*,[1] the original and archetypal tale of fatal passion.

Written by clerics in the personal service of aristocrats, these romances synthesized the Provençal courtly love lyrics

Reprinted with permission from Leslie W. Rabine, *Reading the Romantic Heroine: Text, History, Ideology* (Ann Arbor: University of Michigan Press, 1985), pp. 20–49.

*Portions of this chapter appeared in "The Establishment of Patriarchy in *Tristan and Isolde,*" *Women's Studies* 7 (1980): 19–38.

1. The versions of the romance consulted were: Béroul, *Le Roman de Tristan* (Paris: Firmin Didot, 1903); Eilhart von Oberg, *Tristrant*, Edition diplomatique des manuscrits et traduction en français moderne par Danielle Buschinger (Göppingen: Alfred Kummerle, 1976); Friar Robert, *The Saga of Tristan and Isond*, trans. Paul Schach (Lincoln: University of Nebraska Press, 1973); Gottfried von Strassburg, *Tristan* (Darmstadt: Wissenschaftliche Buchgesellschaft); Gottfried von Strassburg, *Tristan*, trans. A.T. Hatto (Middlesex: Penguin Books, 1960); Joseph Bédier, *Le Roman de Tristan par Thomas*, 2 vols., vol. 1, Tome premier: Texte (Paris: Firmin Didot, 1902).

with northern Celtic and Arthurian legends, transforming both genres to create the romantic love narrative.[2] As the lyric moment of sexual passion develops into narrative, it becomes the shaping force of the hero's and heroine's entire life span, and thus becomes a temporal form which structures their destiny. The authors of the Tristan romances, Béroul, Thomas, and Gottfried von Strassburg, helped to create the new cultural force of romantic love, which for the first time turned sexual love between a man and a woman into an exalted ideal and a central theme of literature. According to René Nelli, it combines sexual desire with a total spiritual union previously reserved for religious experience.[3]

Modern critics like R. Howard Bloch have interpreted this legend as reflecting the "birth of subjective conscience" and "the designation of the individual as an autonomous legal entity,"[4] but this interpretation accounts only for Tristan's story, and excludes Isolde's story, which tells of the destruction of a different kind of individuality. While the Tristan story recounts the development of masculine individualism, the Isolde story, which has remained invisible to readers, recounts the birth of modern "femininity," without which masculine individualism could not exist.

Yet *Tristan and Isolde* does not explicitly recount this historical development, since it does not "realistically" represent

2. For the difference between courtly love and "Tristan Love," see W.T.H. Jackson, "Faith Unfaithful—The German Reaction to Courtly Love," in *The Meaning of Courtly Love*, ed. F.X. Newman (Albany: State University of New York Press, 1968), pp. 55–71.

3. René Nelli, *L'Erotique des troubadours* (Paris: 10/18, 1974), 2 vols., 1:39. M.M. Bakhtin discusses the ancient Greek romances, which in many respects resemble the medieval romances, but he notes: "There is as yet nothing of that authentically solitary individual who makes his appearance only in the Middle Ages and henceforth plays such an enormous role in the European novel" (M.M. Bakhtin, *The Dialogic Imagination: Four Essays*, ed. Michael Holquist, trans. Caryl Emerson and Michael Holquist [Austin: University of Texas Press, 1981], p. 145).

4. R. Howard Bloch, *Medieval French Literature and the Law* (Berkeley: University of California Press, 1977), pp. 238 and 249.

social reality, nor does it consciously reflect history. In the vernacular literature that preceded medieval romances and remained popular after their advent, women were either barely present, as in the epics which treat the love of men for each other, or presented as evil, as in the clerical writings which treat the love of man for God.[5] But courtly love lyrics and romances replace the love of men for God and each other with the love of men for women, at least in the world of literature.

While this new prominence of women in literature might suggest a parallel rise in their social status, most historians agree that their status did not improve. While Joan Kelly-Gadol, looking backward from the perspective of women's lower status in Renaissance culture, says that by comparison courtly love "represents an ideological liberation of their sexual and affective powers that must have some social reference," other historians, like Joanne McNamara and Suzanne Wemple, looking forward from the perspective of women's role in early feudalism, find that women's freedom suffered.[6] The Ideal Woman and the reality of women's lives start to split into two dichotomous directions.

Their status did not exactly fall in a quantitative sense; instead their relation to society was changed by the restructuring of the feudal order that occurred in the late twelfth century in what is now northern France. *Tristan and Isolde* produces an ideological structure which assigns femininity its place within this changed social order, not by the way the romance represents historical change, since it does not directly do so, but by the way

5. Georges Duby, *Le Chevalier, la femme et le prêtre* (Paris: Hachette, Collection Pluriel, 1981). Discussing sermon literature of 1150, Duby says: "a primary theme, dominating the entire discourse, endlessly repeats: woman is bad, as lascivious as a viper, as sneaky as an eel, and in addition inquisitive, indiscrete and shrewish" (p. 224).

6. Joan Kelly-Gadol, "Did Women Have a Renaissance?" p. 144; and Joanne McNamara and Suzanne F. Wemple, "Sanctity and Power: The Dual Pursuit of Medieval Women," both in *Becoming Visible: Women in European History*, ed. Renate Bridenthal and Claudia Koontz (Boston: Houghton Mifflin, 1977); see also Duby, *Le Chevalier*, p. 228; and Susan Mosher Stuart, ed., *Women in Medieval Society* (Philadelphia: University of Pennsylvania Press, 1976).

it combines the courtly love lyric and Celtic legend to produce romantic narrative. While critics have noticed that the first part of the romance is marked by Celtic myth elements and the second part by courtliness and have debated about the predominance of one genre over the other,[7] little analysis has been done of the relation between them, and of how the conflict between Celtic logic and courtly logic in the same text works to produce a new ideological structure, a new literary form, a new concept of sexuality, and a value system for a new European culture.

This culture developed in the course of a profound revolution in every aspect of life, from the shape and form of the sociopolitical world to the most intimate forms of consciousness and sexuality. What emerged were the first shadowy outlines of our world, with its individualistic, self-conscious form of masculine subjectivity, its repressed and obsessive sexuality, the beginnings of a bureaucratic state, and a market economy. What also emerges is a form of patriarchy that has remained strong in capitalism.

The nobility, whose membership had been fluid, became at the end of the twelfth century a closed class with hereditary membership passed from father to son. And while feudalism was tightening into a hierarchical system, it was also being contested by the rise of cities, which had all but disappeared in the early medieval period. The cities reintroduced world commerce and the use of money, and created an urban class, the bourgeoisie.[8] The establishment of a new hereditary aristocracy

7. For a summary of the source debate, see Rosemary Picozzi, *A History of Tristan Scholarship* (Berne: Herbert Lang, 1971), pp. 17 and 24–40; Roger Sherman Loomis, *Celtic Myth and Arthurian Romance* (New York: Columbia University Press, 1927), pp. 26–31; Loomis, *The Development of Arthurian Romance* (London: Hutchinson University Library, 1963), pp. 79–86; Bédier, *Tristan*, 2:106–16, 123–27.

8. Marc Bloch, *Feudal Society*, trans. L.A. Manyan (Chicago: University of Chicago Press, 1961), 2 vols., I:115 and 172; Henri Pirenne, Gustave Cohen, and Henri Focillon, *Histoire du moyen âge* (Paris: Presses universitaires de France, 1933), pp. 40–59; Charles Homer Haskins, *The Renaissance of the Twelfth Century* (Cambridge: Harvard University Press, 1927), p. 130.

meant that the many-branched mixed matrilineal–patrilineal family networks of the early feudal period were being replaced by an exclusively patrilineal family system, marked by strict linear descent. In this system, an aristocratic man could begin to define himself as an isolated entity in relation to his property and to his name rather than in relation to the concrete, immediate reciprocal connections to mixed-lineage, complex kinship groups.[9] Women, by contrast, retained and maintained these connections, even as they were losing their old importance and power.

In general the old feudal social structure as a concrete network of direct dependence relations and mutual service, having for its foundation a many-branched, mixed-lineage kinship network, was transformed by the beginnings of an abstract state, of a cash nexus, of a unilineal patriarchal family system, and of an abstract legal code which began to separate codified law from practical living laws. The Capetian state also began to stand as an abstract, unilateral institution separate from the social world; and although it lacked the elaborate mechanisms and power of the state in later periods, it bore a sharp contrast to the personal, direct relations of early feudalism. The emergence of an abstract realm felt to be autonomous and separate from lived experience, yet which mediated the lived reality of masculine individuals, became a crucial structuring element of a new mentality which is expressed through the text of *Tristan and Isolde*.

In these historical transformations, the rupture of concrete relations between people in favor of relations that link isolated individuals to abstractions is connected to the changed situation of women. During the early feudal period, when there had been no distinction between public and private law, the lord—and the lady—of the manor held the entire manor as their household and

9. R.H. Bloch, *Medieval French Literature*, pp. 128–30; Michael Tigar and Madeleine R. Levy, *Law and the Rise of Capitalism* (New York: Monthly Review Press, 1977), pp. 97, 206, and 244; Karl Ferdinand Werner, "Liens de parenté et noms de personne," in *Famille et parenté dans l'occident médiéval*, ed. Georges Duby and Jacques LeGoff (Rome: Ecole française de Rome, 1977), pp. 25–34.

administered all the affairs upon it. The new legal system, distinguishing the public realm from the private family, also regulated more strictly who could administer what, so that women were excluded from active roles they had played before. Between 950 and 1150, women fulfilled functions in greater numbers as property holders and managers, judges, participants in assemblies, and even on occasion military leaders in the absence of the lord of the manor. Abbesses controlled monasteries, schools, and entire fiefs.[10]

Joanne McNamara and Suzanne Wemple show how aristocratic women lost power as the family lost its public role and its functions as a central institution of society. They also lost property rights and inheritance, as property ownership became more important and more tightly controlled.[11] David Herlihy finds that by the end of the twelfth century, even the children of peasant and artisan families ceased to inherit through their mother or to take their mother's name with the same frequency as earlier.[12] And in order to ensure that the newly won privileges and hereditary wealth of aristocratic men would be passed to legitimate heirs, women found their sexual chastity much more stringently enforced.

Although the early feudal system was far from the pre-class societies Eleanor Leacock analyzes in *Myths of Male Dominance*, its replacement by a stricter system of authority involved, as she says, "not so much a replacement of a formal system by another, as the substitution of formal stabler units for informal, unstable ones."[13] The development of formal hierarchies in all feudal institutions tended to exclude women from active decision-making roles. Ineligible for posts in the new state bureaucracies and for education in the new universities,

10. David Herlihy, "Land, Family and Women in Continental Europe, 701–1200," in *Women in Medieval Society*, ed. Stuart, pp. 13–46.

11. "Sanctity and Power," pp. 107–08.

12. David Herlihy, "Life Expectancies for Women in Medieval Society," in *The Role of Women in the Middle Ages*, ed. Rosemarie Thee Morewedge (Albany: State University of New York Press, 1975), p. 11.

13. Eleanor Burke Leacock, *Myths of Male Dominance* (New York: Monthly Review Press, 1981), p. 67.

they were also denied their independent feminine monasteries, as these were placed under the authority of bishops.

Into this lessening of feminine public activity in the aristocracy comes the courtly love culture, where the adoring knight pledges "fealty" to his distant lady. In courtly love a metaphorical power replaces real social status, while the high position of the single great lady compensates for the lowered position of women as a social group. In a society where abstract systems of power and authority begin to replace more informal social networks, courtly literature, through its treatment of women, helps to produce forms of logic that create and isolate an ideal markedly separate from reality.

The Story of *Tristan and Isolde*

In *Tristan and Isolde* the textual production of form includes the radical separation of a transcendent ideal from concrete experience, and the transformation of an open, fluid network of myth and legend into a closed, unilinear narrative system. Its thematic elements include exiling Isolde from a land where women have independence and power; duping her into believing she is marrying the man of her choice so as to force her into a despotic marriage with a man she has never seen; and suppressing matrilineal kinship relations. Yet the text retains strong traces of a dissident feminine voice which conflicts with the final narrative and ideological structures.

An analysis of formal production in *Tristan and Isolde* presents certain difficulties, because the manuscripts have come down to us in a fragmentary state. I have used the Gottfried von Strassburg text, because, being the most complete, it offers the best version for an analysis of the text as a whole. Since Gottfried claims that he bases his version on Thomas, and since the Thomas fragment takes up where Gottfried's ends, I have used Thomas in analyzing the romance's conclusion. For further evidence for the continuity between the Gottfried and Thomas versions, I have used Friar Robert's Old Norse *The Saga of Tristan and Isond* since it is the only complete version that remains from the Middle Ages. For points of comparison, I have on occasion

brought in other versions. Since this romance may be unfamiliar to today's readers, an analysis of it will be deferred in order to scan briefly its main events here.

The romance begins, as do most legends, before the hero's birth. His father, Rivalin, Prince of Loonois, comes to the court of King Mark in Cornwall, where the king's sister Blanchefleur falls in love with him and conceives Tristan out of wedlock. The lovers then marry just before Tristan is born, but Rivalin dies in battle, and Blanchefleur dies of grief just after giving birth. Ignorant of his parents' identity, Tristan is raised by his father's trusted liegeman Rual Lefoitenant.

As a young adolescent, Tristan is kidnapped by merchants and ends up in Cornwall at Mark's court. Unaware of their kinship, they are nevertheless drawn to each other by "blood instinct," and Tristan swears to protect Mark's domain with complete loyalty. When they do finally learn of their kinship, Tristan is adopted as Mark's heir. At this time, the fearsome knight Morold is harassing Cornwall, demanding yearly tribute on behalf of King Gurmun of Ireland, his sister's husband. No one has been willing to fight against Morold until the arrival of Tristan, who does kill him but receives from him a poisoned wound. Just before Morold dies, he tells the hero the wound can be cured only by his sister Queen Isolde of Ireland, and so the mortally wounded Tristan is put in a boat set for Ireland. As the queen's "mortal enemy," he must hide his identity under the name of Tantris in order to be cured by her and her beautiful, wise, and talented daughter the Princess Isolde.

Upon Tristan's return to Cornwall, Mark's barons, jealous of Tristan and envying him his position as Mark's heir, force the king to marry in order to produce another heir. Mark insists that he will marry only Princess Isolde. Offering to obtain Isolde for Mark, Tristan again goes to Ireland where a dragon is now ravaging the land. The king of Ireland has promised to grant the hand of his daughter to the one who will slay the dragon. Again only Tristan will slay it, but no one knows of his deed. He cuts off the dragon's tongue and puts it in his pocket, where it begins to poison him. As he lies hidden in agony, the cowardly steward of the Irish court, seeing the dead dragon, cuts off its head and goes to court where he claims Isolde's hand.

Isolde, refusing this match, and disobeying her father's authority, takes her mother to find the real dragon-slayer. For a second time the two women save Tristan's life. Princess Isolde bathes Tristan to cure the poison, but while he is in his bath, she notices that a notch in his sword matches a fragment of sword she had taken from the skull of her dead uncle Morold. Preparing to avenge her uncle's death, she raises the sword to kill Tristan, but he dissuades her.

Isolde leads Tristan to her father, and it is only here for the first time that Tristan, talking to the king, reveals his intention to take Isolde for King Mark. On the boat for Cornwall, Isolde laments her hatred for Tristan. By accident, during the boat voyage, Isolde's maid gives the two young people a magic potion, specially prepared by Queen Isolde for her daughter to drink with King Mark. The powerful philter makes the two people who drink it together love each other exclusively and eternally unto death.

Having drunk the fatal potion, the lovers are forced by their love to live a life of treason and adultery. From perfect loyal knight, Tristan becomes the traitor to his kinsman and liege lord Mark. Mark's barons discover the illicit passion and denounce Tristan, who goes off into exile. He and Isolde live for four years in the isolation of the Morois Forest, after which Isolde returns to Mark's court while Tristan continues his knightly adventures in the service of Kaherdin, whose sister he marries, because her name, also Isolde, reminds him of his beloved. After a series of adventures, more numerous and discontinuous in some versions, more unified toward a single conclusion in Gottfried, Tristan is again mortally wounded in battle. Isolde leaves her position and reputation in Mark's court and comes to cure him, but a plot by Tristan's wife prevents her from arriving before her lover dies. She arrives in time to die beside Tristan as the two are finally united in death.

Denis de Rougemont's
Love in the Western World

The most famous and influential interpretation of this romance is Denis de Rougemont's *Love in the Western World*.[14] Since his theory repeats in a curious way the production of the same ideological structure that the Tristan romance produces, a discussion of the theory can show how the same patriarchal logical process operates in the romance and in twentieth-century critical discourse. Therefore, an analysis of the romance will again be deferred for a short discussion of de Rougemont's theory.

Briefly, his theory holds that the twelfth-century legend constitutes a cultural myth which both "expresses and veils" (p. 16) the foundations of Western consciousness. By falling in love, Tristan and Isolde willfully but unconsciously choose to desire what they cannot have, because the object of their passion is not each other but their own suffering, through which Western man gains his self-consciousness. Their ultimate object of desire is death, in which they find the absolute they seek. Thus the love philter symbolizes, like a Freudian symbol in a dream, this unconscious will, the internalization of formerly exterior repressive forces, and a secret death wish. The philter hides from us and from the lovers the fact that they choose to repress their sexuality by turning away from their guilty passion, because they really do not love each other. They love instead the ideal represented by their love, or their own ideal self, their "deified Ego" (p. 239), which is reflected in their love.

Like other critics, de Rougemont neglects to examine how the role of Isolde modifies his theory, and in two self-contradictory ways. On the one hand he assumes her to be the *same* as Tristan and simply merges them together in his analysis. On the other hand, he sees her as Tristan's objectified *other*. Merging her with Tristan, he says: "They are in love, but each

14. Denis de Rougemont, *L'Amour et l'occident* (Paris: 10/18, 1939). Translations are mine. Further references to this text are indicated in parentheses after the quotation.

loves the other *only for the sake of the self, not for the sake of the other.* Their misery arises from a false reciprocity, the mask of a double narcissism" (p. 43, italics in text). Here he sees Isolde as a subject of narcissistic desire, but in other passages he denies the possibility that she could be the subject of any kind of desire or engage in any kind of reciprocity with a man: "For Tristan, Isolde was nothing but the symbol of luminous Desire: . . . Therefore, Isolde had to be the impossible" (p. 239). Forgetting about reciprocity in love, he says: "Isolde is always the stranger, the very strangeness of woman" (p. 238).

As in the romance itself, in de Rougemont's theory the exclusion of women from membership in humanity flows out of a logic that separates spiritual ideals from social reality. To support his main contention, that romantic love is a completely and exclusively destructive force, "the *anarchic invasion* into our lives of a spiritual heresy to which we have lost the key" (p. 158, italics in text), de Rougemont states a connection between the Tristan legend and the twelfth-century Catharist heresy with its Manichaean theology. Other critics have made this connection, which in itself is quite compelling, but de Rougemont does so by creating his own new and fantastic version of the pre-Christian Celtic religion in which *Tristan and Isolde* ultimately extends it roots. He claims that Celtic paganism is fundamentally identical to this Christian Manichaeism, which posits a rigid and absolute separation between earthly life and the life of the spirit: "Every dualist, Manichean conception sees in daily life misery itself; and in death the ultimate good, . . . reintegration into the One. . . . The fulfillment of Love denies all earthly love. . . . Such is the great background against which our myth stands out" (p. 53).

While Celtic Druidism is in fact very far from this Manichaean doctrine, de Rougemont holds that in Druidism, as in Christian Manichaean heresies, the Christian idea of incarnation would be the "supreme scandal . . . for our reason which in no way can accept this unthinkable confusion between the finite and the infinite" (p. 53).

De Rougemont claims to take his information on Druidism from Henri Hubert's work, but Hubert, as well as the Rees brothers and Jean Markale, point out that although the Druids

were concerned with death and the afterlife, the boundaries between this world and the other world in that religion were remarkable for their fluidity and permeability to each other. The confusion of the finite and the infinite, far from "unthinkable," was accepted as the normal state of affairs.[15]

This distortion of Druidism permits de Rougemont to transform women from the active participants in the college of Druids that history shows them to have been into an ahistorical emanation of male Druids' minds.

> In the eyes of the Druids, woman constitutes a divine and prophetic being. She is the Velleda of the *Martyres*, the luminous phantom who appears to the vision of the Roman general lost in his nocturnal revery. . . . Eros has taken on the appearance of Woman, symbol of the beyond and of that nostalgia which makes us despise earthly joys. . . . The Essylt of sacred legends, "object of contemplation, mysterious spectacle," was an invitation to desire what is beyond bodily forms. She is beautiful and desirable in herself . . . and yet her nature is fleeting. "The Eternal feminine pulls us forward," Goethe will say. And Novalis: "Woman is the goal of man." (p. 51)

Besides noting that de Rougemont cannot see women outside the "eyes," the "visions," or the quotations of men, one can also note that there exists no "sacred legend" of Essylt (the Old Welsh version of Isolde) that has come down to us. This is a complete fabrication of de Rougemont. The only extant references to Essylt are in two very brief Welsh Triads and a catalog of the "leading

15. Henri Hubert, *The Greatness and Decline of the Celts*, edited and brought up to date by Marcel Mauss, Raymond Lantier, and Jean Marx, trans. M.R. Dobié (New York: Benjamin Blom, 1972), pp. 232–37; Jean Markale, *La Femme celte* (Paris: Payot, 1976), p. 306; Alwyn and Brinley Rees, *Celtic Heritage: Ancient Tradition in Ireland and Wales* (London: Thames and Hudson, 1961), pp. 154 ff.

ladies of the Island" in the Welsh Mabinogion *Culhwch and Olwen.*[16]

De Rougemont's "dualism," whose irreconcilable separation between matter and spirit makes spirit (masculine spirit) the primary or even the only reality, is really a rigid monism. Finding "scandalous" the "confusion" of matter and spirit, it necessitates this desire to return to "the One"—to the *mono*tony of pure spirit and the vision of *one* sex. It is a monologic ideology that preserves its dominance by negating that which differs from or does not conform to it.

This same ideological form takes shape in the course of *Tristan and Isolde*, but in the opposite direction from that which de Rougemont proposes. For de Rougemont, the romantic love of the Tristan legend "surfaced with the same movement that raised into the half-light of consciousness . . . that Feminine Principle" (p. 105) always/already buried within it. But the romance traces precisely the opposite process. It first transforms concrete women into an abstract "Feminine Principle," then interiorizes that principle into the hero's spirit, and finally suppresses an independent feminine presence. This gradual suppression of feminine difference in the course of the narrative is precisely what differentiates *Tristan and Isolde* from Celtic mythology. The Tristan legend does not "revivify . . . ancient religions," as de Rougemont says (p. 119), but on the contrary marks a rupture with them, as is illustrated by the way Celtic myth elements in the romance serve to represent that which is disappearing and are themselves gradually excluded from the text in which they leave their very telling traces.

16. Joseph Bédier, *Le Roman de Tristan par Thomas*, vol. 2: Introduction (Paris: Firmin Didot, 1905), p. 107; "Culhwch and Olwen," in *The Mabinogi and Other Medieval Welsh Tales*, ed. Patrick K. Ford (Berkeley: University of California Press, 1977), p. 131.

Women and Celtic Culture

Those Celtic myth elements in *Tristan and Isolde* retain the feminine activity that marks so strongly the original myths. In Celtic literature—Irish legends and Welsh mabinogi—feminine characters have greater prominence and power, a wider range of action, and a different function in the structure than in romantic narrative. The inclusion and ensuing repression of those myth elements in the romance entail the inclusion and repression of a powerful, active femininity. Since they are so decisively at play in the text of *Tristan*, the analysis of the romance will once again be put off, to allow for a short analysis of these myth elements.

Preserved in oral form by Druids and by an official class of bards called Fili, Celtic legends were compiled and written down by Christian clerics in Ireland from the seventh to the ninth centuries, in Wales in the twelfth century, and are still transmitted orally today. The compilers divided Irish legend into four cycles, each of which relates, in a combination of myth and history, the stories of four successive peoples who invaded and inhabited Ireland.

The first cycle, the "mythological cycle," recounts the adventures of the Tuatha de Danaam (Tribe of Danu). The earliest known inhabitants of Ireland, the tribe is said to trace its descent back to its primal ancestress Danu, who is also the mother of the gods, and whom Robert Graves associates with the Great Goddess, worshipped in the Eastern Mediterranean during the second millennium B.C.[17] When defeated by the second group of invaders, the Gaels, the Tuatha de Danaam become the ever-living supernatural beings of the Other World, where women continue to have the power of enchantment and the sexual freedom they now lack in This World. An illustration of this double feminine sexual code—freedom to bear children out of wedlock for women of the Other World and severe

17. See Lady Augusta Gregory, *Gods and Fighting Men: The Story of the Tuatha de Danaam and of the Fianna of Ireland* (New York: Oxford University Press, 1970), pp. 139, 197, and 214. Further references to this text will be made in parentheses after the quotation.

punishment for adultery for women of this world—appears in the fairy tale "The King of Erin and the Queen of the Lonesome Island."[18] In the Tristan romance, Isolde confronts a similar split, freedom in Ireland, severe punishment for adultery in Cornwall.

In the mythological cycle of Irish legend, women are not passive incarnations of the "Feminine Principle," but warriors, founders of capital cities, physicians, and Druids. Even in the third or "heroic" cycle and the fourth or "Fenian" cycle, the greatest heroes like CuChúlainn and Finn MacCumhail are trained by women warriors who live away from men and who teach the heroes secrets of invulnerability. Only women, like "the mother of Fear Dubh who is more violent, more venomous, more to be dreaded, a greater warrior than her sons," outsmart Finn and CuChúlainn and defeat them in battle.[19]

In the extensive critical debates over how much *Tristan and Isolde* retains elements from Irish and Welsh legend, Gertrude Schoepperle Loomis's work, often considered the most authoritative and extensive work on sources, claims that what has been incorporated into the Tristan legend are *motifs* from Celtic and especially Irish folklore. Important among these motifs is the *Imrama* or "Voyage," in which a young hero sails, guided by magic forces, to the supernatural Other World, often called the Land of Women, as Tristan sails to Ireland to find Isolde.[20] Another motif is the "Elopement," in which a young married woman runs away from her old husband with a younger man, of which the most famous example is the story of *Diarmuid and Grainne.*

18. "The King of Erin and the Queen of the Lonesome Island," in *Myths and Folktales of Ireland*, ed. Jeremiah Curtin (New York: Dover, 1975), p. 64.

19. "Finn MacCumhail and the Fenians of Erin in the Castle of Fear Dubh," in *Myths and Folktales*, ed. Curtin, p. 153. For legends of Finn and CuChúlainn see: *The Cattle Raid of Cualnge* (Tain Bo Cuailnge), trans. L. Winifred Faraday (London: David Nutt, 1904); Gregory, *Gods and Fighting Men*; and Jean Markale, *L'Epopée celtique d'Irlande* (Paris: Payot, 1971), pp. 75–138.

20. Gertrude Schoepperle Loomis, *Tristan and Isolt: A Study in the Sources of the Romance* (New York: Bert Franklin, 1963), p. 326.

But Schoepperle points out that while the first part of *Tristan and Isolde is* folkloric, the later part, with its celebration of adulterous, distant love between Tristan and Isolde, falls entirely into the courtly ethos (pp. 120 and 177). This seeming dichotomy is really a process which first integrates and then excludes elements of Celtic culture and by so doing gives form to an ideology that is patriarchal not only in the narrow sense of male kinship descent, but in the broader sense that it justifies, naturalizes, and totalizes the institutions and thought structures that make masculine hegemony seem natural.

Elements of an ideology more open and more inclusive of feminine difference appear in the first part of *Tristan and Isolde*, and also characterize early medieval Irish culture. The social structure of early medieval Ireland is in some ways similar and in other ways very different from that of early medieval Western Europe. Based on a patriarchal kinship structure, the clans of Ireland still retained up to the end of the twelfth century traces of matrilineal descent; and Henri Hubert notes in Irish writings the feminine elements we have already seen: "the epics, history and laws of the Celts . . . contain memories of important remnants of the uterine family."[21] The Irish legal code, although repressive to women in the sixth century, had by the ninth century given equal property rights and "equal lordship" to the majority of women.[22]

Technically less "matrilineal" than early medieval Western Europe, medieval Irish society, until the Norman invasions of the late twelfth century, maintained its ancient clan structure in a stable form, and so incorporated to a relatively high degree that informal decision-making structure which Leacock sees as so favorable to women. The only part of Europe never conquered by Rome, Ireland continued to develop a flourishing, energetic culture, which, unlike that of the rest of Europe, was not interrupted by the fall of the Roman Empire, did not succumb to the anarchy of early feudalism, and did not experience a Dark

21. Hubert, *The Greatness and Decline of the Celts*, p. 204.

22. Donncha O'Corráin, "Women in Early Irish Society," in *Women in Irish Society: The Historical Dimension*, ed. Margaret MacCurtain and Donncha O'Corráin (Westport, Conn.: Greenwood Press, 1979), p. 11.

Age. This culture grew in a context free from the Roman property system, legal system, and government bureaucracies.

The Irish property system, combining individual ownership and collective clan ownership, did not give women inheritance of property, but gave both men and women the right to keep the products of their own labor. In the frequent case of divorce, the woman took back with her the products of her labor along with the instruments that produced them, while the property she had brought into the marriage went back into her clan. This floating of property between rival clans coincided with the absence of a separate state bureaucracy or police force above the clan. In ninth-century Ireland there were no towns and no central government. The kingship and other positions of leadership tended to be elective, temporary, and limited in scope, without the vast privilege, wealth, and unilateral power associated with inherited positions.[23]

While Celtic law gave the husband authority over the family, that authority was undercut by many other laws. If the wife had equal or greater property, she had equal or greater authority in the marriage. Moreover, since the clan remained primary over the family, the woman remained a member of her own clan even in marriage. The clan protected her from the power of her husband because it protected in her its own property, and it also raised her children through the institution of fosterage.

Although female adultery was as severely punished as anywhere else in Europe, the divorce laws manifest, according to Donncha O'Corráin, a "care for the individual personality of the woman" that was unheard of anywhere else in Europe.[24] A

23. See Carole L. Crumley, *Celtic Social Structure: The Generation of Archaeologically Testable Hypotheses from Literary Evidence*, Museum of Anthropology, University of Michigan, no. 54 (Ann Arbor: University of Michigan, 1974), p. 22; Hubert, *The Greatness and Decline of the Celts*, pp. 189–222; Markale, *La Femme celte*, p. 17; P.W. Joyce, *A Social History of Ancient Ireland* (New York: Benjamin Blom, 1968), 2 vols., I:168; and Katharine Scherman, *The Flowering of Ireland: Saints, Scholars and Kings* (Boston: Little, Brown, and Co., 1981).

24. O'Corráin, "Women in Early Irish Society," p. 12.

woman could divorce for a sexually unsatisfactory husband, for maltreatment by him; or for his revealing sexual secrets of the marriage or violating her privacy. In addition to keeping her property after divorce, the woman also received compensation and a fine.

In certain ways the Irish system of property tenure has the features that, according to anthropologists like Eleanor Leacock, Rayna Reiter, Kathleen Gough, and Karen Sacks, differentiate egalitarian societies from patriarchy.[25] In societies where the clan is more important than the individual family and maintains its right over the woman's property even when she marries a man from another clan, the status of women is doubly strengthened. Private property ownership and the power it confers do not consolidate in the hands of one man, but float among different clans. In addition, the woman's clan protects her from her husband, allowing her more independence and respect.

In such a society the ties between husband and wife are loose, and the social role of the biological father relatively unimportant. Instead, the clan forges sacred bonds between brother and sister, and between maternal uncle and sister's children. Much has been written about the remnants of this kinship structure that are found in medieval epics and romances as exemplified by the relation between Roland and Charlemagne. Lancelot and Arthur, Tristan and Mark, but little

25. Besides Leacock, *Myths*, the main writings on matriliny consulted were: Frederick Engels, *The Origin of the Family, Private Property and the State* (New York: International Publishers, 1973); Merlin Stone, *When God Was a Woman* (New York: Harcourt Brace Jovanovich, 1977); George Thompson, *Studies in Ancient Greek Society: The Prehistoric Aegean* (New York: Citadel Press, 1965); two articles were consulted in *Becoming Visible*, ed. Bridenthal and Koontz: Eleanor Leacock, "Women in Egalitarian Societies," pp. 11–35, and Ruby Rohrlich-Leavitt, "Women in Transition: Crete and Sumer," pp. 36–59; three articles were consulted in *Toward an Anthropology of Women*, ed. Rayna R. Reiter (New York: Monthly Review Press, 1975): Kathleen Gough, "The Origin of the Family," pp. 51–76, Patricia Draper, "Kung Women: Contrasts in Sexual Egalitarianism in Foraging and Sedentary Contexts," pp. 77–109, and Karen Sacks, "Engels Revisited: Women, the Organization of Production, and Private Property," pp. 211–34.

has been written about the relation between Isolde and her maternal uncle Morold that will be discussed here.

When private, inherited property replaces the collective and/or floating property of the clan, private, male-headed families become dominant over the clan. They seclude women to ensure their sexual purity, isolate them from the clan relations that give them independence from their husbands, and place them under the control of one man, and a stranger at that. The clan gradually disappears, fragmenting into a collection of separate families on the one hand, and an abstract state ruling from above on the other.

Celtic society, combining as it does contradictory elements of both matriliny and patriarchy, produces a literature, exemplified by the four mythical cycles and the CuChúlainn saga, whose structure is based on multiple logic and opposes the unilogic or monologic we have seen in de Rougemont's analysis of Celtic society. Celtic legends with their women warriors like CuChúlainn's enemy Macha, and their passive men like Pwyll, husband of the warrior goddess Rhiannon in the Welsh Mabinogion "Pwyll, Prince of Dyfed,"[26] do not have a rigid categorization of "male" qualities and "female" qualities. Furthermore, characters can adopt the form and attributes of the other sex. For instance, in the CuChúlainn cycle, Macha puts a curse on the Ulster soldiers that make them periodically experience labor pains and menstrual weakness. The most extreme example of the fluid exchange of sexes appears in "Math son of Mathonwy" where King Mark punishes his sister's sons Gwydion and Gilfaethwy by changing them first into a hind and a stag who mate and bear a fawn. Then he changes the hind into a wild boar and the stag into a sow. After the two mate and produce a piglet, the boar is transformed into a wolf bitch and the sow into a wolf. The final result is that each of the two men ends up "bearing the other's child."[27]

A telling example of this sexual fluidity is found in the varying versions of what we now know as the Cinderella tale. While children today believe that there is only *one* version of the

26. "Pwyll, Prince of Dyfed," in *The Mabinogi*, ed. Ford, pp. 35–56.

27. "Math Son of Mathonwy," in *The Mabinogi*, ed. Ford, p. 98.

tale in which the handsome, active prince puts the shoe on the
passive, obedient Cinderella because only she has a dainty
enough foot to fit it, the Irish versions, of which there are
many,[28] show a different logic and set of sexual values. In a tale
like "Fair, Brown, and Trembling," it is the heroine who must fit
her foot into the shoe, but in a tale like "The Thirteenth Son of
the King of Erin," it is the hero who must fit his foot into a boot
in order to marry the princess. Moreover, the shoe does not fit
the maid because her foot is small enough and dainty enough to
meet a set and rigid visual model of femininity. Instead the size
of the shoe *changes* to fit the maid or the lad who has done the
actions showing the most desirable moral qualities.

In this literature is found the logic based on multiplicity
and contradiction that will appear in the first part of *Tristan and
Isolde*. Irish and Welsh legends contrast to the type of
romanticism that defies contradiction and sees the relation
between man and woman as one in which the man cancels out
the autonomous difference of the woman and absorbs her into
identity with him. In Celtic legends the relation between man
and woman is irreducible to oneness. Instead of intolerance of
difference as in de Rougemont's "dualism," there is a true
dialogic that promotes ambiguity and contradiction, defies linear
logic, and rejects hierarchies.

Contrary to de Rougemont's characterization of women in
Celtic myth, they appear as both desirable maidens and as ugly
but powerful old hags. The same woman in a given myth often
takes both forms, and she can with her magic powers make the
same man both young and desirable or old, weak, and ugly. The
legendary women are not only desirable, as de Rougemont says,
but also desiring, and their relations with men, especially in the
Fenian cycle, are marked by complex patterns of desire and
rejection on both sides, of hostility and alliance.

In sexual relations, and in human relations generally,
hierarchies in the legends tend to cancel each other out. Class
hierarchies begin and end in the Other World, whose
inhabitants, as Rees says, are at the same time the lowest—

28. See, for instance, "Fair, Brown and Trembling" and "The
Thirteenth Son of the King of Erin," in *Myths and Folktales*, ed. Curtin.

scapegoats, serfs, and outcasts from this world—and also the highest, since they are gods and goddesses (p. 145). In the Irish myths in the Curtin edition, supernatural gods visit this world in the form of servants, cowherds, and henwives.

Most of the Celtic legends concern the fluid exchanges and interpenetration of boundaries between this world and the Other World: figures who are both mortal and gods; relations between people and gods who exchange form; gods visiting this world and mortals voyaging to the Other World, as Tristan voyages to Ireland. This fluidity between the earthly realm and the supernatural realm, between masculine and feminine, between matter and spirit, is completely opposed to de Rougemont's notion of a separate, isolated spiritual realm and the desire to return to its oneness. Here the spiritual realm is not transcendent, but multiple and always present in matter.

The mutual existence of contradictory and equally true visions of a same reality is illustrated by the voyage to the Other World, the Land of Women, in the legend of Bran.

> It is what Bran thinks, he is going in his curragh over the wonderful, beautiful clear sea; but to me from far off in my chariot, it is a flowery plain he is riding on.
>
> What is a clear sea to the good boat Bran is in, is a happy plain with many flowers to me in my two wheeled chariot.
>
> It is what Bran sees, many waves beating across the clear sea; it is what I myself see, red flowers without any fault. . . .
>
> Let Bran row on steadily, it is not far to the Land of Women; before the setting of the sun you will reach Emhain, of many-coloured hospitality. (Gregory, p. 105)

Women in this kind of culture do not have "equality" in the abstract sense that "equal" people are the "same" as each other, or that they all have some identical attribute. The respect, freedom, and independence women have are based on a multiplicity and ambiguity of relationships which work against the establishment of hierarchy and prevent unilateral dominance of one group over another.

to take over and/or disrupt this world.[32] Like Finn, Tristan, in killing the dragon, called a "serpent" in the romance, overthrows matriliny and establishes patriarchy.

Gottfried's sentence—"the King swore by his royal oath that he would give his daughter to whoever would make an end of it [the serpent]" (p. 159)—is rich in latent significance. Whoever kills the dragon not only wins the daughter, but also reduces her to the position of "being given away" by her father, and moreover gives the father the power to dispose of his daughter. Indeed, after Tristan kills the dragon, Isolde loses the power granted her as niece of her *maternal uncle* and must submit as daughter of her *father*. Once he gives her away and she leaves her native land, both Ireland, as representative of an accessible Other World, and Queen Isolde disappear forever, while Princess Isolde loses her wisdom and her healing power.

In clanic societies, especially if they have any form of matriliny, men play a significant role not as husbands and fathers but as brothers of the women and uncles to their sister's children. Blood ties are all-important. Bell and Farnsworth see in the emphasis on maternal uncle–nephew relations in the medieval epic the survivals of ancient matriliny, and George Duby's study of ninth-century Macon shows the historical existence of matriliny.[33] But if *The Song of Roland* represents, as Bell and Farnsworth say, the uncle–nephew relation in its perfect form, *Tristan and Isolde* traces the breaking of this bond.

Critics have noted that Tristan, by loving his uncle Mark's wife, betrays that most sacred of bonds with his closest kin, after which he becomes an isolated individual. Just as important, however, Isolde, by failing to kill Tristan in his bath, also betrays

32. Curtin, ed., *Myths and Folktales*, pp. 142, 145, 176, and 204; Gregory, *Gods and Fighting Men*, pp. 206–07.

33. Clair Hayden Bell, *The Sister's Son in the Medieval German Epic: A Study in the Survival of Matriliny* (Berkeley: University of California Press, 1922), esp. pp. 69 and 68; William Oliver Farnsworth, *Uncle and Nephew in the Old French Chansons de Geste: A Study in the Survival of Matriarchy* (New York: AMS Press, 1966); Georges Duby, "Lignage, noblesse et chevalerie au XIIe siècle dans la region maconnaise," *Annales* 27, no. 4–5 (July–October, 1972): 803–24.

her sacred tie to her uncle Morold, but with the different result that she loses her magic power and her prestige. Both characters break the bond, before which they have equal and very different forms of power. Afterward the hero develops his individualism, and the heroine falls into a subservient and relative existence.

When, during Tristan's second voyage, Isolde raises the sword to kill him as the murderer of her uncle, she is exercising not only a duty but also a right. The right over Tristan's life and death, as the right to avenge her uncle, is the source of her power and independence in Ireland. When she allows herself to be persuaded by Tristan not to kill him, she falls under his power, becomes an object for him to dispose of at will, and is taken away from her clan to a land of strangers. Tristan says to her father King Gurmun: "Your majesty, remember your word—I am to dispose of your daughter" (Gottfried, p. 189). When the exchange is concluded, Gottfried tells us: "Gurmun solemnly surrendered Isolde into the hands of Tristan her enemy" (Gottfried, p. 191). When she fails to kill her uncle's murderer in his bath, she loses her matrilineal rights.

She also, by this act, loses her place in the mythic world of feminine supernatural power. In one of the major Celtic myths, the story of the god Llew Llaw Gyffes, Llew is killed in a bath with the complicity of his wife Blodeuwedd. According to Robert Graves, this is also a common motif in god myths of Eastern Mediterranean, pre-Achaean goddess religions.[34] By failing to murder Tristan in his bath, Isolde loses her connection to the Celtic goddesses.

Isolde's active, independent life while she is in Ireland, as well as her magic healing powers, come to her not through a mystic source but because she is surrounded by kinspeople and retainers who protect and defend her actions. The early section of *Tristan and Isolde*, which emphasizes the all-important relations between Tristan and his maternal uncle, as well as Isolde and her maternal uncle, also accents in Gottfried, Thomas, and the Old Norse versions the close ties between mother and daughter, which aid Isolde to be free and independent. It is her

34. Graves, *The White Goddess*, pp. 315–16.

mother who helps Isolde refuse her father's order to marry the
steward and go out on her own to find the real dragon-slayer.

Repeatedly, when Isolde, after she has left Ireland for
Mark's court, complains of her weakness, she attributes it not to
her weak womanly nature but to the fact that she has been put
among strangers. When she is spied upon, entrapped, and
denounced for her adultery by Mark's barons, she says to Mark:

> "And so I am not surprised to be the victim of such talk.
> There was no chance that I should be passed over and not
> be accused of improper conduct, for I am far from home
> and can never [find helpers here, nor] ask here for my
> friends and relations. Unfortunately there is scarcely a
> soul in this place who will feel disgraced with me."
> (Gottfried, p. 245; German version, ll. 15494–98)

In Bédier's Thomas version, Isolde's fall from a former high
status protected by close kin is expressed even more clearly. She
tells Mark: "For the sake of your love I have left all my support:
father, mother, kin and friends, honor, joy and power!" (p. 186).

After Isolde's marriage to Mark, the courtliness which then
comes to dominate the romance works as a sign that sexual
relations between people not related by blood overtake in
importance blood relations. Courtly mores accompany the new
hegemony of sexual ties between people who choose each other
as individuals without regard for the needs of the clan. But in the
Middle Ages such sexual love always takes place outside of
marriage, which remains an economic arrangement between
powerful families in which the bride has no say. Therefore the
courtly adultery in *Tristan and Isolde* also has as its corollary
Isolde's revolt against subjugation to her husband, her lack of
legal and also physical freedom, the constant portrayal of her as
hemmed in, trapped, spied upon, pushed into a corner, able to
escape only by the most desperate of measures.

One such desperate move appears in the scene where
Isolde must swear, on pain of carrying red hot iron, that she has
been faithful to Mark. She makes Tristan disguise himself as a
poor pilgrim and carry her across a stream on his back in front of
Mark's court. She then swears that "never did a man born of
woman approach my body, except you, sire King, and the pitiful

pilgrim who carried me from the boat and who in front of you fell on top of me" (Bédier's Thomas, p. 201).

Critics like de Rougemont, who have criticized Isolde (in itself a dubious practice of literary criticism) for her "feminine ruse" and her "blasphemy,"[35] neglect to see her reacting in the total context of the legend, as a formerly "happy and carefree" (Gottfried, p. 186) woman who has been reduced to the state of a hunted animal, or as she says in Bédier's Thomas version, "a prisoner of war" (p. 207), by foreign marriage laws of which she had no knowledge, and by a despotic marriage which she did not choose.

Another significant contrast between multiple logic in the first part of the romance and unitary logic in the second part is found in the notion of love itself. While in the second part the only model for love is the fatal romantic passion between Tristan and Isolde, the first part has two different models of love. One is the love of Tristan's mother Blanchefleur for his father Rivalin, which resembles the fatal passion of the second part, but which does not structurally dominate the narrative as Tristan's and Isolde's love will after they drink the potion. The second model is Isolde's love for Tristan when he is in Ireland and before she discovers he has killed her uncle. This love of Isolde is so much outside our cultural framework that some critics deny she loves him. Hatto, for instance, says:

> Sentimental critics, wise in the wisdom of latter-day psychology, attribute Isolde's inability to kill Tristan to her being more or less consciously in love with him, even before drinking the love potion, a conception which was foreign to Gottfried. Gottfried's own explanation, which one may be excused for preferring, despite its not being entirely free from prevarication, is that Isolde's womanly instincts forbade her to kill.[36]

35. "Then by a final feminine ruse, exploiting this concession, the queen declares she will rejoin the knight" (de Rougemont, *Love*, p. 23); "How can they present us . . . as a virtuous lady this adulterous wife who does not even recoil before a clever blasphemy?" (p. 25).

36. Hatto, Introduction to *Tristan*, p. 23.

Hatto's logic, based as it is on an "eternal feminine," is reminiscent of de Rougemont's. While Hatto does note that Tristan appeals to Isolde's femininity in order to dupe her, he does not mention that Gottfried *invents* these "womanly instincts," nor that the more primitive Eilhart version, as well as the Old Norse version, are more explicit in telling us that Isolde loves Tristan. In these two other versions, she is prevented from killing Tristan by the thought that if she kills him, she will have to marry the steward instead of him.

This "conception" is "foreign" to Gottfried not because he is too premodern, but because he is too modern. Yet the very structure of the dragon episode makes it impossible to suppress entirely from the Gottfried text Isolde's preromantic, prepatriarchal form of love. When Isolde says: "Never will I consent to what my father wants, to marry this man [the steward]" (Bédier's Thomas, p. 119), and when she goes out to find the real dragon-slayer, she is not only rejecting her father's authority, but also going out to *choose her own husband* according to her ancient Celtic right. Only later does she find out that Tristan has come to seek her as Mark's wife, and Tristan is very careful to hide this fact from her when, handsomely naked in his bath, he is persuading her not to kill him.

In the Irish myths of the Curtin collection, the heroine almost always chooses her own husband, and significantly enough, this choice is never directly expressed. But when she helps a warrior to accomplish exploits that would be impossible without her aid, or when she saves his life, or when she asks him to save her, this means, according to the code of that literature, that she has chosen him to marry her. The legends do not say that she loves the hero, do not analyze her motives, and never show her reflecting on her love. But the man who rejects such a marriage is considered unfaithful enough to receive harsh punishment, and when women are sold into marriage without their consent, as in "The Weaver's Son and the Giant of the White Hill," it is treated as a disastrous situation. Each of these stories states that the father or brother gives the heroine to the hero who can accomplish a dangerous exploit, but no hero can gain victory unless the daughter or sister chooses to help him, to save him from danger, or to heal him when he is wounded.

Contrary to what Hatto says, he himself, in denying that Isolde loves Tristan, projects modern psychology onto the romance.

Isolde's psychology is that of the mythical Celtic maidens. Like them, she chooses, while she is still unaware of Tristan's identity, to bring him back to life and to prove he really killed the dragon, because she knows she is destined to be the wife of the dragon-slayer. According to the multiple logic she operates under, the fact that her future is determined would not prevent her from exercising her power to choose and to realize her own desires. Although her resistance to her father and her intention to seek and choose Tristan as her husband are much more explicit in other versions of the romance, Gottfried, even by having Tristan as part of his disguise claim to have a wife already, cannot prevent traces of this older version from breaking through, especially since polygamy still existed in Celtic culture.

In the crucial scene where Isolde, having discovered that the dragon-slayer is also the man who killed her uncle, tries and fails to kill Tristan, Gottfried expresses her conflict as a purely psychological one between abstract, eternal forces. But it is also a mythical and historical conflict between the past status and the future status of women.

> Those two conflicting qualities, those warring contradictions, womanhood and anger, which accord so ill together, fought a hard battle in her breast.... Thus uncertainty raged within her, till at last sweet womanhood triumphed over anger, with the result that her enemy lived, and Morold was not avenged. (Gottfried, p. 176)

While this "sweet womanhood" seems to signify an eternal force, the language in the passage also makes it a historical quality that comes into being in this moment. By bringing into opposition "womanhood" and "anger," this passage gives both terms a new meaning in relation to each other. Womanhood now excludes anger, and no longer connotes the women of Irish legend, but a more subdued type of femininity, while anger, formerly associated with the ancient bisexual clanic duty of vengeance, is now reserved for "manhood." The "triumph" of womanhood signifies that by this nonvengeance of Morold the maternal uncle, femininity becomes defined as submission.

In the Old Norse version, Isolde goes so far as to ask Tristan to be her husband (p. 61), but we can see why this un-self-reflecting, unspoken, but very active love of Isolde, which resembles that of the maidens in Irish folklore, is not considered "love" when we compare it to Blanchefleur's love for Rivalin, characterized by a self-reflective anguish and torment which conforms to our modern conception of love. Because Blanchefleur experiences love as a mysterious "suffering" (Gottfried, p. 44), it leads her to self-questioning and self-consciousness, and thus resembles the romantic love de Rougemont defines. Likewise, Isolde's passion for Tristan after drinking the potion, in opposition to her love for Tristan while they are still in Ireland, also brings her to self-reflection, since in her anguish she tells herself explicitly for the first time that she loves Tristan.

But beyond attributing this self-consciousness and suffering to guilt, de Rougemont does not say what causes it. Blanchefleur suffers because her love is forbidden for reasons of her brother's political power in a set hierarchy, his lineage which must be protected, and the difference of rank between herself and her lover Rivalin. In other words, all those accoutrements of patriarchal society force her to repress her love.

For Isolde the role of patriarchy in making her reflect upon her love and try to repress it is even more striking. She is no longer free to love the man of her choice because the purpose of her marriage is to provide Mark "a wife from whom he could get an heir" (Gottfried, p. 151) other than his nephew Tristan. Mark's barons, by forcing their king to reject his sister's son as heir and to take only his own child, are committing much more than a mere act of envy. They are suppressing the principle of matrilineal succession and enforcing the exclusive principle of patrilineal succession. Both Tristan and Isolde experience forbidden love as tormented self-consciousness because Isolde must ensure the purity of patriarchal inheritance.

Isolde's loss of freedom is most clearly expressed in the famous "Isolde's Lament," chanted while the two are on the boat for Cornwall, after Isolde has submitted to Tristan and right before they drink the love potion.

She wept and she lamented amid her tears that she was leaving her homeland, whose people she knew and all her friends in this fashion, and was sailing away with strangers, she neither knew whither nor how. . . . The loyal man hoped to comfort the girl in her distress. But whenever he put his arm around her, fair Isolde recalled her uncle's death. . . .

"But lovely woman, am I offending you?"

"You are—because I hate you!"

"But why? dear lady?" he asked.

"You killed my uncle!"

"But that has been put by."

"Nevertheless, I detest you, since but for you I should not have a care in the world [I would be free from cares and woes]. You and you alone have saddled me with all this trouble, with your trickery and deceit. What spite has sent you here [to Ireland] from Cornwall to my harm? You have won me by guile from those who brought me up, and are taking me I do not know where! I have no idea what fate I have been sold into [how I have been sold], nor what is going to become of me!" (Gottfried, p. 193; German version, ll. 11552–95)

When Tristan reminds Isolde that without him she would have had to marry the steward, she answers:

"You will have to wait a long time before I thank you, for even if you saved me from him, you have since so bewildered me with trouble that I would rather have married the Steward than set out on this voyage with you." (Gottfried, p. 194)

The themes of losing power and freedom by losing family and defenders, and of succumbing to her uncle's murderer and therefore renouncing the matrilineal kinship rights, are repeated here, but with the added emphasis on personal humiliation through submitting to Tristan's clever manipulations; Tristan's rational calculation has conquered Isolde's magic power. In interpreting Isolde's hatred, Jackson says:

The reasons she gives are perfectly logical—he murdered her uncle and has taken her from her parents. Yet they are unconvincing. The first was, so far as Isolde was concerned, a technical offense. . . . Tristan haunts Isolde's

> cabin, and she shows an anger toward him which seems
> so excessive as to be akin to love. . . . It is against this
> emotional background that Gottfried introduces the
> *Minnetrank*, the draught of love.[37]

Like Hatto, Jackson projects onto Isolde a modern psychology.
Her reasons are unconvincing only from a point of view that
adopts an exclusively patriarchal logic. It has been shown that
from a prepatriarchal point of view, Tristan's offense is far from
technical and Isolde's anger far from excessive, given the
momentous upheaval Tristan has just accomplished. It is entirely
probable that Isolde's formerly forthright love really has turned
to hatred, and that there is quite another reason why her lament
is juxtaposed to the love potion scene.

If we study the love potion scene, we find that the potion
affects the two characters differently. De Rougemont assumes
that since the love between Tristan and Isolde is "reciprocal" (p.
43), it is also symmetrical, but such is not the case. After drinking
the potion, each of the lovers experiences a conflict of a far
different order from that of the other. Tristan's conflict sets
feudal codes against individualist codes: "When Tristan felt the
stirrings of love he at once remembered loyalty and honor, and
strove to turn away. . . . The loyal man was afflicted by a double
pain. . . . Honor and Loyalty harassed him powerfully, but Love
harassed him more" (Gottfried, pp. 195–96). Tristan's conflict is
one of guilt, which as R.H. Bloch points out, internalizes the
external prohibitions of a clan society and replaces them with the
self-imposed inhibitions for the autonomous subject of the
abstract corporate state. For Tristan, the onslaught of this
forbidden passion serves "the emergence of a divided guilt-
ridden self" (Bloch, p. 247).

Isolde also experiences conflict: "And so it fared with her.
Finding her life unbearable, she, too, made ceaseless efforts"
(Gottfried, p. 196). But the text says nothing about her
experiencing guilt, and indeed she has no reason to. Although
Gottfried does not, as he does for Tristan, explain directly the
cause of her conflict, he does juxtapose it to her lament, and he

37. W.T.H. Jackson, *The Anatomy of Love: The Tristan of Gottfried von
Strassburg* (New York: Columbia University Press, 1971), pp. 85–86.

does say: "Isolde's hatred was gone. Love, the reconciler, had purged their hearts of enmity" (Gottfried, p. 195). Isolde's conflict is that she loves the cause of her misery, her subjugation, and her loss of personal autonomy. She loves that which for every reason she should hate.

But the love philter, as the mechanism which internalizes repression, also represses the memory of what came before the establishment of this internalized censor, of her hatred and of the enslavement and humiliation of feminine autonomy which lie at the origin of romantic love. Perhaps this is why critics cannot go behind its origin to another form of psychology and another form of love.

Romantic Love as a Double Force

Yet Isolde is now caught in a contradiction even more intense than Tristan's. For her (as for us) there is no way back to the mythical matrifocal culture. The only route for her to express her refusal to her enslaving marriage, her resistance to it, and her yearning for freedom is through her adulterous love for Tristan, the man who caused that enslavement. Because de Rougemont's notion of "reciprocity" is a false reciprocity which reduces Isolde's role to a function of Tristan, he does not see that romantic love is a double and contradictory force, but denounces it as only destructive (pp. 31 and 42). His view of Isolde as a function of Tristan and his view of love as a single, unambiguous force go together.

It is not only inaccurate but futile to view romantic love as a uniformly destructive force to be condemned. It is the love of its historical epoch, belonging to it just as much as the state, the market economy, the patriarchal family, and the monologic ideology; with the one major difference that romantic love is a double force, since it is a protest against this social order from within it. Just as patriarchal ideology is characterized by the separation between a material and a spiritual realm, so does romantic love open up the mind/body split. But at the same time it is a yearning to heal the split and must be seen in this dual light.

Although when they first drink the potion, Tristan and Isolde love each other "with all their senses," after the Morois Forest episode they separate and increasingly Tristan loves the image of Isolde as preserved in memory and sculpture. The personal sexual relation which replaces the feudal relation is more and more, like the individual's relation to the state, an *imaginary* one. Tristan's love is conclusively transferred from the real woman to the internalized image within him upon his meeting of the second Isolde, Isolde of the White Hands, whom he marries because her name reminds him of his beloved. His meeting with Isolde No. 2 brings his memory of Isolde No. 1 even more prominently to his mind: "she reminded him strongly of the other Isolde, the resplendent one of Ireland" (Gottfried, p. 290). This image of Isolde No. 1 inhibits Tristan from having sexual relations with his wife.

This doubling of Isolde and the introduction of a second purely material Isolde succeeds in completing the idealization of Isolde No. 1 and the separation of the ideal object of love from the material woman for Tristan. Isolde of the White Hands is like the heroines of nineteenth-century novels who in the eyes of their lover must always represent and reincarnate an ideal preexisting in his mind, which she can never quite measure up to. Isolde of the White Hands is the Great Ancestress of heroines like Flaubert's Madame Arnoux in *L'Education sentimentale* where the hero Frédéric falls in love with her because she "resembled the women in romantic books,"[38] but ceases to love her when she becomes accessible.

Tristan's love is more and more a relation to this image within himself, or in other words a relation to himself in which both Isolde No. 1 and Isolde No. 2 are nullified except as mediators. The apparently reciprocal and mutual love of the beginning becomes a one-sided, linear relation. After Tristan leaves Isolde, he calls her his "other life" (German version, ll. 19157) or as Hatto translates it, his "other self" (Gottfried, p. 293).

While an autonomous feminine other is ejected from the exterior world of the romance, the masculine self projects into it

38. Gustave Flaubert, *L'Education sentimentale* (Paris: Garnier, 1964), p. 9. Translation is mine.

his own alter ego as a fictive other. For Tristan this exteriorized self is Tristan the Dwarf, appearing only at the end of the Thomas version, whom he meets at the end of his adventures, and who takes on more reality for him than either of the two Isoldes. He is mortally wounded when he takes up Tristan the Dwarf's battle and so really dies for the sake of his alter ego rather than for the sake of his mistress.

Throughout *Tristan and Isolde* the transformation of Tristan's personal identity from social and dialectical to individualist and linear can be traced through the series of his loyalties. He is first loyal both to his maternal uncle Mark and to his liege man and foster father, Rual Lefoitenant; then to Isolde the single object of desire; then to the internalized image of Isolde as his "other life"; and then to his alter ego Tristan the Dwarf. Although at the beginning of the romance, Tristan's identity comes from his position in a complex of kinship ties, through the idealization of Isolde, who becomes more and more like his mirror, he gains an identity based on self-reflection. The process of producing this new form of identity merges the autonomous feminine into the masculine spirit.

This new form of identity also serves to suppress social contradiction within the romance. In the last part of the romance, Tristan's love seems "more refined" and "noble" (Jackson, p. 41), and no longer makes him disloyal to Mark. But what really happens is that the contradiction between feudal ethics and courtly love ethics which so haunted Tristan after he drank the potion has now been smoothed over, because Tristan has transferred his love to the image in himself and gone away to serve another lord. His form of selfhood serves a society which cannot recognize its own internal contradictions, especially that between patriarchal marriage and sexual love, and so dissolves them in imagination into identities, as the relation to the other turns into a relation to the self. The social oppression of women and the ideological repression of an autonomous feminine presence serve complementary purposes.

In conformity with this new monologic, Tristan also develops in the course of his legend a new art form, based on self-reflection. In the Thomas version, after he has left Mark's court, Tristan builds a statue grotto representing Isolde and the

characters from all his past exploits, in figures described as more lifelike to Tristan than they appeared in life. The statue grotto also expresses the rupture between ideals and reality, since it is removed from lived reality and represents realistically that which is absent from reality. Moreover, like the courtly love lyric, the statues, offering Tristan a pretext for isolated meditation, serve to make him more self-conscious. But beyond this, the statue grotto "episode" is not really an episode like the other adventures which continue the legend, expanding it beyond itself in an open-ended, infinite way. Instead it repeats and reflects the past episodes, internalizing them to the text, and idealizing them in a purifying mirror of the romance. This self-reflection makes the text identical to itself and also closes it in upon itself.

While Tristan's unity of self develops through appropriating the other to the same within the structure of a unified totalizing narrative, his meditations in the statue grotto are sporadic; he remains very much in the world of adventure. In addition to neglecting the difference between the development of Tristan and that of Isolde, Bloch, in interpreting the passion of Tristan and Isolde as tending to "isolate the couple from the rest of society and thus to discourage their participation in and responsibility to the community as a whole" (p. 216), has also been inaccurate. Tristan's passion only prevents him from fulfilling his responsibility to his maternal uncle, and isolates him from the matrilineal kinship system. After the Morois Forest and sermon episodes, he again becomes the "hardy warrior" (Eilhart, p. 461) and the honorable, loyal feudal knight, but under the vassalage of Kaherdin's family.

The person who does become isolated and who must completely change her way of life is Isolde. It is she whose life becomes totally identified with love because there is nothing else for her. Her only escape from her enslavement is through romantic love. But love succeeds as an escape only if it cures the mind/body split and allows the ideal to be practiced in reality. For Tristan and Isolde, who must remain physically separated, the ideal can be practiced only in death.

But contrary to de Rougemont's analysis, their inevitable death is not caused by the romantic myth *in and of itself.* The

necessity of fulfillment in death is more precisely located in the paradoxical *relation* between the ideal represented by the myth and the society that produces it. In and of itself, the romantic myth represents the ideal of love not as an unattainable absolute, but as the opposite of the mind/body split. Courtly love and the romantic love of Tristan and Isolde before Tristan goes into exile represent a higher form of love than that practiced before, a total love which for the first time in society combines in its ideal form emotional, mental, and sexual faculties in the relation between a man and a woman. The twelfth-century lyric poet Le Châtelain de Coucy expresses most eloquently this ideal as represented by the legend of Tristan.

> C'onques Tristanz, qui but le beverage,
> Pluz loiaument n'ama sanz repentir:
> Quar g'i met tout, cuer et cors et desir,
> Force et pooir, ne sai se faiz folage;
>
> [Even Tristan who drank the potion
> Never loved so loyally without repenting;
> For I commit my all: heart and body, desire,
> Strength and will; I know not if this be madness;][39]

But this ideal of a total love becomes unattainable by the very way it is produced. It emerges in a society based on fragmentation, structured, as we have seen, to fragment the old clanic order, to isolate women and separate them from their sexuality, and to separate the spiritual from material and social life.

Romantic love then serves a double purpose in such a society. It represents the quest for freedom from a society that fragments human relations and isolates people, alienates the masculine individual and subjugates women; but at the same time romantic love perpetuates alienated individualism and feminine oppression. This second and destructive facet of romantic love plays the dominant role as long as the rigid sexual roles and gender divisions, initiated in the twelfth century, and

39. La Chanson III du Châtelain de Coucy, quoted in Paul Zumthor, *Essai de poétique médiévale* (Paris: Seuil, 1972), p. 194. Translation is mine.

finally entrenched in the nineteenth, remain in force, along with a social order which promotes the rupture between mind and body, the dominance of one group over another, and an ideology which cancels out difference and the autonomy of the other.

The transformation of an ideology recognizing contradiction and otherness to a monologic ideology in *Tristan and Isolde* can be summarized if we remember that there are two Isoldes not only at the end but also at the beginning. The first pair of Isoldes, by their close mother-daughter relationship, ensures the strength of an autonomous feminine vision cohabiting with a masculine vision and the mutuality of matter and spirit. The second pair of Isoldes, each making the other only half a woman, symbolizes the separation of matter from spirit and the collapsing of the feminine into an adjunct of the masculine. In this society which tolerates neither contradiction not autonomous feminine activity, romantic love becomes the place of refuge for both.

How Lovers Lie Together: Infidelity and Fictive Discourse in the *Roman de Tristan*

E. Jane Burns

In the medieval legal system of immanent justice, guilt or innocence is established solely on the basis of what is seen. Whether in trial by combat, where guilt is ascribed to the slain party, or trial by ordeal, where exoneration is granted when the accused can place his hand in the fire without being burned, la *vérité*—which is called *li voirs*—is deduced from visible evidence.[1] This kind of feudal jurisprudence is based on the belief that God makes his Truth visible through a trial designed to establish a clear distinction between the opposing parties.[2]

Reprinted with permission from *Tristania*, 8.2 (Spring 1983), 15–30.

1. I do not mean to suggest here an etymological relation between *li voirs* which derives from Latin *veritas*, and *veoir* (to see) which comes from *videre*. The purpose of this essay is rather to discuss the emphasis which Béroul's text places on both the act of seeing and the process of establishing the truth, and to demonstrate how this relation is subverted.

2. See for example "On Doom Concerning Hot Iron and Water," *Aethelstanes Domas*, IV, c. 7: "Afterwards let it [the iron] be placed on a frame, and let no one speak except to pray diligently to God, the Father Omnipotent, to deign to manifest His truth in the matter"; and Hincmar of Reims' "Description of the Cold Water Ordeal," in *De Divortio Lotharii*, c. 6, *P.L.*, 125, 668–69: "And in the ordeal of cold water whoever, after the invocation of God, who is the Truth, seeks to hide the truth by a lie, cannot be submerged in the waters above which the voice

The first step in the process is the swearing of oaths: after the accuser alleges criminal activity through an officially formulated statement, the defendant swears his innocence by rejecting the accusation word for word. Proof of these verbal assertions is then established through single combat or ordeal, the purpose of which is to make God's will manifest. The case is thus reduced to a simple either/or proposition: if the accused is innocent of the charges levelled against him, he will win the fight or withdraw his hand unburned. If he is guilty, he will be *shown tangibly* to be a perjurer.[3]

This is the legal system at work in many French courtly romances, but it is particularly well attested in the earliest version of the Tristan story: *Le Roman de Tristan* by Béroul.[4] Accused of adultery, both lovers in the tale present their defense in line with the conviction that Truth resides in the visible. Tristan offers to perform an *escondit* (in this case trial by combat) through which those who contest his declaration of innocence will be proved wrong by their death. Iseut's *deraisne*, or exculpatory oath, is accompanied by no such physical ordeal in Béroul's version.[5] It serves nevertheless to establish a visual truth, and is described characteristically as being *seen* as well as heard. At the conclusion of the trial, King Arthur, as presiding judge, declares that since the Truth has been *seen*, it can no longer be contested:

of the Lord God has thundered," cited by Henry Charles Lea, *The Ordeal* (1866; rpt. Philadelphia: University of Pennsylvania Press, 1973), pp. 190, 192.

3. On the medieval judicial system see R. Howard Bloch, "From Grail Quest to Inquest: The Death of King Arthur and the Birth of France," *Modern Language Review*, 69 (1974), 40–55; A. Esmein, *Cours élémentaire du droit français* (Paris: Sirey, 1930), and *A History of Continental Criminal Procedure* (Boston: Little Brown, 1913); Otto Gierke, *Political Theories of the Middle Ages* (Cambridge: The University Press, 1900); Fritz Kern, *Kingship and Law in the Middle Ages* (Oxford: B. Blackwell, 1956).

4. See Pierre Jonin, *Les Personnages féminins dans les romans français de Tristan au 12e siècle* (Aix-en-Provence: Gap, 1958).

5. Thomas' version includes the ordeal by hot iron.

"Rois, la deraisne avon *veüe*
Et bien oïe et entendue.
Or esgardent li troi felon,
Donoalent et Guenelon,
Et Goudoïne li mauvés,
Qu'il ne parolent soi jamés." vv. 4235–40[6]

Within the legal system that Béroul's text reflects, judicial truth depends, at least in part, on relationships of conformity: the conformity of human will with divine will, and of positive law with divine law,[7] both of which are anchored in the unassailable union of word and deed. In judicial duel and trial by ordeal, a verdict of innocence results from the triple parity between the historic incident (past and now invisible), the verbally-articulated oath, and the physical trial which demonstrates God's judgement. Guilt, on the other hand, is characterized by disjunctive relationships. Error is understood as the wandering away from the Truth, witnessed in particular in the medieval association of *erratum* and *peccatum*.[8] Legal guilt, viewed as a kind of deviance from the straight path, is established when the verbal and the visual fail to coincide, when a disparity exists between what is seen in the trial proceedings and what is stated in the oath. The usual punishment for perjury under medieval law is consonant with the notion of severance: the hand of the guilty party is cut off.[9]

In the case of Tristan and Iseut, the crime itself is a particularly apt illustration of disjunction, since adultery constitutes an overt splitting of the marriage bonds that join two partners in a sanctified union. Under the system of medieval jurisprudence, trial could be foregone legally in only a few instances: a known outlaw who returned to the community from

6. Line references throughout are to *Le Roman de Tristan*, ed. Ernest Muret (Paris: Champion, 1962).

7. See Paul Rousset, "La Croyance en la justice immanente à l'époque féodale," *Le Moyen Age*, 54 (1948), 225–48.

8. Ernout et Meillet, *Dictionnaire étymologique de la langue latine* (Paris: Librairie Klincksieck, 1959), p. 201.

9. Henry Charles Lea, *Superstition and Force* (Philadelphia: Henry C. Lea, 1878), pp. 149–50.

which he had been banished could be killed on sight, and adulterers caught in *flagrante delicto* could be punished immediately by death. The offended husband had only to catch the lovers "seul a seul en lieu prive."[10] To *see* them alone together defied the visual truth (unity) of the marriage contract, and justified killing them forthwith. The visual proof of their union established their guilt automatically, eliminating the need for a trial which would only re-establish *li voirs*.

In Béroul's text, however, the system of immanent justice does not hold. Substantial legal evidence which is brought to bear as proof of the lovers' guilt (their secret meeting under the pine tree vv. 1–256, the blood on the bed attesting a hasty midnight rendezvous vv. 725–80, their entrapment in the forest by King Marc vv. 1995–2000), is ultimately overturned by Iseut's exculpatory oath, a statement which is finely crafted to tell the truth, but with the intent to deceive. Through an elaborately planned ruse in which Tristan, disguised as a leper, carries Iseut across a ford in the river and delivers her to the site of the trial, the queen is able truthfully to dispel the charge of adultery. She states that no man has ever been between her thighs except this leper and her husband:

> "Qu'entre mes cuises n'entra home,
> Fors le ladre qui fist soi some,
> Qui me porta outre les guez,
> Et li rois Marc mes esposez." vv. 4205–08

This shrewd twisting of words stands in direct conflict to the straightforward parallel between word and deed assumed to be the basis of feudal jurisprudence. Tristan's disguise itself defies the equivalence of *vérité* and *voir*. He is living proof that appearances deceive just as language (which re-presents) also distorts. For this reason a convincing case can be made that Béroul's interest in the *Tristan* is not to establish the moral guilt or innocence of the lovers, but to demonstrate how they aptly manipulate the medieval legal system to their advantage,

10. Philippe de Beaumanoir, *Les Coutumes de Beauvaisis*, ed. A. Salmon, 2 vols. (Paris, 1889), I, 943: 473.

exposing thereby its weakness.[11] It is true that in Béroul's text little consideration is given to the theme of sin while many lengthy passages are devoted to the lovers' justification of their behavior, and that questions of law are meticulously observed while questions of conscience are accorded less importance.[12]

What is of further significance, however, is that the lovers' defense, like the socially deviant act of adultery, rests entirely on linguistically deviant forms of discourse. Sexual misconduct, the crime of which they are accused, is exonerated by a kind of linguistic perversity, a statement not untrue, but designed to subvert the legality of God's Truth. Language, like appearance, is thus shown to exist in arbitrary relation to reality. Although they are guilty in deed, the lovers are deemed innocent by the offended husband, the bystanders and witnesses in the text, God, and the narrator of the tale, simply because they assert their innocence repeatedly and with conviction (Tristan: vv. 128, 253–54, 2228–30, 2573–77, 2853–66; Iseut: 23–24, 35–36, 4197–4216). Throughout the 4500 lines of Béroul's unfinished romance, the veracity of visible proof is repeatedly challenged and finally nullified by the power of deceptive language.

Drawing on the legal conventions of *escondire, deraisne, deraisnier, soi alegier,* and *esligier* (all meaning to exculpate oneself), Béroul puts these judicial formulas to the service of a larger, and ultimately literary purpose. The formula "dire son lai" (to make one's law) routinely used in the literature of the period to refer to the trial by oath,[13] is here recast in a novelistic frame where it serves more accurately the function of *lai* meaning a "récit d'une aventure amoureuse." The question posed by Béroul's text is not so much moral or legal as it is literary. The issue is no longer one of judgement, but one of interpretation. On one level, at least, the problem at hand is not

11. R. Howard Bloch, *Medieval French Literature and Law* (Berkeley: University of California Press, 1977), pp. 238–43.

12. Alberto Varvaro, *Béroul's Romance of Tristan*, trans. John C. Barnes (Manchester University Press, 1963), pp. 73–127.

13. See *La Folie d'Oxford*, vv. 833–34, "Del serement e de la lai / Ke feistes en al curt le rai," and Ernest C. York, "Iseut's Trial in Béroul and *La Folie Tristan d'Oxford*," *Medievalia et Humanistica*, 6 (1975), 157–161.

whether Tristan and Iseut are guilty of a sinful amorous liaison, for their carnal rapport is well-attested and even encouraged. Rather, the narrative appears specifically to be concerned with the generation of faulty, or more accurately, fictive discourse.[14] One could conclude in fact that the project of Béroul's text is not to establish whether Tristan and Iseut lie together as lovers, but to demonstrate how well these lovers lie together as tellers of a fictional tale.[15]

Sexual deviance is systematically linked to linguistic distortion throughout Béroul's *Tristan*, and both of these phenomena are consistently posited as the counterpart to legal marriage and legal truth. As Marc seeks in vain to establish justice in the feudal sense, through accurate (visible) documentation of the lovers' relationship, and subsequent restoration of his sexual union with Iseut, his efforts are characterized by the harmonious linking of *accordement* (v. 2225) and *amendement* (v. 3187). The text, on the other hand, shows us a *vérité* based on the crooked path of bifurcation, a truth which is constantly vanishing behind elaborate layers of ambiguity and deception. What is interesting, is that within this world of delusion, both the adulterous lovers and the cuckolded husband are presented as equally deviant actors. The lovers, it is well known, have been deceived (*decoivre*, v. 2220) by the fateful potion which has led them away from the straight path of social convention. Marc, however, is characterized by the same combination of deception and deviance. Iseut alleges quite early in the text that Marc has been tricked (*deceü*, v. 134) by the subversive language of the barons' supposed lies. Tristan puts it differently: that the barons have made Marc believe something "qui n'est voire" (v. 84), something which is not true because, until this moment at least, it has remained *unseen*. Although

14. This shift from the concrete proof of *li voirs* to the abstraction of fictive discourse is consonant with the historical shift from the feudal system based on direct ties of allegiance between men, to a later form of government grounded in the abstract notion of the fictive state. See Bloch, "From Grail Quest to Inquest."

15. On loving and lying see Christopher Ricks, "Lies," *Critical Inquiry*, 2, No. 1 (August 1975), 121–42.

Iseut's allegation seems at first preposterous, since we know that the barons are telling Marc the "truth," it is accurate on two counts: Marc has been swayed linguistically by the barons' suggestion of Iseut's infidelity, and he admits, thereby, the possibility of a kind of sexual deviance on his own part: the horror of cuckoldry. While the lovers and offended husband are pushed to their respective positions by different means, the result is the same. When Tristan repents in the forest, he remarks that Iseut, "Por moi a prise male *voie*" (v. 2184). Marc, led astray by the *traison dite* of the felonious barons, is said, similarly, to have followed by the wrong path (*desveier*, v. 89).[16]

Marc's response to the dilemma is, in the beginning, to effect a return to the straight road, to catch the lovers in the act and show them to be either guilty or innocent, realigning the legal trinity of truth, act, and word. The root of the problem is, however, the potion, whose association with *folie* (as it makes the lovers fall madly in love) contains the seeds of the text's metaphors of deviance. In legal parlance of the thirteenth century *folie* was defined as an "écart de conduite,"[17] derivative of the Latin *follis* which meant literally a hot air balloon; by analogy it suggested the action of inconstance, of wandering back and forth.[18] As victims of *fol'amor* (vv. 2297, 3042) Tristan and Iseut are made to wander through the forest in both senses of the Latin term *errare*: 1) aller à l'aventure, 2) s'écarter de la vérité dans le sens moral (v. 2217).[19] Madness is, moreover, associated throughout the text with deception, and with the effects of deviant speech. Marc calls himself *fous* after

16. See also vv. 4144–45 where Arthur says to Marc, "Tu es legier a metre en voie, / Ne dois croire parole fause."

17. *Grand Larousse de la langue française* (Paris: Larousse, 1973), I, 2000.

18. Albert Dauzat, *Nouveau Dictionnaire étymologique* (Paris: Larousse, 1938), p. 355. On the medieval *fou* see Philippe Ménard, "Les fous dans la société médiévale," *Romania*, 98 (1977), 433–59.

19. Ernout et Meillet, p. 201. Iseut tells Tristan that they have fallen into *grant error* (v. 2217), a deviance which the hermit later terms *folie* (v. 2297). Marc errs repeatedly in a similar sense: "Li rois n'a pas coriage entier, / Senpres est ci et senpres la" (vv. 3432–33).

any response from the opposition. While Iseut's strength is rhetorical, Tristan's is literal: the combined effort is therefore doubly powerful. In both cases, Iseut's elaborate oath and Tristan's false declarations, we are faced with language which does not identically match the deed it describes, but curves away from past actions in willful and deceptive contours. The hand severed as the usual punishment for perjury in trial by combat, is here replaced by language severed from its referent. Against this deviant discourse of signifiers which assure the lovers' innocence, the barons' more strictly referential language is shown to be powerless.

The essential difference between the barons' calumny and the lovers' lies is that the barons seek repeatedly to substantiate their assertions by visible proof in order to arrive at *li voirs*. The lovers prefer to weave verbal coverings that distract from what otherwise might be seen. Marc is caught as a kind of straightman between the text's rival speechmakers, supporting now one, now the other as "truthful." Unable to discern shades of grey, his judgements are always in black and white:

> "Que li nains m'a trop deceü.
> . . .
> De mon nevo me fist entendre
> Mençonge, porquoi ferai pendre." vv. 266, 269–70

> En son cuer dit or croit sa feme
> Et mescroit les barons du reigne. vv. 287–88

Marc's dilemma is that he "reads" (interprets) language univocally, remaining insensitive to the play of ambiguity and polysemy that would enable him to perceive the partial truth and partial lie of each account. When following the barons' advice, he opts for the visible over the verbal, telling Tristan for example that his *escondit* will be worthless against the hard and fast evidence of the blood on the floor (vv. 778–80).

Yet as the text progresses, it becomes increasingly clear that the visible is incapable of establishing the Truth, and that those who pursue it are victimized by the very system they seek to impose. The barons, as champions of the legal system of immanent justice, are silenced at the end by death (vv. 4040–53, 4381–86, 4466–83). Marc, in both scenes of entrapment, tries to

catch the lovers in a verbal snare, but becomes entangled himself in a visual one. Hoping to overhear their conversation from his hiding place in the pine tree (v. 477), Marc is foiled because Iseut *sees* his reflection in the stream. The plan to catch the lovers *a parlement* (v. 662) in the bedroom chamber is dashed when Tristan *sees* the trace of Marc's concealed plot: the flour sprinkled on the floor to record the adulterer's footprints. It is rather the lovers who are shown to be masters of both sight and speech in a literal sense, for they perceive the king's deceit while he remains oblivious to theirs.[24] Although they are in fact caught in the act under the pine, they ably talk their way out of the dilemma, through an astute performance of feigned innocence and complaints of mistreatment. In the second incident, Tristan avoids the flour trap, but is incriminated by the blood which has dripped from his wound onto the sheets of Iseut's bed. This proof of adultery is summarily nullified, however, through his subsequent false *escondit*. Caught in a whirlwind of guileful talk from both barons and lovers, Marc is described later in the text as the victim of the *losengiers'* game (vv. 3486–3494). He could be likened further to the blindfolded player in a game of pin-the-tail-on-the-donkey. Because he cannot see clearly, the king is unable to walk the straight path towards unequivocal Truth to hit the mark squarely. Ironically, the king who relies so heavily on visible evidence is *blind* to the truth in the figurative as well as the literal sense.

What Béroul shows us, both through the success of the verbally shrewd lovers and the failure of the barons to match valid accusations of guilt with proof of illegal acts, is a universe in which truth cannot be discerned; a world based on linguistic deceit, on the necessary dissociation of act from intent and the willful bifurcation of word and deed. A shift has thus taken place from *seeing* to *telling*: from the unity of demonstrable legal truth to the plurality of fictive discourse. This shift is based on a distinction which holds in both French and English: the difference between witnessing *the* Truth and the more relative

24. On the disparity between the lovers' double vision and Marc's limited sight, see Norris J. Lacy, "Irony and Distance in Béroul's *Tristan*," *French Review*, 45, Special Issue No. 3 (1971), 21–29.

process of telling *a* lie, or many lies, which themselves could be truthful. This is the textual (fictional) reality which Marc fails to perceive.

Yet the king, as we have said, plays both sides of the game. When he comes to the defense of the lovers and pleads a case for their innocence, he does not seek tangible evidence of *li voirs,* but becomes involved in creating a truth based on verbal virtuosity. In the scene under the pine, for example, after having witnessed the lovers alone in the trysting place and listened to their embroidered tale of innocence, Marc has taken his cue from what he has heard, not what he has seen. In interpreting the lovers' secret meeting, he simply continues to weave the tale that was begun by Tristan and Iseut, insisting that their relationship is platonic, not passionate:

> "Or puis je bien enfin savoir.
> Se feüst voir, ceste asenblee
> Ne feüst pas issi finee.
> S'il amasent de fol'amor,
> Ci avoient asez leisor,
> Bien les veïse entrebaisier.
> Ges ai oï si gramoier,
> Or sai je bien n'en ont corage.
> . . .
> Au parlement ai tant apris
> Jamais jor n'en serai pensis." vv. 298–305, 313–14

The forest scene provides a more developed version of the same process. In this case the lovers, again caught in *flagrante delicto* and legally punishable by immediate death, are unable to speak in their defense because they are asleep. Their helplessness does not result in legal incrimination, however, because Marc steps in and plays their part. Through an exchange of ring and sword (vv. 2029–51), he substitutes his tokens for theirs, making his hidden and silent presence known indirectly to the lovers. Here he voluntarily provides visible evidence of his effort to trap the couple, signs of his intrusion which were revealed, in the scene under the pine, only accidentally through his reflection in the water. Marc also provides in this instance the entire exculpatory fiction, explaining that Tristan and Iseut's amorous

embrace should not be taken as a sign of *fol'amor* because they are clothed and separated by a sword:

> "Ci sont el bois, bien a lonc tens.
> Bien puis croire, se je ai sens,
> Se il s'amasent folement,
> Ja n'i eüsent vestement,
> Entrë eus deux n'eüst espee,
> Autrement fust cest'asenblee." vv. 2005–2010

This rationalization of adulterous behavior constitutes a complete reversal of the king's original intent in approaching the forest hideaway: to catch the lovers in the act and kill them forthwith (vv. 1986, 2011). Whereas Marc has the legal right to condemn Tristan and Iseut without trial or *escondit*, he chooses instead to override the visual proof of guilt with a fictionalized account of innocence. This action resembles that of defendant rather than judge. In his justification of the lovers' secret liaison, Marc offers a kind of *deraisne* that is very similar to Iseut's exculpatory oath. In both cases, meticulous attention to factual detail is used to weave a half-truth. In both cases, verbal deceit is paired with sexual deviance, as we have seen before. Iseut's fictionalized tale of innocence is designed to ensure the continuance of her adultery. Marc's contribution to the lovers' tale helps to establish him firmly as a cuckolded husband.[25]

Béroul's romance reaches its narrative climax in a scene of consummate and accomplished lying that occurs most appropriately at a site called the Mal Pas. Here the sexual misstep and linguistic untruth that form the cornerstones of this love story are unequivocally merged. Heretofore held apart in a delicate and uncertain balance, the competing poles of the narrative—the legal discourse of Truth based on what is seen, and the fictional discourse of love based on a hidden liaison—are now collapsed. As a result, the supposed identity between word and deed and the infallible union of partners in marriage are

25. For an explanation of how Béroul's text subverts not only religious and social institutions, but also the literary tradition of *fin'amours*, see J.-C. Payen, "Lancelot contre Tristan: La Conjuration d'un mythe subversif (Réflexions sur l'idéologie romanesque au Moyen Age)," *Mélanges Le Gentil* (Paris: SEDES, 1973), pp. 617–32.

problematized by their overt association with verbal deceit and
sexual misconduct.

Iseut's celebrated oath at the Mal Pas is preceded by an
elaborate scenario of "lies" delivered by Tristan who wears a
leper's disguise (v. 3812). Summoned to the site of the trial by
Iseut herself, who plans to use Tristan's concealed presence as
part of her sly defense, the leper engages in cunning dialogue
with passersby, cloaking his words as he has his body (v. 3661).
His verbal exchanges with Marc, King Arthur, and other
witnesses are characterized significantly by a ritualistic litany of
covering and uncovering. While waiting for Iseut to arrive,
Tristan gives faulty directives to those who approach the
treacherous ford, ensuring that they will slip or fall and become
completely covered with mud (v. 3710). Their reaction is most
often to remove articles of clothing (vv. 3863–64) in accordance
with Tristan's instructions: "Ostez ces manteaus de vos cox, / Si
bracoiez parmié le tai" (vv. 3816–17). King Arthur gives Tristan
his gaiters (v. 3730), and Marc offers his hood (vv. 3749–50).

As each character uncovers himself, by divesting himself
of soiled or superfluous garments, he contributes indirectly to
Tristan's cover: his disguise as an impoverished and helpless
leper. While the others expose their naked truth and
vulnerability, Tristan shelters himself in a protective cloak of
borrowed appearances analogous to the language he borrowed
previously: language that did not really fit the truth. This is a
moment symbolic of the radical ambiguity of appearance and
language, for Tristan, in this scene, is both a leper *and* a
nobleman *and* neither. The disrobed kings and knights share a
similarly ambiguous status, for like Tristan they represent a form
of social deviance: a nobleman smeared in mud and a leper
dressed in aristocratic garb are equally inappropriate personages
at King Arthur's court. Under the strict rules of feudal
jurisprudence, they both would be dismissed as actors whose
visible and essential realities do not match. Of further
importance is the fact that as witnesses at Iseut's trial, these
mud-soaked noblemen are expected to uncover the Truth, to see
clearly. But they succeed only in the reverse, casting off garments
which contribute to Tristan's disguise and to his lie. This scene
marks the final stage in the systematic devaluation of signs that

characterizes Béroul's text and provides the clearest example of the hero's deviant role: through contact with Tristan, any attempt to uncover (to reveal the Truth) becomes necessarily an act of covering up.[26]

The necessary association between lovers and lying in Béroul's *Tristan* is crystallized in the image of the leper, a figure used throughout the text as a metaphor for sexual and linguistic deviance. The first leper mentioned in Béroul's tale is Ywein, the man who offers to take Iseut into his community of outcasts as punishment for her crime, detailing at length how this punishment will include sexual congress with the leprous men (vv. 1195–97, 1204–06). The text here reflects the medieval belief that leprosy was transmitted sexually, and especially through illicit sexual intercourse.[27] Ywein, as the first example of a leprous victim, represents the most traditional and straightforward view of the disease in which lepers are considered to be social deviants who have erred or been led astray by the Devil, and who are duly punished by God (Brody, pp. 59, 96, 127ff.). In legal terms they are official outlaws, outsiders whose mutilated bodies alert others to their status as criminals. Medieval medical texts, ecclesiastical documents, and records of folk belief all characterize lepers specifically by their appearance, citing their physical difformity as a mark of moral decay, and emphasizing the necessity of standardized dress to ensure immediate recognition of them.[28]

26. For an explanation of how cloth and clothing (*les dras*) serve first to incriminate the lovers by revealing the truth of their secret affair, and then to exonerate them by providing misleading, unclear, subtly deceitful evidence, see François Rigolot, "Valeur figurative du vêtement dans le *Tristan* de Béroul," *Cahiers de civilisation médiévale*, X (1967), 447–53.

27. Saul Nathanial Brody, *The Diseases of the Soul: Leprosy in Medieval Literature* (Ithaca and London: Cornell University Press, 1971), pp. 35, 51–56, 106, 143–44; P. Jonin, pp. 109–38; Paul Rémy, "La Lèpre, thème littéraire au moyen âge," *Le Moyen Age*, LII, 43, No. 2 (1946), 195–242.

28. Peter Richards, *The Medieval Leper and His Northern Heirs* (Cambridge, England: D.S. Brewer, Rowan & Littlefield, 1977), p. 124.

This conception of lepers conforms exactly to the medieval system of immanent justice in which guilt cannot be hidden from view; crime is made visible when God's Truth is seen. Ywein's suggestion to house Iseut with the lepers constitutes an attempt to mete out a punishment that fits the crime. Her wandering away from social norms into adultery (in the double sense of *errare*: to wander and to err) would be matched by the leper's exclusion from civilized life and the ultimate reunion of her real and apparent character. Her sexual deviance, furthermore, would be acted out visibly in the sexual liaisons she would be forced to form with social outcasts. This would be the most just punishment in the medieval scheme of things since it conforms to the feudal notion of truth based on the visible.

The two other lepers in Béroul's romance are Tristan and, curiously, Marc. Just prior to the trial of the Mal Pas, Tristan disguised as a leper accuses Marc of having the same disease (v. 3771). Tristan explains that he contracted leprosy while lying with his *cortoise amie* (Yseut) whose husband was a leper (vv. 3762, 3772–73). The rapport between Marc and leprosy is suggested further in Iseut's oath when she posits an equivalence between *le ladre* and *mes esposez* as the only men who have come between her thighs (vv. 4206–08). Marc and Tristan are here equated as lovers of the queen and as lepers in · some metaphorical sense which is not immediately apparent.

Tristan and Marc certainly do not suffer the physical symptoms of leprosy that characterize Ywein. In their case, the role of the leper has been radically redefined to reflect a second meaning: that of verbal trickery. From Biblical times, the leper's ill-deserved reputation as a wild fornicator is coupled with an attribution of evil speech: he is thought to be a schemer, a deceiver, a calumniator, and a perjurer (Brody, pp. 51–115). The "leprosy" of Tristan and Marc exists on a figurative level only and depends on the necessary split between what is seen and what is hidden. Tristan as a leper is playing a role, much as he plays the innocent lover in the performance beneath the pine tree earlier in the text. Marc, similarly, is a leper in name only. When Tristan calls Iseut's husband "leprous" (*meseaus*, v. 3771) it is a reference to him as the queen's sexual partner who transmits the disease through her to Tristan. But what exactly is this disease?

Is it sexual deviance or the linguistic perversity that seems always to accompany it in Béroul's text? Leprosy, it appears, has come to mean sexual misconduct *and* deceitful speech. Both Marc and Tristan are engaged in socially aberrant behavior that remains hidden from view. The harmless leper is really Marc's devious, adulterous nephew, and Marc, who appears to be an upstanding husband, is actually a certified cuckold. Both men are disguised, and both participate, as we have seen, in weaving the illusory tale of the lover's innocence.

This transformation of the leper in Béroul's text from the paragon of legal Truth to the master of deceit simply reinforces the paradigm governing the romance as a whole: the incompatibility of legal truth and fictive discourse. What is seen in the treatment of the leper mirrors exactly the process at work in the numerous scenes of *escondit* and *deraisne*. The one-to-one relationship between a criminal act and God's punishment of it, the very foundation of both legal and religious institutions in the Middle Ages, is called into question. The problematization of religious Truth is made particularly clear when the hermit, who on other occasions speaks for God and counsels the lovers to confess their sins and repent (vv. 2295–99, 2344–49), suddenly instructs them to lie and thereby cover their tracks: "Por honte oster et mal covrir / Doit on un poi par bel mentir" (vv. 2353–54). Marc acts in accordance with this same principle whenever he speaks in defense of the lovers and conceals thereby their adultery. It is appropriate in this respect that Marc be called a leper because he, like Tristan, is a sexual deviate and a linguistic fabricator. Both stand outside the law according to which word and deed must coincide.

Indeed, through its entangled web of carefully-crafted misstatements, Béroul's *Tristan* substantiates, in the end, the validity of the truthful lie. Iseut's talk proves more persuasive than that of the barons because they merely tell the truth. She invents an intricate and complex fiction that is embroidered and tailored by Tristan's false declarations, the leper's "lies," and Marc's lengthy rationalizations. At the close of Béroul's romance, adultery triumphs, and with it deceitful speech. But these phenomena are not advanced as crimes or untruths. Rather, we

find a radical redefinition of the social contract in which sexual and linguistic deviance surface as the new norm.

As one of the earliest examples of vernacular literature in France, Béroul's *Tristan* systematically undermines the legal and religious notions of immanent truth that it depicts. It questions, at the same time, the power of referential language on which these institutions depend. Whereas the witnesses at Iseut's trial are prevented, by their stalwart single-mindedness, from seeing the duplicitous truth of the lovers, we, as readers of the text, are given the privileged sight that they lack. What we see is the following: that once Divine Justice is denied as a fact of the social code, language becomes ambiguous as it appropriates the power to deceive. We are reminded here of St. Thomas who is careful to delineate two uses of metaphor; he explains how tropes in theological discourse are effective in clarifying God's Truth, while tropes in poetic discourse tend to hide and deform (*tropare*) the true meaning. Fictive discourse, according to St. Thomas, seduces the reader and runs the risk of leading him astray (*errare*) into the domain of lies.[29] This latter proposition is precisely that which Béroul's text exploits.

At the forefront of a long tradition of romance literature which is developed later in such texts as the *Roman de la Rose* and *Aucassin et Nicolette*, Béroul's *Tristan* attests that the linguistic "misstep" (*mal pas*) with its allied sexual connotations, is a sure step for the lovers in medieval romance. The *Roman de la Rose* by Guillaume de Lorris opens with a long defense of dreams which is actually a plea that the reader not equate *songe* with *mensonge* or fabrication with lies. We are asked instead to accept the dream text, the fictional love story as true. In *Aucassin et Nicolette* the lovers' liaison is tolerated and allowed to flourish only in a topsy-turvy "otherworld" where social values are reversed, where the categories of truth and falsehood cannot be differentiated.

What we find in Béroul's text is a thorough fusion of *vérité* and *mensonge* into a fiction that is both seductive and subversive. Once Tristan and Iseut lie together in adultery, they are forced to

29. See Eugene Vance, "Désir, rhétorique et texte," *Poétique*, 42 (April 1980), 137–56.

lie together linguistically as well. But the verb "to lie" no longer carries the derogatory connotations of breaking with the truth, or lying down as opposed to remaining upright and righteous. Rather, "to lie" in Béroul's *Tristan* signifies above all the act of *lying with* someone. The lovers' adulterous coupling here inaugurates a new kind of unity in which the love bed replaces single combat or trial by ordeal as the truth-testing situation; in which the criterion for judgment is not what is seen, but what is said. In this version of the Tristan legend, the lie of love becomes the truth of fiction, a truth apart, not dependent on God's immanence, but firmly rooted in the sexual and textual detours that are the very substance of medieval romance.

The Representation of the Lovers' Death: Thomas' *Tristan* as Open Text

Matilda Tomaryn Bruckner

Thomas' version of the Tristan legend offers its audience a picture of Tristan and Iseut's love that invades the boundaries of our emotional lives. It sets in motion channels of positive and negative fascination whose polarities appear already in the medieval reception of Thomas' work, eagerly translated into different languages and forms, while its own identity as text was reduced to the fragments we now label for the most part by their geographically dispersed locations. These same polarities reappear in the tradition of modern scholarship, which alternately classifies Thomas as the poet who transforms fatal love into a sublime religion of love or the moralist who warns us against the bankruptcy of a love linked to death. Whether perceived across the variety of scholarly opinions surveyed or, in some few cases, grasped by individual readers of Thomas' version,[1] such critical ambivalence is, I think, the necessary result of Thomas' choices as author of his own "true" version: he

Reprinted with permission from *Tristania*, 9 (Autumn 1983–Spring 1984), 49–61.

1. See, for example, Pierre Le Gentil, "Sur l'épilogue du *Tristan* de Thomas," *Mélanges Jeanne Lods* (Paris: Collection de l'Ecole Normale Supérieure de Jeunes Filles, no. 10, 1978), vol. I, pp. 365–70, and Larry M. Sklute, "The Ambiguity of Ethical Norms in Courtly Romance," *Genre*, 11 (1978), 315–32.

generates such ambivalence in part through the invention of a
narrator whose point of view remains essentially unresolved, in
part through his choice, amplification, and blocking of material
from the diverse possibilities of the Tristan matter.

Without the luxury of time and space that full analysis of
such complicated problems would require, I have decided to
focus here on Thomas' representation of the lovers' death. Much
of the disagreement about his version centers on differing
interpretations of the ending: is it a success or a failure,
endorsement of a union that transcends the boundaries of death
or condemnation of a love that kills without redemption? Both
kinds of interpretation operate on the same underlying
assumption: if Thomas accents the harmony of union, he is "for"
the lovers; if, on the contrary, he insists on their failure to achieve
true union, he is "against" them. If for the moment we accept
that assumption, we need to follow through by testing it against
the romance's own criteria for judging union and disunion. Such
guidelines are drawn up explicitly by the discourse of narrator
and characters and implicitly by the characters' actions. All
commentators would doubtless agree that in Thomas' version,
Tristan and Iseut are especially characterized by their obsessive
desire to duplicate the experience of the other in the couple.[2] The
key to understanding this desire for doubling may be grasped in
the interchange between Tristan and his strange double, Tristan
le Nain. When the second Tristan explains his problem (Estult
l'Orgueilleux has carried off his *bele amie*), Tristan at once agrees
to help win the lady back, but proposes first a return to his
castle, in order to prepare for an early morning departure.
Tristan le Nain angrily concludes that he is not talking with
"Tristran le Amerus" who, having experienced the pain of love

2. The basic pattern of doubling operates at every level and in
every facet of Thomas' romance, as previous studies have abundantly
shown. See, for example, Susan Dannenbaum, "Doubling and *Fine Amor*
in Thomas' *Tristan*," *Tristania*, 5 (1979), 3–14; Joan Ferrante, "Artist
Figures in the Tristan Stories," *Tristania*, 4 (1979), 25–35; John Grigsby,
"L'Empire des signes chez Béroul et Thomas: 'Le sigle est tut neir,'"
Mélanges Foulon/Marche Romane, 30 (1979), 118–22; Ann Trindade, "The
Enemies of Tristan," *Medium Aevum*, 43 (1974), 6–21.

and thus knowing the other Tristan's suffering, would act without delay on his behalf:

> "... Par fei, amis
> N'*estes* cil que tant a pris!
> Jo *sai* que, si Tristran *fuissét,*
> La dolur qu'ai *sentissét,*
> Car Tristran si ad amé tant
> Qu'il *set* ben quel mal unt amant ...
> Qui que vus *seiét,* baus amis,
> Unques ne amastes, ço m'est avis.
> Se *seüsez* que fud amisté,
> De ma dolur eussez pité:
> Que unc ne *sot* que fud amur
> Ne put *saver* que est dolur,
> E vus, amis que ren amez,
> Ma dolur *sentir* ne poez;
> Se ma dolur pussét *sentir,*
> Dunc vuldriez od mei venir."[3]

Three ideas, three verbs, are repeatedly interwoven in Tristan le Nain's long outburst: if you *know* love, then you can *feel* another's pain, then you must *be Tristan the Lover.* All of these motifs are moved into the negative by the second Tristan's disappointment in the face of delay; his persuasive oratory, however, provokes an affirmation of his experience and identity from "Tristran le Amerus":

> "Par grant reisun mustré l'avez
> Que jo dei aler ove vus,
> Quant jo sui Tristran le Amerus
> E jo volenters i irrai." (Douce, vv. 1012–15)

3. Thomas, *Les Fragments du Roman de Tristan. Poème du XIIe siècle,* ed. Bartina H. Wind (Genève: Droz, 1960), D, vv. 977–82, 987–96. All subsequent references to Thomas' romance will be taken from this edition and will be identified in the text by manuscript fragment and verse number(s). In general, I shall limit my analysis of Thomas' narrative techniques to what can be learned from the extant fragments alone, since the reconstructions of his text based on the German and Norse translations cannot reveal the nuances of his style or the exact nature of his interventions, even if they may serve as some indication of the narrative events included in his version.

Experience, knowledge, and identity are thus intertwined and reveal the underlying premise of Tristan's and Iseut's efforts to double each other: shared experience furnishes knowledge of self and other that leads to oneness, the identity of the couple as a unit. By blocking the connection between self and other, lack of the same experience leads conversely to "twoness"—ambiguity, multiplicity, and uncertainty.

In the description of the couple's experience, three verbs recur like leitmotifs to explore and reiterate the nature of this connection: *assaier*, *partir*, and *dubler*. Each verb is, in fact, a set of double meanings. Given the couple's desire to fuse their two identities into a single, undifferentiated one, every time one of the lovers perceives a gap between self and other—be it across time, space, or sexual identity—he or she tries to try out (*assaier*) the other's experience of joy or suffering. As Tristan reasons during his debate on whether or not to marry the second Iseut, how can he eliminate the difference between himself and the Queen if not by trying out, imitating, her own situation?[4] *Assaier*: the connection between experience and knowledge is embedded in the verb itself, at whose center is, not coincidentally, an expression of knowledge, *sai*. In Old French the verb *partir* also expresses the lovers' desire for shared experience. Tristan wants to marry the second Iseut not because he hates the first,

> "Mais pur ço que jo voil *partir*,
> U li amer cum ele fait mei
> Pur *saveir* com aime lu rei." (Sn[1], vv. 180–2)

Likewise, Iseut decides to wear a hairshirt in order to recreate in her own body the suffering Tristan has described to her (D, vv. 741, 746–52). But *partir* also has another meaning in Old French, the one retained in part by modern usage: *partir* is to divide or separate—that is, precisely, what the lovers can never really do

4. Sn[1], vv. 157–62, 172, 187, 209, 211. Cf. Sn[1], vv. 285, 289; T[1], v. 141; D, v. 500. *Esprover* (Sn[1], v. 163; T[1], v. 147) and *proveir* (Sn[1], v. 595) function as synonyms for the same idea. Cf. Tristan le Nain's use of *saver*, *sentir*, and *estre* quoted above.

and yet must repeatedly do.[5] The same verb *partir* expresses both the centripetal and centrifugal forces of their love, which bind them together as strongly as they drive them apart.

Even more troubling—and dangerous—is the double meaning of *dubler*. At its best, doubling fuses the two members of the couple, eliminates the difference of now and then, here and there, him and her, and thus acts as a source of joy and comfort for Tristan and Iseut. When, however, doubling escapes the bounds of the couple—as it inevitably does, through Tristan's *errances*—it becomes a source of new pain, further separation and renewed efforts to eliminate differences. Tristan's "duble Isolt" (Sn[1], v. 472) unleashes double pain and doubles the number of sufferers:

> . . . la raine *duble* entent . . .
> *Duble* paigne, *doble* dolur
> Ha dan Tristran por s'amor. (T[1], vv. 94, 109–10)[6]

Iseut as Blanches Mains remains other; the gap opened between Tristan and the Queen must be filled again—hence the statues of Brengain and Iseut which allow Tristan to remember and retell their past (T[1], vv. 1–4). Tristan's projects of doubling exacerbate rather than satisfy the desire for unity: the verb *dubler* catches not only the sought-for duplication (reducing two to one), but also the doubling of sorrow and the multiplication of victims from two to four that leads ultimately to Iseut as Blanches Mains' duplicity and the *duble tref*.

Now that we have the criteria for judging successful union—based on the connection between experience, knowledge, and identity—and have been apprised of the dangers that accompany such efforts to double the other, we are ready to ask which of these possibilities, what kind of doubling, appears in the final scene? And in order to answer that question, we need to see the death scene through the separate, converging points of view offered by Tristan, Iseut, and the narrator.

5. See C, vv. 40–50, Sn[1], vv. 54, 55, 168, 453, 802; D, vv. 1120, 1238, 1240, 1245. Cf. also *departir* (Sn[1], v. 409) and *departie* (C, v. 29, Sn[1], v. 82).

6. See also Sn[1], vv. 215, 216, 300 (cf. 335–42), 350; T[1], v. 123; D, v. 79, 1037, 1290.

Gender is the essential, irreducible difference in the couple that, in a sense, originates and fuels the lovers' drive toward unity. This is especially clear in the way each of the lovers approaches the moment of death. Tristan's last vision of their love is a double one, focused at once on Iseut's absence—which he mistakenly believes to be a voluntary refusal to come heal him—and the tie of *pité* and *dolur* (D, vv. 1765–8) that he believes will nevertheless link them beyond his own death. When Tristan pronounces Iseut's name three times (his own personal Trinity) and then dies on the fourth, he makes the Queen present at least verbally, an acoustical image of the couple's unity. Tristan's last words and his death freeze him in a moment of understanding and misunderstanding: his *errance* here and earlier attributes a lack of fidelity to Iseut which bears no relation to the truth of her actions and emotions, yet expresses the ambiguity of Tristan's own wandering thoughts, as they draw him toward and away from Iseut.

Of course, Iseut, like Tristan, does at times waver in her belief about the absolute unity and unanimity of the couple—and insofar as she does, we see that the narrator's comments on human *errance* as a general principle are indeed generally true. But there is an essential difference between Tristan and Iseut in this respect, which Thomas' text represents without acknowledging in an explicit way through the usual narrative interventions: Iseut's momentary wavering never wanders outside the bounds of the couple—and that despite the opportunities presented by a character like Cariadoc, whose very unsuitability may be a reflection of how unlikely Iseut's infidelity to Tristan really is. While Thomas' commentary blames women more than men for their inconstancy, his story consistently reveals greater constancy in Iseut than in Tristan.

"Cum veraie amie" (Sn2, v. 807), Iseut always ends up reinforcing her tie to Tristan and the oneness of the couple. This is especially striking in the death scene, when she discovers Tristan's body. Her lament first describes the scene she would have shared with Tristan had she arrived in time to cure him, how she would have recalled ("recordé," Sn2, v. 798) all the joy and pain of their love (vv. 790–9). But, since she has come too late, "ensemble poissum dunc murrir" (v. 801): she will take

comfort from the same *beivre* as Tristan (v. 805). She thus carries out her vision of their death as imagined earlier in her monologue during the storm at sea. Her lament finished, she places her body next to Tristan's in a way that recalls his careful placement of statues in the cave. Like Tristan, she returns to the episode of the garden for a model to duplicate; she chooses, however, not the moment of parting, but rather the earlier moment of unity, when their two bodies lay side by side. In the Cambridge fragment we only catch the end of a description in the garden: "Entre ses bras Yseut la reïne" (v. 1). But we can see Iseut doubling that moment in the final scene, as she arranges their bodies in the quintessential position of lovers, body to body, mouth to mouth (Sn2, vv. 809–15). Within the story it is Iseut who has the last vision of their love, one of complete fidelity and unity.

But the narrator's summary quickly reminds us of the duality in their experience of death:

> Tristrans murut pur sue amur,
> Ysolt, qu'a tens n'i pout venir.
> Tristrans murut pur sue amur,
> E la bele Ysolt par tendrur. (Sn2, vv. 816–19)

These four verses catch the essence of doubling in Thomas' text, not only as stylistic pattern, but as organizing principle in the lovers' lives and in their story: the exact repetition of the verse describing Tristan's death reminds us of the lovers' desire to fuse two into one, to eliminate all distinction, all difference within the couple; the variations of the two verses describing Iseut's death, alternating, interwoven with Tristan's own, both say the same thing, but with different words, suggest a distinction, a difference that is as fundamental to the couple as their desire for unity. The lovers die together, but consecutively; they die for love, but not exactly for the same reasons. Their unity in death is marked visually by the final description of the two bodies, tightly embraced, but necessarily two, male and female.

The difference of gender—the essential difference the lovers obviously had to maintain in their love however strong their desire to experience and be exactly what the other is and experiences—remains an important aspect in the duality that characterizes their representations of death. Can we attribute

Iseut's more positive view of that death—and therefore of the couple's life—at least in part to her identity as woman, life-giver, healer?[7] Her vision is more simple, that is to say undivided, than Tristan's double vision, which repeatedly fails to unite them because of the interference of his own uncertainties, jealousies, and desires, while those very desires still compel him to seek the goal of unity across and in spite of the obstacles of diversity and multiplicity. Doubling functions both as attachment and detachment, fusion and separation within the couple, each member supplying more or less of the positive and negative charges that keep the current alive between them. Both lovers die for the sake of the other, but without correct understanding of the other's death. Their desire to share everything, to be doubles of each other falls necessarily short of identity, though they may come as close to doubling each other as any two human beings, male and female, can.

In the ordering of the last scene we are presented first with Tristan's view of the couple and death, then with Iseut's: a mixture of positive and negative views, followed by a fully positive one. With the lovers' own final visions, we have an example for practically any judgment of their success or failure— any judgment that is, except a totally negative one, since the opposition presented is not a clear distinction between negative and positive views, but rather an asymmetrical opposition in three overlapping parts: negative + positive vs. positive. What about the narrator's role here? He has shown himself on the whole to be particularly in tune with the kind of *errance* that characterizes Tristan's feelings and less "conscious"—at least in his commentary—of the singleness of mind more characteristic of Iseut. On the other hand, it is interesting to see a verbal link in the closing· commentary between Iseut's own description of

7. Cf.·Joan Ferrante, "Artist Figures", pp. 27–8, and Françoise Barteau, *Les Romans de Tristan et Yseut: Introduction à une lecture plurielle* (Paris: Larousse, 1972), p. 222. Iseut as life-giver is completely focused on Tristan: their love never bears fruit in the production of children (that might be too confusing with Mark as a rival parent); her power to give life is used rather to restore Tristan's, i.e., ultimately, to keep the couple alive.

herself as "true friend" and the narrator's insistence on the truth of his version: "[E dit ai] tute la verur,/ [Si cum] jo pramis al primur" (Sn², vv. 828–9). What is the truth of Thomas' version? Is it to be located in the mixed pessimism of Tristan's view or in the optimism of Iseut's?

In order to answer such questions, even partially, we need to take a closer look at Thomas' narrator, his self-representation and his relation to the story narrated. The kind of sympathetic interjection or exclamation that Béroul's narrator typically uses to mark a new episode or emphasize a dramatic moment in his narrative can also be found in Thomas' romance. But, if we can judge by the extant fragments and thus generalize about his narratorial habits, such exclamations appear infrequently—in fact, only twice in the three thousand or so verses that remain (C, v. 6 and D, vv. 1583–4). Much more characteristic of Thomas' narrator are the long commentaries in which he analyzes and elaborates his characters' situations. He frequently seems to enjoy the status of omniscient narrator, able to report actions, words, and inner feelings—a narrator with special interest and penetration in the area of human psychology (as commentators of Thomas have long remarked). The vocabulary of his commentaries reveals, moreover, a continuity between his own discourse and that of his characters: a shared linguistic experience especially connects his analytic discussions to Tristan's own interior monologues, as they both explore the same sets of oppositions—*desir/poeir, desir/voleir, amur/haür, colvertise/franchise*.[8] They play the same verbal game of numbers in which two opposed terms present the challenge of finding a third that will resolve or replace the opposition: 2's flirting with

8. Both Jean Frappier, "Sur le mot 'raison' dans le *Tristan* de Thomas d'Angleterre," *Linguistic and Literary Studies in Honor of Helmut A. Hatzfeld*, ed. A.S. Crisafulli (Washington, D.C.: The Catholic University of America Press, 1964), pp. 174–5, n. 46, and Omer Jodogne, "Comment Thomas a compris l'amour de Tristan et d'Iseut," *Les Lettres Romanes*, 19 (1965), 104–5, discuss Thomas' use of *desir, poeir*, and *voleir*. While I wholeheartedly agree with their insistence on the changes of meaning attributed to these terms, it does not seem to me to be a lack of precision on Thomas' part, so much as a sign of his penetration into the world of his character's own ambiguity and ambivalence.

l's—or is it 3's?—but invariably remaining 2. This pattern of
debate that shows Tristan as *homo duplex*[9] is mirrored by the
narrator's own pleasurable entrapment in stylistic doubling. The
narrator's knowledge suggests then a kind of participation in his
characters' lives that recalls the fusion sought by Tristan and
Iseut within the unit of the couple.

We may notice, however, as the narrator picks up and
repeats his characters' own vocabulary, in order to explore and
then magnify their particular experience into generalities about
human nature, that the process of generalization itself
occasionally leads his commentary off the mark. For example,
when the narrator moves from a specific analysis of Tristan's
motivations in wanting to marry Iseut as Blanches Mains (Sn[2],
vv. 233–91), his description evokes a mentality that we can easily
recognize: "the grass is always greener on the other side" (Sn[2],
vv. 255–60). But does this really apply to Tristan's case? Is he
really giving up "what he can have" to get something else, which
only his fancy presents to him as something better? While this
may be true on the spiritual level of Tristan's love for the Queen,
it is not true on the physical level, since he does not presently
"have" the Queen—and physical possession is precisely what
most bothers him at this point in the narrative. Furthermore,
again the narrator singles out women as especially prone to this
sort of behavior (Sn[2], vv. 287–90), while throughout the story it is
Tristan alone, and never Iseut (not even Iseut as Blanches
Mains), who exhibits a desire for *novelerie*. In fact, the narrator
himself seems to recognize the lack of pertinence when he states:
"Ne sai, certes, que je en die" (Sn[1], v. 291)—and subsequent
remarks return to general and specific comments that do
correspond to Tristan's situation.

The last set of generalities in the series is supported by the
narrator's own direct observations: "A molz ai veü avenir" (Sn[1],
v. 345). This guarantee of veracity comes from the realm of
experience and reminds us of another important aspect of the
narrator's self-representation vis-à-vis the story he narrates: he is

9. Ruthmarie H. Mitsch, "The Monologues of Tristan in the
Tristan of Thomas," *Tristania*, 2 (1977), 31.

not a lover, has not experienced for himself what his characters suffer.[10]

> Hici ne sai que dire puisse,
> Quel de aus quatre a greignor angoisse,
> Ne la raison dire ne sai,
> Por ce que esprové ne l'ai. (Turin[1], vv. 144–7)

The narrator thus excuses himself from judging which of his main characters suffers most—Tristan, Iseut, Mark, or the second Iseut. Lack of experience cuts him off from both sets of triangles that link these four together in a web of love and suffering.

Our first impression of omniscience obviously must be corrected: Thomas as narrator is quite willing to step aside from what his characters know and experience.[11] Indeed, since he seems to accept the same premise as they do regarding the link between shared experience and knowledge, we are led by his own explicit commentary to question the limits of his reliability. How well he knows, understands, and represents his characters varies with the character involved. His "omniscience" dips considerably, as he moves from Tristan to Iseut as Blanches Mains, as his level of "sympathetic" participation rises and falls. But even when he seems most fused with a character, as he is with Tristan, we have been warned not to confuse the narrator's experience and that of the lovers. Alternately, and sometimes simultaneously, attached to and detached from his story and characters, Thomas is a narrator above all bent on delineating his role as that of the teller of a tale, while the best judges of the tale told are the lovers who read or hear his version.

> La parole mettrai avant,
> Le jugement facent amant,
> Al quel estoit mieuz de l'amor
> Ou sanz lui ait greignor dolur. (T[1] vv. 148–51)

10. Thomas' stance here is in direct contrast to his German translator's: Gottfried von Strassburg identifies himself as a lover who addresses a select public of lovers. See his Prologue, for example, or his comments on the "Cave of lovers."

11. Cf. "Monologues", pp. 35 and 39, n. 13.

While dissociating himself from the characters, the narrator simultaneously associates his public with them: lovers know and can therefore judge what the narrator does not know and can only present. Once again, such statements imply that only direct, lived experience gives us knowledge of others—at least in the domain of love.[12]

And such instruction returns us once again to the end of Thomas' romance to follow through on our evaluation of his narrative stance in the concluding verses. As we begin to read the epilogue, we are immediately struck by an abrupt shift from the end of the lovers' story—narrated with dramatic concision, its high points marked by the direct discourse of the characters themselves—to the narrator's final commentary, where we are removed from the world of fiction and placed in its surrounding context, that of the storyteller and his literary public. After the four verses I quoted above linking and differentiating Tristan and Iseut in death, Thomas begins his epilogue by naming himself and greeting his public. Before commenting on what the epilogue contains, I would like to emphasize what is left out by this narrative shift. After the lovers die, there is nothing, no survivors, no miraculous plants growing out of the lovers' tombs. In Thomas our final vision of the lovers remains fixed on two bodies, side by side, closely embraced; no transcendence moves them beyond that final, static vision. Tristan's earlier message to Iseut, as elaborated to Kaherdin, prepares us for the final blocking of the death scene. The first part of Tristan's message lyrically embroiders his *salut d'amor*, plays on the different meanings of *salut*, as his salutation gradually leads into the question of health and salvation (D, vv. 1195–1208). This is not a religious *salut*, but one consistently tied to the saving powers of Iseut and love. The two alternatives envisaged by Tristan are death without Iseut, *salut* (life and health) with her. As Le Gentil has pointed out, the lovers call upon God only to

12. Cf. Jodogne, "Comment Thomas," on Thomas' use of *amor*: that term never appears in the fragments to represent a personified god of love, but only refers to the passion of human participants (p. 112).

make sure that they remain together in death.[13] Tristan as martyr of love may play Saint Alexis underneath the staircase, but he does not project a view of joyous union in Paradise—at least insofar as Thomas' narrative reports it.

In contrast to the enormous drive for doubling that characterizes all aspects of Tristan and Iseut's story until this final moment, their death is represented as an absolute end to all further doubling. While it doubles back to the earlier scene in the garden, it refuses to include the double beyond death offered by the legend of the miraculous plants, new perennial doubles for the lovers. From this point of absolute stasis—which is, in fact, the infinite mirroring of the doubles already constructed reflecting each other back and forth, but only within the confines of Thomas' version—we in the public are ejected by the closing comments into another order of discourse, where the narrator's commentary opens the doors so dramatically closed by the plot.

Two lyric enumerations mark the epilogue's opening and close: the first (D, vv. 822–4) evokes Thomas' public, the second their sorrows (D, vv. 837–9).

> Tumas fine ci sun escrit:
> A tuz amanz saluz i dit,
> As pensis e as amerus,
> As emvius, as desirus,
> As enveisiez e as purvers,
> [A tuz cels] ki orunt ces vers.
> [S]i dit n'ai a tuz lor voleir,
> [Le] milz ai dit a mun poeir,
> [E dit ai] tute la verur,
> [Si cum] jo pramis al primur.
> E diz e vers i ai retrait:
> Pur essample issi ai fait
> Pur l'estorie embelir,
> Que as amanz deive plaisir,
> E que par lieus poissent troveir
> Choses u se puissent recorder:
> Aveir em poissent grant confort,

13. "L'Epilogue," p. 367. See especially Tristan's last salutation (D, v. 1760) and Iseut's monologue (D, vv. 1627, 1636, 1664, 1675, 1692).

Encuntre change, encuntre tort,
Encuntre paine, encuntre dolur,
Encuntre tuiz engins d'amur! (Sn[2], vv. 820–39)

Like Tristan to Iseut, the narrator sends his *salut* to all lovers,
lovers of all types, good and bad, as E. Baumgartner and R.C.
Wagner persuasively argue.[14] In between these two enumera-
tions, the storyteller describes his own role with relation to the
story told and the possible reactions of his public. His
vocabulary here recalls not only his earlier commentaries, but
also key words in Tristan's own discourse: the *saluz*, the
opposition between *voleir* and *poeir*, the important verb *recorder*,
and of course the words that express love's pain (*paine*, *dolur*,
engins). What is striking in this closing commentary is the
combination of voices presented by the pronoun *je*. One is the
lyric voice of the poet/lover we recognize from troubadour and
trouvère poetry: that lyric *je* claims personal experience at the
base of his exploration of love's conventions; it is a *je* fused with
the poetic expression of love. Thomas' narrator is fully capable of
speaking with such a voice, as he has abundantly shown through
the language of Tristan's monologues. The narrator can thus
dub/double the voice of the lover, but it is not his own; he has a
distinct voice as storyteller, the detached voice of the romancer
who mediates between story and public.

In the closing commentary we notice again the narrator's
capacity for fusion and separation in regard to his matter—just
as the final image of the lovers captures the essence of their
union and disunion. As narrator, Thomas makes no comment on
the lovers' story *per se*, but rather on his treatment of it and its
usefulness for the public. The story is exemplary for the public of
lovers. A model for emulation or warning? We are not told,
though we might speculate that the same story would function
differently for the different types of lovers enumerated. We are
told the story has been embellished to please lovers and to offer
them the comforts of remembering their own love suffering as
mirrored in that of Tristan and Iseut. The doubling now ended

14. "'As enveisiez e as purvers': commentaire sur les vers 3125–
3129 du *Roman de Tristan* de Thomas," *Romania*, 88 (1967), 527–39.

within the story is projected out beyond the world of fiction to link characters and audience. It is a lyric voice that has the last word here, expressive of an identification with the bitter experience of love. The last series of nouns, arranged in a pattern of anaphora and doubling synonyms culminating in the single, all-inclusive "tuiz engins d'amur" (Sn2, v. 839), highlight the negative effects and powers of love (as does Thomas' version in general). Does this suggest a negative comment on the matter that Thomas has not made explicit? But whose personal experience and knowledge is furnishing the sense of identification with the lovers expressed here? The narrator has explicitly denied such involvement and refers us to our own experience as lovers. The audience's sentimental energies are surely engaged by the story's example and by this last incantatory enumeration, but our powers of judgment may be as varied as our capacity for different types of love. Indeed, we might attribute the ambiguity of Thomas' narrative stance, neither definitely opponent nor apologist, to his desire to attract such a varied public.

More profoundly, we need to accept Thomas' own claims to ignorance: his lack of experience in matters of love removes his capacity for judgment. He can neither endorse nor condemn, but—to the best of his limited ability—only tell. If we return once again to the judgment offered by the lovers themselves, we have an example of no single judgment, but rather a continually oscillating one, a judgment always renewed out of the asymmetrical tension that opposes Tristan's double vision of wandering and fidelity to Iseut's single vision of union in love. Thomas has not given us a key to eliminate any of the possible points of view represented within his romance. He has instead left us spellbound, caught between the two voices of lyric identification and critical distance that echo in our ears, as our eyes remain fixed on the final image, two bodies intertwined in death.

The Glass Palace in the *Folie d'Oxford*: From Metaphorical to Literal Madness, or the Dream of the Desert Island at the Moment of Exile—Notes on the Erotic Dimension of the Tristans*

Jean-Charles Payen

This is a reading of the *Folie d'Oxford* as the nostalgic projection of a dream of light. Tristan's ravings when he evokes the glass palace suspended between earth and sky (vv. 299–308)[1] convey his aspiration for another existence where Yseut and he might love each other in complete freedom, in absolute transparency, far from society and its repression. What the *Folie d'Oxford* expresses, among other things, is the impasse reached by a

Originally published as "Le Palais de verre dans la *Folie d'Oxford*: De la folie métaphorique à la folie vécue, ou: le rêve de l'île désert au moment de l'exil: notes sur l'érotique des *Tristan*," *Tristania*, 5.2 (Spring 1980), 17–27. Reprinted with permission.

*Translated by Joan Grimbert.

1. References are to my own edition-translation of the French verse *Tristans*, Paris, Garnier, 1974, but the standard academic editions of these texts are E. Muret's edition of Béroul, 4th ed. revised by L.M. Defourques, CFMA, Paris, Champion, 1970; Bartina H. Wind's edition of Thomas, Geneva, Droz, 1960; and E. Hoepffner's edition of the *Folie de Berne* and the *Folie d'Oxford*, Strasbourg, Publ. de la Fac. de Lettres, 1949 and 1943.

passion that is madness in its very essence and that can only be fully realized as an insane fantasy. Here poetry becomes pure escape—and compensation. The work suggests, in its own way, the failure of a fascinating but impossible eroticism: it reflects not social reality, but rather the frustrations of a period when the romantic notion of a love experienced in a secret place remained an inaccessible and dangerous ideal, admissible only if conceived of as a chimera. The author of the *Folie d'Oxford* follows the tradition of Béroul, who describes the lovers' happiness in the Morois forest only to exorcise more effectively its perverse attractions. The happiness of a couple was possible in the twelfth century only if it was inscribed in a relational context and conformed to a set of constraints. Such is the lesson of numerous works, like the romances of Chrétien de Troyes and the lays of Marie de France, to which I will be referring in my analysis of Tantris's delirious monologue. Besides reflecting on an important text, I would like to explore not only the Tristanian eros, but also the literary status and meaning of madness in a poem whose exasperating mysteries continue to provoke commentary. What does the image of the glass palace in the *Folie d'Oxford* signify? And, more generally, what is its function in the myth's development? These are the main questions I shall attempt to answer.

Tristan, separated from Yseut, goes mad. His sickness brings him to the brink of death. His frenzy is suicidal: what for the troubadours, and then for the trouvères, is simply a figure of style (that the absence of the beloved drains life of all meaning and causes the lover to aspire to death) becomes in the more tangible universe of romance an objective description that presents, with regard to reality, a behavior that is both abnormal and tragic. Tristan, unable to go on, takes the first boat he sees, and, to gain access at last to his beloved, he chooses the most adequate disguise: he exchanges his clothes for those of a fisherman; in so doing, he ceases to belong to the order of knights, and in changing his status he becomes more difficult to identify. But to be even more certain that he will not be recognized, and especially in order to use his changed status to gain entry into King Marc's court, he must push his metamorphosis even farther. He becomes a madman, i.e., a

buffoon. This madness transforms the frenzy of his heart and mind;[2] the fool's discourse furnishes a pretext: while entertaining Marc and his courtiers, Tristan will be able to draw near to Yseut and reaffirm his love for her in ambiguous terms.

I shall pass over the matter of Tristan's disguise, with its mysterious cruciform tonsure[3] and his deliberately illogical behavior (attacked on the right, he strikes back on the left, etc.).[4] This bestial monster, whom the porter calls the son of Urgan le Velu (a giant actually vanquished by Tristan not long before), assumes with ease his clownish role, claiming he has just been to the marriage celebration of an abbot of Mont-Saint-Michel and a fat abbess where feasting clerics and monks caroused joyously. Marc asks the identify of the intruder, setting off a fantastic spiel that is easily deciphered: the fool was born of a whale on the high sea (and Tristan was in fact born during a dramatic crossing); he was taken in by a tigress who raised him (meaning that his cruel childhood/infancy both taught him combat and made him ferocious). He has a sister, whom he proposes to give to the king in exchange for Yseut: a fool's bargain, a queen for nothing, since he has no sister; but Marc does not possess Yseut, for she does not love him: if he is master of anything, it is of her body alone. But the fool's discourse has attained its true object: to recount the poetic history of a forbidden love. From that point on, Tantris will give voice, in veiled terms, to the ardor from which he is dying for having brooded over it alone, unable to confide in anyone.[5]

2. See the yet unpublished but forthcoming thesis by Stoian Atanassov, "Le problème de l'unité dans les romans français de Tristan et Iseut," Sofia, 1977, pp. 114 ff. of the manuscript, where the author uses Jakobson to develop a theory of metonymic and/or metaphorical madness in the *Folies.*

3. See Philippe Ménard, "Les fous dans la société médiévale," *Romania,* 98 (1977), 433–59.

4. Se nus l'asalt devers le destre,
 Il turne et fert devers senestre. (*F.O.,* vv. 255–56).

5. Vv. 227 ff. (the Abbot's marriage); 241 ff. (Urgan le Velu); 269 ff. (Tantris's fantastic infancy); 287 ff. (the proposed exchange of the women). Tristan's inability to communicate is underlined in vv. 25 ff. of

Marc replies jokingly: "Where will you take the queen if I entrust her to you?" And the fool, unperturbed, answers with these famous lines:

> ". . . La sus en l'air
> Ai une sale u je repair.
> De veire est faite, bele et grant;
> Li solail vait par mi raiant;
> En l'air est et par nuez pent,
> Ne berce, ne crolle pur vent.
> Delez la sale ad une chambre
> Faite de cristal et de lambre.
> Li solail, quant par main levrat,
> Leenz mult grant clarté rendrat." (vv. 299–308)

The text of the *Folie de Berne* is more succinct, but no less interesting:

> ". . . Entre les nues et lo ciel,
> De flors et de roses, sans giel,
> Iluec ferai une maison
> O moi et li nos deduison . . ." (vv. 166–69)

Tristan wishes, then, to take Yseut to a refuge (which in the *Folie de Berne* has yet to be built) suspended between the earth and the sky, where intemperate weather (*sans giel*) has no sway and flowers bloom all year long. It is a luminous and stable place: the wind does not disturb it, and it is always filled with sunshine. It is entirely transparent, for it is made of glass— indeed, crystal. It will be resplendent with light at the break of dawn: the passage here to the future tense signifies the buoyant hope of euphoric days to come. Or could this manor in the air symbolize the union of the lovers in death? On the contrary, this imagined existence promises the joyous burgeoning of a vital plenitude. It is a vision bathed in warmth and florescence. Tristan's dream is not the expression of somber consent to non-existence: it conjures up idyllic futures, far from the society of men, in an open, protected space, the romantic *topos* of the desert island where a couple can relish their dual solitude to the fullest.

the *Folie d'Oxford* (he does not dare tell any of his friends about his plan to join Iseut).

The notion of just such a flight from a hostile world was the delight of at least one troubadour: Bernard Marti, who used it to conclude a *canso* (perhaps inspired by Bréri)[6] in which he evokes the pleasure of physical union with his lady (a union which he says has since been granted) and expresses his desire to live with her in a hut in the woods. The poem opens with the typical evocation of spring and closes with the notion that one can love just as well in winter as in spring or summer:[7] Pierre Gallais, who heard the reading I gave of this text at a seminar in Poitiers, theorized—not at all implausibly—that Bernard Marti could have known through Bréri not only the Morois episode, but also a version of the legend close to the *Histoire Tristan*, a much later Welsh text in which King Arthur, chosen as judge by Marc and his nephew, assigns Yseut to her husband for the summer and to her lover for the winter.[8]

Béroul's *Tristan*, in turn, fashions the Morois exile as a morose quest for an ascetic and precarious paradise for two. The lovers lead a harsh and difficult life (*aspre vie et dure*): they have no bread, subsisting only on barely cooked game; their clothes are in tatters: this forced return to a wild existence deprives them of any "cultural" luxury, and they suffer[9] to such a degree that

6. It is he who actually introduced the court of Poitiers to the Tristan legend, according to Pierre Gallais, "Bléhéri, la cour de Poitiers et la diffusion des récits arthuriens sur le continent," in *Actes du VII^e congrès national de littérature comparée* (Poitiers, 1965), Paris, Didier, 1967, pp. 47–79.

7. I refer to IX (P.C., 63, 9) in E. Hoepffner's CFMA edition, Paris, Champion, 1929. Cf. vv. 36 ff.:

En bosc ermita m.vol faire
Per zo qe ma domna ab me.s n'an;
Lai de fueill aurem cobertor . . .

("I would become a hermit in the woods, if my lady would come with me, and there we would have a leafy hut.")

8. See R.L. Thompson's English translation of the text in Joyce Hill, *The Tristan Legend, Texts from Northern and Eastern Europe in Modern English Translation*, Leeds Medieval Studies, II, 1977.

9. Ed. Payen, vv. 1618 ff. (Muret, vv. 1644 ff.):

Mot sont el bois del pain destroit.

the "natural state" which is their lot becomes a trial endured only with great difficulty. They endure it solely because they have the inner strength with which their love endows them, but each fears that the other, weary of his/her fallen state, will finally give in and return to civilization, even if it means their separation.[10] And yet, their isolation is not total: their faithful friend Gouvernal is with them, and they have at their disposal to help them their dog Husdent and the horse that Tristan's squire-tutor gave him after his famous leap from the chapel. Furthermore, they can count on the complicity of the forester Orri, whose presence is evoked much later, since Béroul does not tell us everything at once, preferring to present various characters only as they are needed in the story.[11] Nevertheless, Tristan and Yseut experience in the woods only a relative happiness, and it is with some relief that they return to society when, after three years, the effects of the philter dissipate. I shall not analyze the passage in which they become conscious of their alienation, for I have already done so in previous studies.[12] But let me reiterate my conviction that in the twelfth century an

> De char vivent, el ne mengüent.
> Que püent il se color müent?
> Lor dras rompent: rains les decirent.

10. Ed. Payen, vv. 1623 ff. (Muret, vv. 1649 ff.):

> Chascuns d'eus soffre paine elgal,
> Car l'un por l'autre ne sent mal.
> Grant poor a Yseut la gente
> Tristran por lié ne se repente,
> Et a Tristran repoise fort
> Quë Yseut a por lui descort,
> Qu'el repente de la folie.

On the meaning of this passage, see Eugène Vinaver, "Pour le commentaire du v. 1650 du 'Tristan' de Béroul," in *Studies Alfred Ewert* (Oxford: Clarendon Press, 1961), p. 90.

11. See my article, "Irréalisme et crédibilité dans le 'Tristan' de Béroul," in *Mélanges Jeanne Wathelet-Willem*, Liège, Marche romane, 1978 (Cahiers de l'A.R.U.G.), pp. 465–75.

12. See my thesis, *Le Motif du repentir dans la littérature française médiévale des origines à 1230*, Geneva, Droz, 1967, pp. 345 ff.

individual could not achieve complete fulfillment away from his or her peers, for such fulfillment implied meeting one's social obligations. Even for a poet as free and as passionate as Béroul, the flight of the couple from society remained a chimeric ideal that could only end in an impasse.

Was it the same for Thomas? If Gottfried von Strassburg's poem is a reliable indication, Thomas had the audacity to show the lovers proudly leaving court, happy to be departing together, far from the company of the traitors and the king.[13] We know how Gottfried himself, after expressing his disapproval of this banishment, transformed the *Minnegrotte* into a sanctuary of love. But in the so-called "courtly" version (which I prefer to call "lyrical"),[14] the couple's solitary idyll lasts no longer than in the "common" version, and the scene where the lovers are discovered by the king (who finds them, as in Béroul's version, asleep, separated by a sword) leads to their return to court, to the greatest satisfaction of both. For the very ecstasy of their reciprocal love counts less, in the lovers' estimation, than the just awareness of their social status and their obligations. In the twelfth century, an individual did not willingly choose to live on the fringes of society, and even *Minne*'s most sumptuous paradise is only temporary.

A possible solution is offered by the *Prose Tristan*, where the primitive character of the Morois is attenuated: Tristan and Yseut take refuge in a luxurious manor house (the home of the "*Sage Demoiselle*") where, moreover, they do not even live in total isolation.[15] But this impressive shelter soon reveals itself to be

13. On this passage, see Joseph Bédier's edition of Thomas's *Tristan*, Paris, SATF, 2 vol., 1902–05, t. I, pp. 234–38, and Jean Frappier, "Structure et sens du 'Tristan,'" *Cahiers de civilisation médiévale*, 6 (1963): 255–81 and 441–54 (esp. 442). The bibliography on the *Minnegrotte* is too long to list here; I will refer only to the very recent study by Sylvia C. Harris, "The Cave of Love in the *Tristramssaga* and Related Tristan Romances," *Romania*, 97, pp. 306–30 and 460–500.

14. See the introduction to my edition, p. vii.

15. The passage is in vol. II of Renée Curtis's edition of the *Tristan en prose*, Leyden, Brill, 1976, pp. 150–51. In addition to Gouvernal and the dog, the lovers enjoy the company of a young lady named Lamide. And the couple does not live very far from society, since they are

tragically precarious: it is not entirely safe from the scheming tactics of Marc, who takes advantage of Tristan's momentary absence one day to repossess the Queen. Rather than fostering the insane dream of the desert island, the *Prose Tristan*, which aligns the Tristanian eros with that of the *Lancelot*,[16] proposes another sort of utopia: whereas in Cornwall the lovers are condemned to a guilty secrecy, in the kingdom of Logres they are allowed to love openly, thanks to the nearly unanimous complicity of Arthur's knights, who recognize that *fin'amors* has the merit of nourishing prowess and generosity. This is another literary myth that would have been inconceivable before Chrétien de Troyes. And, in any case, this recourse to a utopian solution bolsters an oft-expressed verity of the feudal age: that there is no salvation to be found outside of society, no matter how intense one's ardor.

Such is the lesson of many texts. The secret, protected place—a bed closed off by curtains, or a garden enclosed by high walls—permits only brief encounters which may have no tomorrows; whether it takes the form of the bedroom of the *malmariée* in *Yonec*, or the tower, and then the garden, where Cligès and Fénice take refuge, the idyll is fleeting at best, and society always manages to penetrate such enclosures. A voyeur turns up to pierce the veil of secrecy, or it may be the lover who gives herself away, because her new-found happiness has restored her beauty. The protected garden in *Guigemar* lasts only long enough to prepare the hero for great trials. And Lanval's flight to Avalon is not really a happy ending, for it demonstrates the protagonist's failure to survive in this world, where he has known only misfortune.

denounced not by a forester but rather by shepherds who have noted their presence. It is a *vavasseur* who proposes this refuge to Tristan and Yseut. See the analysis and commentary of this passage by Emmanuèle Baumgartner, Le *"Tristan en prose." Essai d'interprétation d'un roman médiéval*, Geneva, Droz, 1975, pp. 7 and 110.

16. As I have tried to demonstrate in my article, "Lancelot contre Tristan ou la conjuration d'un mythe subversif," in *Mélanges Pierre Le Gentil*, Paris, CDU et SEDES, 1973, pp. 617–32.

These remarks are deliberately cursory, for I am dealing here with established truths, but I could not avoid making them in order to situate the *Folies Tristan* in their proper context. What accounts for the originality of these poems (which I take literally, i.e., as a series of assertions conveying a double meaning) is that they transpose an impossible ideal to its true medium, a dream poetics, while preserving at the level of reality its full weight of nostalgia. I mean that Tristan, his heart rent by such a long absence, reveals in his ambiguous discourse the despair he feels at not being able to love Yseut except in secret, bereft of the mutual presence and accessibility without which no couple can live in true symbiosis; at the same time, he transposes his passion into a compensatory poetic fiction that takes an emotional, lyrical form: what their fate denies to the lovers, poetry makes accessible to them, and Tristan, mad with love, hopes to make Yseut capable of this escape towards an imaginary happiness, a dream that grants them what is unattainable in this world, except in brief, perilous encounters. Tristan's discourse is not to be read in terms of deep psychology: it is an opening towards a new solution, an escape into fantasy, to be sure, but to an individual bereft of hope, fantasy can become a reason to persevere even under the crushing weight of misfortune and tragedy.

In a previous article, Huguette Legros and I reexamined the Tristan legend from the perspective of an anthropology of the imaginary similar to the one so masterfully described by Gilbert Durand.[17] Tristan's passion for Yseut condemns him to night and to darkness. It distracts him from heroic action performed in broad daylight (and it is in the disguise of a knight with black armor that he triumphs at Mal Pas, after having taken the ignoble form of a leper the day before). I recall that Charles Méla argued, in a brilliant presentation given at a colloquium held at the University of Caen in June 1976, that the love presented in the *Tristan* romances is fundamentally (and objectively) sinful, and thus impure, despite the lovers'

17. "La femme et la nuit . . ." forthcoming in *Mélanges Pierre Jonin*, Aix-en-Provence, CUERMA. The study by Gilbert Durand to which I refer is, of course, *Structures anthropologiques de l'imaginaire*.

protestations of innocence: this latent culpability explains why Tristan is drawn, irresistibly, towards "ignoble" things (and he uses the disguise of a leper or a fool to approach his beloved). Given such a fate the only escape possible is death. Tristan's acute awareness of this impasse tortures him. The opening verses of the *Folies* underscore his hopeless state, a suffering so extreme that he is compelled to set out for Cornwall, lest he lose his mind and his life. This act alone signifies madness, for the trip involves incalculable risks (but Tristan does not weigh them: he decides to depart and does so). He becomes a madman almost spontaneously because he is already mad and knows it ("Quant ne la voi, a po ne deve"—v. 93, *Folie de Berne*). He arrives at Marc's court. In the *Folie d'Oxford* (and at a later point in the *Folie de Berne*), he reveals his pseudonym: Tantris, Tristan inverted, the exact opposite of what he is: the very name he used to designate the ragtag thing he had become when, on the brink of death, he had entrusted his fate to a boat with neither sail nor oars that took him to Ireland. More precisely, in the *Folie de Berne*, Tristan becomes Tantris as soon as he resolves to leave, and the poet confirms that he is already quite mad,[18] but when he arrives at court, he chooses another name which deprives him still more of his real identity and alludes to an even more ridiculous signifier, if "*Picous*" (v. 98) truly means a deformed, grotesque figure.[19] This human debris never had a mother or a father of the human race. The fool is a monster from nowhere (that is, from the sea), with no past that is not a fantasy, and whose sole ties are to a chimera: he lives between earth and sky, in a place made only of poetry, and it is there that he wishes to take Yseut in some delirious future, to another world that is really no more absurd than the one depicted in fairy tales. The

18. Et si vos di qu'il a pieça
 Tel poine soferte por li
 Et mout esté fol, je vos di.
 Change son non, fait soi clamer
 Tantris . . . (vv. 123–27)

19. As Jean Frappier has shown in his article, "Sur Pecol/ Quepol," in *Mélanges Hiram Peri (PFLAUM)*, Jerusalem, Magnes Press, 1963, pp. 206–10.

ostensibly deranged discourse of this fallen individual "functions" according to an internal logic that is not as incoherent as it seems. From his birth at sea to his glass palace, I am willing to admit that Tristan reveals a "Jonas complex" that traces a regression towards the maternal breast through a whole network of images (whose symbolism is that of a warm, reassuring, enclosed refuge); but before resorting to a psychoanalytical interpretation, as does Françoise Barteau,[20] we should examine in this important passage the linking of the various figures, and it becomes quickly apparent that the progression is hardly fortuitous.

The aerial manor is cut off from our world for all time; it is untouched by the events that mark human History. Up there, the lovers will no longer have to fear the traitors' schemes or Marc's fury, for his power does not extend beyond the clouds. Up there, they will be able to love in the light, no longer in the shadows; they will finally be able to watch themselves love each other, and, above all, their union will no longer be tainted by the guilty conscience that has always poisoned their relations. As fear is forever abolished, so also will be guilt, hence the transparency. To be sure, it is hard to imagine how the gaze of men could reach so far and close to heaven as to invade their solitude; but what is important is that Tristan and Yseut might manage, at least in their dreams, to live together in the light of day, prepared to be discovered by any witness, however improbable, in this their new-found innocence. To live together finally in the face—if not of everyone—then of God, at least, in an "elsewhere" with no potential for bad surprises. But especially to rid themselves forever of night's obsession. . . .

The glass palace in the Folie d'Oxford is an intense expression of this tension. But Tristan is too lucid not to know that the luminous home beyond the clouds is simply a projection of a desperate desire. What he celebrates in the insane ravings that he throws out to amuse and abuse an audience incapable of deciphering such enigmas is the very tragedy of his love and his fate, just as Yseut herself has experienced it; indeed, I discern in

20. In her book, Les romans de Tristan et Iseut. Introduction à une lecture plurielle, Paris: Larousse, 1972, pp. 193 ff.

his discourse an appeal to the one he has loved too well. But Yseut remains silent. She will only intervene a little later, when she feels more directly targeted (at the point where pseudo-Tantris confesses unambiguously that he is mad with love for her).[21] It is not that the philter has affected her to a lesser degree,[22] or that she suffers any less from their separation: what the *Folies* convey is that the queen cannot admit her beloved's degeneration (to such a point that she fails to recognize him in such a vile disguise). Paradoxically, it is only men who are driven mad by love's despair: Yvain goes mad, not Laudine; Lancelot, but not Guenièvre; Amadas, but not Ydoine, etc. Is the female less fragile or more balanced? She has in any case more will, as long as she remains the lady, the one in charge (and Yseut does not give up this status, as dependent as she may be with regard to her husband).

I have just brought up a new line of inquiry, but to pursue it would no doubt take me quite far, well exceeding the limits set for this modest study. I must restrict myself to my original project, which was to define the relation that exists in the *Tristan* romances between the hero's madness and an escape towards an imaginary place that is a compensation for the lovers' misfortune. In the course of this study, however, another relationship has become apparent, one linking death to love and alienation (in the psychological sense of the term): Tristan

21. "Reis, fet li fols, mult aim Ysolt:
 Pur lu mis quers se pleint e dolt.
 Jo sui Tantris, ki tant l'amai
 Et amerai tant cum vivrai."
 Ysolt l'entent, del quer suspire.
 Vers le fol ad curuz e ire;
 Dit: "Ki vus fist entrer ceenz?
 Fol, tu n'es pas Tantris: tu menz." (vv. 313–20)

Yseut's anger upon hearing the name Tantris indicates that she remembers this pseudonym and that she considers fraudulent the fool's use of a name to which Tristan alone has a right.

22. Cf. Renée Curtis, "Le Philtre mal partagé," in *Mélanges Jean Frappier*, Geneva, Droz, 1970, pp. 193–206; reprinted, in English, at the beginning of Curtis's *Tristan Studies*, Munich, Fink, 1969.

becomes mad because his sickness has brought him to the brink of death. In his quest not so much for a cure as for a slight relief, he realizes that it is not enough to grant himself the too fleeting comfort of a short night of pleasure; he needs as well, and as a more lasting solution, the illusion of living out a dream, along with (and why not?) its whole panoply of physical pleasures, but in another world, a *là-bas*—I was going to say a *lai* (the *lai* [= elsewhere] in which the troubadour hopes to meet his *dompna* when he cannot do so in the *çai*, the *"ici"* [= "here and now"] where he is situated), which has nothing to do with the *hic et nunc* where his ardor is forbidden and condemned in the name of social and religious constraints that he has no right to contest, as much as he may rage against them in his inner core. It is the dialectic of the id (*ça*) and the super-ego: but what a wonderful transformation of the *ça* is represented by the glass palace bathed in sunlight for all eternity.

One would prefer not to conclude. An island in the sun, near the empyrean: what poetic radiance! We should be sensitive to what seems at first to be lyrical nonsense, a delirium that is soon revealed, however, to be more coherent than we thought. A dual solitude, where absolute love can be fully experienced—it is perhaps in the Tristan legend that we see it treated for the first time in a nostalgic and lavish manner through the failure of the Morois experience, then in the nebulous delirium of the *Folie d'Oxford*. But this chimera contradicts too many social constraints and is too provocative, by ethical and religious standards, to be transcribed in terms other than those of a failure or of a fool's discourse. Once again, poetry is the ultimate recourse of fantasy. But the imaginary is tantamount to revelation: tell me what your dreams are and I will tell you who you are. This truism is applicable not just to Tristan, and I leave it to my audience to ponder its full significance.

Tristan the Artist in Gottfried's Poem

W.T.H. Jackson

Although the thinkers of the Middle Ages did not develop any theories about the function of the artist which can be compared with those of Plato or the Romantics, they had definite views on art and its relation to society. Art in its broadest sense had for them an ethical and social function which inevitably became part of the grand design of the universe. None of the great writers of romance is without consciousness of this function. In the creation of the Arthurian romance in particular they were fully aware of their responsibilities, but they interpreted them in differing ways. It seems to me that Gottfried von Strassburg realizes most fully the intellectual aspects of his responsibility and takes most note of the esthetic theories which justified the arts, and in particular music, as beneficial for Christian men and women and as leading towards that harmony of the spirit with the eternal which was regarded as the highest good.[1]

It should hardly surprise us that Gottfried should show this awareness. Of all the German courtly poets, he gives immeasurably the greatest evidence of formal learning—his knowledge of the classics, his skill in the formal style which some rather unwisely persist in calling rhetoric, his acquaintance

Reprinted with permission from *PMLA*, 77 (1962), 364–72.

1. Extensive use has been made in this article of the evidence provided by Edgar de Bruyne, *Études d'esthétique médiévale*, Rijksuniversiteit te Gent, werken uitgegeven door de faculteit van de wijsbegeerte en letteren, XCVII–XCIX, 3 vols. (Bruges, 1946).

with French literature, and his grasp of mystical theology and its terminology—all these stamp him as formally trained, as a *magister* or *dominus*. Whatever the compiler of the manuscripts of lyric poetry may have meant when he called Gottfried "meister," we shall be 'safer to interpret the word as "magister" than as merely a bourgeois of Strassburg. An earlier generation of critics saw in Gottfried's non-aristocratic status the reason for his failure to describe the ceremony of Tristan's knighting and for his disagreements with Wolfram von Eschenbach. Such views are unsound, as I hope to show. More recently Wolfgang Mohr has sought to interpret *Tristan und Isold* as a *Künstlerroman* but only in the limited sense that its hero behaved as a *Spielmann* and that his attitudes and activities were those of that class.[2] There is some truth in this, but I shall attempt to go further and to indicate that the quarrel with Wolfram was a fundamental disagreement on the nature and purpose of the courtly epic. The omission of the *swertleite* and the insertion of the passage of literary criticism in its stead thus become a rejection of the type of knight whom Wolfram and, even more, other writers made their hero and the substitution of one whose approach to life and above all to love was based on criteria quite different from theirs. Gottfried's contempt for his fellow-writer is well known. He describes him as "vindære wilder mære, der mære wildenære,"[3] a description whose form is as significant as its content, for in describing Wolfram as an inventor of wild tales and a poacher of stories Gottfried graphically portrays the confusion in the cross-fusion of his words. What Wolfram lacks is a sense of form, of disciplined structure, in a word, artistry. Wolfram's reply is revealing: "Schildes ambet ist min art"[4]—I am a man of my

2. W. Mohr, *"Tristan und Isold* als Künstlerroman," *Euphorion,* LIII (1959), 2 ff.

3. *Tristan und Isold,* ed. F. Ranke (Berlin, 1930), ll. 4665 f. All quotations of the poem are from this edition.

4. Wolfram von Eschenbach, *Parzival,* ed. K. Lachmann, 7th ed. E. Hartl, Vol. I (Berlin, 1952), 115, 11 (Prolog to Book III). All quotations of the poem are from this edition. A recent article on the Gottfried-Wolfram quarrel is W.J. Schröder, *"Vindaere wilda maere.* Zum

weapons, not of the pen, a man of action, not an intellectual. His much quoted denial of his ability to read falls into the same category of anti-intellectual statements. Nor should we overlook the passage in which he makes mocking reference to the man caught naked in his bath:

> disiu aventiure
> vert ane der buoche stiure
> e man si hete vür ein buoch,
> ich wære e nacket ane tuoch,
> so ich in dem bade sæze
> ob ich des questen niht vergæze.[5]

The allusion to Tristan's unfortunate situation when trapped by Isold is surely very obvious. Wolfram and Gottfried knew that they could not agree on the *raison d'être* of the courtly epic. They were using the form for completely different purposes.

Even more significant than these chance remarks is the passage of literary criticism in which the references to Wolfram are found. The *swertleite* was the introduction of a young man not only to knighthood but to a whole new way of life. The ceremonial marked for him the path he was to tread and the ideals towards which he was to strive. It is interesting to note that the author of the *Nibelungenlied* felt it incumbent upon him to have a *swertleite* for his hero, however awkwardly such an event sat with his source material and his story. Since he was intent on imparting a courtly veneer to his work, he had to introduce Siegfried to knightly society and, as we might expect, the emphasis is on the ceremonial rather than on the physical and moral preparation necessary. Parzival does not have an official *swertleite*, but there is a detailed account of the various stages of his training by Gurnemanz and of his knighting.

Tristan receives his sword at a ceremony at his uncle's court, an event which might be expected to call forth Gottfried's finest powers of description—if he were writing a courtly romance in the normal sense. But he refuses to describe it. His

Literaturstreit zwischen Gottfried und Wolfram," *Beiträge zur Geschichte der deutschen Sprache und Literatur*, LXXX (1958), 2 ff.

5. *Parzival*, ll. 115, 29.

ironic apology that he cannot compete with those who have
done so before is no more convincing than the view of those who
assert that he, a bourgeois, would not know the details of the
ceremony. Gottfried was not usually lacking in information,
particularly information which could be found in books—and
even in his own source, Thomas of Britain.[6] We must regard his
refusal as deliberate and equally deliberate his insertion of a long
passage of what can only be called literary criticism. There is
little logic in the substitution unless we observe that Gottfried
wished to discuss not knightliness but the literature of
knighthood, not the knight's physical prowess, his ability to win
victories or his success as a "courtly lover," but rather the knight
as a man, as a sensitive being, a thinker and artist.

Gottfried has already given us several clues that he is not
writing a courtly epic in the normal sense of the term. In the
prologue he points out that he has nothing against previous
writers of the Tristan story, indeed that he appreciates their
efforts and knows that they wrote "niwan us edelem muote,"
with the best of intentions. But he adds that few have told the
Story aright and that he will himself write for the "edelen
herzen," that is, for hearts above the normal courtly audience
which wants only pleasure. These remarks are usually taken to
mean that his treatment of the love theme would be different,
and that he was writing for a select audience which would be
able to appreciate his novel approach to the subject. This
interpretation is no doubt correct, but it does not exclude another
aspect of Gottfried's work, namely, that he wished to stress the
artistic and intellectual approaches to love. His transition in the
literary criticism passage is smooth enough; he states that
knightly glory has been so frequently described that it has been
worn out by speech and that he could give no pleasure to anyone
by further attempts. Hartmann von Aue, he says, knew how to
color and ornament the subject both outwardly and inwardly
(note that he has moved from the *swertleite* to knighthood in
general), and he thus pays his respects to the master who

6. *Die nordische und die englische Version der Tristan-sage*, ed. E.
Kölbing (Heilbronn, 1878), Pt. I, "Tristrams Saga ok Isondar," chap. xxiv
(p. 27). German trans. p. 132.

understood the outward and inward meaning of courtly romance—in the accepted sense of the term. In his genre and style, Hartmann is unapproachable. For Wolfram he has nothing but scorn, but it is worth noting that it is mainly to his style that Gottfried is alluding, to his side leaps and high jumps on the field of words. Gottfried is soon done with the narrative poets. Although he mentions Heinrich von Veldecke as well as Hartmann, it is as a lyric poet that he praises him. Far more attention is paid to the lyric poets—one hundred thirty lines against seventy—and in describing them the stress is upon the musical aspects of their work. For, says Gottfried, speaking of Walther von der Vogelweide, the music is in the mode which comes from Cithaeron, where the goddess of love holds sway both within and without, for she [Music] is the mistress of the chamber of that court; she shall be the leader of the "nightingales," of whom Walther is now the greatest. The meaning of the passage is clear—music is the way to love, and it descends from Aphrodite and the stream of Helicon to be the inspiration of the *Minnesänger*, even if the mythology becomes a little confused in the process. After a brief glance at Tristan, who is still unready for his initiation, Gottfried returns to his theme, the need of inspiration and skill in words for the poet and in particular the need for inspiration from classical sources, from Apollo and the Muses. Finally we are told what Tristan is to be equipped with—not arms but "muot unde guot, bescheidenheit und höfschen sin." The exact nature of these virtues is not easy to determine, but it is certain that they are moral and intellectual qualities, not physical ones.

This playing down of the physical aspects of Tristan's character is found throughout the poem. Naturally, Tristan is an excellent knight in the normal sense of the term. His prowess in arms is far above that of any contemporary. He defeats Morolt and Morgan, dragons and giants, but in none of these actions does Gottfried stress his hero's bravery and some of his actions are definitely not in the best knightly tradition. As Petrus W. Tax has shown, much of the description of Tristan's combats seem to imply mockery of knightly standards.

A few examples must suffice to show the aspects of his hero which did interest Gottfried. Let us first note that his father

Riwalin is almost always described in sensual and external terms:

> "seht" sprachen si "der jungelinc
> der ist ein sæliger man:
> wie sælichliche stet im an
> allez daz, daz er begat!
> wie gar sin lip ze wunsche stat!
> wie gant im so geliche in ein
> diu siniu keiserlichen bein!
> wie rehte sin schilt zaller zit
> an siner stat gelimet lit!
> wie zimet der schaft in siner hant!
> wie wol stat allez sin gewant!
> wie stat sin houbet und sin har!
> wie süeze ist aller sin gebar!
> wie sælichliche stat sin lip!
> o wol si sæligez wip,
> der vröude an ime beliben sol!" (704–719)

Gottfried places these words in the mouths of those who see Riwalin. This is the impression that he makes on a courtly audience when they first see him. Almost every line is an emotional exclamation at a different feature of his appearance and physical prowess and it is worth noting how often the word "sælic" and its compounds are associated with him. He is the happy, worldly knight rejected by Gottfried in his prologue, at least so far as the courtly audience which sees him is concerned. The passage just quoted should be compared with the careful description of the first impression which Tristan makes on the same court some years later (see below).

The dominant features of Tristan are made apparent as soon as Gottfried begins to describe his education. He is handed over to a wise man and begins the study of books. (There is an obvious parallel here with the story of Vergil and Lucinius[7] as

7. E.g., Johannis de alta silva, *Dolopathos*, ed. A. Hilka (Heidelberg, 1913), pp. 14 ff.

there is later with Apollonius of Tyre.)[8] This study of books, we are explicitly told, was the beginning of his sorrow:

> der buoche lere und ir getwanc
> was siner sorgen anevanc;
> und iedoch do er ir began
> do leite er sinen sin dar an
> und sinen vliz so sere
> daz er der buoche mere
> gelernete in so kurzer zit
> dan ie kein kint e oder sit. (2085–92)

He also learned music and other arts, but his accomplishments in such skills as riding and fencing are merely listed. No comment is made on their importance for his later life.

Tristan's first contact with Mark's court comes about through his meeting with the huntsman and his knowledge of hunting ceremonial, a fairly common device in medieval works,[9] but the impression he makes on the court is entirely due to his skill as an artist and musician:

> "a Tristan, wære ich alse duo!
> Tristan, du maht gerne leben:
> Tristan, dir ist der wunsch gegeben
> aller der vuoge, die kein man
> ze dirre werlde gehaben kan."
> Ouch macheten si hier under
> mit rede michel wunder:

8. *Historia Apollonii regis Tyri,* ed. A. Riese (Leipzig, 1893), chaps. xvi ff. It is, of course, true that the hero in the *Tristan* of Thomas of Britain is trained in books, music, and the other arts, but the description of the training and its results is very brief and amounts to little more than a recognition that these accomplishments were desirable for a knight. We can judge only from the Norse prose rendering, however, and perhaps we are doing Thomas an injustice.

9. E.g., in the *Ruodlieb.* The connection between hunting ceremonial and the pursuit of love was an obvious parallel which was worked out in painstaking detail by the author of the hunt allegories of France and Germany, e.g., *La chasse dou cerf amoureus* and Hadamar von Laber, *Die Jagd.* In *Tristan und Isold* the knowledge of hunt ceremonial is designed to show Tristan as more civilized than his hosts.

"hora!" sprach diser, "hora! sprach der
"elliu diu werlt diu hœre her:
ein vierzehnjærec kint
kan al die liste, die nu sint!" (3710–20)

There is the same quality of exclamatory surprise here, but the
qualities admired and the attitude are different. The courtiers
wish that they could be like Tristan but they know they cannot.
It is not his beauty or physical strength that they admire, but his
skill and knowledge, his *liste*, a term of many meanings. He is
the *niuwe spilman*, the fresh face and the new type at court. The
admiration he excites is increased by surprise that a person of his
age should be capable of such feats, both in playing and singing
and in knowledge of foreign languages. He is the infant prodigy,
the young genius who knows more than grown men, and the
effect of his skill and knowledge is to turn all men to his favor.
Even here, however, the classical connection is not forgotten. It is
the story of Pyramus and Thisbe that he sings, the *locus classicus*
for unhappy love. Tristan is well aware of the burden imposed
on him by his learning. The simple physical joy of the
uncomplicated knight will never be his:

wan ritterschaft, also man seit,
diu muoz ie von der kintheit
nemen ir anegenge
oder si wirt selten strenge.
daz ich min unversuohte jugent
uf werdekeit unde uf tugent
so rehte selten güebet han,
daz ist vil sere missetan
und han ez an mich selben haz.
nu weiz ich doch nu lange daz:
senfte und ritterlicher pris
diu missehellent alle wis
und mugen vil übele samet wesen.[10]

10. Tristan, ll. 4417 ff. Clearly Gottfried is referring back to his
remarks in the prologue. The knight Tristan has *not* become is the
normal, worthy but uncomplicated type. As I have pointed out
elsewhere (*Germanic Review*, XXVIII [1953], 290 ff.) and as Petrus W. Tax
makes clear in *Wort, Sinnbild, Zahl im Tristanroman* (Berlin, 1961), many

Tristan goes on to say that if he had known before how things would stand with him, he would have organized his life differently. (He is still only fourteen!) There are other passages where it is made clear that the kind of training which Tristan had received was incompatible with the duties of a knight as they are normally understood. Tristan was bound to suffer for not being as other men are. The arts, and in particular the music which he loves and which is part of his being, do indeed give him a fuller life but one where, as Gottfried has already observed, sorrow and joy combine and sorrow predominates.

We must discuss in some detail the arrival of Tristan in Ireland, for it is central to the study of Tristan as artist. The hero has left Cornwall in a ship, and when he is near the coast, he has himself put into a small boat with only his harp—no weapons, no rich possessions. He is now dependent entirely on his music, and when a boat approaches, it is his music which draws a group of interested hearers, and, ultimately, Isold's own tutor, even though, as Gottfried emphasizes, the music he is playing, while technically superb, is that of a lifeless man. We are told that the tutor who hears him had already imparted to Isold over a period of years his own skill in music and the book-learning which he possessed. In other words, she had already received the normal education for a girl of her station from the court chaplain. The tutor soon recognizes in Tristan a skill far above his own and out of pity and admiration recommends him to his mistress, Isold's mother. She promises to cure Tristan but strikes a bargain—that he shall undertake to teach her daughter. Clearly he could teach her daughter only something exceptional, above the common run of playing skill and reading which she already possessed. The lines which describe this scene are so full of double meaning that they defy translation. Tristan, whose playing in the boat had been so lifeless, now plays

> niht alse ein lebeloser man,
> er vieng ez lebelichen an
> und alse der wol gemuote tuot. (7825–27)

of Tristan's difficulties stem from his attempts and those of others to treat his love for Isolde as "courtly."

He played no longer as a lifeless man—a man without liveliness.
He was to be cured of his bodily wound and attain life once
again, but that life was to be different, as the queen says with
double implication:

> dar umbe wil ich dir din leben
> und dinen lip ze miete geben
> wol gesunt und wol getan:
> diu magich geben unde lan,
> diu beidiu sint in miner hant. (7855–59)

She can indeed give and refuse, but which action will produce
which result is deliberately left unclear. Tristan for his part
expresses his joy that he could be cured through music, but the
phrase "mit spil genesen kan" could equally well mean "flourish
through music," or "through my playing," or "through play."
No educated listener could fail to be reminded of the story of
Abélard and Héloïse, for there too a brilliant young man was
called upon to instruct a sensitive girl, with dire results for both.
Gottfried has altered his source material considerably in this
scene, for in Thomas of Britain's version, if Brother Robert
represents him accurately, the younger Isold asks to hear Tristan
play and then herself asks for him as an instructor. The kind of
instruction she receives is described only in general terms. Nor
can we ignore the strong troubadour and *Minnesänger* tradition
of the wound of love which was curable only by the person who
had inflicted it. Gottfried seems to have written the whole of this
scene with the double background of instruction and the wound-
cure motif in mind. Tristan's bodily cure is succeeded by an
incident in which other wounds, less easily curable, are inflicted.

We have already noted that Tristan's instruction of Isold
goes beyond what she had already learned from the chaplain. In
the account of the instruction which follows, two elements
predominate, music and *moraliteit*. We are given a description of
Isold's acquisition of outstanding technical skill in playing and
singing in various languages. But it is on the effects of music
which Gottfried dwells, and to these we must now turn our
attention. To understand them we must look at the statements on
the esthetics of music which, we may safely assume, were known
to Gottfried. As so often is the case in medieval studies, we must
begin with Boethius, for he incorporated the theories of Plato

and the Neoplatonists into his treatise on music, as well as the views of the Greek theorists.[11] His *De institutione musica* was the basis of all medieval studies of the subject and was certainly read by any student who had progressed as far as Gottfried. For Boethius music was the queen of the arts and hearing the highest of the senses. Music embodied that harmony which found its loftiest expression in the music of the spheres, inaudible to mortals but expressing external cosmic harmony. Beauty as perceived by the senses was regarded by medieval writers as transitory and external. As the documents quoted by De Bruyne show, the deeper, truer beauty lies in the universal design, in harmony and proportion. (Perhaps this is why number relationships are important apart from the symbolic associations of the numbers themselves.) Music, more than any other of the arts, reflects this harmony and proportion. Boethius remarks: "Nulla enim magis ad animum disciplinis via quam auribus patet."[12] The ears are the best way for the disciplines to reach the mind. The very word *consonantia* can refer to music, to harmony of character, and to eternal harmony. Cassiodorus is even more definite about the priority of music than his great contemporary: "Haec cum de secreto naturae, tamquam sensuum regina, tropis suis ornata processerit, reliquae cogitationes exsiliunt omniaque facit eici ut ipsam solummodo dilectet audiri."[13]

We can trace the effects of these pronouncements very clearly in Gottfried's work—the effect on Mark and his court, on the strangers in Ireland, on the Queen and Isold. It is through music, not through knightly prowess that Tristan makes his way. But this alone would do little more than confirm Mohr's statement that Tristan is essentially a *Spielmann* and place him in

11. The importance of Boethius for medieval music hardly needs to be demonstrated. See G. Reese, *Music in the Middle Ages* (New York, 1940); N.C. Carpenter, *Music in the Medieval and Renaissance Universities* (Norman, Okla., 1952); Th. Gérold, *La Musique au moyen âge* (Paris, 1932). Quotations from Boethius are taken from *Anicii Manlii Torquati Severini Boetii, De institutione musica libri quinque*, ed. G. Friedlein (Leipzig, 1867).

12. Boethius, I, 1.

13. Cassiodorus, letter to Boethius, quoted by de Bruyne, *Études esthétiques*, I, 66.

the same category as a score of other medieval heroes. Tristan
teaches Isold a great deal more than mere musical skill. Gottfried
constantly emphasizes that he improves her, and he reinforces
this statement with details of her progress by naming the
forms—*pastourelle, rotruange, chanson, reflet*. He stresses the
"foreignness" of this accomplishment:

> leiche und so vremediu notelin,
> diu niemer vremeder kunden sin,
> in franzoiser wise
> von Sanze und San Dinise.[14]

His reference to Saint Denis is interesting when we remember
that the school there was in the forefront of the great innovations
in music theory of the later twelfth century.

Isold, in other words, is being elevated by Tristan to his
own high level of musical accomplishment, not only in practice
but in theory, which latter, according to contemporary writers,
was by far the more important branch. I am reluctant to run the
risk of being accused of reading into Gottfried's text meanings
which could not possibly be there, but I cannot refrain from
noting that the musical theories of the twelfth century
recognized a distinction between two kinds of performed music,
musica practica pura, which was designed to appeal to the senses
and move through them, and *musica practica mixta* or *musica
theoretica practica* designed to appeal to the higher faculties.[15] The
division corresponds to the well-known separation of perception

14. *Tristan*, ll. 8059 ff. The meaning of this passage has caused
trouble to the commentators. Bechstein in the note to his edition
assumes that the saints themselves were the subject of songs. I disagree.
There would be no point in introducing lives of saints at this point. It is
much more likely that *Sanze* is a rendering of "Sens" and that the
references in both instances are to places. Sens was an ecclesiastical
province in which were not only the church of St. Denis but also
Auxerre and other famous musical centers. Paris was, technically, part
of the ecclesiastical province of Sens, as were Chartres, Troyes, Nevers,
Meaux, and Orléans. See W.B. Aspinwall, *Les Écoles épiscopales
monastiques de l'ancienne province ecclésiastique de Sens du VIe au XIIe siècle*
(Paris, 1904).

15. De Bruyne, II, 108.

by sight into the *sensus et imaginatio,* perceived by the *oculus carnis,* and *ratio et intelligentia,* perceived by the *oculus rationis et oculus contemplationis.* Isold's instruction is obviously concerned with *musica practica pura,* as we can see from Gottfried's careful description of its effects, a description which naturally has strong resemblances to the scene in which Tristan's impact on Mark's court was described.

> Wem mag ich si gelichen
> die schœnen, sælderichen
> wan den Syrenen eine,
> die mit dem agesteine
> die kiele ziehent ze sich?
> als zoch Isot, so dunket mich,
> vil herzen unde gedanken in,
> die doch vil sicher wanden sin
> von senedem ungemache.
> ouch sint die zwo sache,
> kiel ane anker unde muot,
> zebenmazene guot:
> si sint so selten beide
> an stæter wegeweide,
> so dicke in ungewisser habe,
> wankende beidiu an und abe,
> ündende hin unde her,
> sus swebet diu wiselose ger,
> der ungewisse minnen muot,
> reht als daz schif ane anker tuot
> in ebengelicher wise. (8085–8105)

Isold is so able to move the senses of her audience through her playing that all their emotions are concentrated on love. A careful examination of the simile shows, however, that there is a destructive element in the music she sings. The Sirens led ships to crash upon the rocks and destroy themselves. So Isold's music arouses the senses, awakens love which had never been suspected, and causes the hearers to lose control both of emotion and thought.

The passage which follows details the effects even more precisely and we should note that there is more than emotion involved:

diu gevüege Isot, diu wise,
diu junge süeze künigin
also zoch si gedanken in
uz maneges herzen arken,
als der agestein die barken
mit der Syrenen sange tuot.
si sanc in maneges herzen muot
offenlichen unde tougen
durch oren und durch ougen.
ir sanc, dens offenliche tete
beide anderswa und an der stete,
daz was ir süeze singen,
ir senftez seiten clingen,
daz lute und offenliche
durch der oren künicriche
hin nider in diu herzen clanc.
so was der tougenliche sanc
ir wunderlichiu schœne,
diu mit ir muotgedœne
verholne unde tougen
durch diu venster der ougen
in vil manic edele herze sleich
und daz zouber darin streich,
daz die gedanke zehant
vienc unde vahende bant
mit sene und mit seneder not.
Sus hæte sich diu schœne Isot
von Tristandes lere
gebezzeret sere. (8106–34)

Isolde is described as "the wise" and the effects of her singing
are combined with the effects of her personal beauty. As so often
in Gottfried's work, there is a double effect both in the emotion
described and in the language used. The obvious impact is
through the sounds of the music, the secret effect through Isold's
presence; the first impact is on the senses, the second on the
thoughts. Immediately after this passage we are told that Isold
composed songs—as indeed one might expect from the earlier
description of her instruction. She knows how to write material
which will produce the effects she desires. In other words, she is
showing herself the complete musician, the theorist as well as
the practical performer. But when describing her impact on the

members of the court, not on Tristan, Gottfried confines himself to sensual description.

That music brings *consonantia* to Tristan and Isold can hardly be denied. But there is more. Let us return once more to Boethius, this time for his definition of a musician. A musician, he says, is a person who understands modes and rhythms, types of songs, combinations, and everything which will be discussed later in his treatise. He should also know the works of the poets according to the theory and method proposed and suited to music.[16] Thus he does not regard mere performers or even poets as complete musicians. Only those who have also mastered the theory are really worthy of the title. It will be noted that either Tristan or Isold could meet these qualifications, according to the way Gottfried describes them. In the teaching of Isold, Tristan has taken the first step towards their ultimate harmony. He raises her to the same musical level which he has himself already attained; he gives her the power over men which his own music gave to him. But this is not all. Gottfried stresses that he also teaches her something called *moraliteit,* "diu kunst diu leret schœne site." There have been numerous attempts to explain the meaning of this term, none of them very successful. Gottfried seems to have introduced the word to German and would hardly have done so if he had intended by it nothing more than "polite education" or even training for the courtly virtues. By the introduction of a word new to his audience he clearly meant to call their attention to the fact that Isold was acquiring a quality different from those normally taught to young ladies of the court circle. His careful description confirms this:

16. Boethius, I, xxxiv: "Tertium [genus] est quod iudicandi peritiam sumit, ut rythmos cantilenasque totumque carmen possit perpendere. Quod scilicet quoniam totum in ratione ac speculatione positum est, hoc proprie musicae deputabitur isque est musicus, cui adest facultas secundum speculationem rationemve propositam ac musicae convenientem de modis ac rythmis deque generibus cantilenarum ac de permixtionibus ac de omnibus, de quibus posterius explicandum est, ac de poetarum carminibus iudicandi." It may be seen that Gottfried follows Boethius closely.

da solten alle vrouwen mite
in ir jugent unmüezic wesen.
moraliteit daz süeze lesen
deist sælic unde reine.
ir lere hat gemeine
mit der werlde und mit gote.
si leret uns in ir gebote
got unde der werlde gevallen:
sist edelen herzen allen
zeiner ammen gegeben,
daz si ir lipnar unde ir leben
suochen in ir lere;
wan sin hant guot noch ere,
ezn lere si moraliteit. (8006–19)

It should be noted that *moraliteit* is the nurse of the *edele herzen*, the people for whom Gottfried wrote his poem and who are described in his prologue as not satisfied with a love which involves only pleasure. It is *their* nourishment and *their* life. It can hardly, therefore, be mere superficial behavior but something deeper and more permanent. It is strange that no one, to my knowledge, has called attention in this connection to another passage of Boethius: "Musica vero non modo speculationi verum etiam moralitati coniuncta est. Nihil enim tam proprium humanitati quam remitti dulcibus modis astringique contrariis."[17]

17. Boethius, I, i. The passages in Boethius' treatise on the definition of a musician and the moral aspects of music interested many medieval commentators and there are frequent references to them. I am very grateful to Father Rembert Weakland, O.S.B., for calling my attention to several instances of such comment and in particular to the passage from Aribo, *De Musica,* ed. Jos Smits van Waesberghe, Corpus scriptorum de musica, II (Rome, 1951), 46–48, here quoted:

Sed histriones et caeteri tales musici sunt naturales
non artificiales. Artificialis autem musicus est, qui
naturalem omnium specierum: diatesseron, diapente,
diapason constitutionem intellegit subtiliter; qui
dispositionem troporum naturae pedissequam
cognoscit rationabiliter; qui principialium chordarum
operationem perpendit efficaciter; qui troporum
proprietates, quae in sex chordis consistunt, tenet

The word *speculatio* is used throughout this treatise in the sense of "theory," that is, the study of music as an art. This, of course, is what Gottfried has been describing. But also, Boethius says, music is important for its relation to the character of man. *Moralitas* is a word hard to define exactly—it is not "morality" but the total "mores" of man, his character viewed as an abstraction. Music can affect this character, it can be soothed or aggravated, ennobled or debased. It is surely no accident that we see the double effect of music upon spirits dedicated both to the joy and the sorrow of love. Gottfried has already made clear the effects of the playing both of Tristan and Isold on a courtly audience. *Moraliteit,* however, is something higher. It links the higher spirits and pleases both the human and the divine. So, too, does Boethius describe music as linking the human and the divine, producing that *consonantia* which is a harmony both of sounds and souls. Is it too far-fetched to suppose that the use of the word *moraliteit* is at least inspired by Boethius' use of *moralitas*? The fact that his description of the training in music is followed immediately by the mention of this quality would seem to indicate that this is so. Harmony of character and of soul come through music.

memoriter. Ipse quoque artis facultate optime sciat legitima comprobare, viciosa quaelibet emendare, irreprehensibiles per semetipsum cantilenas excogitare.

DE MUSICAE ARTIS MORALITATE Ethicam, id est moralem esse musicam, quivis ex hoc potest percipere, quod, ut supra dictum est, sua confert beneficia sine artis perceptione. Unde eius usus arte posses tanto nobis stabilior et perseverantior, quanto ipsa nobis est naturalior, ut diuturnius argento inhaeret aurum quam cupro. Moralis esse penitus ostenditur, cum omnis sexus, omnis aetas in illa delectatur. . . . Musicae moralitatem etiam Plato demonstrat dicens: Animorum item placiditatem constituebamus in delinimentis et affabilitate musicae. Merito dicit Plato placiditatem animorum esse in musica cum nulla inquietudo cum assidua musicae conversetur delectatione.

Isold is a different person after Tristan's teaching. It is worth noting that he never performs knightly service for her, as Lancelot does for Guinevere. The episode with the dragon is almost a travesty of such affairs in courtly romance, for Tristan kills the dragon without intending it as a service. If the action had any importance, it was to win Isold for Mark! He never has to fight the seneschal, for the wretch is beaten by the production of the dragon's tongue. We have already noted the failure of the lovers and of Brangaene to put their love affair on the same level as that of a courtly intrigue. It is to the scene in the *Minnegrotte* that we must turn to see the realization of the preparation made by Tristan's instruction.

This is not the place to add anything to the enormous amount already written about the literary use of the Minnegrotte, but one or two points must be recalled. The grotto is described as quite separate from the normal world and in particular from the world of the court. This is, of course, a permanent tradition in the source material, but in most other versions the separation is one which the lovers hate and which they bring to an end as soon as they are able. Even in the work of Thomas of Britain the grotto, although pleasant enough, is not the shrine which Gottfried makes of it. All the literary devices which designate the earthly paradise appear in Gottfried's version—the *paysage idéal*, the separation by wasteland and forest, the mountains, the long journey to reach it. In this place love could attain levels which were not possible on earth. Such a view is not, of course, confined to Gottfried. We find similar use of the *hortus conclusus* motif in the Phyllis and Flora poem[18] and in the *Roman de la Rose*. It is also to be observed that the lovers are alone—they are not in Thomas' poem. That Gottfried allegorizes his edifice, if such it can be called, by the techniques described by Hrabanus Maurus, Honorius of Autun, and later by Durandus is well recognized. But it is less often noted that the grotto itself is explicitly stated to be pagan and dedicated to the goddess of love. Classical allusions again appear, the stories which the lovers tell are those of famous couples of antiquity.

18. *Carmina Burana*, ed. A. Hilka and O. Schumann (Heidelberg, 1931, 1941), Vol. II, Part i, No. 92.

Tristan and Isold have withdrawn into an idealized world many of whose elements derive from the classics and whose relation to their love is depicted by the use of allegorizing techniques similar to those employed by the Christian fathers in relating the church edifice to the soul. The virtues proclaimed, however, are those which suit Gottfried's conception of perfect love.[19] The whole passage is an attempt to describe in allegorical terms the shrine of love in the heart. What other meaning can we attach to the statement "Diz weiz ich wol, wan ich was da." Gottfried has himself been to the cave, he has done everything which the lovers do except lie in the crystalline bed, for there only the elect could come. But all the other experiences he has had: he has indeed frequented the grotto, that is, been in love so often that the marble at the side of the bed would show traces if it were not for its power to renew itself.

> und aber den esterich da bi,
> swie herte marmelin er si,
> den han ich so mit triten zebert:
> hæt in diu grüene niht ernert,
> an der sin meistiu tugent lit,
> von der er wahset alle zit,
> man spurte wol dar inne
> diu waren spor der minne. (17117–24)

The virtues of true love have also affected his heart—even though he has never been to Cornwall.

> diu sunnebernde vensterlin,
> diu habent mir in daz herze min
> ir gleste dicke gesant:
> ich han diu fossiure erkant.
> sit minen eilif jaren ie
> und enkam ze Curnewale nie. (17133–38)

Clearly it is not a place which Gottfried is describing, but a state of ideal love, and he is using the grotto allegory as a background

19. Although there is considerable general correspondence, the qualities are not exactly those described by Guillaume de Lorris in the *Roman de la Rose,* where the emphasis is rather on behavior than on intellectual and moral qualities.

for figures which would evoke in his readers a realization of the
ideal state he is describing. Prudentius had done something very
similar, for the battle he described was in the soul, even though
one would not know it from his descriptions. Gottfried's lovers
are still mortal but they are shown as raised above mortal
experience. They need no mortal food, as Gottfried emphasizes.
But once again it is in the arts and in particular in music that
their inner harmony expresses itself. As often in lyric poetry, the
paysage idéal reflects the perfection of their state, but there is
much more emphasis than usual on bird song.

> diz gesinde diende zaller zit
> ir oren unde ir sinne. (16894 f.)

We need not see here any more than the author's general
stressing of the delight and satisfaction of all the senses in the
state of love. Much more important is that when the lovers retire
to their *kluse,* their inner shrine, they join in harmony:

> und liezen danne clingen
> ir harphen unde ir singen
> senelichen unde suoze.
> si wehselten unmuoze
> mit handen und mit zungen:
> si harpheten, si sungen
> leiche unde noten der minne.
> si wandelten dar inne
> ir wunnenspil, swie si gezam: (17205–13)

The harmony between them is complete:

> ouch lutete ietweder clanc
> der harphen unde der zungen,
> sos in einander clungen,
> so suoze dar inne
> als ez der süezen Minne
> wol zeiner kluse wart benant:
> la fossiure a la gent amant (17218–24)

Their music was more clear and more pure than any which had
ever been heard in this shrine dedicated to the goddess of love.
There is little doubt in my mind that Gottfried is here using
musical imagery as he used the allegory of the church and of the
paysage idéal. He is showing his two lovers achieving a higher

harmony, the *consonantia* of which we have spoken. It is not the *consonantia* of the human soul with the universe. The lovers do not hear the music of the spheres, but here, as so often, Gottfried is applying the imagery common to the whole Christian tradition of his day to illustrate the higher love of which Tristan and Isold are the representatives. At the beginning of his study of the poem, Petrus Tax asks the very pertinent question: "ob diese *minne* eine nach der Intention des Dichters im ganzen Werk einheitliche, wandlungsunfähige Gestalt aufweist, oder aber ob Gottfried nicht vielmehr zeigen will, wie Tristan und Isolde erst allmählich, und nach vielen Rückfällen in eine ihnen eigentlich ungemäße Form der Liebe, den schmalen und gefahrvollen Weg ihrer *minne* bis zum hohen Gipfel erklimmen" (p. 17). The thesis outlined in this paper contributes something to the solution of the problem. Both Tristan and Isold required to be trained before they were capable of the highest form of love. Tristan was trained in books and music until he was intellectually and spiritually capable. This training he subsequently imparted to Isold. I am not, of course, arguing that theirs was an intellectual love. The exact nature of the love, however interesting as a problem in itself, is not, in fact, strictly relevant. It is the means of arriving at perfect harmony which we are discussing. This harmony was achieved through and within the arts and particularly through music. Such a viewpoint does not exclude the consideration that the lovers themselves at first believed their situation to be courtly, nor that Gottfried wished to show the depth of their attraction by using the terminology of mysticism. The disrespect for the trappings of courtly romance, however, and the ironical treatment of those who follow its methods are best explained by Gottfried's determination to make his hero an artist. He is much more than a *Spielmann*, much more than a *homo ludens*, even though he incorporates many of their characteristics. The love of Tristan and Isold rests on a harmony attained through the arts, just as Gottfried, in describing the growth and flowering of their love, uses the style of the schools which forces the hearer to interpret what he hears. The quarrel with Wolfram was thus fundamental. It concerned not only the style but the attitude which style represents. Wolfram's obscurity is often humorous: usually, one suspects, deliberate, sometimes

out of ignorance. Gottfried uses a style of which double and triple meanings are an essential constituent. It is the style of a formally educated man, and this man was Gottfried's hero.

Gottfried von Strassburg: *Tristan* and the Arthurian Tradition

William C. McDonald

The *Tristan* of Gottfried von Strassburg, composed about 1210, is an unfinished poem of over 19,000 lines which breaks off at the point where Tristan is contemplating marriage to Isolde of the White Hands. Gottfried's chief source was the Tristan romance of Thomas of Britain, or Thomas d'Angleterre (Gottfried: *Thomas Von Britanje* 150). The response of both poets to the intersection of the Arthurian and Tristan milieus is subtle and open to interpretation, but it is arguable that the concept of the hero in Gottfried's *Tristan* is less ambiguous. His Tristan is an artist-figure whose chivalric duties the poet construes to be of marginal importance.

Gottfried's absorbing interest is Tristan-love, to the degree that it has become a cliché of criticism to speak of the poet—by all accounts a cleric active in the urban setting of Strassburg—as an advocate of a religion of love. In the prologue, which is peculiar to his version, Gottfried clearly aims at a special aesthetic reception, addressing those "noble hearts" who are prepared to endure sorrow. The "world" from which he expects audience response "together in one heart bears its bitter-sweet, its dear sorrow, its heart's joy, its love's pain, its dear life, its

Reprinted with permission from *In hôhem prîse: a Festschrift in Honor of Ernst S. Dick*, ed. Winder McConnell (Göppingen: Kümmerle, 1989), pp. 243–66.

sorrowful death, its dear death, its sorrowful life" (59–63).[1]

Gottfried is writing, Michael S. Batts has said, "for those who, like Tristan and Isolde, understand that in life and love, joy and sorrow are inextricably commingled, that life and love cannot be understood or appreciated unless these two are fully accepted."[2] Through the story of Tristan and Isolde, which, with tragic clarity, confers on love and suffering a special meaning as intense spiritual values, Gottfried hopes to counteract the fragmentation introduced by another "world" of listeners and literature.

The prologue opposes the prescient members of the exclusive community appreciating *Tristan* to that community of "the many who . . . are unable to endure sorrow and wish only to revel in bliss" (50–53). "Bliss" (*vröude*) is of course a valuative key word for Arthurian romance and an encapsulation of the tendencies of the genre. Since the signification of courtly joy will cause the initiated reader to draw a connection to the conventional romance, one observes here an example of the allusive signals emitted by a text filled with nuance, irony and ambiguity. A sophisticated and complex interplay of levels of understanding grants established concepts a wide range of meaning, while intrinsically connecting other concepts in mysterious and unpredictable ways. By virtue of the negative accent on joy in the prologue, Gottfried both communicates his attitude toward the vein of joyous optimism underlying the courtly romance and introduces a subplot-hero who will illumine Tristan's prehistory: his father, Rivalin, is a happy worldly knight. An Arthurian hero in all but the name, Rivalin is the prototype of the worthy and gay champion in whom the values of the code of knighthood are triumphant. The father's life celebrates the attractions of the world: he leads a pleasure-filled life which smiles on the world (307), and he revels in the

1. English translations of Gottfried's *Tristan* are by A. T. Hatto (Middlesex, 1980); line numbers from the 11th edition of *Tristan und Isold* by Friedrich Ranke (Dublin, 1967).

2. Michael S. Batts, *Gottfried von Strassburg* (New York, 1971) 76–77.

sweets of living (310). But the wages of this merry life are death (at the hands of Morgan), due to prideful exuberance.

Rivalin's story is primarily conceived as an exemplary and a cautionary tale, a frame scene providing insight into Gottfried's attitude to the conventions of the court and its literature. For Rivalin, whose values are "Arthurian," neither shows humility nor gains wisdom and self-knowledge. His capacity for self-deception, born of pride, creates a perspective by which to measure Tristan's own system of values. As a type of romance hero, Rivalin is the parodic formal exemplar for his scion; Tristan's progress will thus be measured by his distance from the conventional chivalric ideal. (Tristan's career urges the view that the hero is a possessor of chivalry, but the dictates of chivalry that he applies show regard for individual rights in preference to a societal code.) Rivalin is the very kind of man, a knight of happy mood, who seeks out the court of King Mark. Mark's court is characterized by courtliness and revelry. Who can fail to be reminded, as a saturnalian pattern is constructed, of King Arthur's Whitsun festival, when Mark's spring-festival, at which Rivalin is present, is described?

> By behest and by request Mark had so established this festivity that when he summoned his knights they promptly made the journey from the kingdom of England to Cornwall once in every year. They brought bevies of charming ladies with them and many other lovely things. Now the festivities were fixed, agreed, and appointed for the four weeks of blossom-time from the entry of sweet May until its exit. . . . (525–540)

Using zealous commitment to sport, joyous chivalry and the high courtly culture as unifying motifs, Gottfried is able to link Mark, Rivalin—and Arthur—as merry men of May. The dominant mode of the landscape they traverse is the celebration of a world suffused with festive emblems.

According to the conventional courtly—and romance— ideal, Mark is a paragon. His court, which early in the story achieves secular felicity, is the locus of acclaim, and he is an Arthur-like combination of qualities expressed in a world-centered idiom. The king's character is drawn in traditional epithets: he is excellent, noble and distinguished; esteemed; he is

the bestower of merit; and Rivalin interprets his as "a good and courtly way of life" (501). At Mark's pleasant court Rivalin will learn "new military exercises"/"feats of arms" (*niuwan ritterschaft*, 458), a puzzling compound coined without further definition. But Rivalin, the hero-protagonist of the early part of the narrative, grasps its sense. The *summa facti* are that Mark is a teacher of chivalry and that Rivalin willingly places himself in the tutelage of the king.

This tutor in courtliness is, as subsequent events reveal, a *roi-fainéant*. Gottfried's portrayal of Mark is very subtle, and the German poet joins Thomas in raising the figure to psychological complexity. W.T.H. Jackson sketches the characterization thusly: "He is neither the outraged and cruel husband of the earlier versions nor the jealous lover of Thomas's account, but a person incapable of loving in the true sense."[3] Ambiguity controls the depiction of Mark, even as it guides his vision of life. He does possess virtue, for example, kindness and forbearance, but vices intrude to color the picture of the king—fickleness, weakness, an undiscriminating attitude, suspicion, credulity (even fatuity). As the highest authority and the symbol of the rule of law in society, Mark has the duty to set his subjects an example of courtly behavior and the ideals of knighthood. While Mark himself is not a man of false piety and consistent deviousness, the climate of his court is corrupt and distinguished by envy, intrigue and hatred. Mark's society adheres to a rigid formalism which makes its ethic of public morality superficial, if not aberrant, and which reduces its quest for honor to the absurd. His court is, in sum, the ultimate parody of communal living, and for its deviations from the social norms of decorum Mark bears responsibility.

The intertext of *Tristan* thus constructs the following theorem: if Mark is the avowed apotheosis of courtly life, and if his court is the goal of heroes wanting to increase prowess and polish manners, then the values of this merry world susceptible to vice are skewed and perceptions of the king's status are suspect. It is in the light of identification with Mark and his court

3. W.T.H. Jackson, *The Literature of the Middle Ages* (New York, 1962) 152.

that we have to understand the courtly ideal and its institutions; each necessarily takes on a dark coloration. The poet and his narrator infect the story with the trappings of (Arthurian) knighthood and the courtly ideal in order to underscore the inadequacy of these in the face of sexual love. The combination of attitudes that Gottfried conveys therefore enables us to see chivalry and romance conventions for what they are: glad fictions which must be viewed with ironic detachment.

Mark resumes his role as definer and bestower of knighthood when Tristan is ready for investiture. Hugo Bekker correctly observes that knighthood signals for the hero an anticipated—negative—change in his life: "The narrator makes a show of his agony now that he is about to turn Tristan into a knight, hence into a full-fledged member of society, with the rights as well as the duties commensurate with that position; toward the end it is clear that the narrator himself is not much interested in Tristan's knighthood as understood in the common sense of that term."[4] Mark, it is clear, is the representative of traditional knighthood, whose aims he defines for Tristan and the reader: modesty, straightforwardness, truthfulness, kindness, pride (to the mighty), good appearance, honor and love of women, generosity and loyalty (5025 ff.) His concluding words in the episode show how well-orchestrated is Gottfried's poetical statement. For Mark casts the ceremony and the institution in the familiar framework of bliss: "Always be courteous and gay!" (*vro*: 5045). This admonition has the hollow ring of irony about it, since Tristan, born to sorrow, art and love, will not—and cannot—follow it. He may possess the qualities of a perfect knight, but he will not use these in the manner of the Arthurian hero.

Verbal and structural irony course through the passages on Tristan's knighthood, in that he discards all of the honorable precepts articulated by that paragon of courtliness, King Mark. The hero's attitude toward knighthood, and the narrator's own, become explicit in the scene of Tristan's investiture (4547–5068) just mentioned. At the point where the clothes and chivalric

4. Hugo Bekker, *Gottfried von Strassburg's 'Tristan': Journey Through the Realm of Eros* (Columbia, SC, 1987) 89.

equipment of Tristan and his comrades are described, the narrative is interrupted by a *digressio*. Claiming that "knightly pomp . . . has been so variously portrayed and has been so overdone that I can say nothing about it that would give pleasure [*vröude*!] to anyone" (4616–4620), the narrator violates audience expectations. He replaces a description of the knighting ceremony at Mark's court, which would be conducted by Tristan's uncle as bestower of sword, spurs and shield, with a literary excursus, a kind of history of German literature of Gottfried's time and place. This narration by omission— knighthood as a blank in the text—is both a technique of ironic understatement and didactic commentary *ex silentio*.

The first message conveyed by this divagation on literature is that, both figuratively and literally, art replaces knighthood. The second emerges from the shape of the literary excursus itself: Gottfried mentions Hartmann von Aue first, and then signals his interest in lyric production, as opposed to the romance. Hartmann was of course known for his adaptations of the Arthurian romances of Chrétien de Troyes, which Jackson has characterized as showing "how a man, as an individual, must evolve a relationship with his lady which will enable him to fulfill himself as a member of society—not merely of the Arthurian court—and also to live a life of sexual harmony with his partner, with each contributing to that harmony."[5] Gottfried's allusions to Hartmann and to other poets ineluctably reveal that the excursus expresses the essence of the popular courtly romance, whose literary views he beholds with considerable reservation. The subtle, but pointed commentary in the excursus shows Gottfried narrowing his target from conventional knighthood to amusing chivalric stories of fairy-tale bliss, harmony and happy endings, in which the protagonists achieve their goals and are accepted by society. In the process, the poet orchestrates, in his skepticism about each, a masterly cultural and literary critique.

5. W.T.H. Jackson, *The Anatomy of Love: The 'Tristan' of Gottfried von Strassburg* (New York, 1971) 29.

Gottfried's literary excursus, especially as decoded by Jackson,[6] reveals itself to be a kind of programmatic statement, an analysis of alternative styles and theoretical positions that are set against Gottfried's own in Tristan. Gottfried uses the genre of the courtly romance, but with the purpose of showing its inadequacies, in one way by encouraging a more realistic assessment of its depiction of love in society. Jackson summarizes the narrator's position: ". . . Even though I have produced all the accepted literary devices and types of today, this is still insufficient to make a knight of Tristan in the sense that I would like it" (997). The sense of knighthood conveyed is a departure from Gottfried's fellow poets and insists on an absolute demarcation between the knightly romance of popular culture and his own poem. No existing literary type—save Thomas of Britain's in modified form—can do justice to the story of Tristan and Isolde; all are inadequate to it. The inference is clear. Tristan's knighthood adheres neither to literary convention nor to an accepted code or aesthetic character. He is a courtier and artist-knight, and no Arthurian champion as depicted in courtly romance.

At the conclusion of the excursus, the narrator laments that "Tristan is still unequipped for his knighting" (4824–4825), and only comes to mention knighthood in Mark's words noted above, clichéd locutions and grandiloquent phraseology which manage to be both all-inclusive and perfunctory. The ceremony of investiture itself, the fodder of literary topoi is never described. Willingly alienating himself from conventional notions of chivalry in respect to Tristan, Gottfried views his hero with sympathy as a man who masters knighthood only to transcend it by an admixture of art and love. In his own series of "adventures," Tristan shows himself, in Peter K. Stein's succinct phrase, to be "kein Musterritter, letztlich beruhen seine Hilfeleistungen jeweils auf einem ganz handgreiflichen

6. W.T.H. Jackson, "The Literary Views of Gottfried von Strassburg," *PMLA* 85 (1970): 992–1001.

Eigeninteresse."[7] Adventure in *Tristan* is in fact not at all like the *adventiure* of romance narrative, which centers on solitary quests for identity, glory and love in battle and at the tournament. The self-knowledge resulting from such quests becomes for Gottfried the knowledge of self through passionate love which, in turn, brings deep knowledge of the other.

Further defining the place and nature of knighthood in *Tristan*, Batts has said that Tristan is a knight of a different order: he exhibits prowess, but "breaks every rule in the book" (77–78), the other knights being portrayed as "either courageous failures or poltroons" (77). To do justice to the type of knighthood Gottfried has in mind for Tristan, according to which his adventures take place in the domain of eros, scholars speak of the hero as a "literary knight."[8] Tristan's education, with its emphasis on books and languages, sets him apart from other knights, and the narrator makes it obvious that the traditional training and trappings of knighthood interest him little. Representative of the hero's concerns is the fact that music and musicianship play a role in bringing him to Isolde.

Just as the digression on literature interrupts Tristan's induction into knighthood, so, too, does Gottfried interrupt Tristan's knightly career, which, as parallels with Thomas have shown, plays a progressively lesser role.[9] The ritual monuments of courtly culture are supplanted by the exploration of love, longing and the secrets of human passion. To focus on the nature of the lovers' affection, the narrative line is so reduced to essentials that nearly all knightly exploits are removed, or played down. But Gottfried does more than diminish the part given over to chivalry: he seeks to divorce chivalry from love.

7. Peter K. Stein, "Tristans Schwertleite: Zur Einschätzung ritterlich-höfischer Dichtung durch Gottfried von Strassburg," *DVJS* 51 (1977): 340.

8. See W.T.H. Jackson, "Tristan the Artist in Gottfried's Poem," *PMLA* 77 (1962): 364–372; Jackson, "Literary Views" 992 ff.; and Bekker, *Gottfried von Strassburg's 'Tristan'* 95–96.

9. Sarah Kay, "The Tristan Story as Chivalric Romance, Feudal Epic and Fabliau," in: *The Spirit of the Court*, ed. G.S. Burgess and R.A. Taylor (Cambridge, 1985) esp. 188.

Unlike the Arthurian hero, Tristan cannot reconcile chivalry and love, which last in *Tristan* is antisocial. In every sense of the term, the hero takes a cavalier attitude toward the courtly ideal.

Scholarship increasingly focuses on the degree to which Tristan strays from the pattern of an Arthurian knight; the clear implication is that the poet subverts the chivalric ideal.[10] In Gottfried's retelling, the legend assumes the shape of an Arthurian romance *ex negativo*: he pays heed to the predominant criteria of the genre, for example, the romance patterns of adventures and the quest, but so distorts the poetic tradition as to remove its fundamental coherence. The effect is the repudiation of standardized rhetorical forms and an ironic distance from the literary culture of the Round Table. *Tristan*'s departure from conventional precepts is everywhere to be seen—in Tristan's battles (Morgan, Morold, the dragon), which are bereft of chivalric etiquette and courtly stylization; in Tristan's lack of combat in defense of Isolde; in Gottfried's willingness to accord (brutal) realism to scenes of conflict (for example, his encounter with the giant Urgan), thus rejecting the fairy tale element characteristic of popular fiction; in the relationship of the protagonists with God; in the failed harmony between the individual and society; as well as in the lovers' confrontation with a court which has an adversarial relationship to them and whose values they do not affirm, but undermine. We have already alluded to Gottfried's conception, in contrast to that of his contemporaries, of adventure and of knighthood; he is reacting to the depiction of arms and investiture in literature (Hartmann von Aue, Wolfram von Eschenbach, etc.). Even Tristan's bravery and feats of arms (which show an overstepping of the bounds of decorum and de facto reprehensible behavior) are purged of their wonted function in the courtly romance.

All this makes amply clear Gottfried's orientation towards Arthurian romance, which he connects to *Tristan* in a complex and allusive way. In lieu of romance ideals, the reader receives parody, as D.H. Green has shown. This technique prevails

10. Stein, "Tristans Schwertleite" 336 ff. See also Joan M. Ferrante, *The Conflict of Love and Honor* (The Hague, 1973) 137 ff.; and Ruth G. Kunzer, *The 'Tristan' of Gottfried von Strassburg* (Berkeley, 1973) 37 ff.

especially in the social dimension in which Arthurian romance explicates its ideal of love. Gottfried depicts said dimension, according to Green, "either as divorced from the ideal of love (thus, none of Tristan's knightly exploits is performed in the service of Isold) or as opposed to it (in the institution of marriage or in Marke's court)."[11] Convincingly Green shows that Gottfried also abandons the feudal imagery of service, a common social aspect of love in Arthurian romance, supplanting it with "complete union, to the necessary exclusion of concepts like service and reward" (115).

To review our findings up to this point, Gottfried's *Tristan* is a poem composed in clear awareness of the courtly romance, against which it begs to be measured. The poet plays with traditional form and content, observing chivalry, courtliness and Arthurian ideals of love from the distance that irony and parody provide. It is crucial to his argument to establish Tristan's apartness from a code of (Arthurian) knighthood.

There is disdain for the courtly world and its literary manifestations in *Tristan*, but Gottfried's attitude is neither adamantine nor amenable to easy deciphering. The valid point is made that he does not totally reject the courtly ideal and the society in which it is performed, but instead relativizes each, allowing a clash between reality and fiction, between theory and practice.[12] (One thinks of the lovers' wish for worldly repute in the episode of the Cave of Lovers.) We must not forget that Tristan is a master of courtly skills. He is not restricted, however, to conventional courtliness as an absolute ideal; such courtly culture is inadequate in the realm of love. None of the existing modes of behavior, certainly none discouraging love outside marriage, can sustain or do justice to Tristan-love—freely-bestowed, linked to death and threatening to social reputation. Gottfried is by no means negative in his portrayal of sexual desire, depicting the intensive union of Tristan and Isolde as the coming-to-terms with longing, anxiety and gratification. Calling

11. D.H. Green, *Irony in the Medieval Romance* (Cambridge, 1979) 115.

12. Green, *Irony*, esp. 298–299. See also Bekker, *Gottfried von Strassburg's 'Tristan'* 217–218.

the bond that unites the lovers "destructive," C. Stephen Jaeger accurately observes, "the love is affirmed even in its most negative aspects: the disruption of the social order, the betrayal of friendship and blood relationship."[13]

Since Gottfried uses the love of Tristan and Isolde as a yardstick for judging true affection, he is discomfited by the social texture of contemporary literature, most prominently its treatment of love and society. The assumptions guiding such literature are tainted by an idealism and sentimentality that demystifies love by reducing it to an ethic of marriage and domesticity insisting upon a cheerful resolution. This reflects a generally optimistic view of the courtly worlds and its ideals. Accepting such a system of values uncritically, authors minimize the problems encountered by protagonists in effecting harmony between the individual and society. Judged as rebellion against the conventional mores advanced in the romance, which cannot accommodate erotic urgency, *Tristan* develops tendencies seen already in Thomas and carries them to a conclusion nourished by a "micro-essay" on literature—the literary excursus. The foil for his critique is, in no small measure, the Round Table itself.

Given the literary topography of *Tristan*, it is not surprising that Gottfried excludes King Arthur from active participation in the story. His poem thus offers a different orientation from that of Thomas of Britain, who, it will be recalled, introduces Arthur as a giant-killer of an earlier generation. Gottfried follows Thomas in the other excisions, eliminating the episode of the Sharpened Blades and omitting allusion to the Round Table in the Flour on the Floor and the Ambiguous Oath scenes. Tristan is a giant-killer (the Urgan episode 15915 ff.), as in Thomas, but Arthur does not set the model for his combat.

Though physically absent in Gottfried's *Tristan*, Arthur does, however, remain in Gottfried's angle of vision. The auctorial technique employed is a situational conceit that has gone largely unremarked. Patterned sequences built upon interlocking reminiscences allot to King Mark a homologous

13. C. Stephen Jaeger, "Gottfried von Strassburg," *The Arthurian Encyclopedia*, ed. N.J. Lacy (New York, 1986) 255.

role. Some three decades ago Maria Bindschedler advanced in outline form the thesis: "Im ersten Teil des Romans ist es König Marke, der die Rolle von Artus selbst vertritt."[14] With the exception of a few comments in notes to Rüdiger Krohn's edition on Mark's spring-festival and on the king's courtly qualities,[15] the suggestion that Gottfried's Mark assumes the feigning disguise of Arthur has been overshadowed by other concerns which the vast recesses of *Tristan* inspire. If Gottfried seeks to communicate a synthesis of these figures in broad outline—King Mark in the guise of Arthur, or Arthur in new garb—then certain symbolic patterns deserve closer analysis.

The ordeal of Isolde evokes one of these comparisons between the regents. The episode is motivated by the "Flour Trick," as in Thomas. In the absence of conclusive proof of adultery, Mark decides to require public evidence of the Queen's innocence. What follows contributes, through swift allusion and a pattern of ritual, to the context under review. Before Isolde promises to submit to judgment in Carleon (*Carliune* 15531), the narrator reports that the council which Mark has called to meet in London did so "after Whitsun week when May was drawing to a close" (15310–15311). This reference to Pentecost and the month of May points in two directions, the one to the Scriptures (the bestowal of fiery tongues by the Holy Ghost), and the other to the time of Arthurian festivities (see, for example, *Yvain* 1–6). Both are relevant, for Isolde will need the power of tongues to frame her ambiguous oath, but what interests us here is the subtle reference to the world of King Arthur. Although the king is offstage and therefore denied his function in Béroul as arbiter and instrument of justice, we observe that the ordeal by hot iron has an allusive Arthurian frame.

Commentary on the choice of Pentecost as the chronological marker for the council in Gottfried focuses on the religious and legal spheres, only Jackson noting in passing that the time chosen is "an ironical reversal of the usual courtly

14. Maria Bindschedler, "Die Dichtung um König Artus und seine Ritter," *DVJS* 31 (1957): 97.

15. Rüdiger Krohn, ed., *Gottfried von Strassburg: 'Tristan'* (Stuttgart, 1980) 3: 28–30.

springtime."[16] But more is implied, especially in the light of Gottfried's attitude toward Arthurian romance and the active role that a king plays in the episode. In contrast to Thomas, where Isolde suggests and plans her ordeal, Gottfried has Mark assume the organizing duties. Mark himself tells Isolde, who fears the ordeal and places herself in God's keeping, to take the iron in her hand (15727), and she accepts her husband's cruel test. Societal control and the ideals of courtly justice are thus epitomized in King Mark, the presider over the ordeal.

Regarding Pentecost in the ordeal scene, Gottfried certainly knew that Arthur was famed for celebrating this festive holiday welcoming summer; Chrétien introduces the king at the Whitsun festival. And Gottfried was surely equally familiar with the passage in the *Parzival* by Wolfram von Eschenbach—a poet singled out for criticism in the literary excursus in *Tristan*— where Wolfram refers to King Arthur as "the man of May:"

> Arthur is the man of May,
> and whatever has been told about him
> took place at Pentecost
> or in the flowering time of May.
> What fragrance, they say, is in
> the air around him! (281.16–20)[17]

Wolfram expresses himself here in an ironic mode. For he opposes the landscape into which the knight Parzival is released, a snowy scene, with the conventional, ideal landscape of King Arthur, who is searching for the hero. Wittily exploiting the incongruous situation of knights in contending natural scenes, Wolfram upsets audience expectations. Gottfried adopts a

16. Jackson, *Anatomy of Love* 112. See also Lambertus Okken, *Kommentar zum Tristan-Roman Gottfrieds von Strassburg* (Amsterdam, 1984) 1: 75–77; 519–520.

17. English translation of *Parzival* by H.M. Mustard and C.E. Passage (New York, 1961); line numbers from the edition by Karl Lachmann (Berlin, 1965). "The man of May" is a rendering of *der meienbaere man* (281, 16). Cf. Horst Brunner, "Artus der wise höfsche man: Zur immanenten Historizität der Ritterwelt im 'Parzival' Wolframs von Eschenbach," in: *Germanistik in Erlangen*, ed. D. Peschel (Erlangen, 1983) 61–73.

similar tactic of contrast and expectation, Isolde's council preparatory to the ordeal falling in May, the month of gaiety and mirth. The literary season-convention resonates from hollowness, as the heroine (and the reader) are estranged from the traditional *temps courtois*. But where is King Arthur in *Tristan*? Scenic parallelism presents itself, as we realize that the protagonist in *Parzival* has the opportunity to meet the king, whereas the lovers in *Tristan* encounter King Mark.

Whether we witness here the parody of a parody, Wolfram and Gottfried reacting to each other as well as to the traditional Arthurian romance, is not crucial. The reader of *Tristan* is confronted, however, by the indisputable facts that the judicial assembly falls during a time firmly associated with Arthurian romance, and the ordeal takes place at *Carliune* (15531; 15766), the Caerleon-upon-Usk where King Arthur customarily holds court. One wonders how much of an accident it is that this subtle chain of tableaux is imbued with Arthurian echoes. At the very least, the narrator is signalling—through parodic discourse?—that the ordeal, as in the French tradition, will have a happy romance ending.

Gradually a narrative circle suggests itself, a story pattern involving frame scenes, which have the character of diptychs. Early in *Tristan*, as noted, King Mark organizes and presides over a spring celebration, occurring in May. Rivalin, Tristan's father, takes part in the knightly sport and revelry. Later Mark orchestrates Isolde's ordeal, the council taking place in May. Tristan carries Isolde ashore at Carleon (!) and thus provides justification for her version of the oath. Completing the spatio-temporal pattern, the narrator observes in the earlier scene that Mark summoned men to journey "from the kingdom of England to Cornwall" (530–532), while in the later scene the movement is from Cornwall to England (15308 ff.). A reinscription in circular form, the environmental surface thus draws our thinking to parallel tracks. Mark's arrival at the ordeal allows us to penetrate further the level of rhetoric Gottfried is deploying. The narrator guides the reader to the relation of the episode to Arthurian romance when, using phraseology consonant with it, he states: "With much banter about this bold rogue [Tristan/pilgrim] they set out towards Carleon" (15630–15633).

The recurring May-scene suggests that there is symbolic linkage between the two episodes and the two kings as visual analogies. Mark and Arthur emerge as iterative images, whose interconnectedness to each other is expressed, in one important way, in their relationship to ceremonies. Even as each is impressario and arbiter of disputes, each is celebrant and man of May.

Gottfried's Mark is a composite figure, formed from generous borrowings from Thomas. It will therefore not do to reduce the king to a single type. Still, the emblematic staging of rituals with its implied transvestitures permits the conclusion that King Arthur presents a model for King Mark. The figure of the great king retains its significance in a new setting, for ceremonies and celebrations reveal Arthur and Mark, in a form of masque genre, to be the masters of revels. And each is avowedly the epitome of courtesy. Assuming adroitly camouflaged narrative technique, it is thus only partly accurate to state that Arthur is supplanted, during the ordeal-episode, by God, Christ and the bishop.[18] There is a fourth, a man who polite society says is "noble [*höfsch*] and distinguished" (421)—Mark. He, too, is Arthur's surrogate. The organizer of the May-festival and the agent of the ordeal sets aside any doubts and suspicions about Isolde after her trial by hot iron, judging her innocent in his mind (15751 ff.). The poet seems to draw here on the traditional qualities of King Arthur—his loyalty, faith, tolerance and flawed powers of discernment—and heightens these traits until, in Mark, they become spiritual blindness and simple gullibility.

Now the absence of King Arthur during the ordeal is accounted for. Gottfried does not merely follow his main source in this poetic regicide. In a symmetry of inversions, Arthur is not truly absent, but playfully introduced in the costume of another king—of England! This masque ritual rivals any disguise of Tristan's, and the parodic ambition equals Wolfram's, both reliant on the knowledge and expectations of sophisticated readers. We are in the presence of a poet who also seeks to outdo his model text, which implies that Arthur the giant-killer is

18. See Ulrich Mölk, "Die Figur des Königs Artus in Thomas' Tristanroman," *GRM* NF 12 (1962): 100–101.

Tristan's symbolic relative. Speaking of Thomas, Joan M. Ferrante has said: "By implication, Arthur replaces Mark as Tristan's proper uncle, and Tristan is the heir to Arthur's glory."[19] In Gottfried, Mark retains his place as Tristan's uncle and usurps Arthur's function, thus making himself "heir to Arthur's glory."

Such glory is indeed hollow in Tristan, since it is expressed in emphasis on aspects of public show, the trappings of knighthood, festivals, sport, external convention, royal vacillation and courtly intrigue. This is hardly an edifying picture. To examine the ideological concerns of Mark's court, Gottfried resorts to parody, irony and caricature. But these are not restricted to the society of Mark. Above we observed how the overall intention of Tristan is opposed to that of Arthurian romance: Gottfried rejects the central premises of traditional courtly literature, offering competing perspectives to its social texture, ethic of marriage, idealism and to its fundamental optimism. Insofar as King Arthur testifies to the rightness of his ideology and coheres with the generic tradition, the poet challenges any idealization of the Arthurian court (at Carleon?) as well as the classical Arthurian romance itself. Both kings occupy him as a symbol for spiritual disharmony—hardly as a model of civilized behavior.

In the light of the affinity that Arthur enjoys with Mark, Gottfried's stance is not the mere intellectual remove from the Round Table that his fellow poets display. Rather, he mounts, through association, an assault on the court of Mark, seeking to delineate the inadequacy of its example to human desire and to controvert its manners and morals. There is more. By virtue of Gottfried's clever allusions and parallels when framing the dimensions of Isolde's ordeal, one is prompted to perceive the episode in terms of emblematic staging, namely as a type of courtly (Arthurian) spectacle. The ordeal as festive holiday? Isolde, in the festival setting of the *temps courtois*, marching in a triumphal procession and engaged in the game-playing of a mock trial? There is precedent, we recall, for the trial of the

19. Ferrante, *The Conflict of Love and Honor* 17.

heroine in the context of court revels: Béroul's *Tristan*.[20] In this poem the jousts and merrymaking of Arthur and his men (Tristan also jousts) place the ordeal on an axis of knightly pageantry signalling, by virtue of its celebratory air, that the event will have a joyful ending.

The same holds true for Gottfried's poem. The ordeal has a happy, indeed joyous, conclusion, and Isolde (soon to be joined by Tristan) experiences a societally approved reintegration deeply nourished by romance convention. As for Tristan, the narrator soon notes that "the King and his court and the land and its people all held him [Tristan] in high esteem, as before. He had never been shown greater honour at court . . ." (16312– 16315). These key terms, joy and honor, connote, when combined with courtly ritual, the folly of the lovers' return to an alternate world which cannot claim their allegiance. Soon, in this web of irony, it becomes clear that courtly bliss cannot last. The victory of Tristan and Isolde, more apparent than real, is Pyrrhic, for the happy ending—and their honored place in society—have only temporary duration. No harmonious conclusion is permitted the lovers, whose flouting of courtly codes and practices nourishes a love that is socially destructive. The result is parting, the very opposite of the romance solution, and death.

The only direct allusions to King Arthur appear, as noted, in the episode "The Cave of Lovers," a vignette which, in its allegory of the cave, marks a clear departure from Thomas. Arguably the most-discussed aspect of Gottfried's poem, the place has a profound function relative to theme and structure which we can only touch on in these pages. Suffice it here to say that the Cave of Lovers fully demonstrates the role of narrative setting in defining the protagonists' relationship to society and to its depiction in literature. Mark inaugurates the scene by his avowal that he will no longer endure dishonor for the behavior of Tristan and Isolde. The king says, "This fellowship between the three of us can hold no longer; I will leave you two together . . . Go, the two of you, with God's protection. Live and

20. See Alberto Várvaro, *Béroul's 'Romance of Tristran'* (Manchester, 1973) 95 ff.

love as you please: this companionship in love is ended!"
(16607–16620).

Thus banished from court, the lovers and Curvenal,
Tristan's tutor and friend, traverse forest and heath until they
come to a cavern in a savage mountainside. The narrator's
allusions to this cavern as the former refuge of giants when
taking their sexual gratification (16692–16696) establishes a
subtle Arthurian background. For one thinks immediately of the
giant in the poem of Thomas whom King Arthur, in anticipation
of Tristan's similar act, slays.[21] This rapaciously cruel man lived
in a cave and abducted a woman. But the echoes in Gottfried
remain muffled, for he does not directly link the giants to Arthur
as giant-killer. That function falls to Tristan himself, who, as
noted, dispatches the giant Urgan in the episode separating
Isolde's ordeal and the lovers' banishment from court (15915 ff.).

Formal references to King Arthur and the Round Table
function within a didactic scheme: Eckhard Höfner[22] has
classified the overall form as the rhetorical technique of
outdoing or outbidding, "Überbietung," which is distinguished
by comparisons to the benefit of the lovers. The narrator
anticipates audience incredulity over the sustenance of Tristan
and Isolde in the scene, observing that "some people . . . plague
themselves with the question how these two companions,
Tristan and Isolde, nourished themselves in this wasteland?"
(16807–16812). The answer is that "they fed in their grotto on
nothing but love and desire. The two lovers who formed its
court had small concern for their provender" (16819–16823).
Next, he comes to speak of the lovers' isolation. "Their company
of two," the narrator states, "was so ample a crowd for this pair
that good King Arthur never held a feast in any of his palaces
that gave keener pleasure or delight" (16859–16865). Before the
next, and final, open reference to King Arthur's court, the
narrator makes it clear that, even in a state of separation from
polite society, the lovers are concerned about their reputation:

21. Thomas, *Tristan*, ed. G. Bonath (Munich, 1985): *Sneyd Fragment*,
v. 712 ff.

22. Eckhard Höfner, "Zum Verhältnis von Tristan- und Artusstoff
im 12. Jahrhundert," *ZFSL* 92 (1982): Table, 322.

"They would not have given a button for a better life, save only in respect of their honour" (16875–16877). Returning to the topic of sustenance, the text continues, "Their high feast was Love, who gilded all their joys; she brought them King Arthur's Round Table as homage and all its company a thousand times a day!" (16896–16901).

The Round Table, the prototype of communal courtly life, is counterpointed, if not opposed by the community of two, Tristan and Isolde. Arthur's company is identified with high courtly custom, specifically with the merry feast, a link to bliss that is reflected in the epithet Gottfried grants the king: *saelic* (16861), that is, "happy," "blessed," "kind," or "bliss-bestowing." But Arthur's world of bliss is surpassed by the lover's own ecstasy which, as a private code of devotion flourishing in exile from court, is paid fealty by the Round Table. The paradoxical structure here constructed indicates the unequivocal contrast between the courtly community and a loving pair, courtly bliss and the bliss of the lovers, the court and nature, and between festivities of the court and the celebration of affection. We can agree with James A. Schultz that Gottfried mentions Arthur "in connection with the well-known Arthurian *hochzit* ["festival," "celebration"], in order to have a recognized standard of *vreude* ["gladness," "joy"] against which he can measure the much greater *vreude* of Tristan and Isolt. . . . "[23] To reconcile the split in the lovers' morality from that of the court, as well as to point to the physical and emotional separation of Tristan and Isolde from the courtly system of values, Gottfried chooses the loaded word "bliss" and grants it two meanings, the joys of the lovers emphatically set apart from the joys of the court—and the Arthurian romance.

The German Arthurian romances usually cited to help explain Gottfried's allusions to King Arthur's court are *Iwein* (c. 1205) and *Erec* (c. 1185) by Hartmann von Aue. The first of these contain the verses:

> During the feast of Pentecost,
> In customary grandeur,

23. James A. Schultz, *The Shape of the Round Table: Structures of Middle High German Arthurian Romance* (Toronto, 1983) 29.

King Arthur
Had proclaimed such a magnificent festival [*hochzit*]
At his residence at Karidol
That nothing before or since
Ever rivaled it. (31–37)[24]

Again commenting on the unequalled grandeur of Arthurian society, the narrator claims:

For, of course, nothing was its equal,
Nor is it possible that
Anything on earth could
Begin to compare with it. (2659–2662)

Gottfried's point is that, Hartmann to the contrary, the Round Table can be rivaled, indeed surpassed.[25] In the battle of contending absolutes, the lovers outshine the Arthurian world. Even nature contributes to the outdoing, for the forest is no Arthurian woods where the knight suffers alienation from the court, but is a happy spot adjacent to the *locus amoenus* where Tristan and Isolde enjoy their isolation. Such rhetorical twists presuppose of course an audience familiar with the conventions of the traditional romance.

Among these conventions is love-service, which appears in exaggerated form in *Erec*. Erec's final adventure, "Joie de la curt," involves his battle with Mabonagrin and the restoration of courtly joy. Mabonagrin lives an antisocial life, held in bondage to a love-ideal that deprives him of free will and separates him from courtly society. Hartmann's disapproval of such isolation is conveyed in the line, "It is very nice to be with other people" (9438).[26] Gottfried makes himself a deflator of this cliché drawn

24. English translation by P.M. McConeghy (New York, 1984); line numbers from the edition by Benecke and Lachmann (Berlin, 1964).

25. Petrus W. Tax, *Wort, Sinnbild, Zahl im Tristanroman*, 2nd ed. (Berlin, 1971) 120–121. See also Kunzer, *The 'Tristan' of Gottfried von Strassburg* 164–165.

26. English translation by J.W. Thomas (Lincoln, 1982); line numbers from the edition by L. Wolff and A. Leitzmann (Tübingen, 1972). See Green, *Irony*, esp. 119; and Gerhard Schindele, *Tristan: Metamorphose und Tradition* (Stuttgart, 1971) 80 ff.

from Arthurian tradition, converting the separation from court into an ideal of love on the nonconformist example of the lovers: "Nor were they greatly troubled that they should be alone in the wilds without company" (16847–16849). Seclusion from court thus appears in a new aspect, revaluated positively as a contrasting philosophic attitude to that found in Arthurian romance. This reversal of courtly ideology underscores the antithesis between love and society that informs *Tristan*.

Reading the Cave of Lovers against the backdrop of Arthurian romance, we see that the metaphors and thematic echoes betray sufficient structural meaning to infer that they were consciously drawn. The aim is not the confirmation of Arthurian ideology, or its prestige, but the opposite. To this radical emendation of romance matter we can add the evocation of comparisons of Tristan with Chrétien's *Lancelot* and *Yvain* and the presence of vocabulary which hearkens back to the Arthurian world.[27] The very term *wunschleben* ("perfect way of life," "ideal existence"), which in Hartmann's *Iwein* characterizes the life at Arthur's court (44), describes in *Tristan* the gift love bestows in the Cave of Lovers: "Love . . . gave them an abundant store of all those things that go to make heaven on earth" (16842–16846). (The court of King Arthur, as described in *Iwein*, is again evoked in the May festival scene at King Mark's court, where the description of courtly joy is similar.) As well, Gottfried attempts to create a type of adventure which is sharply delineated from romance models. Jaeger describes the tradition well: "The knight of Arthurian romance finds his destiny alone in the forest of adventure, facing adversaries natural and supernatural, whom he overcomes by his strength, knightly prowess, and constancy" (254). Systematically bringing into focus the disparities between the conventional questing pattern and adventures in *Tristan*, Gottfried expands the solitary quest to a dual expedition, and then couches the courtly virtues in a new frame, excellence in loving. The nuances of courtly romance serve therefore through opposition to define the character of Gottfried's love-ideal. In an elaborate parody, known fully to an

27. See Krohn, *Gottfried von Strassburg*, 3: 249–250. Cf. Kay, "The Tristan Story" 186 ff.

initiated readership only, he both strips away the figurations of convention and enhances the lover's stature, claiming our sympathy through implicit contrasts with the Arthurian code. Tristan and Isolde, living in a form of prelapsarian perfection, surpass, and therefore have no need of, the Round Table.

Granting Gottfried these qualities of vision, which extend to an "allegorische Gegenposition"[28] relative to love in Arthurian romance, as well as to the technique that Karl D. Uitti[29] has called in another context "parallelism-in-reversal," we still have not exhausted the dimensions of his use of counter-ceremonies and counter-texts. For, embedded in his imitations and parodies of courtly romance, is the willful misrepresentation of a key text against which *Tristan* begs to be compared, Hartmann's *Iwein*. Verses from it, we recall, provide the basis for reversal in *Tristan*: the narrator of *Iwein* claims that nothing rivals Arthur's festivals and that nothing can compare with the hospitality and enjoyments of the Arthurian court (31–37; 2659–2662). But the story proper portrays a clash between the idealization of Arthur's court and the realities of the Arthurian, courtly separation, as Gottfried was certainly aware. Already in Chrétien's version, the stature of Arthur, "li buens rois de Bretaingne" (1),[30] is called into question. His poem documents, in the words of Green, a "changing attitude towards (or growing detachment from) the ideal of Arthur's court . . . In *Yvain* Arthur has been ousted from his position of unique authority by the function of Laudine's court, and it is at this new centre that the action of the romance is now concluded" (315). Green adds his voice to the increasing chorus of opinion that Hartmann follows his source by maintaining a distance from the Arthurian ideal.

For Hartmann, King Arthur is, contrary to the laudation of the Round Table here cited, by no means perfect in his ethos. He is essentially impotent, his characterological aspects negatively

28. Schindele, *Tristan* 80.

29. Karl D. Uitti, "Le Chevalier au Lion (Yvain)," in *The Romances of Chrétien de Troyes: A Symposium*, ed. D. Kelly (Lexington, KY, 1985) 224.

30. Chrestien de Troyes, *Yvain*, ed. I. Nolting-Hauff, 2nd ed. (Munich, 1983).

drawn in respect to pacification and defense of the oppressed. And his court, filled with ineffectual knights subject to *superbia*, is at war with itself. The discrepancy between the narrative commentary and the plot is, in fact, so great that critics speak of an unreliable narrator.[31] Subject to ironic undertones, in the light of disparities between the ideal and the real, are the concepts of justice, reputation, virtue, the recognition of virtue, right and wrong, as well as courtly behavior in general. Arthur's court will have to recognize that Iwein is the model for it—and not the reverse—and must publicly admit to its shortcomings. Hartmann undermines the entire set of implications of Arthurian adventure, even as he subjects the rigidly formalistic Arthurian world to scrutiny. The Round Table, a storybook world of stasis, is deficient in the very ideology that it proclaims, which is signalled by Iwein's final departure. Robert E. Lewis describes this act as freedom from "the limitations of the Arthurian court."[32] Having progressed beyond the superficial system of conventions and externals of the Round Table, the hero, now at a higher state of knightly virtue and altruism, leaves the Arthurian circle to find reconciliation at another court. Rehabilitated, he learns to reconnect himself to civilization, but the reintegration—and the humanity—that he seeks do not reside in Arthurian society. In sum, *Iwein* holds sufficient criticism of Arthur's court for Patrick M. McConeghy to make the following, generally accepted, assessment: ". . . the Arthurian values and concerns are being called into question by the poet [Hartmann] and . . . the hero's failure in Part One is related to his adherence to those values."[33]

What does this all imply for Gottfried's direct allusions to King Arthur in the Cave of Lovers episode? The poet grants proper deference to King Arthur as an ideal, sketching a conventional silhouette of a carefree, Panglossian society which incorporates the standards of excellence for knighthood. But he

31. Cf. Hartmann von Aue, *Iwein*, ed. and trans. Patrick M. McConeghy xxxii.

32. Robert E. Lewis, *Symbolism in Hartmann's 'Iwein'* (Göppingen, 1975) 101. See also 59 ff.

33. McConeghy, *Iwein* xxii.

frames his affirmation of the prestige of the Round Table in clear echoes for a German Arthurian romance, *Iwein*, which systematically undermines the view that Arthur's court is the fullest expression of an ideal community. Similarly, the thematic reminiscences of *Erec* cast the tradition in a negative light, showing the inadequacy of romance values for the lovers. The result is literary criticism and reader disorientation in the very process of orientation, for the absolutes against which the status of Tristan and Isolde is measured prove, ironically, to be no absolutes at all. For the moment, then, Gottfried wryly acknowledges the status of the Round Table, which has sufficient romance stature to evoke high literary tribute, for example, in portions of *Iwein* which we have cited. Thus having secured a precarious balance between the ambivalent status of Arthur's court and the lovers' "court," he sets the civilized ideal of the former against the embodied dream of the Cave of Lovers. There, in the almost utopian scene apart from society, Tristan and Isolde live out an ideal of earthly love in the absence of, and in superiority to, the Round Table.

Fundamental to Gottfried's achievement is the evocative exploitation of Arthurian romance, as noted repeatedly. Whether this substructure is exposed in reversals of convention or in the use of stock figures, for example, the Irish seneschal as the counterpart to Sir Kay, the traditional romance supplies correlates and a point of view. Scholars are in general agreement on the "generic ambiguity"[34] of *Tristan* as well as on the presence of structural interconnections. But they hesitate to acknowledge the analogies between King Arthur and King Mark, even though such a comparison is fruitful. There is a strong suggestion that the two kings are cast as complementary figures, the most immediate inspiration for the distinct resemblances deriving from *Iwein*.

Jackson's critical approach is typical. Although he recognizes that the conventions of Arthurian romance provide the milieu for Gottfried's "work—and the lower level of culture

34. See esp. Kathleen J. Meyer, "Allegory and Generic Ambiguity in Gottfried's 'Tristan,'" in: *Genres in Medieval German Literature*, ed. H. Heinen and I. Henderson (Göppingen, 1986) 47–58.

and love above which his own characters must rise"[35]—he excludes the possibility that Mark and Arthur are unified in aspects of characterization. In identifying Mark as the most important representative of non-Tristan love, Jackson maintains: "To have made Mark into a figure corresponding to Arthur in the Lancelot-Guinevere story would have defeated his purpose, for he does not wish the king to be a despicable figure."[36] In fact, the Lancelot parallels to the Tristan story are very strong and have been consistently commented upon.[37] That Lancelot bows to the principles of courtly love-service only highlights the opposite response of Tristan; in any event, the inference that such parallels (or their reversal) are possible directs attention to the links between *Tristan* and Arthurian romance—a social framework joining Arthur and Mark becomes distinguishable. More useful is the comment by Rosemary Morris that "[i]n *Lancelot* Arthur has no spiritual resources to deal with the Meleagant crisis."[38] And this is the point: Arthurian society can no more solve problems than Mark's can.

Each ruler, situated in a cultural milieu in which he is the victim of connubial infidelity, is prey to human frailties and imperfection. The value system of each, constrained as it is by the spiritual limitations of the king, is inadequate to the narrative situation. Jackson recognizes the failings of Arthur, as when he observes: "The king who appears in the romances often seems incapable of putting such values [the values which the knights observe] into practice. . . ."[39] But then Jackson, summarizing the prevailing opinion which seeks to see antipodes in Arthur and Mark and which elevates the former at the expense of the latter, claims that Mark "has no achievements,

35. Jackson, *Literature of the Middle Ages* 151.

36. Jackson, *Anatomy of Love* 99.

37. Xenja von Ertzdorff, "Tristan und Lanzelot," *GRM* NF 33 (1983): 21–52. See also Kunzer, *The 'Tristan' of Gottfried von Strassburg* 106; and note 27.

38. Rosemary Morris, *The Character of King Arthur in Medieval Literature* (Cambridge, 1982) 123.

39. Jackson, *Anatomy of Love* 164.

172 William C. McDonald

he has set no values" (164). To challenge this widely credited
idea, it is only necessary to point to the glorification of Mark in
the Rivalin episodes. How is it possible that "no king was so
esteemed" (453) as Mark, if he had not accomplished anything?
The climate of Mark's court, as of Arthur's, is surely redolent of
the monarch himself, who gives structure to the social fabric of
his world. Indeed, Mark sets values, but these are not shared by
the lovers. It is not against a beliefless system that they struggle.
Rather, the hermetic circle which is Mark's society is unable to
create a locus spacious enough to house the love of Tristan and
Isolde. In response to a constricting system of courtly standards
which cannot accommodate their passion, the lovers' response is
necessarily adversarial.

A very recent attempt to come to terms with the
connections between Gottfried's *Tristan* and Arthurian romance
is revealing, both for its recognition of the imprint left by
Arthurian fiction and for its customary reluctance to observe the
interaction of the two ruler figures who, in a series of echoes and
responses, are connected through a type of doubling. Kathleen J.
Meyer recognizes that *Tristan* fulfills—on the surface—many of
the features of Arthurian romance.[40] Thus framed, however, the
story, which has a very complex relationship to literary
forerunners, offers a radical reversal of the structure of the
courtly romance at the same time it ironically undercuts the very
values nourishing it. But, having confirmed that a parodic attack
on the conventions of the genre is in view, Meyer concludes:
"Outside of this fleeting reference [16859–16865], Arthur plays
no role in *Tristan*. What does function as a geographic center for
the poem is the court of Mark" (49). Of course Mark's court is
the center. To assume, however, that Arthur "plays no role" on
the basis of verbal categories alone is to ignore the subtle
parallels Gottfried constructs which, consistent with the multiple
meanings and levels of *Tristan* in general, class Mark's court
with Arthur's.

In recognition of Gottfried's manipulation of romance
conventions and the interchange he permits between Tintanjol
and Carleon, we have suggested that the noble and

40. See note 34.

distinguished King Mark, bestower and defender of knighthood, arbiter and organizer of festivities, shows a likeness to King Arthur and that both figures, men of May, exhibit failings making their courts unworthy to be held up as a model for the protagonists. Gottfried further encourages the assessment of the two rulers as complementary by joining the topography of the May-festival to the landscape of the Cave of Lovers.[41] This emblematic union asserts itself again when Mark and his huntsmen pursue a white stag which leads them to the cave (17283ff.)—Arthur's Custom of the White Stag in new guise? It is hard to suppose that these correspondences are entirely coincidental. The role of King Arthur is, in any event, neither minimized nor restricted to a "fleeting reference" in *Tristan*, a reference which, with its allusions to feast and festivities, can be read in the spirit of both the Arthurian tradition and that of Mark's court.

What disturbs Meyer is that, while the moral values of Mark's court provide to some degree a standard for Tristan and Isolde, this standard is "transformed by Gottfried's irony to a sort of anti-standard" (49). She accurately remarks that Mark's court is depicted, at the beginning, "in glowing terms" (49); this is the blissful place that Rivalin seeks out and to which Tristan is drawn. But, while willing to concede that "initially the court seems to function similarly to Arthur's court in other romances" (49), Meyer is adequately troubled by the adversary relationship of the court to Tristan to abandon her parallel. She is bothered that "the values attached to the court are constantly undermined and placed in questionable light by its relation and interaction with the two lovers" (49). This observed failure of the court to nourish and recognize the protagonists is not restricted to Tristan, however. Researchers increasingly isolate "Criticism of the Court" as a tendency in romance.[42] It is not necessary to

41. Bodo Mergell, *Tristan und Isolde: Ursprung und Entwicklung der Tristansage des Mittelalters* (Mainz, 1949) 135; Schindele, *Tristan* 82–83. See also Rosemarie Marquardt, *Das höfische Fest im Spiegel der mhd. Dichtung* (1140–1240) (Göppingen, 1985) 98–99.

42. Horst P. Pütz, "Artus-Kritik in Hartmanns *Iwein*," *GRM* NF 22 (1972): 193–197; Green, *Irony* 306ff.

search far for a text placing a court bent on fame and joy in direct relation to social vices which this attitude encourages. The poem is *Iwein*, an Arthurian romance to which Gottfried invites comparisons, as we have seen. *Iwein* situates the hero in an adversative relationship with courtly standards and casts the king's values in questionable light.

It is possible to see how *Iwein* and *Tristan* relate to one another in respect to courtly culture when reading Lewis's sketch of the former. He is speaking of King Arthur's court, but could just as well be referring to King Mark's: "At the beginning of 'Iwein' the Arthurian court is presented at the apparent height of its glory. Everything that characterizes the excellence of courtly society is present in abundance: food, jousting, music, literature. But the court is flawed" (83). To be sure, the story of *Tristan* does not aim to recreate the plot line of *Iwein*, but patterns involving the rulers are concentric. Each tale holds a description of a glittering court of gleaming exteriors which slides into saturnalian mirth. A scene of peacetime prosperity is sketched—a world of apparent perfection preoccupied with frivolity, festive pastimes and ostentation. What begins in the manner of hagiography soon dissolves, however, into a portrayal of the sunset of the royal society, as achievements of the kings are shown to be fleeting. The bifurcation of the regent figures proceeds according to a coherent design: even as the gracious and noble King Arthur is separated from the glories of the spring-opening, so, too, the esteemed King Mark is removed from a laudatory setting. Neither can disguise the weakly maintained hierarchical order for which he is ultimately accountable.

Although Mark and Arthur are in some respects praiseworthy, their good qualities are negated by their inadequacies. Both exhibit failings which reveal the corruption of values at court and which make manifest neither is the teacher of prowess and courtesy that he pretends to be. Each political system suffers from flaws, for instance, in its deficient responsibility to the individual. And each ruler fails as the ideal prince exemplar of order and, consequently, as an adequate symbol for the ruling elite. It is not so much that the kings depart from the early ideal as it is that their courtly codes prove

inadequate to the protagonists. The auctorial message is conveyed through irony: neither symbol of rule possesses the discriminating sensibility to separate appearance from reality.

The consequence is an embrace of the artifacts of institutionalized courtliness, which brings in its train a deficient appreciation of the hero's interior qualities. What unites the poems is the realization, over the course of the narrative, that the monarchs are reduced in stature even as their societies evince a proneness to self-deception. Each king is shown to be essentially passive and ineffectual, reluctant to depart from the rigid and superficial ethos which he has constructed and for which he is representative. Seeking to bestow their civilization on the hero, the merry men of May await a reintegration. But neither recognizes that the hero has progressed beyond their narrow and ephemeral code of courtly externals and that this code constrains his actions to the degree that he perceives it to be a repressive force.

It is instructive here to compare the endings of *Iwein* and *Tristan* and to point to the pattern of entry and departure in the latter, for each contributes to an appreciation of Gottfried's mediations on Arthurian convention. "Of all the Arthurian romances," Schultz has said, "*Iwein* has the most unusual ending. There is no celebration either at King Arthur's or at the hero's home . . . Instead Iwein sets off for the magic fountain, just as he did at the beginning of the romance . . . " (129). The text states that the hero slips away from Arthur's retinue "so that no one at court / or anywhere else was aware of it" (7806–7807). Iwein therefore denies King Arthur his ceremonial role as the pronouncer of benediction and the sanction-giver of reconciliation, choosing instead the approbation of his lady, who is both the true goal and terminus of his quest.[43] The ultimate power for heroic change and transformation rests with her. "I presume," Hartmann's narrator says, " a good [joyous] life was lived here [at Laudine's court]" (8159). The happy ending of Arthurian romance is disaffirmed by *Tristan*, of course, and is replaced by the tragic ending preordained by the plot.

43. Cf. Volker Mertens, "Artus," in: *Epische Stoffe des Mitteralters*, ed. V. Mertens and U. Müller (Stuttgart, 1984) 305.

Gottfried's poem breaks off during the episode of Isolde of the White Hands, so we cannot know what resolution he had in mind. Assuming that he followed Thomas, the final scene involves the lovers' deaths.

The tragic ending points by contrast to what Schultz has called the "beneficent teleology of Arthurian romance" (129), and is therefore a poetic refutation of courtly harmony and bliss. Beyond this, *Iwein* permits a final assessment—by comparison and contrast with the Round Table—of Mark's court. At the conclusion of the romance, Arthurian society shows a willingness to admit its error, to right wrongs and to follow the model of the enlightened hero. The point is made that Arthur's court does not undergo a transformation, since this would require a reorientation of the court and its concepts of knighthood. Nevertheless, some recognition of its limitations is present. The romance therefore sets up expectations that Mark's court, while incapable of radical modification and essentially as unchanging as the Arthurian world, will experience some form of self-awareness—and contrition—that is beneficial to the protagonists. It does not, however, admit guilt. To do so, would of course imply the recognition of a new morality, individual rights as opposed to conventional norms.

The situation of the monarchs and their courts is therefore essentially the same. Each society is contoured with a fixed, emblematic simplicity, but the Round Table exhibits greater flexibility and the recognition of the hero's claims. Bitter realism replaces romance sentimentality in *Tristan*, for Mark does not abandon his rigidity of attitude. His posture, when measured against that of the king to whom he bears resemblance, casts the fixed social order of his court in a still greater negative light. Once again we see how Tristan interacts with Arthurian romance: momentarily the two heroes, Iwein and Tristan, share behavior in the face of kingship, but then their paths diverge radically. Tristan flees Mark, royal society—and death (18421), slipping away from court even as Iwein does. The flight of Tristan is structurally pertinent, in that it represents a mordant play on the German Arthurian romance. The last episodes of *Iwein*, *Erec* and *Parzival* take place, we recall, outside the royal court. Whereas Iwein's hasty retreat from Arthur ends in

reconciliation with his beloved away from the Round Table, Tristan's escape from Mark results in the forfeiture of both lady and "counter-court" where the two could live. No more than Tristan can bring about the communal clarification and renewal of the romance hero can he claim a court outside the royal sphere. Narrative structure is therefore a functional expression of theme: through the loneliness of the hero, separated from court, Gottfried asserts his point of view.

Tristan is allotted no equivalent of the court of Laudine, no Karnant or Grail castle to which he can repair. Parmenie is one station on his restless path, but it holds equal place with Germany and Arundel—all are absent of Isolde. Tristan's boon, after his reintegration into society and failed reconciliation with Mark, is memory: Tristan and Isolde have already celebrated the harmony of union at the counter-court that is the Cave of Lovers. They must console themselves with the rewards of irony and with retrieving the junction of self and other in their minds. If the lovers are unable to experience the joyful ending of the traditional romance, Mark, too, cannot enjoy the limited rehabilitation and recovered lustre of a man who, by virtue of repetitious structures, constitutes a complementary type—King Arthur.

A feature of the romance terrain that *Tristan* traverses is the pattern of departure from and return to the royal court. A prominent structural feature of Arthurian romance is, as is well-known, the separation of the hero from courtly society and subsequent felicitous reintegration into that society after his rehabilitation on knightly adventures. Beneficiary of the hospitality of the royal court, the hero can, according to one variation, progress beyond it to rule his own community. *Tristan* is punctuated by absences of the hero from court, but these do not interest us here. Rather, we note that twice (a play on the Arthurian "Doppelweg"?) the narrative vividly constructs scenes of Tristan's parting from court and his return to joy and honor. Balancing departure and return, Gottfried acknowledges a world of symmetries. These actions, while echoing romance structure, place, however, the string of adventures through which the hero passes in ironic light: they are no traditional tests

of prowess, expiatory sacrifices or the overcoming of a flaw, but rather adventures aimed at a union beyond flesh.

Tristan's departure from court at the ordeal scene is, as noted, followed by his return to societal honor (16312 ff.) The narrator comments on Tristan's acclaim at court; bestowed by Mark's retinue, it is "honor without honor" (16332). A similar tableau is sketched at the conclusion of the Cave of Lovers, where the lovers are welcomed into Mark's society. (These episodes, whatever the king's motivation may be, do not permit Schultz's blanket assessment that "Marke's court seeks disintegration" (30). In his welcome of the pair, Mark permits the integration associated with King Arthur.) Tristan and Isolde return to court, upon the request of the king, for the sake of God and their honor (17698). They are determined to recover societal honor (which was of course absent in the Grotto), perhaps believing that they can now love within courtly society.[44] Thus, Tristan and Isolde willingly reenter the external world, the "real world" of the existing social order, the royal court. Their return to a decadent environment of flawed social values provides a shocking denouement; the poet emphasizes continuity, however, revealing this homecoming to be as evanescent as the previous reconciliation of the lovers with society.

The self-deception of Tristan and Isolde, which brings inescapable repercussions, is signalled by the presence of that familiar term, *vröude*. This emotion is one with the joy that has been called a topos for life at the Arthurian court. The lovers are glad to return (17694 ff.), and Mark is happy once more (17723). Like Erec and Enite in the episode "Joie de la curt," Tristan and Isolde restore the court to joy: there is general rejoicing over their restored honor. But the irony hangs heavy as the reader realizes that there is no balance here between love and chivalric reputation, as in *Erec* or *Iwein*, nor is Tristan-love conceived as bringing benefits to society. The bliss of Mark's court, grounded as it is in conventional morality, is therefore illusory—and a confirmation of the superficiality of the king's ethos. The social

44. See Bekker, *Gottfried von Strassburg's 'Tristan'* 264 and Herbert Herzmann, "Warum verlassen Tristan und Isolde die Minnehöhle? Zu Gottfrieds 'Tristan,'" *Euphorion* 69 (1975): 219–228.

fame of his court is the acclaim and recognition of ceremony, revels and illusion—honor without honor. Ruth G. Kunzer speaks of pseudo-*ere*, which accurately describes the nature of royal honor.[45] But then she applies it to the Cave of Lovers, arguing that the lovers enjoy there "the pseudo-*ere* of the quasi-Arthurian society in the terrestrial paradise" (181). We would argue that the "quasi-Arthurian society" of *Tristan* is Mark's court itself and that its honor is false; this "ideal" is for those who believe themselves as nothing in the eyes of others without reputation.

The balance between true and false honor cannot hold, for the social repute after which Mark strives is not accordant with the concept of honor to which Tristan and Isolde subscribe. Their abrupt return from an Edenic, quasi-utopian realm to a fallen world of inverted values is therefore an ingress to court that causes their lives to leach away into separation and defeat. Although frustrated by the contradiction between membership in the royal society and the personal freedom resting on internal honor that their love demands, the protagonists are unable to interpret the host of auguries which their situation provides. They fail to see that the pursuit of courtly honor is incompatible with the fulfillment of a sexual love cutting them off completely from this very honor. The message is that Tristan and Isolde find themselves in romance territory—the *pays d'Arthur/Marke*—without the armament of their literary counterparts. Accordingly, any attempt at insinuating themselves into the Arthurian frame is doomed to failure.

A final punishment befalls the lovers. Having accepted the felicitous reintegration into society characteristic of the romance, Tristan and Isolde are trapped in a shallow and materialistic milieu that functions as a coercive state apparatus. Courtly surveillance breeds new suspicions. The persistently ironic attitude towards their situation is made consonant with their striving for social position: public as is the lovers' assimilation into society, public prurience removes their newfound status.

45. Kunzer, *The 'Tristan' of Gottfried von Strassburg*. See notes 10 ff. Cf. Karl Bertau, *Deutsche Literatur im europäischen Mittelalter* (Munich, 1973) 2: 954 ff.

The recovery of the pair is revealed to be only apparent and a fragile, provisional resting point, the terminus of which is the hurried departure of the hero from Mark's court. Tristan is now the outcast.

The hero's separation from the royal court is, as the structurally comparable act of Iwein shows, a romance solution. Before he flees, Tristan, like the Arthurian hero, has successfully reinstated himself, his position secured by an honorable return to society. Just as his absence caused unhappiness, his return to society effects festive joy. According to the general outline of the romance plot, Tristan's return would signal the termination of the quest and allow the poem to be brought to a joyful ending. However, the expected closure does not come, as it does following the blissful reconciliation of Iwein, or the benediction and return home of Erec. There is no potent finality; instead, defying the expectations of the genre, Tristan has the hero embark on new "adventures."

Gottfried's pattern of ingress and egress, as well as his manipulation of the concept of courtly honor, convey the subtlety of experimental design. They draw on the same well of emblematic staging that we have seen in the Arthur–Mark parallels and suggest again that he is attempting to divert Arthurian romance to a new category, even as he exploits its conventions. One means he employs is the introduction of a new character into this tradition, the courtier-knight.[46] (Gottfried thus develops the tendencies he finds in Thomas's version.) But once more the poet incarnates a paradox: this courtier-knight is now barren of one half of his identity, the court, the main theatre for his achievements. Tristan is a homeless man in exile from "humanity," cut off from his cultural traditions and condemned to the solitude of peregrinations for which no lasting palliative exists.

The tragedy of dislocation brings into sharp relief the contrasting structures of aspiration guiding Tristan and his romance counterparts. Iwein, for example, learns to understand the function of knighthood and attains moral responsibility and

46. See C. Stephen Jaeger, *The Origins of Courtliness* (Philadelphia, 1985) esp. 102. See also notes 8 and 13.

social awareness far superior to that of the Arthurian court (specifically as represented by Gawain). And his task, in Uitti's words, is to "unlearn to aspire to make of Arthur's court his locus, his home" (212). Tristan is a figure of a wholly different order, as mentioned repeatedly. The exemplary quality of his life as artist and lover leaves scant room for conventional knighthood or the observance of an heroic code. The moral responsibility and social awareness that he possesses is superior to that of Mark's court, but it is of a piece with unbridled individualism and thus subverts communal values. Most crucial, however, Tristan neglects to unlearn to make the royal court his locus. Thomas tells us that the hero, whose position he depicts as half-outsider, continues his ritually patterned sequence of arrivals and departures. Failing to distance himself from the community of the king, Tristan visits several times.

Tristan therefore cleaves to the court of Mark and cannot end his quest. He does not abandon joy, which is interchangeable with and reliant on love, but instead seeks to renew it. Events on the level of plot now call attention to the greater narrative design of *Tristan* itself. The circularity observed—the recurrent return to the center, the court—is opposed to the pattern of Arthurian romance, which adheres to both a cyclical scheme and a linear, figural one.[47] Whereas the episodes of romance constitute a linear nexus, the scenes in *Tristan* coax into being an iterative, circular construct. Placed in a concentric world, the hero is necessarily constricted and circumscribed in his movements: Tristan-love is a conundrum of circularity. (Those seeking growth or education of the hero—the attainment of a higher state of existence—in the traditional sense are disappointed, for the altered existence is present already in the Love Potion episode and any "progress" is truncated by the careful grouping of figures in a construct where utopianism is out of reach.) Narrative tension arises between the fixed center— the court of the monarch—and the margins, on which Tristan faces the constant flux of the moment. These shifting demands

47. See the recent discussion by Karen J. Campbell, "Some Types of Incoherence in Middle High German Epic," *PBB* 109 (Tübingen, 1987): esp. 370 ff.

set up an irreconcilable situation: although he operates in contradistinction to the mores and codes of society, a realm of domestic tyranny, he dare not learn to live outside the court, for that would mean the renunciation of his beloved.

The final sign of the durability of the oppositions we have been tracing in *Tristan* is Tristan's behavior between his departure from royal society, "The Parting" (17659 ff.), and the end of Gottfried's poem. Tristan embarks on a nebulously explained quest, on which his almost obsessive wandering and drifting on new terrain are so unexpected as to lead to contradictory interpretations. The narrator reports: "He thought that if this agony was ever to become supportable to a point where he could survive it, this would have to be through martial exploits" (18438–18442). These exploits, *ritterschefte*, are consequently a response to the decaying conditions at court, a tactic of self-preservation and a calculated attempt to make the torments of love endurable; they are also an escape and a romance solution. The driven, deluded hero strikes out impulsively for the courtly world—Karke—for knighthood, for honor and adventure, and for a second Isolde whom he contemplates marrying. The interplot relationship to Arthurian romance is now especially glaring: chivalry, adventure, love and marriage—all the pat romance responses from which *Tristan* distances itself.

But once again similarities become contrasts, as form represents self-reflexive, ironic commentary on apparent romance models. Following Thomas, just as the hero does not consummate his marriage with Isolde of the White Hands, he also does not become a questing knight (as the figure is delineated by Eugène Vinaver,[48] for example). Tristan bears the *impedimenta* and absorbs many of the traits of the *chevalier-errant*, for instance, restless traveling. In this, he affirms iconic symbolism with Lancelot, a kind of double in virtue of parallel junctions. But Tristan's gestures when isolated and ostracized from Mark's court are temporary fascinations arising without conviction. His actions betray a sense of theatricality, of

48. Eugène Vinaver, "The Questing Knight," in: *The Binding of Proteus*, ed. M. W. McCune, et al. (Lewisburg, 1980) 126–140.

introjection sufficient to brand them as merely another impersonation. Tristan is redeemed by love, not by feats of arms, and his guise therefore conceals instead of distinguishing his aspirations. His efforts to embrace chivalry, which, as portrayed in Arthurian romance, borders on narrative rhetoric that is obsolete, form a network of illusion and delusion betokening paradoxical values and social dreaming.

If knightly pursuits are fragmentary representations of the search for meaning, and if their horizons are (comically) confining, why, then, does *Tristan* affirm a fantastic world so remote from truth? The answer is that it does not: the poem demystifies knighthood and undermines heroic pride. Tristan's knight-errantry is preeminently a costume and the actions of one engaged in game-playing. He is not preoccupied with military virtue, is no knight of the sword. In spite of the word play on *ritterschefte*, which recalls his father's feats of arms, the ancestral vision is too faint to make of Tristan a second Rivalin. And certainly he is no figure of lineal descent from a knight like Parzival. There is no shaping of Tristan into an Arthurian hero.

Unlike the romance protagonist, the reflective Tristan is not bound by marriage, nor does he find a counter-court that can satisfy him. And his grief of separation is only temporarily assuaged by adopting the pose of the martial hero. He is an amorous hero whose distance from Isolde functions as the problematic field for his knightly activities. Still, Tristan is able to bridge the geographical gaps that separate him from his beloved: in defiance of the king and of the patterns of Arthurian romance he engages in contact with the royal court until his death. In the end the oppositions are relieved somewhat when the court symbolically comes to Tristan—in the person of Isolde—thus exempting the hero from ultimate displacement. But a final, telling confrontation awaits: the protagonists perish. The demise of the hero, the crowning challenge hurled at Arthurian fiction, undermines a tradition that finds social affirmation in happy endings.

From beginning to end, as we have seen, the schematic construction of *Tristan* rests on elaborate interconnections with Arthurian romance. Unifying all is a pattern of parody that mocks, at the same time it levels an indictment against,

conventions of fiction. For its legibility, this pattern requires the reader to impose meanings and to make the necessary connections. The mechanism of the tale does more than trivialize the concerns of its counterpart. The work is stamped with the insignia of opposition, as Gottfried presents a gallery of figures and forms in recombination.

A final word. Krohn observes it is significant that, in contrast to the early versions of the Tristan legend, the courtly adaptations exclude the Arthurian circle from the plot. Arthur and the Round Table are referred to by Gottfried, for instance, as in the past. To explain this technique, Krohn maintains: "Die Kollision der beiden Welten wäre, wenn man die stoffliche Verquickung beibehalten hätte, zu heftig gewesen, und die Gefahr hätte bestanden, daß der individualistische Lebensanspruch der 'Tristan'-Erzählung die Prinzipien der Artusepik in Frage stellte."[49]

The very "collision" of which Krohn speaks does, however, come to pass in Gottfried's *Tristan*, for one reason because the Arthurian world does not retrospectively relate to the ethos of the poem. Through a collage-like interplay of image, situation and perspective, Gottfried conducts a remorseless inquest into the social anatomy of the chivalric romance. He is contestational in exposing the punctilios of the tradition; where possible, he upsets the assumptions behind its body of norms and truths by virtue of key antitheses, character correspondences and contrasts. We repeat: Gottfried delineates the radical self-determination that the lovers assert—their ranking of individual claims over recognized societal codes—from within a well-defined tradition, the Arthurian romance, and invites us to see his figures in this constellation. The dichotomy between the individual and society implied in the Tristan legend is thus confirmed on the counter-strands of connection to contemporary fiction. Krohn himself stimulates the deciphering of the connection between the two traditions by citing again the Lancelot parallels and by acknowledging the implied comparisons between King Arthur and King Mark. These last emerge as sometimes oblique manifestations, but the unity in

49. Krohn, *Gottfried von Strassburg* 3: 249.

juxtaposition is sustained, their paths intertwine. What more effective autopsy of the cultural milieu of the Arthurian court and, by implication, of the romance, than to create a sympathetic bond with the court of King Mark? To identify a form of echoic posture and gesture in their versions of kingship is, of course, to unmask the disjointed worlds they inhabit and to undermine the legitimacy of each. Poetic commentary on Mark's society would therefore have the further goal of exploring the literary institutions that find symbolic expression in Arthurian romance.

If this reading is correct, then, through an iconoclastic fusion of traditions, Gottfried has granted King Arthur a (shadow) role unequalled in the German versions of the story. This encounter underlines and illuminates Arthur's status as a literary king, while at the same time it presents an idiosyncratic version of King Mark. We could then expand our possibilities of narrative intersection from the participation of the Arthurian court as actual players (Béroul, Eilhart), and as background figures (Thomas), to rhetorical schema and a manipulation of masks (Gottfried). That Gottfried's poem—notoriously resistant to interpretation—permits these assumptions is testimony to an elusive, playful and often opaque tale about which the last word can never be said.

La Parole amoureuse: Amorous Discourse in the Prose Tristan*

Emmanuèle Baumgartner

The Genesis ("*raisons*") of the Lyric

Of all the great heroes of twelfth-century Arthurian romance, Tristan is the only one whose childhood, adolescence, and education are described at length. Erec, Yvain, and Lancelot, in Chrétien's romances, are already knights of proven valor when they first appear, and we know nothing or virtually nothing of their early life. As for Perceval, he appears rather as an anti-Tristan, if we consider only his childhood and education.

Originally published as "La Parole amoureuse" in *La Harpe et l'épée, Tradition et Renouvellement dans le "Tristan" en Prose* (Paris: SEDES, 1990), pp. 107–31. Reprinted with permission.

. *Translated by Joan Tasker Grimbert.

References to the prose *Tristan* are to two separate sets of editions. The abbreviations "I," "II," "III" followed by the section number (§) refer to Renée L. Curtis, *Le Roman de Tristan en prose*, vol. I (Munich: Max Hueber, 1963); vol. II (Leiden: Brill, 1976); vol. III (Cambridge: Brewer, 1985). The abbreviations "I," "II," followed by the page number, refer to Philippe Ménard, *Le Roman de Tristan en prose, T. I, Des aventures de Lancelot à la fin de la "Folie Tristan,"* (Geneva: Droz, 1987), and *T. II, Du banissement de Tristan au royaume de Cornouailles à la fin du Tournoi du Château des Pucelles*, ed. Marie-Luce Chênerie and Thierry Delcourt (Geneva: Droz, 1990).

Indeed, on the basis of Eilhart's version, which is generally thought to follow the tradition of the French Tristan poems, and from what we are able to reconstruct from the *Saga* regarding Thomas's version of the hero's early life, Tristan was portrayed in the verse romances of the twelfth century as having received a very extensive and complete education. Not only is he a perfect knight conversant in the techniques of combat, but he is also well-educated: he has apparently completed, at least in Thomas's version, the entire course of medieval studies, the trivium and the quadrivium, and he appears to know foreign languages and to be a musician and accomplished poet as well.[1] These are all attainments that again distinguish Tristan from Chrétien's heroes who, though not uneducated, have no artistic talent: it is only in the thirteenth century, in the prose *Lancelot*, that Guenièvre's lover discovers (through love) the practice and powers of painting.[2]

The prose *Tristan* takes up very briefly the motif of the hero's education which in the verse romances is entrusted to the wise tutor Gouvernal.[3] Tristan, endowed with an extraordinary beauty that makes him an object of desire from a tender age, takes refuge while still a child at the court of King Faramon of Gaule to escape from his stepmother. There,

1. The main passages providing details on Tristan's education are: vv. 103–84 in Eilhart von Oberg, *Tristrant*, translated and presented by Danielle Buschinger and Wolfgang Spiewok (Paris: 10/18, 1986); chap. 17 of the *Saga*, in *Tristan et Iseut, Les poèmes français, la saga norroise*, complete original texts presented, translated, and interpreted by Daniel Lacroix and Philippe Walter, Coll. Lettres gothiques (Paris: Livre de Poche, 1989); vv. 2043–130 in Gottfried von Strassburg, *Tristan*, tr. Danielle Buschinger and Jean-Marc Pastré (Göppingen: Kümmerle, 1980). On this motif see M.R. Blakeslee, *Love's Masks. Identity, Intertextuality and Meaning in the Old French Tristan Poems* (Cambridge: Brewer, 1989).

2. See the episode in *Lancelot, roman en prose du XIIIe siècle*, ed. A. Micha, 9 vols. (Geneva: Droz, 1978–83), V, pp. 51–54.

3. See I § 234. In the prose text, it is Merlin who entrusts the child to Gouvernal.

si crut et amenda tant que chascuns se merveilloit de son
amendement et sa croissance. Il sot tant des eschés et des
tables que nus ne l'en pooit aprendre un sol point. De
l'escremie fu il si mestres en po de tens qu'il ne pooit
trover en nule maniere son per. De bel chevauchier et de
sagement faire ce qu'il faisoit ne se pooit nus jovenciax
aparegier a li. Et sachiez quant il fu en aage de doze anz,
adonc fu il tant preuz et tant biax et tant faisoit a loer de
totes choses que nus ne le veoit qu'il ne se merveillast de
li. Il n'avoit ne dame ne demoisele qui ne se tenist a
beneüree se Tristanz la vosist amer (I § 263).

This portrait, which might seem cursory compared to the
more detailed account of young Lancelot in the prose text,[4] does
not even mention one of the hero's essential traits, his skill in
poetry and music, his mastery of the art of the "*trobar.*" Such an
omission at this point in the text is all the more surprising in that
music and lyricism acquire a very particular importance in the
prose romance where they play a role quite different from that
seen in the verse romances.[5] When Tristan is set adrift at sea, he
does take along, for his enjoyment (*deduire*), his harp, his lyre,
and other instruments (I § 308), but the prose text makes no
mention of the episode in which Tristan, disguised as the
minstrel Tantris, is healed by Iseut,[6] and, similarly, it replaces the
subsequent musical joust between Tristan and the Irish knight[7]
with a combat between the hero and Palamède (II § 506–12).

4. The portrait of Lancelot is in ed. Micha, VII, 70–75.

5. Jean Renart's *Guillaume de Dole* was the first (verse) romance to
introduce "songs" into the narrative. According to its editor F. Lecoy
(Paris: CFMA, 1962), it was composed around 1228, making it only
slightly earlier than the *Tristan* (or at least a first version of the *Tristan*).
This innovation was a great success and gave rise to numerous
imitations in the verse romances, but the author of the prose *Tristan*
could also have drawn inspiration from this precedent. On lyric
insertions in the verse romances, see the definitive study by S. Huot,
*From Song to Book, The Poetics of Writing in Old French Lyric and Lyrical
Narrative Poetry* (Ithaca: Cornell University Press, 1987).

6. The King of Ireland orders his daughter to heal Tristan as soon
as he learns that the young man is a knight (I § 310–315).

7. Episode recounted in the *Saga*, ch. 49–50.

Only the ending, Tristan's death at the hands of his uncle as he
plays a lay in the queen's chamber, takes up again and tragically
transposes the image of young Tristan/Tantris playing the harp
to entertain and instruct the Irish princess, as recorded in the
Folies of Berne and Oxford:

> Bons lais de harpe vus apris,
> lais bretuns de nostre païs.
> Membrer vus dait, dame raïne,
> cum je guarri par la mecine.
> Iloc me numai je Trantris (*Fo*, vv. 361–65).

On the other hand, it is as if the lyrical dimension were
renewed in the prose *Tristan* in the form of the poetic–musical
lay,[8] assuming once more the function attributed to it in the
narrative lays of Marie de France and in the anonymous lays: to
preserve the memory of an event from the distant or recent past.
Indeed, according to Marie, the "Bretons," the poets who
composed the musical lays that were the "sources" of her
narrative lays, did so to record for memory events of which they
had heard: "cil qui primes les commencierent / et ki avant les
enveierent, / por remanbrance les firent / des aventures k'il
oïrent" (vv. 37–38 and 35–36). The "secondary" lay, Marie's text
or that of the anonymous lays, is then presented as the narrative
version—intended no longer to be sung but rather to be read—
which elucidates both the "*raison*" of the musical lay and its
truth: "pur quei fu fez, coment e dunt."[9]

At the end of the episode of Tristan in the *Pays du Servage*,
the prose author recalls for the first time the etiological function
of lyricism. Tristan's victory first of all transforms the name of
the spot, giving it its definitive name:

8. On the lyric lay, see J. Maillard, *Evolution et esthétique du lai
lyrique des origines à la fin du XIVe siècle* (Paris: Centre de documentation
universitaire, 1963), and "Lais avec notation dans le *Tristan en prose*" in
Mélanges Rita Lejeune, II, 1347–64.

9. *Lai du chèvrefeuille*, v. 4 (ed. Lacroix and Walter cited in n. 1
above).

Des celi tens fu ensi cele valee apelee la Franchise Tristan
par la bouche de Seguradés, et encore li dure cist nons et
est encores apelee la Franchise Tristan (II § 614).

Next, it provides the lay's subject matter or theme, which
commemorates the victory, but the actual text remains, as in the
case of Marie, inaccessible to the reader:

Li Breton firent un lai de ceste aventure qui encor est
apelez li lais de la Franchise Tristan (II § 616).

Thus, the genesis of the *Lai de la Franchise Tristan*, though
absent, retraces within the narrative the imaginative process of
poetic creation, of a discourse springing directly from an event
and fixed instantaneously, recording the impression made by
that event.

Yet, the *Tristan* poems, especially Marie's *Lai du
Chèvrefeuille*, offer other, even more precise, images of lyrical
invention, of the birth of the "*trobar*," images that are taken over
and developed in the prose version. In the *Lai du Chèvrefeuille*, it
is no longer an anonymous Breton but Tristan himself who is
given as the author of the lyrical lay commemorating his
encounter with the queen and for which Marie provides the
narrative equivalent:

Pur la joie qu'il ot eüe
de s'amie qu'il ot veüe
e por ceo k'il aveit escrit
si cum la reïne l'ot dit,
pur les paroles remembrer,
Tristram, ki bien saveit harper,
en aveit feit un nuvel lai (vv. 107–13).

Marie's text actually follows the progress of the lay's genesis: the
sight of the honeysuckle entwining the hazel wood; the verse
which, in its verbal interlacing, retraces the concrete interlacing
of the two shrubs and imposes the sensual image of the
entwined bodies and of the union of two hearts; and grafted
thereon is the (absent) lyric text that would develop and
interpret the comparison:

"Bele amie, si est de nus:
ne vuz sanz mei, ne jeo sanz vus."

The experiment attempted in turn by the prose *Tristan*, the empty space it fills by developing the suggestions found in the *Chèvrefeuille*,[10] consists, then, in retracing all the stages, from the original feeling and emotion accompanying the genesis to the production and "actual" utterance of the lay. The narrative sequence which in the text of the *Tristan* introduces the lyric lay functions henceforth as the *razos* / "*raisons*" or explanatory narrative[11] appended, *a posteriori*, to the troubadour's *cansos*: it relates the conditions of the lyric's genesis and ties it to the author's personal history or biography.

Any medieval or modern performer or reader of the *Tristan* could no doubt play or sing the lays composed by the hero or other characters[12] and transcribed in the manuscripts of the romance. But the *je* ["I"] from which the lyric text radiates can no longer be, at least in the space defined by the manuscript, the impersonal or depersonalized *je* of the troubadour or trouvère. It designates the *je* that is Tristan, Iseut, Kahédin, etc., investing in the authentic discourse of the lay the truth of his (or her) very being, relation to the world, or death.

In the world of the prose romances, as scholars have noted, the authorial presence is either eliminated or disguised. The practice of compilation by which a text becomes interlaced with

10. On this aspect of the *Lai du chèvrefeuille*, see R. Dragonetti, "Le lai narratif de Marie de France: —pur quei fu fez, coment et dunt,'" in *Mélanges B. Gagnebin*, 1973; rpt. in *La Musique et les Lettres* (Geneva: Droz, 1986), pp. 99–121.

11. The Old Occitan *razo* (in French: *raison*) designates short prose texts that explain *a posteriori*, and of course fictionally, the motives or "reasons" that determined the composition of a particular troubadour lyric.

12. See, among other examples, the lays composed by Iseut and by Kahédin which a harper performs for the person to whom the lay is addressed (I p. 229 ff.) or the *Lai Voir Disant* which Dinadan has the harper Héliot perform before King Marc (voir *Le Roman de Tristan en prose*, vol. IV, ed. J.-Cl. Faucon [Geneva: Droz, 1991], § 243–45). On this aspect of the *Tristan*, see J. Maillard, "Coutumes musicales au moyen âge d'après le *Tristan en prose*," *Cahiers de civilisation médiévale*, 2 (1959), 341–52, and on Kahédin's lay, see Maillard, "*Folie n'est pas vasselage . . .*" in *Mélanges Jeanne Lods* (Paris, 1978), pp. 414–32.

other texts, probably implies not so much the obliteration of the narrator-compiler as the more or less accentuated marginalization of the author. The lyric lay, on the other hand, becomes the privileged space that lends existence to an author, a "trouveur," in the strict sense of the term, Tristan/the clerk who lends his voice to the lay; it is also the point where the two "sources" of the writing merge, where the contribution and conventions of the literary tradition are renewed by the experience of the singing or writing *je*.

Mortal Lays (*Lais mortels*)

This mode of lyrical production is represented particularly by three moments in the *Tristan*: the composition of Tristan's *Lai mortel*, followed by that of Iseut's *Lai mortel*, and the exchange of letters and lays between the queen and Kahédin ending with the young knight's death.

Tristan composes his *Lai mortel* (III § 864–71) when, convinced that Iseut prefers Kahédin to him, he flees Marc's court and takes refuge in the Morois forest. He spends a week there overcome with his memories and his grief, at the foot of a tower where he once experienced two (or three) blissful days with the queen[13] and in the vicinity of a "fontaine mout bele et mout envoisiee" (III § 864). In an effort to offer him some comfort, a young lady comes to play for the hero, on a harp that once belonged to him (and which she found in the tower), three lays that he himself had composed:

> cestui qu'il avoit fait dedenz la nacele quant il se fist metre en mer por ce qu'il ne pooit garir en Cornoaille. L'autre lai avoit il fait en la mer meïsmes, a celi point qu'il conut premierement madame Yselt par le boivre amorous, ensi com chevaliers doit conoistre dame. L'autre lai avoit il fait ou Morroiz, quant madame Yselt demora tant avec li en la forest. Et le premier lai avoit il apelé Lai de Plor, le secont

13. See I § 512.

le Boire Pesant, et le tierz avoit apelé Deduit d'Amor (III §
868).

These three lays commemorate Tristan's affective and
amorous past of which they record the most important moments.
The *Lai de Plor* alludes to the combat with the Morholt and to the
poisoned wound that Iseut alone could heal, and to the time
spent adrift at sea. The *Boire Pesant* recalls the philtre and the
first moments of passion, while the *Deduit d'Amor*, composed
during that festive hiatus in the Morois forest, celebrates the joys
of love's consummation.

Yet, the conditions of this last lay's composition—the
explanation Tristan gives regarding its title, the place where it
was composed, and the mental state of its "inventor"—
underscore once again the ambiguity of the prose narrative and
the various perspectives from which it considers the love
passion. On the one hand, Tristan declares that consummated
love is the greatest source of poetic inspiration: according to him,
this lay is a "meillor chant et plus delitable a oïr que n'est cestui
[the *Lai de Plor*]. Pleüst ores a Nostre Seignor que je fusse si gais
et si envoisiez com j'estoie a celi point que je le fis" (III § 869). But
the title, the *Boire Pesant*, alludes rather to the commentary made
by the narrator at the time that the philtre was consumed:

> Or ont beü; or son entré en la riote qui jamés ne leur
> faudra tant com il aient l'ame el cors! . . . Diex, quel duel! Il
> ont beü lor destrucion et lor mort! (II § 445).

As in the case of the *Lai de la Franchise Tristan*, the text of
these lays is not given, and it is quite possible that they were not
written down.[14] But the mention of the conditions of their
composition and the young lady's performance of them (III §
868–69) is doubtless a way to construct Tristan's lyric persona, to
give it consistence, and to ground it in a past and a tradition
which would be at once that of the Tristan poems and of the new
prose text.

14. It is possible, as R.L. Curtis believes (III p. xxvii) that the
appearance of the lays within the narrative coincides with the
intervention of the second author, Hélie.

On the other hand, the composition of the *Lai mortel*, whose text is actually given, unfolds simultaneously with the narration before the reader's very eyes and is carefully described. Mention is made of both the time and place of its genesis: a day of meditation and a night (of which we are told nothing) spent in the *locus amoenus* around the fountain. Tristan also explains the title:

> "je l'ai fait anuit tot novel de la moie dolor et de ma mort.
> Et por ce que je l'ai fait encontre mon definement, l'ai je
> apelé *Lai mortel*; de la chose li trai le non" (III § 870).

He performs it weeping, thus harmonizing gesture and poetic discourse, and then, despairing at his failure to take his life with his sword, he goes mad and

> va courant par le Morrois, une ore ça et l'autre ore la,
> criant et breant come beste forsenee" (III § 870–71).

It is as if in the universe of the *Tristan* where words and things have always been manipulated, where even the most palpable of evidence can be questioned or scrutinized—the wine stains in the episode of the Magic Horn (II § 526–31), the wounds and blood-stained sheets in the episode of the sharp blades (II § 532–33), the torchlight on the sleeping lovers (II §543), the shepherds' crude report to King Marc regarding "le fait de monsigneur Tristan et de la roïne" (I p. 272)—and where ruse and love are constantly in league, lyric discourse alone escapes all distortion of meaning. Drawn at the very source, in the agitation of a soul overcome with love's pain or joy, it alone is capable, by virtue of its immanence and immediacy—"je l'ai fait anuit tot de novel de la moie dolor et de ma mort"—of generating authentic discourse.

Just as it gives voice to the speaker's true feelings, it determines the acts that correspond, creating a perfect accord between the word and its enactment, as Iseut states a little later in her *Lai mortel*,

> Dolent, mon doel recordant,
> Vois contre ma mort concordant
> Mon chant qui n'est pas discordant:
> Lay en faz douz et acordant (St. III, § 932),

effecting an exact congruence of the poetic word and the narrative act, and becoming in essence performative utterance. To compose and sing the *Lai mortel* is to take one's life. The trouvère-lover who ends his lay by declaring before God:

> Chant et plor tot en un moment
> Font de moi le definement.
> Je chant et plour. Diex qui ne ment
> Penst ores de mon sauvement! (St. XXIX, III § 870)

must enact his words. And if he cannot find a sword with which to kill himself, he can only sink into madness.

It can be seen, then, that the term "lyric insertions," which is generally used to designate the interlacing of the lyric stanza with the prose in the *Tristan*, is quite inadequate to describe the function and functioning of poetic discourse in this text. Far from being an extraneous element,[15] grafted more or less forcibly onto the narrative or superimposed as a mere ornament, the lyric text becomes in this work a way of giving voice to one's inner truth, to the authenticity of one's passion, which is then endorsed by the gestures and acts that it entails.

The status of *trobairitz*[16] to which Iseut, too, accedes in the prose *Tristan* may have been suggested by Thomas's text: the episode where Iseut, alone in her room, composes and performs the *Lai de Guiron*, using a borrowed "theme," that of the "eaten heart" ("*cœur mangé*").[17] Tristan, in the prose romance, composes his *Lai mortel* rapidly. But Iseut, less experienced no doubt, ponders for some time not the lay's text but rather its melody, which she wishes to compose along the lines of Tristan's *Lai mortel* because

15. Already in the prologue of the *Guillaume de Dole* Jean Renart emphasizes the perfect congruence between the inserted songs and the meaning of his narrative; see F. Lecoy's edition, vv. 1–30.

16. This is the feminine form of trobador in Old Occitan.

17. On this passage, see E. Baumgartner, "Lyrisme et roman: du *Lai de Guirun* au *Lai du Chèvrefeuille*," in *Mélanges P. Bec* (Poitiers, 1991), pp. 77–83.

her lay springs from the same emotion as his and she is composing on the same harp as the one he used:[18]

> "Il a fait por moi lai novel de ses max et de ses dolors, et je aprés, por l'amor de li voudrai un lai trover d'autel guise et d'autel semblance, se je onques puis, com il fist le *Lai Mortel*. Ausi ai je bien achoison de trover com il ot, et por ce vel je trover un lai d'autretel maniere com fu celi lai qu'il fist" (III § 896).

The queen who, according to the narrator, was taught to play the harp by Tristan in the Morois (III § 896), takes up the instrument then and "la vait sonant et atrampant au mieuz qu'ele set et vait trovant chant por son lai. Le dit trove ele en brief termine, mes li chanz la vait plus grevant assez que li diz" (III § 896).

And the narrative gives even more details on the composition of the melody which Iseut, observed/surprised by Marc invents in silence and then in tears, barely speaking "fors que en notant por trover le chant de son lai" (III § 921), which emerges at last as the lyrical, musical formulation of the brief *"complainte"* (in prose) that she addresses to Love and then to Tristan (III § 921).

In Iseut's case, as in Tristan's and later Kahédin's, lyric expression proceeds directly—or so we are led to believe—from the emotion felt, with Iseut's prose monologue forming the intermediate stage, the transition between feeling and its lyrical expression. What unfolds here, what is virtually explicated in narrative time, is the process that troubadours and trouvères express in the short space of the opening verse: "I must sing" (*"Chanter m'estuet"*) of the joy, or more often pain, I feel from loving. Moreover, the lay the queen sings before attempting to take her life—like Tristan and with his sword—is very close in its opening verses to the *chanson courtoise*. The first stanza,

> Li solex luist et clers et biaux

18. Iseut's lay, which reproduces the form of Tristan's *Lai mortel* (monorhymed octosyllabic quatrains) but not the melody, is quite close to a *contrafacture*. But "imitation" here concerns not simply the form, but also inspiration, the lay's *raison*, and the choice of instrument—the harp—for the composition and performance of the poem.

> Et j'oi le dolz chant des oissiaux
> Qui chantent par ces arbroissaus.
> Entor moi font lor chanz noviaux,

takes up again the traditional motif of the *reverdie*. But here this topos is—or seems—inspired or revitalized less by the lyric tradition than by the scene's setting: the grove suffused with sunlight and the singing of birds, where Iseut sits composing her lay. And the lay, her only comfort against death, draws as much on the birds' singing and the resultant *soulas* (mixture of pleasure and relief) as on love's pain and the lover's grief:

> De ces douz chanz, de ces solaz
> Et d'Amors qui me tien as laz
> Esmué mon lay, mon chant enlaz,
> De ma mort deduis et solaz (St. II, III § 932).

The lyrical effusion is nevertheless echoed in stanzas XII–XVII in the recapitulation—the *recort*—of the key moments of the lovers' past as recorded in the prose text: the Morhout's death, the healing of the poisoned wound, the tournament in Ireland against Palamède, Marc's hatred, the lover's passion and life in the Morois. Tristan, before composing his *Lai mortel*, alludes briefly, in the titles and the explanatory narrative of his preceding lays, to his heroic and amorous past, but the lament he addresses to Love and the adieu he addresses to Lancelot (for whom the lay is intended, according to stanza XI),[19] to Iseut, and to life, make no concessions to the narrative. Iseut's lay, which contains more narrative elements and traces a "history" that offers a brief flashback of the narrative, alludes rather—with an inversion of roles—to Tristan's speech in the verse *Folies* where he offers a synopsis of his past.

By introducing lyricism into his prose narrative and thus giving his romance the double—indeed triple—dimension of a text made to be read but with fragments to be sung and performed on the harp, the author of the prose *Tristan*, assumes the status both of a clerk, the author of a romance, and a knight, master of the *trobar*. But with Iseut's *Lai mortel*, he modifies once

19. See stanza XI: "Ha! Lancelot, biaus douz amis, / A vos vel je que soi tramis / Cist lais . . ."

again the traditional forms of literary discourse by making of a lyric text with a very conventional opening the space where the narrative, the lovers' story, is momentarily interlaced with the love poem.

The poetic death of Kahédin, who appears in the *Tristan* as an early sacrificed double for the hero, echoes in many ways the episode of Tristan's *Lai mortel*. Having gradually abandoned his knightly function to devote himself to love meditation and to a somewhat unfocused poetic activity,[20] driven to despair over Iseut's response to his first lay, *Folie n'est pas vaselage*, Kahédin too flees society, taking refuge in the *locus amoenus* around the fountain. It is in this place that he gives his *complainte* the ordered (*ordenee*) form of a lay (I p. 237) before dying of languor and love's distress (*destrece*), like Galehaut before him[21] or like Narcissus, transcribing it himself on a *brief*, a letter intended for Iseut, and singing it just one time for the harper in order to teach him the melody.

The harper who is present at Kahédin's death is doubtless a reminder of the young lady who watched over Tristan and played for him. But he also incarnates, for the purposes of the narrative, the character(s) often mentioned in the envois (or *tornadas*) of the troubadour songs: the messenger entrusted with the task of taking the song and confession of love to the lady, whose privacy is protected by the *senhal*. But here the song's reception, which in the lyric text nearly always remains in a latent state,[22] is both achieved and refused. While Iseut does praise the poet's art—if it was madness for him to love, he was

20. See I p. 225. It is a very diversified (scattered?) poetic activity, since it includes *notes, canchons, rotruenges, cans* et *descors,* as if Kahédin still had not found, in the lay, the vehicle for the precise expression of his love, the definitive form of his inspiration.

21. In the prose *Lancelot,* Galehaut, consumed by his love for Lancelot, also dies of languor. See ed. Micha, I, 388–89.

22. It should be noted also that the two preceding *Lais mortels*— that of Tristan (although he sends it to Lancelot, see n. 19 above) and that of Iseut, who thinks her lover is dead—have no receiver except the reader/listener.

wise enough to make of his death a work of art (I p. 246)—she carefully refrains from performing or circulating Kahédin's lay. This silence reduces the trouvère's *complainte* to the status of a dead letter (*lettre morte*), a closed written text from which the spoken word (*parole vive*) will never be regenerated, unless another work should somehow, somewhere, preserve its trace. In this gesture of refusal, lyricism rediscovers its very essence and meaning as the solitary lament of the lover Narcissus unable to reach or to touch *la belle dame sans merci*.

Troubadours, trouvères, authors of Arthurian romance, and others recycle incessantly the motif of love's wound, of the fatal power of the lady's beauty and the oxymoron of the sweet/piercing savor/bite of the death that results from love:

> En morant de si douche mort
> C'ainc nus si dous morsel ne mort,
> Me plaing d'icele ki m'a mort:
> Ardours d'amours a ce m'amort (I p. 238, vv. 1–4).

But just as Tristan discovers and demonstrates the equivalence between love and madness by composing his lay and then going mad,[23] Kahédin lends a certain reality to the topical image of fatal love by creating and enacting his poetic discourse, singing his own death in the bucolic setting of love's fountain:

> Las, com je muir a grant destreche:
> Mors toutes mes vainnes m'estreche!
> Je sent la daerraine asprece
> Du fu d'amours, ki si me bleche (I p. 242, vv. 125–28).

Instead of creating once again hyperbolic imagery on the relation of love to death, the lay becomes letter—a love letter—commemorating and inscribing within the narrative this experience, of the outermost limit, this passage to the act which marks the end of the trouvère's passion.

23. But Iseut, who is closely watched by Marc, does not—unlike Dido, for example—succeed in killing herself with Tristan's sword (III § 933).

Amorous Prose

In the *Tristan*, the lyric voice causes an abrupt break in the flow
of the narrative's *commune parleüre*.[24] This effect of rupture,
which is still perceptible to the modern reader on the manuscript
page,[25] must have been accentuated even more in the course of a
performance reading where the singer's voice and instrument
could be heard alternating with the more or less dramatized
diction of the prose. Other medieval texts, such as the *Chevalier
au lion*, Thomas's *Tristan*, and *Galeran de Bretagne*, inscribe
fleetingly within the narrative certain scenes that mime the
reading of a *"roman"* or the performance of a lay.[26] In the
thirteenth century, Jean Renart was to increase the number of
such scenes in his *Guillaume de Dole*, skillfully alternating
singing, music, and dance sequences with the narrative, thus
launching the vogue for "lyric insertions" that was to last for at
least two centuries. The *Tristan* may well be one of the earliest
examples of this trend.[27] Increasing still more the incidence of
voice recital and song, the *Tristan* also expands the scenes
depicting the writing and reading of letters and the composition
and performance of lays, and it highlights the work of the writer
and composer and the skill of the performers. This "literary"
activity, which is poetic and—even more so—musical, is at first
limited to the small circle represented by the protagonists, but
little by little the circle grows to encompass other characters.

24. Expression borrowed from Brunetto Latini who uses it to
define prose in his *Livre du Trésor*, ed. F. Carmody, p. 327.

25. In Vienna MS 2542, for example, the transcription of the
strophes of the lays, with notation of their melody, produces a kind of
breathing space in the cramped calligraphy of the prose narrative, a
musical punctuation of the text which complements the iconographic
punctuation provided by the miniatures.

26. See Chrétien de Troyes, *Le Chevalier au lion (Yvain)*, ed. M.
Roques (Paris, CFMA, 1963), vv. 5354–64; Thomas, *Tristan*, ed. Lacroix-
Walter, Sneyd[1], vv. 782–95 (Iseut performs the *Lai de Guirun*); *Galeran de
Bretagne*, ed. L. Foulet (Paris, CFMA, 1925), vv. 2276–327.

27. See n. 5 above.

Héliot *l'envoisié*, the harper who performs for Marc the *Lai Voir Disant*, composed by Dinadan, is thus presented as an official harper of Arthur's court where he performs the lays composed by the knights (L. § 269); and, in the narrative's finale, the entire Arthurian court composes lays to mourn and commemorate Tristan.[28]

But between the poles of narrative prose and lyrical expression, there is in the *Tristan* a whole range of intermediate modes of discourse that rework in the new prose format various modes found in the verse romances, such as the monologue, or forms more specifically linked to the development of romance prose, such as the dialogue. The author of the *Tristan*, like that of the prose *Lancelot*, grants a substantial role to dialogues involving two or more characters. This mimesis, which, according to Maurice Blanchot, is *"facile,"*[29] plays in the *Tristan* an important role in the creation of the effect of duration in the romance. Lacking the protracted descriptions of objects and the portraits that are so frequent in the *romans antiques* and so rare in the prose *Tristan* and the prose *Lancelot*, the "real time" represented by the dialogues and "parlements" shape and fill out the protagonists' adventures, their moments of leisure, and the narrative passages devoid of action.

The delegation and proliferation of speech and the linguistic variety authorized thereby also serve to individualize the characters. It is through dialogues, which seem to convey more vividly the reality of the characters and virtually to provide direct contact with them, that the reader can sometimes forget the narrative types and motifs underlying the characters and listen with interest, sympathy, or amusement to, say, Palamède's amorous outbursts and excesses, the *demoiselle médisante*'s

28. See E. Baumgartner, *La Harpe et l'Epée, Tradition et Renouvellement dans le 'Tristan' en prose*, Paris, SEDES et CDU réunis, 1990), p. 73.

29. According to M. Blanchot, *Le Livre à venir*, Paris, Gallimard, 1959, p. 225, the so-called "dialogued" portion of novels is the expression of indolence and routine: the characters speak simply to put blanks on the page, in an imitation of life where there is no narrative, only conversation.

sarcasm, Keu's naive assertions, Guenièvre's and Iseut's equivocal, duplicitous discourse, Kahédin's increasingly incisive and despairing ironic commentary, and the measured responses of that great *courtois*, Lancelot. There is a study to be made as well of the clues embedded in the numerous dialogues between Tristan and Dinadan—between the representative of the traditional courtly and knightly ethic and the younger knight (the *jeune*) who is always ready, like Kahédin whom he follows in this regard, to question that ethic—clues which alert the reader to the deficiencies, perils, and contradictions of a world that is increasingly devoted to *errance*, to the impossible quest for meaning.

Dialogue and the game of pro and con it authorizes and stimulates quite often leads, as has been observed, to a "parlement" or debate on a given subject. These are skillfully led by such experts in the genre as Kahédin or Palamède (and later Dinadan) who, pretending simply to engage in worldly conversation between people of good and selfsame company, have a tendency to desacralize both the myth of love and the chivalric ideal and to subvert by their language even more than by their acts the foundations, rites, and outmoded routine practices of the Arthurian order.

In the *romans antiques* as in the romances of Chrétien de Troyes, the privileged domain of subjective discourse is the love monologue and its most common variations, the lyric lament and the tormented inquiry on the nature of love and its various fortunes. This type of discourse is virtually unknown in the prose *Lancelot*, in which the hero's absolute love for Guenièvre is debated or questioned only on very rare occasions. The situation is quite different in the *Tristan*. The constant, reciprocal love of Tristan and Iseut is very often thwarted by Marc and the absences imposed on the insanely jealous, exiled, and imprisoned hero; for this reason their passion is experienced and above all expressed in absence and in solitude. As for the impossible love that Kahédin, Palamède, and still other knights[30]

30. See, for example, the monologue in which Méléagant expresses his love for Guenièvre (III § 796), and the lay in which Hélys expresses his love for Iseut (L § 399).

nourish for the queen, it scarcely takes any other form than the
kind of monologue that the *Tristan* was the first to supply in
prose.

Like the lay, which it often precedes and prepares, the love
monologue is linked in the prose text to the fountain, the place
where the knight, believing he is alone and protected by the dark
of night (III § 903 ff.), can meditate, weep, and finally give voice
to his secret, while those hiding in the shadows can listen with
awe, compassion, or anger to the forms taken by his lament. This
type of discourse echoes the most traditional motifs of the
courtly topos. Thus, Kahédin's lament, heard by Palamède and
Lancelot (I p. 165), evolves from the oft-used image of Love as
the lord and master of the lover and underscores the perfidious
cruelty of a god who, ignoring feudal conventions, persistently
mistreats the one he has "nourished," his liege vassal whom he
has taken into his service and who expects in exchange, as a
reward (*guerredon*), the lady's acquiescence to his desire:

> car je, ki me tieng bien du tout a vostre et ki tout le monde
> ai laissié pour vous servir, ki sui vostre sers racateïs et
> vostre hom liges, ki plus ai en vous ma creance que je n'ai
> u pooir de Dieu, voi tout apertement de moi que je muir
> pour vous servir plus loiaument que onques mais vous
> servist nus hom (I p. 165–66).

Then the unhappy knight ends his monologue on the no
less traditional hyperbole recording the lover's inability to find
the words that would do justice to the lady's beauty:

> "Dame . . . ki tant estes bele voirement que de vostre
> biauté ne porroit nul langhe morteus dire la somme, dame,
> mar vi onques vostre biauté, car je en morai
> prochainnement, ce voi je bien."[31]

This rather short monologue could well be compared to
the one that the narrator attributes earlier to Palamède (III § 903–
05) which features multiple comparisons illustrating the abrupt

31. Note how Kahédin's exclamation recalls (in parodic fashion?)
Galaad's exclamation upon seeing the Grail: "ore voi ge tot apertement
ce que langue ne porroit descrire ne cuer penser" (*La Queste del saint
Graal*, ed. A. Pauphilet [Paris, CFMA, 1923], p. 278).

changes and variations in feeling of that most faithless of gods, or the illusionary tactics by which love fascinates the lover and leads him to despair, granting the rose to some while reserving the thorns for the others—comparable to a day when the sun shines brightly in the morning, only to end with wind and rain in the evening, or to the moon "placed" above the mountain which the poor fool thinks he can carry off. . . .

But at this stage in the narrative this speech is probably still too sacrilegious, and in the second part of his monologue Palamède picks up and reverses the accusations made, excusing the god and justifying all his lapses of logic and acts of cruelty. But we should note that no synthesis emerges from this "statement" ("dit") and "counterstatement" ("contredit"):[32] the neighing horses break off abruptly poor Palamède's meditation and repentance, to the great regret of Kahédin, who takes more pleasure in the beauty of the speech than in the logic of an argument that could please the foolish as well as the wise. . . .

> "Sire, ce dit Kaherdins, or sachiez que se vos celi parlement que vos aviez encomencié maintenissiez dusqu'au jor cler, je ne vos deïsse un sol mot, car il ne fust mie bien saiges, se m'eïst Diex, qui de si bel parlement com celi estoit que vos ores teniez vos ostast. Je endroit moi vosisse bien, se Diex me saut, qu'il ne finast devant le jor, ne il n'est orandroit en tot cest monde un chevalier ne fol ne saige a cui il ne deüst bien plaire" (III § 906).

The beauty of the love monologues in the *Tristan* and their spellbinding power, which Kahédin echoes here, does indeed stem from the varying but flawless rhythms and cadences of this lulling oratory prose. In the monologue's in-finite lament, the prose of the *Tristan* seems to attain the very goal of the lover's discourse: to manage with a profusion of words, images, comparisons, reiterated with contrasting echoes, to define and enclose the very contradictions of love, the constant oscillation

32. The same situation prevails in the *Traité de l'amour courtois* by André le Chapelain (tr. C. Buridant [Paris, Klincksieck, 1974]) in which a defense and methodical illustration of courtly love is juxtaposed, in the third part of the treatise, with a violent condemnation of carnal love that has a very misogynous tone.

between the joy and pain of loving, between the moments of
gladness and sadness of Tristan-lovers.

Radix Amoris: The *Tavola Ritonda* and Its Response to Dante's Paolo and Francesca

Donald L. Hoffman

Although each version of the prose *Tristan* is a unique text, it may be difficult to define precisely the ways in which different versions of the same narrative may convey divergent meanings. Despite Shakespeare's feeling that "love is not love that alters when it alteration finds," the alterations among Tristan texts amount to a profound meditation on the shifting meaning and value of love. The most important Italian version, the *Tavola Ritonda*, is a particularly complex response to the prose *Tristan* because it not only reverses the French text's subjection of love to chivalry,[1] but directly confronts Dante and his condemnation of

1. Anne Shaver (*Tristan and the Round Table: A Translation of* La Tavola Ritonda [Binghamton, N.Y.: Medieval and Renaissance Texts and Studies, 1983]), provides a concise review of contemporary discussions of the *Tavola* (p. x). The basic problem is that, at least until recently, the Italian romances have been seen as mere translations of the *Tristan en prose*, discussion of which tends to have been dominated (again, at least until recently) by Vinaver's extraordinarily influential opinion that "the Prose *Tristan* enables us to see what happens when the disintegration takes place. Loose threads are scattered everywhere: quests are undertaken and abandoned, interpolations occur that have no bearing on any of the earlier or later episodes, and the work as a whole tends to become a vast *roman à tiroirs*" (Eugène Vinaver, "The

erotic love as defined and practiced by Francesca da Rimini in *Inferno* V.

Against the grain of the prose romances, the *Tavola* restores the vibrant spirit of the original verse narratives, reinvesting the potion with its original grandeur and mystery. Indeed, it is not only Tristano and Isotta who fall in love; the space itself is affected by the potion. From the puppy who licks up a few drops and becomes hopelessly devoted to the lovers, to Governale and Brandina who smell the perfume and swear eternal loyalty to the lovers, to the silvery foam that envelops the ship, nothing is untouched by the power of love. The *Tavola*, however, recognizes, as did W.T.H. Jackson (who was, of course, speaking of Gottfried's *Tristan*) that "In drinking the love potion, the lovers drink not simply of inextinguishable love for each other but of death itself."[2] In other words, Tristanian love is rooted in death: *radix amoris mors est*.

For this reason, the deaths of the lovers are treated with the same grandeur as the moment of their recognition of love. The lovers are virtually canonized, so that when Tristano is killed by Marco, his death is tinged with hagiographical reminiscences that seem to echo the five sorrows of the Virgin in the five sorrowful consequences of Tristano's death: (1) he dies at the age of 33, as did Christ; (2) his death robs the world of the flower of courtesy, and (3) fatally diminishes the Round Table; (4) his death causes the death of the gentle Isotta, and, (5) it is a loss to Love itself, "perch' egli usò l'amore leale mente, e savia mente lo mantenea" ("because . . . he practiced love loyally, and wisely he kept its laws").[3] When Marco allows Tristano to see

Prose *Tristan*," *Arthurian Literature in the Middle Ages: A Collaborative History*, ed. Roger Sherman Loomis [Oxford: Clarendon, 1959], p. 345).

2. "Gottfried von Strassburg," in Loomis, p. 153.

3. *La Tavola Ritonda o L'istoria di Tristano*, ed. Filippo-Luigi Polidori (Bologna: Gaetano Romagnoli, 1864), p. 497. The translation is that of Anne Shaver, p. 317. All future quotations from the *Tavola* will be identified in the text by page numbers referring to Polidori's edition for the Italian, followed by the translation and page numbers to Shaver's translation.

Isotta one more time, they die as they loved, locked in each other's gaze.

> E Tristano, vedendo Isotta, disse:—Bene venga la mia dilettosa speranza. Ma vostra venuta è tarda a mia guarigione; ch'io sì vi dico che voi vedrete tosto morto il vostro Tristano, lo quale avete tanto amato in questo mondo—. E la reina disse:—O cara mia speranza, dunque sete voi a tal partito, che morire vi conviene?—E detto che la reina ebbe le parole, sì cadde in terra trangosciata, e astrisse tanto, che neuna maniera potea parlare (499–500).

("Looking at Isotta, he said, 'Welcome, my beloved hope. You have come too late to heal me. I tell you that you will soon see the death of your Tristano, who has loved you so much in this world.' And the queen cried, 'O my dearest hope, are you so badly hurt that you must die!' And when she had spoken those words she fell to the ground senseless, in such distress that she could no longer speak," 318–19.)

Entombed with iconographic insignia, Isotta with a flower as a sign of her beauty and Tristano with a sword as a sign of his prowess, their love survives death and

> conta la vera storia . . . che compiuto l'anno, in quel dì subitamente, cioè dal dì che Tristano e Isotta furono sopelliti, nel pillo sì nacque una vite, la quale avea due barbe o vero radici; e l'una era barbicata nel cuore di Tristano, e l'altra nel cuore di Isotta (508).

("The true story tells, . . . a year later to the very day that Tristano and Isotta were buried, out of their grave grew a vine which had two roots, one of which had its start in the heart of Tristano, and the other came out of Isotta's heart," 324.)

In its revision of the prose *Tristan*, the *Tavola* reinscribes the primal mystery of the potion and its connection to the mystery of death. But beyond death, the *Tavola* in its elaboration of the vines issuing from the lovers' tomb, celebrates an eternal love that survives the death of the body.

It is unlikely that any work written in Italy after 1321[4] that dealt with the linkage of love and death and the survival of love after death could have avoided raising the specters of Dante's Paolo and Francesca. The *Tavola*, however, consciously recalls these lovers. Just as Francesca had evoked Tristano and Isotta as the implicit pattern of love beyond the explicit invocation of Lancelot and Guinevere, the *Tavola* reflects Francesca's infernal desire and reconsiders (1) the love that leads to death, (2) the concept of *concordia*, (3) the tomb as the ultimate model of the pleasure palace, (4) the authority of Lancelot, and (5), finally, the restoration of the book as potion, as the originating cause of love.

When Dante emerges into the second circle, he finds a place whose meteorology ("che mugghia come fa mar per tempesta" ["which bellows like the sea in tempest"])[5] recalls the voyage from Ireland to Cornwall in the course of which Tristano and Isotta drank the fatal potion. Thus, in the place where Dante meets Francesca the weather itself pronounces judgement on the shipboard encounter of Tristano and Isotta. Like the ship, the souls themselves are buffeted by the hurricane, enacting the destabilizing effects of love in their visible bodies, as the infernal tempest defines the moral directionlessness of those overwhelmed by the amorous tempest.

When summoned by Dante, Francesca sails into view fettered to her silent lover.[6] In her threefold invocation, she defines love as flammable, inescapable, and fatal: "Amor

4. E.G. Gardner (*The Arthurian Legend in Italian Literature* [London: Dent, 1930], pp. 152–53) dates the composition of the *Tavola* to the second quarter of the fourteenth century partly on the basis of (unidentified) echoes of Dante.

5. Dante Alighieri, *The Divine Comedy: Inferno*, tr. Charles S. Singleton. Bollingen Series 80 (Princeton, N.J.: Princeton University Press, 1970), V, 29. All verse references to Dante's text (and to Singleton's translation) are to this edition.

6. The fact that Francesca speaks while Paolo remains silent may merely reflect Dante's technique which seems (in Hell, anyway) only able to accommodate one respondent to his questions, but it may also have been determined by an understanding of love as "effeminizing," as an activity more suited to women than to men.

condusse noi ad una morte" ("Love brought us to one death,"
106) she explains, recalling the essential feature of the Tristan
story, the rootedness of love in death. Like Paolo and Francesca,
Tristano and Isotta in the *Tavola* (as in other versions) ". . .
ebbono una vita e feciono una morte," 122) (". . . had one life and
went to one death," 80). When the *Tavola* adds, "e credesi che le
anime abbiano uno luogo stabilito insieme," 122 ("it is believed
now that the two souls dwell together in one place," 80), the
primary reference to the lovers' tomb competes with the image
of Paolo and Francesca together forever in Hell. While the *Tavola*
strives to reinvest the notion of love with virtue and valor,
Francesca's fate recalls the danger in the text's redemptive
project.

The distinctive theme of the *Tavola*'s treatment of love is its
emphasis on *concordia*, a harmony most perfectly created by the
potion that chains the hearts, thoughts, bodies, and wills of the
lovers. While Paolo and Francesca again define the antitype of
this eternal bondage, the *Tavola* never wavers in its commitment
to the praise of chained hearts indissolubly linked even at the
risk of death and damnation.

The issue of *concordia* is first raised when Bellices, the King
of France's daughter, becomes the first woman to fall in love
with Tristano. While her love has all the passion and single-
mindedness of Tristano's love for Isotta, it lacks one crucial
quality: it is not returned. Her unrequited love introduces the
paradoxes and ambivalences of desire that initiate the *Tavola*'s
theorizing about love. Her prayer "che lo amore fosse *una*
dolcezza e *una* cosa," 57 ("that love might be a sweetness and a
single thing," 40) was, the text affirms,

> giusta, imperò che nullo perfetto amore non è, se l'altra
> parte none è in *concordia*. E perchè Tristano non era in
> *concordia* sua volontà con quella di Bellices, di ciò ella
> molto si doleva (57; my emphasis).

("[Her prayer was] just, because no love can be perfect unless
both are in love; because Tristan's will was *not in accord* with
Bellices's, she was very sorrowful," 40.)

With this discordant love, the *Tavola* begins to prepare for
the harmonious love of Tristano and Isotta, a love not only
absolutely shared, but absolutely adequate, stable and

unchanging. This absolute degree of concord is, the text implies, miraculous, enabled only by the miracle of the potion; the discordant antitype of which is the "drunkenness of desire"[7] that Bellices exhibits in her frenzy of unsatisfied longing.

Rejected by Tristano, Bellices kills herself and

> l'anima si partì dal corpo sanza troppo dolore: imperò ch'ella era una cosa collo amore, e quella morte dopo lo dolore passato, cioè amando di sie leale amore Tristano (61–62).

("[Her] soul escaped without much pain, because she was one with love and after her death her sorrow was gone, the sorrow of loving Tristano," 42.)[8]

This end of sorrow, however, forces a rethinking of the problem of *concordia*. She is now "one with love," but still separated from her lover, her marriage with death predicated upon her divorce from Tristan, so that she achieves harmony with Love, but not with the lover. She represents, one might say, the downside of desire, the unheeded call for reciprocity answered only by silence and a union only with the void.

This longing for *concordia* is satisfied in the love of Tristano and Isotta, who are united, even chained together.

> E fue quella una catena la quale incatenò il cuore degli due amanti; sicchè degli [due] cuori fece uno cuore, cioè uno pensamento; e delli due corpi fece una volontà (122).

("It was as if one chain bound the hearts of the two lovers so that the two became one heart, that is, one thought, and of the two bodies made one will," 80).

In Dante, on the other hand, the *concordia* that binds the hearts of lovers becomes ominous when the inseparability of Paolo and Francesca becomes part of their punishment. Dante's heroine is oppressed by her inescapable coupling with Paolo,

7. In the original, she behaves "come donzella innebriata dell'amore e del dilettoso piacere a del disìo d'amore," 57 ("like a maiden drunk with pleasure and full of the desire for love," 40).

8. Note that Shaver leaves out of her translation the phrase "di sie leale amore," thus losing the defining quality of true love in the *Tavola*, the "loyal" love that lasts until death.

whose silence may not imply his loving acquiescence, but his sullen disapproval and despair. The contrast between the two sets of lovers reveals the diverse operation of bonds imposed versus bonds perpetually chosen, eternally embraced, the difference between the incarceration of the body and the submission of the spirit.

The perfect *concordia* of Tristano and Isotta, depends, however, on the miracle of the potion. And it is in the definition of the potion that the *Tavola* confronts Dante's definition of lust and redeems it. While Dante learns that the second circle holds those "che la ragion sommettono al talento"—who subject reason to desire (V, 39), the *Tavola* does to this Augustinian notion of sin what Marx said he did to Hegel: it is stood on its head. The absolute subjection of the will to desire that damns Paolo and Francesca is precisely what comes to justify Tristano and Isotta. "Imperò che 'l detto beveraggio fue ordinato a sforzare la natura, e a sottomettere la ragione e la volontà, e dare volontà di piacere," 122 ("or the potion was made to compel nature, and to set the reason under the will, and awake the will to pleasure," 80). It is not, in this case, the function of the potion merely to permit the lovers to indulge themselves without guilt. Beyond erasing guilt, the potion here confers a blessing. It is this potent potion that allows Tristano and Isotta to transcend worldly obligations (like marriage ties and feudal duties) and ordinary human limitations. It is the potion that allows Tristano and Isotta to achieve the *concordia*, the mutuality and stability of desire, that makes them unique and even, by the end of the *Tavola*, the saints of a new erotic hagiography when their tomb becomes a shrine and their tale a legend.

This justification of love through fidelity unto death, usually thought to mark the end of Eros, is reiterated throughout the narrative in the multiplication of spaces that are both Love's temple and love's tomb. Gottfried's Minnegrotte establishes the archetype of this sort of sacred space, but the prose *Tristan* as well as its verse predecessors provide models for the *Tavola*'s conception of sites that associate the hoped for permanence of love with the finality of the tomb. While the figures of Paolo and Francesca continue to haunt the borders of desire as the negative Other, the *Tavola* contrasts their restless whirling in the hellish

winds with the marble stability of the lovers' tomb, which, as it memorializes mortality, also praises stasis. But the tomb is merely the last of the spaces that Tristano and Isotta carve for themselves in their retreat from a world at worst mired in betrayal and at best celebrating a vainglorious chivalry or an anemic quest for an irrelevant Grail.

The carved out spaces include the ship on which the lovers drink the potion, the Castello dello Proro, the castle of the Wise Damsel (the Savia Donzella) and the palace of the Lady of the Lake. In all of these spaces, the lovers are both liberated and trapped. The adventure of the Castello dello Proro ratifies the union of Tristano and Isotta through the castle's custom, which determines the most valiant man and the most beautiful woman. As victors of the custom, Tristano and Isotta prove their excellence and their union of *prodezza* and *bellezza* is given social approval outside the confines of Cornwall. In the *Tavola*, the approval is ratified in a marriage that supersedes the accidental, insubstantial marriage of Isotta to Marco, a marriage already contracted but not yet consummated. Although Anne Shaver (348, n. 18) and Joan Ferrante[9] agree that the marriage serves to demonstrate the "social emphasis" of the *Tavola*, the events in the castle on the Isola Malvagia, seem more appropriately designed to establish the supremacy of Tristano and Isotta over merely social goals and customs, and to provide them a time away from either Cornwall or Ireland, where, restrained by no laws but their own,

> allora stave bene Tristano con grande diletto e a suo modo
> colla bella Isotta; e niuna cosa mancava loro, se non che
> non si potevano dell'isola partire (133).

("Then Tristano lived in great delight with the beautiful Isotta, lacking nothing except a means of leaving the island," 87.)

While the hint of eternal entrapment may again recall the punishment of Paolo and Francesca, the lovers themselves are less distressed by a sense of entrapment than by the knowledge that this indulgence must end, a flaw ultimately remedied in the

9. *The Conflict of Love and Honor: The Medieval Tristan Legend in France, Germany and Italy* (Paris: Mouton, 1973), p. 42.

eternal union of the shared grave, which the Castello dello Proro darkly prophesies.

In the Tower of the Savia Donzella on the border of Cornwall and Lyonesse,[10] the brutal forest of the verse romances[11] is no longer *aspre et dur*, but fully equipped with food, servants, and a beautiful bed ("bello letto") for entertainment ("a diportare," 163). Here, the lovers spend their time hunting, fishing, playing chess, and otherwise enjoying themselves in this civilized Forest, where, for seventy-five days, they indulge again in the private pleasures of their shipboard love, as they had in the Castello del Proro. Again, however, the unstable, but ever present, world imposes the only defect in their pleasure, the compulsion to leave (when Marco discovers them).

The most suggestive of these places is, however, that of the Lady of the Lake, who drugs Tristano—a variant of potion—and locks him in her garden. To cover the loss of Tristano,

> la Dama del Lago fae allora, per arte, una corpo morto, lo quale pareva proprio quello di Tristano; ed era addobbato delle insegne di Tristano, ed era innaverato in tre parti, tutto insanguinato; e fallo porre in sullo mezzo della strada del cammino, e favvi porre il suo scudo e alquante lance tutte spezzate, sì come quivi avessoro combattuto più cavalieri (416).

("By magic the Dama del Lago made a dead body which looked as if it were Tristano's, and dressed it with Tristano's insignia. It was all bloody, wounded in three places, and she had it put in the middle of the roadway, and had a shield put with it, and shattered lances, as if he had died fighting many knights," 267.)

A short time later, she repeats this trick with Lancilotto, so that the two knights are free to indulge in every pleasure known to a medieval aristocracy. To complete their pleasures, however, the Lady of the Lake repeats her ruse of feigned death to reunite the knights with their ladies.

10. The fact that the Tower is on the border between two worlds evokes the theme of the threshold and the other worldliness of Tristano and Isotta once they have fallen in love. They are *in* but no longer entirely *of* the world.

11. And the original of Gottfried's Minnegrotte.

When the two sets of lovers are together, the Lady of the Lake

> gittò una polvere, la quale, per arte, di súbito misse una sì oscura e folta nebbia e tanto grande, che lo re Artù e gli altri cavalieri, per la grande oscuritade, l'uno non vedea l'altro (424).

("[The Dama del Lago] threw a powder over it that covered [the palace] by magic with a dense, dark cloud so large that King Artù and the other knights, because of the great darkness, could not even see each other," 272.)

This cloud, a visual echo of the vapor that canopied the ship, encloses Tristano and Isotta once more in a privileged space like that in which they first declared their love. When the Lady of the Lake extends her protection to allow (compel?) Lancilotto and Ginevra to join them, she creates an inclusive society of lovers that, at this point in the narrative, reveals the separation of the knights of love from the ascetic Galasso. We should also note that this union, which will become permanent for Tristano and Isotta, is only an interlude for Lancilotto and Ginevra.

The *Tavola* posits these pleasure palaces suspended between the horror of the grave and the hope that love survives it. The final locus, Elergia's Palace of Great Desire in the Wilderness of Andernantes, seems, however, to question this hope, for this palace of desire must, according to Merlin's prophecy, "cadere per lo primo tuono che veniva alla fine del mondo; e caderàe innanzi che niuno altro edificio" (228)—"[The tower would] fall in the first thunder which signaled the end of the world, and would fall first before any other structure" (148). This destined fall might seem to deny any possibility of an eternal erotic love, but the text distinguishes between things made by art and things made by faith. Elergia's artful palace, designed by a lustful sorceress to trap an unwilling lover, is a monument to lust and rampant *discordia*, a temporary paradise destined to fall when only truth and true love will stand. When Elergia's palace falls, for Tristano and Isotta, time's defect will be rectified in the tomb, where they will be united for eternity. The single death to which love leads them is not, however, tragic, but

redemptive. With them, as with any martyr, death does not defeat; it justifies.

In order to justify erotic love while also establishing its orthodoxy, the *Tavola* takes great pains to distinguish true love from mere lust. To do this, the *Tavola* returns us to Francesca's library. Tristano and Isotta will be confirmed as redeemable patterns of true love by dethroning Francesca's damned models, Lancilotto and Ginevra.

The most direct attempt to demote Lancilotto is seen in the *Tavola*'s revision of the split-shield motif.[12] The broken shield that will join when true lovers unite, the shield that first reveals the subjection of Guinevere and Arthur to Lancelot at the tournament at Roche Dure, is now designed to prophesy that the *carnal* love of Lancilotto and Ginevra will be superseded by the *loyal* love of Tristano and Isotta. The *Tavola* introduces this prophecy after Tristano has offered to fight for King Languis, before he has even arrived in Ireland and met Isotta. When the damsel cannot locate Arthur and Guinevere, she delivers the shield to Tristano in words that echo the Loathly Lady's denunciation of Lancelot on the day of Galahad's investiture.

> Ed èe più pro' cavaliere che non èe Lancialot, e più perfetto e più leale amore che non èe lo suo. E quando lo perfetto e lo leale amore saranno congiunti in fra li due belli e liali amanti del mondo; ciò sarà in fra la più bella dama, e lo più bello cavaliere e lo più cortese del mondo e lo più pro'; questo scudo aperto, sì si risalderà, sì come mai non fosse stato rotto. E quando gli due liali amanti verranno a morte per cagione dello amore, questo scudo s'invecchierà tutto, sicchè non vi si parràe veruna figura (104).

("No longer is Lancilotto the noblest knight, and the most perfect and loyal love is not his. When perfect, loyal love will join the most beautiful and loyal lovers in the world, it will be between the most beautiful lady and the handsomest, most courteous, bravest knight in the world, and this shield will resolder itself, as

12. Carol Dover ("The Split-Shield Motif in the Old French Prose *Lancelot*," *The Arthurian Yearbook*, I [1991], 43–61) provides a thorough discussion of this motif in the French romance.

if it had never been broken. And when the two loyal lovers die
because of their love this shield will wear out, so that the figures
on it will disappear," 69.)

The text goes on to emphasize the excellence of Tristano
and Isotta, their unequalled *bellezza* and *prodezza* proving to
"Lancialot e alla reina Genevra, ch'egli era al mondo più bello
cavaliere e più bella dama di loro; e doveva essere più corale e
liale amore che non era lo loro," 105 ("[Proving to] Lancilotto
and Queen Ginevra that there was in the world a handsomer
knight and more beautiful lady than they, and that these two
were going to have a stronger and more loyal love than theirs,"
70).

Although the prophecy makes it clear that Tristano and
Isotta will surpass Lancilotto and Ginevra in the nature of their
love, both pairs of lovers could be perceived as equally carnal.
The crucial difference, however, is again the potion, which may
induce carnality, but, is simultaneously "tanto perfetto, che gli
condusse a una morte," 105–106 ("so perfect that it led them to
one death," 70). Lancilotto and Ginevra may die, but they do not,
like Tristano and Isotta, die for love. Tristano and Isotta are
greater lovers because their commitment to each other endures
beyond the grave. The damsel's shield prophesies this as well,
for, just as it closes on the day they drink the potion, "e 'l dì della
loro morte, lo scudo diventò indíco, tale che niuna figura entro vi
si pareva," 106 ("on the day of their death the shield grew old,
and the figures faded," 70). The prophetic shield reveals that
Tristano and Isotta, unique patterns of love, clearly surpass
Lancilotto and Ginevra, who may, however, remain the greatest
of merely carnal lovers.

Carefully, then, the *Tavola* rejects the *Lancelot*'s chivalric
love that led Francesca to her damnation. A more difficult
problem, however, is to reject the alternative kind of love
represented by Galasso, the spiritual antithesis to the Tristanian
thesis. The *Tavola* introduces Galasso, as do the sources, as the
measure of his father's failure, when the Loathly Lady condemns
the father on the day of the son's investiture. The *Tavola*
emphasizes, however, that it is "per la grazia di Dio, Galasso era
lo più grazioso e lo miglior cavliere del mondo, salvo che messer
Tristano," 430–31 ("by the grace of God [that] Galasso was the

most gracious and the best knight in the world, *except for Sir Tristano*," 276; my emphasis). In distinguishing between grace given freely and grace given as a reward, the *Tavola* claims that

> la grazia rimunirata riceve ogni persona; ma Iddio diede a Galasso una grazia la quale s'appella grazia data, per la quale grazia trasse la spada del petrone; e innanzi che suo scudo ricevesse colpo, fue appellato lo migliore cavaliere del mondo, in grazia e in opera data da Dio. E Tristano fue lo più pro' cavaliere mondano che nascese in questo mondo, lo più gentile e lo più cortese (431).

("Everyone . . . receives grace as a reward, but God also gave Galasso free grace, . . . So before his shield had received one blow he was called the best knight in the world, because of the grace and the works of God. *But Tristano was the noblest worldly knight ever born on this earth, the gentlest and the most courteous*," 276–77; my emphasis.)

The *Tavola* has little difficulty demonstrating the supremacy of Tristano over Lancilotto, but its celebration of Eros is threatened by the example of Galasso, embellished as he is with ecclesiastical origins and clerical authority. The *Tavola* accepts Galasso's excellence, but stresses that he owes his success to God's favor, while Tristano, on the other hand, achieves his chivalric greatness by his own strength; his *prodezza* is his alone.

There is, however, a peculiar similarity between Tristano and Galasso. While Lancilotto is simply carnal, both Galasso and Tristano are inspired by a higher power. What God does for Galasso the potion does for Tristano, so that the *Tavola*, despite its assertions of orthodoxy and expressions of pious sentiments, can barely repress a subversive rivalry between God and the potion, between an ascetic orthodoxy represented by Galasso and an erotic paganism represented by Tristano. If, however, it manages to achieve a Christian erotics, it does so by rejecting the excesses of both Lancilotto and Galasso and establishing Tristano as the locus of carnally spiritual love, resolving the Pauline split between body and spirit.

The *Tavola*, however, is interested not only in replacing Lancilotto with Tristano, but also in investigating the pre-text that celebrates him, Francesca's *Lancelot en prose*, the archetype of the book as pander. Francesca recalls her textual seduction:

"Quando leggemmo il disïato riso
esser basciato da cotanto amante,
questi, che mai da me non fia diviso,
la bocca mi basciò tutto tremante.
Galeotto fu 'l libro e chi lo scrisse:
quel giorno più non vi leggemmo avante."

("'When we read how the longed-for smile was kissed by so
great a lover, this one, who never shall be parted from me, kissed
my mouth all trembling. A Gallehault was the book and he who
wrote it; that day we read no farther in it,'" V, 133–38.)

The courtly, literary elegance of Francesca's narrative,
undermined only slightly by the implicit irony of a compelled
concordia, shifts the office of go-between from bawd to book, a
more literate pandering, but one that nevertheless efficiently
conveys her to damnation with her mute, compulsory
companion. What the *Tavola* intends is not only to replace the
carnal Lancilotto with the loyal Tristano, but to itself replace the
prose *Lancelot* as the true lovers' text. In its gloss on the vines
that grow from the lovers' graves, the *Tavola* allegorizes the
branches the root and bole and fruit to define the perfections of
Tristano and Isotta and concludes by finding in them a
continuing source of inspiration.

E la detta vita faceva uve di tre maniere; cioè in fiore e
acerba e matura; a dimostrare che negli due leali amanti
furono tre nature: imperò ch'eglino furono fiore di cortesia
e di bellezza e di gentilezza; e furono acerbi in quanto e'
ricevettono molta tribolazione; e furono maturi e dolci,
imperò ch' el loro diletto fu tanto, che no' curavano di
neuna tribolazione. E fu quell' albero vite, a significare che
sì come la vite fae frutto e 'nebria altrui, così la vita di
Tristano e di Isotta fu albero d'amore, e appresso il quale
confortava e inebriava ogni fine amante (508).

("Grapes grew on the vine in three stages, that is, in flower,
green, and ripe, to show that in the two loyal lovers were three
natures, for they were the flowers of beauty, courtesy, and
nobleness; they were green and bitter in that they endured many
sorrows; and they were mature and sweet in that, in their delight
in each other, they cared nothing for their troubles. And the
plant was a grapevine to show that as vines bear fruit that brings

rapture to all mankind, so the life of Tristano and Isotta was a tree of love which long afterward comforted and inspired all courtly lovers," 324.)

This life, the legend, now becomes the text that leads not to the Francescan damnation of the prose *Lancelot*, but to the Tristanian apotheosis. The book, the *Tavola* itself, replaces the corrupt Galeotto to become the equivalent of Tristano's potion bestowing its beneficence on all true lovers who can read and understand. The force that through the green fuse of these luxuriant vines invests the spirit of Tristano with the majesty of Dionysos, leads, in the allegory of this literally pious text, to a glimpse of the possible inauguration of Tristano as the god of erotic ecstasy.

Memorialized in death and at peace in the tomb, the final space of absolute *concordia*, Tristano and Isotta reign eternally as guides to lovers, and the *Tavola Ritonda*, the Book of Tristano and Isotta, replaces Galeotto to become the New Testament of love, the gospel instituting the Eucharist of Eros with the miraculous grapevines potentially providing wine for this lovers' sacrament.

In replacing the *Lancelot*, however, the *Tavola* also challenges the *Divina Commedia* itself, a text and a quest rooted, like the love of Tristano and Isotta, in death. As the *Tavola* reorients Francesca's "Amor condusse noi ad una morte," so that what leads Lancilottian lovers to damnation redeems Tristanian lovers, the Dantean authority is called into question. Just as the *Tavola* rejects Lancilotto for being merely carnal, Dante's love is also, by implication, defective, because it lacks *concordia*. Since true lovers die as well as love together, the very basis of Dante's quest, the search for the ascended Beatrice, becomes a sign of defective love, a love that, like Bellices', is defined by the absence of mutuality, a love more narcissistic than true.

Thus, the *Tavola* and the *Commedia* confront each other as opposing models of love, both of which reject simple consolations to accept the challenge of dealing with the most painful fact of love, the mortality of lovers. For the *Tavola*, true love inextricably knots the lovers joining them irrevocably in love and death. The poisonous potion that ties the knot fructifies *concordia*; its visible sign the potent vines and potential wine. Dante, on the other hand, unknots *concordia*, so that from the

perspective of the *Tavola*, his quest is a poignant pilgrimage of belatedness, and his reunion with Beatrice in Purgatory not a healing, but a dissonant reminder that what he seeks has already been lost, that his journey to past love merely traces a trajectory towards the forever irrecoverable. Reinscribing Eros in the realm of Agape, the *Tavola Ritonda* holds out the painful hope that love can bind the body and the spirit in an everlasting concord, expressing the hope that death, although it cannot be avoided, can be shared. Dante and Tristano, then, define opposing paths and, while one journey may be grander and its author undeniably greater, the fact remains that Dante struggles toward a bliss indefinitely deferred, while Tristano's history records his once and future acquisition of what Dante so profoundly sought. Rooted in the miracle of love and death, the *Tavola* leaves us with the thought that for true lovers passions and potions are more permanent than poems. [13]

13. My romantic, even sentimental, reading of the intersection of love and death in the *Tavola Ritonda* is a cheerful *caballetta* that should, perhaps, be read in the imagined context of the more tragic symphony on the same subject painfully recorded by Georges Bataille in *The Tears of Eros*, tr. Peter Connor (San Francisco: City Lights Books, 1989).

Malory's "Tale of Sir Tristram": Source and Setting Reconsidered

Dhira B. Mahoney

Scholarly opinion has long been severe on the section of Malory's *Morte Darthur* which has been known since Eugène Vinaver's edition of the Winchester MS as Book 5 or the "Tale of Sir Tristram."[1] Critical attitudes range from a benign neglect of the Tale, as if in tacit agreement that it is only a rather tiresome digression from the main Arthurian story—"largely irrelevant," as E.K. Chambers put it[2]—to outright condemnation. Thomas C. Rumble introduces his chapter on the Tale in *Malory's Originality* with an impressive array of such indictments, which he proceeds to refute; but his study and Donald G. Schueler's article on the "Tristram" (both of which I shall discuss later) have, until recently, been the only serious reconsiderations of the Tale as a

Reprinted with permission from *Medievalia et Humanistica*, n.s. 9 (1979), 175–98.

1. Quotations from or references to the text and Vinaver's Commentary are taken from *The Works of Sir Thomas Malory*, 2nd ed., 3 vols. (Oxford, 1967), hereafter cited as *Works*. To avoid confusion I have employed "Tale" rather than "Book" as the title of the "Tristram" section, and to facilitate comparison with the French I have spelled proper names such as Trystram, Launcelot, etc., in the form in which they most frequently appear in the text rather than in the customary form.

2. *English Literature at the Close of the Middle Ages* (Oxford, 1945), p. 191.

whole.[3] Now further remedy has been provided by Larry D. Benson in his recent book on the *Morte Darthur*, which counters criticisms of the Tale's disorganized prolixity by demonstrating its "solidly coherent, even elegant, thematic structure."[4]

Benson is not interested, however, in studying in detail Malory's source for the Tale or his treatment of it, for his chief purpose is to put Malory back into the context of fifteenth-century culture and English romance tradition (p. viii). Many critics have suggested that the faults of the "Tristram" were really due to its source; as Chambers said, "the prose *Tristan* was the worst of models."[5] Benson recognizes that Malory might have been attracted to the history of Tristan for "the image of chivalry embodied in his career" (p. 115), and asserts that the principal theme of the "Tale of Sir Tristram" is Trystram's "attainment of full knighthood as one of the four best knights in the world" (p. 116). I do not quarrel with the essence of Benson's statements, but find them incomplete: the theme of the "Tristram" is not just the attainment of knighthood but the pursuit of "worship" gained by fighting, and the bond of fellowship that develops among those who achieve it. In his earlier discussion of Malory Benson suggested that the English knight's method of handling his sources was dictated by his desire to "'anglicize' them, to adapt them to the forms and conventions he admired in English romance,"[6] and in his recent

3. Thomas C. Rumble, "'The Tale of Tristram': Development by Analogy," *Malory's Originality: A Critical Study of "Le Morte Darthur,"* ed. R.M. Lumiansky (Baltimore, 1964), pp. 118–83; Donald G. Schueler, "The Tristram Section of Malory's *Morte Darthur*," *Studies in Philology* 65 (1968): 51–66.

4. *Malory's "Morte Darthur"* (Cambridge, Mass., 1976), p. 109. Benson's work was published after the bulk of this paper was written; it will be apparent that I agree with his study of the "Tristram" in essentials, but approach the material from a different perspective.

5. *Sir Thomas Malory*, English Association Pamphlet no. 51 (London, 1922), p. 5.

6. Larry D. Benson, "Sir Thomas Malory's *Le Morte Darthur*," *Critical Approaches to Six Major English Works: "Beowulf" through "Paradise Lost,"* ed. R.M. Lumiansky and H. Baker (Philadelphia, 1968), p. 111.

study Benson demonstrates those conventions convincingly. However, he is, I believe, ignoring a vital dimension of that "anglicizing" process—the heritage of the alliterative revival. One of those admired English romances is the alliterative *Morte Arthure*, which Malory used as his source for Book 2, the "Tale of Arthur and Lucius." The alliterative *Morte* differs from the other English romances Malory might have known by its demonstrably heroic spirit, which is transmitted, slightly diluted but still characteristic, into Malory's Book 2, from where it subtly pervades the whole work. Vinaver points out that Malory's familiarity with this native epic may well have shaped and colored his concept of Arthurian knighthood as a whole (*Works*, p. lvii). It is certainly in the light of this heroic spirit that his choice of the *Tristan* as a source and his consistent modifications of it are best illuminated; this paper will consider some of these modifications in that light, and, as a corollary, the function of the Tale in the *Morte Darthur* as a whole.[7]

7. The exact text of the prose *Tristan* used by Malory is unfortunately unidentified and probably nonextant. Vinaver reconstructs it from its best and closest representatives, MSS Paris, Bibliothèque Nationale f. fr. 103, 334, and 99, corresponding to *Works*, pp. 371–513, 513–619, 619–846, respectively; he also uses Chantilly 646, Pierpont Morgan Library fr. 41, Leningrad fr. F. v. XV, 2, and Sommer's selections from British Museum Add. 5474 (see end of note), among others. As a supplement to Vinaver's Commentary I have consulted the first three MSS, hereafter cited as B.N. 103, 334, and 99, all transcriptions from these MSS in my text being my own unless otherwise attributed. However, B.N. 103 is abridged, and it and 99 belong to the fifteenth century; only 334 is definitely earlier than Malory's work, and it is incomplete (see note 12). Thus the originality of episodes, motifs, or striking verbal patterns in Malory's work cannot be assumed only by comparison with the appropriate "source" MS; a wider base of comparison must be employed. No complete edition of the romance exists, but the first 130 folios of MS Carpentras 404, chosen as the best representative of the oldest family of *Tristan* MSS, have been edited by Renée L. Curtis, *Le Roman de Tristan en prose*, Vol. I (Munich, 1963), Vol. 2 (Leiden, 1976), hereafter cited as Curtis. I have checked significant passages against this edition (providing the relevant transcriptions in my text with cross references to paragraph numbers in Curtis) and also against the following comparative analyses and partial editions: Eilert

The term "heroic" may need further definition. Malory departs most obviously from his source when he ends the "Tristram" on a note of harmony and joy with the welcome of Palomydes into the Round Table, while the news of Trystram's death is suppressed for nearly two whole Tales. It might seem inappropriate to call such a conclusion "heroic." However, the heroic spirit is a coin with two faces: the joy and cohesiveness of the "Conclusion" of the "Tristram" is but the positive and celebratory face; the reverse has tragic potential which is only fully realized in the last Tale of the *Morte Darthur*. Benson characterizes the final movement of the work as an "interweaving" of two kinds of narrative, the historical tragic narrative and the thematic "comic" one (p. 209); I prefer to describe it as a modulation to the tragic which has always been implicit in the heroic mode. In the "Tristram" both comic and tragic potentialities co-exist.

Malory's source, the Second Version of the prose *Tristan*, was not part of the great early-thirteenth-century cycle called the Vulgate, which provided the sources for four other Tales, but dated probably from the second half of the century.[8] This version

Löseth, *Le Roman en prose de Tristan, le roman de Palamède, et la compilation de Rusticien de Pise: Analyse critique d'après les Manuscrits de Paris* (Paris, 891), cited as Löseth, *Le Tristan et le Palamède des Manuscrits français du British Museum* (Kristiania, 1905), *Le Tristan et le Palamède des Manuscrits de Rome et Florence* (Kristiania, 1924); Eugène Vinaver, *Le Roman de Tristan et Iseut dans l'oeuvre de Thomas Malory* (Paris, 1925), cited as *Le Roman de Tristan*; C.E. Pickford, ed., *Alixandre l'Orphelin: A Prose Tale of the Fifteenth Century* (Manchester, 1951), from Pierpont Morgan fr. 41; H.O. Sommer, ed., "Galahad and Perceval," *Modern Philology* 5 (1907–8): 55–84, 181–200, 291–341, selections from B.M. Add. 5474, cited as Sommer. Source study under such conditions cannot he conclusive, but can be extremely suggestive.

8. Eugène Vinaver, *Etudes sur le Tristan en prose* (Paris, 1925), pp. 22–33, and "The Prose *Tristan*," *Arthurian Literature in the Middle Ages: A Collaborative History*, ed. R.S. Loomis (Oxford, 1959), hereafter cited as *ALMA*, p. 339. Vinaver's simple distinction between the First and Second Versions has, however, been challenged: see the exhaustive discussion by E. Baumgartner, *Le "Tristan en prose": Essai d'interprétation d'un Roman médiéval* (Geneva, 1975), pp. 18–62. Malory's source was

of the Tristan legend was far removed from the bittersweet, delicate narrative of the original poetic form as in Béroul or Eilhart, or even the more courtly versions of Thomas and Gottfried von Strassburg. In the prose romance the center of interest had shifted from the moral complexities of the love affair to Tristan's progress as a "chevalier errant," the first climax of which is reached when he is solemnly received at the court of Artus and made a knight of the Table Ronde. Whereas in the poems the death of the lovers is an inevitable result of their unlawful love,[9] in most versions of the prose romance Tristan's death is caused by the treachery of Marc, who stabs him from behind while he is harping to Yseult, and the context of his death is predominantly chivalric. Yseult is called to his deathbed, but before she dies in his death embrace, Tristan kisses his sword and arms and entrusts them to Saigremor, taking a formal leave of chivalry: "desormais comant a Deu toute chevalerie. Ormés preing je a lui conjé; molt l'aime et honore. . . ." When the news is brought to Artus, the court is plunged into terrible despair: Lancelot laments, "puis que li bons Tristan est mort, toute chevalerie est morte."[10]

Such a chivalric atmosphere must clearly have attracted Malory. Sir Walter Scott suggested a further source of attraction when he commented on "those eternal combats, to which, perhaps, the work owed its original popularity."[11] It was certainly popular, as witnessed by seventy-eight extant MSS and fragments in French, translations and adaptations in Italian, Spanish, Portuguese, Danish, German, and Russian, and nine printings between 1489 and 1533.[12] It was probably a close rival

clearly a late version, either Version IV or derived from it (see pp. 71–87).

9. See W.T.H. Jackson, "Gottfried von Strassburg," *ALMA*, pp. 153–5, and Vinaver, *Le Roman de Tristan*, pp. 127–9.

10. "The Death of Tristan, from Douce MS 189," ed. E.S. Murell, *PMLA* 43 (1928): 374 and 383.

11. Ed., *Sir Tristrem* (Edinburgh, 1819), pp. lxxii–iii, quoted by Vinaver, *Etudes*, pp. 83–4.

12. For a classification of the MSS and the printings, see Curtis, 1:12–17, 2:12–15; for more detailed discussion of the MS tradition see

to the *Lancelot* in later medieval times. The combats must also have been to Malory's taste, for, though his version is some six times shorter and a great deal more simplified than his source (*Works*, p. 1443), it is still remarkably full of them; indeed, the Tale resounds with the joy of fighting. A cursory survey alone reveals three major tournaments, nine smaller tournaments or jousts, individual quests, fights in fulfillment of a vow, and single combats for judicial or political reasons. There are also four individual combats of thematic importance, which I shall discuss later, and any number of chance encounters, challenges in the forest, fights with and rescues from the ubiquitous sir Brewnys Saunz Pité, fights undertaken by both Trystram and Launcelot in their madness, and fights during the establishment of the Sangreal. They are essential to the texture of the Tale.

In his treatment of the combats, however, Malory shows a different emphasis from his source. As Maria Rosa Lida de Malkiel has shown, the pursuit of glory was a theme common to the greater part of medieval romances of chivalry: "la renommée est ressentie comme la fin première et naturelle de la chevalerie."[13] The prose *Tristan* was no exception. However, in the French courtly romances "chevalerie" is inseparable from "cortoisie," and "cortoisie" is as much an attribute of love as of fighting. In this aspect Malory is less interested. Take, for instance, his treatment of the great battle between Tristan and Lancelot. In the *Suite du Merlin*, a romance which dates from before the Second Version of the prose *Tristan*,[14] Merlin inscribes on the tomb of Launceor and Columbe: "en ceste place assambleront a bataille li dui plus loial amant que a lour tans soient" (*Works*, pp. 1308–9). The two most loyal lovers are Tristan and Lancelot, and the prophecy is fulfilled in the *Tristan* when

Curtis, 2: 15–52 and her *Tristan Studies* (Munich, 1969), pp. 66–7 (*re* Part I), also Baumgartner, pp. 18–87, summed up in pp. 85–7; for versions in other languages, see Vinaver, *ALMA*, p. 346, n. 4.

13. *L'Idée de la Gloire dans la Tradition occidentale* (Paris, 1968, trans. from Madrid, 1952), pp. 163–4; Dr. Malkiel is specifically discussing the *Libro de Alixandre* by Juan Lorenzo de Astorga.

14. See Fanni Bogdanow, "The *Suite du Merlin* and the Post-Vulgate *Roman du Graal, ALMA*, pp. 334–5.

they meet in battle by mistake. Though on this occasion the prophecy itself is not repeated, the tradition is clearly recalled: the stone where they meet is called the "perron merlyn" (B.N. 334, f. 298b), and when the two knights finally discover each other's identity they embrace and sit down to discourse on love (*Works*, p. 1484).

Malory's focus is subtly but fundamentally different. The *Suite du Merlin* is his source for Book 1, the "Tale of King Arthur," and his Merlyne renders the prophecy thus:

> "Here shall be," seyde Merlion, "in this same place the grettist bateyle betwyxte two knyghtes that ever was or ever shall be, and the trewyst lovers; and yette none of hem shall slee other." (72.5–8)

And in the "Tristram," before the event itself, the narrator recalls the prophecy:

> And at that tyme Merlyon profecied that in that same place sholde fyght two the beste knyghtes that ever were in kynge Arthurs dayes, and two of the beste lovers. (568.18–20)

Thus, where the French tradition designated the two knights as lovers, Malory has shifted the emphasis to their prowess as fighters: it is here that their source of fascination lies.

Even more revealing is his treatment of another incident in the *Tristan*. During the tournament of Lonezep Launcelot and Arthur ride out in disguise to catch a glimpse of Isode, who is accompanied by Trystram and Palomydes. Arthur, who has not seen Isode before, is struck by her beauty and gazes at her so long that Palomydes takes offense and knocks him off his horse. Launcelot is then in a dilemma: his duty is to avenge Arthur and unhorse Palomydes, but this will bring him into conflict with Trystram, his friend. He knocks down Palomydes, but calls out to Trystram:

> . . . I am lothe to have ado wyth you and I myght chose, for I woll that ye wyte that I muste revenge my speciall lorde and my moste bedrad frynde that was unhorsed unwarely and unknyghtly. And therefore, sir, thoughe I revenge that falle, take ye no displesure, for he is to me such a frynde that I may nat se hym shamed. (744.23–9)

Not only is this speech subtly different from the source, where Lancelot explains his attack on Palamedes thus: "se je labaty fait lancelot ce ne fu mie sans raison Car il abaty par son oultrage un mien chier amy qui icy est" (B.N. 99, f. 479d), but terms equivalent to "moste bedrad frynde" could not be found in a French courtly romance. (Significantly, Caxton also excises the phrase in his edition, just as he tones down the heroic flavor of Book 2.) The position of Malory's Arthur in relation to his followers is closer in spirit to that of the "seigneur" of *chanson de geste* or the "wine-dryhten" of Anglo-Saxon poetry than the more formal, technical, feudal relationship of the French. Indeed, in Book 1 he is called a "chyfftayne" (54.19); his knights owe him a direct and personal obligation.

Whereas the French Lancelot has been concerned more with his own honor, fearing that if he failed to avenge Artus "len ly pourroit atourner a grant honte et a trahison et a trop grant laschete de cuer" (f. 479c), Malory's Launcelot is torn between his friendship with Trystram and his unstated obligation to Arthur (744.6–11). The French Tristan ponders on the phrase "un mien chier amy," but does not guess Artus's identity; and he asks Palamedes solicitously how he is, for in ʰis view there is nothing reprehensible in defending the Queen of Cornwall from impudent knights. Malory's Trystram guesses the truth from Launcelot's hint and proceeds to rebuke Palomydes severely for his unknightly deed against "my lorde kynge Arthure, for all knyghtes may lerne to be a knyght of hym" (745.28–9). The essentially courtly episode of the source has been given a different *sen* by the alteration of a few details.

There is, indeed, a fundamental difference in outlook between Malory's work and his sources. Where in the French an old knight releases Tristan, his prisoner, less for love of him than "pour l'onneur de chevalerie mettre en avant" (*Works*, p. 1481), the corresponding character in Malory acts because he has appreciated that Trystram could not have helped killing two of his sons at a tournament: "'All thys I consider,' seyde sir Darras, 'that all that ye ded was by fors of knyghthode'" (552.24–5). "Fors of knyghthode" is Malory's own singular phrase, and Trystram's compulsion to act by it his own concept. In the prose *Tristan* characters may expound on "cortoisie," "frankise,"

"onneur," make vows to or take action for the sake of "chevalerie," and so on, but these are abstract concepts, existing outside and independent of the knights who may exemplify them from time to time. The desire for fame that impels Malory's knights is more urgent, tense and personal. It is the individual knight's own reputation that concerns him, his "worshyp." "Worshyp" is an old word: the *OED* records "weordscipe" as first occurring in Alfred's translation of Boethius, c. 888, and the Old English form shows its meaning more clearly. To gloss it as "honor" is inadequate; it is, rather, worth-ship, a man's total self-concept, measured by what is said and known about him publicly recognized.

Mark Lambert in his recent study, and D.S. Brewer before him, have demonstrated the importance of public recognition of worth in the *Morte Darthur*. Indeed, Lambert shows that Launcelot's behavior in the last two Tales makes sense when he is viewed as acting within a shame system rather than a guilt system: "in the imagined world of Sir Lancelot, where one's official, social identity is one's real identity, shame is more significant."[15] In the Malorian world it is the public concept of self that directs action; values are externally apprehended. Public identity is defined in "name," a term equivalent to "worshyp" in the Malorian vocabulary, as demonstrated by Arthur's rallying cry in Book 2: "Fayre lordys, loke youre name be nat loste! Lese nat youre worshyp for yondir bare-legged knavys" (221.4–6). I need hardly repeat that the source for Book 2, the "Tale of Arthur and Lucius," is the alliterative *Morte Arthure*: it is predominantly from the heroic alliterative tradition that Malory's terminology comes. The chivalric preoccupations derived from his French sources were tempered by his long familiarity with native alliterative poetry[16] and the elements of

15. D.S. Brewer, ed., *The Morte Darthur, Parts Seven and Eight* (London and Evanston, 1968), Intro., pp. 23–35; Mark Lambert, *Malory: Style and Vision in "Le Morte Darthur"* (New Haven, 1975), p. 179. Lambert's whole section on the function of public values in the final catastrophe, "Shame and Noise" (pp. 176–94), is excellent.

16. See William Matthews, *The Ill-Framed Knight: A Skeptical Inquiry into the Identity of Sir Thomas Malory* (Berkeley, 1966), pp. 100–3.

Germanic heroic tradition still retained by it. In this context
Thomas Greene's remarks in his paper "The Norms of Epic" are
illuminating:

> A man's name is very important in heroic poetry; it
> becomes equal to the sum of his accomplishments. It is
> always assumed that a man's action is knowable and is
> known, and is known to be *his*. . . . It is important that
> every combatant who is killed in the *Iliad* have a name, for
> the name is an index to the victor's accomplishment. A
> hero wears his victims' names like scalps and his own
> name is aggrandized by theirs.[17]

Thus the distinction between "name" as identity and "name" as
reputation becomes so fine as to be almost nonexistent. A
knight's name is not only the formula that identifies himself and
his lineage, but the formula that conjures up for the hearer all his
known achievements. As Vinaver has shown from the first, one
of Malory's chief divergences from his French sources is his
practice of naming characters left anonymous in the French, or
refusing to delay their identification.[18]

The desire for worship is the desire for a name, and the
knight's life is devoted to informing that name with meaning:
"hit ys oure kynde to haunte armys and noble dedys," says
young Percyvale when his mother begs him to stay at home
(810.6–7, not in *F*). Similarly, witnesses to those noble deeds are
necessary. Throughout the early Tales defeated or rescued
knights come to "bear recorde" to the exploits of the hero of their
respective adventures (e.g., 286.25–36); indeed, Malory sends
them to court when his source does not (104.16–17, 175.5–8,
178.31–3). Worship cannot exist in isolation; name has meaning
only in the context of one's peers. It is measured by what they
say: "tyll men speke of me ryght grete worship" (132.11–12); "I
pray you . . . force yourselff there, that men may speke you
worshyp" (1103.19–20); "I woll never se that courte tylle men
speke more worshyp of me than ever they ded of ony of them
bothe" (814.24–6). It is precarious, fragile; and it needs constantly

17. *Comparative Literature* 13 (1961): 198–9.

18. *Malory* (Oxford, 1970, reprint of 1929), pp. 34–8.

to be maintained, as Isode recognizes when she objects to Trystram staying away for her sake from the great feast and tournament at Pentecost: "ye that ar called one of the nobelyste knyghtys of the worlde and a knyght of the Rounde Table, how may ye be myssed at that feste?" (839.31–3).

We confirm that the concept of self expressed in Malory's work owes much to his heroic alliterative source when we recognize that the "boste" or "avaunte" in the *Morte Darthur* is more than merely swagger or self-advertisement. In Book 2, the "Tale of Arthur and Lucius," when Gawayne is accused of not being able to back up his "boste," his answer is to cut off his taunter's head, even though the Arthurian party is totally outnumbered in an enemy camp (207.20–7). The incident recalls an OE "beot." Though ME *boste* and OE *beot* do not seem to be etymologically related, they are both clearly used in the same way,[19] and it is instructive to turn to OE scholarship to explain the concept. The warrior who makes a *beot* is making an oath, dedicating himself to some promised action. In his study of the covenant in Anglo-Saxon thought, Father Zacharias Thundyil has demonstrated that such an oath in the ancient world implied a self-imprecation, a curse of self, if the promised action were not fulfilled.[20] The result would be shame, not only to the self, but to kin also; the man who was dishonored dragged his race down with him. Later in Book 2 Arthur rebukes Launcelot for having persevered in battle when heavily outnumbered, and is in turn rebuked by Launcelot:

> "Not so," sayde sir Launcelot, "the shame sholde ever have bene oures."
> "That is trouth," seyde sir Clegis and sir Bors, "for knyghtes ons shamed recoverys hit never." (217.28–218.2)

19. Both are used in similar constructions, and both have been glossed as L. *jactantia*: see *beot*, III, *An Anglo-Saxon Dictionary*, ed. Bosworth and Toller; *bost*, I (a), and (b), *The Middle English Dictionary*, ed. H. Kurath; *boast*, 3 and 4, *OED*.

20. *Covenant in Anglo-Saxon Thought* (Madras: The Macmillan Co. of India, Ltd., 1972), pp. 13–14. This is the published form of the author's Ph.D. dissertation for Notre Dame, 1969.

Whereas the incident of Gawayne's embassage is closely translated from the *Morte Arthure*, the quotation above is original to Malory. Not only does he transmit, but he accentuates the heroic flavor of his source.

Father Thundyil has shown that the covenant state or relationship did not only exist among kinsmen, but was "a kind of brotherhood which was an extension of blood-brotherhood or natural kinship" (p. 3). In Germanic society the health of such a brotherhood depended on internal love and harmony, of *friđ* and mutual fidelity, or *triuwe* (see pp. 55–66). In Malory's work the *comitatus* of Germanic literary tradition has become a more fluid kind of brotherhood, but one whose roots are still recognizable. The rules by which the state of harmony is maintained in the Arthurian brotherhood may never be verbalized, yet all know when they are transgressed. To break that state of harmony is treachery, and "traytoure" is one of the most frequent terms of abuse in the *Morte Darthur*, surfacing in the last Tale as a formal charge that must be answered in public combat (1215.7–1216.6). Similarly, the loyalty which held the *comitatus* together has been transmuted into an emotion equally forceful, if less restricted, a bond which may even override the most fundamental tie, the tie of blood, as we see in the love of Gareth for Launcelot, who made him knight. The most evocative word in the *Morte Darthur* is "felyshyp": it denotes the compelling attraction between great knights, the centripetal pull which draws the great together and the less toward the great in admiration. The chief center of attraction is naturally the place where the great can "infelyshyp," the glorious Arthurian court, which draws all to it like a beacon. When Arthur hears of a particularly noble knight, he longs to make him a knight of the Round Table, for his glory is increased by theirs, and they glow as jewels in his crown.

The strength of this centripetal pull between the great names of the Arthurian world is revealed in the public occasions, the great tournaments. There are three major tournaments in the "Tale of Sir Tristram," contests which last for several days, and for which the contestants may come from far afield. The atmosphere of excitement that is generated before one of them is like that of the Olympic Games: much of the interest lies in getting a sense of who has come, identifying the great names. On

the day before the tournament opens at the Castle of Maidens, for example, Trystram and Persydes stand before a bay window, watching the knights riding to and fro. When Trystram hears that one of them, Palomydes, has smitten down thirty knights, he cannot bear to miss the action: "Now, fayre brother . . . lat us caste on us lyght clokys, and lat us go se that play" (515.5–7).

Similarly, before Lonezep, many days elapse as kings and knights and nobles gather from many realms. Trystram, Palomydes, Dynadan, and Gareth ride together toward the castle and marvel at the great "ordynaunce" of four hundred tents and pavilions; but, characteristically, the conversation reminds them of previous tournaments and those who won worship at them (698.3–18). The great contests of the past are remembered and create resonances through the Tale.

It is minor events, however, that show most clearly how Malory's source modifications consistently emphasize the cohesive aspects of fellowship, particularly in certain details that have escaped Vinaver's otherwise extensive commentary. In the "Tristram" the extension of the field of action beyond the Round Table proper displays the centripetal bond of attraction between great knights in its most fluid, yet powerful state. When Trystram, the young Cornish knight, having returned from his first visit to Ireland, goes out to rescue Segwarydes's wife after her abduction from king Mark's court, he encounters two "lykly" knights of the Round Table, sir Sagramoure le Desyrous and sir Dodynas le Savyayge (398.6–10). Governayle warns him that they are both proved knights, but Trystram is eager for a fight: "As for that . . . have ye no doute but I woll have ado with them bothe to encrece my worshyp, for hit is many day sytthen I dud any armys" (398.14–16). His challenge is accepted, and the two proved knights are defeated by the young Cornish knight whom they had mocked. But when they learn his name they are delighted: "Than were they two knyghtes fayne that they had mette with sir Trystrames, and so they prayde hym to abyde in their felyshyp" (399.28–30).

Though the incident is minor, it is useful, for comparison with the source episode shows differences which Vinaver does not note. In B.N. 103, Tristan does not mention that he is spoiling for a fight, but is more tactical:

Maitre dit tristan . . . se ils sont preudommes tant vault
mieulx Et se ilz sont tielz comme vous dictes ilz ne
masaudront pas tous ensemble mais chascun par soy . Et
puis quil nen vendra que lun corps a corps contre moy le
mencheviray bien. (f.47d; Curtis, § 383)

After the fight, when Saigremor learns that he and his
companion have been defeated by one of the despised Cornish
knights, his reaction is not delight but chagrin. He declares that
he will never be able to carry arms after the court has learned the
truth, and that rather than be deprived of them by a judgment of
the court, he will forswear them himself (f. 48b; Curtis, § 385).

Two other battles further demonstrate the strength of
mutual knightly attraction. First is the chance encounter between
Trystram and Lameroke in the Forest Perilous. In the source,
B.N. 103, Tristan and Lamourat, having fought for some time,
pause for breath, and, following chivalric etiquette, ask each
other's name. Hearing that he has been fighting the knight who
sent the magic horn to Marc's court to dishonor Yseult, Tristan
challenges Lamourat to further combat, and Lamourat defies
him to do his worst. However, their "cortoisie" prevents them
from actually fighting again; Lamourat agrees to surrender to
Tristan, and Tristan admits that he had challenged Lamourat the
second time only to test his "orgeuil" (f. 109a, b). Malory's
version of the encounter has a significant alteration. When
Trystram and Lameroke challenge each other to further battle,
the challenge is taken up and they fight till they are weary of
each other:

Than sir Trystrams seyde unto sir Lamorak,
 "In all my lyff mette I never with such a knyght that was
so bygge and so well-brethed. Therefore," sayde sir
Trystramys, "hit were pité that ony of us bothe sholde
here be myscheved."
 "Sir," seyde sir Lamerok, "for youre renowne and your
name I woll that ye have the worship. . . ." (483.14–20)

Vinaver's note here is confusing, for he implies that the knights'
dialogue is "interrupted" by their "laysshing" at each other
(*Works*, p. 1469), whereas in fact the dialogue has led to a second
and sourceless combat. Though the scene ends with the same
sense of reconciliation, Malory has changed its central

motivation. His knights swear friendship like their French counterparts, but it is admiration for each other's fighting prowess, not their "cortoisie," which has prompted it.

The second battle takes place later in the Tale. Palomydes and Dynadan have decided to fight the knights of Morgan's castle because of their shameful "custom," but are forestalled by a strange knight with a red shield who asks their leave to take on the task. When this stranger has overcome three knights in succession, Palomydes offers to help, but is rejected. The stranger overcomes two more opponents, and again Palomydes begs to joust, suggesting that the red knight needs rest. The latter takes this as an aspersion on his stamina, and challenges Palomydes, unhorsing both him and Dynadan before returning to his task to defeat another seven of the castle knights. Narrative comment is always sparse in Malory, but reference to the source confirms the suggestion of his text that Palomydes is motivated not only by a genuine desire to help a brave knight, but also by annoyance that the stranger is hogging all the fighting. He accepts the red knight's challenge eagerly, and when unhorsed is so angry that he follows the stranger to demand a return battle in spite of the latter's weariness. They fight mightily on foot, until Palomydes grows faint from his earlier wound, and requires his opponent's name, as they have "assayed ayther other passyngly well" (602.12); when he hears that it is Lameroke, for so it is, he is overcome at his unknightly behavior in forcing a further fight on a weary man. He begs Lameroke's pardon, and they swear a lasting friendship. The account is much compressed from the source, but Malory's most important change is in leaving out the French Dinadan's mockery at these sudden changes of the combatants' moods: "voirement font il tout ausint comme les enfanz . qui legierement se couroucent et legierement se racordent" (B.N. 334, f. 326c). As Vinaver has pointed out, Malory frequently draws Dinadan's sting by deleting or shortening his antichivalric speeches (*Works*, pp. 1447–8). In Malory's work the battles and friendships are neither arbitrary nor motiveless. The compulsion of his Arthurian knight is always to test himself against his peers, and when he has met a worthy opponent, to forge a bond of brotherhood. As the King with a Hundred Knights comments on the tournament field,

"evermore o good knyght woll favoure another, and lyke woll draw to lyke" (527.5–7).

To decide on the function of the "Tale of Sir Tristram" in the *Morte Darthur* as a whole requires, first, a definition of its major theme. Subtitling his study of the Tale "Development by Analogy," Thomas Rumble was the first critic to recognize a significance in the parallel between the stories of Trystram and Launcelot: "these similarities of incident and episode reinforce each other" (p. 182). However, what they emphasize is, in his view, the adulterous nature of both knights' love affairs; thus the relationship between Trystram and Isode becomes "symbolic of the moral degeneration to which the potentially perfect world of Arthur's realm is so inevitably being brought" (p. 181). But Malory does not stress the adultery. In fact, he cuts almost all of the stratagems which the French lovers Tristan and Yseult employ in order to meet or to escape discovery (Löseth, §§ 48–51). Far from exploiting it as a moral omen, he seems to have forgotten it altogether by the end of the Tale, representing his lovers living in comfortable domesticity in Joyous Garde.

Rumble's contention has been attacked by Vinaver (*Works*, p. 1446), and, more recently, by Donald G. Schueler, who argues that the parallel between Trystram and Launcelot serves rather to emphasize the difference between them, and Trystram's independence from Arthur's court: "Tristram has no significance larger than himself; he is ever the aimlessly wandering knight-errant of chivalry in its decline. Lancelot, on the other hand, is the archetype of Arthur's ideal fellowship, the heroic right arm of a heroic king" (pp. 65–6). Schueler's contention does not allow, though, for the extent to which Trystram and Launcelot are balanced in worship throughout the Tale, their names almost interchangeable as measures of greatness (e.g., 388.29–32, 487.16–17). Whereas the source, on the whole, presents Tristan as the better knight (see *Works*, p. 1486, n. to 578.4), Malory will never allow it: he goes out of his way to establish the equality of their prowess, even interrupting the account of a combat to do it:

> (Than was sir Trystrames called the strengyst knyght of the worlde, for he was called bygger than sir Launcelotte, but sir Launcelot was bettir brethid.) (415.31–3)

During Lonezep Malory inserts a whole narrative passage of praise for Launcelot and Trystram (742.23–33), where in the source all the members of the house of Artus are praising Palamedes: "tout le loz et tout le pris donnent a palamedes . ilz ne parlent fors de luy" (B.N. 99, f. 478c). Similarly Ector's speech urging Launcelot to return to court after his exile as Le Shyvalere Mafete has even less authority from the source:

> . . . ye muste remembir the grete worshyp and renowne
> that ye be off, how that ye have bene more spokyn of than
> ony othir knyght that ys now lyvynge; for there ys none
> that beryth the name now but ye and sir Trystram.
> (831.26–30)

In B.N. 99, f. 546a, b, Hector merely assures Lancelot that the Queen desires his return.[21]

Therefore, although his interpretation of the purpose of the analogy is misguided, Rumble's stress on the similarity between the two knights seems to be more faithful to Malory's text. The French romance operates against a vaster, more populated canvas; by excising many rival knights and reducing the roles of others,[22] Malory narrows the focus to Trystram and Launcelot. Indeed, the events of the Tale are balanced around these twin presiding genii, though Vinaver's sometimes arbitrary narrative divisions slightly obscure the architecture.[23] The long section that establishes Trystram's fame is counterweighted by the long section of Launcelot and Elayne, and the love madness of one knight echoes the other's, even to the extent of the addition by Malory of a sourceless scene when Trystram is recognized in the

21. Malory has altered the end of the Tristan-Brunor fight (415.29–35, cf. B.N. 103, f. 60c, d; Curtis, § 463), as Vinaver has implied but not clarified; Vinaver does not note the originality of 742.23–33; thirdly, Vinaver comments on Ector's notorious "twenty thousand pounds" (831.32–3) but does not make clear that the whole speech is considerably expanded from the source.

22. E.g., two important narrative threads in the French romance are the friendship between Galeholt le hault prince and Lancelot, and the rivalry between Tristan and Brunor (La Cote Mal Taillée).

23. E.g., there are no breaks in the Winchester MS between Vinaver's Sections I and 11, or V and VI.

garden by his hound, paralleling Launcelot's recognition by Elayne (*Works*, p. 1473, and *Malory*, pp. 40–1). The three great tournaments are also carefully distinguished: at the Castle of Maidens Trystram wins the *gre* on two days, though his wound prevents his winning on the third; at Surluse (while Trystram is in Cornwall), Gwenyver presides, and Launcelot and Lameroke win the *gre*; at Lonezep Isode presides, for Gwenyver is ill, and Palomydes wins the first day, Trystram the second, and Trystram and Launcelot share the prize for the third day. Even the minor characters revolve in association with one or the other, drawing the almost independent stories of La Cote Male Tayle and Alysaundir le Orphelyne into the pattern.

Benson's recent study has shown that the parallel between Trystram and Launcelot is thematically essential, informing the entire Tale (p. 122), and he examines its "elegant structure" with perception and insight. Each quest of a subordinate knight, he points out, "by parallel or contrast helps define the quest in which Tristram is engaged and, by the very multiplicity of perspectives, helps us to recognize that the real subject of this book is not Tristram's quest but knighthood itself" (p. 133). The explanation of the process is brilliant, but the conclusion drawn from it needs qualification. The subject of the Tale is not knighthood in a chivalric context, as Benson assumes, but rather knighthood in a heroic one. Benson demonstrates convincingly that fifteenth-century aristocratic preoccupations with chivalry explain why Malory chose to write a chivalric work (Chs. 7 and 8), but it does not necessarily follow that the concerns of Malory's work are therefore identical with those of his real life contemporaries. No king of Malory's day was likely to be called a "chyfftayne," as Arthur is (54.19). Throughout his work Malory looks back to an earlier day, "at that tyme" (287.24), "in tho dayes" (1051.12). His Arthurian world is a fictional construct, a heroic world in which cohesiveness and harmony depend on the achievement of "name" and the recognition and reward of loyalty. A brief scrutiny of the first six sections of the Tale, for instance, will demonstrate that Trystram builds up his "name" in a traditional heroic manner before he can be welcomed into Arthur's court.

Trystram's first victory, over Marhalte, gives him the right to wear his opponent's shield (383.7–10, not in *F*). His second victory is over Palomydes at the Irish tournament, and by the time he returns to Cornwall both triumphs are part of his "name":

> "Truly," seyde sir Bleoberys, "I am ryght glad of you, for ye ar he that slewe Marhalte the knyght honde for honde in the ilonde for the trwayge of Cornwayle. Also ye overcom sir Palomydes, the good knyght, at the turnemente in Irelonde where he bete sir Gawayne and his nine felowys." (401.5–9)

Similarly, when Trystram fights on behalf of king Anguyssh at his treason trial, the judges and spectators are equally delighted with his "name" (408.13–19), whereas in the source episode Tristan is still incognito.[24] When Trystram is caught in bed with Isode, and delivered to his judgment by Andret, the victory over Marhalte is still a vital element of his "name." Trystram appeals to the Cornish lords to remember what he has done for their country, and Andret's answer, "For all thy boste thou shalt dye this day" (431.24–5), confirms that a "boste" in Malory's Arthurian world is still a *beot*, an account of past deeds and worth-ship.

Stages in Trystram's early career are marked by such metaphorical signposts, as he sums up his past exploits and dedicates himself to a new task. Shipwrecked on the Ile of Servayge, for instance, he is told of the perils of the valley, and answers:

> Wete you well, fayre lady . . . that I slewe sir Marhalte and delyverde Cornwayle from the trewage of Irelonde. And I am he that delyverde the kynge of Irelonde frome sir Blamoure de Ganys, and I am he that bete sir Palomydes, and wete you welle that I am sir Trystrames de Lyones that by the grace of God shall delyver this wofull Ile of Servage. (442.17–23)

24. Vinaver does not note the originality of either passage: in B.N. 103, f. 49b (Curtis, § 392), Blioberis does not mention these specific victories, simply Tristan's fame in general; for the King of Ireland's treason trial see B.N. 103, f. 53c (Curtis, § 418).

It is Malory who has turned this speech and the one answered by Andret into *beots*: in the source both are delivered by other speakers (*Works*, pp. 1464–5).[25] The most elaborate *beot* is that made by Trystram when exiled from Cornwall for ten years by Mark and his barons: the short speech of justification in the source (*Works*, p. 1475) is expanded and elaborated into a long, formal, reproachful lament, enumerating all the exploits done and dangers endured for Mark and his country, building up on a refrain to its climax: "And at that tyme kynge Marke seyde afore all hys barownes I sholde have bene bettir rewarded" (503.25– 504.15).

Once in the realm of Logres the need for self-justification seems to disappear. However, as Trystram's reputation mounts, so does king Arthur's desire to draw him into the Round Table fellowship, and, at the same time, Launcelot's desire to meet him. Trystram and Launcelot were first excited to admiration by accounts of each other's exploits, and long before they meet they express that admiration in loving terms (e.g., 418.9–11, 435.14– 16). One of the main narrative threads in the first six sections of the Tale is this compulsion of Trystram and Launcelot to "infelyshyp," and suspense is created by their repeated failures. When on the second day of the Castle of Maidens tournament Trystram and his friends slip away unseen, Launcelot rides here and there "as wode as a lyon that faughted hys fylle, because he had loste sir Trystram" (527.19–20). "Mad as a hungry lion": the vivid image captures the undercurrent of rivalry in the attraction which marks this stage of the relationship, the urge to test themselves on each other as opponents worthy of their mettle.

On the third day of the tournament they do meet, and Launcelot mistakenly wounds Trystram in the side. Arthur's comment on the incident points up the paradox of the heroic ethic: "whan two noble men encountir, nedis muste the tone have the worse, lyke as God wyll suffir at that tyme" (535.13–15). If the heroic code is taken to its logical extreme, one man must

25. However, in the Ile of Servage speech Malory is clearly recalling Tristan's slightly earlier speech designed to bolster up his own courage and that of the despondent Segurades (B.N. 103, f. 86b; Curtis, § 595)—yet another example of retained *matiere* but altered *sen*.

die. On most occasions the Round Table knights are aware of the wastefulness of the principle, and their respect for prowess prevents their fighting to the "outrance" when they face a really good opponent. The encounter between Trystram and Lameroke in the Forest Perilous and between Palomydes and Lameroke outside Morgan's castle are both occasions when potentially fatal combats turn into sworn friendships. As long as the strong centripetal pull of attraction, the love of worship, operates, fatal possibilities are avoided; but they remain latent, ready to rise to the surface. The tension and fragility of the bond are always apparent.

The element of danger, then, is present in the desire of Trystram and Launcelot to "infelyshyp," but the love of worship triumphs. Vinaver has shown how Malory has altered his source to set the two knights out on separate quests which will eventually come to fruition together. After the Castle of Maidens tournament Launcelot and his fellows swear an oath to bring Trystram to court (537.23–31)—whereas in the source he embarks on a quest simply to identify the Knight with a Black Shield (*Works*, p. 1477). Later Trystram sets out to find the white knight with a covered shield who served him and Palomydes so summarily at the fountain, and who is finally revealed as sir Launcelot, quite without authority from the source (*Works*, p. 1484). Meanwhile rivalry with Palomydes intervenes, so that when the white knight with the covered shield appears at the appointed meeting place, Merlyne's stone, Trystram assumes it is Palomydes. Thus the long-delayed, yet half-expected encounter takes place, a meeting not in love but in combat. The battle lasts for four hours while the two squires stand by and weep, and only when the combatants pause to require each other's name do they discover what they have done. This is the signal to yield to each other, to take off their helmets in order to cool themselves, and to kiss each other a hundred times (569.32–570.2). The suspense which leads up to the fight and the importance of the fight itself are not, of course, original to Malory: in B.N. 334 the description of the fight fills three and a half columns (ff. 298c–299b). But the emphasis of the French event is on the meeting of the two greatest Arthurian lovers. In Malory, as the two knights take their horses and ride toward

Camelot, they are met in turn by Gawayne and Gaherys, Arthur, and finally the Queen and her ladies, in a crescendo of joy and welcome which owes nothing to the source in effect (*Works*, p. 1485). Trystram had concealed his identity when he arrived in Logres, but had begun to reveal it in his own quest; now he is fully known. The movement from disguise to discovery is deeply revelatory here: as in the source, Trystram's name is found written on Marhalte's seat, but unlike the source, what follows is a narrative recapitulation of the fight with Marhalte, the first adventure which gave him "name" (572.17–25).[26]

In developing the theme of the pursuit of worship Malory has altered his source to focus on Trystram's acquisition of "name" and his development through the Tale as a twin hero to Launcelot. It is in the function of the lesser knights, Palomydes and Lameroke, however, that his most striking alterations appear. Palomydes and Lameroke represent the two faces of the coin, the two potential modulations of the heroic mode. There is no space in this paper to discuss in detail the role of Palomydes; that will have to wait for a later article. Suffice it to say that, whereas the French Palamedes is a melancholy, noble figure whose chief function is to be Tristan's unsuccessful rival for the love of Yseult, Malory's Palomydes is Trystram's rival as much in worship as in love, and, furthermore, a disciple as much as a rival. His relationship with Trystram is a complex mixture of jealousy at Trystram's possession of Isode and admiration for his prowess and nobility:

> "What wolde ye do," seyde sir Trystram, "and ye had sir Trystram?"
> "I wolde fyght with hym," seyde sir Palomydes, "and ease my harte uppon hym. And yet, to say the sothe, sir Trystram ys the jantyllyste knyght in thys worlde lyvynge." (529.12–16)

As Benson also shows, the development of this rivalry is one of the narrative patterns that structures the Tale (pp. 117–18).

26. Benson also comments on Malory's thematic recapitulation of the Marhalte fight (p. 117).

Two abortive attempts at a rendezvous are resolved in the "Conclusion" of the Tale, when Trystram, riding without his armor to court for the feast of Pentecost, meets Palomydes in the forest. He challenges Palomydes, who refuses to fight an unarmed man; but when Trystram learns that their battle is all that remains for Palomydes to fulfill his vow, he borrows some armor from a wounded knight, and a magnificent two-hour battle follows, till Palomydes appeals for an end to the combat:

> . . . I have no grete luste to fyght no more, and for thys cause . . . myne offence ys to you nat so grete but that we may be fryendys, for all that I have offended ys and was for the love of La Beall Isode. (844.20–4)

They make peace, and Palomydes is baptized at Carlisle and then welcomed with joy at the court. In the French episode, after Palamedes's courteous refusal to fight, there is no further combat (see Sommer, pp. 56–60). Vinaver points out Malory's originality in providing a reconciliation: "Dans le roman français, il n'est point question de l'amitié entre Tristan et Palamède" (*Le Roman de Tristan*, p. 206, n. 2); but he suggests that this final battle must have been in the immediate source: "It would be contrary to M's practice to replace a friendly conversation between two knights . . . by a fight" (*Works*, p. 1532). But we have seen that, unremarked by Vinaver, Malory did precisely that in the Trystram-Lameroke encounter (483.12–14); and how could the rivalry between Palomydes and Trystram be satisfactorily resolved except by a splendid final battle ending in a bond of love? The French Palamedes is not baptized or sworn into the company of the Table Ronde until much later, and his reconciliation with Tristan in this scene is only temporary. In Malory, the bond is permanent: after Trystram's death, Palomydes becomes a follower of Launcelot (1109.2–4; 1170.22; 1205.15–16).

If Malory had continued with a "rehersall of the thirde booke" (845.31) of the prose *Tristan*, he would have embarked on a version of the Quest which included as questers Tristan, Palamedes, Erec, and many others. He chose not to; thus his Tale ends on a note of reconciliation, acceptance, and joy. Yet we are never to see Trystram alive again. Even in joyful, cohesive moments of the heroic life we may be made aware of its tragic

potential. It is the career of Lameroke that strikes this note most poignantly, providing, as Benson puts it, "a dark, ironic undertone" (p. 127) to this Tale of positive achievement.

Few scholars have failed to recognize the importance of Lameroke. Rumble, for instance, has devoted some pages to Malory's heightening of his role from the source (pp. 172–6), and Charles Moorman describes the murder of Lameroke as a "focal point" in the Tale.[27] Both scholars, however, judge the event in terms of plot structure, seeing it as the turning point of the Lot-Pellynor feud which is, in their view, one of the chief causes of the failure of chivalry in Arthur's kingdom. But, as Vinaver has shown in *The Rise of Romance*,[28] and Benson in his book on Malory (pp. 51–64), concepts which belong to naturalistic fiction or organic structure are irrelevant to medieval romance, which depends for its organizing impulses on principles of design, such as repetition and reversal, amplification and ornament. Lameroke's career functions as a contrast to that of Palomydes and creates important resonances in the *Morte Darthur* as a whole.

Though Lameroke appears as third in the roll of honor in the "Tale of Sir Gareth" (e.g., 316.23–6), we have no sense of his character till the "Tristram," where we first see him at the jousts held by king Mark beside the river at Tintagel. Lameroke and his brother sir Dryaunte defeat thirty Cornish knights, arousing Mark's ire. Mark orders Trystram to encounter Lameroke, which Trystram does only reluctantly, lecturing Mark on the unknightly behavior of a fresh man and horse attacking a weary one (428.5–12, 16–23). He gives Lameroke a fall, but refuses to continue the fight on foot, which Lameroke takes as a personal insult. The whole episode emphasizes the contrast between Trystram, the exponent of "jantyllnesse," and the young knight burning to make his name against proved fighters. As Lameroke's reputation increases, Arthur wishes he would come

27. *The Book of Kyng Arthur: The Unity of Malory's "Morte Darthur"* (Lexington, Ky., 1965), p. 58.

28. Oxford, 1971, pp. 85–92, on the French Arthurian romances. Vinaver sees Malory as attempting a more modern *novella* structure, but Benson shows that Malory belongs firmly in the medieval tradition.

to court; and at the same time Lameroke's meetings with
Trystram in the Forest Perilous and with Palomydes outside
Morgan's castle lead, in both cases, to sworn brotherhood. As
Trystram comments after hearing of this second battle, "there is
no knyght in the worlde excepte sir Launcelot that I wolde ded
so well as sir Lamerok" (606.11–12).

Benson states that Lameroke's "doleful career" provides
an analogy with Trystram's (p. 126). It does indeed, but the effect
Malory creates is due less to structure than to tonality and
emotion. In the quick succession of events that develop before
the tournament of Surluse, relationships take form, and incidents
that are present in the source are given new emphasis by
Malory's juxtapositions. Lameroke's arrival at court is welcomed
by all except sir Gawayne and his brethren (608.1–24). They plot
against him, and Gaherys murders their mother after catching
her in bed with Lameroke. Meanwhile Arthur has reconciled
Trystram and Mark, and the two have left for Cornwall, with the
court "wrothe and hevy" (609.19) at Trystram's departure. Now
Lameroke rides away from court in shame and sorrow, and
Launcelot, who warned Arthur that Mark's "accorde" with
Trystram would not last, warns him that treason may also rob
them of Lameroke (613.15–17). Dynadan encounters Aggravayne
and Mordrede, whose hatred is roused against him although he
has just rescued them from sir Brewnys Saunz Pité. Vinaver
explains this ungrateful response by referring to the source,
where the brethren's friend Dalan turns them against Dinadan
because of a previous grudge of his own (*Works*, p. 1494).
However, Malory has given the incident a new motivation.
Mordrede and Aggravayne hate Dynadan "bycause of sir
Lameroke":

> For sir Dynadan had suche a custom that he loved all good
> knyghtes that were valyaunte, and he hated all tho that
> were destroyers of good knyghtes. And there was none
> that hated sir Dynadan but tho that ever were called
> murtherers. (614.27–31)

By cutting the French Dinadan's antichivalric mockery during
the scene (*Works*, p. 1494, n. to 614.21), Malory has turned the
episode into a wholly serious one, which leads naturally into the
prophecy of Dynadan's murder (615.5–8), retained from the

source (Löseth, § 258). Thus the characters begin to fall naturally
into two groups, those who love and foster worship, like
Trystram, Launcelot, Lameroke, and Dynadan, and those who
envy it to the point of destruction, like Gawayne and his
brethren (excluding, always, Gareth). The ominous notes build
up the theme of future treason and loss.

Lameroke's reputation is at its highest peak at the
tournament of Surluse, in which, again, Malory has diverged
from the source, as the French account makes it Lancelot's
occasion. Lameroke outdoes Palomydes, and there is much
sourceless admiration and congratulation at his exploits on the
fourth day, at the end of which he wins the prize.[29] The fifth day
shifts to Arthur's rival tournament beside Surluse, where
Lameroke revenges the defeat of Gawayne and his brethren for
Arthur's sake. Arthur urges him to join his fellowship, promising
to curb his nephews, but Lameroke refuses; this conversation, as
Vinaver shows in *Le Roman de Tristan* (pp. 193–5), is not found in
any *Tristan* MS. Again, at the end of the contest of Surluse
proper, Launcelot repeats Arthur's invitation, and again
Lameroke refuses, saying he will never trust the brethren. "Than
sir Lameroke departed frome sir Launcelot and all the felyship,
and aythir of them wepte at her departynge" (670.26–7). P.J.C.
Field has commented on Malory's use of the word "depart" in
tragic contexts;[30] this is no exception, for we never see Lameroke
again.

It is not until the next section of the Tale, when a casual
discussion on worship leads into it, that we learn that Lameroke
is dead. Palomydes tells Ector that there was a third knight
besides Trystram and Launcelot who had bested him:

> . . . and he myght have lyved tyll he had bene more of
> ayge, an hardyer man there lyvith nat than he wolde have
> bene, and his name was sir Lamorak de Galys. And as he

29. Cf. B.N. 99, ff. 390d–391b (Löseth, § 282.d). Vinaver notes only
that 662.16–18 is original, and not that Malory has altered the whole
episode (661.24–662.22) by bringing Lameroke into Galahalte's party
and having Launcelot rescue rather than defeat him.

30. *Romance and Chronicle: A Study of Malory's Prose Style* (London,
1971), p. 82.

> had justed at a turnemente, there he overthrewe me and
> thirty knyghtes mo, and there he wan the gre. And at his
> departynge there mette hym sir Gawayne and his
> bretherne, and wyth grete payne they slewe hym
> felounsly, unto all good knyghtes grete damage! (688.3–10)

The news is as much a shock to us as it is to Lameroke's brother
Percyvale, who falls over his horse's mane, swooning. He
laments:

> Alas, my good and noble brother, sir Lamorak, now shall
> we never mete! And I trowe in all the wyde worlde may
> nat a man fynde suche a knyght as he was of his ayge.
> And hit is to muche to suffir the deth of oure fadir kynge
> Pellynor, and now the deth of oure good brother sir
> Lamorak! (688.15–19)

Lamourat's murder certainly occurs in the prose *Tristan*,
but most of the MSS only report it in a brief statement, and those
that provide a description follow that of B.N. 99, which is
Vinaver's "source" for this section. Here the brethren kill
Lamourat's brother Drian, and when Lamourat, already badly
wounded, follows them to avenge his brother, they set on him
and bring him near to death. Gauvain taunts Lamourat with the
information that it was he who killed Lamourat's father, Pellinor,
and then beheads him. A nearby hermit inters the brothers'
bodies and sends Lamourat's head to the court of Artus with an
accusing message about his relatives (ff. 532b–533a). One MS,
however, B.N. 103, gives an account somewhat similar to
Malory's version in 688.1–10 and 699.14–27. It is close enough to
suggest that Malory's actual source resembled it (*Works*, p. 1511),
and one of its repeated phrases, "ce fut grant dommage a toute
chevalerie" (f. 298a, c), becomes Palomydes's lament, "unto all
good knyghtes grete damage" (688.10).

The Old French "dommage" meant "harm, injury or
loss,"[31] and this meaning was preponderant in Middle English
also, but a secondary meaning had developed, of "a matter of
regret, a misfortune, a pity" (*OED*, 3b). Malory is using both
senses simultaneously: such murders are both a source of lament

31. F. Godefroy, *Dictionnaire de l'ancienne Langue française*, s.v.
damage.

and an injury to all good knights. His retentive ear has also caught another near–formulaic verbal motif which had been used frequently in connection with Lamourat in the prose *Tristan*: "il est bon chevalier de son aage, et croy quil sera preudome sil vit longuement." It is found in all three of Vinaver's "source" MSS.[32] Used by Malory only in the context of lament, it becomes deeply poignant: Lameroke might have been the best knight of the world if he had lived, "suche a knyght as he was of his ayge."

This conversation between Palomydes, Percyvale, and Ector, which is our first report of Lameroke's death, is not present in the "source" MS, B.N. 99, but a conversation of similar form is found in other similar MSS (e.g., B.N. fr. 772, B.M. Add. 5474, etc. [see Löseth, § 359]) and is therefore likely to have been present in Malory's immediate source. Yet in these MSS the dialogue concerns only Palamedes expressing his admiration of Lamourat and Perceval his grief: there is no description of the murder, nor is it Perceval's first intimation of his brother's death. Furthermore, the account of the murder in B.N. 103 is narrative, not dialogue. It is a brilliant and bold stroke on Malory's part to combine the narrative account and the conversational form to give readers and knights alike such dramatic and startling news of Lameroke's death. The manner in which he develops the theme is even more original.

Palomydes becomes the chief spokesman of Lameroke's death, and as the theme is repeated it causes ripples and eddies that widen and swell; each time, it gains a formidable accretion of anger, sorrow, and loss, becoming ultimately a steady undercurrent of lament. Trystram reproaches the brethren angrily, crying, "I wolde I had bene by hym at hys deth day" (691.33–4), and when he, Dynadan, Gareth, and Palomydes are together outside Lonezep the cry is repeated:

> ". . . wolde God I had bene besyde sir Gawayne whan that
> moste noble knyght sir Lamorake was slayne!"
> "Now, as Jesu be my helpe," seyde sir Trystram, "hit is
> passyngly well sayde of you, for I had lever," sayde sir

32. The quotation is from B.N. 103, f. 72b; see also B.N. 99, ff. 119d, 529a, b, 533a, B.N. 334, ff. 328c, 330c, and Löseth, §§ 246, 250.

Trystrams, "than all the golde betwyxte this and Rome I
had bene there."

"Iwysse," seyde sir Palomydes, "so wolde I. . . ."

. . .

"Now fye upon treson!" seyde sir Trystram, "for hit
sleyth myne harte to hyre this tale."

"And so hit dothe myrie," seyde sir Gareth, "bretherne
as they be myne."

"Now speke we of othir dedis," seyde sir Palomydes,
"and let hym be, for his lyff ye may nat gete agayne."
(699.7–14, 28–33)

The lament has become a refrain, the keynotes of which are
treason and loss. Palomydes meets Hermynde on his quest in the
Red City, and finds himself telling yet another kinsman of the
murder: "For as for sir Lamorak, hym shall ye never se in this
worlde" (716.2–3). Percyvale, taking leave of his mother, is
reminded by her of the loss; she too links it, as he did, with the
murder of her husband, king Pellynor:

And alas! my dere sonnes, thys ys a pyteuous complaynte
for me off youre fadyrs dethe, conciderynge also the dethe
of sir Lamorak that of knyghthod had but feaw fealowys.
(810.13–16)

All these laments are original to Malory. D.S. Brewer has
commented that Malory's narrative sequence "weaves patterns
whose effects come from events which are held in memory by
the reader, and which thus interact as it were out of time" (p. 21).
Events are held in memory by Malory's characters also, and the
narrative progression is not only linear, but cumulative, so that
each time the event is recalled it is weighted more heavily with
emotional significance. The phrases which characterize the
lament for Lameroke are repeated in different situations, and in
the last two Tales of the *Morte Darthur* they recur in association
with Trystram also. As with Lameroke, we are given little
warning of Trystram's death. The narrator slips in the briefest of
allusions, coupling his name with Lameroke's (1112.10–11), and
then we hear:

Also that traytoure kynge slew the noble knyght sir
Trystram as he sate harpynge afore hys lady, La Beall

> Isode, with a trenchaunte glayve, for whos dethe was the
> moste waylynge of ony knyght that ever was in kynge
> Arthurs dayes, for there was never none so bewayled as
> was sir Trystram and sir Lamerok, for they were with
> treson slayne. . . . (1149.28–33)

Launcelot recalls Trystram's death when speaking to Bors: "for
all the worlde may nat fynde such another knyght" (1173.20),
just as he recalls Lameroke when facing Gawayne: "he was one
of the beste knyghtes crystynde of his ayge. And hit was grete
pité of hys deth!" (1190.8–10). Percyvale's and Palomydes's
phrases are echoing again.

It is significant that, although Malory's source is likely to
have contained long, tear-bestrewn death scenes for both
Lamourat and Tristan, he chose in both cases to eschew them. It
is loss rather than death which is emphasized. Lameroke is more
important in memory than in life, for it is in memory that his
"name" is purest. He has become the permanent symbol of
knighthood cut off in its prime, the formula "the beste knyght of
his ayge" ringing like a knell. When those elegiac phrases are
associated with Trystram, he too becomes, like Lameroke, pure
"name," atemporal, frozen in memory. Death of a hero in this
heroic mode has nothing of the flavor of late medieval religious
convention, an affair of bodily corruption and earthly vanity. To
the heroic mind death simply makes fame permanent: "He was a
man, take him for all in all / I shall not look upon his like again"
(*Hamlet*, I.ii.187–8). Poignancy lies in the fact that the moment of
death is both the moment of greatest flowering, when "name" is
purest, and simultaneously the moment when the living realize
most clearly what they have lost. Elegy rises naturally out of the
heroic mode.[33]

Let me repeat, however, that Malory obviously did not
intend the elegiac note to predominate in the "Tale of Sir
Tristram." It was to be reserved for the final Tale, where the
mourning is not for the loss of one knight, but for the dissolution

33. See Stanley B. Greenfield, "*Beowulf* and Epic Tragedy," *Studies
in Old English Literature in honor of Arthur G. Brodeur*, ed. S.B. Greenfield
(Eugene, Ore., 1963), pp. 91–105, an article to which I am greatly
indebted.

of a kingdom, the passing of a way of life. Thus the death of Trystram is not recounted either in the "Tale of Sir Tristram," which ends on a romance note of reconciliation and achievement, nor in the following Tale, the "Quest of the Holy Grail," Malory having chosen to return to the Vulgate version for his source. The absence of Trystram from Malory's Quest indicates that for the English writer he was associated more purely with the heroic world whose values were to be disturbed and questioned during the search for the Grail. Launcelot had to be retained, for the Grail Quest is defined in his failure or partial success; but the achievement is on a different plane, and needs no distraction from Trystram's world. That world returns in the last two Tales, when the memories of Trystram and Lameroke underscore Launcelot's magnificent final *beot* before exile; indeed, a deliberate parallel is evoked with Trystram's *beot* at his own exile (see 503.25–504.15; 1198.1–1199.4). The most stirring passage occurs when, with no way to avoid open breach with Arthur, Launcelot and his kinsmen call on old fellowships:

> Than there felle to them, what of Northe Walys and of Cornwayle, for sir Lamorakes sake and for sir Trystrames sake, to the numbir of a seven score knyghtes. (1170.26–9)

The centripetal attractions that operated when these knights were alive do not die out with their deaths. Old loyalties are still honored and the past is always alive. The heroic vision is imprisoned, encapsulated in the past; this is the source of both its strength and its despair. The essence of the "Tale of Sir Tristram" has been its portrayal of the heroic world, with all its energy and tension, joy of brotherhood and rich memories; yet implicit in its ethic are its severely limited responses, its narrow inevitability of action. When the fragility of all earthly institutions is evoked, Malory's own voice tells us that worship and the love of worship provide the only stability, the only cohesion: "Lo ye all Englysshemen, se ye nat what a myschyff here was?" (1229.6–14). It is the "Tale of Sir Tristram" that displays worship in action and in memory. Far from being "irrelevant," it is the center of the *Morte Darthur*, the heart of the work.

Tristan in Medieval Art

Julia Walworth

In the course of the last thirty or so years, the study of "literary" works of art has undergone a shift in emphasis, away from the measuring of pictorial works against the apparent standard of the critical edition of the relevant text and towards investigations in which the written text is only one of any number of factors that contribute to the creation of pictorial works which are essentially independent representations of the subject. The clearest statement of this redirection in the case of pictorial Tristan works is found in the 1973 article on medieval Tristan imagery by Hella Frühmorgen-Voss.[1] The majority of previous studies dealing with Tristan works had taken the form of inventories or lists, with more or less detailed descriptions of the work in question.[2] The salient question had been that of

1. Hella Frühmorgen-Voss, "Tristan und Isolde in mittelalterlichen Bildzeugnissen," *Deutsche Vierteljahrsschrift für Literaturwissenschaft und Geistesgeschichte*, 47 (1973), 645–63; rept. in Frühmorgen-Voss, *Text und Illustration im Mittelalter*, ed. Norbert Ott, Münchener Texte und Untersuchungen zur Deutschen Literatur des Mittelalters, 50 (München: Beck, 1975), pp. 119–39.

2. Among the fuller of the early studies enumerating works of art depicting or alluding to the Tristan legend are E. Hucher, "Lettre à M. Paulin Paris sur les représentations de Tristan et d'Yseult dans les monuments du Moyen Age," *Bulletin de la Société d'Agriculture, Sciences et Arts de la Sarthe*, ser. 2, vol. 12 (1869–70), 633–59; and Wolfgang Golther in *Tristan und Isolde in den Dichtungen des Mittelalters und der*

identification of the subject matter, and beyond that, an
investigation into whether the pictorial works conformed to the
known textual versions of the Tristan legend. The culmination of
such studies, in scope, if not chronologically, is the Loomises'
Arthurian Legends in Medieval Art, which includes several
chapters on Tristan as well as extensive pictorial documen-
tation.[3] Still the most comprehensive treatment of the pictorial
Tristan material, this work is more than a collection of
descriptions, for the Loomises' general discussions and entries
on particular works raise questions of methodology and
interpretation (such as whether different pictorial media should
be treated separately) which continue to concern literary and art
historians.[4]

neuen Zeit, Stoff- und Motivgeschichte der deutschen Literatur, 2
(Leipzig: de Gruyter, 1907), esp. pp. 407–12.

3. Roger S. and Laura H. Loomis, *Arthurian Legends in Medieval
Art*, Modern Language Association of America Monograph Series (New
York: Modern Language Association of America, 1938).

4. More recent surveys of medieval works of art depicting the
Tristan legend or the figure of Tristan are found in Doris Fouquet, *Wort
und Bild in der mittelalterlichen Tristantradition. Der älteste Tristanteppich
von Kloster Wienhausen und die textile Tristanüberlieferung des Mittelalters*,
Philologische Studien und Quellen, 62 (Berlin: E. Schmidt, 1971), chap.
1; Norbert Ott, "Katalog der Tristan-Bildzeugnisse," in Frühmorgen-
Voss, *Text und Illustration*, pp. 140–71; and Muriel Whitaker, *The Legends
of King Arthur in Art*, Arthurian Studies, 22 (Woodbridge, Suffolk: D.S.
Brewer, 1990), chaps. 2 to 7 (passim). The latter work does not always
take account of important recent findings (e.g., it still refers confidently
to "Meister Hesse's" atelier in Strasbourg, pp. 30, 51), but it is
nonetheless valuable for the scope of the survey and because the author
has made a point of getting to know the works of art at first hand.
Almost all of the works discussed in the present study are included in
Loomis or Fouquet, and several of them are described and reproduced
in Whitaker as well, but unless reference is being made to a particular
observation, I have not cited these general compilations in each
instance. Alison Stones, "Arthurian Art Since Loomis," in *Arturus Rex.
Vol. II: Acta Conventus Lovaniensis 1987*, ed. Willy Van Hoecke et al.,
Mediaevalia Lovaniensia, Ser. 1, Studia; 17 (Leuven: Leuven University
Press, 1991), pp. 21–78, not only brings together many recently

The aim of Frühmorgen-Voss's essay was not, therefore, the introduction of new material into the Tristan corpus, or the re- or de-attribution of contested works. Instead, she critically examines the way in which "literary" works of art had traditionally been studied, rejecting as oversimplified and ultimately unsatisfactory those which sought only to judge works of art as an attempt, usually unsuccessful, to translate into pictures a particular textual version of a given story. The very complexity of the Tristan material, its chronological and geographical spread, its representation in both cyclical and single-scene works, the multiplicity of known textual versions, made it the ideal subject for such a study.

Frühmorgen-Voss provides a rapid chronologically ordered overview of Tristan material. Throughout, she stresses that rather than exemplifying direct text–image relationships, both pictorial and textual works are essentially independent responses to the Tristan story. While the particular textual version most common in a given region might be expected to influence the narrative presented in a cyclical work from that region, other criteria, such as artistic tradition and techniques, the type of work and the function for which it was made and in which it was viewed, all must be taken into account as well. Where inscriptions form part of the work, the situation becomes more complicated still, for these too may relate only indirectly to known texts, and discrepancies in any case should not be immediately interpreted as evidence of contemporary textual variants.

Frühmorgen-Voss also draws attention to the problems raised by the great number of single-scene Tristan images. From the fourteenth century onwards, depictions of the nighttime rendezvous of the lovers in the orchard, during which they are spied upon by King Mark but succeed in averting his suspicions, are found in a variety of media and contexts. From walls to shoes, from mirror and writing cases to misericords in church choirs, the Orchard Rendezvous must have been one of the most familiar secular images of the Middle Ages. The multiplicity of

identified instances of medieval Arthurian art, but raises questions of interpretation and approach that must be addressed in future studies.

occurrences, however, raises questions about the meaning and use of such an image. Frühmorgen-Voss's extensive work on the single (non-narrative) images in the well-known Manesse Codex was clearly of relevance to her later examination of the depictions of the Orchard Rendezvous.[5] As she observes, an awareness of formal and iconographical ambiguities is essential for any attempt at understanding the significance of these images. The isolated depiction of the Orchard Rendezvous might well represent the whole Tristan narrative, but in the context of a series of other such images, as in the Regensburg "Medallion" tapestry (plate 1, opposite page), it takes on a life of its own as an exemplum of the power of love that makes fools of men. In another context—for instance, the enamelled cup decorated with scenes of courtly lovers, now in the Museo Poldi-Pezzoli in Milan—the same image might be more properly interpreted as an exemplum of the victory of true love over adversity.[6] The point made so convincingly by Frühmorgen-Voss is that the power of these images lies in the ambiguity inherent in their formal composition and interpretation—an ambiguity apparently recognized and appreciated by the society for which these works were made.

The broad approach advocated by Frühmorgen-Voss reflected in part her work for the Kommission für Deutsche Literatur des Mittelalters on the Catalogue of German Illuminated Manuscripts, which was organized by subject matter (*Stoff*) or text groups rather than solely by author. Her ultimate concern was a fuller understanding of the significance of literary themes in medieval society, an understanding that could be achieved only by the study of the visual as well as the written manifestations of these themes. Frühmorgen-Voss's examination of the types of medieval Tristan imagery raised issues which

5. Hella Frühmorgen-Voss, "Bildtypen in der Manessischen Liederhandschrift," in *Text und Illustration im Mittelalter*, pp. 57–88.

6. See Ronald W. Lightbown, *Secular Goldsmiths' Work in Medieval France: A History*, Reports of the Research Committee of the Society of Antiquaries of London, no. XXXVI (London: Society of Antiquaries of London, 1978), pp. 91–92. Ott, "Katalog," no. 54.

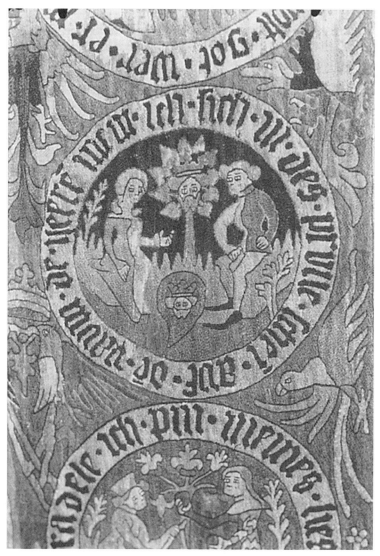

1. Regensburg "Medallion" tapestry, detail. Bavaria, late fourteenth century. Photo courtesy of the Museen der Stadt Regensburg.

continue to concern art and literary historians, and which were more fully explored in the work of her successor on the Kommission project, Norbert Ott.

In several articles dealing with non-manuscript pictorial Tristan narratives, Ott not only further develops Frühmorgen-Voss's methodological arguments, but examines in detail several particular works of art.[7] Like Frühmorgen-Voss, Ott emphasizes the significance of pictorial works as independent narratives that may, in some instances, follow the plot structure of a known textual version of the Tristan story, but which may even so make a different point, or give a different interpretation or coloring to the events depicted. Key elements in Ott's approach to pictorial narrative cycles are an awareness of artistic traditions which may have influenced the presentation of the subject matter, whether they be practices within particular artistic genres or the preference for certain types of images or pictorial formulae, and an emphasis on the importance of the social context or function (*Gebrauchssituation*) for which a work was made and the effect this might have had on the creation and contemporary reception of the work. The meaning of these works of art comes not just from the plot or text of the literary subject, but from a whole range of possible factors.

The approaches advocated by Frühmorgen-Voss and expanded by Ott apply to works of art with secular, "literary," subject-matter methods that would have been familiar to art historians dealing primarily with religious art of the Middle Ages. Historically, one of the problems besetting the study of

7. Norbert Ott, "Katalog der Tristan-Bildzeugnisse" (see note 4); "Tristan auf Runkelstein und die übrigen zyklischen Darstellungen des Tristanstoffes. Textrezeption oder medieninterne Eigengesetzlichkeit der Bildprogram," in *Runkelstein: Die Wandmalereien des Sommerhauses*, ed. Walter Haug (Wiesbaden: Reichert, 1982), pp. 194–239; "Geglückte Minne-Aventiure. Zur Szenenauswahl literarischer Bildzeugnisse im Mittelalter. Die Beispiele des Rodenecker *Iwein*, der Runkelsteiner *Tristan*, des Braunschweiger *Gawan*- und des Frankfurter *Wilhelm-von-Orlens*-Teppichs," *Jahrbuch der Oswald von Wolkenstein Gesellschaft*, 2 (1982–83): 1–32; "Epische Stoffe in mittelalterlichen Bildzeugnissen," in *Epische Stoffe des Mittelalters*, ed. Volker Mertens and Ulrich Müller (Stuttgart: Kroner, 1984), pp. 449–74.

"literary" art has been not only the difficult, dual-nature of text–image relationships (i.e., the nature of the works themselves), but the divisions between the disciplines which usually deal with these works—a problem of which Frühmorgen-Voss and Ott were very conscious. Works of art with literary subject matter were more commonly studied by literary historians, for whom the text was of prime consideration. On the other hand, such works of art were often difficult for art historians to study because they did not fit easily into stylistic groups; nor, from such disparate material, could one construct an iconographic stemma relating the works chronologically. These were problems of which the Loomises too were well aware, choosing to organize their massive study by subject matter in the case of non-manuscript material, and by country of origin in the case of illustrated manuscripts.

Tristan Iconography

As Frühmorgen-Voss observed, works of art depicting individual scenes or series of scenes from the Tristan story presented such a complex picture that they made an excellent example of the need for a very flexible, multi-directional approach. A look at a few examples of both the narrative and the single-scene works demonstrates that while some common themes can be identified, the question as to whether one can speak of a Tristan iconography is not easily answered.

Narrative Cycles

The earliest clearly identifiable pictorial Tristan narratives, the "Chertsey" tiles and the illustrated manuscript of Gottfried's poem (Munich, Bayerische Staatsbibliothek, Cgm 51), were produced in the mid-thirteenth century. Differing greatly in format and function, these two works are among the fullest of the extant visual cycles dealing with Tristan. The "Chertsey" tiles, so-called because they were excavated from the ruins of Chertsey Abbey in Surrey, are a series of figurative and

decorative ceramic tiles, which probably originally were designed for use in a royal palace, perhaps Westminster (plates 2–3).[8] The designs on the tiles include several chivalric subjects, such as the military deeds of Richard I, and more general combat and hunting scenes, but the vast majority depict scenes from the story of Tristan. The occurrence of the same scenes on both round and square tiles, and the discovery of additional tiles with some of the same Tristan scenes at Halesowen Abbey in the West Midlands, suggest that the dies for the Tristan designs were in use for approximately forty years, from the 1250s to the 1290s.[9] In his lengthy study of the tiles, Loomis identified thirty-four scenes as relating to the plot of Thomas's poem, and although the identification of some of the subjects is problematic, many of the scenes are easily recognizable and appear to cover the story from the abduction of the young Tristan to the second journey to

8. The earthenware roundels and square tiles with scenes from the Tristan legend are dated 1250–1270 and are thought to have been designed for one of Henry III's residences. The majority of examples are now housed in the British Museum. An extensive discussion of the tiles is found in Elizabeth Eames, *Catalogue of Medieval Lead-Glazed Earthenware Tiles in the Department of Medieval and Later Antiquities British Museum* (London: British Museum Publications, 1980), vol. I, chap. 8. The fullest treatment of the iconography of the tiles is still Roger Sherman Loomis, *Illustrations of Medieval Romance on Tiles from Chertsey Abbey*, University of Illinois Studies in Language and Literature, vol. II, no. 2 (Urbana: University of Illinois, 1916). Recent literature is found in *Age of Chivalry: Art in Plantagenet England 1200–1400*, ed. J.J.G. Alexander and P. Binski, exhib. London, Royal Academy of Arts (London: Royal Academy of Arts in association with Weidenfeld and Nicolson, 1987), no. 60 and no. 320.

9. See Eames, *Catalogue*, I, 157–65. Since the evidence is, in several senses, fragmentary, it would be unwise to assume that, although found together at Chertsey, the Tristan, Richard the Lionheart, and combat designs were always used together. Eames points out that examples of the combat series were also found at Winchester. There is also no proof that the Tristan tiles were always used as an entire series.

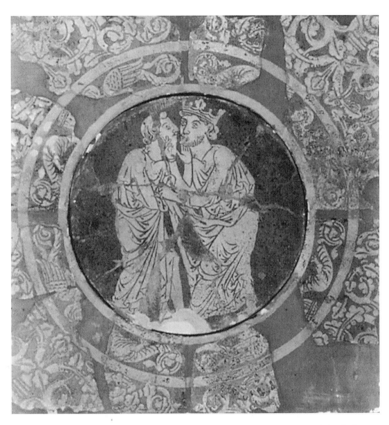

2. Ceramic tile from Chertsey Abbey. England, 1250–1270. Mark kisses
Tristan. Photo copyright British Museum.

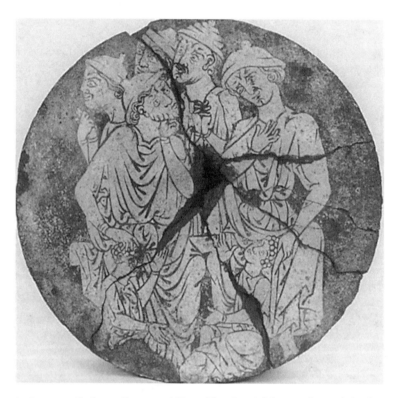

3. Ceramic tile from Chertsey Abbey. The Cornish barons bewail the fate of their sons. Photo copyright British Museum.

Ireland and the fight with the dragon, perhaps to Tristan's death.[10] It is impossible to say whether a complete narrative was originally intended and how these tiles would have been arranged. If one analyzes the number of scenes devoted to each episode and considers the overall effect of the scenes chosen for depiction, episodes from Tristan's youth and early knighthood predominate. (This approach places importance on the work itself, rather than on an enumeration of agreements and disagreements with the most compatible existing text, but should also be employed with caution when, as here, the work in question is undoubtedly incomplete and the original extent unknown). One is also struck by the frequent inclusion in the tile compositions of onlookers and secondary participants; this provides a sense of the court setting in which many of these episodes take place—an ambience appropriate, perhaps, for the setting in which the tiles were originally viewed.

The extensive illustrations in the Munich *Tristan* manuscript, although roughly contemporary with the Chertsey tiles, express other themes and reflect different artistic concerns. Produced in southern Germany, Bayerische Staatsbibliothek Cgm 51 contains Gottfried von Strassburg's *Tristan* along with Ulrich von Türheim's continuation, both texts in an idiosyncratic redaction characterized by omissions and occasional changes in wording.[11] The colored pen drawings, the work of three or four

10. The inscriptions and some of the complete scenes provide unequivocal evidence that many of these tiles did depict scenes from Tristan. Some of the scenes however, are extremely fragmentary, while others are rather general, so that some of Loomis's references to specific Tristan episodes (based on Thomas and the Saga) are more convincing than others. The (justifiable) hesitancy expressed by Loomis in *Illustrations of Medieval Romance* about some of the identifications, particularly those relating to the story from the drinking of the love philtre onwards, is much less evident in the more compressed descriptions of the tiles in *Arthurian Legends in Medieval Art*.

11. The changes and omissions in the Cgm (codex germanicus monacensis) 51 text have led to suggestions that this text might represent an early version of the poem by Gottfried himself (Gottfried von Strassburg, *Tristan*, ed. Kurt Marold [Leipzig: Avenarius, 1906]; and Gerd-Dietmar Peschel, *Prolog-Programm und Fragment-Schluss in Gotfrits*

artists of varying ability, depict approximately 118 scenes and
are arranged in several registers on separate leaves that were
inserted at intervals into the text.[12] Thus, while accompanying a
written text, the Munich illustrations function in many ways like
an independent narrative, and the story told varies markedly in
tone, though not in basic plot structure, from that found in
Gottfried's poem.

Tristanroman, Erlanger Studien, 9 [Erlangen: Palm und Enke, 1976]) or
be the work of a thirteenth-century "editor" seeking to alter Gottfried's
style to approximate that of (the more popular?) Hartmann von Aue
(Kurt Herold, *Der Münchener Tristan: Ein Beitrag zur Über-
lieferungsgeschichte und Kritik des Tristan Gottfrieds von Strassburg*,
Quellen und Forschungen zur Sprach- und Culturgeschichte der
germanischen Völker, 114 [Strasbourg: K.J. Trübner, 1911]). More
recently Alan Deighton has convincingly argued that the Cgm 51
redaction, instead of being the product of a single unified plan, was the
result of a combination of factors, the most important of which may
have been simply the desire to shorten the poem (Alan Deighton,
"Studies in the Reception of the Works of Gottfried von Strassburg in
Germany during the Middle Ages," D.Phil. thesis, Oxford University,
1979). Many questions raised by abbreviated and altered texts like Cgm
51 still remain to be answered.

 12. The Munich *Tristan* has been reproduced in facsimile: Gottfried
von Strassburg, *Tristan und Isolde. Faksimile Ausgabe des Cgm 51 der
Bayerischen Staatsbibliothek München*, 2 vols. Commentary volume by
Ulrich Montag and Paul Gichtel (Stuttgart: Müller und Schindler, 1979).
See also Bettina Falkenberg, *Die Bilder der Münchener Tristan Handschrift*,
Europäische Hochschulschriften, Reihe XXVIII Kunstgeschichte, Bd. 67
(Frankfurt a. M.: Peter Lang, 1986) and Julia Walworth, "The
Illustrations of the Munich *Tristan* and *Willehalm von Orlens*: Bayerische
Staatsbibliothek Cgm 51 and Cgm 63," Ph.D. diss., Yale University 1991,
both of which include references to previous literature. Several of the
illustrated folios are analyzed in Jörg Hucklenbroich, "Einige
Bemerkungen zum 'Münchener Tristan,'" in *Diversarum artium studia.
Festschrift für H. Roosen-Runge zum 70. Geburtstag*, ed. Helmut Engelhart
and Gerda Kempter (Wiesbaden: Reichert, 1982), pp. 55–74; and Michael
Curschmann, "Images of Tristan," in *Gottfried von Strassburg and the
Medieval Tristan Legend: Papers from an Anglo-American Symposium*, ed.
Adrian Stevens and Roy Wisbey, Publications of the Institute of
Germanic Studies, 44 (Cambridge: Brewer, 1990), pp. 1–18.

In the second half of the narrative, in which Tristan and Isolde contrive to meet secretly, the pictorial version in the Munich manuscript, through the selection of incidents illustrated and the composition of the relevant scenes, emphasizes the repeated triumph of the lovers over their enemies. Gottfried, on the other hand, uses these episodes to explore the ambiguous relationships between Tristan, Mark, and Isolde. The illustration of the *Minnegrotte* episode, for instance, on folio 90r (plate 4) presents a simplified, three-part narrative sequence. In the top register on the folio, Tristan and Isolde are banished from Mark's court. The middle register depicts Mark discovering the two lovers. The sparseness of the setting has been remarked upon several times, but the suggestion that this may be due to the omission of Gottfried's allegorizing descriptions in the redaction of the text found in Cgm 51 is not on its own a sufficient explanation.[13] In fact, few of the Cgm 51 scenes include much incidental detail of setting. It should also be noted that the Cgm 51 text *does* include the description of the lovers' ideal existence in the forest, along with their amusements of music, nature, and love—all of which might have served as possible subjects for illustration. The scene as it is depicted, however, shows only the moment in which Mark, by blocking the sunlight at the window, demonstrates his forgiveness of Isolde; in other words, the scene is confined to the lovers' victory. The last register shows the return of the lovers to court and to royal favor. The page as a whole neatly conveys the whole episode reduced to a three-part structural pattern: 1) trouble, 2) crisis and trouble successfully averted, 3) return to the status quo (confirmation of the lovers' success). This pattern is repeated in the depiction of similar episodes in the manuscript, creating a series of light-hearted episodes in which the lovers, and particularly Tristan, evade their enemies.

Compositional parallels and selection of illustrated scenes, expansion of some episodes and contraction of others, serve to emphasize other themes as well. Michael Curschmann has

13. See Gichtel in *Tristan Facsim.*, p. 85. Falkenberg, *Münchener Tristan*, p. 181, also notes the inadequacy of Gichtel's explanation.

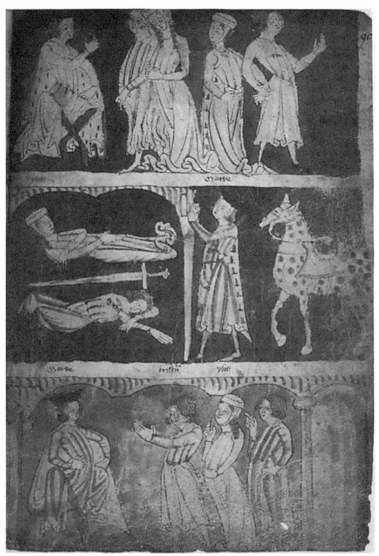

4. Munich, Bayerische Staatsbibliothek, Cgm 51, fol. 90r. S. Germany, mid-thirteenth century. Photo courtesy of the Bayerische Staatsbibliothek.

observed how, earlier in this manuscript, visual similarities appear to have been used to highlight certain themes such as chivalric prowess and the reversal of the knight's normal position of power when he is conquered by erotic love—themes which are common to many epic romances.[14] Although completeness, the communication of the whole narrative, was obviously one of the goals of the creators of the Munich cycle, the illustrations do not seem to present a single, unified approach to the story, nor do they emphasize a particular aspect or interpretation of Gottfried's poem. The rather episodic nature of the treatment of the visual Tristan narrative in Cgm 51 might be partially explained by the number of artists involved in the production of the illustrations, but probably owes much to the structure and general popularity of the story itself. The emphasis on certain episodes, through changes in composition and layout, raises questions about models or pictorial traditions on which the artist may have drawn. The episodes given particular visual emphasis in Cgm 51—Tristan's combat with Morolt, the fight with the dragon, the Orchard Rendezvous, and the exile in the *Minnegrotte*—are all episodes given prominence in the majority of the verse versions of the Tristan story, and several appear in the prose versions as well. They are also, as a glance through the illustrations in Loomis reveals, among the most commonly depicted Tristan scenes. Certainly the Munich artists were familiar with an extensive range of secular and religious pictorial formulae and types, but the cycle does not appear to have been copied in its entirety from an earlier source. It is not impossible, however, that a visual Tristan-tradition, perhaps comprising main episodes, was known to the Munich artists, although extant material offers little in the way of proof. It is equally plausible that these episodes received special attention simply because they were such popular components of the longer narrative (and may have circulated informally as self-contained narratives in their own right?), or that the images themselves were particularly popular types. This certainly might apply to the

14. Curschmann, pp. 3–7. As Curschmann observes, "visual representations of the subject [of a text] may reflect and articulate perceptions that are essentially non-textual, social perceptions" (p. 7).

combat scenes, which follow established pictorial tradition.[15] Thus, some scenes may have been popular because they were particularly associated with Tristan—either Tristan as hero or Tristan as lover—while, on the other hand, the plot of the Tristan story offered the opportunity to depict the types of scenes that were favorites with a particular audience, regardless of the narrative context in which they occurred. Both factors played a role in the creation of other non-manuscript Tristan cycles, which usually concentrate on selected episodes rather than endeavoring to convey the entire story.

The most frequently depicted episodes in the extant non-manuscript Tristan cycles are, with some variation in emphasis, the combat with Morolt and the defeat of the dragon in Ireland, linked with the successful winning of Isolde. Tristan is thus shown as successful in martial deeds and successful in love. Of the three fourteenth-century embroidered hangings from Kloster Wienhausen in Lower Saxony, only the latest, dating from c. 1360, depicts scenes from Tristan and Isolde's life after their arrival in Cornwall.[16] The other two, of which the earliest, c. 1300–1310 (plate 5) is substantially complete, concentrate on the

15. Depictions of single-combat episodes of particular importance to a narrative, such as Tristan's fight with Morolt, are frequently depicted in two parts: combat on horseback with the lance and combat on foot with swords. The recurrence of the two-part combat formula in medieval art has been discussed by Fouquet, *Wort und Bild*, pp. 83–88; Ott, "Tristan auf Runkelstein," pp. 206–07; and Rita Lejeune and Jacques Stiennon, *La Légende de Roland dans l'art du Moyen Âge* (Brussels: Arcade, 1966), pp. 72–73, 92–93.

16. Ott, "Katalog," no. 16. The hanging, which is incomplete, includes Isolde's marriage to Mark, the deception with Brangane and Isolde's attempt to have her murdered, Tristan and Isolde in the Minnegrotto and the Orchard Rendezvous, and, unusually, Tristan's marriage to Isolde of the White Hands (three scenes), and the Blond Isolde travelling with the magic dog Petitcrieu. The final extant scene appears to be Isolde travelling in a boat, perhaps her journey to the wounded Tristan, which suggests that the death of the lovers was shown in the last scene (now missing). See Fouquet, *Wort und Bild*, pp. 33–46, and Ott, "Tristan auf Runkelstein," pp. 206, 208.

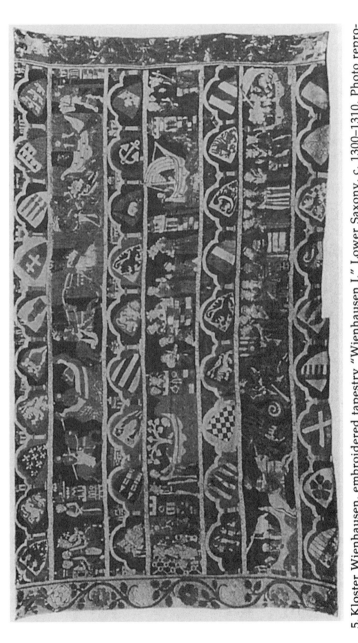

5. Kloster Wienhausen, embroidered tapestry "Wienhausen I." Lower Saxony, c. 1300–1310. Photo reproduced by permission of the Klosterverwaltung, Kloster Wienhausen.

figure of Tristan as the model hero of literary court culture. In Ott's analysis of the earliest Wienhausen embroidery (Wienhausen I), he concludes that of twenty-two individual scenes, eight are dedicated to the episode of the fight with Morolt and six to the killing of the dragon and the revelation of Tristan as the true dragon slayer at the Irish court (Ott, "Tristan auf Runkelstein," 206).

The choice of scenes was influenced not only by thematic concerns, but by the compositional structure of the hanging and overall compositional concerns. Each of the three superimposed narrative registers in Wienhausen I opens and closes with compositionally similar scenes, providing a sense of decorative symmetry. This framing of the internal, "action" scenes by more static outer scenes continues to some extent farther into the register as well. The second register, for instance, opens with the wounded Tristan standing before Mark, requesting permission to travel to Ireland to be healed. The next scene shows Tristan in the boat, followed by two scenes representing his brief stay and recuperation at the Irish court, where he meets Isolde for the first time. The penultimate scene of the register depicts the journey, by boat, back to Cornwall, and the last scene shows, once again, Tristan standing before Mark, compositionally symmetrical with the first scene. The last scene of the second register also introduces the episode portrayed in the third register, through the inclusion of two birds between the figures of Tristan and Mark, indicating that this is the scene in which the swallow brings a strand of Isolde's hair to Mark's court. Thus, the aesthetic considerations which may have influenced the symmetrical arrangement of the scenes also structure the pictorial narrative, dividing and linking discrete episodes.

The concentration on those episodes which depict Tristan as the ideal knight and lover, and which, by omission, play down the themes of adulterous love, broadens the significance of the narrative depicted in works such as the earliest Wienhausen embroidery. As Ott has observed, these works use the plot of the Tristan legend as a vehicle for the portrayal—and thus the reinforcement—of stereotypical social models for courtly

society.[17] Similarly, the conclusion of Wienhausen I with the drinking of the love potion may not be an allusion to the future tragic fate of the lovers, nor an indication that a second embroidery depicting the second half of the story has not survived, but a positive "ending" to the narrative as presented on the tapestry. This suggestion is supported by "happy endings" in other medieval non-manuscript pictorial narratives, also effected by curtailing the narrative at an appropriate point.[18] This is not to imply that the creators and the viewers of the Wienhausen embroidery did not know the "correct" ending of the Tristan story, but is a further example of the way in which such narratives could be manipulated to articulate given themes.

All of the pictorial Tristan cycles vary in content and emphasis, even though the events depicted are often the same. An appliqué tapestry made in Würzburg about 1375, and now in Erfurt Cathedral, depicts twenty-five scenes from the story, of which fifteen concern the fight with the dragon and winning of Isolde.[19] Particularly noticeable here, however, is the amount of

17. "Sie nehmen den Text zum Anlass, die verbindlichen Rollenmuster der höfischen Gesellschaft darzustellen." Ott, "Tristan auf Runkelstein," pp. 207–08.

18. See Ott, "Geglückte Minneaventiure," passim. Among the works discussed by Ott are the Runkelstein Tristan murals, which conclude with Isolde's successful completion of the ordeal, and the Frankfurt Willehalm von Orlens tapestry, in which the final scene is the hero's nighttime abduction of his lover, Amelie. These curtailed pictorial narratives exhibit some similarities with the short literary (written or oral) narratives extracted from longer works (such as the *Folie* poems in the case of Tristan), but because they generally begin at the beginning and stop midway, they create tension between the presentation of a seemingly complete narrative and the viewer's almost certain knowledge of "the rest of the story" (which, as in the case of *Willehalm von Orlens*, is not always tragic).

19. Ott, "Katalog," no. 17, with further references. I have unfortunately been unable to see von Freeden's article, cited by Ott, which localizes the hanging to Würzburg: M.H. von Freeden, "Ein Würzburger Tristan-Teppich aus der Abtei St. Stephan," in *Heiliges Franken: Festchronik zum Jahr der Frankenapostel 1952*, ed. Theodor Kramer and Helmut Holzapfel (Würzburg: Echter Verlag, 1952), Heft 5,

attention devoted to the claims of the Irish steward to have killed
the dragon himself, the discovery of his deceit and subsequent
punishment by beheading (plate 6). This example of deceit and
revenge is paralleled in the following scenes which depict
Tristan and Isolde in Cornwall, the Orchard Rendezvous, and
the punishment of the dwarf Melot. The Erfurt tapestry thus
could be described as showing two of the common Tristan
episodes, the dragon-fight and the orchard rendezvous, but the
emphasis on the punishment of the enemies of the lovers,
particularly enemies whose power came through secrecy and
deceit in a court milieu, lends the pictorial narrative an almost
admonitory significance.

The textile examples just discussed were all made in
German-speaking areas, but one could also cite examples of
Tristan cycles from other areas such as France or Italy, where the
prose rather than the verse version predominated. A
complementary pair of fourteenth-century Sicilian quilted
Tristan embroideries are now housed in the Victoria and Albert
Museum and the Bargello (plates 7–8).[20] It is assumed that these

pp. 134–35. Because the two registers in the Erfurt hanging are placed so
that the tops of the scenes are joined, it is often referred to as a tablecloth
or bedspread, but it is far more likely that the hanging was hung over a
horizontal pole or cord as a room divider (see Fouquet, *Wort und Bild*, p.
47; and Ott "Epische Stoffe," p. 457).

20. Ott, "Katalog," nos. 20 and 21. A photograph of the quilt in
Florence displayed as a bed covering is reproduced in Luciano Berti, *Il
Museo di Palazzo Davanzati* (Florence: Cassa di Risparmio di Firenze,
[1972]), pl. 140. Scholarly opinion appears to be divided on whether the
two quilts were originally one work or two. M. Schuette and S. Müller-
Christensen imply that the two quilts were originally one work "now
divided into two parts" (*The Art of Embroidery* [London: Thames and
Hudson, 1964], p. 307); and Leonie von Wilckens, *Die textilen Künste:
Von der Spätantike bis um 1500* (Munich: C.H. Beck, 1991) p. 234, writes of
a "Coperta Guicciardini," of which half is in Florence and half in
London. The fullest analysis of the Sicilian embroideries remains that by
Pio Rajna, "Intorno a due antiche coperte con figurazioni tratte dalle
storie di Tristano," *Romania*, 42 (1913), 517–79, who argues that the two
quilts were designed as a complementary pair. Analysis is hindered by
the incomplete state of the Florence quilt, and because both works show

works originally formed a single sequence showing in great detail the events leading up to Tristan's defeat of Morolt. Although the particular incidents differ necessarily from those of the verse tradition, the main thematic message of these tapestries—Tristan as a model knight, delivering his country from a feared oppressor—is familiar and is emphasized by the placing of the combat scenes in the center of the works. The elaborate courtly scenes depicting the events preceding the combat are relegated to side panels.

Even this brief look at a few of the Tristan cycles raises some of the issues common to all. There did not exist a predominant European pictorial cycle relating to Tristan. Most often, pictorial narratives roughly parallel the plot sequence of the version of the story that was best known in the geographical region in which they were made. In German-speaking areas, for instance, this is usually Eilhart (not surprisingly, since Eilhart's version appears to have had a wider geographical distribution than Gottfried's), but this does not imply that there was a single "original" Eilhart pictorial tradition on which all Tristan works of art from those areas depend.[21] Even when, as is sometimes the case, the pictorial narratives are accompanied by inscriptions, these do not relate directly to texts. The creators of pictorial narratives usually select episodes to convey particular themes, or may select those episodes and scenes *because* they convey popular themes or incorporate favorite picture-types. If one had to summarize the figure of Tristan presented in these works, it is an overwhelmingly positive one: Tristan is the model knight, victorious lover, but not the victim of his love. The same cannot

some evidence that the scenes are not in their original order. It is to be hoped that further research on these works will soon be undertaken.

21. Thomas Klein, "Ermittlung, Darstellung und Deutung von Verbreitungstypen in der Handschriftenüberlieferung mittelhochdeutscher Epik," in *Deutsche Handschriften 1100–1400*, ed. Volker Honemann and Nigel Palmer, Oxforder Kolloquium 1985 (Tübingen: Niemeyer, 1988), pp. 125–26. Klein cautions that name forms (e.g., Tristrant [Eilhart] vs. Tristan [Gottfried]) are not always reliable indicators of dependence on a particular textual source (p. 125, n. 24). See also Ott, "Tristan auf Runkelstein," p. 201.

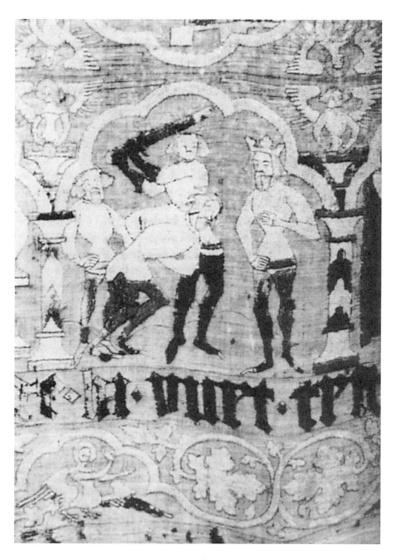

6. Erfurt Cathedral, embroidered tapestry, detail. The deceitful steward
is beheaded. Würzburg, c. 1375. Photo courtesy of the Katholisches
Dompfarramt Erfurt.

7. London, Victoria and Albert Museum, Sicilian quilted embroidery, fourteenth century. Photo courtesy of the Board of Trustees of the Victoria and Albert Museum.

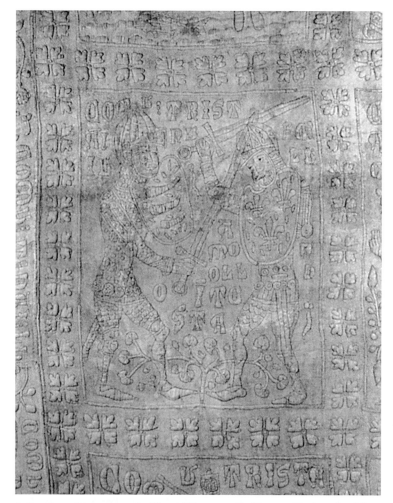

8. London, Victoria and Albert Museum, Sicilian quilted embroidery, fourteenth-century detail. Tristan gives Morold the fatal blow. Photo courtesy of the Board of Trustees of the Victoria and Albert Museum.

always be said for the Tristan depicted in the single-scene images of the Orchard Rendezvous which became so ubiquitous in the fourteenth and fifteenth centuries.

Single-Scene Images

As noted above, the one scene that must have been the best-known pictorial representation of Tristan throughout Europe in the later Middle Ages was the Orchard Rendezvous. In its many manifestations, the basic composition of this scene remains remarkably static: the two lovers stand or sit on either side of a tree, at the base of which is a fountain or stream. In the crown of the tree one can detect the head of the eavesdropping King Mark, and his reflection is often visible in the water below. Alone or as part of a series of related images on similar themes, this scene is found on a wide variety of objects, such as ivory caskets and mirror-backs, on shoes and combs, writing-cases and enamelled plate, as well as in wall paintings or figurative textiles. Ott listed twenty-three examples of this scene in his Tristan inventory in 1975, and additional instances have been cited by other scholars in subsequent years.[22] In fact, the Orchard Rendezvous image has received more scholarly attention than most of the Tristan narratives, from the extensive survey by Doris Fouquet in 1973 to Michael Curschmann's more recent detailed analysis.[23]

22. More recently, several works have been added to the list, including an ivory mirror case in the Museum Mayer van den Bergh in Antwerp and five fragments of decorated leather shoes (see W. Verbeke et al., eds, *Arturus Rex: Volumen 1, Catalogus, Koning Artur en de Nederlanden, La Matière de Bretagne et les anciens Pay-Bas*, Mediaevalia Lovaniensia, ser. I, studia XVI (Leuven: Leuven University Press, 1987), p. 84, no. 1.5.6, and p. 134, no. 2.2.6, fig. 2). Curschmann, p. 7, n. 17, also lists a wooden comb in the Museum of Fine Arts in Boston.

23. See Doris Fouquet, "Die Baumgartenszene des *Tristan* in der mittelalterlichen Kunst und Literatur," *Zeitschrift für deutsche Philologie*, 92 (1973), 360–70; and more recently, Curschmann, pp. 7–17. Insight is also provided by Ott and Frühmorgen-Voss (who wrote

The appeal and power of this image, both in the Middle Ages and the present day must be attributed in large part to its ambiguity.[24] On the one hand, this scene, easily recognizable because of Mark's reflection in the water (or an indication that the lovers see a reflection), neatly encapsulates the whole situation of Tristan, Isolde, and Mark, referring in a single image to the themes of the whole legend. On the other, isolated from a specifically narrative context, and often appearing as one in a series of "emblematic," non-narrative images, the Orchard Rendezvous comes to have a significance of its own which extends beyond merely representing the Tristan legend. The meaning of this scene is colored by visual allusions to several different traditions and is further inflected by context.

Compositional similarities between the usual depiction of the Orchard Rendezvous and depictions of the Fall of Man, with Adam and Eve on either side of the Tree of Knowledge in which lurks the serpent, have long been noted.[25] The significance of this similarity for the understanding of the Orchard Rendezvous image goes beyond the simple re-use of conventional compositions, however. In his detailed exploration of this motif, Curschmann suggests that the visual allusion to the Fall links Isolde's power over both Tristan and her husband to Eve's seduction of Adam. As part of a series of "Minnesklaven" images, as on the Regensburg "Medallion" tapestry (plate 1), the Orchard Rendezvous thus acquires a playfully moralizing

contemporaneously with Fouquet and arrived at many of the same conclusions); see Frühmorgen-Voss, "Tristan und Isolde," pp. 125–29.

24. Alison Stones has recently drawn attention to the problems and questions associated with images isolated from a fuller (original) context: "central to the issue is whether, and to what degree, meaning as well as form is transferred when an image is copied from one context to another, and by whom the transferred associations were understood." M.A. Stones, "Arthurian Art Since Loomis," p. 31 (see also her discussion, p. 25).

25. See Fouquet "Die Baumgartenszene," p. 363; Ott, "Tristan auf Runkelstein," p. 216; Curschmann, pp. 7–16, notes that the elements of this scene, the tree and the stream or pool at its base, are also elements of the more positively viewed Earthly Paradise.

aspect, prompting the viewer, perhaps, to think not only about the deceitfulness of women, but of the consequences of erotic love.[26] It is in the nature of the image, however, that the viewer

26. Ott, "Katalog," no. 19. The Regensburg "Medallion" tapestry (now in the Regensburg Stadtmuseum) is an embroidered wool hanging, measuring 355 × 275 cm, made in Bavaria in the late fourteenth century. In the large central field of the hanging, twenty-four single-scene vignettes of pairs of lovers are depicted in medallions encircled by brief inscriptions in contemporary Regensburg dialect. A further twenty-six pairs of lovers are included in the outer framing strips. The scenes represented in the central medallions are not all negative in character; the majority of them portray erotic love in a positive light, with lovers plighting their troth, various stages of courtship and desire. Even the significance of the Orchard Rendezvous scene here appears to depend on how one views the arrangement of the medallions. It has been suggested that each of the six rows of four medallions presents a different aspect of erotic love. (See Leonie von Wilckens, *Bildteppiche. Museum der Stadt Regensburg* [Regensburg: Buchverlag der Mittel-bayerischen Zeitung; Museum der Stadt Regensburg, 1980], p. 8.) Read in this way, the Tristan scene would be grouped with other images of passionate love: in other words, the secret tryst and deception of Mark exemplify the power (and legitimacy) of the love between Tristan and Isolde. On the other hand, Tilo Brandis briefly describes the hanging as presenting progressive stages of love, in which the woman finally conquers and subjugates the man: "Werben des Mannes, Sieg der Frau, Unterwerfung des Mannes." (See Tilo Brandis, *Mittelhochdeutsche, mittelniederdeutsche und mittelniederlandische Minnereden: Verzeichnis der Handschriften und Drucke*, Münchener Texte und Untersuchungen zur deutschen Literatur des Mittelalters, Bd. 25 [München: Beck, 1968], p. 91, No. 243a.) If one views the medallions as four columns, reading vertically, the Tristan scene is grouped with other scenes in which the power of love leads to man's humiliation (e.g., a woman leading a wild man on a chain, a man depicted as a toddler in a walker). In this case, it is ambiguous whether Mark or Tristan (or both) is the victim of love for Isolde. The accompanying inscription, "I see reflected in the water my lord in the tree" ("ich sich (sehe) in des prune[n] schei[n] auf de[m] paum de[n] herre[n] mein," transcribed in von Wilckens, *Bildteppiche*, p. 10), indicates that Mark is perhaps the main "victim" here. The heraldic imagery on the hanging indicates that it may have been produced in connection with the wedding of Wenzel I of Bohemia and Sophie of

might also recollect that Tristan and Isolde were successful in their schemes, while in some senses, Adam and Eve were not.

The Orchard Rendezvous might also have more positive connotations, presenting Tristan and Isolde as exemplary courtly lovers. Frühmorgen-Voss notes that the elements of this scene, the tree and the stream or pool at its base, are also elements of the Earthly Paradise (Frühmorgen-Voss, "Tristan und Isolde," 127). The frequent addition to the composition of courtly gender attributes such as a lapdog and falcon brings the depiction of the Orchard Rendezvous on ivory boxes and mirror cases (plate 9) closer to the generic scenes of lovers that frequently adorn these luxury items.[27] Indeed, the Orchard scene sometimes appears among a series of images of lovers. On a number of ivory boxes produced in France in the fourteenth century, the Orchard Rendezvous is included in a series of scenes representing both positive and negative examples of the power of love—from Lancelot crossing the sword bridge to the hunting of the unicorn (plate 10).[28] The composition of the Orchard Rendezvous also

Bavaria. It is probable, therefore, that a certain amount of playful ambiguity, rather than a strictly didactic message, was intended.

27. Ott, "Katalog," nos. 45 and 46, lists two mirror covers, one in the Vatican Museum, the other in the Musée de Cluny in Paris. To these must be added the mirror cover in the Museum Mayer van den Bergh in Antwerp mentioned by Curschmann, p. 7, n. 17.

28. There are seven ivory caskets that appear to have been made in the same Parisian workshop; see Ott, "Katalog," nos. 38–44. Each external surface of these caskets (except the bottom) portrays a popular scene or scenes from the repertoire of courtly love images, many of them literary. The top is dedicated to the storming of the castle of love, with some variations, the sides to the story of Aristotle and Phyllis, the fountain of youth, Pyramus and Thisbe, Gawain's fight with the lion and the Perilous Bed, Lancelot crossing the sword bridge, Galahad receiving the key of the Castle of Maidens, a wildman, knight and maiden. Although there is some variation in the selection of scenes used on each casket, all in this group include the Orchard Rendezvous in conjunction with the unicorn hunt. See the discussion of these and related caskets by D.J.A. Ross, "Allegory and Romance on a Mediaeval French Marriage Casket," *Journal of the Warburg and Courtauld Institutes*, 11 (1948), 112–42. Both Frühmorgen-Voss and Curschmann make the

resembles the contemporary depiction on an ivory mirror case of the winged God of Love poised over two lovers (plate 11), which may have suggested a humorous inversion of the role of Mark in the tree. Even the importance of reflections for the narrative implied in the Orchard scene may have added piquancy to the use of the motif on a mirror case.

In short, there is no single interpretation of this image, nor can one say that in one context the Orchard Rendezvous is to be given a wholly negative interpretation, while in another it is humorous, or positive. The very power of the image lies in the range of its possible connotations, and its significance is best understood as a joint process involving both the creator and the viewer. "Workshop pragmatism and practice, and intellectual history combined and reinforced each other to produce an image that was essentially ambiguous, at least for those who, by experience, training, temperament or inclination were sensitive to such ambiguities" (Curschmann, "Images of Tristan," 14).

Manuscripts

Within the body of Tristan material, illustrated manuscripts present problems of their own, and rather ironically, it may be that because they do not obviously present the problems inherent in other media, they have been relatively neglected in studies of Tristan imagery. Even *Arthurian Legends in Medieval Art*, still the best source for descriptions and reproductions of Tristan manuscripts, deals with manuscripts in a separate section, arranged by country of origin rather than subject matter. (The Loomises were conscious of the problems raised by this arrangement and include a discussion of the reasons for their

observation that, juxtaposed with the Orchard Rendezvous, the unicorn hunt is probably to be interpreted as an example of seduction and deception, rather than as a representation of virginal purity. See Frühmorgen-Voss, "Tristan und Isolde," pp. 133–35; Curschmann, p. 8.

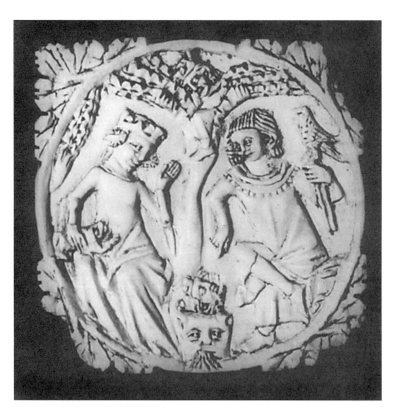

9. Vatican Museum, ivory mirror case. Paris, fourteenth century. The Orchard Rendezvous. Photo courtesy Biblioteca apostolica vaticana.

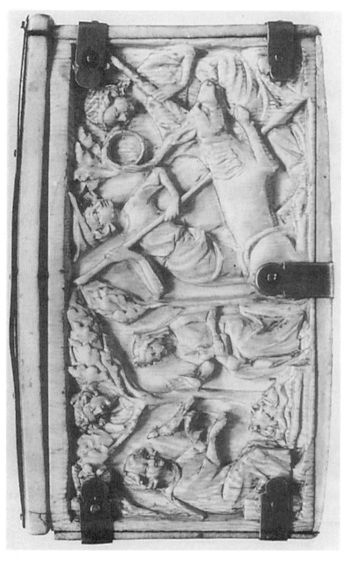

10. London, British Museum, ivory casket. Paris, fourteenth century. End panel depicts the Orchard Rendezvous and a unicorn hunt. Photo copyright British Museum.

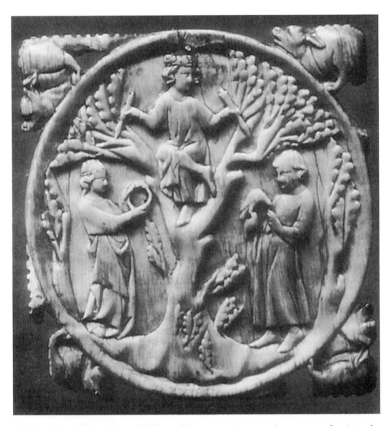

11. London, Victoria and Albert Museum, ivory mirror case depicts the God of Love and two lovers. Paris, fourteenth century. Photo courtesy of the Board of Trustees of the Victoria and Albert Museum.

decision).[29] Since manuscript illustrations are linked physically to a text, there might seem little doubt as to which version they depict, and the assumption is easily made that they simply seek to translate more or less successfully into pictures scenes from the text they accompany. In addition, illustrations are usually subordinate to the text in the manuscript, not the primary means of communication, but a luxury "extra" as it were. In some cases the illustrations are discounted by modern observers as being too general and repetitive to be interesting. The tendency to treat illustrated manuscripts in a different manner from independent cycles is further strengthened by disciplinary divisions in the teaching and practice of art history, where traditionally, those who studied manuscript illumination did not always also study "decorative" arts. Manuscripts are housed in libraries, other works in museums. The interest of literary historians in establishing a critical or original edition of a given text also meant that until relatively recently individual manifestations of a particular text (i.e., individual manuscripts) were given less attention.

While no one would dispute that illustrated manuscript books are a different sort of object from other cyclical works of art, the distinction is not always absolute, and some attention should be given to the possibilities of interrelationships between the imagery in manuscripts and that in other media. Indeed in some respects, the presence of illustrations gives a manuscript book some of the qualities of a luxury object itself, and they unavoidably alter the reception of the text, even if they do not appear to present an independent narrative retelling or interpretation of the text.

29. ". . . the miniatures fall into schools, whose artistic development can in most cases be traced. That development would be completely lost if the manuscripts were to be arranged according to the heros or branches of the cycle which they celebrated," Loomis, *Arthurian Legends in Medieval Art*, p. 7. Loomis also notes that to try to deal with the prose romances by concentrating on central figures would mean discussing the same manuscript in several places, since the stories of so many heroes are interwoven in these lengthy works.

12. Cologne, Stadtsarchiv ms. *W*88, fol. 112. Gottfried's *Tristan*. Germany, 1323. Tristan slays the dragon. Photo courtesy Rheinisches Bildarchiv.

13. Cologne, Stadtsarchiv ms. W*88, fol. 197. Tristan defeats the giant Urgan. Photo courtesy Rheinisches Bildarchiv.

14. London, British Library, Add. ms. 11619, fols. 6v–7r. England, late thirteenth century? Isolde threatens Tristan with his own sword; Tristan slays the dragon. Photo reprinted by permission of the British Library.

Apart from the Munich *Tristan* (discussed above), there survive three other illustrated manuscripts of the verse Tristan legend, all produced in Germany (Cologne, Historisches Archiv der Stadt W*88 (plates 12–13); Heidelberg, Universitätsbibliothek Cod. Pal. germ. 346; Brussels, Bibliothèque Royale ms. 14697).[30] The fragments of English Tristan illustrations recently published by Tony Hunt (London, British Library Add. ms. 11619, plate 14) are a special case, since they do not accompany a text of the Tristan story, but have been inserted at the beginning of a didactic, religious miscellany.[31] None of these cycles of

30. Neither the Cologne nor the Brussels manuscripts have been studied in detail, but both are described briefly in Fouquet, *Wort und Bild*, pp. 17–20. See also Peter Jörg Becker, *Handschriften und Frühdrucke mittelhochdeutscher Epen* (Wiesbaden: Reichert, 1977), pp. 44–45, 49–50. Cologne W*88, with nine small line drawings set in the text columns, is dated 1323 and contains Gottfried's poem with the continuation of Ulrich von Türheim, while Brussels 14697 is a fifteenth-century paper manuscript with ninety-two large line drawings, and contains Gottfried's poem, Ulrich von Türheim's continuation and *Tristan als Mönch*. Heidelberg cod. pal. germ. 346 is the only surviving illustrated manuscript of Eilhart's poem. It is a fifteenth-century manuscript illustrated with ninety-one line drawings set in the text and has recently been made available in facsimile on microfiche, with a commentary by Norbert Ott. Eilhart von Oberge, *Tristrant und Isalde: Heidelberg, Universitätsbibliothek Cod. Pal. Germ. 346*, Codices illuminati medii aevi, 19 (Munich: Lengenfelder, 1990).

31. British Library Add. ms. 11619 is described by Tony Hunt, "The Tristan Illustrations in Ms. London B.L. Add. 11619," in *Rewards and Punishments in the Arthurian Romances and Lyric Poetry of Mediaeval France: Essays Presented to Kenneth Varty on the occasion of his Sixtieth Birthday*, ed. Peter V. Davies and Angus J. Kennedy, Arthurian Studies, 17 (Cambridge: D.S. Brewer, 1987), pp. 45–60. See also M.A. Stones, "Arthurian Art," p. 28. Stones relates the line drawings to those in London, B.L. Cotton Claudius B. VII, suggesting that the illustrations may have been made in London in the mid-thirteenth century. The drawings, which include both easily identifiable scenes, such as Tristan in the bath, the death of Morgan, and the Orchard Rendezvous, as well as several more general court and travelling scenes, form fols. 6r–9v of the manuscript. They appear to be single leaves tipped-in, and the fragments of drawing on the stubs indicate that there were once further

illustrations appears to be iconographically related to any of the others, and they are geographically and chronologically diverse.

Much more numerous are the illustrated manuscripts of the French Prose *Tristan* (plates 15–18) and the related Italian texts. Here there is certainly scope for the investigation of patterns of illustration. Although a number of these manuscripts have been studied from the viewpoint of stylistic development and manuscript production, only recently has attention been turned to the format and content of the illustrations.[32] To a

illustrations. This suggests that these pictures were cut down, perhaps from sketches for a Tristan cycle, or even from an illustrated manuscript. Further comparative work is necessary before one could posit more then this tentative suggestion. Hunt argues that the Tristan pictures had a place in this composite manuscript as a form of negative exemplum, an interpretation of the legend which, Hunt believes, also underlies Thomas's Anglo-Norman poem. (See Tony Hunt, "The Significance of Thomas' *Tristan*," *Reading Medieval Studies*, 7 [1981]: 41–61.) Although the Add. ms. 11619 illustrations were executed a considerable time after Thomas's poem, perhaps in the mid- or second half of the thirteenth century, their *creation* should perhaps be seen more in the context of the Chertsey Tiles and the positive view of Arthurian chivalry at the English court. Hunt's hypothesis that they were subsequently included in B.L. Add. 11619 (which appears to have been compiled in the early fourteenth century) as a pictorial exemplum may be supported, however, by the arrangement of the scenes, which are not in chronological order. Instead, the scenes appear to have been chosen to form several contrasting pairs. At the center of the illustrated folios are the Bath scene facing the Dragon Fight (fols. 6v and 7r) and the Death of Morgan facing the Orchard Rendezvous (fols. 7v and 8r). Each of these openings pairs a well-known scene of physical prowess with a scene in which the hero is at the mercy of Isolde (or, in the case of the Rendezvous, a scene which could be, and sometimes was, interpreted to Tristan's disadvantage). This arrangement may have been chosen to make a—rather humorous—comment on the deleterious power of women and love. I hope to explore this possibility in greater depth elsewhere.

32. P.M. Gathercole, "Artistry on the *Roman de Tristan*," *Romance Notes*, 9 (1967), 141–47, represents a post-Loomis attempt to draw attention to the illuminations in manuscripts of the prose Tristan, but only recently have serious studies of the codicology and decoration of

certain extent, the apparent "neglect" of the Prose *Tristan* manuscripts (from a iconographical point of view) is due to their very high quality. Thus, while low artistic quality often deterred art historians from studying German illustrated literary manuscripts, because they were deemed unsuitable for stylistic history, the high quality of the French manuscripts kept art historians focused on stylistic relationships. It is unfortunate that the recent partial facsimile of the Duc de Berry's *Tristan* (Vienna, Österreichischen Nationalbibliothek Codex 2537), while describing the miniatures and analyzing the relationships between the artists involved in their production, says nothing about the manuscript in the context of other illustrated Prose Tristans.[33]

these manuscripts begun to appear: C.C. Willard, "Codicological Observations on Some Manuscripts of the Complete Version of the *Prose Tristan*, in *Actes du 14e Congrès International Arthurien* (Rennes: Presses Universitaires de Rennes, 1985), II, 658–67; and especially Emmanuèle Baumgartner, "La 'première page' dans les manuscrits du *Tristan en prose*," in *La Présentation du Livre: Actes du colloque de Paris X—Nanterre (4, 5, 6, décembre 1985)*, ed. E. Baumgartner and N. Boulestreau, Littérales 2 (Paris: Centre de recherches du Département de français de Paris X—Nanterre, 1987), pp. 51–60. Although more and fuller studies are desirable, they are hindered by lack of available information (full descriptions and reproductions) and of a complete edition of the text, which itself is far from straightforward. In the meantime, besides the descriptions and reproductions in Loomis, *Arthurian Legends in Medieval Art*, the presence of decoration and illustration is noted in the descriptions of manuscripts in E. Vinaver, *Études sur le Tristan en Prose* (Paris: Champion, 1925), pp. 37–58, and in the manuscript descriptions in the introductions to the volumes of recent edition of the Prose *Tristan* published under the direction of Philippe Ménard (*Le Roman de Tristan en Prose*, various eds., vols. 1–6 [Geneva: Droz, 1987–93]).

33. See Michel Cazenave and Edmond Pognon, *Tristan und Isolde: Codex 2537 der Österreichischen nationalbibliothek* (Graz: Akademische Druck- und Verlagsanstalt, 1992). (Only the German-language edition was available to me.) The authors express a marked preference for the Tristan legend as transmitted in the verse versions, though admitting that the "regrettable" superabundance of episodes characteristic of the prose version at least provides an occasion for splendid manuscripts ("Der Text dieser Handschrift ist der "Tristanroman in Prosa". Die gut

The situation is somewhat better for Italy, since a number of studies have been dedicated to the production in Italy of illustrated manuscripts of French prose romances and of the Italian texts, such as the *Tavola Ritonda*, related to French texts.[34] There still remains much work to be done, however, on images of Tristan in Italian art. In the case of both the French and Italian prose works, iconographical research has been hampered by the lack of full pictorial documentation for these manuscripts.

In contrast to the non-manuscript material, so little is known about the pictorial cycles in Tristan manuscripts that to offer any generalized conclusions at this point would be premature. Now that some studies of the illustration of other prose cycles are available,[35] it would be worthwhile to see

bekannte Legende der Liebe von Tristan und Isolde wird darin mit einer aus zahlreichen Episoden bestehenden Rittererzählung verknüpft. Vom literarischen Standpunkt aus kann man das bedauern, doch gab dieser mannigfaltige Text zumindest Anlass für prachtvolle Ausgaben. . . .") (p. 63).

34. See, for example, B. Degenhart and A. Schmitt, "Frühe angiovinische Buchkunst in Neapel: Die Illustrierung französischer Unterhaltungsprosa in neapolitanischen Scriptorien zwischen 1290 und 1320," in *Festschrift Wolfgang Braunfels*, ed. Friedrich Piel und Jorg Traeger (Tübingen: Wasmuth, 1977), pp. 71–92; François Avril and Marie-Thérèse Gousset, et al., *Manuscrits enluminés d'origine italienne*, Vol. 2, *XIIIe siècle* (Paris: Bibliothèque nationale, 1984), esp. nos. 19, 46, 194; A. Perricioli Sagesse, *I romanzi cavallereschi miniati a napoli*, Miniatura e arti minori in Campania, 14 ([Naples]: Società editrice napoletana, 1979); M. Dachs, "Zur Illustration des höfischen Romans in Italien," *Wiener Jahrbuch für Kunstgeschichte*, 42 (1989), 133–54.

35. See in particular the work of Alison Stones: M. Alison Stones, "The Illustrations of the French Prose *Lancelot* in Flanders, Belgium, and Paris: 1250–1340," Ph.D. diss., University of London 1970; "The Earliest Illustrated Prose *Lancelot* Manuscript?" *Reading Medieval Studies*, 3 (1977), 3–44; "Arthurian Art Since Loomis" (see note 4); "Illuminated Manuscripts," in *The New Arthurian Encyclopedia*, ed. Norris J. Lacy (New York and London: Garland Publishing, 1991), pp. 299–308, and Elisabeth Remak-Honnef, "Text and Image in the *Estoire del Saint Graal*: A Study of London, British Library MS Royal 14. E. iii," Ph.D. diss. University of North Carolina at Chapel Hill 1987, as well as E. Baumgartner, "La couronne et le cercle: Arthur et la Table Ronde dans

whether, as one might expect, the illustration of the Prose *Tristan* followed some of the same patterns, and what changes in the type of illustration occurred over the centuries in a work that was so popular. Another fruitful approach would be to focus on the interrelationship of text, image, and other decoration in particular manuscripts, attempting to understand the work as a whole from the point of view of its reception.

At the risk of over-simplification, the conclusions presented in the foregoing can be baldly stated as follows. Written or oral "texts" are only one of the many factors that contributed to the creation and reception of works such as the cyclical and single-scene Tristan images. Even with illustrated manuscripts, the illustrations were not derived solely from the text they accompany, while for their part, illustrations and other decoration affect the reception of that text. By and large, Tristan as presented in medieval works of art is more the ideal hero and successful lover than a tragic figure, but there was no single pictorial presentation of Tristan at any one time. A particular image, such as the Orchard Rendezvous, could have any number of meanings, either simultaneously or according to the context in which it was used or viewed. Furthermore, pictorial cycles, such as those in manuscripts, presenting Tristan both as ideal Arthurian hero and tragic lover were produced at the same time as the above-mentioned Orchard Rendezvous scenes (which show him, as we have seen, in a rather different light) and for the same aristocratic audience.

Just as the figure of Tristan plays many roles within the various versions of the Tristan story, so too the figure of Tristan in medieval art neither remains constant nor exhibits a single chronological development. Fuller investigation of individual works as well as comparative studies supported by more extensive visual documentation will help elucidate the significance of this hero who, in whatever manifestation, remained so popular for hundreds of years. One may say

les manuscrits du Lancelot-Graal," in *Texte et Image: Actes du Colloque international de Chantilly (13 au 15 octobre, 1982)* (Paris: Les Belles Lettres, 1984).

15. Vienna, Österreichische Nationalbibliothek, Cod. 2542, fol. 223r. *Roman de Tristan en prose*. N. France, c. 1300. King Arthur shows Tristan a book in which are recorded the deeds of the knights of the Round Table. Photo courtesy of the Österreichische Nationalbibliothek.

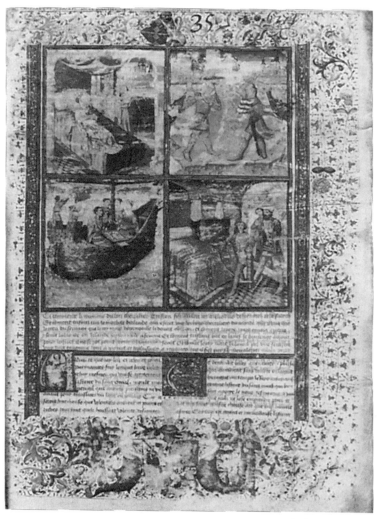

16. Paris, Bibliothèque Nationale, ms. fr. 99, fol. 1r. *Roman de Tristan en prose*. France, 1463. Opening page with four scenes: the birth of Tristan, Tristan's combat with Morhaut, the love potion, the death of Tristan. Photo courtesy of the Bibliothèque Nationale Paris.

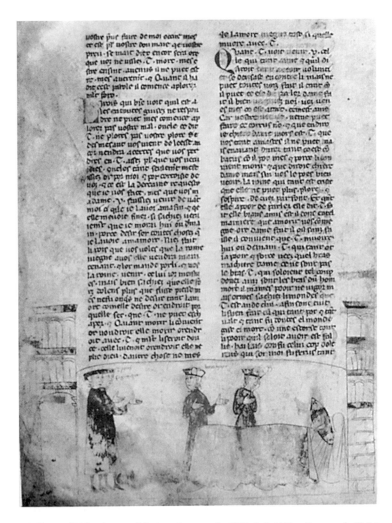

17. Paris, Bibliothèque Nationale, ms. fr. 760, fol. 122v. *Roman de Tristan en prose*. Genoa? thirteenth-fourteenth century. Marc and Isolde are called to Tristan's deathbed. Photo courtesy of the Bibliothèque Nationale Paris.

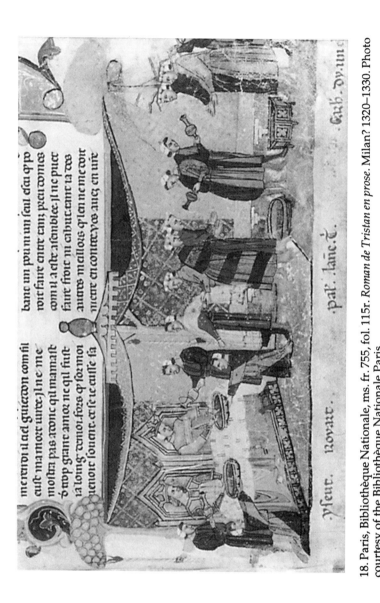

18. Paris, Bibliothèque Nationale, ms. fr. 755, fol. 115r. *Roman de Tristan en prose.* Milan? 1320–1330. Photo courtesy of the Bibliothèque Nationale Paris.

Swinburne's *Tristram of Lyonesse*: Visionary and Courtly Epic

Antony H. Harrison

Although Swinburne himself considered *Tristram of Lyonesse* his masterwork,[1] this poetic embodiment of his mature system of beliefs has only recently begun to receive the attention it deserves from both readers and critics.[2] Difficulties with Swinburne's long Arthurian poem have resulted from its philosophical, prosodic, and even grammatical complexities. But a more basic and surprising obstacle to an appreciation of the poem seems to be presented by its formal peculiarities. Unlike most epic poems by great poets, this one is more lyrical than

Reprinted with permission from *Modern Language Quarterly*, 37 (1976), 370–89.

1. Edmund Gosse plausibly asserts that Swinburne had intended it to be "the very top-stone of his poetical monument" (*The Life of Algernon Charles Swinburne* [London, 1917], p. 262).

2. The most detailed and useful commentaries on the poem are John R. Reed, "Swinburne's *Tristram of Lyonesse*: The Poet-Lover's Song of Love," *VP*, 4 (1966), 99–120; Kerry McSweeney, "The Structure of Swinburne's 'Tristram of Lyonesse,'" *QQ*, 75 (1968), 690–702; and Jerome J. McGann, *Swinburne: An Experiment in Criticism* (Chicago, 1972), pp. 137–42, 152–67. See also Francis Jacques Sypher's incisive comparisons between Swinburne's and Wagner's versions of the Tristram legend in "Swinburne and Wagner," *VP*, 9 (1971), 165–83; and B.F. Fisher, IV, "Swinburne's *Tristram of Lyonesse* in Process," *TSLL*, 14 (1972), 509–28.

narrative. In fact, many of its special felicities are due to this
typically Swinburnian, antitraditional aspect of the work.
Readers seem perpetually unable to define exactly what kind of
poem *Tristram* is, and they attempt to evaluate it solely and
blindly in terms of its adherence to the prerequisites of narrative
poetry.[3] Often the best critic of his own work, Swinburne himself
did not attempt to classify his *magnum opus* in any conventional
terms. Rather, while working on the "Prelude" in December
1869, he designated the projected poem a "moral history" in a
letter to Rossetti.[4] Later, with *Tristram* nearly completed, in a
letter to Burne-Jones, he explained that he had tried to write
merely "a harmonious narrative" and with "as little
manipulation as was possible of the different versions of the
story" (*Letters*, IV, 287). But Swinburne's definitive statement on
the work appears in the "Dedicatory Epistle" to the 1904 edition
of his poems.

> My aim was simply to present that story, not diluted and
> debased as it had been in our own time by other hands,
> but undefaced by improvement and undeformed by
> transformation, as it was known to the age of Dante
> wherever the chronicles of romance found hearing, from
> Ercildoune to Florence: and not in the epic or romantic
> form of sustained or continuous narrative, but mainly
> through a succession of dramatic scenes or pictures with
> descriptive settings or backgrounds: the scenes being of
> the simplest construction, duologue or monologue,

3. John D. Rosenberg astutely notes this imaginative failure on
the part of Swinburne's critics. He asserts that "*Tristram* is undervalued
largely because the wrong demands have been made upon it. As
narrative or as a drama of action the poem inevitably disappoints, in
precisely the ways that Wagner's *Tristram and Isolde* disappoints. In both
of these essentially *lyrical* re-creations of the legend, action and
characterization are wholly subordinate to the all-absorbing theme of
love" (*Swinburne: Selected Poetry and Prose*, ed. John D. Rosenberg [New
York, 1968], pp. xii–xiii).

4. *The Swinburne Letters*, ed. Cecil Y. Lang, 6 vols. (New Haven,
1959–62), II, 78; hereafter cited as *Letters*, with appropriate volume and
page numbers.

without so much as the classically permissible
intervention of a third or fourth person.[5]

In spite of Swinburne's explicit emphasis here on the dramatic
and lyrical elements of his poem, critics until recently have been
unyielding in their refusal to read the work on its own terms.
Edmund Gosse insists upon its "total want of energy" as a
narrative. There are, he rather inaccurately asserts, "no exploits,
no feats of arms; the reader, avid for action, is put off with pages
upon pages of amorous hyperbolical conversation between
lovers, who howl in melodious couplets to the accompaniment
of wind and waves." In his summary view of the work, Gosse
castigates Swinburne for producing a long poem, interminably
monotonous because of the "strain and effort to make every
passage a purple one" (p. 263). Most commentators have merely
relied and expanded upon Gosse's inadequate critique.[6]

5. *The Poems of Algernon Swinburne*, 6 vols. (London, 1904), I, xvii–
xviii. Quotations from *Tristram of Lyonesse* are from volume IV of this
edition and are identified by page number.

6. For instance, T. Earle Welby. *A Study of Swinburne* (London,
1926), p. 217, claims that "the final effect [of *Tristram*] . . . is one of
fatigue. One puts down the poem with dazzled, aching eyes. The fate of
Tristram was settled when Swinburne wrote the prelude to it, not
realizing that no narrative or quasi-narrative poem could possibly
maintain that pitch without losing hold on the ostensible subject."
Similarly, Samuel Chew, *Swinburne* (Boston, 1929), p. 170, complains of
the "impression of strain, of constant effort after large effects, of
attempting to sustain the whole at a consistently lofty level, in meter,
diction, imagery and idea," and he faults the poem for "redundancy,
flamboyance and incontinence." Even as late as 1949, Humphrey Hare
virtually dismisses Swinburne's epic: "As always the narrative or epic
form eluded him" (*Swinburne: A Biographical Approach* [London, 1949], p.
195). Even Swinburne's best early critic, Georges Lafourcade, hardly
takes the work seriously. He merely notes: "The atmosphere of the
poem, with its flesh-painting effects and somewhat anachronic
rhapsodies on Liberty and Fate, is . . . that of the Renaissance; it has not
the true Pre-Raphaelite ring, and one regrets a little the awkward
unfinished ballad [*Queen Yseult*] which Swinburne composed at
Oxford" (*Swinburne: A Literary Biography* [New York, 1932], p. 292).
Harold Nicolson provides the most enthusiastic though brief early
commentary on *Tristram*, but even his praise is equivocal. He notes that

Although *Tristram* does not adhere strictly to the conventional criteria for narrative and epic poetry by which early critics evaluate it, and in spite of Swinburne's own disclaimers, his highly wrought masterwork is indeed a species of epic, an undeniably successful and unified tour de force. No more unique in its form than some of the major Romantic, narrative poems, it is a hybrid, brilliantly synthesizing many of the narrative and dramatic elements of the traditional epic, as well as lyric and Blakean visionary qualities. In addition, it depends heavily for its formal and philosophical accomplishments upon conventions of courtly love romance and troubadour poetry. Attention to the form as well as the literary and philosophical background of the poem can provide readers with a familiar context in which to approach what is clearly one of Swinburne's greatest achievements and perhaps the most magnificent and truly cohesive "epic" poem of the Victorian era.

Tristram of Lyonesse grew out of the same inspiration which spawned his halting and balladic *Queen Yseult* twenty five years earlier. Yet, his epic version of the Tristram legend displays a unity and depth of artistic intent entirely foreign to that Pre-Raphaelite exercise in imitation of Morris.[7] Two critics have convincingly discussed the structural and thematic integrity of *Tristram*, as well as many of the techniques used to achieve it. Their commentaries attest to the operation of "Aristotelian" skills in most of Swinburne's compositions.[8] This self-conscious

"about the narrative . . . there hangs a sense of lethargy" (*Swinburne* [New York, 1926], p. 179).

7. For the best discussion of *Queen Yseult* in these terms, see Georges Lafourcade's *La Jeunesse de Swinburne*, 2 vols. (London, 1928), II, 41–48. As with all of Swinburne's undergraduate works, an updated and more substantive analysis of this poem is needed.

8. McSweeney points out that the "basic organizing principles" of *Tristram* are "parallelism and contrast." The most important instances are "the matching invocations to Love and Fate which open and close the poem; the contrast . . . between Iseult of Ireland's vigil in Book V, where she prays for Tristram's safety, and the vigil of the other Iseult in Book VII, during which she demands of God that Tristram be damned eternally; and the two carefully contrasted episodes (in Books II and VI) during which Tristram and his Iseult are united, which nicely balance

craftsman was incapable of producing a merely episodic
rhapsody during his mature period. It is not surprising, then,
that *Tristram* does contain numerous qualities that unequivocally
define its atmosphere, intent, and final effect as genuinely epic: it
begins *in medias res*; an elevated tone dominates throughout the
narrative; Swinburne's Tristram and Iseult of Ireland are of epic
stature, as is Brittanic Iseult when she becomes Tristram's
demonic adversary; many of the verbal devices Swinburne
employs are characteristic of the classic epics; and finally, the
subject of his narrative is represented as of supreme
metaphysical importance.

 Tristram is an epic, however, that could have been written
only with the formal developments initiated by the Romantic
poets well in the background. Karl Kroeber goes far in defining
the nature of Swinburne's formal accomplishment in *Tristram*
when he describes in general terms the kind of narrative form
introduced and sanctioned by the Romantics. Kroeber terms
their use of story "visionary (rather than realistic)" and explains
that "in many Romantic poetic tales the naturalistic function of
story is minimized or dropped altogether and narrative is
employed as a means of expressing a philosophic position, a
moral attitude, or a vision of what the poet believes to be
genuine reality, a reality which transcends naturalistic
appearance." In Swinburne's "moral history" narrative functions
in all of these ways. In contrast to Homer, Vergil, Dante, or
Milton, emphasis is not on action, but on expository
metaphysical valuation of event and pure lyrical expression with
a narrative framework. With Swinburne, as with the Romantic
poets, "story is the realization of value. Narrative tension springs

the rising and falling halves of the poem. Finally, twice during the poem
Tristram dives from a great height into the sea" (p. 691). With
substantially greater subtlety, Reed cites the accretive significance of
particular words as the source of *Tristram*'s unity: ". . . words not only
recur, but recur like leitmotivs with particular significance assigned to
them. In fact, the recurrent words are an adjuvant technique to convey
the philosophical import of the poem. The real unity of the poem resides
in its intellectual pattern. . . . Swinburne's attention to the concinnity of
his composition is demonstrated by his use of rhymes and meters . . .
and by such devices as the ironic opposition of similar phrases" (p. 101).

not from naturalistic suspense but from the . . . emergence of a system of precious truth, profound insight."[9]

Swinburne's *Tristram* is, however, considerably more than a visionary poem which extends Romantic narrative innovations. All of Swinburne's works invoke specific literary traditions, and, like all great poets, Swinburne was a superb pasticheur. His undergraduate lyrics, for example, are remarkable adaptations of the idiom of William Morris. In *Erechtheus* he produces the most starkly brilliant Aeschylean imitation in English. Even his ponderous closet dramas are extraordinary for their fidelity to the form and technique of his favorite Elizabethan and Jacobean playwrights. As we might expect, then, *Tristram of Lyonesse* is a self-consciously epic poem which simultaneously imitates epic tradition and tries to transcend traditional constraints in producing an entirely original work which supersedes its models. Of course, Swinburne is by no means unique in literary history for his attempt. As Brian Wilkie convincingly points out: "Like the Old Testament prophets, the great poets of literary epic have always shown . . . both a dedication to the past and a desire to reject or transcend it. No great poet has ever written an epic without radically transforming it or giving to it new dimensions, and often that intention is explicitly declared." And he adds, "The poets observe the fine print in the letter of the law as markedly as they vaunt their independence in the larger matters of subject and heroic theme."[10]

For Swinburne, as for the traditionally acknowledged epic poets, "the anxiety of influence" presented a challenge. In a characteristically Blakean spirit, he did not wish his masterwork to be bound by the constraints of generic definition. As Wilkie explains, "The epic poet seldom states generic rules or delimits formal critical categories . . . for the epic poet must use or implicitly claim to use an old form, a tradition that everyone already understands, so that the new values he preaches will stand out the more boldly" (p. 25). Swinburne was content with his own vaguely ironic designation of *Tristram of Lyonesse* as a "moral history" because to him the importance of the poem

9. *Romantic Narrative Art* (Madison, 1960), pp. 76, 77.

10. *Romantic Poets and Epic Tradition* (Madison, 1965), pp. 11, 13.

depended upon the truths self-consciously espoused and the unorthodox values defiantly embodied in it. In large part, these values represent a more literal, natural, and sensual version of courtly love convention. Indeed, the poem can be viewed as an epic transposition of the courtly love lyric.

In writing *Tristram of Lyonesse* Swinburne found the perfect opportunity for a complete formulation of the unique synthesis of passion, pantheism, and courtly love ethos upon which his most important philosophical intuitions were primarily founded. At the same time, however, he felt that the myth needed to be restored to something like its original integrity. Arnold's version (1852) and Tennyson's (1871) had merely appropriated the legend, ignoring what Swinburne took to be the whole significance of the original myth. To R.H. Horne he wrote on February 13, 1882:

> I am working just now as hard as ever I worked towards the completion of a poem in nine parts on the story of Tristram, which is and was always in my eyes the loveliest of mediaeval legends. I do not forget that two eminent contemporaries have been before me in the field, but Arnold has transformed and recast the old legend, and Tennyson—as usual, if I may be permitted to say so—has degraded and debased it. (*Letters*, IV, 260)

He suggests the purpose of his own projected poem (and provides a damning critique of Tennyson) in an earlier letter (November 4, 1869 [?]) to Burne-Jones:

> I want my version to be based on notorious facts, and to be acceptable for its orthodoxy and fidelity to the dear old story [and, one might add, its antagonism to current orthodoxies]: so that Tristram may not be mistaken for his late Royal Highness the Duke of Kent or Iseult for Queen Charlotte, or Palomydes for Mr. Gladstone. I shan't of course include—much less tell at length, saga-fashion—a tithe of the various incidents given in the different old versions: but I want to have in everything *pretty* that is of any importance, and is in keeping with the tone and spirit of the story—not burlesque or dissonant or inconsistent. The thought of your painting and Wagner's music ought to abash but does stimulate me: but my only chance I am aware will be to adhere strongly to Fact and Reality—to

> shun Fiction as perilously akin to lying, and make this
> piece of sung or spoken History a genuine bit of earnest
> work in these dim times. Ahem. (*Letters*, II, 51)

The parody of Carlyle here has a double thrust, because this
particular "fiction" for Swinburne is something that must not be
either transformed or debased. It is in fact a Reality, albeit a
metaphysical one whose debasement constitutes for Swinburne
the same kind of anathema that Sham and Lying always
represented for Carlyle. Although Swinburne emphasizes
fidelity to "the dear old story" in describing his intent in
Tristram, he is clearly concerned with preserving the
philosophical precepts which he saw embodied in this legend
that had deeply moved him since early childhood.[11] At least
eight centuries of sustained popularity surely seemed for
Swinburne adequate validation of the spiritual truths underlying
the Tristram myth and sufficient reason for annexing and
designating it as the subject for "the very top-stone of his
poetical monument," his single poem of epic scope and
significance.

The epic dimensions of *Tristram of Lyonesse* become clearer
from a brief survey of its use of traditional epic devices. Typical
are the thematic repetitions and parallelisms already discussed
by John Reed and Kerry McSweeney (see n. 2), but just as
important is the strategic use of epic similes to transfigure the
central characters. The "Prelude" openly sets the metaphysical
tone for the rest of the poem and defines the patently heroic
stature of its two ideal lovers. Their story is no merely
entertaining tale, but, like those of the other lovers cited in the
"Prelude," one whose pattern has significance for our own
lives.[12] In the symbolism of the poem, sun and light represent the
irrepressible impulse of Love which governs all people who are
totally receptive to the forces of life and therefore in harmony
with nature. To the extent that they are always "subject to the

11. Swinburne acknowledged in a letter to Paul Hamilton Hayne
(May 2, 1877), "The [Tristram] story was my delight (as far as a child
could understand it) before I was ten years old" (*Letters*, III, 332).

12. For the best available discussion of the "Prelude" see McGann,
pp. 138–41.

sun" (p. 53), these two lovers are "sphery signs" (p. 8) for living generations, just as many of Dante's figures and Spenser's *exempla* were intended to be. As such, Tristram and Iseult are frequently exalted, characterized in elevated terms with epic similes.

This is inevitably the case with the descriptions of Tristram's martial exploits. For instance, when Tristram assaults Palamede as he flees with Iseult from King Mark, the tumult of the two knights' encounter appears

> As when a bright north-easter, great of heart,
> Scattering the strengths of squadrons, hurls apart
> Ship from ship labouring violently, in such toil
> As earns but ruin. . . . (p. 47)

Later, after sanguine and energetic battle with Mark's noblemen, Tristram is backed onto a pinnacle above the sea where, as he prepares to dive, his pugilistic excitement culminates in a Hopkinsian intuition of a bird's love of his element:

> And as the sea-gull hovers high, and turns
> With eyes wherein the keen heart glittering yearns
> Down toward the sweet green sea whereon the broad
> noon burns,
> And suddenly, soul stricken with delight,
> Drops, and the glad wave gladdens, and the light
> Sees wing and wave confuse their fluttering white,
> So Tristram one brief breathing-space apart
> Hung, and gazed down. . . . (p. 71)

Emphasis on Tristram's heroism in the poem is reinforced not only by his chivalric accomplishments, but also by such descriptions as this one, which demonstrate his harmony with the passionately receptive spirit of natural objects. His epic stature is further defined by his explicit association with other epic heroes. Thus in canto 8, "The Last Pilgrimage," Tristram on the morning of his last battle is about to consummate his communion with nature by once again plunging into the scintillating sea. He stands at its edge,

> Naked, and godlike of his mould as he
> Whose swift foot's sound shook all the towers of Troy;
> So clothed with might, so girt upon with joy

As, ere the knife had shorn to feed the fire
His glorious hair before the unkindled pyre
Whereon the half of his great heart was laid,
Stood, in the light of his live limbs arrayed,
Child of heroic earth and heavenly sea,
The flower of all men: scarce less bright than he,
If any of all men latter-born might stand,
Stood Tristram, silent, on the glimmering strand. (p. 127)

Like Tristram, his fatal antagonist, Iseult of Brittany, is the object of careful characterization in the poem. If she is to be worthy of her role as an instrument of Fate, this Iseult must be represented first as attractive and innocuous, but gradually as a developing and finally implacable threat to the original lovers. Only the crucial stage in her development is depicted at length by Swinburne, and that stage is portrayed in canto 7, "The Wife's Vigil," primarily a long soliloquy parallel to the powerful monologue of Irish Iseult in canto 5. Ironically, the soliloquy of Iseult of the White Hands is simultaneous with Tristram and Irish Iseult's last described moments at Joyous Gard (canto 6), where they enjoy a rapturous sunset communion that includes observations on the fated tragedy of Arthur, Guenevere, and Morgause, as well as ominous speculations on death. Canto 7 represents Brittanic Iseult's single night of "passion." Her monologue is adequately prepared for by a narrative introduction that associates her with the natural forces of incipient darkness which are fated regularly and always demonically to overpower the forces of light. Swinburne's characteristically exact observations of nature are reflected here in the description of darkness *ascending* from the depths of earth toward heaven, an apt simile for the birth of evil from within Iseult:

As darkness from deep valleys void and bleak
Climbs till it clothe with night the sunniest peak
Where only of all a mystic mountain-land
Day seems to cling yet with a trembling hand
And yielding heart reluctant to recede,
So, till her soul was clothed with night indeed,
Rose the slow cloud of envious will within
And hardening hate that held itself no sin,
Veiled heads of vision, eyes of evil gleam,

> Dim thought on thought, and darkling dream on dream.
> (p. 106)

Here, Brittanic Iseult's metamorphosis is accomplished at once and in simple natural images which contain moral resonances gathered as the poem has progressed. This extended simile endows Iseult with the epic qualities needed to make her fatality to Tristram plausible, and it provides a clear, but not facile counterpoint to the light imagery with which Tristram and Irish Iseult are consistently described and ennobled.

Indeed, the introductory description of Irish Iseult which opens "The Sailing of the Swallow" dazzles us with images of her radiance. She possesses "bright flesh" which appears to be made of "light woven and moonbeam-coloured shade / More fine than moonbeams." Her "eyelids shone / As snow sun-stricken that endures the sun" (p. 14). Finally, she proves a very incarnation of light, the perfect complement to Tristram, a "man born as at sunrise" (p. 62). As light and sun images used to describe them accumulate, Iseult and Tristram develop into beings who possess the highest kind of integral relationship that exists between omnipotent natural forces and all men. These lovers become symbolic: human extensions of the natural world, at once sources and unique receptacles of radiance. Swinburne represents on this level the relationship between each lover and nature as one of reciprocal illumination. For instance, at the conclusion of their first conversation at sea, Iseult looks into the sun whose "face burned against her meeting face / Most like a lover's thrilled with great love's grace / Whose glance takes fire and gives" (pp. 25–26). Earlier, Swinburne had described her "unimaginable eyes":

> As the wave's subtler emerald is pierced through
> With the utmost heaven's inextricable blue,
> And both are woven and molten in one sleight
> Of amorous colour and implicated light
> Under the golden guard and gaze of noon,
> So glowed their awless amorous plenilune,
> Azure and gold and ardent grey, made strange
> With fiery difference and deep interchange
> Inexplicable of glories multiform. (p. 14)

In this extraordinary instance of metonymy, Iseult's eyes are symbolic of the whole complex of symbiotic relationships that characterize the natural world and without which it cannot be imagined to exist. Iseult's proportions in this epic simile become universal. Like Tristram, she is not merely in harmony with the natural world, but is indistinguishable from it. She contains elemental creation, while being contained by it. And since the central power behind that creation is defined throughout the poem and especially in the "Prelude" as Love whose essence is light, Iseult is depicted as the very power of love itself, a power that is compelled to irradiate, to anoint, and to attract all things.[13]

In the ways that I have described, strategically placed epic similes characterize Swinburne's major figures in an elevated "naturalistic" manner. The result of this frequent device, along with a repeated but less conspicuously epic use of images from nature, makes up what might best be described as the pantheistic vision of *Tristram of Lyonesse*. However, other epic qualities of the poem depend largely on its courtly love elements, its stress on particular values and patterns of behavior that have been derived from courtly literature, as well as its explicit setting in the legendary court of King Arthur.

The Arthurian context has a more significant function in *Tristram* than commentators have yet acknowledged.[14] In fact, it

13. Reed conveniently ignores the complex suggestions of Iseult's personal immortality in descriptions of the intangibles which comprise her being. He emphasizes her transient attributes and claims that she merely "wears the 'fiery raiment' of Love" (p. 105). But the "deep interchange / Inexplicable of glories multiform" which Iseult's eyes contain is framed to suggest an expansive merging of the external infinitude which they reflect and the internal infinitude they contain. For a discussion of the craftsmanship involved in constructing the poem's "light schema," see Fisher, pp. 517–20.

14. Chew claims that the Arthurian matter is not integral to Swinburne's narrative purpose. He insists that it obtrudes primarily in order to create "dramatic relief" which "is sought but not very well obtained by introducing one or two unrelated episodes such as the story of King Arthur's incestuous love. In itself this passage is interesting as

occupies dialogue which dominates two of the three time-
periods that Tristram and Iseult are able to spend freely together:
their journey to Tintagel in canto I and their sojourn at Joyous
Gard. Their conversation in these episodes is taken up largely by
discussions of the Arthurian court which emphasize the fatal
passions of Arthur for his sister Morgause and of Merlin for the
enchantress Nimue. The first discussion is placed as a prelude to
Tristram and Iseult's drinking of the love potion, and serves
much the same function as a foreboding chorus would in a
Greek tragedy.[15] Here, unaware of the ironic significance of their
conversation for their own lives, Tristram and Iseult openly

an indirect attack upon the Tennysonian conception of 'blameless king'
but in the context it forms an irritating interruption of the narrative" (p.
171, n.). The most obvious argument against Chew's notion is that the
longest Arthurian section (five pages of verse in all) occurs only seven
pages into the first canto, where dramatic relief is hardly needed.

15. Swinburne was able to construe the whole cycle of Arthurian
romances unambiguously in terms of Greek tragedy. To him, a single,
fundamental intuition of the dynamic forces ruling all lives operated in
Greek and Celtic myth alike. In Swinburne's mind, the philosophical
substance of *Atalanta in Calydon* and *Erechtheus* was in complete accord
with that of *Tristram* and *The Tale of Balen*. In *Under the Microscope* (1872),
while explaining the nature of Tennyson's mistreatment of the
composite Arthurian legend, he observes: "The story as it stood of old
had in it something almost of Hellenic dignity and significance; in it as
in the great Greek legends we could trace from a seemingly small root
of evil the birth and growth of a calamitous fate, not sent by mere
malevolence of heaven, yet in its awful weight and mystery of darkness
apparently out of all due retributive proportion to the careless sin or
folly of presumptuous weakness which first incurred its infliction; so
that by mere hasty resistance and return of violence for violence a noble
man may unwittingly bring on himself and all his house the curse
denounced on parricide, by mere casual indulgence of light love and
passing wantonness a hero king may unknowingly bring on himself and
all his kingdom the doom imposed on incest. This presence and
imminence of fate inevitable as invisible throughout the tragic course of
action [i.e., to the actors] can alone confer on such a story the proper
significance and the necessary dignity: without it the action would want
meaning and the passion would want nobility" (*Swinburne Replies*, ed.
Clyde K. Hyder [Syracuse, 1966], pp. 58–59).

speculate on the accidental relationship between Arthur and Morgause, whose "sin," like that predestined for Tristram and Iseult, was both unavoidable and fatal.

Both discussions of Arthurian matter originate from Iseult's preoccupation with two characteristic courtly concerns: "fairness," or beauty viewed from the competitive aspect, and the fidelity of her lover.[16] In these dialogues Iseult appears always ingenuous. She actually begins her relationship with Tristram, in Swinburne's version of the myth, by innocently suggesting a comparison of herself with Guenevere. Tristram's first words to Iseult constitute an ironic apotheosis of her, one that has already been verified in the "Prelude." He praises her with conventional courtly exaggeration: "'As this day raises daylight from the dead / Might not this face the life of a dead man?'" In reply, Iseult cleverly denies any interest in her own beauty, but displays enormous concern for the beauties at Camelot whom she will be compared with as Mark's queen. She tells Tristram not to "'Praise me, but tell me there in Camelot, / Saving the queen, who hath most name of fair?'" (p. 20). She thus initiates a discussion of Morgause and the doom presaged for Arthur and, by extension, for his knights.

This discussion explicitly formulates the visionary fatalism which characterizes the whole body of Arthurian legends and which has become inextricable from the courtly conception of love as expressed by medieval romanceurs, as well as the troubadours and trouvère poets. Courtly love implicitly rejects the possibility of total consummation. It requires obstruction to perpetuate its ennobling conventions of chivalric praise and virtuous service by the knight on his lady's behalf. In troubadour lyrics the passion involved is by definition beyond gratification, an idealized passion (no matter what steps may have been taken to obtain satisfaction in historical courtly love situations). And death is exalted as the most profound consolation for the courtly

16. Cf. pp. 20 and 97. Also note how both Iseults consistently require and are exalted by their lover's praise of their beauty (e.g., pp. 65–67 and pp. 99–102), as well as the significance to both of them of fame. Palamede also demonstrates an adherence to courtly courtesies that we would hardly expect.

lover.[17] Thus, in myths that take up the courtly themes, all true love becomes tragic by definition; and it is a natural step to represent a love situation, with all its original courtly values, as predestined to be tragic. This is precisely what happens in *Tristram*, and one can guess that the story was attractive to Swinburne from an early age because it allowed for the indulgence in verse of his propensities for fatalism, as well as sensual experience and courageous adventure.

In *Tristram of Lyonesse*, as in all the major versions of this courtly legend, the presiding deity is Fate. Here that omnipotent power is the source of energy behind all generation, of all unity and diversity, change and changelessness. *Tristram's* last canto begins with the invocation to Fate that is comparable to passages that ritually invoke God (or the gods) in the traditional epic, and it is also suggestive of invocations to the poem's acknowledged muse, the active hand of Fate, Love.[18] Here, however, the poet does not figure self-consciously, and the rhetoric is that of explication rather than humility and deference:

17. Swinburne's persistent preoccupation with death as the culmination of human passions is clearly derived from courtly love conventions. Leonora Leet Brodwin, one of the best commentators on postmedieval uses of courtly love motifs, remarks that, although the courtly lover does not have a morbid love of death, he does aspire to unite with a mystical Absolute, "the Infinite, all that is beyond the sphere of mortal contingency. . . . his fearless embrace of death in the name of an infinite love raises him above its power and unites him to the Absolute" (*Elizabethan Love Tragedy, 1587–1625* [New York, 1971], p. 8).

18. The two major invocations to the muse of Love include, of course, the entire "Prelude" and, in the body of the poem, a passage in "Joyous Gard" where Love is addressed as "Lord," "Bard," and "Seer": "And now, O Love, what comfort? God most high, / Whose life is as a flower's to live and die, / Whose light is everlasting: Lord, whose breath / Speaks music through the deathless lips of death / Whereto time's heart rings answer: Bard, whom time / Hears, and is vanquished with a wandering rhyme / That once thy lips made fragrant: Seer, whose sooth / Joy knows not well, but sorrow knows for truth, / Being priestess of thy soothsayings: Love, what grace / Shall these twain find at last before thy face?" (p. 92).

Fate, that was born ere spirit and flesh were made,
The fire that fills man's life with light and shade;
The power beyond all godhead which puts on
All forms of multitudinous unison,
A raiment of eternal change inwrought
With shapes and hues more subtly spun than thought,
Where all things old bear fruit of all things new
And one deep chord throbs all the music through,
The chord of change unchanging, shadow and light
Inseparable as reverberate day from night;
Fate, that of all things save the soul of man
Is lord and God since body and soul began. (p. 133)

In this poem's delineation of Swinburne's mature philosophy, Fate is analogous to the subject of his earlier lyric, "Hertha," which characterizes the world's presiding monistic life-force. In *Tristram*, before the main action begins, the discussion of Arthurian matter in "The Sailing of the Swallow" serves to suggest the two religious systems at conflict in the poem: that of orthodox Christianity and that presided over by the forces of Fate and Love, which have inexorable power over men's lives but are always only half-perceived by men. In this iconoclastic epic, whatever "suspense" the stories of Arthur, Merlin, and Tristram hold for us must depend upon the gradual discrediting of orthodox religion and the realization of a benevolent visionary destiny for these legendary victims of Fate, one which is inevitable but only partially discerned by them.

Because of its fatal implications for Tristram and Iseult, their initial discussion of the Arthurian court is full of irony. For instance, at the mention of Morgause's beauty, Iseult asks in typical courtly fashion, "'is she more tall than I? / Look, I am tall.'" Indeed, if Arthur's sister is in fact so tall and fair, she insists, then "God" must have "'made her for a godlike sign to men.'" Tristram, in response, explains at length the disconcerting significance of this "godlike sign": the prospects for Arthur's kingdom that result from his affair with Morgause. In fact, Arthur's sister is both a woman and the vehicle of destiny's self-fulfillment and self-knowledge; she reveals a "'fearful forecast of men's fate'" in Arthur's realm. To Tristram's explanation Iseult again reacts innocently, and her response would be comical, were it not tragic: "'the happier hap for me, / With no such face

to bring men no such fate'" (p. 21). But the entire discussion is a pedagogical experience for Iseult. When she learns what events resulted from Morgause's beauty and the tragedy they presage, her faith in the orthodox deity begins to be undermined. The conversation ends with her (once again innocent and ironic) observation:

> "Great pity it is and strange it seems to me
> God could not do them so much right as we,
> Who slay not men for witless evil done;
> And these the noblest under God's glad sun
> For sin they knew not he that knew shall slay,
> And smite blind men for stumbling in fair day.
> What good is it to God that such should die?
> Shall the sun's light grow sunnier in the sky
> Because their light of spirit is clean put out?" (p. 25)

The obvious answer to Iseult's first question is that the lovers "sinned" and therefore should die in order to vindicate the Christian God's repressive laws. However, in terms set out by the poem's "Prelude" and by the recurrent use of sun and light imagery in the poem, the answer to her second question is an unequivocal yes, which complexly underscores one of the central motifs of the work. We are told in the "Prelude" that the sun-god, Love, is fed by the fame of tragic lovers. It is "One fiery raiment with all lives inwrought / And lights of sunny and starry deed and thought" (p. 5). Moreover, its radiance is enhanced at second hand (as it decidedly is in Swinburne's poem) by those who celebrate the tragedies it presides over. The orthodox God, by contrast, ultimately suffers from the apparently unjust doom of tragic lovers. The fate of Tristram and Iseult themselves, who commit less culpable a sin than Arthur and Morgause, proves finally (in canto 9) that God is a fiction devised by men to rationalize their insipid inhibitions, their fear of opening themselves to the primal and passionate instincts of life.

Iseult's ingenuous questions in canto I suggest the opposition maintained throughout the poem between the orthodox God and the sun-god. The latter is continually and expansively defined as the poem's light and day imagery accumulates. The former is characterized in appeals made to it

by the central figures, especially the two Iseults, and in an iconoclastic denunciation of God following the apostrophe to Fate in the last canto. There, as a prelude to Tristram's delirious monologue in which the absolute value of guiltless passion is revealed to him, the narrative describes men's vision of God as

> That sovereign shadow cast of souls that dwell
> In darkness and the prison-house of hell
> Whose walls are built of deadly dread, and bound
> The gates thereof with dreams as iron round,
>
> .
>
> That shade accursed and worshipped, which hath made
> The soul of man that brought it forth a shade
> Black as the womb of darkness, void and vain,
> A throne for fear, a pasturage for pain,
> Impotent, abject, clothed upon with lies. (p. 136)

Fate in the end is a far more benevolent deity than man's God or than men can understand. It bestows death and promises no punishment for joy; rather, it assures an "undivided night" that is "More sweet to savour and more clear to sight" (p. 134) than life itself. Fate alone, in fact, promises the traditionally desired consummation to courtly passion: release.

Yet the poem's narrative vision, which keeps us continually conscious of this fact, is always far in advance of the limited personal vision of Tristram and the two Iseults. The most that Tristram is able to hope for on his deathbed is the gift of a courtly *consolamentum* to undercut the threat of God's punishment. Fatally wounded, Tristram is inconsolable, awaiting Irish Iseult in a limbo between life and death. Only she can cure his wound, heal him of life and bestow a blessing that irradiates the dimness of death and transcends even the radiance of life:

> "Ay, this were
> How much more than the sun and sunbright air,
> How much more than the springtide, how much more
> Than sweet strong sea-wind quickening wave and shore
> With one divine pulse of continuous breath,
> If she might kiss me with the kiss of death,
> And make the light of life by death's look dim!" (p. 143)

At this moment, as at other moments of epiphany in the poem, Tristram's voice seems to merge with that of the omniscient narrator. Yet, although Tristram's sentiments here are validated by the poem's narrative voice, this speech of Tristram's is, ironically, mere courtly rhetoric. Throughout his experiences with Iseult, he never really learns what the poem makes explicit—that this posthumous destiny will not consist in hellish torments but will be the same as that envisioned for Merlin here and for Meleager in *Atalanta in Calydon*: perfect peace in harmonious union with the elements. Thus, in spite of Tristram's more typical insistence on the fact that only "'unrest hath our long love given'" (p. 142), Fate is throughout the poem a force of goodness, a deity whose benevolence, however, is never permanently believed in by Tristram or Iseult. The fact is that the courtly ethos, literally subscribed to, defines passion as a source of pain and prevents a full vision of the inevitable and beneficial interaction of Love, Fate, and natural creation which Swinburne in his mature years intuited as fundamental to all life. The joy of passion is always mitigated (as it is in Swinburne's *Rosamond*, *Atalanta in Calydon*, and *Chastelard*) by fears of transience, concern for fidelity, or a sense of sin. The courtly lovers' vision is tragically limited to the sorrow which attaches to their love, but which paradoxically, becomes a value in itself because it is a consequence of the supreme spiritual experience.

Thus, in "The Queen's Pleasance" and "Joyous Gard" the lovers dwell in part on the dolorous aspects of their passion: its transience, its sinfulness, or the inevitability of death. Similarly, in canto 1 the vision that Morgause's passionate moments with Arthur precipitate is wholly dark. It is a vision informed by orthodox taboos rather than by natural sanctions:

> "... then there came
> On that blind sin swift eyesight like a flame
> Touching the dark to death, and made her mad
> With helpless knowledge that too late forbade
> What was before the bidding: and she knew
> How sore a life dead love should lead her through
> To what sure end how fearful. .." (p. 23)

This description, we must remember, is made by Tristram and primarily characterizes his perception of the event. In spite of the

joy which has transfigured his own "sin" with Iseult, even by the
time he dies, he cannot transcend the limitations of his courtly
and Christian perspective. He sees in death only the
perpetuation of his life's unrest and still perceives Merlin as
"'Exempt alone of all predestinate'" (p. 98). He is unable even to
imagine the truth that Swinburne repeatedly prepares for and
explicitly states at the poem's end: that the rest to which Tristram
and Iseult are delivered is much the same as the "'strange rest at
heart of slumberland'" (p. 98) that occupies Merlin's spirit in
Broceliande. Tristram is saved by following his passions, as
Merlin is by Nimue, whose "'feet . . . move not save by love's
own laws'" (p. 100). Tristram and Iseult defy Christian
inhibitions, but not without fear of retribution. They instinctively
perceive their passion as a supreme good, but their joy is
burdened by guilt. At the end of "Joyous Gard" Iseult confesses
to Tristram the destiny she passionately desires:

> "To die not of division and a heart
> Rent or with sword of severance cloven apart,
> But only when thou diest and only where thou art,
> O thou my soul and spirit and breath to me,
> O light, life, love! yea, let this only be,
> That dying I may praise God who gave me thee,
> Let hap what will thereafter." (p. 102)

Despite her defiance of threatening Christian laws here, Iseult's
devotion to passion is finally requited precisely as she wishes.
She kisses Tristram just after he has died, and "their four lips"
become "one silent mouth" (p. 118). Similarly, although at the
end of her soliloquy in canto 5 Iseult rejects abstinence and
disdains the hell promised by God as punishment for her sin, her
final prayer for reunion with Tristram is granted in explicit
opposition to what we would expect of the orthodox God, whose
efficacy in the world the poem is at pains to disprove: the lovers
are allowed a respite from sorrow at Joyous Gard.

Nonetheless, neither Iseult nor Tristram ever feels worthy
of the posthumous blessing they know Merlin and Nimue have
"earned." In their discussion of death at the end of "Joyous
Gard," Iseult, with only momentary belief in the possibility of
her own worthiness, rhetorically asks Tristram,

> "Nor am I—nay my lover, am I one
> To take such part in heaven's enkindling sun
> And in the inviolate air and sacred sea
> As clothes with grace that wondrous Nimue?" (p. 100)

But both are worthy of such an organic apotheosis because

> This many a year they have served Love, and deserved,
> If ever man might yet of all that served,
> Since the first heartbeat bade the first man's knee
> Bend, and his mouth take music, praising thee,
> Some comfort. . . . (p. 92)

Indeed, Tristram and Iseult have been devoted, faithful, and long-suffering courtly lovers, examples to the world, whose sensual indulgences are vindicated by the power of the symbolic love-draught that first united them, and by the fact that, in typical courtly fashion, their indulgences never dissipate, but rather intensify, their passion.

Perhaps Swinburne was reticent in defining the form of his courtly epic in purely conventional terms because he was more concerned about its substance—the irrepressible truth of "the dear old story"—than its form. In spite of the poem's patently epic qualities, his first description of it as a "moral history" may be the most useful, because Swinburne believed that the Tristram legend and the courtly mythology which inspired it embodied the highest laws which rule men's lives, the greatest of which is Fate, and his primary intent was to communicate and glorify that belief. Like Carlyle, Swinburne knew that the supreme spiritual truths constantly realize themselves in history and thus in individual lives, which are governed by a unitary and presiding impulse in the world. For him, Fate was no intelligent, supernatural force, but rather a sort of natural necessity whose active essence was Love. All vital men and women succumb to its power and are tormented by the obstacles to its full consummation until death bestows fulfillment, and the greatest of these men and women function as immortal *exempla* for the rest of us.

As early as 1857 Swinburne felt this as an intuition. In writing *Queen Yseult* he harbored an aesthetic purpose that grew and nourished him through much of his career. In the final pages

of that work, Yseult, mourning Tristram as dead, consoles herself
with the knowledge that her love "'Shall not perish tho' I die,'"
because "'men shall praise [Tristram] dead,'" and thus "'All my
story shall be said.'"[19] Swinburne is the perennial bestower of
such praise. The creator of numerous love tragedies, he became
for this time the self-appointed preserver of the essential
mythology of courtly love.[20] *Rosamond, Chastelard,* many of his
poems and ballads, *Atalanta in Calydon, Tristram, The Sisters,
Locrine*—most of his finest works reflect his dedication to
describing the various historical and mythical forms tragic
passions can and must take in order to immortalize lovers. For,

> Hath not love
> Made for all these their sweet particular air
> To shine in, their own beams and names to bear,
> Their ways to wander and their wards to keep,
> Till story and song and glory and all things sleep? (p. 7)

Long before writing *Tristram* Swinburne had enrolled himself in
the small class of Sapphic poets devoted to preserving in song
the high reality of insatiable and doomed love, whose fatality

19. *The Complete Works of Algernon Charles Swinburne,* ed. Edmund
Gosse and Thomas J. Wise, 20 vols. (London, 1925–27), I, 59.

20. Critics have so far only noted in token fashion what is really a
major influence on many of Swinburne's most important works. Lionel
Stevenson, speaking of *Rosamond* and *The Queen Mother,* accurately
observes, "The predominate role of the women in both plays is to some
extent derived from the chivalric exaltation of the sex in the Courts of
Love" (*The Pre-Raphaelite Poets* [New York, 1972], p. 198). Philip
Henderson also notes the compatibility of Swinburne's view of love
with the one dominant in courtly literature: "For Swinburne, love is
always inseparable from sadness, cruelty and often death. It is the note
of *Tristan*—passion felt in its original sense of suffering, as a madness
and a subtle poison, usually doomed (as in his own case) to frustration.
At the same time it was a literary convention, reaching right back to the
twelfth century, to the romantic view of love involving martyrdom"
(*Swinburne: Portrait of a Poet* [New York, 1974], p. 50). In addition,
McGann forcefully and cogently argues that Swinburne's obsession
with love and his treatment of it are "essentially a slightly modernized,
that is, romanticized version of the topos of the Provençal poet-lover"
(p. 216).

insured that its participants' immortality would be sustained by poets like himself. Swinburne literally gives "Out of my life to make their dead life live" (p 12). His relentless devotion to the stories of tragic lovers evidences this feeling of kinship with them, a kinship more strongly attested, perhaps, by the incorporation of a legend of tragic love into his own life. His personal tragedy is enticingly hinted at in many of the first *Poems and Ballads*, and especially in his two novels. Appropriately, it has been raised to the condition of myth by the tireless investigations of his critics.[21] Swinburne's concept of the appropriate functions of great poetry, along with his sense of kinship with the doomed lovers of myth and history, inspired him to treat in a unique, but predominantly epic manner the greatest myth of tragic courtly love in order to preserve his intuition of the truth behind the legend. As he confides at the end of the "Prelude" to *Tristram of Lyonesse*,

> So many and many of old have given my twain
> Love and live song and honey-hearted pain,
> Whose root is sweetness and whose fruit is sweet,
> So many and with such joy have tracked their feet,
> What should I do to follow? yet I too,
> I have the heart to follow, many or few
> Be the feet gone before me. . . . (p. 12)

21. For a history of attempts by critics to identify the object of Swinburne's numerous lost-love poems and a startling but now generally accepted argument that his *innominata* was Mary Gordon, his cousin and childhood playmate, see Cecil Y. Lang, "Swinburne's Lost Love," *PMLA*, 74 (1959), 123–30.

"That Most Beautiful of Dreams": Tristram and Isoud in British Art of the Nineteenth and Early Twentieth Centuries[1]

Christine Poulson

> I began the perusal of this [the Prose *Tristan*], as being the
> most celebrated of all these romances, with great
> expectations; these expectations were not answered: the
> story in its progress not only disappointed, but frequently
> disgusted me. Vile as the thought is of producing by a
> philtre that love upon which the whole history turns, and
> making the hero . . . live in adultery . . . these are the

1. This essay is based in part on material from my Ph.D. thesis on
"Arthurian Legend in Fine and Applied Art of the Nineteenth and Early
Twentieth Centuries," which was submitted to the University of Keele
in 1986. The thesis forms the basis of a book on the same subject
currently in preparation for Cambridge University Press. For a
comprehensive treatment of Arthurian legend in Victorian art, see
Debra N. Mancoff, *The Arthurian Revival in Victorian Art* (London and
New York: Garland, 1990). I wish to thank Johns Hopkins, Senior
Lecturer in Music at Homerton College, for discussing Wagner's *Tristan
und Isolde* with me and reading the section of the article which deals
with Wagner. I am also grateful to Laura Hendrickson for her advice
generally and in particular for discussing her work in progress with me
and showing me a draft chapter from her Ph.D. thesis, "Aesthetic
Movement Painting and Illustration in the Context of English
Wagnerism," which was submitted to Brown University in 1992.

conditions of the romance, which must be taken with it for
better or worse. . . . But it is the fault of the author that so
many of the leading incidents should shock not merely
our ordinary morals, which are conventional and belong
to our age, but those feelings which belong to human
nature in all ages. (Robert Southey's introduction to
Thomas Malory, *The Byrth, Lyf, and Actes of King Arthur; of
his Noble Knightes of the Rounde Table, Theyr Merveyllous
Enquests and Aduentures, Thachyeuyng of the Sanc Greal; and
in the End Le Morte DArthur with the Dolourous Deth and
Departyng out of Thys Worlde of Them Al with an Introduction
and Notes by Robert Southey*, Esq., 2 vols. [London:
Longman, Hurst, Res, Orme, and Brown, 1817], I, xv.)

We are held—simply by the idea of a love philtre: it's that
alone that interests us . . . the love-philtre that performs
this miracle. . . . We see a vision of a state of mind in which
morality no longer exists: we are given a respite, a rest: an
interval in which no standard of conduct oppresses us. It
is an idea of an appeal more universal than any other in
which the tired imagination of humanity takes refuge.
(Joseph Conrad and F.M. Hueffer, *The Nature of a Crime*
[London: Duckworth and Co., 1924], pp. 45–46.)

In the first of these quotations Southey records his response to
the thirteenth-century Prose *Tristan*, one of Malory's French
sources. His reaction was one which would be shared by many
others: even Tennyson, who did more than anyone in the
nineteenth century to popularize the Arthurian legends,
distanced himself from Malory and his French sources, referring
to "Art with poisonous honey stolen from France."[2] The second
passage is from a novel written jointly by Conrad and Ford,
serialized in the *English Review* in April and May of 1909 and
published in book form in 1924: a man attends a performance of
Wagner's *Tristan und Isolde* and writes of it to the married
woman whom he has long loved. A gulf lies between these two

2. *The Poems of Tennyson in Three Volumes: Second Edition
Incorporating the Trinity College Manuscripts*, ed. Christopher Ricks
(London: Longman, 1987), p. 563, l. 56.

responses to the story of Tristram and Isoud:[3] it is bridged by the extraordinary impact of Wagner's opera in which the love-philtre is the symbol of an erotic love which in its overwhelming force releases the lovers from moral responsibility and transcends the limits of the material world, bringing death as well as love. The power of this concept and its musical expression created an impact on European culture that spread like ripples in a pond, reaching both literature and the visual arts in England as the nineteenth century drew to a close.

At the beginning of the nineteenth century the Tristram legend was little known in Britain: Southey's disappointment on reading the Prose *Tristan* suggests that, despite his interest in medieval romance, he was not already familiar with it. Indeed, at this date there were few sources in English through which the story could have been generally known. The most extensive treatment of it was in Books VIII–XII of Malory's *Le Morte Darthur*, which had been out of print between 1634 and 1816.[4] The only other vernacular treatment of the legend was *Sir Tristrem*, a thirteenth-century romance, which had been recently edited by Sir Walter Scott and published in 1802. This edition provided a source for the first British literary painting to be based on Arthurian romance in the nineteenth century: in 1839 Ronald McIan, a Scottish painter of historical genre scenes, exhibited at the Royal Society of Artists a painting called *Mark, King of Cornwall, and his Retinue, Conducted by the Dwarf, find*

3. For the sake of consistency, the forms used in referring to the romance in general will be those used by Malory, i.e., "Tristram" and "Isoud."

4. During the 1810s both Scott and Southey were planning new editions of Malory. Scott relinquished the task, and Southey's 1817 edition was forestalled by two cheaper editions in 1816, both based on the corrupt Stansby text of 1634, which had modernized spelling and thousands of variants from Caxton's edition. The Southey edition was not reprinted and became a collector's piece. Quotations from *Le Morte Darthur* in the text of this essay are taken from this edition, which was used by both Dyce and Morris. As there were no further reprints of Caxton until Sir Edward Strachey's edition of 1868, the Stansby text continued to be the one most available to readers of *Le Morte Darthur*. It was the one used by Tennyson.

*Queen Isoude and Sir Tristrem Sleeping in a Cave, Being Fatigued
with the Chase: vide Thomas of Ercildonne.*[5] This long explanatory
title is an indication of just how little knowledge of Arthurian
legend the artist felt he could assume on the part of the
exhibition-going public even by the late 1830s. Attempts in the
1840s and 1850s to add Malory to the history-painting canon
along with Shakespeare, Spenser, and Milton were not
successful. Even Dyce's use of Arthurian material in the Queen's
Robing Room frescos in the new Palace of Westminster, begun in
1846 and in progress during the 1850s, did not encourage other
establishment artists to make use of the legends, in spite of their
impeccably British origins. Dyce's struggles with his Arthurian
material are fully documented in his letters to Eastlake, secretary
of the Fine Art Commission, which was responsible for the
decoration of the Palace of Westminster.[6] His efforts to find
suitable subjects from Malory's *Le Morte Darthur* reveal very
clearly what it was about Malory's account of the legends,
including the Tristram story, that could not be accommodated by
mid-Victorian morality.

Dyce researched the subject thoroughly, using Southey's
1817 reprint of Caxton's 1485 edition of *Le Morte Darthur*, then
regarded as the closest to Malory's original text. The doubtful
historicity of the legends and absence of accurate antiquarian
detail were perhaps the most pressing difficulties, but less
immediately obvious objections to the use of Malory as a source
soon came to light. Writing to Eastlake, Dyce complained that

5. For details of paintings on Arthurian subjects exhibited in
Britain during the nineteenth and early twentieth centuries, see
Christine Poulson, "Arthurian Legend in Nineteenth and Early
Twentieth Century Fine and Applied Art: A Catalogue of Subjects,"
Arthurian Literature, 10 (1990), 111–134. These works are also listed
according to artist in Christine Poulson, "Arthurian Legend in
Nineteenth and Early Twentieth Century Fine and Applied Art: A
Catalogue of Artists," *Arthurian Literature*, 9 (1989), 81–142.

6. Dyce Papers, Aberdeen Art Gallery: typescript of "The Life,
Correspondence, and Writings of William Dyce, R.A., 1806–64: Painter,
Musician, and Scholar" by his son, Stirling Dyce, consisting chiefly of
transcripts of Dyce's correspondence; original manuscripts are no
longer extant. A microfiche copy is lodged in the Tate Gallery archive.

"the story of Arthur, though quite full of material for pictorial description and effect, is not only much too large to be adequately rendered . . . but the chief part of it turns on incidents which, if they are not undesirable under any circumstances, are at least scarcely appropriate in such an apartment."[7] Dyce had in mind the adulterous relationship between Launcelot and Guenever; the story of Tristram and Isoud, another adulterous queen, would have seemed even more shocking judged by the moral standards of the nineteenth century. In the story of Launcelot and Guenever, conflict between the Christian code, which condemns adulterous love, and the courtly love convention, which glorifies it, is at the heart of Launcelot's dilemma and the story ends in failure, pain, and repentance. But in the story of Tristram and Isoud Malory seems to accept the convention of courtly love as quite properly governing the sexual behaviour of his characters: love and marriage are seen as separate. After Isoud's marriage to King Mark, Mark is seen not primarily as a wronged husband, but as an impediment to the love of Tristram and Isoud, of which the author by implication approves. The reader's sympathy is invited not for the cuckolded husband but for the lovers. At one point Tristram is perceived as sinning, not because of his adultery, but because he marries another woman, another Isoud, Isoud La Blanche Mains. Tristram realizes his mistake just in time and does not consummate the marriage. He returns to La Belle Isoud, and Malory makes it clear that he behaves correctly in returning to the lady to whom he first pledged himself, even though this makes their relationship doubly adulterous.

The moral queasiness which Dyce felt in dealing with the story of Tristram and Isoud is evident in his choice of subjects. Tristram figures in two of the frescos: *Courtesy: Sir Tristram Harping to La Belle Isoud* (plate 1), finished 1852, and *Hospitality: The Admission of Sir Tristram to the Fellowship of the Round Table*, incomplete at the time of the artist's death in 1864. In the first Dyce illustrates a point very early in the story, when Tristram first goes to Ireland to be cured by Isoud of the wound inflicted

7. Dyce to Eastlake, 15 August 1848.

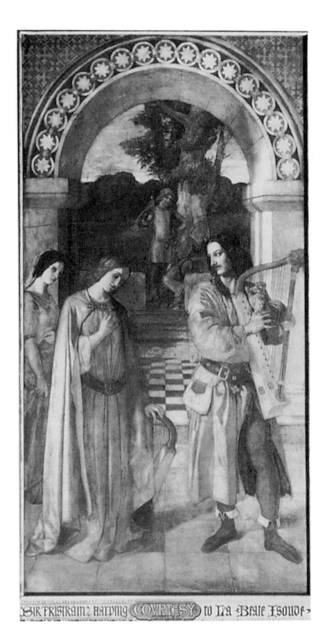

1. William Dyce. *Courtesy: Sir Tristram Harping to La Belle Isoud* (finished 1852). Fresco. 342 × 178 cm. Photo courtesy of Queen's Robing Room, Palace of Westminster, London.

by Sir Marhaus. This is before Tristram's mission to bring Isoud to Cornwall as King Mark's bride and before the drinking of the love potion. Malory relates how "she heled him within a whyle, and therfore Tramtrist cast grete loue to la beale Isoud, for she was at that tyme the fairest mayde and lady of the worlde. And there Tramtryst lerned her to harpe, and she beganne to haue a grete fantasye vnto him" (VIII, 9). Although Tristram and Isoud begin to fall in love, they can still be counted to be in a state of sexual innocence as they have yet to drink the love potion. Thus Dyce succeeds in avoiding the impropriety of illustrating a scene of adulterous love; besides, it is Tristram's skill as a musician which is emphasized rather than his fame as a lover. Similarly, in *Hospitality*, Tristram is welcomed to Arthur's court and to the seat reserved for him at the Round Table because of his qualities as a knight, a huntsman, and a musician:

> [W]elcome said Arthur for one of the best knyghtes, and the gentylst of the world, and the man of mooste worship, for of alle maner of huntynge thou berest the pryce, and of alle mesures of blowynge thou arte the begynnynge, and of alle the termes of huntyng and haukyng ye are the begynner, of all Instrumentes of musyke ye ar the best, therfor gentyl knyght said Arthur ye are welcome to this courte (X, vi).

It is significant that in spite of Tristram's figuring prominently in a decorative scheme of national importance during the 1850s only one picture on the subject seems to have been exhibited in this decade; this was James Eckford Lauder's *Sir Tristram Teaching La Beale Isoud to Play the Harp* which appeared at the Royal Scottish Academy in 1856. It deals with the same point in the legend as Dyce's first Tristram fresco, and was no doubt inspired by it. Lauder was, like McIan, who exhibited the only earlier Tristram subject, a Scottish artist (as indeed was Dyce), and may have been drawn to the legend by its Celtic origins as were Scottish Arts and Crafts artists such as John Duncan later in the century. Lauder could have felt justified in choosing the subject as it had been sanctioned at the highest possible level by its use in the Queen's Robing Room frescos. Nevertheless, the absence of other paintings illustrating the Tristram story

suggests either continued unfamiliarity with the Arthurian legends or that artists shared Dyce's moral qualms.

It was not until the 1860s that subjects from Arthurian legend generally became popular at the Academy exhibitions, and then it was not Tristram but the Arthurian women, Elaine, Enid, and the Lady of Shalott who provided the subjects. For it was Tennyson, not Malory, who from the 1850s onwards was to be chiefly responsible through his serial poem, *Idylls of the King*, for creating a vogue in Britain for Arthurian legend. Dyce's struggles over planning the Queen's Robing Room frescos indicate the gulf between medieval and Victorian sensibilities and the extent to which the legends needed reworking before they would be palatable to Victorian moral taste. Tennyson undertook this task with superlative success, boldly omitting the story of Arthur's unwitting incest with his half-sister, Margawse, and the birth of their son, Mordred, who is eventually instrumental in bringing about the destruction of Arthur's kingdom.[8] Once this element is removed, the moral balance of the legends shifts, laying the entire burden of guilt on Guenever. The destruction of Arthur's kingdom through Guenever's adultery is really the central theme of *Idylls of the King*. It is her moral laxity which allows the wicked Vivien, Nimüe in Malory's account, to gain a foothold in Arthur's otherwise ideal society, her adulterous example which is followed by others, in particular Tristram and Isoud, leading to the moral degeneration of the court and so to the final disaster. Hallam Tennyson records his father's conviction that "upon the sacredness of home life . . . the stability and greatness of a nation depend": in the first Idylls to be published, "Elaine," "Vivien," "Enid," and "Guinevere" (1859), different relationships are explored to demonstrate that the moral health of a nation depends to a great extent on the purity of its women and their devotion to their husbands.[9] Given this intention, it is not surprising to find that

8. For the ways in which Tennyson adapted his sources, see David Staines, *Tennyson's Camelot: The Idylls of the King and Its Medieval Sources* (Waterloo, Ontario: Wilfred Laurier University Press, 1982).

9. Hallam Tennyson: *Alfred Lord Tennyson: A Memoir by His Son*, 2 vols. (London: Macmillan, 1897), I, 189.

although Tennyson did not actually omit the story of Tristram and Isoud, he treated it far more cursorily than Malory. Furthermore, the story did not appear until "The Last Tournament," published in 1871, when the moral framework of the poem was already firmly in place. Most importantly, as with Tennyson's treatment of the love of Launcelot and Guenever, there is a radical shift of emphasis which diminishes the great love story into an episode of sordid adultery, emblematic of the decline of Arthur's ideal kingdom. The episode of the drinking of the love potion, the device which absolves Tristram and Isoud from moral responsibility, is altogether omitted. The lovers, seen after Tristram's marriage to Isoud La Blanche Mains, are shown as shallow and flirtatious, their love reduced to bickering and manipulation. This contrasts with Malory who leaves the story at the point where the lovers have escaped to Arthur's court and are living happily together at Joyous Gard, Launcelot's castle: love, adulterous or not, conquers all.

Given Tennyson's unsympathetic treatment, it is not surprising that during the 1870s only two works relating to the story of Tristram and Isoud were exhibited at the Royal Academy: Emily Mary Osborn's *Isolde* of 1871 and Mrs. William J. Stillman's *Sir Tristram and La Belle Isoude* of 1873. This contrasts strongly with the response to the publication of "Elaine" and "Enid" twelve years earlier: by 1871 those two paradigms of feminine virtue had inspired at least thirty-eight exhibited works between them. Moreover, in the titles of both these Tristram pictures the spelling of Isoud, which does not agree with Tennyson's spelling, "Isolt," suggests that "The Last Tournament" was not the source. The precise subject of Osborn's picture is not known, but that of Stillman's is clearly taken from Malory, for it represents an episode not described in "The Last Tournament": that of Tristram recognized by a little dog which he had given Isoud. Stillman (Maria Spartali before her marriage to the American journalist, William J. Stillman) was a close associate of the Pre-Raphaelite circle, and acted as a model for Rossetti. The scene from Malory which she chose to illustrate was a favourite of William Morris's, and his treatment of the subject was very likely her inspiration. Interestingly, both these Tristram subjects of the 1870s are by women, who necessarily

would not have had an Academic training at this date and may have thus been a little less bound by establishment views about the suitability of certain subjects. In the case of Stillman it was certainly her connection with a group of artists whose work represented an alternative to Academic art, and whose lives represented an alternative to conventional bourgeois respectability, which led her to choose Malory rather than Tennyson as a source. Exhibitors at the Royal Academy and elsewhere may have been reluctant to use such a morally equivocal source but, as early as the 1850s, Arthurian legend in the form of Malory, rather than Tennyson, had been a favourite source for the group of young artists that clustered around Rossetti. Prominent among them were William Morris and Edward Burne-Jones, who discovered Malory through a copy of Southey's edition found by Burne-Jones in a Birmingham bookshop in 1855.[10] To them the book "was so precious that even among their intimates there was some shyness over it, till a year later they heard Rossetti speak of it and the Bible as the two greatest books in the world...."[11]

Morris's and Burne-Jones's early passion for Malory, in particular the special attraction of the Tristram story for Morris, needs to be seen in the context of their general interest in the Middle Ages. Malory's *Le Morte Darthur* served as a kind of talisman, an antidote to what they perceived as the mechanistic spirit of the age. Amongst contemporary writing Ruskin's analysis of art and society in the chapter entitled "The Nature of Gothic" in *The Stones of Venice*, published 1851–53, served a similar function. These two works seemed to be windows into a distant world which had vanished with the encroachment of industrialization and urbanization and the rise of capitalism. Malory struck a special chord, for he too, writing at the close of the Middle Ages, was living in a time of transition and flux, when old values and certainties seemed to be crumbling; in *Le Morte Darthur* Malory was celebrating what he imagined to have

10. G[eorgiana] B[urne-] J[ones], *Memorials of Edward Burne-Jones*, 2 vols. (London: Macmillan, 1904), I, 116–17.

11. J.W. Mackail, *The Life of William Morris*, 2 vols. (London: Longman, Green, 1899), I, 91.

been the true age of chivalry and nobility, now sadly vanished. Honour and constancy, in both public and private life, are the supreme values for Malory, and he often praises the past at the expense of the present; he contrasts, for instance, the constancy of Launcelot and Guenever with the fickleness of present-day lovers: "Ryghte soo fareth loue now a days, sone hote soone cold, this is noo stabylyte, but the old loue was not so . . ." (XVIII, 25). Yet there is nothing sentimental about Malory: his idealism is combined with a robustly virile narrative style and a matter-of-fact frankness about the pleasures and pains of sexual love which for Morris and his friends acted as a release from mid-Victorian reticence and prudery about sex. Morris and Burne-Jones responded to Malory in an intensely personal manner: the legends provided myths which helped them give order to, and even to dramatize, their private emotional experiences. This is very emphatically the case with Burne-Jones for whom the Quest of the Holy Grail and the beguiling of Merlin were the most attractive elements of the legends. For Burne-Jones, introspective, highly imaginative, and always very vulnerable to feminine beauty and charm, the mystic and sensual elements of the legends provided continuous inspiration. He painted five versions of *The Beguiling of Merlin*, the best-known of which had Mary Zambaca, a woman with whom he was passionately in love, as the model for Nimüe. The same is true of Rossetti who, in his Oxford Union mural and elsewhere, chose to illustrate the adulterous love between Launcelot and Guenever and Launcelot's consequent failure in the Grail Quest. Rossetti, himself in the middle of a long-standing, stormy and unresolved relationship, was sympathetic to the emotional conflict suffered by Launcelot. He had a habit of identifying intensely with the subjects of his pictures, seeing, for instance, himself as Dante and Elizabeth Siddal as Beatrice. In the late 1860s life was to mirror art to a startling degree with Rossetti playing the role of Launcelot to Jane Morris's Guenever and Morris's long-suffering Arthur. In the story of Tristram, Morris was to take two roles, playing first the successful lover and then, when this role was usurped by Rossetti, playing the cuckolded husband. Jane's appearance as Isoud in Morris's only completed oil painting, *La Belle Iseult* (plate 2), is significant in this context.

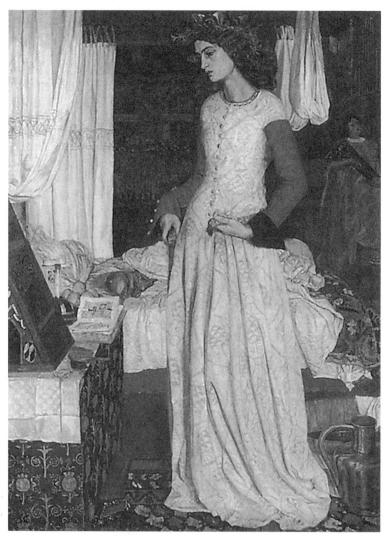

2. William Morris. *La Belle Iseult* (1858). Oil. 71.8 × 50.2 cm. Photo courtesy of Tate Gallery, London.

From the beginning of his career Morris was strongly attracted to the story of Tristram as a subject. His first commission, begun in the summer of 1857 for T.E. Plint, a patron of Rossetti's, was *How Sir Tristram, after his Illness, Was Recognized by a Little Dog He Had Given to Iseult.* Its present whereabouts, or even what happened to the canvas after Morris abandoned it, is unknown. In the summer of 1857 it was left unfinished when Morris went to Oxford to join Rossetti and a group of other young artists in painting a series of murals on Arthurian subjects in the Oxford Union Society's Debating Hall. There, he again chose a subject from the story of Tristram and Iseult: *How Sir Palomydes Loved La Belle Iseult with Exceeding Great Love out of Measure, and how She Loved Him Not Again but Rather Sir Tristram.* Unfortunately not much of Morris's work remains, but one can make out the figures of Tristram and Iseult embracing, watched by Sir Palomydes, and surrounded by sunflowers. The theme of Palomydes's fruitless love of Isoud occurs often in Malory but, from what one can see of the painting, it does not depict a specific point in the narrative, being rather a blending of several incidents: an imaginative intermingling of several elements of the Tristram and Isoud story to create a picture on the theme of jealous, unrequited love.

After Morris had finished work on the murals he stayed on in Oxford, working on the picture for Plint begun earlier. The subject is readily identifiable from the title, which refers to Book IX, chapter xxi of Malory's *Le Morte Darthur* and bears a relation to Morris's *La Belle Iseult* of the following year and to a later stained glass panel, thus revealing a special interest in one particular episode in the story. Through a misunderstanding, Tristram comes to believe that Isoud has fallen in love with another man; he leaves King Mark's court and, driven mad by grief, runs wild in the woods, playing his harp and being fed by herdsmen and shepherds. So thin and unkempt as to be unrecognizable, he is brought back to Mark's court. Isoud recognizes him when her little dog, which once belonged to Tristram, jumps up and licks his face: the lovers are then reunited. Perhaps Morris had also read Scott's edition of *Sir Tristrem*, a version in which the dog, Hudain, also drinks the love potion and so is bound to the lovers for life. *La Belle Iseult,*

painted in the following year, illustrates a different moment in the same episode.[12] The iconography of the picture, in particular the detail of the little dog curled up in the bed, suggests the incident which Morris illustrates. While Tristram is running wild in the woods, an enemy puts out false rumours of his death. Isoud goes almost mad with grief and tries to kill herself. She is restrained by Mark, who confines her in a tower: "and there he made her to be kept and watched her surely, and after that she lay longe seke nyz at the poynte of dethe" (IX, xx). This part of the story is suggested in the picture by the woman's haggard heavy-eyed face, by her withdrawn expression as she listlessly dresses, and by the unkempt bed and rumpled sheets. A sense of claustrophobic confinement is created by the absence of windows, the sombre decoration of the room, and by the cramped picture-space.

Morris's fullest exploration of the Tristram story took the form of thirteen panels of stained glass commissioned from the firm of Morris, Marshall, Faulkner, and Company in 1862 for Harden Grange, the Yorkshire house of Walter Dunlop, a Bradford merchant.[13] Malory's account of Tristram's story contains many adventures not directly linked with Isoud, although the story of their love is the strongest thread in the

12. It was originally catalogued by the Tate Gallery as *Queen Guenevere*, but there is strong documentary evidence to support the title of *La Belle Iseult*. The most telling is contained in a letter of 7 July 1901 from Jane Morris to her daughter, May: "'La Belle Iseult' is what the dear Father always called the picture and I think we ought to keep to that," Additional Collection, 43546, British Museum. I am grateful to Jan Marsh for drawing my attention to this source. The iconography of the picture also supports this.

13. In Bradford City Art Gallery a manuscript in Morris's hand, headed "Short abstract of the Romance of Tristram," gives a summary of the story with points thought suitable for illustration listed in the margin. These are in fact the subjects which the panels, now in Bradford City Art Gallery, illustrate. They were designed by Morris, Burne-Jones, Rossetti, Val Prinsep, Arthur Hughes, and in addition, Ford Madox Brown, who was one of the Firm's principal stained glass designers. See H.E. Wroot, "Pre-Raphaelite Windows at Bradford," *Studio*, 72 (November 1917), 69–73.

story. Morris pulled out this thread for the Tristram panels; even *The Fight with Sir Marhaus* is closely associated with Isoud in that it provides the reason for the lovers's first meeting: Tristram goes to Ireland to be cured by Isoud of a wound inflicted by Marhaus. The panels go on to illustrate the main points of their story: their setting out for Cornwall, the drinking of the love potion, and so on. This selection of scenes provides narrative coherency and also suggests that it was Tristram and Isoud's love which Morris found the most moving aspect of the story. As well as choosing the subjects which the other designers were to illustrate, Morris reserved four designs for himself: *The Brachet Licking Sir Tristram* (plate 3), *Tristram and Isoude at Arthur's Court*, and two panels representing figures rather than scenes, *Queen Guenevere and Isoude Les Blanches Mains* and *King Arthur and Sir Launcelot*. The other designs were carried out by four of the artists who had also worked on the Oxford Union murals: Burne-Jones, Rossetti, Prinsep, Hughes, and in addition, Ford Madox Brown, who with Burne-Jones had become one of the firm's principal stained glass designers. There is less disparity in style than one might expect since Morris exercised overall control, deciding all the colours and the placing of the lead lines himself. The small scale of the panels (on average, 68 by 60.5 centimetres) the brilliance of their colouring, and the charm with which the story is told must have produced a delightful effect in situ in the hall at Harden Grange. It is interesting that neither Morris nor his patron seem to have felt that this story was an inappropriate one for a domestic setting, suggesting that Dunlop exercised an independence of judgement typical of Pre-Raphaelite patrons. Morris's fascination with the Tristram legend was also in the late 1850s spilling over into poetry. According to his daughter, May, he had planned to write a complete cycle of Arthurian poems; little was actually produced, but fragments include a poem entitled "Palomydes's Quest" in which, as in Morris's Oxford Union mural, the subject is Palomydes's unrequited love for Isoud. It is impossible to tell whether the mural or the poem came first, but it is significant that Morris was reworking the legends to the extent of adding new episodes. Similarly, another fragment, "St. Agnes Convent," tells a story not told by Malory: the fate of Isoud La Blanche

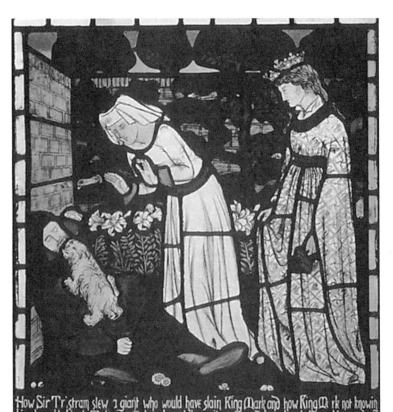

How Sir Tristram slew a giant who would have slain King Mark and how King Mark not knowing him brought him to Tintagel and how he got his wit again and how Isoude knew him again because of the brachet which Tristram had given her which leaped upon him and licked him

3. William Morris. *The Brachet Licking Sir Tristram* (1862). Stained glass. 68 × 60.5 cm. Photo courtesy of City Art Gallery, Bradford.

Mains, the wife whom Tristram abandoned on their wedding night in order to return to his first love, La Belle Isoud. This may have been inspired by Matthew Arnold's poem "Tristram and Iseult," published in 1852, part of which also dealt with the fate of the discarded wife. Isoud La Blanche Mains also provided the subject for one of the embroidered hangings designed by Morris for Red House, suggesting that he felt sympathy for the abandoned wife as well as for the lovers. The hanging, which is unfinished, was worked by Jane Morris and her sister, Elizabeth, and now hangs in Kelmscott Manor.

Morris's absorption in Arthurian legend continued certainly up to the late 1860s, and Mackail, Morris's biographer, suggests that he was thinking of giving the Tristram story further poetic form. He refers to Morris's "unwritten poem on . . . the story of Tristram and Iseult: the one which his 'soul yearned to do' . . . when he had completed 'The Earthly Paradise' [1870] and which was the episode of the whole Arthurian cycle that held his imagination most strongly" (Mackail, II, 76). Morris confessed to the attraction that the story had for him. Writing in 1873 to an acquaintance in Iceland, he asked about the publication of a Nordic version of the legend:

> May I speak on a subject in which I am very much interested, the publication of the Tristram's saga: all my literary life I have been deeply moved by that Cycle of Romance, as indeed I ought to be, being myself Welsh of kin, and I am very anxious to see the earlier version of that great story written in the noble language of the classical Icelandic time.[14]

The reason given by Morris does not seem adequate to account for his absorption in the story. In discussing Morris's Oxford mural *The Jealousy of Sir Palomydes*, Mackail suggested that this was "a subject for which he felt a singular and morbid attraction, that of the unsuccessful man and despised lover" (Mackail, I, 119). This explanation is almost as unsatisfactory as Morris's own, and it may be that Mackail's judgement was influenced by his knowledge that in the late 1860s and early 1870s—the period

14. *The Collected Letters of William Morris*, ed. Norman Kelvin, 3 vols. (Princeton, N.J.: Princeton University Press, 1984–), I, 181.

of Jane Morris's greatest involvement with Rossetti—this was just what Morris did feel himself to be. But during the late 1850s and early 1860s when Morris's interest in the Tristram story was at its height, he was a successful suitor and then a happily married man. In identifying with the legend he would surely have seen his character reflected more accurately in the energetic, many-talented Tristram. Morris disliked "the maundering side of medievalism", of which there is very little in the story of Tristram, who has none of the introspection and self-doubt of Launcelot (Kelvin, I, 216). He is a man of action, performing deeds of amazing courage and strength. The quality of the Tristram story which most appealed to Morris was probably its most obvious one: its idealization of erotic love as a supreme value in life, along with Malory's general espousal of the chivalric code.

But during the 1870s Morris was coming to feel that the chivalric ideals, particularly that of romantic love, were no longer a sufficient guide to life: the private and personal was not enough. His son-in-law, Halliday Sparling, records how in later years Morris electrified his friends by seizing a volume of *Love is Enough*, his poem of 1871–72, rapping it with a paper-knife, and exclaiming "There's a lie for you, though 'twas I that told it! Love isn't enough in itself! Love and work! Work and love! That's the life of a man! Why, a fellow can't even love decently unless he's got work to do, and pulls his weight in the boat!"[15] During the 1870s Morris was becoming increasingly involved in public affairs and beginning to think deeply about political issues. He came to feel that he had outgrown the legends and that they no longer had much to say to him. In 1882, shortly before his conversion to socialism, he wrote of Swinburne's reworking of the Tristram story in *Tristram of Lyonesse*, published that year:

> I have made one or two attempts to read it, but have failed. . . . [In] these days when all the arts, even poetry, are like to be overwhelmed under the mass of material riches which civilization has made and is making more

15. H.H. Sparling, *The Kelmscott Press and William Morris, Master-craftsman* (1924; rpt., Folkestone: William Dawson and Sons, 1975), p. 10.

and more hastily every day . . . in these days when the issue between art, that is, the godlike part of man, and mere bestiality, is so momentous, and the surroundings of life are so stern and unplayful, that nothing can take serious hold of people, or should do, but that which is rooted deepest in reality and is quite at first hand: there is no room for anything which is not forced out of a man of deep feeling, because of its innate strength and vision (Kelvin, II, 119).

If Morris had not disliked opera, he could have heard that year in London an interpretation of the Tristram legend which was certainly something of "innate strength and vision" "forced out of a man of deep feeling": on 22 June 1882 Wagner's *Tristan und Isolde* was performed for the first time in England at the Theatre Royal, Drury Lane. Wagner certainly regarded this work as rooted in reality and first-hand experience, inspired as it was by his passionate longing for love and his relationship with Mathilde Wesendonck. The responses of Wagner and Morris to the Tristram legend have more in common than might at first be apparent. Certainly both men were unaffected by the view that this was an immoral story that needed careful handling if it was to be handled at all, the view that had made Tennyson so anxious, when writing the first *Idylls*, to avoid the imputation of corrupting the young. Wagner succeeded where Tennyson had failed or, perhaps it is truer to say, had not even tried, since the very subject that had been most taboo and that had been assiduously avoided by Tennyson—the drinking of the love potion—was to become through the influence of Wagner the most frequently illustrated aspect of the story.

Tristan und Isolde was composed between 1857 and 1859, coincidentally the years in which Tennyson was writing the first *Idylls*. The score was published immediately, but Wagner's reputation as a dangerous revolutionary and the difficulties posed by performance of the opera, in particular the prodigious demands placed on the leading singers, led to rejections from many opera houses, and the opera was not staged until 1865 in Munich. Although the first performance of *Tristan und Isolde* in London was not until 1882, it was to a certain degree familiar in musical circles before that date. Wagner had his champions in

England from the 1860s, and his work was played at private gatherings, arranged for the piano, from the late 1860s. In 1873 the Wagner Society was formed and sponsored public performances of his work; in the same year the *Athenaeum* was claiming Wagner to be now "enrolled among our classics."[16] 1882 saw the first performances not only of *Tristan und Isolde*, but also of *Die Meistersinger*, both conducted by Hans Richter, and the entire *Ring* cycle, brought to London by Angelo Neumann. Both men had obtained the performance rights from Wagner, and to some extent had his sanction for their productions. The impact was enormous and heralded the beginning of Wagner-mania, the composer's death in 1883 naturally increasing the reverence, even adulation, with which he was regarded. In the following year the Wagner Society was refounded as the London branch of the Universal Wagner Society and began publication of a quarterly journal, *The Meister*; the first volume contained a translation of the libretto of *Tristan*.

The two operas that excited most controversy in the 1882 season were *Die Walküre*, because of the incest between Siegmund and Sieglinde, and *Tristan und Isolde*, in part because of its subject, but also because of the deeply erotic nature of the music. This was expressed in musical forms of extraordinary novelty that seemed, as Baudelaire wrote of *Tannhäuser*, to express the "onomatopoeic dictionary of love."[17] The swooning rapture of the lovers finds its counterpart in the music's chromaticism, its continuous modulation, and avoidance of cadence. The musical climax of the opera, Isolde's *Liebestod*, its long delayed resolution, has an orgasmic force in which the conflicts and oppositions of the opera are dissolved in the finality of death. Bryan Magee's view that there is no "more erotic work in the whole of great art"[18] scarcely seems

16. Anne Dzamba Sessa, *Richard Wagner and the English* (London: Associated University Presses, 1979), p. 29. I am indebted to this account of Wagner's reception in England.

17. Raymond Furness, *Wagner and the English* (Manchester: Manchester University Press, 1982), p. 33.

18. Bryan Magee, *Aspects of Wagner* (London: Alan Ross, 1968), p. 57.

exaggerated. Wagner himself was fully aware that the erotic power of *Tristan und Isolde* would be disturbing, fearing the audience would find it emotionally overwhelming, rather than that they would disapprove: in April 1859, while the work was still in progress, he wrote to Mathilde Wesendonck, "This *Tristan* is turning into something frightful! That last act!!!—I'm afraid the opera will be forbidden—unless the whole thing is turned into a parody by bad production—: nothing but mediocre performances can save me! Completely good ones are bound to drive people crazy . . ."[19] Reviews of the first production in England of *Tristan und Isolde* show that Tennyson's earlier caution in dealing with the legend had been well founded. The music critic of *The Era*, while admiring the performance and some of the music, raised objections which suggest that general perceptions of the legends had not changed much since Southey had first been shocked in the 1810s:

> [W]e cannot refrain from making a protest against the worship of animal passion which is so striking a feature in the later works of Wagner. We grant that there is nothing so repulsive in *Tristan* as in *Die Walküre*, but the system is the same. The passion is unholy in itself and its representation is impure, and for these reasons we rejoice in believing that such works will not become popular. If they did we are certain that their tendency would be mischievous, and there is, therefore, some cause for congratulation in the fact that Wagner's music, in spite of its wondrous skill and power, repels a great number more than it fascinates.[20]

The critics were not all in agreement: F. Corder, writing in the same year in the *Musical Times*, referred to *Tristan und Isolde* as "the supreme masterpiece of its author—the ideally perfect lyric tragedy."[21] The only reasons he could see for the opera not being popular, in the sense of being frequently performed, were the

19. Derek Watson, *Richard Wagner: A Biography* (New York: McGraw-Hill, 1983), p. 161.

20. Raymond Mander and Joe Mitchison, *The Wagner Companion* (London: W.H. Allen, 1977), p. 170.

21. March 1, 1882, p. 131.

tremendous demands it made on the leading performers, and an inability on the part of the English public to appreciate its musical complexity. That great champion of Wagner, George Bernard Shaw, took a different view, suggesting that "To enjoy Tristan it is only necessary to have had one serious love affair; and though the number of persons possessing this qualification is popularly exaggerated, yet there are enough to keep the work alive and vigorous."[22]

Then, as now, Wagner was a composer who provoked powerful responses of either attraction or antipathy: there were those who were not only fascinated by him, but for whom he acquired an almost god-like status. That Wagner's influence on European culture was tremendous cannot be doubted. Raymond Furness argues persuasively that the musical forms employed by Wagner, in particular the use of the *leitmotif*, are reflected in the development of the modern novel, in particular in the stream of consciousness technique. Such an influence is less readily discernable in the visual arts, but Furness suggests that the acceptance of music as the superior art form—in which Wagner played a leading role—is closely associated with a move away from a naturalistic and figurative approach towards abstraction. "In painting a movement towards abstraction, in literature the increasing use of private images and autonomous metaphors, abstracted from their context, demonstrate the way in which empirical experience becomes of lesser importance: it is true to say that the adoption of the principle of musical composition by the other arts is the most dominant characteristic of modernism" (Furness, 5). However, this article is necessarily concerned less with Wagner's broader influence than with the ways in which Wagner's interpretation of the Tristram legend, as represented by the score and libretto of *Tristan und Isolde* and by stage production, affected the way in which artists treated the legends and how they visualized the historical setting. Nevertheless, it is worth noting that in the work of Beardsley, who idolized Wagner, both influences seem to have been at play. Beardsley's

22. *Shaw's Music: The Complete Musical Criticism in Three Volumes*, ed. Dan. H. Lawrence, 3 vols. (London, Sydney, Toronto: Max Reinhardt: The Bodley Head, 1981), I, 723.

later illustrations to Malory's *Le Morte Darthur* appear to have been inspired by Wagner rather than by Malory in terms of style as well as content: the drinking of the love potion is presented as a violent and reckless action, which is expressed not only through Tristram's gesture but through the stark contrast of black and white and the spiky angularity of the design; Isolde's dual role as bringer of death as well as love, literally a femme fatale, is implied by her writhing, Medusa-like locks of hair. The design is flat, emblematic, representing a strong shift away from the Burne-Jones pastiche of the earlier designs towards greater abstraction.

Beardsley's associations with aestheticism are significant, for prominent among Wagner's early admirers in England were Swinburne and Franz Hueffer, who published *Richard Wagner and the Music of the Future* in 1874. Hueffer married Ford Madox Brown's youngest daughter, Catherine. It was among the generation of Arts and Crafts artists descended from the Pre-Raphaelites and their circle that the Tristram subject was to be most popular, particularly in the first two decades of the next century. This has some bearing on an interesting feature of artistic treatment of the Tristram legend from the late 1880s onward: the range of media which is used. The subject is not confined to oil painting, and is found also in enamel and in stained glass panels, one of which, by James Sparrow (c. 1896), alludes to Wagner by including musical notation in the design. Those artists who did produce oils often had a strong Arts and Crafts background, for example, Sidney Meteyard (1868–1947), who studied and then taught at the Birmingham School of Art, the centre of the Birmingham Arts and Crafts Movement. A striking example of the purely fashionable element of the adulation of Wagner is the Wagner girdle (plate 4), designed in the early 1890s by Alexander Fisher, the leading Arts and Crafts enamelist. Celtic in inspiration, it is made of steel with enamel plaques which illustrate scenes from a variety of Wagnerian operas. *Tristan und Isolde* is given pride of place with two plaques, each twice the size of the others, which function as buckles and which illustrate the drinking of the love potion and the death of Tristram.

4. Alexander Fisher. The Wagner girdle and buckle (1896). Steel with enamel plaques. 98 × 56.5 cm. Photo courtesy of the Board of Trustees of the Victoria and Albert Museum, London.

The decades between 1900 and 1920 represented the peak of artistic interest in the legend as reflected in Royal Academy exhibitions: between 1900 and 1910 six works featuring some aspect of the story were exhibited there, and a stained glass panel was exhibited at the Glasgow International Exhibition. In the 1910s there was a further five. Of course, not all works of art illustrating the Tristram legend were exhibited. An example is Maxwell Ashby Armfield's watercolour, *Tristan and Isolde*, which is also undated, making it difficult to fit into the chronology of Tristram subjects. Thus, frequency of exhibition at the Royal Academy can be only a rough, although not insignificant, guide to the more general popularity of a subject among artists. Still, there does appear to be a peak of interest which accords with Zuckerman's view that "between the last years of the nineties, when Mann wrote his first Wagnerian stories, and 1911, when *Death in Venice* appeared, lay the decade of Wagner's greatest posthumous influence. Many of the earliest Wagnerites were still at work, while the composers and writers who grew up during the vigorous years of the adolescence of Bayreuth had reached maturity."[23] He points out that "between 1899 and 1910 *Tristan* was premiered in fifty cities, including Cairo, Buenos Aires and Rio de Janeiro" (Zuckerman, 151). Less exotically, the first performance in English—rather than in German or even in Italian—was given in London and then Liverpool in 1899.

Wagner's influence not only created a general climate of heightened awareness of the Tristram story, but also extended further than this to affect the ways in which some artists visualized their subjects. The best example of this is Hubert Draper's oil, *Tristram and Iseult* (plate 5), exhibited at the Royal Academy in 1901. Draper seems tacitly to disclaim Wagnerian influence by using English spellings for the names and by expanding the title with a description which is in part a quotation from Book VIII, Chapter 24 of Malory: "Then did King Mark's bride and then did Tristram drink of that cup, all unwitting, so that a great love entered into them; the which love

23. Elliott Zuckerman, *The First Hundred Years of Wagner's Tristan* (New York and London: Columbia University Press, 1964), p. 14.

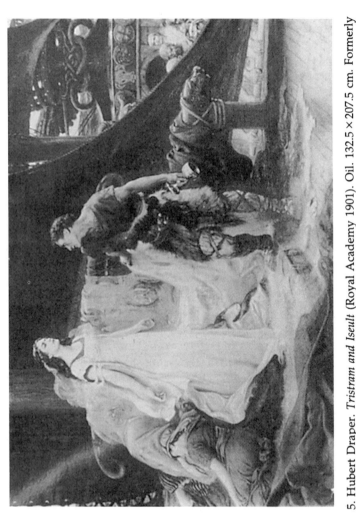

5. Hubert Draper. *Tristram and Iseult* (Royal Academy 1901). Oil. 132.5 × 207.5 cm. Formerly Walker Art Gallery, Liverpool, destroyed in World War II.

departed not from them all the days of their life for weal or for woe." Yet the picture not only has a strongly histrionic flavour but also contains several elements apparently from stage production of the opera. Wagner's belief in the total work of art, which would be the art of the future, led him to control the staging of his operas as closely as every other element; yet the staging of *Tristan und Isolde* was surprisingly conventional, given the absolute novelty of the work in every other respect. Bauer writes of "the historicist magnificence"[24] of the set designs and costumes; typical of this tendency was the set design for Act One of the original Munich production which consisted of a pavilion whose crimson draperies were drawn back to show the open deck of the ship (plate 6). In Draper's picture the foreground and background are divided in a similar way with the drapery being provided by the sweep of the sail. Most interesting of all is the way in which the carved animal's head that appeared on the stern on stage is featured here on the post to which the sail is lashed. The style established by Wagner and enshrined at Bayreuth dominated the production of his opera until Appia's designs for the 1903 Viennese production of *Tristan* conducted by Mahler, which introduced the use of atmospheric lighting effects in the place of a quasi-historical setting. However, photographs of English productions of 1910 and 1913 show the familiar Wagnerian accoutrements of chain mail, animal skins, and winged helmets still in place.

It is not only the setting but also the conception of the two principal figures which gives Draper's picture such a strong Wagnerian flavour. In English representations of the legend the figure of Isoud usually conforms to Victorian and Edwardian stereotypes of female beauty and character. George Frampton's bronze of Isoud's head, *La Beale Isoude* (plate 7), for instance, shows her as wistfully pretty with bent head and downcast eyes, modest and passive. In John Duncan's *Tristan and Isolde* (plate 8), 1912, Isoud has the prettiness of a fairy-tale princess and a

24. Oswald Georg Bauer, *Richard Wagner: The Stage Designs and the Productions from the Premieres to the Present* (New York: Rizzoli International Publications), p. 150.

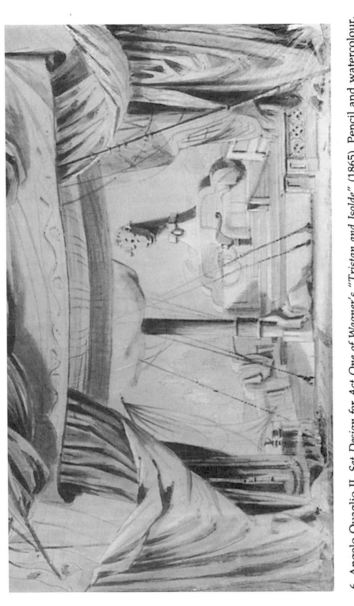

6. Angelo Quaglio II. *Set Design for Act One of Wagner's "Tristan and Isolde"* (1865). Pencil and watercolour. 29.1 × 41.7 cm. Photo courtesy of Theatre Museum, Munich.

7. George Frampton. *La Beale Isoude*. Bronze head. 29.2 cm. high. Photo courtesy of The Fine Art Society, London.

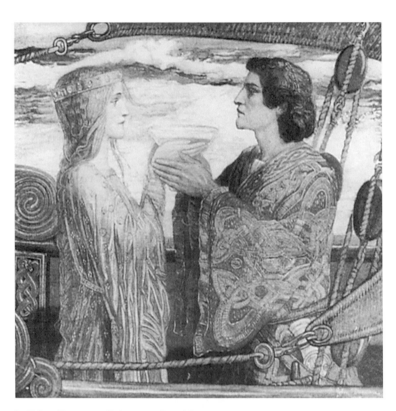

8. John Duncan. *Tristan and Isolde* (1912). Tempera on canvas. 76.6 × 76.6 cm. Photo courtesy of City Art Centre, Edinburgh.

childlike appearance which is remote from the powerful, passionate, and strong-willed woman of Wagner's conception. In the opera she is the dominant figure: it opens with her exposition of her situation and ends with the *Liebestod*. In his rendering of the episode of the drinking of the love potion, Wagner transformed his source, Gottfried von Strassburg's *Tristan*, in which, as in Malory, the potion is drunk by accident. Wagner's Isoud forces the love potion on Tristram in the belief that it is poison, which in a sense it is, for the love it brings can only be consummated in death. In Draper's picture she is placed above Tristram, and it is her ecstatic response which dominates the picture.

Many of the other artists who took the legend as a source also employed English-name spellings, and a smaller number used as well a quotation from Malory as their title. Nevertheless, there are still valid reasons for supposing that it was Wagner who was mostly responsible for the increase of artistic interest in the legend, although it would be a mistake to assume that artists were always firmly focused on one source. It is perfectly possible that artists were alerted to the visual possibilities of the legend through hearing or seeing Wagner's opera, or even through seeing the work of other artists who had been influenced by Wagner's treatment of the legend, but might then have looked for an English literary source on which to base a picture. This is particularly likely to be the case with British Arts and Crafts artists, whose concern for the vernacular led them to an interest in folklore and myth: the deepest origins of the Tristram legend are after all Celtic.

It is impossible to establish the extent to which Wagner was a catalyst in the re-emergence of myth as a central element in European culture and how far he is himself a product of the great late Romantic wave of revulsion against contemporary materialism and scientific rationalism. Morris also, in his passionate embracing of medieval myth and archetype, was engaged on a search for meaning and stability in a society that seemed to be disintegrating under the pressure of social, economic, even philosophical, change. The exaltation of the purely personal, in particular passionate mutual love, offered a means of escape from the complexities of contemporary life,

from the erosion of religious faith and political strife. It offered a
fixed point in a world of increasing chaos, as Matthew Arnold
suggests in the poignant conclusion to "Dover Beach," referring
to the world as only seeming to be a land of dreams. The image
of the dream, offering escape from the harshness of reality, is
common in nineteenth-century literature and reflects a sense of
impotence in dealing with the present. The young Morris, feeling
powerless to bring about change, wrote in a letter of 1856, "I
can't enter into politico-social subjects with any interest, for on
the whole I see that things are in a muddle, and I have no power
or vocation to set them right in ever so little a degree. My work is
the embodiment of dreams in one form or another" (Mackail, I,
107). Almost contemporaneously, in 1854, Wagner wrote of his
intention to compose *Tristan und Isolde*: "Since never in my life
have I tasted the real happiness of love, I intend to raise a
monument to that most beautiful of dreams in which from
beginning to end, that love shall be for once thoroughly satiated"
(Zuckerman, 33). That he succeeded cannot be doubted, and in
his success lies the explanation for the recurrence of the Tristram
legend in the late nineteenth and early twentieth centuries. As
the protagonist of Ford and Conrad's novel explains, Wagner
offers "a vision of a state of mind in which morality no longer
exists . . . a respite, a rest: an interval in which no standard of
conduct oppresses us. It is an idea of an appeal more universal
than any other in which the tired imagination of humanity takes
refuge" (*The Nature of a Crime*, 45–46).

Wagner's *Tristan und Isolde*: Opera as Symphonic Poem

Joseph Kerman

We come at last to Wagner, the man who arrogantly preempted to himself the very concept of opera, and wrote *Tristan und Isolde* and the *Ring* to stake his claim, and managed in doing so to shake the musical world into alignments that are still in evidence today.

Only fairly recently has it become possible to view the old redoubtable wizard with some impassivity and with some clarity. In our century Wagner has been the most problematic of the great composers: criticism has been stultified by the furious partisanship that first idolized him and then exorcised his spell. By now, however, the fervor of the original Wagnerians seems fairly remote, and the incantation of the anti-Wagnerians too seems less forceful and obligatory. Since Nietzsche and Debussy, many have set out to expose the chicanery, while many more have declared that the magic vision of Bayreuth has simply faded away. But as high feelings and self-interest abate, *Tristan und Isolde* remains; and Richard Wagner remains a name to conjure with.

Originally published as "Opera as Symphonic Poem," in Joseph Kerman, *Opera as Drama* (New York: Knopf, 1956); rev. ed. Berkeley and Los Angeles: University of California Press, 1988, pp. 158–77. Reprinted with permission from Knopf.

Following the lead of Bernard Shaw, Eric Bentley in *The Playwright as Thinker* set up Wagner and Ibsen at the poles of the nineteenth-century dramatic tradition which is our immediate heritage. In *The Idea of a Theater*, Francis Fergusson saw Wagner with Racine in a longer perspective—the "theater of passion" as against the "theater of reason." Thomas Mann had three major essays put together, not altogether fortuitously, as a book entitled *Freud, Goethe, Wagner*; and Mann's novel *Doktor Faustus* is still the most impressively Wagnerian work of our time. Jacques Barzun produced a study of *Darwin, Marx, Wagner*. With Wagner, more than with any other opera composer, the musician's insight is to be enriched with others; the *Gesamtkunstwerk* calls loudly for its *Gesamtkritik*.

The plain musician, accustomed to thinking along relatively direct evolutionary lines, would probably write on *Beethoven, Wagner, and Schoenberg*. When opera is in question, he has traditionally pitted Wagner against Verdi, and discoursed of Italian lyricism, German orchestral technique, leitmotivs, arias, and the like. But as far as the basic principles of operatic dramaturgy are concerned, it is actually more enlightening to consider Wagner in contrast with Debussy. Wagner and Debussy took the extreme opposite positions; this is true in spite of everything that Maeterlinck willingly and Debussy unwillingly learned from the formidable earlier master. Wagner tended towards the ideal of opera as symphonic poem, Debussy towards the ideal of opera as sung play, and although neither ideal was attained, the results were imposing and far-reaching. *Pelléas et Mélisande* is the more refined, self-conscious, constrained, freakish work; *Tristan und Isolde* is much the more radical, the more imaginative, and the more difficult to come to terms with. Both of these operas must be encompassed in order to understand the scope of the famous operatic "reform" of the nineteenth century.

As Bentley insisted, *Tristan und Isolde* is not a tragedy. Wagner never intended it to be. It is a religious drama. Antireligious, fascist, bogus, cry Wagner's enemies; but the form of the opera is that of religious drama nonetheless, however we may be inclined to value its message. Whether *Tristan und Isolde* is bogus or not depends only on its artistic truth or success, and

this depends on an appreciation of its dramatic intention (for Wagner intended a drama, not a philosophy, a self-justification, a demonstration of chromaticism, a consummation of romanticism, etc., etc.). Here I should like to follow a point made by Una Ellis-Fermor in her admirable and admirably lucid book *The Frontiers of Drama*:

> Milton, in his prefatory note to *Samson Agonistes*, made it clear that he regarded his play as a tragedy; but some modern readers do not find it precisely the kind of play that they have been accustomed to call tragedy, either ancient or modern. It ends with the death of Samson, and has a clear technical claim to inclusion in the category. But few of us, if thinking in terms of experience and not of names, are content to call Samson's triumphant death a tragic catastrophe. How could we, indeed, when 'nothing is here for tears'? We are accustomed to associate with tragedy a balance between conflicting moods, between the sense of pain, grief, or terror on the one hand and, on the other, something that triumphs and illuminates. But in Milton's play we find instead a progression towards triumph and illumination which gradually subdues the sense of pain, grief, and loss and at the end transcends and utterly destroys it. Here is clearly something other than the balance of tragedy. Milton oversets the balance in the direction of positive interpretation; by justifying the ways of God to man he leaves no room for tragic ecstasy and substitutes ecstasy of another kind. He has written, that is, a play that belongs to the rare category of religious drama, a kind which, by the nature of some of its basic assumptions, cannot be tragic.[1]

What is said here of *Samson Agonistes* applies very exactly, it seems to me, to *Tristan und Isolde*: the fundamental sense is of a progress towards a state of illumination which transcends yearning and pain. The fundamental rhythm of the piece is towards Tristan's conversion and the concluding "Liebestod" of Isolde—a triumphant ascent, not a tragic catastrophe. And *Tristan*, I believe, meets three other conditions that Miss Ellis-

1. Una Ellis-Fermor, *The Frontiers of Drama*, 3rd ed. (London: Methuen, 1946), p. 17.

Fermor would have wished to apply to religious drama. The nature of the experience is properly religious; the experience is the main matter of the drama; and the religious experience is actually, paradoxically, projected in a dramatic form.

That *Tristan und Isolde* is much more than a love story is only too evident. The extraordinary conception slowly and surely grips the audience: love is not merely an urgent force in life, but the compelling higher reality of our spiritual universe. The essential action of the opera is that the lovers are drawn more and more powerfully to perceive this reality and submit to it. In their vision of this reality, all the appurtenances of ordinary existence are sloughed off: subsidiary feelings, convention, personality, reason, and even life itself. If this is not to be called a religious experience, it is hard to know what meaning to attach to the term; and while it is certainly no Christian vision, it is one with some precedent in historical fact (or so we are told). Manifestly, too, this experience permeates and controls the drama with the greatest rigor. Francis Fergusson reformulated the facts with a breadth of view and a dispassionate clarity unusual in Wagner criticism. The central "action," "to obey Passion as the one reality," subdues plot, setting, diction, imagery, dramatic rhythm, and, I am sure he would add, the music.[2] This was the inexorable art that Maeterlinck and Debussy learned from Wagner. "Passion itself is taken as the paradoxical clue to human life transformed; to the true nocturnal scene of our existence; and to the 'absolute and despotic' form of the work itself" (p. 73).

Is Wagner's "absolute and despotic form" actually a *dramatic* form? This question is crucial, because the genuineness of Wagner's vision is not expressed by his intention, or by the pervasiveness or primacy of the vision in his piece, but by the success of the work of art in the particular form chosen. As everybody knows, fashionable opera-goers deplore *Tristan und Isolde* as the most undramatic thing in the world, just as many readers deplore *Samson Agonistes*. But dramatic criticism enters no such complaint. Fergusson, if anything, takes the dramatic

2. Francis Fergusson, *The Idea of Theater* (Princeton: Princeton University Press, 1949), p. 78.

efficacy of *Tristan* a little too much for granted, and does not bring out what I take to be the strongest point in the dramatic articulation.

This is Wagner's presentation of the decisive progress in Tristan and Isolde. Miss Ellis-Fermor very truly observes that a relevant dramatic treatment of a religious experience is bound to involve progress into that experience. Religious drama, that is, centers about the act of conversion. So it is with *Tristan und Isolde*: the last act, which is the greatest in every way, is concerned specifically with the conversion of Tristan in a long scene known as the "Delirium," and with a reflection of this conversion in Isolde's "Liebestod." The preliminaries are long, sometimes undramatic and tedious, but every one of them falls into place with this incandescent climax in view. Needless to say, it is music that defines the conversion in *Tristan und Isolde*, and gives the sense of truth to the ultimate mystic vision.

2

The dramatic structure of *Tristan und Isolde* shows hard lines of development superimposed upon elaborate symmetries. Each of the three acts is rather simply arranged to head toward one single active element of the myth as interpreted by Wagner: the drinking of the love-potion on the ship to Cornwall, the wounding of Tristan after the discovery of the lovers' tryst, and the death of Tristan in Isolde's arms. The limitation of action in each act is striking, ingenious, and very appropriate to Wagner's essentially psychological drama; and quite unlike the practice of Eugène Scribe, though some details of construction do betray Wagner's admiration for that notorious craftsman. Other symmetries may be pointed out. For example, each act opens impressively with some music actually heard on stage: the nostalgic song of the Sailor, the hunting-horns of Mark and Melot, and the Shepherd's piping in Kareol. These musical ideas are all symbolic, and permeate the beginnings of the acts in question—most profoundly in the case of the Shepherd's *alte Weise* of Act III. At the same time, the opera is planned to increase the concentration on Tristan, act by act. Act I is mainly

about Isolde, with her long expository "Narration," but the final deed, the drinking of the love-potion, involves both lovers equally. They share the stage in Act II, but here the final deed is the wounding of Tristan. Act III is centrally concerned with him. Isolde does not enter until he is ready to die, and her "Liebestod," an amplifying reflection of his more active conversion, completes the cycle by quietly returning the interest to her.

The three deeds that form the climaxes of the three acts are also highly symbolic in Wagner's scheme. In Act I, as is generally recognized, the drinking of the love-potion is a device to dramatize the love of Tristan and Isolde, or more exactly, their final confession of it. Wagner changed the myth with some care to indicate that this all-dominant love had smoldered long before the shipboard explosion. (Later, at the climax of the "Delirium" scene in Act III, Tristan makes things very clear: "Den furchtbaren Trank! ich selbst, ich hab' ihn gebrau't!") Wagner changed the myth again in connection with the wounding of Tristan in Act II: it is not so much Melot who stabs Tristan, as Tristan who tries to kill himself on Melot's sword. Like Samson and Othello and Orpheus, Tristan has his time of weakness, and Act II leaves him in a crisis of despair; "day" is triumphant. Act I showed the lovers struggling to deny their love; the love-potion at the end symbolizes their inability or refusal to do so. Act II shows their attempt to realize their love in this world, the world of Melot and King Mark, of friendships, marriages, conventional loyalties, and sex. Tristan's wounding, by the thrust of Mark as well as by the thrust of Melot, symbolizes his abandonment of self under the shock of frustration and inner conflict. This is the price for his total involvement, paid with Tristan's characteristic passion.

However it is only at the start of Act III that the nature of the wound is properly revealed. The curtain rises on the bleak, sun-baked, ruined castle by the sea, Kareol; the wonderfully oppressive opening music on the strings gives way to the solo *cor anglais* of the Shepherd's strain, which hangs on the heavy air like lead. Tristan, brought home wounded by his faithful Kurvenal, has been languishing here in a coma. After the disingenuous Shepherd has promised to signal the arrival of

Isolde's ship by means of a lustier tune, Tristan wakes for the
first time, his mind practically a blank. To Kurvenal's joyful
exclamations and explanations he can only bring pathetic broken
phrases, which nevertheless show in the music a profundity that
Kurvenal does not grasp. His first speech of any length is
scarcely more coherent; the verse is almost formless, and the
music, with its unusual *absence* of passion, flow, cadence,
leitmotiv, or musical idea of any sort, corresponds perfectly to
Tristan's halting memory.

> Wo ich erwacht,
> weilt' ich nicht;
> doch wo ich weilte,
> das kann ich dir nicht sagen.
> Die Sonne sah ich nicht,
> nicht sah ich Land noch Leute:
> doch was ich sah,
> das kann ich dir nicht sagen.
> Ich war—
> wo ich von je gewesen
> wohin auf je ich gehe:
> im weiten Reich
> der Weltennacht.
> Nur ein Wissen
> dort uns eigen:
> göttlich ew'ges
> Urvergessen . . .

> Where I awoke
> there did I not stay;
> but where I stayed—
> yet that I cannot tell.
> The sun I did not see,
> nor land, nor people;
> but what I saw—
> yet that I cannot tell.
> I dwelt—
> where I have been from eternity,
> where I shall ever go:
> the boundless realm
> of worldwide Night.
> One thought alone
> belongs us there:

blessed everlasting
fathomless oblivion . . .

Tristan has wanted to escape; he has willed forgetfulness. The wound of Melot symbolizes what we would call a complete nervous breakdown, with suicidal impulses and amnesia, brought about by the collapse of Tristan's values in Act II. It is perhaps only now that our full interest and sympathy swing dramatically to him.

It is tempting to substitute a Freudian mythology here for the one offered by Wagner. The long "Delirium" scene is a record of the man pulling himself back together, dredging through his past life and feelings to reach a new synthesis. The process, which I have called Tristan's conversion, is the greatest dramatic feat in the opera, and, I would be inclined to say, in all of Wagner's works. Dramatic, even though no external agents are involved, and the more heroic exactly on that account. If the audience can only feel with Tristan, they will ask for no more explosive struggle, no greater agony, and no finer victory, than in his hour of darkness here. Certainly it could not have been matched in some set of violent thoughtless actions, such as Wagner might have salvaged from medieval saga material. And music, crucially, brings the audience to feel with Tristan.

His progress is organized into a large symmetrical double cycle—a typically Wagnerian pattern. After recalling his urge to oblivion, Tristan painfully wrenches back to memory one grief after another from the past. Leitmotivs reflect them; Wagner's leitmotiv technique never fell in with a dramatic situation more naturally and powerfully, or with such delicate psychological justness. At the start things are necessarily still vague for Tristan. Clarity grows only later. He remembers first his dreadful yearning, and in remembering of course feels it through again, and resents it bitterly, and with one part of his spirit wishes still for the oblivion ("night") that another part has rejected. His yearning seems the one reality to be found in life ("day"); he remembers no events yet, only this torturing complex of feeling—day, life, yearning, pain. As he summons up a great curse on them all, his surge of emotion is handled in a protracted musical *crescendo* of the kind that Wagner made peculiarly his own. After the curse on "day," Tristan sinks back exhausted, but

also relieved and lightened. When Kurvenal tells him that Isolde has been summoned, he comes to life in another surging ecstasy of anticipation. But the ship is not yet there; Tristan is not yet ready. With a huge deceptive cadence characteristic of Wagner, and especially of this opera, the excitement yields pathetically to the sound of the Shepherd's piping, which we know to be a sign of a still empty sea. "Noch ist kein Schiff zu seh'n."

This then is the first cycle: *recollection—curse—relapse—anticipation.* It is now paralleled by another cycle which is on the same plan, but in every way more profound than the first, and which will indeed bring Tristan to Isolde. Up to now the introspection (*recollection*) has been in general terms; Tristan recaptures only the surface of his feelings. Such purgation (*curse*) as he accomplishes leaves him more or less as he was at the end of Act II: rejection of life, suicide, even abandonment of love. Yet this has been an essential and enormously arduous journey from willed amnesia to re-acceptance of the initial agony. This time Tristan can go on, and in the second cycle he will find his journey's meaning.

The Shepherd's piping, *die alte Weise*, had wakened Tristan for his first struggle; now it is heard again to begin the new cycle. This time Tristan's eyes are clear. He can penetrate into the events of his past and seek their significance, not only those that we already know from the opera, but also events from his childhood and even before, symbolized by the rich gloomy strain of the Shepherd, playing as he played when Tristan's mother and father died. By a fine inspiration, Wagner kept *die alte Weise* sounding all through this passage of introspection, combined with the other motives and woven into the musical texture. Thus Tristan sees everything now in the light of what we would classify as his traumatic past, or, as he says, the fate that has always governed his existence. This is a deeper motivation than "day"; the callow curse on day has yielded to an older memory, and a more thorough understanding. One by one the events related in Act I (all musically recalled by their motives) come back to Tristan, guiding his memory at last to the fatal love-potion. Suddenly there is a flood of revelation—that fearful drink: he himself was the one responsible, not day, not Isolde, but his fate, he himself. The music reaches its climax in a new

motive, the most powerful and agonized of this whole intense score (Example 1). "I myself, it was I that brewed it!"—and the curse, the purgation, of his own guilt.

Example 1

Just as this passage of *recollection—curse* is in every way deeper and more decisive than the earlier one—searching deeper into the soul, shifting responsibilities, seeing anew—so the subsequent *relapse* is more serious. Kurvenal thinks that Tristan is dead, and the orchestra plays a sweetly attenuated version of the famous "love-death" music which had opened the opera, and which soon is to accompany Tristan's actual dying. Tristan, however, now recovers, and the crowning episode that follows is without a precedent in the earlier cycle. The miracle, this time, has been accomplished: Tristan achieves a new integrity, a state of felicity, in which he can invoke Isolde with a purity apart from or above yearning, without undertones of day or anxiety or passion or curse. One's feeling of course is determined by the music; it is one of the great moments in the opera (Example 2).

This represents an incredible intensity of consciousness for one who an hour before abandoned being. The parallel step of *anticipation* for the ship bearing Isolde is more violent than before, and this time not to be frustrated. The Shepherd pipes his new tune, the miserable quality of which may perhaps be

Example 2

excused by the tremendous frenzied drive that masks it.[3] As Isolde enters and Tristan dies, the whole complex of themes of love and death sounds loudly in the orchestra—a complex stated strongly in the Prelude, and heard at many important junctures of the action. Paradoxically, the notorious shifting chromaticism acts here as a resolution to the excruciating prior surge. Tristan finds in death no longer oblivion, but triumph. The "Delirium" has been for him a novitiate, a great preparation.

The beatitude for which he prepared is left to Isolde. In Wagner's regular scheme, it is man who suffers and draws himself to the point of revelation, but woman whose sublime intuition complements life's struggle and expresses its meaning. This may be biologically questionable, but in this opera, at least,

3. For this passage, Wagner coolly suggested that a special alphorn-type instrument be constructed. It would not help.

it is dramatically ingenious and just. Isolde's concluding "Liebestod" achieves the intense, ecstatic concentration on and identification with the ultimate reality of Passion, sharing Tristan's experience from a more inspired standpoint. Impossible for a woman just to expire in these circumstances, say critics who have swallowed the love-potion only with difficulty. But like the love-potion and the wound of Tristan, Isolde's death is another grandiose symbol: of the final mystic ascent, evaporating into a supreme nothingness, partaking of the divine, unworldly essence of Love.

3

Wagner's highly individual musical style, and only that style, made possible the dramatic achievement of *Tristan und Isolde*. In what does the Wagnerian reform consist? This is the most famous question in modern operatic criticism, and in approaching it, one has to take a solemn warning from the mass of generalization and aggressive plain statement that the question has promoted. I shall stress two points only: first a historical one, relating to a view of opera that has been implicit to this study, and then a specific one, concerning the scene of Tristan's "Delirium."

Musical form in opera, the essential articulating element of the drama, is always best understood as a reflection of, or as the original image of, musical form as it exists generally at the time in question. When opera was first created, Monteverdi gathered elements of operatic style from various musical genres of that vigorous, confused, transitional period. The orderly baroque plan of Metastasian aria and recitative finds expression also in the instrumental music of the time. Mozart's operatic technique parallels his symphonic style. In a similar way, the Wagnerian operatic continuity adopts, defines, or consummates the characteristic formal ideal of romantic music.

I write "the ideal" deliberately, for today we have serious doubts as to its attainment; it was characteristic enough of romanticism to strive towards the unattainable. The romantic ideal was of a grandiose organic unity according to the

principles of the symphonic style. Beethoven took the first steps by gradually welding the movements of the symphony into a psychological whole lasting thirty or fifty minutes. I have related this symphonic unification to the unification of the operatic ensemble, the finale, and the composite aria. The sense of continuity in the last finale of *Fidelio*, with its several interlinked sections, is analogous to that of the sectional *Egmont* Overture; and ultimately to that of the Quartet in C# minor, whose seven movements flow into one another without a pause, sustaining the progress with an unparalleled certainty and beauty.

Wagner, who deserves credit for "discovering" this quartet, must have noted with great satisfaction that one theme in the last movement is very similar to the fugue subject of the first movement. Such thematic relationships are exceptional in Beethoven, but as his principles of musical organization were superseded or else simply misunderstood, composers sought more and more to achieve the large-scale, organic whole by means of long-range thematic connections of one kind or another. Berlioz's program symphony presents a series of movements held together (he hoped) by the use of an emphatic tune which suffers transformations as the work proceeds. Significantly, such tunes were given specific symbolic meanings. Soon themes were multiplied and shortened, the musical flow eased, and more intellectual techniques developed, in the symphonic poem of Liszt, the cyclic symphony of César Franck and others, and the frankly Wagnerian tone poem of Richard Strauss.

Opera had to share in this ideal. As it happened, opera spurred it on as Berlioz and Liszt never could. Wagner carried the organic ideal to a monstrous climax: a single, pulsing, theme-ridden ostensible continuity over four hours—over four evenings, even. Once opera in the nineteenth century had interested an *avant-garde* German composer like Wagner, it was bound to become strongly symphonic; for the motivic texture of the symphony (characteristically the texture of the first-movement development section) dominated musical thought in Wagner's time as melody did in the time of Handel, and declamation in the time of Monteverdi.

Beyond this point, however, it is dangerous to make extreme statements about the Wagnerian musical continuity. Wagner was a big talker, but as an artist he was practical and opportunistic, a fact that his critics do not always keep firmly enough in mind. Some have enthusiastically claimed Wagner's operas as supreme, purely musical, organic unities. Alfred Lorenz so analyzed seven of them, with the aid of fantastic special pleading, and at a length dreadful to contemplate; his work is all the more infuriating as a *reductio ad absurdum* of certain valid insights. Donald Tovey, too, no fanatic, insisted that *Tristan und Isolde* is hugely organized on the same principles as a Beethoven symphony; but nowhere in his writings does he ever come to grips with this important concept. I would insist that "opera as symphonic poem" is no more viable dramatically than "opera as sung play." Opera must be regarded not as a purely musical form, but as a dramatic one in which music has an articulating function. The grief that Wagner causes many listeners is caused, or at least amplified, by a feeling that in being "symphonic" Wagner sets up purely musical conditions which then indeed he does not fill. But Mozart's operas are not coherent in the same way as his symphonies, though they reflect the same aesthetic preoccupations; Wagner did not write symphonic poems, though his operas tended in that direction. It has been said that *Tristan und Isolde* could make its point without the stage and without the singers. This is no more true of *Tristan* than of *Don Giovanni*.

On the other hand, critics in the opposite camp are equally wrong to claim that Wagner's continuity is altogether formless, amoebal, inarticulated. When Nietzsche complains of unending melody, one wonders whether his early love for Wagner was ever based on any properly musical understanding at all. A hundred years later there is little excuse for such deafness; Wagner's mastery of musical shape in *Tristan und Isolde* is a matter of fact, not opinion. One understands Wagner no better with a weak musical ear than with a head predisposed to theories of organic perfection.

As purely musical forms, Wagner's operas succeed as well as any romantic symphonic poems of their length might be expected to succeed; which is to say, not too well. The program

symphony and the symphonic poem never achieved the kind of unity to which they seem to have aspired. Like Berlioz's symphonies, Wagner's operas break down into passages of great eloquence and power, loosely bound together. Long-range connective effects, of detail and of larger intent, are sometimes poetic and impressive, sometimes mechanical and esoteric; but Wagner never failed to use the loose binding available in his technique as a forceful instrument of mood, and as with Debussy, this binding in itself is of great dramatic value. As for the coherence of the whole, that is determined by action as well as music. *Tristan und Isolde*, like a Liszt symphonic poem, includes musically dull passages such as neither Beethoven nor Brahms (nor Verdi in the late years, I might add) would willingly tolerate. The wonder is that there are so few, over the four hours. For the rest, there are passages that do, emphatically, succeed; not arias, as in Verdi, but passages of a symphonic, developmental nature. And more rigorously symphonic, of course, than such examples as may be found in *Otello* and *Falstaff*.

The point to be made about the "Delirium" scene in relation to the Wagnerian reform is this: not only is the scene one that emphatically succeeds, but as it is the climax of the opera, its success determines the success of the work as a whole. A good deal of Act I of *Tristan und Isolde* is rather on the blatant side; Act II includes, before and after the superb love duet, the monotonous conversation between the lovers and then the plaint of King Mark. But Act III is practically perfect, and the "Delirium" scene is one of the great long sustained passages in Wagner. It can be shown to relate to every other section of the opera, though with varying degrees of relevance. Considered simply in itself, the "Delirium" scene offers the most convincing evidence of the dramatic vitality of all of Wagner's dramaturgical techniques.

First and foremost, the idea of the leitmotiv is particularly well realized here. With Debussy, as we have seen, a fastidious use of leitmotivs contributes to the general atmospheric texture in a subsidiary way. With Wagner, leitmotiv technique is central, far from reticent, and, from *Tristan und Isolde* on, highly involved.

The constructive and symbolic aspects of the leitmotiv are worth distinguishing, though of course both aspects work together (even in Debussy). Short suggestive motives are the necessary material from which Wagner constructs his dense symphonic web. They are always present, always busy, recombined, reorchestrated, reharmonized, rephrased, developed. Now such symphonic writing, from Haydn to Schoenberg, has flirted with one main danger: in trying to make much out of slender material, music comes to a delicate point at which suddenly there is a feeling of effect without cause. Material can be pushed too far. Wagner was especially prone to this kind of bathos on account of the arrogant length to which he pursued the technique, and on account of certain undeniable blindnesses. In *Tristan und Isolde* an added danger came from the family likeness of all the music within the lovers' sphere; it was fatally easy to produce an overall impression of gum. On the other hand, much could be gained through the "organic" effect, to the extent that it could be carried off, and the composer could slip readily from one theme into the next, during a long developmental passage, without sounding arbitrary or forced.

The subtle introduction of the new theme of "Tristan's Guilt" (quoted on page 362) shows Wagner's manipulation of these conditions at its best. The motive is similar to all the others; when it finally appears, it carries a sense of consummation and inevitability, as well as the force of a revelation. Compare a famous earlier instance: the self-conscious, cryptic introduction of the new theme of "The Sword" (the C-major trumpet arpeggio) at the end of *Das Rheingold*. Another inspired stroke is the development of fragments of *die alte Weise* throughout the second, more serious cycle in Tristan's "Delirium." It is wonderfully suggestive, first of all, that so many pregnant motives grow out of what was originally a fairly coherent tune. With the greatest skill Wagner combined them contrapuntally with all the prior themes, which are thus modified or colored with unsuspected richness.

This thematic pervasiveness has a fine symbolic value, too: under the spell of the Shepherd's ancestral strain, Tristan's renewed soul-searching takes on a deeper and more intense reality. Themes associated with every step of his spiritual

journey return and order themselves in combination with the
mournful tune of Tristan's past. The symbolic use of leitmotivs,
more generally recognized than the constructive use, is also
more obviously precarious in its effect. The correspondence of
musical symbol and its object easily becomes absurd, especially
when the themes are as forthright as usual in Wagner; the
"Sword" motive in the *Ring* is an obvious example, if perhaps an
attractively naïve one. As Erik Satie is said to have warned
Debussy, the stage-trees do not shudder or grimace whenever a
character walks on. But Wagner had revealed dramatic
possibilities in the leitmotiv technique that Debussy could not
ignore. The virtue of the technique depends, as always, on the
composer's sensitivity to the individual context.

Leitmotiv symbolism in *Pelléas et Mélisande* is extremely
elegant and restrained; in the *Ring*, often reckless; in Tristan's
"Delirium," whole-hearted but imaginative and just, and
dramatically central. As Tristan feverishly struggles to put his
mind and memory in order, vague impressions out of the past
struggle in his consciousness. To Tristan, each one of them is at
the moment vital, terribly real, tangible, loud. Images combine
and recombine musically—feelings associated with ideas, rather
than clear concepts, such as the burghers in *Die Meistersinger* are
represented as entertaining. To such feelings, as forceful and yet
as indefinite as Tristan's raving words, the flux of always-related
musical fragments is ideally suited.

Two other notorious Wagnerian techniques are especially
well handled in the "Delirium" scene (and by "well" I mean, as
always, dramatically well). The first is the long passage of plot
résumé, during which some major character relates the course of
previous action, with the liberal assistance of leitmotivs. Most
opera-goers suffer plot résumé for the purpose of initial
exposition (Isolde's long "Narration" in Act I), barely tolerate it
in the *Ring* (they may not have been there the previous evening),
but object strongly when Wagner reviews in leisurely fashion
action that they have actually just seen on the stage. This he does
often enough—and what aware listener has not quailed at the
beginning of Act III when that disingenuous Shepherd asks
Kurvenal to explain Tristan's illness? But the principle behind
such résumés is a genuinely dramatic one: to reinterpret past

action in a new synthesis, determined by fresh experience. In Act
II, for instance, the lovers review their early acquaintance with
some dramatic force from quite a different standpoint than in
Act I. Never has such a reinterpretation been more necessary
than in the case of Tristan's conversion; the whole dramatic point
of the opera depends on Tristan seeing his prior experience in a
new mystic light. The newness of *die alte Weise* is of prime
importance here.

The second matter is the firm and beautiful double
construction of the scene. This was the feature that especially
fascinated Lorenz; but Lorenz refused to see that the relevance of
such structures depends sharply on the strength of their
articulation. In the "Delirium" scene the musical parallelism is
manifest thanks to the striking *alte Weise* placed at the start of
each cycle. The dramatic structure is parallel too: in each cycle,
quiet recollection growing in hysteria to a curse, then a relapse,
then ecstatic anticipation. The second cycle is in every way more
profound than the first, and includes the crowning episode of
beatitude, and reaches resolution. One can only admire that iron
sense of form by which Wagner could sometimes span the great
arcs of time that he dared to encompass.

The most emphatic formal pillar in *Tristan und Isolde* is the
concluding passage, Isolde's so-called "Liebestod"; Tovey liked
to make this point. The last eighty-odd bars of the score are
rather closely repeated from the height of the love-duet in Act II,
with new words, of course, and a new musical counterpoint of
secondary interest for Isolde. But missing now is the rending
deceptive cadence at the end of the love-duet, when Brangaene's
scream greets the arrival of Mark and Melot to interrupt the
lovers' passion; missing indeed is the whole sense of frenzy and
yearning, the sexual excitement which has excited many critics.
The mistaken effort to capture love in the terms of the "day" of
this world is now transfigured, *verklärt*, into the consuming,
serene mystic acceptance, the union in death. At last the
continual surging, shifting, renewing, interrupting, and aspiring
ceases, and the long-avoided cadence comes with unparalleled
weight in B major. In fact Wagner's regular and exasperating
cliché, the evasion of solid harmonic settling, finds its true
symbolic place in *Tristan und Isolde*, the drama of the agony of

yearning and its transformation. The final resolution is superb; the constructive force of the great recapitulation goes to define Wagner's ultimate meaning.

From the purely musical point of view, the effect of the "Liebestod"—Wagner called it "Verklärung"—is unlike any effect obtainable by the use of leitmotivs. It is more like the recapitulation of a Beethoven symphony movement, or (to get closer) like the reappearance of the first-movement theme in the final pages of the César Franck Symphony in D minor. It is more like the return of the music for the kiss at the end of *Otello*—a grand climactic repetition summing up the drama in a single gesture, rather than a momentary detail, however striking. Verdi had no sympathy for the patient funding of the leitmotiv technique. But Wagner's recapitulatory summation in itself constitutes no proof that *Tristan und Isolde* makes a stern, symphonic, Beethovenian, purely musical unity. This is no more true of *Tristan* than of *Otello* or the César Franck symphony (*pace* Tovey). Unlike Franck, Wagner was free of any such abstract formal commitment.

<center>4</center>

Of all Wagner's works, *Tristan und Isolde* has always seemed to me (since I came to know them all) the best, the clearest in form and idea, and the most complete in realization. *Tristan* deserves its general reputation as the most quintessentially Wagnerian of operas. In many ways, admittedly, it can be seen to be technically inferior to his masterful later compositions. From the point of view of dramaturgy, the virtuoso exercise in well-madeness is *Die Meistersinger*, while *Parsifal*, on the other hand, realizes that purity of structure to which *Tristan* tends, admitting nothing so crude as the gratuitous disposing of Mark, Melot, Kurvenal, and Brangaene at the end of Act III. *Tristan* is the most thoroughly "symphonic" of Wagner's operas; but compared with the ripe texture of *Parsifal*, much of the music can appear insensitive, even gauche. It is not only the boisterous crew of Act I that makes one think of *The Flying Dutchman*.

But *Tristan*—four hours of unresolved chromaticism or no—has the terrible, grasping conviction of *The Flying Dutchman*, too. And final conviction is what the later operas somehow lack, for whatever reasons. The great thing about *Tristan und Isolde* is that Wagner forced himself to center his drama in the soul of his hero, and contrived to bring everything to a head in the "Delirium" scene and in its reflection, Isolde's "Liebestod." These scenes equal anything in his later operas or in anyone else's for dramatic force; the music works best when it is most needed. Defining Wagner's unequivocal, intense mystic view, the conversion of Tristan and the symbolic death of Isolde draw everything in the drama to a consummation. Only the fury of Wagner's vision enabled him to justify his verbosity, defeat sentimentality, and subdue a tremendous wealth of detail to the central dramatic idea.

Of the religious experience and dramatic form, Miss Ellis-Fermor writes: ". . . the only type of conflict that this subject can offer for the use of drama is that of a heroic contest rising to exultation and passing on, in a few rare cases, into beatitude. This is the only point at which this content and this form can be reconciled, and it is at this point that, in all genuine religious drama, the reconciliation has been made. Are we now on the way to understand why the drama of religious experience is rare at all times and why the great plays of this kind can be counted almost upon the fingers of one hand?" (pp. 23–24). *Tristan und Isolde* too, I suggest, "achieves what is apparently impossible, pushing forward the limits of drama into territory which, by the very nature of its mood, dimensions or form, seemed forbidden to it."

Wagner and Decadence

Raymond Furness

"Wagner est une névrose"

<div align="right">Nietzsche, 1888</div>

"Renoir's portrait, painted in Palermo in 1882, shows the face decomposed and drained of colour, the eyes rheumy and lips pursed in sickly connoisseurship of sensation; the head is surrounded by an impressionistic blizzard of streaks and daubs, threatening a dissolution of form . . . It is not Wotan's head, but Alberich's, feverish, obsessive and expiring."[1] The portrait is that of Richard Wagner who, two days before the sitting, on 13 January 1882, had finished the score of *Parsifal*. It is this work above all, with its highly questionable fusion of Christian mysticism and blatant sexuality, its holy grail and gaping wound, its imagery of spear and chalice, its incense, castration, flower-maidens and cult of blood, which led Nietzsche to damn Richard Wagner as "decadent," as "une névrose." Far from representing a break with his previous *œuvre*, Wagner's last work may be seen as a continuation of themes, frequently morbid, which are found as early as *Tannhäuser*. The sultry

Reprinted with permission from Raymond Furness, *Wagner and Literature* (New York: St. Martin's Press, 1982), pp. 31–68.

1. Peter Conrad, "Unmasking the Master," in *Times Literary Supplement*, 23 July 1976. Wagner himself, when he saw the portrait, preferred to liken himself to the embryo of an angel, or else a swallowed oyster (see Cosima Wagner *Tagebücher* II, p. 873).

religiosity of *Parsifal*, the death-intoxicated eroticism of *Tristan und Isolde* and the glorification of incest in *Die Walküre* could not fail to enrapture and appal, and it is those "decadent" aspects of Wagner's work, and their literary manifestations, which this chapter will attempt to discuss. In vain might Max Nordau in his sensational castigation of degeneracy reject Wagner's music as immoral and harmful to the senses, and denounce the composer as a purveyor of sadistic delights, going so far as to claim that he might well have been a sex-murderer had he not been able to sublimate his erotic urges:[2] the Master of Bayreuth remained the paradigm, the godly dispenser of ultimate *frissons*, the magus who had created his own temple of art, and the supreme fount of unheard-of emotional excesses. Refinement and intoxication, voluptuous yearning and headiness, a world "in love with both death and beauty"[3]—Thomas Mann thus described the cluster of associations that Richard Wagner's name brought forth, seeing in that artist the most perfect example of European *fin de siècle*. Wagner and Poe: an unusual juxtaposition, but one which Thomas Mann suggested with sensitivity and acumen—the name of Baudelaire immediately asserts itself here, one of the earliest and most perceptive writers on Wagner. It is with Baudelaire and *Tannhäuser* that this chapter will begin, for it is this work, together with *Tristan und Isolde* and *Parsifal*, which would fire the imagination of a whole generation of *poètes maudits*.

On 25 January 1860 Wagner conducted the first of his three Paris concerts, giving excerpts from *Tannhäuser*, *Lohengrin*, the

2. Max Nordau, *Entartung*, Berlin, 1892, I, p. 324. Nordau also denounced the manifestations of French symbolism as "symptoms of imbecility" (*op. cit.*, p. 198), and claimed that Verlaine was a frightful degenerate with an asymmetrical skull and mongoloid features (*op. cit.*, p. 200); he also drew attention to Mallarmé's ear, claiming that its shape was frequently found amongst criminals and lunatics (*op. cit.*, p. 204).

3. Thomas Mann, *Gesammelte Werke*, Frankfurt, 1960, IX, p. 424: "Eine farbige und phantastische, tod- und schönheitsliebende Welt abendländischer Hoch-und Spätromantik tut sich auf bei seinem Namen, eine Welt des Pessimismus, der Kennerschaft seltener Rauschgifte und eine Überfeinerung der Sinne . . . In diese Welt ist Richard Wagner hineinzusehen . . ."

overture to *Der fliegende Holländer* and the prelude to *Tristan und Isolde*; he repeated the concerts on 1 and 8 February and gathered a circle of admirers around him, including, among others, Saint-Saëns, Charles Gounod, Gustave Doré and Catulle Mendès. These would form, in 1861, the nucleus of the *Revue fantaisiste*, with its ardent championship of Wagner, but also, more importantly, would prepare the way for the idolatry of the *Revue Wagnérienne*. After the concerts, on 17 February, Baudelaire wrote an enthusiastic letter to Wagner explaining that "I owe you the greatest musical joy that I have ever experienced," and, further, "It seemed that I myself had written this music."[4] The poet of *Les Fleurs du mal* sensed that here in Wagner was an artist capable of overwhelming, indeed overpowering his audience: the poem "La musique" with its line "La musique souvent me prend comme une mer!" seemed to describe perfectly that forceful ravishing. Listening to *Der fliegende Holländer*, Baudelaire experienced Wagner's music as an infinite, tempestuous art, submerging and ecstatic. Erotic associations are undeniable here and, writing about the Grand March from *Tannhäuser* and the Wedding March from *Lohengrin*, Baudelaire continued to equate that music with voluptuousness and sensual abandonment: "I often experienced a bizarre sensation, namely a feeling of pride and joy at knowing, and feeling, myself ravished and flooded—a truly sensual voluptuousness was experienced which resembled flying, or tossing in the sea . . ."[5] The poet felt that he was raped by this music, that he was hovering, or floundering in deep waters: only a total surrender was possible. He gave no address to his letter, but Wagner knew how to seek him out, and invited him to his Wednesday evening soirées; it was Baudelaire who,

4. Charles Baudelaire: see *Richard Wagner: Vues sur la France*, Paris, 1943, 71–2: "Je vous dois *la plus grande jouissance musicale que j'aie jamais éprouvée* . . . il me semblait que cette musique était *la mienne*." (I have used this edition because it is a most useful anthology of comments by French writers on Wagner.)

5. Baudelaire, *op. cit.*, p. 72: "J'ai éprouvé souvent un sentiment d'une nature assez bizarre, c'est l'orgueil et la jouissance de comprendre, de me sentir pénétrer, envahir, volupté vraiment sensuelle, et qui ressemble à celle de monter dans l'air, ou de rouler sur la mer."

one year later, leapt to Wagner's defence after the scandalous
uproar surrounding the performances of *Tannhäuser* on 13, 18
and 25 March in the Opéra.

The essay *Richard Wagner et Tannhäuser à Paris* (1861) is
indispensable in any attempt to recapture the thrill, the
exhilaration and the full force of the Wagnerian explosion. The
Paris version of the overture, with the rapturous bacchanal, was
felt to reproduce the moans and cries, the yearnings and
ecstasies of passionate abandonment: "Languidness and febrile
delights, delights fraught with anguish, incessant twists and
turns towards that voluptuousness which promises to slake, but
which never extinguishes, thirst; furious palpitations of the heart
and the senses, imperious demands of the flesh—the complete
onomatopoeic dictionary of love is heard here."[6] The whole
"onomatopoeic dictionary of love," as well as a desire for
religious salvation, Baudelaire writes, are strangely fused in this
music; even more fascinating and disturbing is the proximity of
savagery and sexual love, the almost inevitable juxtaposition of
the delights of the flesh and the delights of crime: "The diabolical
titillations of an ill-defined love are soon succeeded by
allurements, by vertigo, cries of triumph, moans of gratitude,
and then by ferocious howls, by the victim's reproaches and the
blasphemous hosannas of the sacrificers; it would seem as if
barbarism would always take its place in the drama of love and
that carnal joy would, by its satanic and inevitable logic, lead to
the delights of crime . . ."[7] The sadism which Baudelaire
observed in the transports of love and which he felt that

6. Baudelaire, *op. cit.*, p. 89: "Langueurs, délices mêlées de fièvre
et coupées d'angoisses, retours incessants vers une volupté qui promet
d'éteindre, mais n'éteint jamais la soif; palpitations furieuses du coeur et
des sens, ordres impérieux de la chair, tout le dictionnaire des
onomatopées de l'amour se fait entendre ici . . ."

7. Baudelaire, *op. cit.*, p. 89: "Aux titillations sataniques d'un
vague amour succèdent bientôt des entraînements, des éblouissements,
des cris de victoire, des gémissements de gratitude, et puis des
hurlements de férocité, des reproches de victimes et des hosanna impies
de sacrificateurs, comme si la barbarie devait toujours prendre sa place
dans le drame de l'amour, et la jouissance charnelle conduire, par une
logique satanique inéluctable, aux délices du crime . . ."

Wagner's music so well portrayed, as well as the prurient dallying with thoughts of religious salvation during sexual abandonment would, some twenty years later, excite the generation of the "decadents"; those esoteric worlds which the symbolists had explored will give way to realms both bizarre and perverse where Wagner would reign as hierophant and magus.

It was Baudelaire who determined the reception of Wagner in France: Gérard de Nerval had written on *Lohengrin* (the Weimar performance of 1850), and Léon Leroy and the Comtesse de Gasparin were others who sought to describe the new music, but Baudelaire's insights above all inspired the contributors to the *Revue Wagnérienne* to clarify their own artistic canons *sub specie Wagneri*. This amazing journal, which was founded in 1885 and which survived for two and a half years, was not, as was mentioned in Chapter One, an academic organ which sought an objective appraisal of Wagner but rather one which used his name as a touchstone or a magic cipher by which contributors sought to uncover recondite worlds. Mallarmé's *Richard Wagner: rêverie d'un poëte français* (8 August 1885) which wove around Wagner's achievement a fabric of speculation concerning an Absolute Theatre has already been mentioned; it might be argued that Mallarmé must surely be out of place in a discussion of literary decadence, although Huysmans, in *A rebours*, hailed him as the favourite poet of des Esseintes and claimed: "Literary decadence, irreparably affected in its organism, weakened by the age of its ideas and exhausted by the excesses of its syntax, was, in fact, exemplified by Mallarmé."[8] Suffice it that the famous "Hommage à Wagner" be noted here, that poem of subtlety, complexity and ellipsis which extols Wagner as that deity whose dazzling vision, hardly realisable in this world, transcended the base and the mundane in its glorious

8. Huysmans, *A rebours*, Paris, 1961, p. 245: "En effet, la décadence d'une littérature, irréparablement atteinte dans son organisme, affaiblie par l'âge des idées, épuisée par les excès de la syntaxe . . . s'était incarnée en Mallarmé."

epiphany.[9] The same number of the *Revue Wagnérienne* published
Verlaine's "Parsifal" sonnet, made famous by that line with its

9. Mallarmé, "Hommage à Wagner"; the poem appeared in the
Revue Wagnérienne in 1886 and runs as follows:

> Le silence déjà funèbre d'une moire
> Dispose plus qu'un pli seul sur le mobilier
> Que doit un tassement du principal pilier
> Précipiter avec le manque de mémoire.
>
> Notre si vieil ébat triomphal du grimoire,
> Hiéroglyphes dont s'exalte le millier
> A propager de l'aile un frisson familier!
> Enfouissez-le moi plutôt dans une armoire.
>
> Du souriant fracas originel haï
> Entre elles de clartés maîtresses a jailli
> Jusque vers un parvis né pour leur simulacre,
>
> Trompettes tout haut d'or pâmé sur les vélins,
> Le dieu Richard Wagner irradiant un sacre
> Mal tû par l'encre même en sanglots sibyllins.

It is a notoriously difficult poem, and can only be paraphrased thus:
"The already funereal silence of watered silk arranges more than a
single fold on the accessories, which a collapse of the main pillar is to
reduce to obscurity. Our old triumphal revels taken from the
incomprehensible book of spells, those hieroglyphics which the masses
exalt to spread a familiar shudder with their wing! Banish these, rather,
in a cupboard. From the radiant original uproar which master
brilliances hated amongst themselves there has sprung from on high,
right to the outer square, created for their image, the trumpets of gold
swooning aloud on the vellums, the god Richard Wagner illuminating a
consecration hardly kept silent by the ink itself in Sybilline sobs." The
"main pillar" would seem to be Wagner, whose disappearance and
whose apotheosis are celebrated here. The image of watered silk brings
to mind Wagner's passion for wearing silk, and also suggests fabrics
and draped furniture. The second stanza suggests that something else
should be buried, namely the claptrap associated with trivial art. The
third stanza tells of a "smiling fracas" or radiant uproar, that is,
Wagner's music, which established masters rejected, but which pours
forth into the outer world ("parvis" means a square in front of a
cathedral); the final three lines express the idea that Wagner's music is a

memorable hiatus: "Et, ô ces voix d'enfants chantant dans la coupole . . ."[10] which T.S. Eliot would later quote in *The Waste Land*. Edouard Dujardin's "Amfortas" is a symbolist concoction *à la* Mallarmé, but what is important here is Huysmans's *Ouverture de Tannhäuser*, an attempt to render in prose the impact of that outrageous Paris version which Baudelaire had heard in 1861. Huysmans had given no description of Wagner in *A rebours*, but here the omission is made good; Wagner is equated with a decadent eroticism which would have thrilled even the jaded appetites of des Esseintes:

> Suddenly in this musical scene, in this fluid and fantastic site, the orchestra bursts forth and paints with a few pronounced and brilliant passages which shake us to the very depths of our being a heraldic melody—the approach of Tannhäuser. The shadows spread rays of light, and the swirling clouds assume the forms of rearing haunches, of swelling breasts, throbbing and distended; the blue avalanches of space throng with naked forms, with cries of desire and appeals to lustfulness, with outbursts of the carnal life beyond, pouring from the orchestra: and above the sinuous wall of nymphs who faint and swoon Venus arises, but no longer the antique Venus, the Aphrodite of old, whose immaculate form made men and gods bray as beasts during pagan orgies, but a Christian Venus, if such sin against nature and such coupling of words were possible! . . . It is the incarnation of the Spirit of Evil, the effigy of omnipotent luxuriousness, the image of an irresistible and magnificent female satan which levels its

consecration which is heard even in the silent musical symbols which have been inked on to the score sheet. This music is not trivial, but mysterious, prophetic and tinged with suffering. Wagner's death makes his apotheosis possible, and this in turn enables us to understand his music for what it really is. In this respect "Hommage à Wagner" is akin to "Le tombeau d'Edgar Poe," which expresses the view that Poe's death has transformed him into that which he essentially is. (I am grateful to Ronald Rowe for many of the points raised here.)

10. Verlaine, *Richard Wagner: Vues . . ., op. cit.*, p. 148.

delicious and baleful weapons, ceaselessly on the watch
for Christian souls ... [11]

Eroticism spiced with sin, the ultimate *frisson* being the
knowledge of damnation, a revelling in forbidden delights: a
piece of typical *fin de siècle* impudicity is given here, where it
seems as though Huysmans had found in Wagner the archpriest
of satanism. The equations of sinful sexuality with a perverse
yearning for redemption is very much of its time; the heady
fusion of self-indulgence and self-mortification, the white lily
and the purple orchids, the Madonna and whore topos, certainly
derives from the Elisabeth–Venus juxtaposition in Wagner's
opera, but French decadence drove it to extraordinary lengths.
Pierre Louÿs (who had, in a letter to Debussy written at the end
of the 1890s, reminded the composer that "I simply said to you
that Wagner was the greatest man who ever lived. I didn't say
that he was God himself, but I was tempted . . ."[12]) wrote his
own *Ouverture de Tannhäuser* where it is difficult to differentiate
the powers of Venus from those of Elisabeth or even the Virgin
Mary; Joséphin Péladan's novel *Pomone* likewise tells of a
composer who desires that his forty-year-old wife should

11. Huysmans, *Revue Wagneriénne, ed. cit.*, I, pp. 59—61: "Soudain,
dans ce site musical, dans ce fluide et fantastique site, l'orchestre éclate,
peignant en quelques traits décisifs, enlevant de pied en cap, avec le
dessin d'une héraldique mélodie, Tannhaeuser qui s'avance;—et les
ténèbres s'irradient de lueurs; les volutes des nuées prennent des formes
tourmentées de hanches et palpitent avec d'élastiques gonflements de
gorges; les bleues avalanches du ciel se peuplent de nudités; des cris de
désirs incontenus, des appels de stridentes lubricités, des élans d'au
delà charnel, jaillissent de l'orchestre et, au dessus de l'onduleux
espalier des nymphes qui défaillent et se pâment, Vénus se lève, mais
non plus la Vénus antique, la vieille Aphrodite, dont les impeccables
contours firent hennir pendant les séculaires concupiscences du
Paganisme, les dieux et les hommes, mais une Vénus . . . chrétienne, si le
péché contre nature de cet accouplement de mots était possible! . . . C'est
l'incarnation de l'Esprit du Mal, l'effigie de l'omnipotente Luxure,
l'image de l'irrésistible et magnifique Satanesse qui braque, sans cesse
aux aguets des âmes chrétiennes, ses délicieuses et maléfiques armes."

12. Pierre Louÿs, Richard Wagner: *Vues* . . ., p. 186. His *Crépuscule
des Nymphes* should also be noted.

acquire more original sexual response and holds Elisabeth as an example: "Elisabeth, wife of the Minnesänger, followed her lover along the paths of passion, not even distinguishing whether or not Venus had been the teacher."[13] The pure Elisabeth would seem to have learned much from Tannhäuser's sojourn in the Venusberg; despite Strindberg's championship, indeed apotheosis of Péladan as the supreme prophet of "Germanic" profundity and Wagnerian sublimity, Péladan's effusions, particularly in *La Victoire du mari* (1889), with its description of the boat of mother-of-pearl, the Knights of Monsalvat and the magic fire, seem meretricious and ultimately unconvincing.

Such vagaries are, however, the exception rather than the rule; the treatment of the *Tannhäuser* material elsewhere is content to remain within a traditional portrayal of the spirit— flesh dichotomy. Arthur Holitscher's novel *The Poisoned Well* is worth mentioning here: the heroine, a lascivious widow by the name of Désirée Wilmoth (with echoes of "Melmoth" perhaps) lives a life greatly reminiscent of that of des Esseintes and, in a gigantic greenhouse, has created a garden based, apparently, on that of the second act of *Parsifal*. The greenhouse topos was a favourite one amongst *fin de siècle* writers: the deliberately unnatural creation of exotic blooms, particularly orchids, provided the imagery of many of the poems of this time, and it is appropriate that one of the Wesendonck-Lieder should bear the title "Im Treibhaus." (Wagner himself had admitted: "I can, indeed must, live only in a sort of cloud. Being solely a man of art, I can only lead an artificial life . . . Quite artificial, and I must cut myself off from the atmosphere of reality like a tropical flower in a conservatory."[14]) To seduce the young poet Sebastian

13. Joséphin Péladan, *Pomone*, Paris, 1913, p. 145: "Elisabeth, épouse du minnesinger [sic], suivrait son bien-aimé dans les voies passionnées, sans même distinguer si Vénus a été l'éducatrice." The self-styled "Grand-Maître de l'Ordre de la Rose Croix de Temple et du Gral" was not the most reliable exponent of Wagner.

14. Richard Wagner, *Das braune Buch: Tagebuchaufzeichnungen 1865–1882* (ed. Bergfeld), Zurich, 1975, p. 42 and p. 44 : "Ich kann und muß nur in einer Art von Wolke leben. Wie ich einzig Kunstmensch bin, kann ich auch nur ein künstliches Leben führen . . . Ganz künstlich, wie

Sasse, Désirée Wilmoth appears in provocative poses and stages of undress; naked, she embraces marble statues and does all in her power to excite the somewhat languid young man. His reactions are, unfortunately for her, those of an aesthete rather than a lover, and she is drawn to lubricous productions of *Tannhäuser* (which she organises herself) to overcome his lassitude: "For a considerable time now she was concerned with the problem of how to replace the very stilted dances which one saw in the theatres in the Venusberg scene of *Tannhäuser* with more appropriate ones, ones which approximated more closely to the abandoned beauty of the music, wild ones, lustful ones which, however, would not harm the sacred delights of the pagan cult of the senses."[15] The "onomatopoeic dictionary of love" which Baudelaire had heard in the music forty years before is meant to act as an aphrodisiac to animate the blasé reactions of Sasse; Thomas Mann, who ostensibly had used Holitscher as a model for the decadent Detlev Spinell in his own story *Tristan*, will employ a similar motif in *Wälsungenblut* where it is act one of *Die Walküre*, as we shall see, which serves as the stimulus. The orgiastic and frenzied bacchanal in Aschenbach's dream, occurring immediately before his moral collapse in *Der Tod in Venedig* could also be mentioned in this context; the *mons veneris*, however, is replaced by "the obscene symbol, gigantic, wooden," a grotesque metamorphosis of Tannhäuser's staff.

In England the Tannhäuser-motif proved to be especially fruitful: Edward Robert Bulwer-Lytton (son of the author of *Rienzi*) collaborated with his fellow-diplomat Julian Fane after seeing a performance of the opera in Vienna on a *Tannhäuser or the Battle of the Bards* which was published under Bulwer Lytton's

ein tropisches Gewächs im Wintergarten, muß ich mich gegen die Atmosphäre der Wirklichkeit abschließen."

15. Arthur Holitscher, *Der vergiftete Brunnen*, Munich, 1900, p. 318: "Sie befaßte sich seit geraumer Zeit mit dem Problem, wie die so überaus studierten Reigen, die man in den Theatern in der Venusbergscene von *Tannhäuser* zu sehen bekommt, durch entsprechendere, der zügellosen Schönheit der Musik näherkommende, wilde, brünstige, jedoch die heilige Anmut des antiken Sinnenkultes nicht verletzende Bewegungsfolgen ersetzt werden können."

pseudonym Owen Meredith in 1868.[16] The theme is treated in Tennysonian fashion and cannot match Swinburne's version in *Laus Veneris*. Swinburne had been led to Wagner by Baudelaire: he had reviewed the latter's *Les Fleurs du mal* in the *Spectator* in 1862 and in the following year had received from Baudelaire a copy of *Richard Wagner et Tannhäuser à Paris*.[17] The hint of sadism in Swinburne (the "crushed grape" image) is closer to the French example than the somewhat genteel English treatment; Theodore

16. Julian Fane, incidentally, had met Wagner and left a record of the meeting with the composer: "I had lately a delightful evening at Lady B.'s with Wagner. He read us the libretto of his new (seriocomic) opera 'The Singers of Nuremberg.' The work may also be called a satire on the art-critics of the day. It is full of humour and wit; sparkles with lively versification; and is really rich in thought. He declaimed it admirably, with much histrionic power. I was greatly struck with the man as well as his work." (See Robert Lytton, *Julian Fane: a Memoir*, London, 1872, p. 136.) Another minor poet who had met Wagner is John Payne (1842–1916), who wrote in his autobiography: "Wagner's music has always been as much and as essential a part of my life as literature. Although all but untaught . . . I have a species of innate gift for music, which enables me to judge and appreciate the strangest and most unconventional compositions and to reproduce upon the piano (without a previous hearing) the most complicated orchestral and other works . . . I cannot but feel that my love and practice of music are to be traced everywhere in my verses." (See his *Autobiography*, Bedford, 1926, pp. 11–12). Payne wrote a "Sir Floris" as a grail poem, dedicated to Wagner as the author of *Lohengrin* a sonnet entitled "Bride-Night: Wagner's 'Tristan und Isolde' Act II scene 2," and devoted twenty-four stanzas to praise of Wagner in *Songs of Life and Death* (1872).

17. The extent to which Swinburne was thinking of Wagner's *Tannhäuser* whilst writing "Laus Veneris" is a matter for debate (see Anne Dzamba Sessa, *Richard Wagner and the English*, Cranbury, N.J., 1979, p. 94), but the fact that he *did* write a "Lohengrin," a "Tristan" and "The Death of Richard Wagner" is not unimportant. "Tristram of Lyonesse" appeared a month after *Tristan und Isolde* was produced in London in 1882. Matthew Arnold's comment might be recalled here; he had written a *Tristan and Iseult* in 1852 and he later maintained that he had "managed the story better than Wagner" (Dzamba Sessa, *op. cit.*, p. 87). For a note on Swinburne's Wagnerism see the Appendix B in Elliot Zuckerman's *The First Hundred Years of Wagner's "Tristan."*

William Wratislaw, however, who left an education at Rugby to write for *The Yellow Book* and *The Savoy*, does provide a more demonic "Black Venus of the nether gulfs of Hell," whose caresses are "fierce and swift and deep." Her adversary is a pallid figure, the "Maid who canst love and canst for love forgive—O far seen phantom of Elizabeth!"[18] Oscar Wilde, who probably knew only the *Tannhäuser* overture, yet who was undoubtedly impressed by the Huysmans paraphrase in the *Revue Wagnérienne*, describes how his young hero in *The Picture of Dorian Gray* sat "either alone or with Sir Henry, listening in a rapt pleasure to *Tannhäuser*, and seeing in the prelude to that great work of art a presentation of the tragedy of his own soul,"[19] a reference, presumably, to his own sensuality and excessive promiscuity. (It is perhaps interesting that Siegfried Wagner visited Wilde in 1892 and was impressed by his wit and charm, although he later rejected out of hand the Wilde-Strauss *Salome*, a work unthinkable without his father's example.) In E.F. ("Dodo") Benson's novel *The Rubicon* (1894) the theme of dualism is apparent, "the war between the lower, bestial side of man and something which mankind itself has declared to be higher—the pure, steadfast soul." Again it is the prelude to *Tannhäuser* which fascinates and convulses: the hero, Reggie, is invited by Lady Eva Hayes, a femme fatale with obvious designs on the young man, to listen in her box to this work:

> The slow, deep notes of the "Pilgrims' March" rose and fell, walking steadfastly in perilous place, weary, yet undismayed. Then followed the strange chromatic passage of transition, without which even Wagner did not dare to show us the other side of the picture, and then the great animal, which has lain as if asleep, began to stir; its heart beat with the life of its waking moments, and it started up. The violins shivered and smiled and laughed as Venusberg came in sight; they rose and fell, as the march before had done, but rising higher and laughing more

18. Theodore Wratislaw, *Orchids—Poems*, London, 1891, p. 31. Arthur Symons, who edited *The Savoy*, contributed a "Parsifal" in *Images of Good and Evil* (1889), also a "Tristan's Song."

19. Oscar Wilde, *The Works of Oscar Wilde*, London, 1966, p. 107.

triumphantly with each fall—careless, heedless, infinitely beautiful . . .[20]

It is during the height of the bacchanal that the helpless Reggie becomes enlightened as to Lady Eva's intentions: "The riot was at its height, the triumph of Venus and her train seemed complete, when suddenly Reggie started up. He stood at his full height a moment, watching the curtain rise on Venusberg. 'I see, I see,' he cried. Then he turned to Eva. 'You are a wicked woman,' he said, and the next moment the door of the box closed behind him."[21] It is not easy to sympathise with Reggie's predicament; the son of Archbishop Benson knew his Wagner (certainly *Tannhäuser*, also *Die Walküre*, for he was commissioned in 1903 to weave a fanciful romance around this music drama), but his imagination was not forceful enough to enable him to recreate Wagner's astonishing work. Mention should perhaps also be made of Maurice Baring's autobiographical novel *C*: like Bulwer Lytton, Baring had been a diplomat; he had travelled widely in Germany and had also visited Bayreuth. The hero of his novel recalls the violent electric shock of a *Tannhäuser* performance in Hanover, an experience which he describes as being similar to witnessing a Swinburne poem in action; a performance of *Tristan und Isolde* in Frankfurt likewise intoxicates the young man who capitulates utterly before the oceanic ecstasy and the stifling twilight of that work.

It is a relief now to turn to the delightful absurdities of Aubrey Beardsley; Beardsley's Wagner drawings are, of course, well known, particularly the rather ambiguous "Siegfried" which Beardsley gave to Edward Burne-Jones to hang in his drawing room, and "The Wagnerites," which established Beardsley's reputation in France. Our interest here, however, is with *Under the Hill*, an amusing transposition of Wagner's theme into a Rococo setting, a *galanterie* of witty and preposterous obscenity. The original version, *Venus and Tannhäuser*, took Baudelaire's poem "La geante" to grotesque extremes of pornotopia: the landscape of hills, woods, chasms, and moist clefts being an obvious masturbation fantasy. *Under the Hill*,

20. E.F. Benson, *The Rubicon*, London, 1894, p. 263.

21. Benson, *op. cit.*, p. 264.

more diverting in its fey improprieties, was left incomplete at
Beardsley's death; certain sections (chapters one, two, three and
seven, and most of chapter five) had already appeared in *The
Savoy*, accompanied by drawings. (The manuscript was printed
privately in 1907, again in 1927 and reached a wider public with
the Olympia Press edition of 1959.) The "Chevalier Tannhäuser,"
more eighteenth-century wit than medieval minstrel, arrives at
the court of Venus, whose companions and servants are a typical
gallery of Beardsley monstrosities; Venus herself is a charming
coquette. The chevalier, excited by amatory perfumes within an
elegant pavilion, thrusts himself upon the goddess: "Her frail
chemise and dear little drawers were torn and moist, and clung
transparently about her, and all her body was nervous and
responsive. Her closed thighs seemed like a vast replica of the
little bijou she had between them; the beautiful tétons du
derrière were firm as a plump virgin's cheek, and promised a joy
as profound as the mystery of the Rue Vendôme, and the minor
chevelure, just profuse enough, curled as prettily as the hair
upon a cherub's head . . ."[22] After waking next morning the
chevalier reads in bed, of all things, the score of *Das Rheingold*:

> Making a pulpit of his knees he propped up the opera
> before him and turned over the pages with a loving hand,
> and found it delicious to attack Wagner's brilliant comedy
> with the cool head of the morning. Once more he was
> ravished with the beauty and wit of the opening scene; the
> mystery of its prelude that seems to come up from the
> very mud of the Rhine, and to be as ancient, the
> abominable primitive wantonness of the music that
> follows the talk and movements of the Rhine-maidens, the
> black, hateful sounds in Alberich's love-making and the
> flowing melody of the river of legends . . .[23]

A drawing of the "Third Tableau of *Das Rheingold*" was added to
the story, and Beardsley explains:

22. Aubrey Beardsley, *Under the Hill* (completed by John Glassco),
Olympia Press, 1966, p. 50.

23. Beardsley, *op. cit.*, p. 55.

But it was the third tableau that he applauded most that morning, the scene where Loge, like some flamboyant primeval Scapin, practises his cunning upon Alberich. The feverish insistent ringing of the hammers at the forge, the dry staccato restlessness of Mime, the ceaseless coming and going of the troop of Nibelungs, drawn hither and thither like a flock of terror-stricken and infernal sheep, Alberich's savage activity and metamorphoses, and Loge's rapid, flaming, tonguelike movements, make the tableau the least reposeful, most troubled and confusing thing in the whole range of opera. How the Chevalier rejoiced in the extravagant monstrous poetry, the heated melodrama, and splendid agitation of it all![24]

The description is a pertinent one, but Beardsley does not remain too long in this earnest manner; the chevalier rises at eleven, slips off a charming nightdress and, after posing before a long mirror, steps into his bath with his servant boys, an obvious variation on the opening scene of that music drama which he had just been studying:

"Splash me a little!" he cried, and the boys teased him with water and quite excited him. He chased the prettiest of them and bit his fesses, and kissed him upon the perineum till the dear fellow banded like a carmelite, and its little bald topknot looked like a great pink pearl under the water. As the boy seemed anxious to take up the active attitude, Tannhäuser graciously descended to the passive—a generous trait that won him the complete affections of his valets de bain, or pretty fish, as he liked to call them, because they loved to swim between his legs. . . .[25]

To speculate upon the reactions of the editors of the *Revue Wagnérienne*, not to speak of the *Bayreuther Blätter*, to these frivolities is indeed diverting, but it is obvious that Beardsley's Tannhäuser, with his "dear little coat of pigeon rose silk that hung loosely about his hips, and showed off the jut of his behind to perfection; trousers of black lace in flounces, falling—almost

24. Beardsley, *op. cit.*, p. 55–6.
25. Beardsley, *op. cit.*, p. 57.

like a petticoat—as far as the knee; and a delicate chemise of white muslin, spangled with gold and profusely pleated,"[26] would be more appropriate to the *Folies Bergères* than to the *Festspielhaus*; the Wagnerian explosion was such that even this *feu de joie* was ignited.

Aubrey Beardsley's "The Wagnerites" has already been mentioned; it was sketched from memory after a visit to the Paris Opera in 1893 to see *Tristan und Isolde*, and the name of the music drama is to be seen in the bottom of the right-hand corner of the drawing. If Wagner was the musician who meant most to the decadents (Beardsley, it is reported, confessed to two great passions in his lifetime—one was for Wagner's music, the other for "fine raiment"[27]), then *Tristan und Isolde*, with its fusion of eroticism and extinction, its yearning, swooning chromaticism, its link with legend and its ultimate modernity, even excelled *Tannhäuser* in its ability to provoke and inspire. The fusion of love and death, the juxtaposition of fecund night and arid day, is a Romantic notion to be found most forcibly in Novalis; it is entirely in keeping that the *fin de siècle* writers, in their rejection of utilitarianism, materialism and vulgar progress, should have turned to *Tristan und Isolde* as an escape into voluptuous morbidity. The orgasmic implications of a "love-death" would also provide the decadents with much material: although Wagner's reading of Schopenhauer provided much of the philosophical substratum of the music drama it should not be forgotten that Schopenhauer's concept of the abnegation of the will, of the futile round of human existence, was modified by Wagner to suit his own aims. In a letter to Mathilde Wesendonck, written in Venice on 1 December 1858, Wagner disarmingly claims that he has re-read "friend Schopenhauer's

26. Beardsley, *op. cit.*, p. 57. At the end of his life Beardsley sold most of his books, but kept four volumes of Wagner's writings; he also wished to know whether or not Leonard Smithers had seen volume five. In his room in Mentone he had the photograph taken of Wagner in London, 1877 (see Willi Schuh's unpublished article for the *Programmheft* of 1953).

27. Stanley Weintraub, *Beardsley*, London, 1972, p. 206.

masterpiece" and felt moved to correct certain details of his system. "It is a question, in fact, of proving that there is a sacred path towards the complete pacification of the will—a path recognised by none of the philosophers, not even Sch[openhauer]—and this is through love, and certainly not an abstract love of humanity, but real love, a love which springs from sexuality, the attraction of man and woman."[28] The way of salvation which leads to the perfect appeasement of the will is not through renunciation, but self-indulgence in absolute abandonment: a post-coital "death" is implied here. In a letter to Schopenhauer, drafted but not sent, Wagner refers to a certain section in the latter's "The metaphysics of sexual love" (in *The World as Will and Idea*), where Schopenhauer could not account for the communal suicide of lovers, and offers an explanation: stressing that sexual love was "a holy path towards the will's self-knowledge and self-denial"[29] he implies that a sexual climax accompanied by physical death would be the ultimate consummation. At the moment of highest ecstasy, and at the point of death itself, the Romantic imagination had glimpsed the infinite; the more prurient writers at the end of the nineteenth century would explore more dubious variations, Arthur Holitscher in his *Of Lust and Death*, for instance, and Horacio Quiroga in his *Tales of Love, Madness and Death*, particularly "La muerte de Isolde."

Wagner himself was under no illusions as to the powerful expressiveness of *Tristan und Isolde*, as a letter from Venice to Mathilde Wesendonck (8 December 1858) quite clearly shows: "I have been working since yesterday with *Tristan* again. I am still

28. Richard Wagner, *Briefe an Mathilde Wesendonck*, Berlin, 1904, p. 79: "Es handelt sich nämlich darum, den von keinem Philosophen, namentlich auch von Sch. nicht, erkannten Heilsweg zur vollkommenen Beruhigung des Willens durch die Liebe und zwar nicht einer abstracten Menschenliebe, sondern der wirklichen, aus dem Grunde der Geschlechtsliebe, d.h. der Neigung zwischen Mann und Weib keimenden Liebe, nachzuweisen."

29: See the draft of the letter quoted in the *Bayreuther Blätter*, April 1886, pp. 101–2: "...ein Heilsweg zur Selbsterkenntnis und Selbstverneinung des Willens..."

in the middle of the second act—but—what music it is! I could
spend my whole life just working on this music. Oh, it is deep
and beautiful and the most sublime miracles fit so easily into the
meaning of it all."[30] Four months later, from Lucerne, he
continues: "Child! This Tristan will be something terrible! This
last act!!! I fear that the opera will be forbidden, unless bad
performances do not parody the whole thing—only mediocre
performances can save me! Absolutely perfect ones will make
people insane . . ."[31] The first performance of the music drama,
on 10 June 1865, the enormous controversy, bewilderment and
final recognition that the work marked a watershed in musical
history need no further description here: our concern is with the
undeniable echoes of Wagner's masterpiece not only in the
minor decadents but also in Thomas Mann, George Moore,
Gabriele d'Annunzio and, in a subsequent chapter, Eliot,
Lawrence and Conrad. Even Nietzsche was pierced by this
music; shortly before his mental collapse acrimony, malice and
hyperbole fade, and memories of *Tristan* transfigure even his
loneliness: "Yet I am still looking today for a work of such
dangerous fascination as *Tristan*—and I look through all the arts
in vain. The world is poor indeed for the man who has never
been sick enough for this 'infernal voluptuousness': it is
permitted—it is even demanded—that we apply mystical
formulae here . . ."[32] Nietzsche, the self-styled "decadent" and

30. Richard Wagner, *Briefe an Mathilde Wesendonck, op. cit.*, p. 83:
"Seit gestern beschäftige ich mich wieder mit dem Tristan. Ich bin
immer noch im zweiten Akte. Aber—was wird das für Musik! Ich
könnte mein ganzes Leben nur noch an dieser Musik arbeiten. O, es
wird tief und schön, und die erhabensten Wunder fügen sich so
geschmeidig dem Sinn . . ."

31. Richard Wagner, *op. cit.*, p. 123: "Kind! Dieser Tristan wird was
furchtbares! Dieser letzte Akt!!! ich fürchte die Oper wird verboten—falls
durch schlechte Aufführung nicht das Ganze parodirt wird—: nur
mittelmässige Aufführungen können mich retten! Vollständig *gute*
müssen die Leute verrückt machen . . ."

32. Nietzsche, *Werke*, II, pp. 1091–2: "Aber ich suche heute noch
nach einem Werke von gleich gefährlicher Faszination, wie der *Tristan*
ist—ich suche in allen Künsten vergebens . . . Die Welt ist arm für den,

also the most astute critic of decadence, saw in Wagner the greatest danger, yet also the source of joy that transcended all scruples and reservations.

It is in Thomas Mann that the most skilful evocation of the entrancement exerted by *Tristan und Isolde* is found, the nervous exhaustion and shimmering morbidity of that music providing an inevitable accompaniment to the physical decline of the members of the house of Buddenbrook. In the presence of the seven-year-old Hanno the organist Edmund Pfühl rejects the music of Wagner, and particularly *that* music drama, as immoral and degenerate: "This is chaos, anarchy, blasphemy, madness! A perfumed fog, shot through with lightning! It is the end of all morality in art! I shall not play it!"[33] But the boy has heard and, intrigued, he yearns for that music, and finally succumbs to its intoxication; the music of Richard Wagner increasingly dominates his life, making him strained, over-excitable and unable to concentrate on practical matters. His own musical compositions are sustained by Wagnerian motifs; one particular piece calls forth an ecstasy which is almost an orgasm, the delayed resolution *à la Tristan* increasing to an unheard-of perturbation the bliss of the final climax. Having reached puberty, and showing many signs of physical degeneration, Hanno completely surrenders to the music which had become an indispensable drug, and it is the *Tristan* music particularly (Thomas Mann speaks of "a swooning and an agonizing blurring of one key and another," a "fervent and supplicating tune emerging in the woodwind" and "horns which summoned to parting"[34]) which seals his fate. This music, a dissolute orgy of

der niemals krank genug für diese 'Wollust der Hölle' gewesen ist: es ist erlaubt, es ist fast geboten, hier eine Mystiker-Formel anzuwenden . . ."

33. Thomas Mann, *ed. cit.*, I, p. 498: "Dies ist das Chaos! Dies ist Demagogie, Blasphemie und Wahnwitz! Dies ist ein parfümierter Qualm, in dem es blitzt! Dies ist das Ende aller Moral in der Kunst! Ich spiele es nicht!"

34. Thomas Mann, *op. cit.*, p. 748: ". . . dieses süße, schmerzliche Hinsinken von einer Tonart in die andere . . . ," "ein inbrünstig und flehentlich hervortretender Gesang des Bläserchores . . . ," "Hörner, die zum Aufbruch riefen."

sound, causes a feverish collapse: "He was very pale. There was
no more strength in his knees, and his eyes were burning. He
went into the adjoining room, stretched himself out on the
chaise-longue and lay there for a time, motionless."[35] Hanno's
sickness and death follow shortly afterwards, yet the naturalistic
details of the symptoms of typhoid fever do not blind the reader
to the inference that it was the Wagnerian delirium which drew a
willing victim to his grave.

Two years after completing *Buddenbrooks—Verfall einer
Familie* Thomas Mann published the novella *Tristan*, a short
narrative imbued with the author's inimitable irony but which
again invokes and paraphrases Wagner in a way which betrays
the author's sincere devotion to the composer and that particular
work. There are obvious echoes of Wagner's "Wahnfried" in the
name of the sanatorium where the action takes place; the
aesthete Spinell (the name is significant), a delicious parody of
Arthur Holitscher, seems again a typical product of decadence, a
grotesque figure of fun in many ways, but his love of Wagner is
something that his creator cannot simply lampoon. As in *Tristan
und Isolde* the lovers are left together whilst King Mark and his
courtiers go on a hunting party, so in Thomas Mann's story it is
Gabriele Klöterjahn and Detlev Spinell who stay behind; in the
gathering dusk it is she who lights the candles and plays the
piano against her doctor's orders, first a Chopin nocturne and
then the prelude to that music drama. Inevitably the music of the
second act is played, and Thomas Mann portrays without irony
the effect of that music and those words, the enraptured
celebration of love, night and death, and quotes Wagner
verbatim and in paraphrase:

> Whoever has gazed in love into the night of death and into
> its sweet mystery, to him there will remain during the
> meaningless delusion of light a single longing, a yearning
> to return to sacred night, to night eternal and true, where
> all things become one . . . O sink upon them, night of love,

35. Thomas Mann, *op. cit.*, p. 750: "Er war sehr blaß, in seinen
Knien war gar keine Kraft, und seine Augen brannten. Er ging ins
Nebenzimmer, streckte sich auf der Chaiselongue aus und blieb so
lange Zeit, ohne ein Glied zu rühren."

grant them that oblivion for which they yearn, enfold them totally with thy joy and redeem them from the world of deception and of parting. Look, the last torch is extinguished. Thought and fancy have sunk in holy twilight, which is spread above the torments of folly and which redeems the world. Then, when delusion has faded, when my eyes close in ecstasy—that from which the deception of day has excluded me, that which opposed my yearning with never-ending torment—then, o miracle of fulfilment, even then—I am the world . . .[36]

Seldom has the young Thomas Mann allowed himself such rhapsodic, almost self-indulgent prose: it is this music which ravishes the two and ultimately causes Gabriele's death. The intensely hymnlike fervour of the language perfectly reflects the power of Wagner's music, and the high earnestness of the tone is interrupted only by the amusing references to the effect that the music has upon one Rätin Spatz (indigestion) and by the entry of Frau Höhlenrauch, wife of a vicar, who had brought nineteen children into the world and was incapable of thinking a single thought any more (a most telling confrontation, this, between the will's perfect tool, in Schopenhauer's terms, and those lovers who followed the path suggested by Wagner in his "correction" of Schopenhauer—abandonment and obliteration).

The lovers at the keyboard with an open score of *Tristan und Isolde* is a situation which, to the English reader, immediately suggests George Moore's *Evelyn Innes*, a novel first published in

36. Thomas Mann, *Werke, ed. cit.*, VIII, p. 245: "Wer liebend des Todes Nacht und ihr süßes Geheimnis erschaute, dem blieb im Wahn des Lichtes ein einzig Sehnen, die Sehnsucht hin zur heiligen Nacht, der ewigen, wahren, der einsmachenden . . . O sink hernieder, Nacht der Liebe, gib ihnen jenes Vergessen, das sie ersehnen, umschließe sie ganz mit deiner Wonne und löse sie los von der Welt des Truges und der Trennung. Siehe, die letzte Leuchte verlosch! Denken und Dünken versank in heiliger Dämmerung, die sich welterlösend über des Wahnes Qualen breitet. Dann, wenn das Blendwerk erbleicht, wenn in Entzücken sich mein Auge bricht: das, wovon die Lüge des Tages mich ausschloß, was sie zu unstillbarer Qual meiner Sehnsucht täuschend entgegenstellte—*selbst* dann, o Wunder der Erfüllung! selbst dann bin ich die Welt . . ."

1898, three years before *Buddenbrooks*. Moore's *Hail and Farewell* trilogy is a rich storehouse of references to Wagner, some of which will be dealt with in Chapter Four: here let it be said that Moore, by 1898, had outgrown the naturalism of *Esther Waters* and chosen to explore the mysteries of music and religion in his subsequent novels, with *Evelyn Innes* describing above all the impact of Wagner's art. (American fiction could point to Willa Cather's *The Song of the Lark*, written some seventeen years after *Evelyn Innes*: Thea Kronborg's passage from Moonstone, Colorado, to the Metropolitan Opera provides an analogous situation.) As in *Buddenbrooks* a contrast is drawn between the music of the polyphonic masters of earlier centuries and that of Wagnerian excess: Evelyn's father, organist at St. Joseph's, Southwark, collector and renovator of such instruments as the viola d'amore and the virginals, is portrayed as a man whose main desire is to restore liturgical chants and to check the spread of Romantic developments. Sir Owen Asher, however, convinced and passionate Wagnerian, wealthy and indifferent to bourgeois morality, hears Evelyn's voice and insists that she sing the great Wagner roles, particularly Isolde and Kundry. It is the music of *Tristan und Isolde* which enthrals Evelyn, and Sir Owen, connoisseur and seducer, knows full well the effect that this work above all would have on the young girl. Rather surprisingly, it is upon a harpsichord that he plays excerpts from the notorious second act:

> And while they waited for tea, Evelyn lay back in a wicker chair thinking. He had said that life without love was a desert, and many times the conversation trembled on the edge of a personal avowal, and now he was playing love music out of *Tristan* on the harpsichord. The gnawing creeping sensuality of the phrase brought little shudders into her flesh; all life seemed dissolved into a dim tremor and rustling of blood; vague colour floated into her eyes, and there were moments when she could hardly restrain herself from jumping to her feet and begging of him to stop . . .[37]

37. George Moore, *Evelyn Innes*, London, 1929, p. 56. (Charles Morgan, the poor man's Moore, describes in terms which are not

Sir Owen, however, is no mere debauchee: his liaison with Evelyn is not simply erotic gratification, but a genuine belief that she could, given the right conditions, sing at Bayreuth itself. "He saw himself taking her home from the theatre at night in the brougham. In the next instant they were in the train going to Bayreuth. In the next he saw her as Kundry rush on to the stage..."[38] Evelyn succumbs to Sir Owen and serves the Wagnerian cause, achieving fame and adulation in the major roles; chapter eight in the book opens with her speculations on her past life, where she saw herself as Elisabeth (*Tannhäuser*) who had been superseded by a passionate Isolde. The morbidity of that music drama, however, evades her, and she sees in Isolde's love a life-enhancing ecstasy: "In the second act Tristan lives through her. She is the will to live; and if she ultimately consents to follow him into the shadowy land, it is for love of him. But of his desire for death she understands nothing; all through the duet it is she who desires to quench this desire with kisses..."[39] When singing the part of Isolde she thinks of her relationship with Sir Owen; when kneeling as a penitent Brünnhilde at the feet of Wotan in act three of *Die Walküre* it is of her father that she thinks, and the actual reconciliation with him is informed and suffused by that great scene in Wagner's work. "She knelt at her father's or at Wotan's feet—she could not distinguish; all limitations had been razed. She was *the* daughter at *the* father's feet..."[40] (It is even with the music of the "Lied" from act one of *Die Walküre*, the famous "Winterstürme wichen dem Wonnemond," that she appeals to her father to forgive.) But the *Tristan* music (and the references to the *Wesendonck-Lieder* which grew out of it) penetrates Evelyn's every nerve and fibre:

dissimilar the attempt made by Piers Sparkenbroke to seduce a young girl: he fails, but works at his novel *Tristan and Iseult* instead. He dies from an attack of angina; she tries, unsuccessfully, to commit suicide. See *Sparkenbroke*, 1936.)

38. George Moore, *op. cit.*, p. 61.
39. George Moore, *op. cit.*, p. 117.
40. George Moore, *op. cit.*, p. 163.

"Eternal Night, oh lovely Night, the holy night of love . . ."[41] that exquisite passage which Gabriele Klöterjahn had played in the gathering dusk of the sanatorium reverberates through Evelyn's blood; the black pearls which Sir Owen had given her for her role as Isolde remain her most precious possession. Yet the intolerable psychological strains imposed by the conflicting demands of conscience and father on the one hand and lover and Wagner on the other, together with her reservations (encouraged by a young friend Ulick Dean) about the propriety and "spirituality" of *Parsifal*, cause Evelyn to withdraw from Wagner and ultimately find solace in the Catholic Church, that almost obligatory haven for the exhausted souls of the 1890s.

There is no "Liebestod" in Evelyn Innes; Carlotta Peel, heroine of Arnold Bennett's *Sacred and Profane Love* (1905) does die, but somewhat bathetically of appendicitis in Paris after swallowing strawberry pips. (The pianist Diaz is no Tristan, but redemption of sorts is achieved in the Five Towns Hotel opposite Knype railway station.) In this novel also there is a scene at the piano with the familiar music from act two of *Tristan und Isolde* (plus absinthe) and Carlotta explains: "Enchanted as I was by the rich and complex concourse of melodies which ascended from the piano and swam about our heads, this fluctuating tempest of sound was after all only a background for the emotions to which it gave birth in me . . . The fervour of the music increased, and with it my fever . . . We plunged forward into the love scene itself—the scene in which the miracle of love is solemnized and celebrated."[42] But these English novels seem pallid indeed when compared with the voluptuous intensity of d'Annunzio's *The Triumph of Death* (1894), which contains the most thrilling evocation of the *Tristan* music in all literature. (It was, of course,

41. George Moore, *op. cit.*, p. 226.

42. Arnold Bennett, *Sacred and Profane Love*, London, 1905, pp. 51–2. Margaret Drabble speculates in her book *Arnold Bennett*, London, 1974, pp. 124–5, that Carlotta is meant to be a humorous character; there is much to be said for this, particularly in the descriptions of her reading Herbert Spencer (in secret binding), her insistence on buying a straw hat from the maid to appear respectable after being disgraced in the hotel, and the alacrity with which she leaps into bed with Diaz.

d'Annunzio who composed that lofty inscription upon the wall of the Palazzo Vendramin after Wagner's death: "In this palace / the souls hear / the last breath of Richard Wagner / perpetuating itself like the tide / which washes the marble beneath."[43]) Son of a wealthy and degenerate Roman family, Giorgio Aurispa, overwrought and nervous, increasingly unable to attend to the trivia of day-to-day living, flees with his mistress Ippolita Sanzio, a fiercely passionate woman, to a lonely retreat, to live entirely for love; death however, in many guises, accompanies the lovers and shows Giorgio that only in obliteration can highest ecstasy be found. The lovers live for months in a highly charged eroticism, enhanced by superstitions, memories and, most significantly, the score of *Tristan und Isolde;* it is the memory of an overwhelming performance of that work at Bayreuth which never leaves Giorgio:

> Giorgio had forgotten nothing, not even the slightest trivial detail, of this his first pious pilgrimage to that ideal theatre; he could remember every moment of the extraordinary excitement that he had experienced when he saw that temple dedicated to the Highest Art, standing on the gentle hill at the end of the shady approach. He felt again the solemn impression made by the spacious amphitheatre, with its pillars and arches, and felt once more the mysterious impact made by the hidden orchestra.
>
> In the darkness and silence of the crowded house, in the darkness and ecstatic silence of each soul present a sigh arose from the "mystical abyss," a moan which rose and fell, a subdued voice which brought the first mournful appeal of solitary desire, the first indistinct forebodings of future anguish. Sigh and moan and voice all rose and swelled from the vagueness of plaint to the sharpness of an imperious cry, with all the pride of dreams, the anguish

43. Upon the wall is written: "In questo palagio / l'ultimo spiro di Riccardo Wagner / odono le anime perpetuarsi come la marea / che lamb i marmi."

of superhuman aspirations, the terrible and relentless
power of possession . . .[44]

The music, and the desire it conveyed, is described by
d'Annunzio as a searing flame, a conflagration bursting from an
unknown abyss, a radiant gleam which rises to an unbearable
intensity before yielding to the desolate awareness of anguish.
As Tristan did when he heard the shepherd's song, so Giorgio
too finds in music an immediate revelation of pain and the
revelation of the tragic meaning of his own destiny; as the drama
was acted out on the stage he felt that no one could penetrate
better than he into the symbolic and mythical meaning of the
love-potion, and that no one but he could measure the inner
depths of *Tristan* in its entirety, this work whose hero had
consumed his life. Giorgio's tendency to mythologise his
obsession, his extreme and perverse form of that "Tristanising"
in which Wagner himself indulged, becomes more and more
apparent; after such memories and with such music in his soul,
Giorgio can never return to normal living with all its
responsibilities and cares, and he hurls himself with his mistress,
locked in a fierce embrace, over a cliff to destruction. This
fascinating book, with its pertinent quotation from Nietzsche's
Beyond Good and Evil at the beginning, ends in Wagnerian
rapture and obliteration.

44. Gabriele d'Annunzio, *Trionfo della Morte* (Mandadori ed.), 1976,
p. 363: "Giorgio non aveva dimenticato alcun episodio di quel suo
primo pellegrinaggio religioso verso il Teatro Ideale; poteva rivivere
tutti gli attimi della straordinaria emozione nell'ora in cui aveva scorto
su la dolce collina, all'estremità del gran viale arborato, l'edificio sacro
alla festa suprema del l'Arte; poteva ricomporre la solennità del vasto
anfiteatro cinto di colonne e d'archi, il mistero del Golfo Mistico.—
Nell'ombra e nel silenzio dello spazio raccolto, nell'ombra e nel silenzio
estatico di tutte le anime, su dall'orchestra invisibile un sospiro saliva,
un gemito spirava, una voce sommessa diceva il primo dolente richiamo
del desiderio in solitudine, la prima confusa angoscia nel presentimento
del suplizio futuro. E quel sospiro e quel gemito e quella voce
dall'indefinita sofferenza all'acuita di un impetuoso grido si elevavano
dicendo l'orgoglio d'un sogno, l'ansia di un'aspirazione sovrumana, la
voluntà terribile e implacabile di possedere."

It is obvious that Giorgio's pathological sensitivity, morbidity and brutality are symptoms of decadence; d'Annunzio, here and in *The Flame of Life* (1900) touches on the proximity of aestheticism and degenerate violence which, it could be claimed, prefigures a fascist mentality. Before looking at that novel the Wagner-Venice link must be considered, for *The Flame of Life* may be seen as the ultimate portrayal of that city and of Wagner's relationship with it. A few biographical details may be of use here: on 29 August 1858, Wagner arrived in Venice; on the following day he moved into the Palazzo Giustiniani on the Grand Canal as the sole occupant. Intolerable tensions and difficulties had driven him from Zurich; emotionally drained, in sombre mood, with *Tristan und Isolde* unfinished (and perhaps unfinishable) he would later describe his melancholy feelings and the mood of apprehension ("bange Stimmung") which the sight of the crumbling palaces called forth. The black gondolas and the overcast skies oppressed him, whilst memories of funerals and cholera could not be dispelled:

> The weather had suddenly become somewhat inclement, and the appearance of the gondolas themselves had given me a not inconsiderable fright, for as much as I had heard about these remarkable vehicles, painted black all over, the actual appearance of one in real life gave me an unpleasant surprise, and when I had to step under the roof covered with its black cloth nothing else occurred to me except the memory of a cholera-scare which I had earlier experienced: I had the distinct impression of having to take part in a cortege during times of plague . . .[45]

45. Richard Wagner, *Mein Leben* (Jubiläumsausgabe), Munich, 1963, pp. 664–5 :"Das Wetter war plötzlich etwas unfreundlich geworden, das Aussehen der Gondel selbst hatte mich aufrichtig erschreckt; denn soviel ich auch von diesen eigentümlichen, schwarz in schwarz gefärbten Fahrzeugen gehört hatte, überraschte mich doch der Anblick eines derselben in Natur sehr unangenehm: als ich unter das mit schwarzem Tuch verhängte Dach einzutreten hatte, fiel mir zunächst nichts andres als der Eindruck einer früh überstandenen Cholera-Furcht ein; ich vermeinte entschieden an einem Leichenkondukte in Pestzeiten teilnehmen zu müssen."

The call of the gondoliers, and the lugubrious canals, the alternating desire for oblivion and the intense yearning for Mathilde Wesendonck, the constant threat from police surveillance and the feelings of isolation, of having pushed his art to the limits of the hitherto acceptable—all united to form a unique pattern. This was the setting for the creation of the music of Tristan's second act, that act which, as we have seen, became the supreme stimulus. It was Nietzsche who described the "dangerous fascination" and the "sweet infinity" of that music, that "voluptuousness of hell" which could only be explained in the terms of the mystic; it was Venice, he claimed in his very last coherent pages, that was music itself: "Whenever I look for another word for 'music' I am only able to think of the word 'Venice.' I cannot differentiate between tears and music—I can only think of happiness, of the South, with a tremulous shudder . . ."[46] Wagner and Venice: it is this motif that commands our attention, for themes of beauty, decay and death cluster round that city more than any other.

The finest example in German literature must necessarily be Thomas Mann's *Death in Venice*.[47] This "complex crystal" was written in 1911, in the year in which Wagner's *My Life* appeared, and from which the account of his 1858–9 sojourn was quoted. Thomas Mann's visit to the Lido, his reaction to the death of Gustav Mahler, the literary echoes supplied by Winckelmann, Platen and George have been sufficiently documented: less well known are the Wagner allusions. The change of weather, the apprehension experienced when stepping into a gondola, above all, of course, the theme of plague, of disease as being somehow the "objective correlative" of an inner condition—these themes Thomas Mann may well have met in Wagner's memoirs. (Even

46. Nietzsche, *Werke, ed. cit.*, II, pp. 1092–3: "Wenn ich ein anderes Wort für Musik suche, so finde ich immer nur das Wort Venedig. Ich weiß keinen Unterschied zwischen Tränen und Musik zu machen—ich weiß das Glück, den Süden nicht ohne Schauder von Furchtsamkeit zu denken."

47. It was Werner Vortriede who first drew attention to the presence of Wagner in this story: see his article "Richard Wagners Tod in Venedig" in *Euphorion*, 1958, pp. 378–95.

the "black flag" which Wagner had spoken of in a letter to Liszt, written on 12 December 1854, the flag of death, is present in Mann's story as the photographer's black cloth, snapping in the wind.) The sick artist, gaping out at the waters after his soul has abandoned itself to a vision of beauty, of beauty inseparable from death, seems to be informed by Wagner's presence; like Wagner, Aschenbach moved from Bavaria to Venice, and Aschenbach's rejection of "Wotan's ravens" in favour of the sea seems a parallel to Wagner's abandoning his work on the *Ring* to write *Tristan und Isolde*. The image of sultry lassitude associated with that city, its lapping water, dilapidated palaces and promise of lubricious adventure seemed to Mann a paradigm of *fin de siècle* aestheticism matched only by the example of Richard Wagner. It is surely no coincidence that it was in the Grand-Hotel des Bains on the Lido that Thomas Mann should have jotted down, partly on hotel notepaper, the following sentence referring to Wagner: "As a mind, as a character he seems to me dubious—as an artist irresistible, even though he is highly suspect with regard to the nobility, the purity and the wholesomeness of his effects."[48] Like Nietzsche, Thomas Mann knew that Wagner was "une névrose"; like Nietzsche he felt a compulsive need to turn time and time again to this phenomenon.

Wagner, Venice, *Tristan* and moral and physical decay— Maurice Barrès's novel *Amori et dolori sacrum: La Mort de Venise* predates Thomas Mann's short story by some nine years and overtly deals with Wagner's stay in the Palazzo Giustiniani. Barrès was, like Nietzsche, a "decadent" and at the same time its opposite: having passed through the blandishments of *fin de siècle* aestheticism he later adopted a belligerent chauvinism, but Richard Wagner remained of perennial interest. *La Mort de Venise*, dating from 1902, delights in portraying "les déracinés," those ultra-sophisticated degenerate souls who were drawn inexorably to Venice, sensing that that city above all was their

48. Thomas Mann, *Werke, ed. cit.*, X, p. 841: "Als Geist, als Charakter schien er mir suspekt, als Künstler unwiderstehlich, wenn auch tieffragwürdig in bezug auf den Adel, die Reinheit und Gesundheit seiner Wirkungen."

spiritual home. The enervating, fetid atmosphere exhaled by the canals, the rippling reflections on crumbling stone, damp walls and ornate bridges produced that "volupté de la tristesse" for which tired souls yearned. A perfect fusion is felt between Wagner's music (particularly the *Tristan* music) and that city:

> Standing at the windows of the Giustiniani palace, which Wagner lived in during the winter of 1857 [*sic*] I have often seen floating above nocturnal Venice those fascinating sorceries which gave it its particular character and which provided the mysterious qualities of its genius. When deepest darkness weighs down upon the canals, neither colour nor form appearing, and when the mighty and radiant Church of the Salute itself seems like a ghost, when it is only with difficulty that a silent boat forces the water to form a reflection . . . , then the bewitching city finds its own way of piercing the denseness of night, and from this solemn secret she breathes like a sacred hymn, overwhelming in its desolation and its nostalgia. These are the hours, I know, which knew how to extract from the deep soul of that German the heartrending rhapsodies of Tristan and Isolde . . . [49]

But the references to night, phantoms and yearning give way to more sombre thoughts, those of fever: "No light—only night itself. For Tristan the night was the realm of love, for the German, Wagner, it was the realm of the inner life and, for

49. Maurice Barrès, *Amori et dolori sacrum: La Mort de Venise*, Paris, 1902, p. 100: "Bien souvent, aux fenêtres du palais Giustiniani . . . que Wagner habitait durant l'hiver de 1857, j'ai vu flotter sur la Venise nocturne les fascinations qui le déterminèrent et qui furent les moyens mystérieux de son génie. Quand la pire obscurité pèse sur les canaux, qu'il n'est plus de couleur ni d'architecture, et que la puissante et claire Salute semble elle-même un fantôme, quand c'est à peine si le passage d'une barque silencieuse force l'eau à miroiter, . . . la ville enchanteresse trouve moyen tout de même de percer cette nuit accumulée, et de ce secret solennel elle s'exhale comme un hymne écrasant d'aridité et de nostalgie . . . Voilà les heures, j'en suis assuré, qui de la profonde conscience de ce Germain surent extraire les déchirantes incantations de Tristan et d'Isolde . . ."

Venice, it was the domain of pestilence . . ."[50] Febrile ecstasies and the cult of death—again it is that second act which is singled out by Barrès for particular attention, that apotheosis of longing and death-intoxication: "Vertigo—the intoxication of high places and extreme emotions! At the height of the waves to which *Tristan* bears us let us recognise that pestilence which rises from the lagoons at night."[51] The delirious frenzies of *Tristan* and the lingering infections exhaled by the waters of Venice are inseparably linked for Barrès; to Richard Wagner it was given to exemplify perfectly in his music, his life and above all his death the morbid sensuality of that city. George Moore had likewise stressed the affinity which he felt between the feverish intensity of *Tristan* and the haunting atmosphere of Venice; Evelyn puts away the music of the penitent Elisabeth and turns instead to the score of that other music drama, and as she does so, memories of Venice surge into her mind:

> The score slipped from her hands . . . The old walls of the palace, the black and watchful pictures, the watery odours and echoes from the canal had frightened and exhausted her. The persecution of passion in her brain and the fever of passion afloat in her blood waxed, and the minutes became each a separate torture . . . The moon rose out of a sullen sky, and its reflection trailed down the lagoon. Hardly any stars were visible, and everything was extraordinarily still. The houses leaned heavily forward and Evelyn feared she might go mad, and it was through this phantom world of lagoon and autumn mists that a gondola glided . . .[52]

It seems entirely appropriate that memories of that city should automatically arise when the alarming intensity of *Tristan* overpowered her in her loneliness.

50. Barrès, *op. cit.*, p. 104: "Plus de lumière: la nuit. La nuit fut pour Tristan le domaine de l'amour, pour le Germain Wagner, le domaine de la vie intérieure et, pour Venise, le domaine de la fièvre."

51. Barrès, *op. cit.*, p. 112: "Vertige, ivresse de hauts lieux et des sentiments extrêmes! A la cime des vagues où nous mène *Tristan*, reconnaissons les fièvres qui, la nuit, montent des lagunes . . ."

52. George Moore, *Evelyn Innes*, *op. cit.*, p. 121.

"This cursed Venice, with its languishing moonlights, its atmosphere of some stuffy boudoir, long unused, full of old stuffs and pot-pourri . . . ," this city, "exhaling, like some great lily, mysterious influences which make the brain swim and the head faint—a moral malaria. . . :"[53] Vernon Lee's novella *A Wicked Voice* (1890) portrays a young Norwegian musician and his struggles in Venice to complete his opera *Ogier the Dane*, an ambitious project, and one inspired by the genius of "the great master of the future." This "great master" is, of course, Wagner, whose "Music of the Future" (*Zukunftsmusik*) became the rallying cry for the younger generation of musicians. In her essays *Tannhäuser* and *Music and its Lovers* Vernon Lee refers frequently to Wagner, extolling the music of the eighteenth century as "healthy" and castigating his own as "degenerate" in true Max Nordau fashion. In *A Wicked Voice* the young Magnus is wasted by a strange and deadly disease, but it is paradoxically a haunting, disembodied voice from the past which destroys his sanity and his will to live, the voice of the brazen, bloated Zaffirino, the description of whose portrait uneasily brings to mind that Renoir portrait referred to at the beginning of this chapter. It would seem that the depravity of the eighteenth century (the century, after all, of the "divine Marquis") re-asserted itself in this Venetian setting; the dubious nature of the composer of "Zukunftsmusik," of music both robust and morbid, is likewise acknowledged, and *Ogier the Dane* is never completed. The juxtaposition "health-morbidity" or "tradition-modernity" is also firmly established in Franz Werfel's novel *Verdi* where, in a rather unsubtle and over-schematised manner, the essentially vigorous, sturdy and harmonic elements of the music of that composer are contrasted with the heady impurities and chromatic adventurousness of Wagner. The opening of the novel provides yet again a Venetian setting, the performance, on Christmas Eve 1882 of Wagner's youthful C major symphony at the Teatro la Fenice. The description of moonlight and sombre

53. Vernon Lee (i.e. Violet Paget), *Hauntings—Fantastic Stories*, London, 1890, p. 217. I am particularly grateful to Erwin Koppen's *Dekadenter Wagnerismus* (Berlin, 1973) for references to Vernon Lee, whose work I did not know.

waters is obligatory: more interesting are Werfel's imaginative reconstructions of Verdi's sense of failure *vis-à-vis* the great Master, of his awareness of belonging to an age which seemed almost simple-minded when compared with the subtleties and searing intensities of Wagner's creation. As Verdi's gondola moves silently down the canals, the Italian finds himself close to those which convey Wagner and his entourage, and with bitterness he is forced to contemplate his rival and victor: "Wagner is sitting on the left hand side, in front of his wife. In the bewitching chiaroscuro of moonlight his head, with its protruding cranium, looks like the pallid and monstrous skull of a gnome: it leans back, and the eyes are closed . . ."[54] Feelings of resentment and envy temporarily blind Verdi, who rises in his gondola, prepared, almost, to attack the sleeping man: "Beneath the force of this emotional upheaval the Maestro stood up in the gondola. Wagner's monstrous cranium gleamed peacefully. His wife gazed mournfully ahead. And as he stood there, watching the side of the rival gondola almost touch his own in that moonlight which transfigured everything, the thought flashed through his mind: 'Near enough to seize!'"[55] Yet this aberration does not last: contrite, confused and ashamed, Verdi sits down again, whilst the Wagner family is carried in silence towards the Palazzo Vendramin. Some seven weeks later, on 14 February 1883, having overcome his feelings of rancour and inadequacy, Verdi announces himself at the Palazzo, only to hear that Richard Wagner had died the day before.

54. Franz Werfel, *Verdi: Roman der Oper*, Berlin, 1930, p. 29: "Wagner sitzt links vor seiner Frau. Sein Haupt mit dem vorgebauchten Schädel, der in der hexenhaftbösen Schattenverteilung des Mondlichts dem bleichen Riesenschädel eines Gnomen gleicht, dieses Haupt ist nach hinten gelehnt und die Augen sind geschlossen."

55. Franz Werfel, *op. cit.*, p. 31: "Unter der Wucht dieser Anwandlung richtete sich der Maestro in der Gondel auf. Unberührt schimmerte Wagners Riesenschädel. Die Frau (Cosima) sandte trübe Blicke geradeaus. Und wie er so stand, und im ungeheuren, alles verwandelnden Mondlicht den Bord der Nachbargondel die seine fast berühren sah, wollte er denken: 'Zum Greifen nah!'"

"Richard Wagner is dead! The world seemed diminished in value . . ."[56] This section must now return to and close with d'Annunzio, whose *The Flame of Life* provides the most sumptuous evocation of Venice, and the most moving account of Wagner's death in that city. (As William Blissett has written: "No book in the realm of Wagner empire is so dominated by the Despot, and no more complete instance is to be found of the phenomenon of Wagnerian nervous strain."[57]) As well as being a thinly veiled account of the relationship between d'Annunzio and Eleonora Duse, the novel contains an ecstatic portrayal of the influence of Wagner upon the young Stelio Effrena, ardent aesthete and *superuomo*. Those recently returned from Bayreuth describe their experiences, and Stelio is carried away by the glory of Wagner, the gigantic hero. (It is tempting to see d'Annunzio's later plans for the organisation of a "Bühnenfestspiel" and his intention to grant music and theatre a supreme role in his constitution for Fiume as stemming from Wagner's example.) Before Stelio's eyes a vision of Wagner arises, ruthless and imperious:

> And the image of the barbaric creator suddenly came closer, his features became visible, the light blue eyes gleamed beneath the mighty brow and the lips, around which hovered sensuality, pride and scorn, closed tight above the powerful chin. His body, small and bent by age and fame, achieved the same gigantic proportions as his work, and assumed the appearance of a god. His blood poured like a mountain waterfall, his breath beat like the wind in the forests. Suddenly Siegfried's youth invaded him, poured through him, illuminated him as dawn lighting the mists. "Follow the beating of my heart, obey my instincts, listen to the voice of nature in me—this is my highest, my one and only law!" The heroic motto resounded again, bursting from the depths as the expression of a youthful, powerful will which, in triumph

56. Gabriele d'Annunzio, *Il fuoco* (Mondadori ed.), 1977, p. 333: "Riccardo Wagner è morto! Il monde parve diminuito di valore."

57. William Blissett, "D.H. Lawrence, D'Annunzio, Wagner" in *Wisconsin Studies in Contemporary Literature*, VII, 1962, p. 32.

with the laws of the universe, blazed in victory above all
obstacles and enmities . . .[58]

The news of Wagner's presence in the Palazzo Vendramin-
Calergi releases a flood of images and visions within Stelio; the
physical proximity of the creator of the radiant Siegfried and the
majestic Brünnhilde, the ravaged Kundry (with whom the
actress La Foscarina feels an inner affinity) and the death-
intoxicated lovers, agitates and inspires the youthful worshipper.
Vulnerable and susceptible, Stelio Effrena cannot rest until he
has seen the Palazzo where his idol is resting; but the conqueror,
the victorious artist-god before whom emperors, kings and
princes had submitted, is touched by death. On the wintry
lagoons Stelio and his companions see the Master, together with
Cosima and Liszt, enveloped in sombre silence, their white hair
and suffering features noble and sublime. The three Northern
figures are mythologised by Stelio as Triumphant Genius,
Faithful Love and Undying Friendship, and motifs from *Der
fliegende Holländer* pass through the young man's mind; yet the
Master collapses, and is helped ashore by the adoring acolytes. A
few weeks later it is Wagner's coffin that Stelio helps to carry on
to a black gondola and across the canals to the railway station;
before the lid is closed the sight of the dead man fills the
mourners with veneration:

58. d'Annunzio, *op. cit.*, pp. 137–8: "E subitamente l'imagine del
creatore barbarico si avvicinò, le linee della sua faccia divennero visibili,
gli occhi cerulei brillarono sotto la fronte vasta, le labbra si serrarono sul
robusto mento armate di sensualità, di superbia e di dispregio. Il suo
piccolo corpo incurvato dalla vecchiezza e dalla gloria si sollevò,
s'ingigantí a somiglianza della sua opera, assunse l'aspetto di un dio. Il
sangue vi corse come torrenti in un monte, il respiro vi alitò come il
vento in una foresta. A un tratto, la giovinezza di Siegfried lo invase, vi
si sparse, vi rifulse come in una nube l'aurora. 'Seguire l'impulso del
mio cuore, obbedire al mio istinto, ascoltate la voce della natura in me:
ecco la mia suprema unica legge!' La parola eroica vi risonò, erompendo
dal profondo, esprimendo la volontà giovine e sana che trionfava di
tutti gli ostacoli e di tutti i maleficii, sempre in accordo con la legge
dell'Universo."

> An indescribable smile lay upon the features of the dead
> hero. infinite and remote, as a rainbow upon glaciers or
> the gleaming of the sea, like the radiance around moon
> and stars. It was too much for their eyes to bear, but their
> hearts, full of religious awe and terror, felt that they had
> received the revelation of divine mystery . . .[59]

In this city, almost thirty years previously, Wagner had written
to Liszt of the black flag with which, after completing *Tristan und
Isolde*, he would drape himself to die; in *The Flame of Life* it is
Roman laurels which adorn the coffin which moves towards the
frost and snow of Bavaria.

The temple of art and the cult of the hero, aestheticism and
victory, death-intoxication and triumph: a disturbing synthesis
seems here to prepare the way for that "aestheticising of politics"
which Walter Benjamin would later associate with fascism.
(Rilke's sonnet "Late Autumn in Venice," written shortly after
The Flame of Life, likewise portrays the arsenal and the fleet of
that city, a powerful force rising from the depths, and the ships
with their streaming pennants, both radiant and sinister.[60]) It is
the fascinating proximity of aestheticism and fascism which
never ceased to preoccupy Thomas Mann, and Wagner would be
for him the supreme paradigm. This will be touched upon in
Chapter Three; we must now return to our examination of
Wagner and literary decadence.

It is *Tannhäuser* and *Tristan und Isolde* which provided so many of
the *fin de siècle* writers with inspiration and example, however
dubious; the sin which possessed the decadents, however, and
which seemed obligatory in any piece of writing which strove to
shock is that of incest, and Wagner's *Die Walküre* must now claim

59. d'Annunzio, *op. cit.*, p. 338: "Un infinito sorriso illuminava la
faccia dell'eroe prosteso: infinito e distante come l'iride dei ghiacciai,
come il bagliore dei mari, come l'alone degli astri. Gli occhi non
potevano sostenerlo; ma i cuori, con una meraviglia e con uno spavento
che li faceva religiosi, credettero di ricevere la rivelazione di un segreto
divino."

60. R.M. Rilke, *Gesammelte Gedichte*, Frankfurt, 1962, p. 365. The
German words are far more impressive: "strahlend und fatal."

our attention. (Well might the unknown author of the article in *The Church Times* of 19 June 1882 castigate act one of that music drama as "the most infamous scene ever put upon any stage in heathen or in Christian times. It consists of a glorification of incest, mingled with adultery, and the betrayal of the commonest rites of hospitality."[61]) Brief mention has been made of *Die Walküre* during a discussion of *Evelyn Innes*, but there it was the father–daughter relationship which was important: it is the glorification of the incestuous love between Siegmund and Sieglinde in act one, and the ensuing act of intercourse, which is of greater significance. The most notorious literary twins bearing these names who go to a performance of *Die Walküre*, return and consummate their incestuous love are Siegmund and Sieglinde Aarenhold in Thomas Mann's story *Blood of the Volsungs*, the German title of which is, in fact, the last word of act one of Wagner's drama ("Wälsungenblut"). There is also a grim irony here: whereas in Wagner it is the hero Siegfried who will be the result of this union the reader of Thomas Mann's story is left with no such reassurance.

The short work, dating from 1906 but withheld from publication for many years because of certain objections and reservations on the part of the Pringsheim family (the family of Thomas Mann's wife), tells, in the author's own words, the "story of two pampered creatures, Jewish twins from the ultrasophisticated West-End of Berlin, whose over-ripe and scornful revelling in isolation takes as its model the primeval act of incest from Wagner's Volsung brother and sister."[62] (The Jewish element was subsequently made less important by Mann; the baleful attraction which Wagner had for many Jews— Beardsley's *The Wagnerites* leaves no doubt as to the Jewishness of at least one member of the audience—is not a problem to be discussed here.) Spoilt and cosseted, Siegmund Aarenhold leads

61. Quoted in Max Moser, *Richard Wagner in der englischen Literatur des XIX Jahrhunderts*, Berne, 1938, p. 19.

62. Thomas Mann, *Werke, ed. cit.*, X, pp. 558–9: "die Geschichte zweier Luxuswesen, jüdischer Zwillinge des überfeinerten Berliner Westens . . . deren üppig-spöttisches Einsamkeitspathos sich den Ur-Inzest von Wagners Wälsungen-Geschwisterpaar zum Muster nimmt."

a life of sterile boredom; his days pass in emptiness and narcissistic self-reflection (again, Beardsley comes to mind in the description of his dressing table with its bottles, perfumes and powder, his "Empire Spiegel," his pink silk underwear, slippers, and fur-trimmed smoking jacket). With his twin sister Sieglinde he has an equal partner in elegant, arrogant refinement; her fiancé, the hapless Beckerath, is their equal neither in sartorial nor in intellectual matters. It is he who is the blundering figure, and it is inevitable that the twins, without him, should drive to the Opera to see *Die Walküre*. Aloof, haughty and blasé they watch the performance on the stage and cannot refrain, amidst the consumption of Maraschino cherries, from ironic and condescending remarks on the singers and the orchestra. Enthusiasm of any kind is alien to their sense of snobbish superiority, but Siegmund particularly feels the powerful and surging momentum of Wagner's work; the passionate turmoil of the music excited him, causing doubts and an unsettling self-awareness: "A work of art! How does one create a work of art? Pain beat in Siegmund's breast, a burning and yearning, something akin to a sweet torment—where? For what? It was all so dark, so wretchedly obscure. He felt two words—creativity, passion. And whilst his temples throbbed with heat there came like a fervent insight to him the knowledge that creativity sprang from passion and again assumed the form of passion . . ."[63] As Wagner's twins had defied Hunding and passed through ecstasy and tribulation, so Siegmund Aarenhold, nervously agitated despite his cool exterior, sinks with his sister on to the rug in stammering agitation; the Wagner parallels are obvious. But whereas Wagner created out of passionate inspiration, it is Siegmund Aarenhold's tragedy that what was probably his first spontaneous act should be one of narcissism and perversion,

63. Thomas Mann, *Werke, ed. cit.*, VIII, p. 404: "Ein Werk! Wie tat man ein Werk? Ein Schmerz war in Siegmunds Brust, ein Brennen oder Zehren, irgend etwas wie eine süße Drangsal—wohin? wonach? Es war so dunkel, so schimpflich unklar. Er fühlte zwei Worte: Schöpfertum . . . Leidenschaft. Und während die Hitze in seinen Schläfen pochte, war es wie ein sehnsüchtiger Einblick, daß das Schöpfertum aus der Leidenschaft kam und wieder die Gestalt der Leidenschaft annahm."

born of defiance and vindictiveness. It is only Wagner who can
stimulate powerful responses within Siegmund, responses
which, however, result in an act of meaningless desecration.

That Wagner's music was the catalyst, the aphrodisiac,
there can be no doubt: the love duet at the end of act one which
leads to joyful recognition and voluptuous abandonment excited
even these cynical and sophisticated young people who despised
the world and its vulgarity. A more gentle treatment of the
theme occurs in Willa Cather's *The Garden Lodge* (1905) where,
during a piano recital of the first act of *Die Walküre*, Caroline
Noble feels the embrace of Raymond D'Esquerre, her spiritual, if
not physical, brother; Siegmund's famous song is skilfully
woven into the narration, and the weather likewise plays its part.
In Elémir Bourges's *Le Crépuscule des dieux*, written some twenty
years before the stories of Willa Cather and Thomas Mann, that
music will drive both Hans-Ulric and Christiane, brother and
sister, to incest and destruction. There are, however, important
differences: Hans-Ulric and Christiane are not twins, and their
relationship is normal until external machinations push them
into perversion; Wagner's music is used to overthrow these last
scions of a princely German house. Hans-Ulric, prone to
melancholy and introversion, loving music and poetry, shares
much in common with the angelic Christiane, but it is not until
they both fall into the clutches of an Italian intriguer that tragedy
ensues. Giulia Belcredi, mistress of the Duke of Blankenburg,
who lives in exile in Paris, is an accomplished Wagner-singer;
she deliberately sets out to destroy Hans-Ulric and Christiane,
and seizes upon the idea of forcing them into an incestuous
relationship, using *Die Walküre* as the stimulus. The Duke is
persuaded to organise an amateur performance of that work
with brother and sister in the leading roles; Christiane
particularly feels that she increasingly identifies with the role of
Sieglinde, and believes that if Wotan had deemed that the
mythological twins should be lovers, then she and her brother
should follow their example. It is the great love duet which
envelops the two, and all barriers fall away:

> Then, as the poem demanded, Hans-Ulric enfolded
> Christiane in his arms, and he felt her heart beat against
> his, her heart so full of him. Their voices rose in unison,

and were followed by an ecstatic silence . . . An instinct,
like a secret impulse, told them when to sing at the given
moment, and this music, more and more ardent, more and
more devoured by flame and passion, embraced them,
intoxicated them; hesitations, scruples, remorse—the two
lovers felt an indefinable heaviness lifting from every
corner of their souls. They were singing again, all that they
had never been able to say—they cried it to each other in
this song which became their wedding vow: they were
triumphant, they adored, they gasped with the
superhuman satiety of their love, their souls interlocked,
they were oblivious to everything, lifted in a powerful
transport of ecstasy which made them rise above each
other and made them taste a gigantic sense of pride at
flaunting their sin before all . . .[64]

The reader is not surprised that after the performance the two
dine together, then fall into an incestuous embrace: Hans-Ulric
shoots himself afterwards, and Christiane becomes a Carmelite
nun.

In Thomas Mann the incestuous intercourse is the climax
of the story, an inevitable act which sets the seal on the lives of
the Aarenhold twins; in Bourges it is but one disaster, albeit a
fearful one, in the history of the house of the Duke of
Blankenburg. The very title of the novel, *Le Crépuscule des dieux*,
necessarily has a Wagnerian ring, and the composer himself

64. Elémir Bourges, *Le Crépuscule des dieux*, Paris, 1954, p. 107:
"Alors, selon que le veut le poème, Hans-Ulric enlaça Christiane dans
ses bras, et il sentait battre contre son coeur, ce coeur plein de lui. Leurs
voix s'élevèrent à l'unisson, suivies d'un silence d'extase . . . Un instinct
leur donna comme un branle secret, pour s'avancer chanter au moment
marqué; et cette musique toujours plus chaude, plus pétrie de flamme et
de passion, les embrasait, les enivrait: hésitations, scrupules, remords,
les deux amants sentaient je ne sais quoi de lourd qui s'envolait, de
toutes les parties de leur âme. Ils chantaient encore; tout ce qu'ils
n'avaient jamais pu dire, ils se le criaient par ce chant, qui était leur aveu
nuptial; ils triomphaient, ils s'adoraient, ils haletaient de ce rassasiement
surhumain de leur amour; et l'âme roulée l'un sur l'autre, soulevés par
un transport puissant qui les faisait être au-delà d'eux'mêmes, goûtant
un orgueil colossal à soutenir leur crime en face, ils ne se souciaient plus
de rien."

makes a brief appearance near the beginning. It is during a concert conducted by Wagner (the *Tannhäuser* overture is being played, together with certain sections of *Die Walküre*) that news arrives of the invasion by Prussian troops of the Duke's territory; unable to remain, he leaves for exile, having first decorated Wagner with one of his highest orders. Before he departs he enquires of the composer the name of the last part of the *Ring* cycle, and the reply "C'est le Crépuscule des dieux, monsieur" startles the Duke who, overcome with vertigo, "stretches himself out on the ottoman, repeating as if in a dream 'The twilight of the gods . . . the twilight of the gods . . .'"[65] The subsequent decline of his whole family, a decline into insanity, incest, suicide, brutality, idiocy and crime seems presaged here; this theme of the degenerate aristocratic line, especially in its more bizarre manifestations, is a favourite one amongst the writers of the period under discussion. The fate of Hans-Ulric and Christiane has already been described; the son Franz is exposed as a criminal; the brutal Otto, after an attempt upon his father's life, ends in a madhouse and Claribel, over sensitive and delicate, dies after a nervous collapse. The end of the dynasty is imminent: over-refinement, morbid sensitivity and Wagner's music have proved its undoing. And immediately the reader thinks of that other princely line, not fictitious but actual and historical, whose young king, enraptured by Wagner's music, fled into a world of make-believe, fairy-tale castles and Wagnerian excess: the house of Wittelsbach and King Ludwig II. That such a king should have adored such a composer provided a fruitful source for any account of wanton aestheticism.

A proliferation of novels, mostly trivial, dealt with the young king's eccentricities, his dream-world suffused by Wagner's music and his death in the Starnbergersee: writers of worth, such as Stefan George, who dedicated his *Algabal* poems to the memory of Ludwig II, saw in him the embodiment of art, an ideal transcending mere politics. Robert de Montesquiou, the literary dandy on whom Huysmans modelled des Esseintes,

65. Bourges, *op. cit.*, p. 26: "Le duc . . . s'allongeait sur le divan turc, en répétant, ainsi que dans un rêve: *Le Crépuscule des Dieux*, le *Crépuscule des Dieux* . . ."

greets Ludwig in his *Treizième César* as the supreme
personification of the aesthetic vision and, in an interior
monologue of the drowning king, lets Wagner's creations pass
before him at the point of death. One day, the dying monarch
knows, "there will come to raise me up, to lead me to the day
with its evening sky, that sky where my friends reign, those
enchanted Floramyes, together with giants, dwarfs of the
Nibelung, and kings of the Lied, whom Siegfried's little bird
cheers without pause . . ." The young king knows that his
infatuation with Wagner will bring its just rewards: "For I have
deserved well of these mythologies, for my lowness of spirit was
only lightened at the subterranean forge of Mime and Alberich; I
have taken unto myself that great, strong Father of Eric and
Senta, the one who gallops through Ortlinde and swims through
Flosshilde, from Elsa to Brünnhilde—that High Priest of word
and sonorousness . . ."[66] The king gives himself to the water's
embrace, confident that he will live in Wagner, that Wagner,
godlike, will ensure his immortality: "I have said that I am
dying: I live as Empedocles did. For ever I shall live! For my
name will fuse with your monument, you, Father of Eva, of
Sachs, of Walther and of Pogner, you, the prince, the king, the

66. Robert de Montesquiou, *Les Chauves-souris*, Paris, 1907, pp.
265–6:

> Viendront me soulever pour me conduire au jour
> Du ciel crépusculaire où règnent mes amies,
> Vertes filles du Rhin, magiques Floramyes,
> Les Géants et les Nains Nibelungs, roi du Lied,
> Qu'égaie incessamment l'oiselet de Siegfried!
> Car j'ai bien mérité de ces mythologies;
> Car mes langueurs de spleen n'apparaissent rougies
> Qu'au foyer souterrain de Mime et d'Alberich;
> Car j'ai pris le plus grand, le fort père d'Eric
> Et Senta, qui, d'Elsa jusques à Brunehilde,
> Galope, par Ortlinde, et nage, par Flosshilde;
> Le haut pasteur de verbe et de sonorité . . .

Again, I am indebted to Erwin Koppen for the references to
Montesquiou.

God—Richard Wagner!"[67] A god, then, in Mallarmé and de Montesquiou; in Catulle Mendès's *Le Roi vièrge* the figure of "Hans Hammer" is eruptive, passionate, almost deranged in his creative fury. This curious *roman à clef*, banned in Bavaria when it first appeared (1881), tells of the country of "Thuringia" (a land of Alpine peaks, apparently, and containing the village of Oberammergau) which is ruled over by the pathological King Friedrich II, the virginal king of the title who, loathing women, falls under the spell of Hans Hammer and devotes his life to beauty, particularly to the creation of an artificial lake across which he is drawn by swans. The king first appears as a young shepherd (there are obvious allusions here to the transformation scene in *Tannhäuser*, also to act three of *Tristan und Isolde*) playing his pipe among the mountain peaks; the scene is idyllic, but his end is grotesque and sombre. Unable to face a senseless reality he sets fire to his castle, castrates himself and is finally crucified during an Oberammergau Passion play.

This novel by Catulle Mendès takes to absurd lengths the doubtless eccentric relationship between Wagner and his young king; "Hans Hammer" verges upon caricature in his frenzy, rage and attitudinising (see Chapter Four). Demonic in his tirades, seductive in his blandishments, iridescent in his ambiguity, Wagner is seen as the embodiment of all those dubious, questionable and yet hypnotic qualities which the writers of decadence felt to be indispensable in the modern artist. This chapter has looked at the meaning of *Tannhäuser*, *Tristan und Isolde* and also *Die Walküre* for certain representative writers of *fin de siècle*, and will conclude, as it began, with comments on *Parsifal*. Its ambivalent import has already been noted, as has Verlaine's sonnet; it is again Thomas Mann who is able to describe its controvertible nature with the finest imaginative precision, pointing out that the coupling of art and religion in this "sex opera of great daring," with theatrical celebration of the

67. Montesqiou, *op. cit.*, p. 266:

> J'ai dit, je meurs; je suis vivant, comme Empédocle.
> A jamais! car mon nom fait corps avec ton socle.
> Père d'Eva, de Sachs, de Walter, de Pogner,
> Toi, le Prince, le Roi, le dieu Richard Wagner!

eucharist, was symptomatic of a spiritual bankruptcy of the most alarming proportions. This work, appealing as it did to the humble believer and the most sophisticated decadent was, for Thomas Mann, a demonstration of that "doppelte Optik" of which Nietzsche had spoken, that quality in Wagner which made him appeal to the simplest, as well as the most recondite, mentality. In his address *Sufferings and Greatness of Richard Wagner*, given on the fiftieth anniversary of Wagner's death and arguably the most profound analysis of Wagner ever written, Thomas Mann compares the characters of *Parsifal* with the most grotesque imaginings of the Romantics: a castrated magician, a desperate, ambiguous temptress and penitent, subject to cataleptic fits, a love-sick priest, desirous of redemption through a chaste and guileless boy, and this boy himself, a most equivocal hero. (The problematic nature concerning the guardianship of the grail, together with the highly suspect ideal of the purity of the blood, is not our concern here; it is reported that Adolf Hitler claimed: "I build my religion from *Parsifal*. Divine worship in solemn garb. Only in the robes of the hero can one serve God.")[68] Nietzsche had not been taken in by such heroism; in a most perceptive statement he had seen that once the grandiloquent gestures of a figure like Kundry had been stripped away, then something resembling Madame Bovary remained, and the other characters looked much like the little Parisian *décadents*, never more than five steps away from the hospital.[69] Nietsche's tone is light and humorous: he delighted in

68. Quoted in Joachim Fest, *Hitler*, Frankfurt, 1973, p. 683: "Aus *Parsifal* baue ich mir meine Religion. Gottesdienst in feierlicher Form . . . Im Heldengewand allein kann man Gott dienen."

69. Nietzsche, *Werke*, ed. cit., II, 922–3. Nietzsche also delights in speculating on the proximity of Madame Bovary to certain of the Wagner heroines; Hans Mayer (*Richard Wagner: Mitwelt und Nachwelt*, p. 74) surprisingly places Emma Bovary at Lohengrin's side. Both attempt a reconciliation between vision and normality: both fail. There seems to be here a variation on the artist and society theme: Wapnewski (*Der traurige Gott: Richard Wagner in seinen Helden*, Munich, 1978) insists on this dichotomy in Wagner, seeing that there is latent "artistry" not only in Walther von Stolzing, where it becomes realised, but also in Tannhäuser, Lohengrin and Parsifal (p. 92). The *aperçus* of Wapnewski

reminding his readers that Parsifal is the father of Lohengrin and invited them to speculate upon that remarkable act of procreation. More serious issues are faced, however, and in *Nietzsche contra Wagner* the work is rejected as perverse, even immoral, in its prurience: ". . . I despise all those who do not experience *Parsifal* as an attack upon morality."[70] Yet in Monte Carlo Nietzsche heard the prelude to *Parsifal* and, brushing aside his reservations, wondered if Wagner, from a purely aesthetic point of view, had ever written anything better. Wagner's psychological finesse, his skill at synthesising apparently totally disparate states of soul, and his searing intensity convinced Nietzsche utterly of his skill as a craftsman; it was when Wagner spoke of chastity, repentance and redemption that Nietzsche raised his objections, the self-styled "Antichrist" paradoxically seeing in *Parsifal* the greatest affront to Christianity.

"*Parsifal* was to Ulick a revolting hypocrisy, and Kundry the blot on Wagner's life."[71] Ulick Dean, in *Evelyn Innes*, attempts, and ultimately succeeds, in dissuading Evelyn from singing that part in Bayreuth. "In the first act she [Kundry] is a sort of wild witch, not very explicit to any intelligence that probes below the surface. In the second she is a courtesan with black diamonds. In the third, she wears the coarse habit of a penitent, and her waist is tied with a cord; but her repentance goes no further than these external signs . . ." Ulick Dean can believe neither in Kundry's contribution nor in Parsifal's ordination: the guileless fool who killed a swan and refused a kiss with many morbid, suggestive and disagreeable remarks could not be taken seriously. The music of the Flower-maidens, however, was irresistible, as was the ensuing duet: "Music hardly ever more than a recitative, hardly ever breaking into an

and Mayer owe much to Nietzsche here; Mayer, however, is not taken in by "Senta-Sentimentalität" but sees her again in the gallery of those figures created by Lermontov, Mickiewicz and Musset, restless and belonging neither to the past nor the future, crippled by "Weltschmerz" (Mayer, p. 189).

70. Nietzsche, *op. cit.*, II, p. 1053: "Ich verachte jedermann, der den *Parsifal* nicht als Attentat auf die Sittlichkeit empfindet."

71. George Moore, *Evelyn Innes*, p. 148.

air, and yet so beautiful! There the notes merely served to lift the words, to impregnate them with more terrible and subtle meaning; and the subdued harmonies enfolded them in an atmosphere, a sensual mood . . ."[72] But the vulgarly-vaunted Good Friday music was rejected, for Ulick Dean sensed here an insincerity which appalled him: "*Parsifal* . . . is the oiliest flattery ever poured down the open throat of a liquorish humanity."[73] An Elisabeth, an Isolde, a Brünnhilde even, Evelyn could sing, but Ulick Dean's strictures and her own upbringing and religious scruples prevented her from singing in *Parsifal*; it is not as Kundry but as Sister Teresa that Evelyn finds ultimate fulfilment, the true church triumphing over the specious theatricalities of Bayreuth.

It may finally not be too fanciful to claim that John Davidson, who drowned himself in 1909, had Kundry in mind when writing his famous *Ballad of a Nun*, which appeared in the collection *Ballads and Songs* in 1894: the poem is shot through with echoes of *Parsifal* as the nun, torn between the convent and the world, "half maiden, half ghoul" approached the young man and offers herself to him. Her beauty, however, turns to haggardness and the world turns hollow; she returns to the convent in mournful joy, her last moments made radiant by a vision of the Virgin Mary.[74] (And how frequently we meet the "jardin des supplices" at this time, the scarlet and white lilies charged with the religious overtones of the wounds of Christ and the immaculate conception, yet also with perverse defloration and wilful sterility.) But Davidson's nun is a pale creation compared with Wagner's Kundry, part Ahasuerus, part Herodias and part Gundryggia-Valkyrie, that hybrid who exemplifies more than any other creature of decadence the tension between sin and saintliness which the writers and artists of the 1880s and 1890s delighted in portraying. That whole gallery of *femmes fatales* described by Mario Praz in *The Romantic Agony* finds in her its most bizarre climax; the "sex opera" whose

72. George Moore, *Evelyn Innes*, p. 149.

73. Ibid.

74. R.K. Thornton (ed.) *Poetry of the Nineties*, London, 1970, pp. 197–8.

first act is traditionally not applauded because its celebration of the mass is believed to elevate the work above stage conventions, ravished the decadents who exulted in Klingsor's necromancy, and who added the chalice motif to their lakes of blood, their sterile gardens and their moon-bathed swans.[75] The Flower-maidens likewise gave rise to the almost ectoplasmic shapes of women who became flowers and plants in much decadent painting, those wandering shadows floating through an opaque mistiness of landscape with outstretched arms and ill-defined faces. (As late as 1939 Julien Gracq, in the preface to *Au château d'Argol*, stressed the infernal elements of *Parsifal*, the oneiric and chthonic realm from which such a work emerges.) And yet the shimmering vision of the grail itself and the purity of the children's voices from on high, as Verlaine and Rubén Darío knew,[76] gave intimations of a realm of beauty beyond the incense and the seductiveness. George Moore saw in Wagner "... a Turk lying amidst houris ... Scent is burning on silver dishes, and through the fumes appeared the subdued colours of embroidered stuffs and the inscrutable traceries of bronze lamps ...";[77] to others he appeared as the Redeemer himself. Those last words from *Parsifal*, "Erlösung dem Erlöser"— redemption to the Redeemer—were inscribed on a wreath placed on Wagner's grave, an inscription whose unique ambiguity seems an entirely fitting token.

75. The early poetry of Juan Ramón Jiménez provides many examples of imagery derived from Wagnerian decadence; "Tropical" is typical in its climate of breathless sensuality and artifice, where sexual climax is reached in a setting of tropical luxuriance and oppressive heat. *A propos* the Herodias-Salome figure, Wagner most certainly read in Jakob Grimm's *Die deutsche Mythologie* (1835) of the punishment of this monstrous female; after attempting to kiss the head and being rebuffed "die unselige wird in den leeren raum getrieben und schwebt ohn unterlass" (quoted Wapnewski, p. 259).

76. See Rubén Darío, "Wagneriana" in *Obras completas*, V, Madrid, 1953, pp. 1278–9. There are two poems, "Lohengrin" and "Parsifal."

77. George Moore, *Memoirs of my Dead Life*, London, 1906, p. 294.

"This too you ought to read":
Bédier's *Roman de Tristan et Iseut*[*]

Edward J. Gallagher

In 1900, two years before the appearance of the first volume of his monumental, scholarly, two-volume reconstruction and critical study of *Le Roman de Tristan par Thomas: poème du XIIe siècle*,[1] the eminent French medievalist Joseph Bédier (1864–1938) published an award-winning romance entitled *Le Roman de Tristan et Iseut*.[2] The publication of Bédier's adaptation of the legend, according to Mario Roques, not only prompted renewed popular interest in medieval literature, but also inspired a whole series of translations and modern adaptations of medieval

Revised by the author from "*Le Roman de Tristan et Iseut*: Joseph Bédier, *rénovateur* of Béroul and Thomas," *Tristania*, 5.2 (Spring 1980), 3–15, and from "Une reconstitution à la Viollet-le-Duc: More on Bédier's *Roman de Tristan et Iseut*," *Tristania*, 8.1 (Autumn 1982), 18–28. Reprinted and revised with permission.

[*]The quote is taken from a letter from James Joyce to Harriet Shaw Weaver dated 7 June 1926. For the full text, see *Letters of James Joyce*, ed. Stuart Gilbert (New York: Viking Press, 1957), 241–42. Dr. Jane M. Ford called this Joycean reference to my attention.

1. Thomas, *Le Roman de Tristan par Thomas: poème du XIIe siècle*, ed. Joseph Bédier, 2 vols. (Paris: SATF, 1902–1905).

2. Joseph Bédier, *Le Roman de Tristan et Iseut*, 576e éd. (Paris: L'Edition d'art H. Piazza, 1946). All references to this work are to this edition.

425

works.[3] Bédier's adaptation, itself translated into English as early as 1903 by no less a talent than Hilaire Belloc,[4] proved enormously popular and is currently in what is billed as its 576th printing.

Bédier based his retelling of the Tristan legend, intended for the general reader, rather than a scholarly audience, upon a number of diverse medieval sources. In a brief note following Gaston Paris's preface to the romance, Bédier himself describes his text as "très composite" (p. xii). As is well known, the two oldest French versions of the legend of Tristan and Iseut, representing two diverse traditions, the so-called "common" version of Béroul and the "courtly" version of Thomas, both composed in the second half of the twelfth century, have unfortunately not survived intact. Each exists only in rather fragmented form. Extant are a long integral section of the Béroul Tristan[5] and equally long but non-integrated fragments of the Thomas.[6] Thus, no complete early French version of the tale exists. Complete texts have survived: in German by Eilhart von Oberge, imitator of Béroul, as well as in Norse by Brother Robert, whose version of the legend is based on Thomas, as is Gottfried von Strassburg's long—but unfinished—poem. These derivative texts offer some idea of what the complete versions of Béroul and Thomas may have contained. It is upon all of these sources, then, and still others that Bédier drew for his romance.

The extant French texts, being the earliest, are thus the most important in the evolution of the legend. Bédier's research in this area led him, in fact, to posit the existence of a French *Ur-Tristan*, pre-dating both Béroul and Thomas. It was while investigating the relationships among the various medieval

3. Mario Roques, "Chroniques," *Romania*, 49 (1923), 319.

4. Joseph Bédier, *The Romance of Tristan and Iseult*, tr. Hilaire Belloc and completed by Paul Rosenfield (New York: Vintage Books, 1965). Belloc suppressed in the 1903 translation Bédier's chapters V, XIII, XVI, and XVII.

5. Béroul, *Le Roman de Tristan: poème du XIIᵉ siècle*, ed. Ernest Muret, 4ᵉ ed. rev. by L.M. Defourques (Paris: Champion, 1962).

6. Thomas, *Les Fragments du Roman de Tristan: poème du XIIᵉ siècle*, ed. Bartina H. Wind (Leiden: Brill, 1950).

versions of *Tristan* for his scholarly reconstruction of the Old French *Tristan* of Thomas that Bédier continued a study, begun as early as 1886,[7] of the Celtic sources of the legend and came to the conclusion that there must, indeed, have existed an even earlier French *Tristan*, called by him the archetype or primitive poem, now lost, that predated and served as a source for both Béroul and Thomas. In Volume II of his *Roman de Tristan par Thomas*, Bédier reconstructs, episode by episode, the probable contents of this *Ur-Tristan*.

Despite the enormous success of Bédier's *Roman de Tristan et Iseut*, the complex question of the versions of the Tristan legend upon which he drew for his plot and characters and the existence of his hypothetical *Ur-Tristan*, there exists no critical study of the precise sources used for his 1900 romance; no study of its unity given Bédier's use of elements from both the common and courtly versions; no study of its relationship to the hypothetical *Ur-Tristan*. In fact, very little at all has been written about Bédier's own version, and that which has is often far from accurate.

With few exceptions, though, critical reaction to Bédier's *Roman de Tristan et Iseut* has been glowing. And, with few exceptions, it repeats Gaston Paris's statements in his preface to the romance: first, that Bédier's objective—accepted as accomplished—was to "faire revivre pour les hommes de nos jours la légende de Tristan sous la forme la plus ancienne qu'elle ait prise, ou du moins que nous puissions atteindre en France" (p. iii) and, second, that Bédier succeeded in creating a unified story from diverse and disparate sources. "[I]l a refait à ce tronc une tête et des membres," Paris writes, "non pas par une

7. See Rosemary Picozzi, *A History of Tristan Scholarship*, Canadian Studies in German Language and Literature, 5 (Berne and Frankfurt: H. Lang, 1971), 11–59, where she presents a review of the scholarship devoted to "The Study of Origins" of the Tristan legend from the early nineteenth century to the present. On p. 41, she mentions Bédier's early interest in the subject and cites his article "La Mort de Tristan et d'Iseut, d'après le manuscrit fr. 103 de la Bibliothèque Nationale, comparé au poème allemand d'Eilhart d'Oberg," *Romania*, 15 (1886), 481–510, in which he suggests the possibility of reconstructing the archetypal French poem.

juxtaposition mécanique, mais par une sorte de régénération organique, telle que nous la présentent ces animaux qui, mutilés, se complètent par leur force intime sur le plan de leur forme parfaite" (p. iv).

Jacques Monfrin, for example, calls Bédier's *Roman de Tristan et Iseut* "une admirable réconstitution de ce qu'avait dû être le premier Tristan."[8] Gabriel Bianciotto, editor of extracts of various versions of the legend, lauds Bédier's reconstruction as "remarquablement fidèle à l'esprit du mythe."[9] In 1971, Michael Batts, in his *Gottfried von Strassburg*, writing on twentieth-century translations of Gottfried's *Tristan*, goes on to evaluate Bédier's novelistic retelling of the legend in these terms:

> Of much greater interest is another modernization of the medieval legend, which appeared in 1900, from the pen of the great French scholar Joseph Bédier. Bédier had long been studying the relationship between various medieval forms of Tristan and, in addition to publishing the results of his work in learned journals, he embodied the fruits of his research in a re-creation of the "original" form of Tristan, basing himself on the extant fragments of Béroul, Thomas, and others. His "translation" is couched in such uniformly excellent style that the work was enthusiastically received by critics and awarded a prize by the Académie Française. . . .[10]

Besides Gaston Paris's twelve-page preface, one finds a single brief scholarly review, which appeared soon after publication of the romance, by the German medievalist and Tristan expert Wolfgang Golther, who, while praising Bédier's art as a novelist, states, without supporting his contentions, that Bédier neither recreated the oldest Tristan poem ("Meines Erachtens hat Bédier freilich keineswegs die älteste Tristandichtung wiederhergestellt") nor succeeded in writing a

8. Jacques Monfrin, "Tristan, Yseult . . . et Joseph Bédier," *NL* (13 février 1964), 7.

9. Gabriel Bianciotto, éd., *Les Poèmes de Tristan et Iseut* (Paris: Nouvelles Classiques Larousse, 1968), p. 10.

10. Michael Batts, *Gottfried von Strassburg* (New York: Twayne, 1971), p. 130.

unified work. For Golther, the contents of Bédier's romance are pulled together from incompatible sources. He writes in this regard: "Aber die Einheitlichkeit liegt doch mehr in der Darstellung als im Inhalt, der mir etwas willkürlich aus unvereinbaren Vorlagen zusammengetragen scheint."[11]

In light of the lack of any but the most perfunctory scrutiny of Bédier's version and because of the fundamental disagreement between Golther's evaluation and the opinions of all those others who have written about Bédier's achievement, a number of questions remain to be answered about Bédier's *Roman de Tristan et Iseut.*

I should like simply to suggest some of those areas of investigation and then attempt to offer some answers without certainly, within the space allotted here, being able to do more than scratch the surface of this vast amount of highly complicated material, for the field of Tristan studies is a highly researched one, and even the most closely focused and narrowly delineated studies have often, of necessity, to be *travaux de longue haleine.*

First, then, since several critics conceive of Bédier's version not as an idiosyncratic composite, but rather as the archetype or, at the very least, as an edition of some authentic text, what is the relationship of Bédier's 1900 romance to his 1905 reconstruction of the *Ur-Tristan*? Secondly, which episodes, motifs, themes, etc. did Bédier adapt from the two diverse traditions represented by Béroul (Eilhart) and Thomas (Gottfried and Robert) and, more importantly, what problems of coherence of plot and characterization result from his eclecticism? Finally, what does Bédier's *Roman de Tristan et Iseut* reveal about the reciprocal influence within one scholar's mind of philological reconstruction and literary creativity?

Bédier writing his romance was, we shall see, much freer than Bédier attempting rigorously—as he contended—to reconstruct the archetype. And so while, with rare exception, he adhered to the same general outline of episodes in both, in the romance his constraints *within* each episode were much less rigid

11. Wolfgang Golther, rev. of *Le Roman de Tristan et Iseut* by Joseph Bédier, *ZFSL*, 23 (1901), 123.

and the contents of individual chapters were, in fact, often dictated by taste or aesthetic principles of dramatic tension, simplicity, grace, balance or richness, and not by any servile adherence to the contents of the hypothetical, reconstructed archetype.

What were Bédier's tastes and feelings—his *partis pris*— and what effects did these have on the nature and contents of his *Roman de Tristan et Iseut*? The key question then is: How, in fact, did he himself conceive of, how did he understand, the Tristan story? Here is Bédier asking and answering this very question: "What did Béroul or Gottfried von Strassburg understand," he asks, "when they told their story long ago, for the men of earlier times and for the men of today? What are Tristan and Iseut?" And he answers: "They are lovers who drank a philtre and, held captive by its power, suffered the fatality of this love against their will. The bitter conflict of love and law; this is the whole of the legend."[12]

Before considering the relationship between Bédier's 1905 reconstruction and his 1900 *Roman de Tristan et Iseut*, several remarks about the reconstruction are in order. Bédier prefaced his chapter entitled "Détermination, épisode par épisode, de la version donnée par le poème primitif" with a statement of the method by which he established the contents of the archetypal poem. And a curious method it was: first, intuitive; then, only subsequently, scientific, as Bédier himself clearly states:

> Nous avons suivi, d'abord, comme de juste, la méthode coutumière: nous comparions, trait pour trait O, R, B, T, F [Oberge, *Roman en prose*, Béroul, Thomas, *La Folie Tristan*[13]], comme on fait en pareil cas, c'est-à-dire que, pour chaque trait, nous nous demandions: de ces deux, trois ou quatre variantes, laquelle peut prétendre à la priorité? Mais quels critères peuvent décider de

12. Joseph Bédier, "The Legend of Tristan and Isolt," *International Quarterly*, 9 (1904), 110. The article (103–28), published in English, was translated by Susan Hilles Taber.

13. What Bédier calls the "Roman en prose" is, of course, the French Prose *Tristan*, and the *Folie Tristan* is the text now referred to as the *Folie Tristan d'Oxford*.

l'ancienneté d'un trait? Son "tour" plus archaïque, son
accord plus exact et plus logique avec les traits
voisins. . . . Or . . . après avoir maintes fois essayé et repris
ces exercices, nous avons cru, non sans surprise, constater
ceci: toutes les fois que la comparaison pouvait porter sur
trois textes au moins, les traits que, pour des motifs de
goût, de sentiment, de logique, nous estimions primitifs,
étaient des traits attestés par les trois versions ou par deux
au moins d'entre elles. . . . Il n'y avait d'exception réelle
que pour Eilhart et Béroul, qui formaient groupe parfois
pour donner une leçon moins satisfaisante que les versions
concurrentes. . . . Par suite, notre entreprise changeait de
face. Il ne s'agissait plus, pour des raisons logiques ou
des impressions de goût, toujours suspectes, de choisir
entre les diverses versions de chaque épisode les traits qui
nous semblaient primitifs. Il suffisait de dresser,
mécaniquement, une *Table des concordances*. . . . A la table
des concordances, nous mettons *tout* ce qui est donné par
deux versions au moins. . . . Ce travail, où jamais
n'intervient notre choix, suffit pour restaurer un récit
continu, excellent: tout ce qui est à la table des
concordances apparaît comme primitif. . . . (Bédier,
Thomas, II, 191–93)

Gertrude Schoepperle, as early as 1913, criticized Bédier's
method on two accounts: first, "it was not until he had reached
his conclusions, that the idea of presenting them in a table of
concordances occurred to him"; secondly—and here is a much
more serious objection than the first—"his classification of the
texts—*y* (Eilhart-Béroul), Thomas, the *Folie*, and the Prose
Romance—as independent derivatives from a common source, is
founded on considerations of taste, sentiment, and logic. On this
classification the tables are entirely dependent."[14]

This brief review of Bédier's method of reconstruction and
Schoepperle's critique of it are important for a consideration of
Bédier's *Roman de Tristan et Iseut*. It will help to explain the
presence of two specific elements in the version, elements totally
incompatible within the framework of the legend as otherwise

14. Gertrude Schoepperle, *Tristan and Isolt: A Study of the Sources of
the Romance* (Frankfurt and London, 1913), 2nd ed., Roger Sherman
Loomis (New York: Franklin, 1959), I, 67–68.

construed, but included in the romance precisely, as Professor
Schoepperle notes in regard to the 1905 reconstruction, for
reasons of personal preference.

It may be noted that this role of individual taste, personal
predilection, and, more specifically, a desire for concision must
also explain the absence from the version of the following two
episodes considered authentic in the reconstruction: "La Harpe
et la Rote" and "Les Faulx," labeled by Bédier respectively as
episodes H and L. And again it can only be individual taste
which dictated the inclusion in the *Roman de Tristan et Iseut* of
briefer episodes, motifs, and incidents rejected from the
reconstruction; to cite but two: the Petit Crû episode and what
Bédier describes as "le gracieux épisode de Dinas de Lidan
endormi sur son cheval et que Tristan ne veut pas réveiller, parce
que peut-être Dinas rêve à son amie" (II, 281). The very choice of
the adjective—*gracieux*—suggests clearly what appeal these two
particular episodes held for Bédier who elected in using them to
borrow from Gottfried and Eilhart respectively.

It is, however, as noted above, a scrutiny of two specific
elements—the nature of the philtre in Bédier's 1905
reconstruction and in the *Roman de Tristan et Iseut* and the
inclusion in both of the episode of the "Jugement par le fer
rouge"—which points up most clearly not scientific method but
personal preference as Bédier the philologist's principle of
reconstruction. It is, in fact, by means of a close analysis of
precisely these very two aspects, the philtre and the ordeal, that
Jean Frappier differentiated between the two distinct traditions
of the Tristan myth represented by Béroul and Thomas.[15]

In the "common" version, the sole cause of the love
between Tristan and Iseut is the love portion—served to them by
error—which, at the same time, frees them from any moral
responsibility for their adultery. As Frappier writes: Béroul's
"idée profonde était que les passions d'amour ont leur mystère,
enlèvent sa liberté à l'homme, et qu'on peut en aimant être
innocent et coupable à la fois" ("Structure et sens," 269).

15. Jean Frappier, "Structure et sens du *Tristan*: version commune,
version courtoise," *CCM*, 6 (1963), 255–79; 441–54.

Bédier had found the very idea of a mechanistic philtre of limited duration—three years according to Béroul, four for Eilhart—unacceptable, describing it once in a conversation with Eugène Vinaver as "cette pharmacie."[16] In order to account for the limited philtre attested by both Béroul and Eilhart, Bédier posited as their common source a text labeled *y*, intermediary between them and the primitive poem. And this for reasons which he himself admitted could be characterized as "raisons de goût et de sentiment" (II, 237).

Along with Schoepperle, Vinaver, and others, Frappier rejects the need for Bédier's *y* and affirms, moreover, a philtre of limited duration as primitive, offering three convincing reasons for its necessity. A philtre of diminishing efficacy not only serves to allow a moral conflict to arise in the lovers' minds between law and the duties of their social state, on the one hand, and fatal, excusable passion, on the other, and serves to suggest the psychological reality of a diminution over time of love's intensity, but also is required as a literary necessity to permit Tristan and Iseut, otherwise immune to suffering under the effects of love drink, to leave the *forêt du Morois*.

Thomas, on the other hand, "a voulu ne pas donner d'autre cause initiale à la passion des amants que leur amour lui-même. Il lui répugnait que le philtre apparût comme un agent extérieur, matériel. Aussi a-t-il vu en lui une image idéalisée de l'amour accepté, désiré, ou plus exactement peut-être, un garant symbolique de l'amour immuable, éternel. . . , la vertu du philtre et de l'amour ne perdant rien de sa plénitude ni de sa permanence" ("Structure et sens," 273).

In Bédier's *Roman de Tristan et Iseut*, the philtre is, as in Thomas, an unlimited one, yet as in Béroul and Eilhart, Bédier's lovers leave the forest, just as if under the influence of a philtre of diminishing effect. It must be noted, though, that Bédier, while ignoring the waning effects of the philtre as a necessary stimulus for their decision to leave the forest, does subsequently quite plausibly explain this decision to leave as based on the conflict, clearly perceived by the lovers, between their present

16. Eugène Vinaver, *The Rise of Romance* (New York and Oxford: Oxford University Press, 1971), p. 45.

exiled state and their essential societal functions, now abandoned. Tony Hunt comparing Abelardian Ethics and Béroul's *Tristan* has written: "I maintain that the diminution of the potion and its attendant ambiguity are indispensable if the conflict between the lovers and society is to be viewed in moral terms."[17] Bédier obviously had difficulty reconciling an unlimited philtre and this moral conflict, yet he undoubtedly felt that each was essential to the legend.

Bédier held other opinions about the nature of the Tristan legend related to the philtre which likewise lead him both into alterations of the texts he used for the *Roman de Tristan et Iseut* in order to fit them into his vision of the legend and into certain logical inconsistencies; to wit, he posited in his writings what he calls two "données primitives et essentielles"; first, the fact that "tant que Tristan et Iseut n'ont pas bu le philtre, ils se voient impunément; ils restent indifférents l'un à l'autre;" second, "l'idée d'une puissance hostile et fatale, qui, contre toute prévision humaine, pousse à leur insu Tristan et Iseut l'un vers l'autre" (II, 212–13).

To underscore his point—"ils se voient impunément"—Bédier, in fact, escalated indifference to hatred—at least on Iseut's part—in the bridequest episode. In his romance, Tristan in an equivocal declaration to Iseut suggests he has come to Ireland to win her for himself. Speaking of the swallows who had brought the golden strands of hair to Marc, he says: "J'ai cru qu'elles venaient m'annoncer paix et amour. C'est pourquoi je suis venu te quérir par delà la mer" (p. 38). Upon learning she is to be Marc's bride, not Tristan's as she had inferred from his declaration, Iseut "frémissait de honte et d'angoisse. Ainsi, Tristan l'ayant conquise, la dédaignait; le beau conte du Cheveu d'or n'était que mensonge, et c'est à un autre qu'il la livrait . . ." (p. 42).

Bédier must have considered the need to underscore a total lack of sexual attraction between the lovers prior to the philtre scene more important than the need for a hostile power pushing them toward each other, for at the beginning of this

17. Tony Hunt, "Abelardian Ethics and Beroul's *Tristan*," *Romania*, 98 (1977), 514.

same quest episode he abandoned this, his second "donnée primitive et essentielle," when Tristan, setting out in search of the Belle aux Cheveux d'Or, orders the ship to Ireland. Bédier thus altered Eilhart's motif of the "voyage à l'aventure" in order, apparently, to make Tristan, who is clearly amorously indifferent to Iseut, the prime mover in the quest. There is no chance storm in Bédier's romance. Rather than sailing off "à l'aventure," like Eilhart's Tristan in hopes somehow of finding the woman whose strand of hair the swallows have brought to Marc, Bédier's Tristan tells the pilot: "Ami, cingle vers l'Irlande, droit au port de Weisefort" (p. 29). Tristan knowingly and of his own volition sets off to procure Iseut for his uncle.[18]

What are the effects of Bédier's divergence here from the "voyage à l'aventure" and the concomitant storm, that "puissance hostile et fatale" which in Eilhart unites the lovers? In addition to avoiding a repetition, so soon after the scene of the wounded Tristan set adrift at sea, of the motif of the aimless voyage with an unexpected happy conclusion, Bédier can, more importantly, highlight both Tristan's absolute fidelity to Marc and, especially, his utter indifference to Iseut for whom, at this point, he has no feelings whatsoever. In his version of the romance, Bédier has chosen the hero himself, rather than some "puissance hostile et fatale," to set into motion the events which will ultimately lead to Tristan's encounter with Iseut after which none of the major characters will ever again be the same.

The second element of Bédier's *Roman de Tristan et Iseut* to be considered—his treatment of the theme of divine intervention—is best demonstrated in the judgment scene after the lover's return from the Morois. In having his Iseut at the Gué Aventureux not only swear her innocence, with her hand on

18. Bédier's use of the "deliberate" departure differs, however, from this same motif in the Prose *Tristan* (see II, 213–14, *variante a*) where it is a cruel and jealous Marc who orders Tristan to Ireland hoping he will be killed there. See also Bédier, *Thomas*, II, 216–17, for a discussion of the same episode in Thomas where the barons, in an effort to have Tristan killed, insist, since Marc has accepted to marry a king's daughter, that she be none other than Iseut of Ireland, the most dangerous for the hero to procure.

saints' relics, but also undergo the ordeal of the *fer rouge*, Bédier borrowed from the "courtly" tradition an element clearly incompatible with the Béroul-Eilhart framework to which, in the main, he adheres.

Frappier conveniently sums up the role of God in the "common" version in this way: "Dans la version commune, en vérité, l'intervention de Dieu au profit des amants reste un élément subjectif, une foi, une présomption. Possibilité ardemment espérée, probabilité si l'on veut, jamais on ne la voit se traduire en acte, objectivement, devenir certitude.... Malgré tout l'élan de sa sympathie envers les amants, Béroul n'a nullement brisé la construction calculée, subtile et forte à la fois, de son modèle: il a préservé soigneusement, sinon renforcé, un pathétique issu d'un espoir invincible et du silence de Dieu" ("Structure et sens," 447).

It is precisely this *silence de Dieu* which Gottfried (presumably following Thomas) and then Bédier broke in the scene of the queen's ordeal. In Gottfried and in Bédier, not only does she swear in a *serment ambigu* her innocence, but this innocence is confirmed, her protests of guiltlessness substantiated, the moral probity of her love for her husband's nephew affirmed, when having grasped the red hot iron, her hand remains unscathed. "Quelle méprise, ou quel parti pris," exclaims Frappier, "si l'on estimait équivalents serment purgatoire [Béroul-Eilhart] et cette ordalie [Thomas-Gottfried]...! La différence est saisissante: d'un côté une épreuve où Dieu est silencieux, de l'autre une épreuve où Dieu déclare sa sentence" (p. 452).

Bédier's use of this motif of the ordeal is indeed curious, for not only does its presence subvert the nature of the *version commune*, but it represents by his own admission nothing more quite possibly than "une de ces végétations parasites qui se sont développées autour de *l'estoire*" (II, 265).

Bédier did not have, it would seem, a clear sense of the fundamental disparities between the "common" version, on the one hand, and the "courtly," on the other, differences lucidly pointed out by Frappier for whom "version commune et version courtoise correspondent à des moments ou à des niveaux différents de la civilisation médiévale" (454) and reiterated by,

among others, Moshé Lazar who writes that "seule la fidélité à l'esprit particulier de chacun des textes peut donner une idée claire et vraie des divers courants idéologiques qui exercent leur influence sur la légende de Tristan."[19]

One may note too that in the final chapter of his romance, where Bédier follows Thomas's dramatic narrative, he does not hesitate to add four other specific elements from sources not attested in his 1905 reconstruction as primitive. From Eilhart whose narration, for Bédier, "est ici d'une simplicité profonde et sublime," he borrows the confrontation, over Tristan's corpse, of the two Iseuts—what Bédier calls "un trait si original." From the Prose Romance of MS 103 he takes the murder of Andret, one of the felons, considered "ancienne" if not "primitive" because of its brutality. Because Iseut's dream of the bloodied boar in her lap resembles "un de ces songes d'animaux si fréquents dans nos plus anciennes épopées, ce récit du roman en prose," writes Bédier, "doit donc être ancien." And finally the motif of the *ronce*—which grows from Tristan's grave and plunges into Iseut's—which Bédier describes as both a "symbole presque païen" and "cette touchante légende"—is included, for it comes, according to Bédier, from "une tradition bien plus ancienne qu'Eilhart."[20]

Turning now from Bédier the reconstructive scholar and philologist and his conception of the contents of the primitive French *Tristan* to Bédier the author, the *conteur*, of one version of the Tristan story, one notices immediately two principal traits which characterize Joseph Bédier *écrivain*. One—prompted perhaps by his interest in producing a written rather than an oral narrative—is the tendency to simplify, to streamline, to avoid the long developments and, at times, redundancies of both Béroul and Thomas. Bédier *conteur* clearly states his conscious concern for succinctness in the first chapter of his version. Quoting directly Brother Robert—and curiously so, since Bédier criticizes Robert's tendency to abbreviate—he prefaces a rapid

19. Moshé Lazar, *Amour courtois et fin'amors dans la littérature française du XIIe siècle* (Paris: Klincksieck, 1964), p. 152.

20. All quotations in this paragraph are from Bédier, "La Mort de Tristan et Iseut," cited in n. 7 above.

highlighting of Rohalt's search for the young Tristan with these words: "Seigneurs, il sied au conteur qui veut plaire d'éviter les trop longs récits. La matière de ce conte est si belle et si diverse: que servirait de l'allonger? Je dirai donc brièvement comment . . . " (pp. 11–12).

There are times, however, when Bédier both as scholar and as novelist wishes to retain and explain to his readers—either specialists or non-specialists—an aspect of medieval belief or practice. For example, when the storm forces the Norse pirates to free Tristan, Gottfried (following, we suppose, Thomas) writes of the pirates' reaction: "Cette tempête, tous ces périls nous viennent de notre propre péché. Oui, si nous les subissons, c'est pour avoir enlevé Tristan à ses amis" (Bédier, *Thomas*, I, 38). Bédier the scholar elucidates the text with a footnote: "Cet épisode repose sur une croyance populaire bien connue. La mer porte à regret les nefs felonnes, et d'ordinaire on ne peut l'apaiser qu'en lui livrant le coupable" (I, 38, n. 1). He then adds three references to consult for similar passages. Bédier the novelist uses no footnotes, of course, but conveys the same information on medieval beliefs by means of one of the many authorial interventions in the *Roman de Tristan et Iseut*: "Mais c'est vérité prouvée, et tous les mariniers le savent: la mer porte à regret les nefs félonnes, et n'aide pas aux rapts ni aux traîtrises" (p. 5).

In order to suggest some of the consequences of Bédier's desire to be brief, of his marked tendency to *raccourcir*, I should like to examine briefly one scene in Bédier's version (pp. 59–74) based on the first extant section of Béroul's *Tristan* where Béroul recounts the episode of the rendez-vous of the lovers, with Marc perched in the pine observing them.[21] Having first presented the clandestine meeting of the pair mainly through long dialogue exchanges between Tristan and Iseut, Béroul then replays the scene four more times as each of the three characters there present recounts the event to another: Iseut to Brangien (vv. 315–

21. Jean Charles Payen, ed. and tr., *Tristan et Iseut: les Tristan en vers* (Paris: Garnier Frères, 1974), pp. 3–19; Béroul, vv. 3–546. All subsequent quotations from Béroul or Thomas are from this most useful edition.

55), Tristan to Governal (vv. 356–59), Iseut to Marc (vv. 360–450), and finally Marc to Iseut (vv. 451–80).

Bédier deletes completely three of these four retellings of the tryst scene from his version and merely refers to the first, Iseut's recounting to Brangien, in these words: "La reine lui dit l'aventure" (p. 72). Bédier alludes to this particular reprise of the scene solely, it would seem, in order to retain the servant's thematically important conclusion that the innocent lovers were indeed saved from harm by God who for them worked a great miracle. Similarly, Bédier reduces markedly the end of this episode summarizing Béroul's vv. 481–546 in a short paragraph, the essence of which is contained in one brief sentence at the beginning of the following chapter: "Le roi Marc a fait sa paix avec Tristan" (p. 74). In so simplifying, Bédier *conteur* has in no way lost any essential element of the plot and has, in fact, enhanced the coherence and quickened the tempo of the tale.

Through another series of deletions and abridgments within the same scene, however, Bédier has greatly reduced the role and, consequently, altered the personality of one of the principal characters. All references to Marc's reaction to the scene he has just witnessed (Béroul, vv. 234–95) are radically reduced by Bédier to two disconnected sentences: "Dans la ramure, le roi eut pitié et sourit doucement" (p. 71) and "Il [Frocin] y [dans les étoiles] lut que le roi le menaçait de mort" (p. 73). Gone completely are Marc's expressions of rage against the evil dwarf who by getting him to climb into the tree has made a fool of the king. Béroul's Marc plans Frocin's punishment in brutal detail: first, hanging; then, burning, so that as a result

> Par moi avra plus dure fin
> Que ne fist faire Costentin
> A Segoçon, qu'il escolla
> Qant o sa feme le trova. (vv. 253–56)

Reduced also by Bédier from nine (in Béroul) to two are Iseut's fearful statements that Marc would kill her should he discover the lovers together. Bédier's Iseut says simply: ". . . il ferait jeter ma cendre aux vents!" (p. 70) and again: "je risque la mort honteuse" (p. 72). Yet in Béroul, she expresses fear of death much more frequently and a death inflicted by quite brutally explicit means: dismemberment (v. 54), burning on a pyre (v.

171), and decapitation (v. 423). While Bédier certainly did not
exclude from his version all Béroul's savage and hence primitive
passages—the most striking, of course, are those describing how
the felonious barons are dispatched—he did, and deliberately, it
would seem, modify those associated with King Marc. It cannot
be by chance either that while in Béroul all three principals—
Marc included—refer to the king as a fool in the course of the
rendez-vous under the pine episode (vv. 106, 249, 284 and 287),
no such epithet is applied to him in Bédier's *Roman de Tristan et
Iseut*.[22]

Bédier has attempted, it would seem, to make not only
Marc but all three of his major characters more sympathetic.
Certainly this is the effect of Bédier's reduction of Marc's role in
the tryst scene to two sentences. Likewise, by deletions Bédier
managed to downplay the deception perpetrated by Tristan and
Iseut, for such, in fact, seems clearly to be the effect of his not
adopting the four repetitions of their consciously played scenario
under the pine. From his transformation of just one line from the
beginning of the scene in Béroul's text, Bédier succeeds in
presenting from the outset a much less devious Iseut. Bédier
renders Béroul's description of Iseut "Or fait senblant con s'ele
plore" (v. 7) as "Elle tremble et pleure" (p. 70).

When adapting Thomas's *Tristan*, Bédier likewise cuts
radically when he considers the text too verbose, as in the case of
Tristan's sensitive and moving—but lengthy—analyses of his
own feelings and those of Iseut, Marc, and Iseut aux Blanches
Mains as he ponders the prospects of marrying this second Iseut.
Bédier completely suppresses here what he calls Thomas's
penchant for "scrupules rationalistes" (II, 212). In the *Roman de
Tristan et Iseut*, Tristan hesitates not at all, reflects not an instant,
when he accepts Duke Hoël's offer of his daughter in marriage:
"Prends-la, je vous la donne." Tristan responds laconically "Sire,
je la prends" (p. 164). In Thomas, his ratiocinations run to well

22. Recent studies of Béroul's characterization of Marc include
Colette-Anne Van Coolput, "Le roi Marc dans le *Tristan* de Béroul," *Le
Moyen Age*, 84 (1978), 35–51; Peter S. Noble, "Le roi Marc et les amants
dans le *Tristan* de Béroul," *Romania*, 102 (1981), 221–26; and Krystyna
Kasprzyk, "La Pitié de Marc," *Marche romane*, 32 (1982), 15–24.

over 650 lines in the Sneyd fragment. Yet, when Thomas writes more compact, more succinct interior monologues or psychological self-examinations like those of Iseut, her approach to Brittany and her attempt to cure Tristan's poisonous wound frustrated, Bédier willingly includes them in his tensely dramatic final chapter.[23]

Abridgement (for whatever reason) is, by definition, negative, that is, quantitatively reductive. What did Bédier bring to the legend? What are his own positive contributions, his novelistic talents, which might justify Georges Duhamel's statement that "Quant à . . . Joseph Bédier, il a su mesurer et faire vibrer une prose exquise qui tire sa valeur poétique et de la beauté des descriptions et des pensées, et du choix des mots, des rythmes, plutôt que d'une cadence imposée."[24]

I should like to examine two passages to suggest some aspects of Bédier's narrative technique and then describe his invention of images and his repeated use of certain motifs which create a richer and more tightly unified romance.

Consider in Bédier's 1905 reconstructed Thomas (in Gottfried and in the Saga as well) the unpoetic and merely factual description of Tristan set ashore by the Norse pirates: ". . . bientôt ils atterrissent, jettent l'ancre, déposent Tristan sur la grève. Ils lui donnent du pain et quelques vivres: 'Que Dieu, lui disent-ils, garde ton corps et ta vie!' Sur quelle terre

23. Bédier's final chapter follows in the main Thomas's version with the interesting addition from Béroul (via Eilhart) of the presence of Iseut aux Blanches Mains at the scene in which Iseut la Blonde finds Tristan dead. Bédier obviously would not have agreed with Pierre Jonin (*Les Personnages féminins dans les romans français de Tristan au XII^e siècle: Etude des influences contemporaines* [Gap: Ophrys, 1958], p. 53) who writes that "Eilhart témoigne cependant d'une certaine maladresse car elle [cette scène où Iseut aux Blanches Mains joue un rôle] empêche l'attention de se concentrer sur les deux amants." The confrontation of the two women, albeit brief, strikes me as much more dramatic while this juxtaposition of their individual reactions points up the quite dissimilar personality of each.

24. George Duhamel, Préface, *Le Roman de Tristan et Iseut par Joseph Bédier* (Paris: Imprimerie Nationale; André Sauret, éditeur, n.d.), pp. 13–14.

l'abandonnaient-ils ainsi? Ils l'ignoraient. Ils remettent à la voile et s'éloignent" (I, 38). Compare this with Bédier's evocation of simultaneous motion in which he also reiterates the thematically important positive role of the sea, and highlights the young, abandoned Tristan by describing *him* last rather than the pirates:

> . . . [ils] parèrent une barque pour le déposer au rivage. Aussitôt tombèrent les vents et les vagues, le ciel brilla, et, tandis que la nef des Norvégiens disparaissait au loin, les flots calmés et riants portèrent la barque de Tristan sur le sable d'une grève (p. 5).

Consider, likewise, the combat between Tristan and the Morholt. In Eilhart, Gottfried, and the Prose *Tristan*, the battle is described—usually at length and in great detail—and its course and outcome "observed" by both Cornish and Irish spectators and, consequently, by the reader. Bédier had the happy idea of abandoning the usual direct narrative point of view and of merely stating that "Nul ne vit l'âpre bataille" (p. 18).[25] Not only can Bédier thus avoid describing for his modern audience the actual battle, which he may well suspect would be of little interest to them, but he succeeds in creating a heightened aura of suspense since in his version the ship that returns from the island is the Morholt's, causing the Irish to rejoice, the Cornishmen and women to lament. Yet these emotions are short-lived and soon reversed when it is Tristan who is sighted at the helm. The scene will, it seems, end happily after all, as Tristan is feted by the Cornish children he has just saved from bondage. Yet, not having observed the battle, neither the folk of Cornwall nor the readers know of Tristan's actual physical condition until he arrives before the king where "il s'affaissa entre les bras du roi Marc: et le sang ruisselait de ses blessures" (p. 20). Bédier makes strikingly effective use of these rapidly accumulated *péripéties*.

Bédier elsewhere artfully underscores thematic or metaphoric parallels where his sources do not choose to or, more

25. This change is not unlike Flaubert's change in narrative point of view in the *fiacre* scene at the beginning of part three of *Madame Bovary*.

likely, did not think to. Here again one can well appreciate the craft of Bédier *l'artiste*. At one point, some time after Marc's reconciliation with Iseut, the king, plagued again by the accusations of the barons, returns to Iseut furious after hearing their demand that she prove her innocence. In Béroul, Iseut sees her husband's face:

> Mot la vit et cruel et fiere,
> Aperçut soi qu'il ert marriz.
> Venuz s'en est aeschariz:
> "Lasse, fait ele, mes amis
> Est trovez: mes sires l'a pris." (vv. 3132–36)

Bédier adds *one* clause of his own making to Iseut's reaction. After writing that she "vit ses nobles traits tourmentés par la colère," he adds "tel il lui était apparu jadis, forcené, devant le bûcher" (p. 131), thus, explicitly recalling the earlier scene to explain Iseut's fear, underscoring her repeated vulnerability and the precarious nature of her situation, and reiterating an essential trait of Marc's character. One clause, but how poetically effective!

The most striking example of this technique of both enriching and tying together two scenes by means of imagery involves the final scene of Bédier's romance, with its central motif borrowed from MS 103: "De dedens la tombe Tristan yssoit une ronche belle et verte et foillue qui aloit par dessus la chappelle, et descendoit le bout de la ronche sur la tombe Ysoult et entroit dedans."[26] In Bédier, it is "une ronce verte et feuillue, aux forts rameaux, aux fleurs ordorantes" (p. 220). Unlike any of his sources, Bédier unmistakably establishes the relationship between this image of enduring union and the philtre. Earlier in his romance, Bédier had suggested the psychological effect of the love drink on Tristan through the use of this same image, in the scene aboard ship when the two by mistake drink the potion: "Il semblait à Tristan qu'une ronce vivace, *aux épines aiguës, aux fleurs odorantes*, poussait ses racines dans le sang de son coeur et

26. Cited by Bédier, "La Mort de Tristan et Iseut," 509. See also Renée Curtis, "Bédier's Version of the *Prose Tristan*" in her *Tristan Studies* (Munich: Fink, 1969), 58–65.

par de forts liens enlaçait au beau corps d'Iseut son corps et toute
sa pensée, et tout son désir" (p. 47; my emphasis). In death, the
metaphor is concretized and yet transformed at the same time.
There is joy and, finally, union; there are still *fleurs odorantes*. But
no longer suffering nor separation; there are not longer any
épines aiguës. This image of the *ronce* allows each of these key
scenes to echo the other in modulated resonance.

Bédier clearly chose not to use Thomas's much more direct
and less metaphoric reprise of the philtre motif when his Iseut on
the point of dying says: "E venue sui à la mort / Del meïsmes
beivre ai confort!" (vv. 3111–12). It is possible that the inspiration
for Bédier's floral image may have come in part from Gottfried
who writes about the effects of the love drink this way: "chacun
des deux amants reconnut, comme il arrive en telle occurrence
que *quelque germe d'amour* avait pénétré le coeur de l'autre"[27] and
elsewhere in a general disquisition on love that it "bears roses as
well as thorns and solace as well as trouble."[28] Still, Bédier's use
of the image of the *ronce* is highly original and through it he
consciously and poetically established a connection between the
beginning of love and the death scene, a *rapprochement* already
announced in the romance's opening sentence: "Seigneurs, vous
plaît-il d'entendre un beau conte d'amour et de mort?" (p. 1).

That Bédier, perhaps more clearly than any of his
predecessors, realized the importance of emphasizing the
connection between these two key scenes is suggested by his
own highly subjective and, indeed, fanciful interpretation of the
meaning of Eilhart's conclusion. Writing of "le beau conte du cep
de vigne et du rosier qui s'enlacent inséparables sur les tombes
des amants," Bédier maintains that "la sève de ces plantes
merveilleuses, ce sera encore le vin herbé" (II, 238–39). In
Gottfried, commonplaces; in Eilhart, one beautiful, yet isolated
image; in Bédier, powerfully evocative and strikingly resonating
images.

Bédier in his role of *rénovateur* of the Tristan material
exhibits a second trait worth noting. He demonstrates a marked

27. Quoted by Bédier, I, 154.

28. Gottfried von Strassburg, *Tristan*, tr. A.T. Hatto (Baltimore:
Penguin Classics, 1960), p. 203.

penchant for a somewhat Victorian treatment of sexuality and thus loses some of the quick wit and ribald humor so typical of his medieval models. In this regard, however, Bédier seems much less marked by his times than his mentor Gaston Paris who in the preface to the *Roman de Tristan de Iseut* declares, in this now curiously dated style, that the story of Tristan and Iseut "a versé jadis, on n'en saurait douter, dans plus d'une âme un poison subtil, et aujourd'hui encore, préparé par le magicien moderne qui y a joint la puissance de l'incantation musicale, le breuvage d'amour a certainement troublé, peut-être égaré plus d'un coeur" (pp. ix–x).

While this story of fatal—but excused—passion can only be described as essentially subversive from a moral point of view, Bédier could not tamper with this basic *donnée* of the legend. Yet, he was able to modify, to soften somewhat, those passages sexually suggestive, and, as such, surely in no way shocking to a medieval audience which his turn-of-the-century readers, if one is to judge by Paris's statement, might have found offensive.

In both Béroul and *Tavola Ritonda* (quoted by Bédier in his notes to the Thomas), Iseut swears her innocence at the pine, albeit equivocably, in these words:

> Mais Dex plevist ma loiauté
> Qui sor mon cors mete flaele,
> S'onques for *cil qui m'ot pucele*
> Out m'amistié encor nul jor!
> (Béroul, vv. 14–17; my emphasis)

> . . . io posso con verità giurare che io non
> diedi giammai mio amore a persona veruna, nè
> animo ò avuto di dare, se none a *colui il quale*
> *ebbe lo mio pulcellaggio*. (I, 202; my emphasis)

Bédier, with the addition of commas and a prepositional clause, attenuates the sexual frankness of this admission when he writes: ". . . jamais je n'ai donné mon amour à nul homme, hormis *à celui qui le premier m'a prise, vierge, entre ses bras*" (p. 70; my emphasis).

Again, in the scene of the oath and the ordeal, Bédier modifies Béroul's text to rehabilitate the blatantly sexual original. In the Anglo-Norman text, Iseut swears thus:

> "Or escoutez que je ci jure,
> De qoi le roi ci aseüre:
> Si m'aït Dex et saint Ylaire,
> Ces reliques, cest saintuaire,
> Totes celes qui ci ne sont
> Et tuit celes de par le mont,
> *Qu'entre mes cuises n'entra home*
> Fors le ladre qui fist soi some,
> Qui me porta outre les guez,
> Et le rois Marc mes esposez.
>
> .
>
> Li ladres fu *entre mes jambes*." . . ,
> (vv. 4168–77/4182; my emphasis)

In the *Folie d'Oxford*, Tristan recalls the scene in these words:

> Suef a la terre chaïstes
> E vos quissettes m'ouveristes,
> E m'i laissai chaïr dedenz.
> (vv. 825–27, quoted in I, 209)

Yet Bédier's Iseut declares the following:

> ". . . je jure que jamais un homme né de femme ne m'a tenue *entre ses bras*, hormis le roi Marc, mon seigneur, et le pauvre pèlerin qui, tout à l'heure, s'est laissé choir à vos yeux" (pp. 137–38; my emphasis).

As a final example, consider the episode of the *eau hardie* where water splashes onto Iseut aux Blanches Mains's thighs. In Thomas, the virgin wife is quite explicit: "Ceste aigue, que si esclata, / *Sor mes cuisses plus haut monta / Quë unques main d'ome ne fist*, / Ne que Tristran oncques ne me quist" (vv. 1192–95; my emphasis). Bédier's narrator states only that it went "plus haut que son genou," while Iseut herself says simply: "Eau, tu es plus hardie que ne fut jamais le hardi Tristan" (p. 168).

* * *

. . . [N]ous autres, qui composons le "grand public," nous sommes reconnaissants à Bédier de nous avoir restitué

> avec une surprenante fraîcheur le fameux récit des amours
> de Tristan et Iseut. Ecrit par manière de divertissement, le
> roman de *Tristan et Iseut* de Joseph Bédier s'est placé tout
> de suite parmi les grands livres de notre littérature.[29]

If these words of Jean Rémond, the Vice-President of the
Paris City Council, seem to be a bit of cloying Gallic hyperbole in
their praise of Joseph Bédier's *Roman de Tristan et Iseut*, he might
well be forgiven, considering the gala occasion on which they
were uttered: the dedication on 14 June 1956 of the Avenue
Joseph Bédier in the thirteenth arrondissement.

Yet while Bédier's might, in fact, not be one of the great
works of French literature, it does have the distinction of
furnishing the twentieth-century reader the gripping and
seemingly timeless tale of love and death which most recently
had worked its spell on Richard Wagner.[30] The French novelist
Georges Duhamel described the qualities of the Tristan story
thus:

> . . . son histoire, telle qu'elle fut contée par les harpeurs,
> telle que nous la lisons, reprise et mise en harmoni e par
> notre cher Joseph Bédier, est la plus belle et la plus
> déchirante de toutes les histoires d'amour et qu'il nous
> suffit de la relire pour en être émus et parfois bouleversés.
> (p. 18)

In the *Roman de Tristan et Iseut*, Bédier, scholar and artist,
attempted essentially the impossible—the reconciliation, the
conflation, of what had become two distinct and, in fact,
irreconcilable traditions. Yet despite certain failings, certain
modifications he made to the content of the extant legends, one

29. This passage is from the "Allocution de Monsieur Jean
Rémond" which appears with the texts of two other speeches, one by
Mario Roques, the other by Marcel Bataillon, in a brochure published on
the occasion of the "Inauguration de l'avenue Joseph Bédier célébrée à
Paris le 14 juin 1956."

30. See Ulrich Müller, "Le Débat sur *Tristan*: L'Oratorio de Frank
Martin, Wagner et Bédier," in *La Légende de Tristan au moyen âge*, ed.
Danielle Buschinger (Göppingen: Kümmerle, 1982), 121–29, who, while
concentrating on Martin's oratorio, suggests a Wagnerian influence in
Bédier's treatment of the *philtre* scene (p. 123).

should not lose sight of Bédier's signal achievement. He brought the Old French legend to the twentieth-century reader. He created a finely wrought romance of his own. In Gaston Paris's words (préface, p. iii), he succeeded in making "revivre pour les hommes de nos jours la légende de Tristan," if not (*hélas!*) "sous la forme la plus ancienne qu'elle ait prise"—an impossible task, no doubt—at least, like his predecessors Béroul and Thomas, in a form, like theirs, inspired by a personal and artistic vision of the highest order.

As students of the Tristan legend, we may criticize Bédier's work. Yet as teachers of literature, we recognize the importance of his *Roman de Tristan et Iseut* for both teaching and the history of French literature, particularly the novel. His work gives modern access to the French legend, unfragmented.[31] In neither his 1905 reconstruction of the archetype nor in his *Roman de Tristan et Iseut* was Joseph Bédier simply a mechanistic establisher of a concordance, a servile translator, or an uninspired adapter.[32] In the romance especially, we see rather

31. It was not until the publication of Payen's 1974 edition/translation (cited in n. 21) that modern French translations of all the fragmented Old French verse versions even existed. Payen was the first to translate Thomas and the *Folie de Berne* into modern French. Two more modern French translations of Béroul appeared the same year, those of Herman Braet (Gand: Ed. Scientifiques) and Pierre Jonin (Paris: Champion). In 1989, all the Old French Tristan poems (including Marie de France's *Chevrefoil* and "Tristan Rossignol—le Donnei des Amants") with facing modern French translations, were collected in one volume, along with a French translation of the Old Norse *Tristrams Saga*, by Daniel Lacroix and Philippe Walter (*Tristan et Iseut, Les poèmes français, la saga norroise*, Paris: Livre de poche). In English, Thomas has been translated by Dorothy Sayers (*Tristan in Brittany*, London: Benn, 1929). English translations of Béroul include: Janet Caulkins and Guy Mermier, *Tristan and Iseut* (Paris: Champion, 1967); Alan S. Fedrick, *The Romance of Tristan by Béroul and the Tale of Tristan's Madness* (London: Penguin, 1970); Guy Mermier, *Béroul: Tristran and Yseut; Old French Text with Facing English Translation* (New York: P. Lang, 1987). Recently, Norris J. Lacy has both edited and translated Béroul: *The Romance of Tristran by Béroul* (New York: Garland, 1989).

32. Here is Bédier's daughter recalling reaction to the publication of her father's *Roman de Tristan et Iseut*: "La première édition parut en

the conscious artist at work restoring access to the Old French legend—unfragmented—by creating what Jean-Charles Payen has called "une reconstitution à la Viollet-le-Duc" (*Les Tristan en vers*, ix). Unlike Payen, I take this comparison as not at all pejorative, for Viollet-le-Duc's definition of *restauration* can aptly be applied to Joseph Bédier's work on the legend of Tristan and Iseut: "Restaurer un édifice, ce n'est pas l'entretenir, le réparer ou le refaire, c'est le rétablir dans un état complet qui peut n'avoir jamais existé à un moment donné."[33] In much the same way that the celebrated restorative architect sought to repair the devastation worked by the ravages of time and saved for us La Sainte Chapelle, Saint Denis, and Notre Dame, Joseph Bédier, "that distinguished mediaevalist, who," according to Dorothy Sayers, "by rare good fortune combines profound scholarship with fine poetic insight,"[34] succeeded in making "revivre pour les hommes de nos jours la légende de Tristan."[35]

The Tristan myth remains one of the most recurrent and frequently reinterpreted in Western art and literature. From the earliest medieval writers discussed above, through the late medieval authors of the vast prose romances to Tennyson,

1900. Mon père avait alors 36 ans. Devant le succès immédiat de cette publication, il aurait pu être tenté de donner moins de temps et moins d'effort aux études austères d'érudition; il aurait pu devenir romancier. Il ne le voulut pas. De même, comme, d'un seul coup, le grand public l'avait connu et apprécié, les salons littéraires cherchèrent à l'attirer; il repoussa ces sollicitations car il n'aimait pas ce que ces salons comportent de mondain et de superficiel." This extract from a typescript in the library of the Collège de France entitled *La Vie, l'œuvre et le caractère de Joseph Bédier* is part of the text of "une conférence prononcée à la Société Littéraire du Maine, au Mans, le 28 décembre 1947" by Madame Roger Mauduit (née Bédier).

33. Eugène E. Viollet-le-Duc, *Dictionnaire raisonné de l'architecture française du XI^e au XVI^e siècle*, 8 (Paris: Morel, 1869), p. 14. It is interesting in this regard to note that the first edition of the *Roman de Tristan et Iseut*, according to the catalogue of the British Museum, bears the subtitle "*traduit et restauré* par J. Bédier" (my emphasis).

34. Dorothy Sayers, tr., *Tristan in Brittany* (New York: Payson and Clarke, n.d.), p. xxxii.

35. Gaston Paris, preface to Bédier's romance, p. iii.

Matthew Arnold, Thomas Hardy, Masefield in England; Wagner in Germany; Edwin Arlington Robinson in America; Bédier and Cocteau in France, this story of fatal passion, that "éternel sujet des méditations de la pensée et des troubles du coeur"[36] has proved again and again a source of fascination and creative inspiration. The importance of Joseph Bédier's *Roman de Tristan et Iseut* in this long tradition calls for further and, at last, a thorough study of its relationship to Bédier's own scholarly research and to the earliest versions of this seminal myth. Bédier intended, with the *Roman de Tristan et Iseut*, to fill a void caused by the ravages of time which had left extant no complete French verse version of the legend of Tristan and Iseut. That that void was filled, is an achievement of the highest significance.

36. Gaston Paris, preface to Bédier's romance, p. xi.

Tristram the Transcendent

Frederic Yves Carpenter

I

The *Tristram* of Edwin Arlington Robinson is more than a fine narrative poem. Published in 1927, it looms already as a landmark in modern American literature, and also as a challenge to criticism. Perhaps the publication of Robinson's letters will illuminate the problem which it raises, but there is little likelihood that they will answer it. For the problem is not so much individual as national. Briefly, it is this: How could a poet morally and intellectually disciplined and even inhibited, as Robinson was, suddenly write a poem describing vividly and celebrating wholeheartedly one of the most passionate love stories in all literature? Not only that—how could he achieve with it his greatest triumph? Did he all at once deny the heritage of his New England past? Or was there some unsuspected spark hidden in the old puritanism, which finally flamed in him?

Whatever the cause of *Tristram*, the effect was immediate and unquestionable. The poem at once achieved a success almost unparalleled in its combination of quantity with quality; the reading public and the professional critics united to praise it. What is even more unusual, the author himself felt it to be his masterpiece. Subsequent writers have largely confirmed the

Reprinted with permission from *New England Quarterly*, 11 (1938), 501–23.

verdict. But since the different critics have interpreted it differently, even while agreeing on its greatness, the history of the poem is worth reviewing.

Before its publication, the Literary Guild chose *Tristram* for its book of the month—an unheard-of honor for a long narrative poem. Soon after publication, the book appeared on the best-seller lists, rivaling even novels in the number of its sales. Financially, it marked the author's first success; when *Tristram* was out, Robinson admitted, "I had a little money to invest."[1] And for the third time, it won him the Pulitzer Prize.

The professional critics, of course, were partly responsible for this. The unanimity of their enthusiasm was remarkable. Mark Van Doren and Lucius Beebe wrote full-length articles in its praise.[2] Ben Ray Redman called it "the greatest poem that has yet been written in America."[3] Percy Hutchinson's comment in the New York *Times*, May 8, 1927, was headlined "American Poetry at its Best." Lloyd Morris described it as "not only the finest of Mr. Robinson's narrative poems, but among the very few fine narrative poems in English."[4] The *Bookman* declared, editorially, in June: "Here is a book that your great-grandchildren will know, even if you neglect it;" and Herbert Gorman, in the July number, added: "One may be quite dogmatic in asserting that this is the finest long poem that has ever been produced in this country."[5] Nor was the enthusiasm limited to America. In France, Professor Cestre wrote in glowing terms of this "*chef d'oeuvre*," this "*couronnement d'un effort créateur*."[6] And the conservative London *Times Literary Supplement* called it a masterpiece by "one of the most magnificent of

1. Rollo W. Brown, *Next Door to a Poet* (New York, 1937), 49.

2. Mark Van Doren, *Edwin Arlington Robinson* (New York, 1927), 77–90; and Lucius Beebe, *Edwin Arlington Robinson and the Arthurian Legend* (Cambridge, 1927).

3. New York *Herald Tribune*, Books (May 8, 1972), 3.

4. *Nation*, CXXIV (May 25, 1927), 586.

5. *Bookman*, LXV (June 1927), 466; *ibid.* (July 1927), 555.

6. C. Cestre, *Revue Anglo-Américaine*, V (December 1927), 97.

modern American poets."[7] In fact, the only major exception to the enthusiasm was that of Conrad Aiken, who considered it "a comparative failure."[8]

But book reviewers have often been mistaken. Perhaps a better index to the significance of *Tristram* is suggested by the change of attitude of representative critics toward Robinson following the publication of the poem. Thus, in 1923, Louis Untermeyer had written: "His language is indirect, but it is not that which brings his poetry to a halt at the very peak of greatness. It is not that he is devious in the way he gives himself, but that, in the sense of complete abandon to an emotion, he never gives himself at all."[9] But later, in praising *Tristram*, Untermeyer wrote: "Robinson, as though reacting against the charge of Puritanism, abandoned himself to a drama passionate and headlong."[10] Likewise T.K. Whipple modified his criticism of Robinson's "constitutional reserve" and "emotional chariness" with the highest praise of *Tristram*.[11]

Finally, Robinson himself felt that the poem contained his best work: "He supposed that he was up about as well in *Tristram* as anywhere."[12] And to an interviewer he expressed the belief that his best poetry was "somewhere" in the Arthurian poems, because "the romantic framework enabled me to use my idiom more freely."[13] Similarly, Robinson spoke of *Tristram* as extraordinary for him, because of the precipitancy with which it was written: ". . . my largest output was 110 lines, one day when I was going strong in the latter part of *Tristram*."[14]

This coincidence of enthusiasm on the part of the reading public, the critics, and the author also, is rare enough. In one way

7. Reviewed September 22, 1927, 640.

8. *New Republic*, LI (May 25, 1927), 22.

9. *American Poetry Since 1900* (New York, 1923), 66.

10. *Modern American Poetry* (New York, 1936), 141.

11. *Spokesmen* (New York, 1928), 61–63.

12. Brown, *Next Door to a Poet*, 81.

13. *Bookman* (November 1932), 676. Interview reported by Nancy Evans.

14. Brown, *Next Door to a Poet*, 74.

or another, the flame had been lit. But more remarkable than this general acceptance, perhaps, is the effect which the writing of the poem produced on the author. His letters have not yet been made public, but his literary executor has summarized their import (not, be it noted, in any specific discussion of *Tristram*). The rereading of these letters, he said, gave "a strong impression that E.A. had put so much vital force into the writing of *Tristram*, had worked on it and lived in it with such utter concentration, that his health never again was what it had been."[15] The flame was a real fire, that had burned. It was not the reflected light of a long-ago, literary love, but a variety of authentic emotional experience.

But why had the spark flamed so suddenly? To many there seemed no connection between the Robinson of the early poems and the Robinson of *Tristram*. All at once he seemed to have abandoned the intellect for the emotions, to have abandoned morality for the precipitancy of passion, to have lowered (or raised) himself suddenly from the plane of metaphysical abstraction to the plane of flesh-and-blood reality. The majority of critics and readers alike gave themselves up to the enjoyment of the new love poem with a sigh of relief, accepting it as a gift of God, not inquiring too meticulously whence the strange gift had come. "Here," they thought, "is an end to all troublesome, outworn transcendentalism."

But was *Tristram* really so simple and unmoral a poem as these critics thought? "There are no abstract themes in it," Mark Van Doren wrote. "The elements which compose it have nothing of metaphysics in them; there is no Light. . . . We have simply two people in love."[16] Would it not be more accurate, and more revealing of the development of modern thought, to say rather that *Tristram* implied, and as it were incarnated, the intellectual ideas which Robinson had formerly described explicitly? Moreover, the poem did give certain explicit formulation and development to the most fundamental of these ideas.

15. Louis V. Ledoux, "Psychologist of New England," *Saturday Review of Literature*, XII (October 19, 1935), 16

16. Mark Van Doren, *Edwin Arlington Robinson* (New York, 1927), 77.

Second, did *Tristram* actually abandon the tiresome morality which had troubled the course of the earlier narratives? "The poem is singularly free of ethical implications,"[17] wrote Lloyd Morris. And Herbert Gorman declared: "In *Lancelot*, love was for the sake of the Light; in *Tristram* love is for itself and builds a world out of itself."[18] But did not *Tristram* rather suggest how "love" and "the Light"—which in *Lancelot* had been divided—might achieve a certain tragic harmony? And are the "ethical implications" absent, or merely latent?

Certainly, the subject matter and mood of *Tristram* are different from those of Robinson's other poems. These differences are obvious. But do they justify us in separating *Tristram* from the rest of the poems, or in saying that it lacks intellectual significance?[19] Does not *Tristram* rather illustrate the natural development of Robinson's literary thought, and therefore achieve "the completest and most characteristic expression of his genius"?[20] This interpretation is not entirely orthodox and has never been fully developed. But if true, it is highly significant. And it is important, not only for the understanding of Robinson's poetry but for the interpretation of American literary thought as a whole.

First, this essay will suggest the continuity of *Tristram* with the rest of Robinson's poetry, particularly with his other two Arthurian poems, *Merlin* and *Lancelot*. Second, it will describe the significant differences between his *Tristram* and other versions of the history, both medieval and modern. Third, the ideal implicit and explicit in the poem will be developed in relation to the transcendentalism of Emerson, whom Robinson

17. *Nation*, CXXIV (May 25, 1927), 586.

18. New York *Evening Post*, "The Literary Review," (May 7, 1927), 3.

19. The two most recent, and most excellent, studies of Robinson's philosophy have largely neglected *Tristram*. See Floyd Stovall, *American Literature*, X (March 1938), 1–23; and David Brown, *New England Quarterly*, X (September 1937), 487–502.

20. Lloyd Morris, *Nation*, CXXIV (May 25, 1927), 586.

greatly admired, both as poet and as thinker.[21] Finally, perhaps, *Tristram* may emerge, not as the denial and refutation of the transcendental tradition in American literature, but rather as the most recent and one of the most fully realized and satisfying embodiments of it.

II

Merlin was published in 1917, *Lancelot* in 1920, and *Tristram*, after a longer interval, in 1927. These three narrative poems group themselves naturally together, not merely because they deal with Arthurian material but because they deal primarily with the problems of romantic love. And these three poems describe progressively three distinct but related types of that love. In the language of Emerson, these are: "Initial, Daemonic and Celestial Love."

Merlin deals with the "initial" type of love—that of the senses. In it there is no admixture of the spiritual. The descriptions of Merlin and Vivian at Broceliande contain much beauty—so much that one wonders at Robinson's capacity for imagining pure pleasure—but the beauty is cloying. Merlin has renounced wisdom and power for mere sensuous enjoyment. In him men see

A pathos of a lost authority.[22]

He has shaved off his beard, to regain youth, but has "gone down smiling to the smaller life." In other words, his love for Vivian, being sensuous only, has led to nothing but dissatisfaction and defeat. The lovers tire of each other and eventually part. It all comes to nothing.

21. See, for example, Robinson's letter to D.G. Mason in the *Yale Review* (June 1936), 861. "He [Emerson] really gets after me."

22. *Collected Poems* (New York, 1929), 249. Permission to quote from this volume has been granted by the publishers, Messrs. Macmillan and Company.

Lancelot deals with a different type of love—partly sensual, partly spiritual. In it there is more than caprice—compulsion enters also. Fate drives the lovers on, but against their wills. Unlike the simple Vivian and the deluded Merlin, Lancelot and Guinevere do what they know to be wrong. In the introductory lines Lancelot is described as seeking to escape from his infatuation—"the Light" commands him away. But the insane vengeance of Arthur and his own inner conflict force him to carry off Guinevere to his retreat at Joyous Gard, and there to defend her. But he knows himself foredefeated: "The Light came and I did not follow it."[23] When, at the end, he and Guinevere discuss a second attempt at escape, they recognize the justice of their lot. What raises *Lancelot* above *Merlin*, then, is the purposefulness of the inner conflict—Lancelot's love was not a mere sensuous escape but a true struggle of loyalties. An inner daemon drove him on against his conscious sense of duty. The result was war, psychological and actual:

> And ever the Daemonic Love
> Is the ancestor of wars
> And the parent of remorse.[24]

Tristram, on the contrary, describes a love which is neither a sensuous escape from thought, like Merlin's, nor a conscious conflict of loyalties, like Lancelot's. Compare the descriptions of Broceliande and those of Joyous Gard, and the difference becomes obvious. Instead of *Merlin*'s

> "fruits and wines and many foods
> Of many savors, and sweet ortolans,"[25]

there is, in *Tristram*,

> knowledge born of all endurance . . .
> Passion and comprehension beyond being[26]

23. *Collected Poems*, 439.

24. Emerson's *Poems*, Centenary Edition (Boston, 1903), 113.

25. *Collected Poems*, 239.

26. *Ibid.*, 675.

Where Merlin's sensuous love denied "knowledge" and "comprehension," Tristram's created them. And in contrast to Lancelot, Tristram's love, being all-inclusive, suffered no division:

> Stronger than God,
> When all was done the god of love was fate,
> Where all was love.[27]

For Tristram, all was love. He had merely followed the transcendental counsel: "Give all to Love." And significantly, it had been Guinevere who had brought Isolt to Joyous Gard, and Lancelot who had given to Tristram his island for their love.[28] The unhappy and divided lovers symbolically offered their unattained happiness to those who could consummate it.

The events, internal and external, which motivate and make possible this consummation may be suggested later—the question here is of continuity. Whatever the causes, the three loves of Merlin, Lancelot, and Tristram came to three different but obviously related ends. Merlin's ended in spiritual defeat; Lancelot's ended in suffering, which, however, promised the hope of salvation; Tristram's ended in spiritual victory.

The final lines of the three poems make clear this continuity. They describe progressive developments of the same theme. Thus *Merlin* concludes:

> Colder blew the wind
> Across the world, and on it heavier lay
> The shadow and the burden of the night;
> And there was darkness over Camelot.

But in *Lancelot*, the darkness lightens, and there is hope of dawn:

> He rode on into the dark, under the stars,
> And there were no more faces. There was nothing.
> But always in the darkness he rode on,
> Alone; and in the darkness came the Light.

27. *Ibid.*, 676.
28. *Ibid.*, 676.

But with *Tristram,* the dawn has come. King Howel says:

> "When the dawn comes, my child,
> You will forget."

But Isolt of the white hands replies:

> "The dawn has come . . .
> And wisdom will come with it. If it sinks
> Away from me, and into the night again—
>
> Then I shall be alone, and I shall die,
> But I shall never be all alone—not now."[29]

Not alone at the end, like Lancelot, nor shrouded in night, Isolt watches the sunlight:

> She watched them there till even her thoughts were white,
> And there was nothing alive but white birds flying,
> Flying, and always flying, and still flying,
> And the white sunlight flashing on the sea.

Clearly, Robinson intended this white sunlight to be symbolic, and to contrast with the earlier darknesses.

More subtly, but no less clearly, the three poems are contrasted with regard to the theme of "peace." The three loves produce three different states of mind, not only in the lovers but in the onlookers; for love is not only individual but social in its implications. Thus Merlin, it was falsely reported,

> "wears the valiance of an ageless youth
> Crowned with a glory of eternal peace."

But no, his peace is not real:

> Dagonet, smiling strangely, shook his head:
> "I grant your valiance of a kind of youth
> To Merlin, but your crown of peace I question
> . . . I look not to Merlin

29. *Ibid.,* 727.

> For peace, when out of his peculiar tomb
> He comes again to Camelot.[30]

This false peace, which Merlin foolishly sought, Lancelot at last finds is not for him. Rather, it is for him to suffer, in order that others may find:

> "Where the Light falls, death falls; a world has died
> For you, that a world may live. There is no peace.
> Be glad no man or woman bears for ever
> The burden of first days. There is no peace."[31]

Merlin found false peace; Lancelot found hope in change. But those who have lived life to the full may find peace at the end. Such—as King Mark mused—were Tristram and Isolt:

> "There was no more for them—and this *is* peace."[32]

And he repeats the theme in the lines immediately following.

Similarly, Robinson contrasts the three loves in their relations to "time." Merlin, seeking to find youth in light love, fell afoul of time:

> "I see the light,
> But I shall fall before I come to it
> For I am old. I was young yesterday
> Time's hand that I have held away so long
> Grips hard now on my shoulder. Time has won."[33]

But in contrast, the central theme of *Tristram* is the triumph of true love over time:

> "Why should he wish to live a thousand years?
> Whether your stars are made of love or fire,
> There is a love that will outshine the stars,
> There will be love when there are no more stars."[34]

And constantly the theme is repeated:

30. *Ibid.*, 238.
31. *Ibid.*, 448.
32. *Ibid.*, 721.
33. *Ibid.*, 295.
34. *Ibid.*, 690.

> "It was not time
> For you or me, when we were there together.
> It was too much like always to be time."

Unlike Merlin and Lancelot, for whom love alone was not enough but seemed merely a means of escape from time, Tristram's love, by filling life to the full, triumphed over time. The theme has philosophic implications—of which, more later. But whatever the exact meaning of the idea, it runs like a thread of unity through the Arthurian poems.

III

Robinson's *Tristram*, then, is not only an unusual poem by an individualistic poet—it also forms one of a series of three Arthurian narratives which describe progressive aspects of the idea of romantic love. But the outlines of the legend of Tristram were traditionally fixed. Therefore it was inevitable that Robinson should change the old plot and mold the old characters to his purpose. In general, the changes which he introduced into the plot are comparatively few, although significant; but the characters have become wholly the instruments of his poetic imagination.

Robinson's plot differs in three important aspects from the conventional legend. In the first place, Tristram's passion for Isolt of Ireland is described as gradual, and as it were, cumulative, rather than merely love at first sight. Ordinarily the lovers consummate their passion on the ship—they are both impetuous and disloyal. Robinson, by postponing the consummation of their love, gives to it the dignity not only of maturity but also of honesty. Following as it does after Tristram's quarrel with Mark and his exile, it ceases to be disloyal, either to liege-lord or to friend. In both these aspects Tristram's love is distinguished from Lancelot's whose love for Guinevere was impetuous:

"I saw your face, and there were no more kings,"[35]

and whose love was also disloyal, because Arthur was Lancelot's king and his avowed friend.

In the second place, Robinson described the meeting of Tristram and Isolt at Joyous Gard, not as a stolen tryst but as an unexpected encounter, managed by others. Tristram himself does not steal Isolt, nor does he even arrange the meeting. On his way from King Arthur's court, he is left by Lancelot at Joyous Gard, as Isolt is also left by Guinevere. Instruments of fate, the two guilty lovers make possible the happiness of the two innocent lovers, whom only an arbitrary authority has separated. If this device seems somewhat indirect, the mechanism is not over-emphasized, and the psychological result remains satisfying.

Finally, Robinson ends the story not with the incident of the white sail, the treacherous words of Isolt of Brittany, and the rather melodramatic death of the lovers, but with the sunlight musings of Isolt. From a tale of lawless passion, treachery, and revenge, the story has become one of a passion purified by suffering, of joy beyond sorrow, and of the slow growth of wisdom.

But these changes of plot have been motivated by more subtle and significant changes in the characters of the four chief protagonists. Tristram himself has changed in subtle ways. And, strikingly, Robinson has described this change as occurring gradually, in the very process of the tale as he tells it. At the beginning, just as in the old legend, Tristram is described as impetuous and warlike, having slain Isolt's kinsman, Morhaus, in battle. But to his mind, this killing marks the beginning of evil:

> "When a man sues
> The fairest of all women for her love
> He does not cleave the skull first of her kinsman."[36]

This killing also marks the beginning of wisdom for him. But wisdom is slow: when he discovers Andred spying upon him and Isolt, he beats the man violently, thus earning his undying

35. *Ibid.*, 376.
36. *Ibid.*, 614.

hatred and sealing his own death warrant. When Mark appears and he is again tempted to warlike resistance, he pulls his sword from the scabbard, but puts it back again, choosing exile rather than resistance. Later he neither seeks to win Isolt by violence, nor, once he has found her, to keep her at Joyous Gard by force of arms. He has now become not the valiant warrior of the old tales, but "the child of thought." In contrast again with Lancelot, who snatched away Guinevere by violence[37] and whose stay at Joyous Gard was troubled by civil war, the mature Tristram refuses to resort to violence, and enjoys his love freed of the fear of defeat and death. This non-resistant wisdom might even have won him final physical victory, but for Andred. From the valiant, violent knight of the conventional legend, the Tristram of Robinson has developed into the wise man who will no longer resist evil with evil.

A similar development occurs in the character of King Mark. Other modern dramatists, beginning with Richard Wagner, had attempted to describe Mark sympathetically.[38] But none had seen in him the potentialities for good suggested by Robinson. Appearing at first as the more or less conventional villain of the old legend, Mark, like Tristram, develops, because he possesses a nature "not so base as it was common." Indeed Mark may represent the reincarnation of the god Demos, whose dialogue with Dionysus immediately preceded the writing of *Tristram*. For Mark, like the proverbial common man, possessed the elements of goodness and wisdom which, if realized sooner, might have averted the tragedy. Near the end of the tale he is given one of the most profoundly moving soliloquies in it.[39]

In keeping with the changed characters of Tristram and Mark, Isolt of Brittany also has changed—perhaps more

37. When he wrote *Lancelot*, Robinson apparently had not yet planned his contrasting version of *Tristram*, but referred contemptuously to "the stolen love" of Tristram and Isolt (page 400) and later to Isolt as a dark temptress (page 416) as in the old versions of the tale.

38. See Maurice Halperin, *Le Roman de Tristan et Iseut dans la Littérature Anglo-Américaine au XIXe et au XXe Siècles* (Paris, 1931).

39. *Collected Poems*, 720–722.

profoundly than they. Since she both introduces and concludes
the poem, and since it is suggested that she alone is to know the
sunlight wisdom of the new day, her significance is obvious.
Robinson has lavished upon her his greatest gift of psychological
analysis. She seems most nearly like the heroines of his other
narratives, and therefore, perhaps, least like the traditional Isolts
of Brittany. Her love is not selfish, but pure. And like all of
Robinson's best characters, she gains our admiration by
remaining true to her inmost nature, not seeking to win Tristram
by feminine wiles or to deceive him by treachery. But when all is
said, she still seems somewhat unsubstantial, living in a dream
world mostly:

> "yet I must have
> My dreams if I must live, for they are mine."[40]

She becomes most real when contrasted most sharply with the
other Isolt.

Superficially like the traditional heroines of the old legend,
it is Isolt of Ireland, nevertheless, who makes the poem unique.
Never elsewhere did Robinson so completely realize a character
so passionate and direct. She seems foreign to the puritan
tradition in her headlong abandon. Yet this very passionate Isolt
of Robinson's has gone far beyond the original of the Celtic
legend, and even the later European tradition. For she is no
longer pagan, nor is her love merely the sensual love of earth:

> "It was not earth in him that burned
> Itself to death; and she that died for him
> Must have been more than earth."[41]

Compare Robinson's heroine with Swinburne's, and the radical
difference becomes clear. Swinburne's, like most of the Isolts of
the past, is only the passionate lover, self-abandoned to emotion.
But Robinson's Isolt is the passionate lover who also is capable of
spiritual growth and wisdom:

40. *Ibid.*, 726.

41. *Ibid.*, 727.

> Till tears of vision and of understanding
> Were like a mist of wisdom in their eyes. [42]

The character of this dark Isolt suggests the reconciliation of passionate, physical experience with the old ideal of wisdom.

The Merlin of Robinson's early poem had once prophesied concerning the means of realizing this ideal:

> "the torch
> Of woman . . . together with the light
> That Galahad found, is yet to light the world."

And Dagonet had repeated after him:

> "The torch of woman
> . . . and the light that Galahad found
> Will some day save us all." [43]

Now this cryptic and seemingly un-puritan prophecy finds realization in *Tristram*, where the dark Isolt points to salvation through passionate love (the torch of woman), while Isolt of the white hands realizes the ideal of purity, which Galahad found.

IV

The contrast between Robinson's *Tristram* and other versions of the legend suggests that his poem possesses definite ideal implications. These, moreover, are related to a philosophy of life, which may be described as transcendentalism. Certain passages in the poem explicitly suggest this philosophy, without ever defining it. What is the meaning of it all?

In *Tristram*, the key word is clearly "time." Indeed, the constant repetition of this word would become monotonous, were it not for the wide variety with which it is used. "Time," almost like a concrete character, takes shape and grows as the poem progresses, until, in the final love scenes, it emerges as a consciously intended and consciously expressed idea. Its poetic

42. *Ibid.,* 675.
43. *Ibid.,* 307, 309.

virtue, of course, lies partly in its evocative vagueness; but we may define it prosaically as "the routine experience of daily life." The theme of the poem is the transcending of "time," or the world of routine experience, by the ecstatic intensity of the mystical or passionate experience.

Throughout the poem, whenever Tristram and Isolt of Ireland appear together, the theme of "time" introduces them. Thus the third canto begins:

> Lost in a gulf of time where time was lost,

and continues:

> Time was aware of them,
> And would beat soon upon his empty bell
> Release from such a fettered ecstasy
> As fate would not endure.

The seventh canto again begins with

> Isolt alone with time, Isolt of Ireland,

and later apostrophizes the lovers:

> But let these two that were not shadows
> Be as they were, and live—by time no more
> Divided until time for them should cease.
> They were not made for time as others were,
> And time therefore would not be long for them. . . ."[44]

Always Robinson describes the experience of the two lovers in terms of time, suggestively. But as the love scene at Joyous Gard develops, Tristram himself formulates the idea more explicitly:

> "Time is not life. For many, and many more,
> Living is mostly for a time not dying—
> But not for me. For me a few more year
> Of shows and slaughters, or the tinsel seat
> Of a small throne, would not be life. Whatever
> It is that fills life high and full, till fate

44. *Ibid.*, 675.

Itself may do no more, it is not time.
Years are not life."[45]

Later he repeats the theme to himself.[46] And finally Isolt echoes it to affirm the final, spiritual victory of the two lovers, in the face of death:

"How shall we measure and weigh these lives of ours?
You said once that whatever it is that fills
Life up, and fills it full, it is not time.
You told my story when you said that to me,
But what of yours? Was it enough, Tristram?
Was it enough to fly so far away
From time that for a season time forgot us?
You said so once. Was it too much to say?"
 ". . . It was enough,"
He said.[47]

Repeatedly, and with progressive self-consciousness and clarity, the idea of "time" recurs. By filling their lives with something other than time, the lovers have escaped from time. They have "islanded their love" for a season in Joyous Gard. They have achieved spiritual victory by transcending time. But as the idea develops, one becomes conscious of a certain ambiguity in it. On the one hand the words "escape," "isolation," and "flight from time" suggest the other-worldly idealistic tradition, the ivory tower of romanticism, and the defeatist philosophy of much post-war literature. On the other hand, the phrases "fill life full" and "defeating time," and also the whole-souled happiness of the lovers' life at Joyous Gard, suggest an opposite philosophy of realization in this world, of immediate experience and of spiritual victory. How, then, did Tristram "transcend" time? Did he conquer time or escape from it?

The answer to the question depends partly upon the point of view. If one takes the position of Mark the materialist, agnosticism and pessimism follow:

45. *Ibid.,* 682.
46. *Ibid.,* 693.
47. *Ibid.,* 713.

 "I do not know
 Whether these two that have torn life from time
 Have failed or won . . .
 Now it is done, it may be well for them,
 And well for me when I have followed them.
 I do not know."[48]

Robinson himself occasionally seems to take the pessimistic
view: death is best; the only peace is that which follows death.
And many critics have developed this interpretation. T.K.
Whipple calls the escape from time ". . . an escape, that is, from
this world, from this life."[49] And Mark Van Doren, in praising
Mark's soliloquy, has made it the key to Robinson's philosophy.
Is transcendentalism, then, a philosophy of escape from this
world, and of defeat?

The analysis of *Tristram* presented earlier in this essay
suggests the opposite conclusion. If Tristram's "escape from
time" had been truly "an escape from this world, from this life,"
it would have ended in spiritual defeat, as Merlin's attempted
escape ended. Time cannot be conquered by cowards—only
those who have passed beyond the fear of death can conquer it.
If Tristram had fled to Joyous Gard to escape the vengeance of
his king, as Lancelot did, and had taken recourse to arms, he
would have failed, whether or not his arms had won. Nor was
there anything of the Hamlet in this modern Tristram, "child of
thought." For in him knowledge did not inhibit action and the
consummation of love. On the other hand, wisdom developed
through experience, and as the crown of experience. And this
wisdom was not other-worldly, or negative.

"Time," it has been said, is the key word. If Tristram had
sought truly to escape from time, he would always have been at
enmity with it. But this he never was. Rather, he and Isolt have
used "time" itself in order to conquer "time." From the
beginning, time has been "on our side,"[50] because the two lovers

48. *Ibid.*, 722.

49. *Spokesmen*, 54.

50. *Collected Poems*, 618.

did not seek stolen love, nor did they offer armed resistance: "Praise God for time," Tristram exclaimed:

> "Praise God for time,
> And for such hope of what may come of it
> As time like this may grant. I could be strong,
> But to be over-strong now at this hour
> Would only be destruction. The King's ways
> Are not those of one man against another,
> And you must live, and I must live—for you."[51]

These are not the words of one who seeks an escape from life in this world. They are rather the words of one who knows that there is a time for all things, and that the renunciation of love and of action at one time may lead to the consummation of love and to the fullness of life at another. *Tristram* describes the achievement of the fullness of life, in this world, in the due course of time.

V

In American literature and thought, two philosophies of life have always struggled for supremacy. The more common of these, popularly identified as "pragmatism," has preached that "time is money," that waste of time is waste of value, and that daily, routine application to work offers the way both to worldly and spiritual success. Economically, this is based on "the labor theory of value," and derives from the mechanistic assumption that one moment is as good as another. Not only is the amount of work which a man can accomplish measurable absolutely in terms of "man-hours," but as a corollary, the amount of experience which a man can realize per hour is likewise limited, and measurable quantitatively. Work neglected is money lost; action neglected is experience lost. "Let us then be up and doing!"

But this mechanical, "pragmatic" philosophy has never gone unchallenged. Even in America, and in the eighteenth century, the evangelists attacked it—men could achieve salvation

51. *Ibid.*, 618.

(*i.e.*, success) not by works, but only by grace. Opposed to Franklin, Jonathan Edwards sought to convert men's souls, not gradually, but suddenly. In the nineteenth century, transcendentalism continued this opposition: Time is not value, because routine repetitive action is unimportant in comparison with new intuitions, new inventions. Nature is saltatory and impulsive.[52] Moreover, daily routine is insignificant in comparison with the ecstatic moment: "We must be very suspicious of the deceptions of the element of time," wrote Emerson. "It takes a great deal of time to eat and sleep, or to earn a hundred dollars, and a very little time to entertain a hope or an insight which becomes the light of our life."[53]

But this "transcendentalism," which denies the supreme value of "time," has always been accused of other-worldliness—of seeking merely to escape from "time." This accusation has seemed credible, partly because of the evangelical and puritan origins of transcendentalism, partly because of certain ambiguities in the philosophy itself. Emerson sometimes spoke as though a man's salvation were purely a personal affair of "self"-reliance, which could have no practical effect on the world, and also as though it belonged to a purely intellectual realm beyond worldly experience. Robinson, primarily interested in psychological and intellectual analysis, sometimes followed him. But Robinson's poetry did develop and clarify two "transcendental" ideas which had often been misunderstood. First, it proclaimed repeatedly that individuals who suffer defeat and death "in time," while gaining "spiritual" salvation, actually do influence the world about them so powerfully that their individual deaths seem unimportant. Second, Robinson's *Tristram* emphasized that those ecstatic moments which transcend "time" by their intensity and power are not merely intellectual insights but deeply felt moments of living experience.

Robinson, like Emerson and Thoreau before him, took John Brown as a historic example of transcendentalism. The

52. Compare Emerson's essays "Experience" and "The Method of Nature."

53. From the essay "Experience," *Works*, III, 85.

individual who dies for a principle does not fail, even in a temporal sense: "I shall have more to say when I am dead."[54] His individual death teaches men wisdom, even though too late to "save" his own body. Thus Mark laments that understanding came to him too late to save Tristram and Isolt, who had almost won victory by not resisting:

> "And what might once have been if I had known
> Before—I do not know."[55]

But Mark, though capable of understanding, was not capable of true wisdom:

> "there are darknesses
> That I am never to know . . ."

This wisdom remained for Isolt of Brittany, who, in her own way, shared the suffering and the wisdom of the other two. Like Zoë in Robinson's allegorical poem *King Jasper*, Isolt of Brittany becomes almost the embodiment of that principle of life which progressively learns wisdom through experience. Toward the end, Zoë exclaimed:

> "Leave me, and let your poor, sick, stricken soul
> Suffer until it feels; and let it feel
> Until it sees. You will have died meanwhile,
> But who knows death?"[56]

So Merlin, Lancelot, and Tristram progressively had suffered, felt, and seen; they had died meanwhile, but others lived who had learned wisdom from them, and on whom the sunlight shone.

But what of the individuals who had died? What was their compensation for self-sacrifice? Was it merely that they had followed "the moral law"? Was it merely that they had enjoyed the satisfaction of an ecstatic moment of insight? Was it merely that, not resisting, they had "given all to love"? The Emersonian language had been mostly negative. Most of Robinson's other

54. *Collected Poems*, 490. The last line of "John Brown."
55. *Ibid.*, 721.
56. *Ibid.*, 1482.

poems had even described wisdom as divorced from positive realization in this life. But *Tristram* for the first time described the ecstatic moment as a period of such intense experience that its quality was worth more than the quantity of a lifetime of daily experiences:

> "Now listen, while I say this:
> My life to me is not a little thing;
> It is a fearful and a lovely thing;
> Only my love is more."[57]

The question in *Tristram* is not one of self-sacrifice or the denial of life in this world for "salvation" in the next, but rather of realization of values in this world. Tristram "transcends" the old mechanical philosophy that one moment of experience is worth as much as another, but *Tristram* does not deny the philosophy of experience. In this one poem, Robinson realized, for the first and perhaps the only time, the positive implications which had lain implicit in the transcendental philosophy from the beginning. Transcending "time," Tristram gained wisdom without sacrificing the fullness of life in this world.

57. *Ibid.*, 685.

Cocteau's Tristan and Iseut:
A Case of Overmuch Respect

Stephen Maddux

Jean Cocteau's *L'Éternel Retour*, filmed in 1942 and premiered in Paris on October 12th, 1943, is probably the best-known film version of the Tristan and Iseut story.[1] It was well received at the time of its release and has continued to be well thought of ever since. Now that it is on videocassette,[2] it is widely available and can be viewed repeatedly, the better for us to appreciate its virtues and perhaps also to reflect on its more puzzling features. Two questions in particular—not unconnected, as it will turn out—may suggest themselves. The first arises from the scholar's

1. More recent versions have been made in German, English, and French. See Meradith T. McMunn, "Filming the Tristan Myth: From Text to Icon," in Kevin J. Harty, ed., *Cinema Arthuriana: Essays on Arthurian Film* (New York: Garland, 1991), pp. 169–80. The French text of the screenplay of *L'Éternel Retour* has been published three times, to my knowledge, twice by itself (Paris: E. Desfossés, 1946; Paris: Nouvelles Editions Françaises, 1947), once together with the screenplay of *L'Aigle à deux têtes* and with brief introductions by Lo Duca, in a series of theatrical texts entitled *Paris Théâtre* (no. 22; 1950). It is this last publication that I have used. It also appears in English translation in Jean Cocteau, *Three Screenplays*, tr. Carol Martin-Sperry (New York: Grossman, 1977). All translations from the French appearing in this article are my own.

2. From the Janus Collection, distributed by Nelson Entertainment (Drama 6080).

concern with antecedents. Cocteau is clearly following rather closely some version of the medieval legend of Tristan and Iseut: On which one has he based his retelling, and how much of himself, if anything, has he put into it? The second question is more the film critic's: How successful is *L'Éternel Retour* as a film, particularly in the context of the rest of Cocteau's cinematic output, and how does it measure up to masterpieces such as *La Belle et la Bête* and *Orphée*, which are likewise modern cinematic retellings of familiar tales?

I will be examining both questions in turn. But first I need to address one other issue: Is *L'Éternel Retour* really Cocteau's film, to the same degree as *Orphée*, or *Le Sang d'un Poète*, or *Les Parents terribles?* In contrast to other films associated, famously, with the name Cocteau, this one was not actually directed by the poet-*cinéaste*. In the credits he is given responsibility only for the "scénario et dialogues"; the actual director was Jean Delannoy. Cocteau was present during the filming, but, in speaking about it, he gives the impression that he was there as little more than an interested observer.[3] One could almost imagine him as a simple apprentice, who was wetting his feet again in the process of filmmaking twelve years after his first brilliant, but singular, essay in the medium in 1930 (*Le Sang d'un poète*).

Yet *L'Éternel Retour* is nonetheless very much Cocteau's film, at least as much as Carné's *Enfants du paradis* is also the creation of *its* famous scriptwriter (Jacques Prévert). As in the Prévert-Carné collaboration, *L'Éternel Retour* is a film in which the screenplay was very important in determining the character of the final product. Through it, Cocteau undoubtedly provided the inspiration and overall conception for this modern cinematic version of the medieval legend. In addition, he must have

3. "*L'Éternel Retour* est un film dans lequel je n'exerçais qu'une surveillance amicale" ("*The Eternal Return* is a film over which I had no influence other than that of a friendly observer," from an essay, "Du merveilleux au cinématographe," originally appearing in *La Difficulté d'être* [Monaco: Editions du Rocher, 1953], pp. 62–70, and reprinted in *Du cinématographe*, Textes réunis et présentés par André Bernard et Claude Gauteur [Paris: Pierre Belfond, 1988], p. 165.)

influenced the final look of the film in yet other ways.[4] His own cinematic productions of the next ten years would resemble this one in a number of respects: characteristic themes or images, key actors (Jean Marais, Yvonne de Bray), music (Georges Auric), and the air of "unreal realism" Cocteau was always striving for and that *L'Éternel Retour*, too, participates in to some degree.

Let us agree, then, to call this Cocteau's film[5] and take up our first question: what version of the medieval legend was Cocteau following? As it turns out, the German incarnations of the story, those of Eilhart and Gottfried, had no more than an indirect influence on him. This may seem surprising, given the ascendancy of Germany in French affairs at the time the film was being shot and the use of a Nietzschean phrase for the film's title (not to mention the enormous prestige Wagner's opera continued to enjoy). Some may also interpret as a sign of German influence the fact that the film's hero and heroine, in the film, sport *exceedingly* blond hair. In truth, however, none of these details or circumstances signifies very much. Regarding the lovers' hair color, for example, motivations other than a desire to please the Germans seem likely to have played a role: on the one hand, there is the historical accident that Jean Marais, the leading man of all Cocteau's theatrical and cinematic productions since the time the two first met, happened to be fair-haired; on the other, the fact that Iseut of Ireland has always been known—to the French at least—as *Iseut la blonde*. Add to these items Cocteau's undoubted desire to make his Tristan and Iseut look as

4. On at least one matter he did intervene during the course of the production: Jean Marais tells of his insisting that Patrice and Natalie I (Madeleine Sologne) should have identical-looking hair (Marais, *Mes quatre vérités* [Paris: Éditions de Paris, 1957], p. 131). See also Cocteau's 1943 remarks on the film (included in *Du cinématographe*, 163).

5. As does John Russell Taylor; see his article on Jean Cocteau in Richard Roud, ed., *Cinema: A Critical Dictionary (The Major Film-makers)*, 2 vols. (New York: Viking Press, 1980), I, 222–32. (The article is particularly good on the recurrence of Cocteau's basic themes in his works for the screen.)

similar to each other as possible[6] and to contrast them sharply
with the other characters (uniformly dark-haired), and the pair's
striking blondness begins to seem less sinister.

Regarding the Nietzschean tag Cocteau used as a title, it
may be no more than what Cocteau makes it out to be in the
introductory words at the beginning of the film:

> L'Éternel Retour . . . ce titre, emprunté à Nietzsche, veut
> dire, ici, que les mêmes légendes peuvent renaître, sans
> que leurs héros s'en doutent. Éternel retour de
> circonstances très simples qui composent la plus célèbre
> de toutes les grandes histoires du coeur.

("The Eternal Return . . . this title, borrowed from Nietzsche,
means, here, that the same legends can be reborn, without their
heroes' realizing it. Eternal return of very simple circumstances,
that go to make up the most famous of all the great stories of the
heart.")[7]

Cocteau wanted, in his story, to bring Tristan and Iseut
forward into the twentieth century and make them relive their
drama; that is what "Eternal Return" means for him. If there is,
beyond the use of the phrase for this purpose, any truly
Nietzschean influence on the film, I am inclined to think it is of
so diffuse a nature as to be quite undetectable.[8]

6. To the extent that, when the hairdresser was through dealing
with him, people would turn and stare at Jean Marais on the street
(Marais, 131).

7. This text does not appear in the published version of the
screenplay I have used; wording similar to it occurs in the
"Avertissement des éditeurs" in the Nouvelles Éditions Françaises
edition.

8. It could actually be argued that this film is profoundly un-
Nietzschean, in the following sense. I gather that central to the concept
of the Eternal Return, for Nietzsche, is the notion that the superior
human being embraces *consciously* and *joyously* the return of all the
circumstances, good and bad, of his existence (see Walter Kaufmann,
Nietzsche: Philosopher, Psychologist, Antichrist [Princeton: Princeton
University Press, 1950; rpt. New York: Meridian Books, 1956], pp. 274–
86). In the film, in contrast, the hero and heroine *do not know*, and
presumably never learn, that they are reliving the past. Possibly at the

As for Wagner, finally, he seems to have had little or no impact on Cocteau's recasting of the legend. Cocteau was a decided anti-Wagnerian in his early days, when he was associating with and promoting "Les Six." By the time he came to write this screenplay he had considerably moderated his views, but by then, he maintains, he had too *much* respect for Wagner to have wanted to borrow from him (*Du cinématographe*, 163). And it does indeed appear that the innovations Wagner brought to the legend—the changes in the plot, the interpretation of various characters—had very little effect on Cocteau's filmic version.[9]

The fact is, the inspiration and model for Cocteau's screenplay, then, was not Germanic, but emphatically French, indeed doubly so. Almost certainly it was Joseph Bédier's attempt to approximate the hypothetical twelfth-century French prototype of the tale, which he made in the form of both a scholarly edition and, for the general public, a modern French prose version (followed, three decades later, by a stage play).[10] Cocteau's source is thus the purported "original" medieval French version of the legend, as reconstructed by a great modern

end of the film they do accept and embrace, in some sense, all the circumstances of their existence, but, even then, they could hardly be said to do so *joyously*. The victims far more than the choosers of their destiny, they really seem to have little in common with Nietzsche's forceful, purposive, self-affirming *Übermensch*.

9. This may be putting the matter of Wagner's influence a little too simply. As with Nietzsche, but with a great deal more likelihood, Wagner might have had a diffuse influence on the film as a whole. (See below on the question of whether or not Cocteau's characters consummate their love.)

10. Drawing on the various extant witnesses to the Thomas-Gottfried tradition, Bédier attempted a reconstruction of Thomas's poem in *Le Roman de Tristan de Thomas, Poème du XIIe siècle*, Société des Anciens Textes Français, 2 vols. (Paris: Firmin-Didot, 1902). Unlike this "edition," his reconstruction in modern French prose, *Le Roman de Tristan et Iseut, renouvelé par Joseph Bédier* (1900; Paris: Piazza, 1946), was based principally on the Béroul-Eilhart tradition and was designed for the general public. His play, co-authored by Louis Artus, was produced in 1929.

French medievalist and retold in modern French prose. However, to state simply that Cocteau was *influenced* by this work does not go far enough: indeed, for all his work of adaptation, he actually follows Bédier's canonical reconstruction religiously, reverentially. Such care, such scrupulosity, is on the part of a poet of Cocteau's independent stamp surprising and altogether noteworthy. Consequently, to bring out this point with sufficient clarity, it will be necessary to make a rather detailed comparison between the scholar's retelling and the poet's. This comparison will have the incidental merit of demonstrating the ingenious character of many of Cocteau's medieval-to-modern transpositions; but its main purpose is to show that Cocteau, for all his wanting to give the story a modern form, preserved the medieval shape of the tale (mediated through Bédier's reconstruction) with (for him) uncharacteristic completeness and exactness.

I. Tristan, Iseut, Joseph et Jean

As is well known, Bédier's *Roman de Tristan et Iseut* is based primarily on the Béroul-Eilhart tradition, drawing also on Thomas, Gottfried, and others, in order to construct a continuous narrative of the lovers' adventures and misadventures that was fairly close to the hypothetical French version.[11] Stylistically, it favors the straightforward narrative manner of Béroul/Eilhart over Thomas's elaborate ponderings, while, with regard to interpretation, it elects Thomas's version of the love-potion's permanent effect on those who drink it;[12] and in some minor

11. Bédier speaks of what he borrowed from whom in a short note prefacing his modern reconstruction (*Le Roman de Tristan et Iseut*, pp. xii–xiii).

12. The Queen of Ireland to Brangien, in Bédier's version: "Car telle est sa vertu: ceux qui en boiront ensemble s'aimeront de tous leurs sens et de toute leur pensée, à toujours, dans la vie et dans la mort" ("For such is its power: those who drink of it together will love each other with all their senses and with all their thought, forever, in life and in death," Bédier, p. 45).

ways, at least, it does not follow any medieval author at all, but is rather Bédier's own creation. (I am thinking, for instance, of some discreetly modern touches Bédier indulges in of foreshadowing, imagery, or psychological illumination; or, again, his use of certain recurrent motifs that either do not appear in the same form or do not occur at all in the medieval versions.[13])

To be sure, Cocteau's screenplay is not at all like Bédier in certain obvious respects. The settings, of course, are all modern. So is the language, which is simple and straightforward, even simpler than Bédier's, for the most part naturalistic and not noticeably poetic, something people living in the twentieth century could actually speak. (Without being inarticulate, Cocteau's characters do not go in for long discourses and avoid altogether the lyrical *épanchements* allowed their counterparts in Béroul/Bédier.) Cocteau has permitted himself no literal borrowings from Bédier apart from one, though admittedly an important one (Tristan's dying words, taken by Bédier from Thomas: "Je ne peux pas retenir ma vie plus longtemps" ("I cannot hold on to my life any longer!" Bédier, 218; Cocteau, 46). Only one other detail, that I know of, appears certainly to have been derived from Bédier (always assuming, as seems likely, that Cocteau himself did not directly consult the different medieval versions of the tale): Tristan's practice of signaling his presence to Iseut by imitating bird song, particularly the song of the nightingale (see the summary below, under the heading of Chapter XIII [*la Voix du rossignol*]). In addition to these few details, Cocteau's screenplay shares, of course, a general harmony of spirit with Bédier's renewed form of the legend, the most important and obvious sign of influence being the fact that

13. Bédier uses the motif of the Celtic Other World in a way that is certainly à propos, but (so far as I know) original with him, i.e., unlike in any medieval version of the legend. Petit-Crû's magic bell, that Bédier would have found in Gottfried and is clearly of Celtic provenance, may have suggested it; however, in Bédier's version, at two other points in the story the lovers evoke the happy Other World, the Land of the Living, where they might some day be able to live in peace (pp. 65–66 [ch. VI], 204–05 [ch. XVIII])—rather like a Celtic Tony and Maria ("There's a place for us . . .").

Cocteau's version preserves the same overall shape—and the same sequence of episodes—as the great scholar's reconstruction.[14]

However, that is not to say Cocteau does not make some very significant adaptations even in narrative shape and sequence. They are all of a sort, however, as to give even greater relief to the fundamental lines of Bédier's Tristan. Cocteau quite freely eliminates entire episodes and characters; likewise, he does not hesitate to *combine* episodes and characters (and places)—all in the interest of clarity. He has largely reduced the *dramatis personae* to the three groups who play an absolutely essential role:

- the central triangle: Marc, Patrice (= Tristan), "Natalie I" (= Iseut la blonde),
- the enemies of the lovers at Marc's "court": the Frossin family, named after the evil dwarf of the medieval tradition, Frocin
- the hero's friend and the hero's bride-to-be: Lionel (= Kaherdin) and his sister "Natalie II" (= Iseut aux Blanches Mains)

Brangien and Governal, faithful companions of heroine and hero, have been eliminated; so have the seneschal Dinas, the hermit Ogrin, and episodic or secondary characters such as Gilain of Wales, Riol, Hoel of Brittany, Kariado, and Bedalis. A secondary but pivotal character like Morholt has not been done away with; rather he has been made to serve multiple functions: the Morolt of the film corresponds not only to Morholt, the champion of Ireland, but also to the dragon Tristan must fight during his second stay in Ireland, to the steward who falsely

14. For the purposes of the second part of this paper, whether Cocteau was in fact using Bédier is ultimately less important than that he was following *some* "canonical" reconstruction of the French prototype similar to Bédier's; however, since its publication at the beginning of the century Bédier's modern French rendering had been the best-known and most readily available version of the legend in France, and simply for that reason—quite apart from the similarity of details mentioned above—it is the most likely candidate to have been Cocteau's model.

claims the victory and Iseut's hand, and even to Yvain the Leper, to whom Marc wants to abandon his unfaithful wife. Likewise, the four wicked barons and the astrologer dwarf Frocin who conspire against the hero have been compressed into a family of three. Yet another case of combination involves the various sea voyages of the story. They are just as important in the film as in the romance, but there are not so many of them; Tristan's two trips to Ireland are compressed into one, and the same goes for his later shuttling back and forth between Cornwall and Brittany. Meanwhile, Tristan's destinations on these journeys; Brittany, Ireland, and the island on which Tristan combats Morholt.have all been collapsed into a single, unnamed island on which the hero delivers Natalie I from Morolt, is healed by her, plans to wed Natalie II, and dies while waiting for Natalie I to come join him.

In spite of all these reductions, the sequence of episodes remains basically unchanged from Bédier, as demonstrated by the following summary, which uses Bédier's chapter headings. Episodes in boldface are retained in the film; the others are omitted.

1. *Les Enfances de Tristan*

The opening scenes of the film, which take place in the imposing château of a wealthy landowner, do precisely what Bédier's first chapter does: establish Patrice's close relationship with his uncle and at the same time reveal the envy and malice of Patrice's enemies, the unholy Trinity of the Frossin family (Gertrude, Amédée, and their dwarf son Achille) (see fig. 1). Patrice and his uncle both would be glad to be rid of the trio, but cannot, any more than the king in the romance can send away his chief barons: the Frossins, incredibly, are family, Gertrude being the sole surviving sister of Marc's deceased wife Édith and Patrice's drowned mother Solange. (The reference made in this opening section to the death by drowning of Patrice's parents corresponds to the sad tale of Tristan's forebears in the romance.) Provoked by his unpleasant relations, Patrice proposes to his uncle that Marc should marry a young bride, to spite the

Frossins and improve his own disposition, and laughingly undertakes to find the woman for him.

2. *Le Morholt d'Irlande; 3. La Quête de la Belle aux cheveux d'or*

Patrice travels by motorboat to a nearby island to collect rent from his uncle's tenants there. (Shots of Marc's château ["*style Louis XIII*"] give no hint as to its geographical location, but as the story continues it becomes apparent that it must be near the sea on the one hand and some rather high mountains on the other.) He gets into a fight with a barroom bully, a certain Morolt, whom he finds tormenting a young woman and whom the locals are unwilling to take on. Patrice manages to subdue his opponent by a bottle-blow to the head, but himself receives a serious knife-wound. The girl, the unbelievably blond Natalie, has Patrice carried to her own dwelling, where she and her foster-mother Anne, a healer and wise-woman, nurse him back to health. Just before it is time for him to leave, Patrice proposes to Natalie on behalf of his uncle, and, though offended by this proposal-by-proxy, she accepts, in order to escape both the island and Morolt (who has taken into his head that they are betrothed). Anne, *connaisseuse d'herbes*, gives Natalie a love-potion she has prepared (labeled "Poison") to ensure the happiness of Natalie's impending marriage with Marc. Natalie agrees to use it, although, more of a modern than her islander friend, she does not believe in its magical efficacy.

(As noted above, the two trips to Ireland have been combined into the one trip to the island; the fight against the Morholt is no longer to preserve the freedom of the Cornish, but to protect Natalie from her suitor-attacker. Natalie, unlike Iseut, is not really of the island; though she was born there, her parents were Norwegian, and they were both drowned when she was only an infant. In this regard, Natalie's circumstances parallel Patrice's far more than Iseut's do Tristan's [they are both "enfants de la mer," says Patrice]. At the same time, however, her circumstances also help explain the melancholy and fatalism that seem characteristic of her and that correspond, at this point

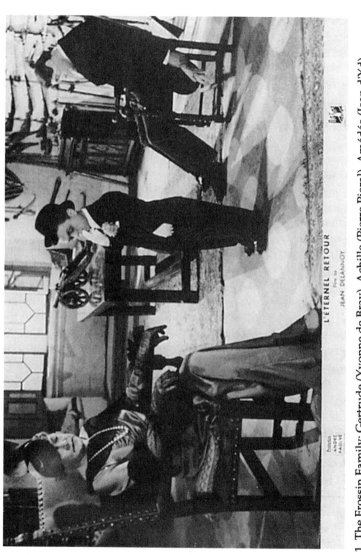

1. The Frossin Family: Gertrude (Yvonne de Bray), Achille (Pierre Pieral), Amédée (Jean d'Yd)

in the story, to Iseut's regret at leaving Ireland. Natalie is also, of course, irritated at the *gaucherie* of the proposal she has been forced to accept, and the misguidedness of the whole undertaking is as manifest in the film as it was in the medieval romance. In both versions, one could say, a fatal blindness prevents the hero from guessing his prize's true feelings and from seeing what an impossible situation he is placing all three of them in.)

4. Le Philtre; (5. Brangien livrée aux serfs;) 6. Le Grand Pin

In the boat trip over from the island, the incipient love of Natalie and Patrice remains so; they do not drink the potion until later. (This is the one major change Cocteau introduces into the order of episodes; I discuss it further below.) Marc receives the newcomer, is taken with her, and soon announces his intention to marry her. The marriage occurs shortly afterwards, but apparently is not consummated right away: the day of the wedding, Natalie asks Marc for time to "get used" to her new life, including him. (Presumably, it never will be consummated, since by the time Natalie returns definitively to Marc she is in the grip of a debilitating illness; Cocteau, like Wagner in this at least, preserves his Iseut from the dishonor of physically belonging to two men at once.) Gertrude Frossin, meanwhile, is convinced that what will shortly become a reality already is (that is, that Patrice and Natalie are lovers), and undertakes with the help of Achille to open Marc's eyes. Destiny lends a hand. One stormy day, Patrice and Natalie are alone together in the château (apart from a drunken and terrified Achille skittering about in the shadows). Filled with murderous rage at his cousin, the dwarf pours into their drinks the contents of the vial marked "Poison" that he has found in Natalie's medicine cabinet. Modern tale though this may be, the potion works. The two have only begun to experience its effects when Marc and the elder Frossins return to the château, but their behavior is such that Gertrude has no trouble arousing Marc's suspicions. Giving as his reason the desire to avoid gossip, Marc asks Patrice to absent himself for a

while from the château (cf. Bédier 62 [ch. VI]). Patrice arranges a final meeting with Natalie, corresponding to the tryst beneath the pine tree in Bédier/Béroul, and everything takes place as in the romance: the dwarf Achille alerts Marc to what is afoot, but Patrice and Natalie realize that Marc is spying on them as they talk, and they are careful to speak in such a way as to regain his confidence for a time.

7. Le Nain Frocin (= the Flour episode)

But only very briefly, for immediately afterwards Gertrude and Achille convince Marc to try another stratagem. As in the flour episode in the medieval tale, Marc pretends to leave the château but returns secretly and surprises Patrice in Natalie's bedroom.

8. Le Saut de la Chapelle → La Forêt du Morois

Even though they have got no further than a full avowal of their love for each other, the circumstances are enough to condemn the pair in Marc's eyes. He announces his intention to send Natalie back to the island—it is equivalent to a death sentence, since Morolt will probably kill her—and banishes Patrice from the château. Patrice rescues Natalie from her guards (Gertrude and Achille) as they are taking her from the château and flees with her to a presumably nearby—but most unexpected—refuge, an abandoned cabin perched amidst snow-covered mountains.

9. La Forêt du Morois; (10. L'Ermite Ogrin;) 11. Le Gué aventureux (= Iseut reconciled with Marc, Tristan exiled)

It is comfortless, dilapidated, "a sort of poachers' refuge," says the screenplay (37). The isolation and discomfort of this mountain repair, in particular the lack of supplies and the cold, correspond to the hardships Tristan and Iseut must undergo in the Forest of Morois. The lovers have no warm clothes, not even blankets, and have been obliged to sleep in their clothes.

They have presumably spent only one night there when the scene opens. If their love has been consummated, it could only have been on this occasion; and perhaps it has not been even now, since this part of the film also corresponds to the episode of Marc's discovery of the lovers in the forest, in which he finds them sleeping together but, to his surprise, fully clothed and separated by a sword.

Marc is, indeed, nearby; Patrice's dog, Moulouk (= Husdent), has discovered Marc's glove and brought it to Natalie (so, in the romance, the lovers discover Marc's glove, ring, and sword that he has left behind). After Patrice has gone off to get supplies, Marc appears, ready to take Natalie back, and she allows herself to be led away—out of fear, out of concern for Patrice, or perhaps out of her tendency to fatalism that renders struggle impossible for her. (In Bédier, it is similarly Marc's visiting the lovers in the forest and leaving signs of his passage that precipitates the lovers' decision to be reconciled with the king.)

Natalie returns to the château, but now goes into a physical decline from which she does not recover. This illness may have begun with the unprotected night on the mountain, but its progress seems more the psychological or symbolic result of her being severed from Patrice.

(12. *Le Jugement par le fer rouge; 13. La Voix du rossignol; 14. Le Grelot merveilleux*)

Cocteau dispenses with the further testing of Iseut by Marc and with Tristan's acquisition of the fairy dog Petit-Crû, borrowed by Bédier from Gottfried (he does, however, have Natalie keep Moulouk, just as Husdent stays with Iseut when the lovers must separate). He does not have Patrice linger for a while in the vicinity of his lover, as Bédier has Tristan do in the chapter "la Voix du rossignol," but he does take over from Bédier the detail of Tristan's being able to imitate the song of the nightingale, which he uses at various other moments in the screenplay.

15. *Iseut aux blanches mains; 16. Kaherdin*

After exhausting himself driving about aimlessly for some time (corresponding to Tristan's finding service in many different countries before winding up in Brittany; cf. Bédier, 154 [ch. XV]), the embittered Patrice ends up in a town in the vicinity of the château. Banished by his uncle and believing himself abandoned by Natalie, he is ready to accept a new family, which now presents itself in the form of an old friend, Lionel (= Kaherdin), who runs a garage in the town, and Lionel's sister, also named Natalie. His new life could not be more different from his existence at the château: the disorder of the living arrangements, the noisy bonhomie of Lionel, the affected cynicism of "Natalie II," the latter's good looks but very dark hair (see fig. 2). It is, nevertheless, a home that Patrice appreciates: all three are, as Lionel states, "enfants abandonnés," and feel themselves drawn together as a consequence. Spurred on by Lionel, and convinced that Natalie I has truly abandoned him (here the Frossins have again played a role), Patrice actually proposes to Natalie II. As he explains later to Lionel, he is hoping to find a way to "heal himself" after his painful experiences.

For the site of the wedding, he chooses, with a sense of symmetry but little of any other kind of sense, the very island where he found Natalie I and from which he delivered her. (Hence this island, previously standing in for the "Ireland" of the legend, now becomes the "Brittany" where Tristan takes a wife and eventually ends his days.) But Natalie II finds out about the original Natalie and tells her brother. Confronted by Lionel, Patrice reveals all and proposes a final trip to the château that will decide matters. If he can be convinced for good and all that Natalie I in truth no longer cares for him, he will be content to settle down with his newfound friends (cf. Bédier, 173 [ch. XVI], where it is Kaherdin who makes this suggestion).

(17. Dinas de Lidan; 18. Tristan fou)

In Bédier, Tristan makes two trips back to Cornwall, once in Kaherdin's company, during which he disguises himself as a

2. Nathalie II (Junie Astor) and Patrice (Jean Marais)

leper, and once alone, during which he disguises himself as a fool. Cocteau allows only a single return, which is at the same time the occasion for Patrice's receiving a fatal wound.

19. *La Mort*

In Bédier/Eilhart/Thomas, the wound is received in a skirmish that takes place in Brittany. In the film, this happens at the château, as Patrice is vainly trying to summon Natalie I with his bird song. Natalie has changed bedrooms in the meantime and cannot hear him; the dwarf Achille does, however, and on this occasion at last succeeds in satisfying his hatred of Patrice by shooting at him and wounding him in the leg. With Lionel's help, Patrice makes it back to the island, but his wound now takes on supernatural or symbolic dimensions (as has Natalie I's sickness). Knowing that he is going to die, he begs Lionel to bring Natalie I to him so he can see her one last time. If he succeeds, he is to replace the ship's pennant with a white scarf of Natalie's (see fig. 3). As in Bédier, out of jealousy Natalie II falsely informs Patrice about the color, and Natalie I arrives just after Patrice has expired. She herself has only enough strength to lie down at his side and join him in death. (Like Tristan's wife in Bédier, but *not* in Thomas [Bédier's chief source at this point], Natalie II at once expresses regret for what she has done.[15] As in Bédier, Marc seems at last to accept that Patrice and Natalie I are lovers and to recognize the transcendent quality of their love [see Fig. 4]: "Personne ne peut plus les rejoindre" ["No one can reach them any more"], he says in the film.)

Having followed Bédier's narrative so closely, it would not be surprising if Cocteau let himself be influenced in other ways by the great medievalist's reconstruction. Temperaments and motives are presented in basically the same way in the film as in the romance: Patrice's naïveté and lack of foresight at the start,

15. Bédier, p. 219. The wife in Eilhart does express regret for what she has done; but she did not have the same motive for misinforming Tristan in the first place.

and his bitterness and suspicions once he has been separated from Natalie; Natalie's anger at the nature of his proposal, and the folly of both of them in not responding earlier to the instinctive attraction they surely feel for each other; Marc's infatuation with Natalie, his desire to protect Natalie from gossip (his original reason for wanting Patrice to leave the château), his rage at being betrayed by his wife and nephew, and his unwillingness to give up his prize; the plottings and poisonous hatred of the hero's rivals; the loyalty of Lionel and the jealous fury of Natalie II. Themes, too, inherent in the story but delicately insisted on in Bédier's version, have been taken over, sometimes developed further or generalized. The love-potion as a kind of poison, the passion that it gives rise to as a kind of death or leading inevitably to death, these are notions that the screenwriter brings in repeatedly, intertwining them with some of his own preoccupations.

What of the temporal development of the passion, the shape it is given in this version? Cocteau has actually introduced one major change here, in that he has given the avowal of the passion a much longer fuse. The lovers are already in Marc's realm, already under suspicion, before they come fully to realize their feelings for each other; and consummation does not come (if it ever comes)[16] until the lovers have fled to their "forest" (and, indeed, are very soon to part forever). Bédier's arrangement:

> A. *potion*
> B. *consummation*
> 1. arrival and marriage
> 2. tryst at the pine tree
> 3. flour episode and condemnation
> 4. escape to the forest of Morois

16. In leaving open the question of whether the love of Patrice and Natalie I is ever consummated, Cocteau may, of course, have been influenced by Wagner, who does not allow the lovers ever to come together physically; however, as the discussion below will show, Cocteau's own conception of love included the idea that the intense desire for union was at bottom impossible to realize in this world.

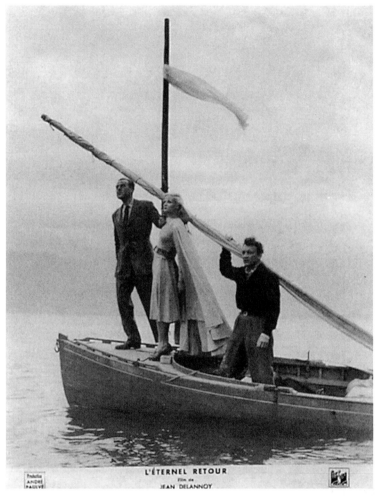

L'ÉTERNEL RETOUR
Film de
JEAN DELANNOY

3. Marc (Jean Murat), Nathalie I (Madeleine Sologne), Lionel (Roland Toutain)

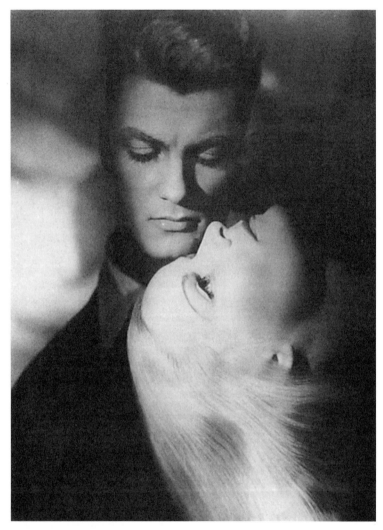

4. Patrice (Jean Marais) and Nathalie I (Madeleine Sologne)

has been reordered thus:

> 1. arrival and marriage
> A. *potion*
> 2. tryst at the pine tree
> 3. "flour episode" and condemnation
> 4. escape to the "forest of Morois"
> B. *consummation* (?)

The rising movement by which the lovers begin to feel the passion, declare it, commit themselves to each other, and satisfy their desire for the first time, is now stretched over the much longer period during which the characters of the medieval romance are discovering the difficulties and sorrows that must follow inevitably upon their love. The feeling of suspense, or at least the feeling that a development of some kind is occurring, is consequently greater in the film. In other respects, however, nothing essential has been changed in the way the love begins and progresses, nor, especially, in what it is eventually revealed to be. Mysterious and ambivalent in its beginnings, it is undeniable and all too clear when it finally establishes itself. The potion that awakens their passion, and that has improbably been carried over unchanged into this modern retelling, is just as ambiguous in the film as in Bédier/Thomas (is it simply a *symbol* of a "fated" love, or is it in fact a brew with magical powers?). Then, as incidents succeed one another, the lovers in the film, just like the ones in the romance, discover certain irrefragable things about the nature of the passion that binds them: that love, for them, means suffering; that their love and their suffering are inescapable, since, though life together is impossible, life apart is unbearable torment; and that the only possible conclusion to their adventures and satisfactory meeting-place for their love is in death.

II. A Close-to-Perfect Fit

By now, we can take Cocteau's fidelity to his model as sufficiently demonstrated. Such close adherence—amounting to an almost religious reverence for the traditional form of the tale,

and producing, in the screen version, a solemnity verging on ponderousness—is remarkable, for the simple reason that Cocteau is *not* a writer one thinks of as primarily reverent. The opposite of conventional and predictable, he is not the sort to follow placidly somebody else's lead, even—or especially—when he is retelling somebody else's story. This is particularly true of his works for the stage and screen. In his first creations for the theater—futurist concoctions like *Le Boeuf sur le toit* (1920) and *Les Mariés de la tour Eiffel* (1921), featuring music by the most progressive composers of the day—he delighted in turning theatrical conventions on their heads. Later, he more than once tried his hand at giving modern theatrical dress to ancient myths. The changes he works on the old stories are startling, irreverent, almost iconoclastic; they serve a purpose, however, which is to lend to the tales a fully modern resonance, one of Cocteau's own making. The stage version of his *Orphée* (premiered 1926), very different from the 1947 film, is just as unexpected in what it does to the classical legend. In both film and play, Orpheus is no antique lyricist, but unquestionably a modern poet, such as Cocteau conceived himself to be, fully endowed, consequently, with Cocteau-like aspirations, duties, and difficulties. In 1934, Cocteau had an even greater success with *La Machine infernale*, his retelling of the story of Oedipus. Unlike *Orphée*, this recasting of an ancient tale does not actually put the characters in modern dress, but it does update the story strikingly in other regards; and, as *Orphée* did with the figure of the poet, so too *La Machine infernale* gives to its hero's fatedness a decidedly Cocteau-ian twist. (Cocteau's manner of updating classical stories for the stage was so striking and so successful that it created almost a new theatrical genre, at which later leading French authors would try their hand.[17])

In his films, too, Cocteau was individual and innovative, not imitative and reactive, even when he was ostensibly

17. Mention should probably be made of the play *Les Chevaliers de la Table ronde*, Cocteau's other foray into the matter of Britain (completed 1933, premiered in 1937). It revolves around a psychological symbolism of Cocteau's invention. Since the story is completely original, this play does not count as one of Cocteau's retellings.

reshaping an older story. His first effort, *Le Sang d'un poète*, was clearly the creation of a genuinely cinematic mind, but it was also the product of a total novice, with no experience in the practice of filmmaking, who for lack of that background had to make up his techniques as he went along.[18] When he took up filmmaking again in the '40s, though he did first take time to observe an experienced director at work (on *L'Éternel Retour*), he again proceeded to make films of a sort no one else had ever done before (or, indeed, in some respects, has ever done since). And, as with his works for the stage, perhaps his greatest successes for the screen were highly inventive retellings of well-known legends or stories: the 1945 *La Belle et la Bête* and the 1947 *Orphée*.[19]

Characteristic of all Cocteau's retellings, for both the stage and the screen, is a fruitful clash that occurs between the audience's familiarity with the legend and the unexpected new perspectives the modern poet/playwright/*cinéaste* brings to it.[20] It is as though one were viewing old and new at once. The

18. On Cocteau as filmmaker, see Taylor, cited in note 4 above.

19. *Les Parents terribles,* based on his own play, and not a retelling of a famous story but a drama about family relationships set in our day, is another great film of the same ten-year period of intense cinematic activity.

20. Cocteau himself speaks of the importance of departing from one's model: "Si Shakspeare [*sic*] adopte Roméo et l'adapte, Molière, Don Juan, Racine, Phèdre, Goethe, Iphigénie ou Faust nul ne le leur reproche. Ils savent que copier est une grande méthode, puisque *c'est par où copier leur est impossible que leur génie se prouve*" ("If Shakespeare adopts Romeo and adapts him, Molière, Don Juan, Racine, Phèdre, Goethe, Iphigenia or Faust, nobody criticizes them for it. They realize that copying is a great method, because precisely where copying is impossible is where their genius shows itself," Cocteau, *Jean Marais,* Collection Masques et Visages dirigée par Roger Gaillard [Paris: Calmann-Lévy, 1951], p. 112; my emphasis). Or again: "Je conseille toujours de copier un modèle. C'est dans l'impossibilité de refaire pareil et dans le nouveau sang qu'on lui infuse qu'on juge le poète" ("I always recommend copying a model. It is in the impossibility of doing exactly the same thing again and in the new blood infused into the model that one judges the poet," *Du cinématographe*, p. 133).

superimposition of perspectives is audacious, even shocking; quite often, illuminating; quite often, convincing, once one accepts the premises of the new version; and also, quite often, funny. In contrast, one of the most striking things about *L'Éternel Retour*—given its author—is that it is *not* very shocking. (Nor very funny. It has its droll moments, but rarely when either Patrice or Natalie is on the screen, and never when they are there together—that is to say, for the bulk of the film.) For this comparative absence of wit and surprise, we know the reason, in part: it was Cocteau's wish in this case to treat the traditional form of the story with the greatest respect, to resurrect it almost unchanged. *L'Éternel Retour* is not a film of clashing perspectives, of the modern imposed upon and fruitfully warring with the old; it is the old recycled, dressed up as the new.

But why, in this one case, was Cocteau so eager to remain faithful to the original form of the story? Why, in retelling the story of Tristan and Iseut, did he not allow himself his usual flights, his usual irreverences? The answer, paradoxical though it may seem, is probably that the story of Tristan and Iseut was, as a vehicle for Cocteau's genius, actually *too* well suited to him; that is, it provided too easy a fit for his central preoccupations, and therefore it did not provoke in him the need, or the wish, to re-envisage very much. Not that Cocteau has not made the story his own. On the contrary, the key themes of his *œuvre* are everywhere present, but they are not very much *in evidence*, because they blend in so thoroughly with the traditional lines of the story.

By way of illustration, let me discuss briefly three interrelated themes that occur elsewhere in Cocteau and also play a role in this film.

1) To judge from some of his major works, Cocteau was not very sanguine about the prospects for love in this world, at least for a certain kind of "ideal" love (ideal for the poet writing about it), a love that is absolute, imperious, and by its very nature world-transcending. This love wants complete possession of what, essentially, it cannot have in so total a fashion; it desires a closeness with its object that, spiritually—and sometimes literally—one could say, makes it into a kind of incest. This kind of love is always, in the end, a forbidden and impossible love. It

sometimes appears as an immensely strong, all-consuming mother-love. One thinks of the two great roles interpreted for the screen by Yvonne de Bray (one was certainly, the other probably, created with her in mind): Yvonne in *Les Parents terribles* and Gertrude Frossin in *L'Éternel Retour*, and of course there is Jocaste in *La Machine infernale*. Sisters can harbor too strong an attraction for their brothers, as Élisabeth does for Paul in *Les Enfants terribles*. A similar case of a female character overstepping the bounds of intimacy is the Princess in the film version of *Orphée*. She is already Orphée's personal "death," a relationship presumably as intimate as that of a close relative, and she illegitimately tries to inject into that her human love for the poet. It should be noted that the desire for the impossible union is not all one way, female to male: the men respond to and share in the women's desire, either by passively accepting the love and allowing themselves to be dominated by it (Paul in *Les Enfants terribles*, Michel in *Les Parents terribles*) or by more actively responding to it and seeking it out (Oedipe, Orphée).

2) This love cannot be realized in this world, or, if it is realized, it cannot *last* here. But it is not without its destiny and its splendor. There *is* a sense, actually, in which it can be realized here, that is, if it is willing to self-destruct, to sacrifice itself (and thereby avoid destroying others). Yvonne, the mother in *Les Parents terribles*, manages to make this sacrifice (though it is very much in question whether she will do so up until the very last moment of the play). So too, in a magnificent and terrible gesture, does the Princess in *Orphée*. Jocaste and Oedipe do so also (they are more or less obliged to). (Élisabeth in *Les Enfants terribles* does not, and ends up destroying both her brother and herself.) In the best of cases, the effect of such a sacrifice is or can be to propel the love into a kind of eternal state, in which it loses whatever was imperfect or sordid about it during its existence in this world and becomes the special concern of the poets. Something like this happens to Jocaste and Oedipe at the end of *La Machine infernale*, after she is dead and he is blinded. Once the violence is past, their relationship actually begins again in a purer form, as they become (so declares Tirésias) the property of "the people, the poets, the pure in heart."

3) The universe, consciously or unconsciously, may help the lovers reach this point. Such a thing as destiny exists, although it is replete with ambiguities. Among other questions, from the point of view of the person with the destiny it is very doubtful whether what the universe has in store for him or her is actually desirable or not.[21] In the immediate—before death has come—it is more likely to seem evil, e.g., the suffering and destruction that Oedipe and Jocaste are forced to pass through. Likewise, it is difficult for the predestined to see where it is all leading, supposing that it seems to be leading anywhere. This latter uncertainty is shared even by the agents of destiny, intermediate beings between mortals and the ultimate purpose of things such as the Princess in *Orphée* and Anubis in *La Machine infernale*. These agents cannot be sure of the nature or the existence of the higher being supposedly acting through them, cannot even be sure of the role they are playing in the whole drama. It is even possible for them to believe themselves to be acting for one end, when in fact their invisible master is using them to bring about the opposite end.

Could a story be better suited to embody this set of themes than the tale of Tristan and Iseut? Their love is imperious, irresistible, and at the same time quite impossible. The union it seeks is quasi-incestuous, because Iseut is Tristan's aunt by marriage, of course, but perhaps also because a love so intense and absolute creates by its very nature too close an intimacy for this world. As I have noted above, in the film Cocteau draws attention to this idea of the lovers as twins, as doubles of each other, by endowing them with similar backgrounds—they have both lost their parents at sea—and by heightening their physical similarity to each other. Such a love is essentially not of this world and cannot long endure here; to give oneself over to it is to give oneself over to death. "You have drunk love and death at the same time!" says Brangien in Bédier's version (50). In the film, Natalie I, it would seem, is the first to realize fully that

21. Not only lovers, but the poet too is troubled by this uncertainty regarding a special destiny or mission bestowed upon him by an ambiguous Beyond. See Jean-Marie Magnan, *Cocteau*, Les Écrivains devant Dieu (Desclée de Brouwer, 1968), *passim*.

death offers the only possible refuge for their impossible love. Such, I think, is the real meaning behind her so readily giving up Patrice, after Marc has found her again, and at once sinking into her fatal illness: she senses that she cannot enjoy Patrice in this life and that death is consequently her true destination. Patrice's so quickly succumbing to the gunshot wound he receives somewhat later bespeaks a similar instinctive understanding. The three onlookers who witness the end of the lovers (Marc, Lionel, and Natalie II) must likewise realize not only that death is a necessary conclusion to their love, but that it serves as both a refuge and an apotheosis for it. Marc's words, as they gaze at the two bodies, are the last of the film: "Personne ne peut plus les rejoindre" ("No one can reach them any more," 46),[22] and at once the setting is transformed, the boathouse where they are lying becoming a lofty chapel. The screenplay concludes solemnly: "... *ET LEUR VRAIE VIE COMMENCE*" ("... AND THEIR TRUE LIFE BEGINS"). With the fittingness of their death so generally recognized, even by the lovers themselves, it is scarcely too much to say that Patrice and Natalie "sacrifice themselves," that is, accept death, for the sake of a transformed and eternized love, just as some other of Cocteau's characters do.

To be sure, as was the case also with Jocaste and Oedipe, it may be a question of accepting the unavoidable. Even in the medieval tale of Tristan and Iseut, a kind of fate—blind though it may be—brings the two together, seems to destine them for each other, and leads them to the dreadful accident of drinking the magic potion which brings love and death in its train. In the film, the impression of the fatedness of the lovers is reinforced by the conceit of having the modern lovers *relive*, unaware that they are doing so, the experiences of Tristan and Iseut; they thus

22. Natalie II has already had an intuition of Patrice's being set apart from other folk. As she says to Lionel: "Même quand je le vois et que je lui parle, il est invisible. . . Patrice habite un autre monde que nous. . . . Nos rires l'agacent . . Notre légèreté le tue. . . Et quand il ne nous évite pas. . . il est encore plus loin" ("Even when I see him and I speak to him, he's invisible. . . Patrice lives in another world than ours. Our laughter sets him on edge. Our frivolity kills him. And when he isn't actually avoiding us, he is even farther away," p. 42).

definitely appear the playthings of supernatural forces beyond their comprehension or control. Are the forces beneficently disposed in their regard? Not, it would seem, as far as their earthly existence is concerned. But on the other hand these forces are aiming at the lovers' ultimate glorification and immortalization. To that end, everything and everyone in the story contributes—even, or rather, especially, those who think they are working for the lovers' harm (the Frossins). As a matter of fact, one or another of the Frossins plays a role in almost every important development of the story, from the moment the lovers-to-be arrive at the château to the very end: arousing Marc's suspicions (Gertrude); giving the innocent Patrice and Natalie the potion to drink (Achille); helping Marc to catch the lovers in the act (Gertrude and Achille), so that he banishes them, which leads to their running off together; persuading Patrice that Natalie no longer cares for him (Amédée, directed by Gertrude), so that he conceives of marriage to another, which leads ultimately to his returning to the château for a final confrontation; giving him his fatal wound (Achille). Like Anubis, however, or like the Princess, the Frossins, unconscious instruments of destiny, always end up working at cross-purposes with themselves. Whatever they do, the effect is invariably to push the lovers a little closer to their final entrance into glory. Cocteau's version of the story has thus taken up and, so to say, generalized the importance of destiny; in his handling, heroes and villains alike are manipulated by an unrelenting, all-powerful, ambiguously benevolent fate.

However, although Cocteau may have intensified certain aspects of the story, the most important of these—the impossible love, love and death, death and destiny, and the ambiguous Beyond that decrees both glory and torment—were already there *in* the story; he did not have to import them, or alter the story significantly in order to emphasize them. Why should this be a problem? Apparently, when the original material is *too* congenial for him, and certainly when he ends up showing it the deference due to a sacred text, Cocteau is less likely to work his usual kind of magic on it, which means that we are less likely to believe what he sets before us. We *need*, in fact, his deviations, the different optic he brings to a story, the unexpected, alien

elements he introduces, the clash of traditional versus modern—
not simply because these things are unexpected and diverting,
but much more because they help us to accept as real what we
have always thought of as legendary.

Now, belief, of a certain kind, was quite central to
Cocteau's cinematic "project." In his *dicta* about the cinema, he
returns repeatedly to the issue of what at one point he calls
"réalisme irréel" ("unreal realism," *Entretiens sur le cinéma*, 46).
"Le cinématographe" he says, using his preferred term for the
seventh art, "est une arme puissante afin d'obliger les hommes à
dormir debout" ("The *cinématographe* is a powerful weapon for
forcing men to dream standing up").[23] It is indeed the business
of the *cinématographe*, according to Cocteau, to deal with the
"unreal," the "poetic," the "marvelous," to take us beyond this
world into another realm; but it must make us accept these
imaginary realms as real, and accept them in exactly the same
way we do the most ordinary things of our daily existence. It
most assuredly does not achieve this end by abandoning the
concrete, the ordinary, the familiarly real; even more important,
it must never reach after the "unreal," the "poetic," and the
"marvelous" in any obvious way. Indeed, it must not seek these
things directly at all; it must come upon them by accident. He
says, writing of *La Belle et la Bête*: "Ma méthode est simple: ne pas
me mêler de poésie. Elle doit venir d'elle-même. Son seul nom
prononcé bas l'effarouche" ("My method is simple: have nothing
to do with poetry. It must come of its own accord. Its very name,
pronounced in a low voice, frightens it off").[24] The only way, in

23. *Du cinématographe*, p. 29. And again: "[Le cinéma] nous offre un
véritable véhicule de poésie, en ce sens qu'il permet de montrer
l'irréalité avec un réalisme qui oblige le spectateur à y croire" ("The
cinema offers us a real vehicle for poetry, in the sense that it makes it
possible to show irreality with a realism that forces the spectator to
believe in it," *Du cinématographe*, p. 138).

24. Cocteau, *La Belle et la Bête: Journal d'un film* (Monaco: Éditions
du Rocher, 1958), p. 17. Similarly, in another place: "Je m'obstine à le
redire: Merveilleux et Poésie ne me concernent pas. Ils doivent
m'attaquer par embuscade. Mon itinéraire ne doit pas les prévoir" ("I've
said it before and I'll say it again: the 'Marvelous' and 'Poetry' don't

fact, to approach mystery is through sticking close to the concrete, because mystery is something that can emanate only from concrete objects: "Plus on touche au mystère, plus il importe d'être réaliste" ("The closer you get to mystery, the more of a realist you have to be," *Du cinématographe*, 133).

L'Éternel Retour, it seems to me, is not on a par with Cocteau's greatest works for the screen precisely in so far as it neglects to follow this indirect method. It gives us mystery in an untransmuted lump, and in that form mystery is no longer itself: it does not compel belief, and it does not move us. Alas, Cocteau thought he had to make Patrice and Natalie as different from the rest of humanity as possible. He largely succeeded, but at the price of creating a heroine and hero who exist so completely in a different realm that the rumor of all they are obliged to undergo scarcely reaches us. Their joys, their torments, the supernatural imperative that uplifts, afflicts, and drives them onward, are difficult to conceive, and hence to empathize with. When Natalie has lain down beside Patrice, and the boathouse is transformed into a chapel, indicating the promotion of the lovers into a state of eternal glory, it hardly seems like a change; they already, to far too great an extent, belonged to a different realm from ours. (Marc, too, curiously, since he is more of a mere mortal, ends up affecting us less than one might expect. This is largely because, after a certain point, the film allows us to see so little of him and reveals so little of what he is going through. The result is that he, too, becomes a distant figure for us.)

The film is most successful in those parts where it does not try to grab hold of mystery, but, on the contrary, eschews it. What could be less redolent of mystery than the household of the boisterous Lionel and his tough-talking sister (or more unlike our imagination of the court of King Hoel of Brittany)? But the picture comes alive here, as we observe this very human pair growing in their attachment for the emotionally distant and preoccupied newcomer.[25] Nor do we leave behind the old story

interest me. They must take me by surprise. I mustn't plan to go out and meet them," *La Difficulté d'être*, p. 68; *Du cinématographe*, p. 164).

25. Cocteau himself recognizes the difference between this part of the film and what precedes it: "Dans *L'Éternel Retour*, le château des

as the film becomes less obviously mysterious. On the contrary, this is where the doubling of perspectives really comes into play: Lionel's generous, affectionate loyalty breathing life into Kaherdin's, Natalie II's more anxious, possessive emotion doing the same for Breton Iseut's—and perhaps vice versa as well, our memory of the ancient characters standing behind their unlikely modern avatars, communicating to the latter an element of mystery that defies analysis: "*un insolite qui échappe à l'analyse.*"[26]

With the Frossin family, too, Cocteau eschews mystery, in the sense that he presents these preternaturally wicked enemies of the two lovers as an "ordinary"—that is, familiar ⸱(if dysfunctional)—kind of twentieth-century family unit, with the weak, self-centered, uninvolved father, the rapaciously adoring mother, and the tyrannized and tyrannizing, criminally antisocial child. The last of these three, the dwarf Achille, has, to

amants leur [aux juges superficiels] semble propre à la poésie. Le garage du frère et de la soeur, impropre; ils le condamnent. Étrange sottise. Car c'est justement dans ce garage que la poésie fonctionne le mieux" ("In *The Eternal Return*, the château strikes [the superficial judge] as suitably poetic. The garage of the brother and sister strikes them as unpoetic; they condemn it. Strange folly! For it's precisely in the garage that the poetry works best"). He goes on to describe this *poésie* with reference to Lionel and Natalie II: "En effet, à comprendre l'abandon du frère et de la soeur, à leur méconnaissance innée et comme organique de la grâce, on la touche du doigt, et j'approche des terribles mystères de l'amour" ("Indeed, in understanding the abandon of the brother and sister, in their innate and as it were organic miscomprehension of grace, one is in the immediate presence of poetry, and I come within the precincts of the terrible mysteries of love," *La Difficulté d'être*, p. 70; *Du cinématographe*, p. 164).

26. "Le merveilleux serait donc, puisqu'un prodige ne saurait être un prodige que dans la mesure où un phénomène naturel nous échappe encore, non pas le miracle, écoeurant par le désordre qu'il détermine, mais le simple miracle humain et fort terre à terre qui consiste à donner aux objets et aux personnages un insolite qui échappe à l'analyse" ("The marvelous, then—since a prodigy can be a prodigy only in so far as a natural phenomenon eludes us—is, not a miracle in the usual sense, revolting by the disorder it creates, but simply the human and very down to earth miracle that consists in giving to objects and characters an unusual element that defies analysis," *La Difficulté d'être*, p. 65).

be sure, some downright mysterious traits, indeed (like the astrologer dwarf in the medieval tale) a suggestion of supernatural powers. (He is devilishly clever at getting into and making away with things: at one point, while he is snooping in Patrice's room, a pack of cigarettes vanishes before our eyes. Has he whisked it away incredibly quickly, or has he made it disappear by magic?) However, even while allowing us to wonder about the nature of Achille's special gifts and the ultimate origin of his malevolence, Cocteau has kept this character firmly attached to the modern, concrete, quite understandable domestic reality of which he is a part. If the portrait of this contemporary horror-family has a special power, it is due primarily to what Cocteau has lent to it of himself, for the morbidly intense love-bond between Gertrude and her son is the quintessential Cocteau love relationship in its evil aspect. In fact, it is this relationship gone as bad as one could possibly imagine it going, the two members aiding and encouraging each other's evil tendencies until as a pair they take on almost mythically malignant proportions.

These two groups, Lionel and Natalie II on the one hand, the Frossin family on the other—the right- and left-hand panels in this medieval-modern triptych—are so well realized, so convincing, and (in their very different ways) so appealing, that one is inclined to wonder if Cocteau was not trying to compensate in them for the other-worldly, hieratic stateliness of the protagonists. In actual fact, the film's passing back and forth between the two kinds of characters, the more realistic and the more mythic-eternal, the earthy and the other-worldly, makes the doomed and noble lovers seem all the paler in comparison. It also makes of *L'Éternel Retour* the most uneven of Jean Cocteau's great retellings of ancient stories: at times immediate and touching, at times solemn and distant; at times light and witty, at times painfully earnest; in some places utterly persuasive, in others not at all. In being thus uneven, however, this inaugural film of Cocteau's great cinematic period bears a special interest of its own: it provides an excellent illustration of how, and how not, an artist like Cocteau should allow himself to be inspired by the past. He is not making the best use of it, one could say, if he shows it too much respect.

Tristan and Isolde in Modern Literature: L'éternel retour[1]

Michael S. Batts

Countless versions of the mediaeval Tristan legend evidence the need for every age to come to terms with the phenomenon of passionate love. The version by Gottfried von Strasburg portrayed the lovers in an existential conflict as they endeavoured to conceal and preserve their love from a society which did not comprehend its value. In later centuries the conflict centred around the opposing claims of love and law, usually ending tragically since the one was irresistible and the other inviolable. In early twentieth-century versions the sex drive and psychological frustrations took the place of love and it became questionable whether a new version was possible in a society without taboos. Nossack's Spätestens im November *offers a fresh approach. For Nossack's lovers, not the husband but the society he represents is the problem. They reject contemporary materialism, conscious of another realm of existence, ineffable and indefinable. The inner conflict arises from the necessity of reconciling this individual awareness with their mutual love. It is not the relationship between love and life but life itself that is problematical.*

Reprinted with permission from *Seminar*, 5 (1969), 79-91.

1. Read at the meeting of the Canadian Association of University Teachers of German in Calgary, June 14, 1968. Only notes have been added and some minor changes made in wording.

E luego que Tristán e Iseo hobieron bebido el brebaje,
fueron así enamorados el uno del otro, que más no podía
ser, e dexaron el juego del axedrez. . . .

Since its first appearance in literary form in the twelfth century,
the story of Tristan and Isolde has been told and retold in
countless versions, in verse and in prose, in drama and in music,
in films and in painting. The subtitle of this essay is in fact the
title given by Cocteau to his film of the legend. The phrase
"eternal return" he has borrowed from Nietzsche, but this does
not mean that I shall be concerned with that philosopher any
more than with Cocteau. Cocteau used the phrase because it
expressed his belief that "ancient myths are reborn without the
heroes' knowing it"—that is to say, myths are relived, re-enacted
at every period unknown to those involved. My intent is to show
not *how* this happens, but how in the process of literary
recreation and revaluation of these myths, the resultant works,
that is to say the forms the myth takes in these works, become a
measure of the spirit of the time. In our own time the question
will be whether the Tristan myth can still be presented in a
viable form, whether it still has meaning for us.

But let me first recall to mind the basic outline of the story
as it appears in the greatest mediaeval version, by Gottfried von
Strasburg. Tristan is sent to fetch Isolde to Cornwall to be
married to King Mark. On the journey they fall in love. The
marriage nevertheless takes place and they continue for some
time their clandestine liaison. Finally they are discovered and
Tristan is forced to flee. He sends, when he is dying, for Isolde,
who, however, arrives too late, but dies over his corpse. There
are numerous minor elements in this story, such as the fight with
the giant Morold, the lonely voyage, the love potion, and the
substituted bride, which appear in all the various versions and
which are part of the common stock of literary motifs. Some may
be found for example also in the Bible. But these features are
only incidental to the main problem which is the relationship
between Tristan, Isolde, and Mark—the love affair, the discovery
of it and the result.

The mathematical centre of Gottfried's symmetrically
constructed epic poem falls immediately after the confession and
the consummation of their love. Preceding and following this

central division are lengthy sections which make up the main part of the poem, devoted first to Tristan's early life and then to the lovers' relationship up to the time of their parting. The brief scenes which immediately precede and follow the central division provide us with the essence of Gottfried's philosophy. After the consummation of their love, Tristan and Isolde are told of the love potion that they have drunk, which—in Brangane's words—"will be the death of you both." Since much is often made in interpretations of the legend of the relationship between love and death, it is important to note Tristan's answer. He says: "If Isolde were always to be the death of me in this manner, then I could ask for nothing better than to die eternally."[2] In this conscious affirmation of what has at the outset been an almost unconscious act, Tristan clearly expresses his desire to continue his present experiences, to continue, that is, to *live*. He puts all thought of physical death from him, the physical death to which Brangane who foresees inevitable trouble, had referred.

What now follows is equally significant, namely the marriage of Mark and Isolde. The lovers make no attempt to flee, nor do they confess their love and brave the world. Instead, they accept the situation as it is and behave outwardly as if nothing had happened. In other words, they do not wish to break with society, but on the contrary endeavour to preserve its outward order. There is therefore for the lovers an existential problem. They consciously accept and affirm their experience, cherishing it and rejecting the worldly scale of values; but at the same time they conceal this experience from the world in which they live and endeavour outwardly to maintain an order in which they do not believe. Their problem is therefore to find a mode of living as it were on two levels, and the deceptions which they henceforth practise have the twofold purpose of maintaining their love on the one hand and of avoiding on the other a conflict with the world, a conflict which might lead to their death, but which would certainly threaten the stability of the social order.

2. "Solte diu wünnecliche Isot/iemer alsus sin min tot/so wolte ich gerne werben/umb ein ewechlichez sterben." Lines 12,499–502 in the edition by Friedrich Ranke (Berlin, 1959).

What their experience is, need not concern us in detail here, but one aspect of it is very important, namely its esoteric nature. The ultimate experience is the total absorption of the self in another being, the complete physical and spiritual union of the lovers, something which in Gottfried's view can be compared only with the *unio mystica* in which the mystic achieves union, if only momentarily, with the Godhead. But—and this is the important point—like the mystical experience, this is given to only a few and then only after great suffering. The few who are capable of understanding the nature of this experience and who hope and strive for it, Gottfried calls the "edele herzen." These, to whom he addresses his work, live *in* the world, but are not *of* it. Outwardly they are a part of the world, and even excel in worldly pursuits, but inwardly they are reserved, withdrawing into the world of the mind and the spirit, largely through the cultivation of the arts—literature and music. The symbol of this complete spiritual withdrawal is the famous episode of the love-grotto, to which Tristan and Isolde retire when they are banished from court. The suffering which Tristan and Isolde experience and which they, in common with the *edele herzen*, affirm as an essential part of their experience, is brought about by those ignorant or jealous of them, by the others—"ir aller werlde"—the world at large. Their alternation in this situation between joy and suffering, security and betrayal, is similar to the mental anguish and spiritual wavering of the mystic during the dark night of the soul. But in all of this there is no reference at all to the comfort of religion, no suggestion at all that the lovers either yearn for death or expect death to bring anything beyond. This question is left by Gottfried entirely in abeyance; his primary concern is to establish his religion of love and to depict the existential problem as the lovers face it.

The emphasis on the life rather than the death of the lovers led, at the end of the Middle Ages, when popular interest demanded matter rather than ideas, action rather than introspection, to a shift in perspective. The conflict was seen as one between compulsive love and jealous lust, and the whole story consisted of plots and counterplots between the lovers and the husband. The underlying idea was entirely lost sight of, and the author's viewpoint—and we may take Hans Sachs as an

example—is vacillating. Intuitively he is on the side of the lovers and he roundly curses those who are against them. On the other hand he also condemns this violent human passion, condemns passionate love *per se* and moralizes at great length on the danger of losing one's salvation through being brought by love to an ultimate and sinful death. In this respect Hans Sachs is typical of his time, when the attitude toward marriage was stiffening. The chivalric ethic, despite its Christian basis, had not actually been bound to the tenets of the church. The bourgeois ethic on the other hand was a code based upon a combination of pragmatic considerations and the requirements of organized religion. To this social norm then also the Tristan story had to conform and it therefore became a moral tale about unlawful love. But although Hans Sachs sums up his story in the familiar couplet—

Und spar dein lieb bis in die eh,
Denn hab ein lieb und keine meh'[3]—

yet nevertheless he is unable to escape completely from the feeling that love is somehow a greater thing than this.

After the end of the sixteenth century the Tristan story disappeared from view, to reappear only when the Romantics began their revival of mediaeval works. However, despite their great interest in mediaeval literature and their numerous attempts to embody mediaeval and renaissance materials in new literary forms, the Tristan theme fared very badly. The only attempts at new versions, by Schlegel, Platen, or Rückert, remained fragmentary. The reason for this can only lie in the Romantics' attitude toward love. The Tristan story seemed to laud adulterous love and condemn the legal husband. This might well have been acceptable to the Romantics, were it not for the fact that Tristan and Isolde made strenuous efforts, as we have indicated, to preserve and enjoy their love *in life*. For the Romantics, love was an experience which transcended life; it was a religious or semi-religious experience and distinctly other-

3. Hans Sachs, *Tragedia . . . von der strengen lieb her Tristrant mit der schönen königin Isalden* in *Werke*, vol. XII, ed. A. von Keller (repr. Hildesheim, 1964), 186.

worldly. Whatever may be the true meaning of Gottfried's poem, the Romantics saw it as essentially immoral since it was concerned with clinging to this life and apparently ignored the transcendental and religious aspects of love, even to the extent of outright blasphemy in the episode of the ambiguous oath.

The only poet to make anything of the theme in the early nineteenth century was Immermann, who, though not a Romantic, was certainly strongly under their influence. His work too is incomplete but it must be mentioned briefly at this point since it provides not only the material but also many of the attitudes characteristic of later writers. [4]

In Immermann's work Tristan and Isolde are in love before they drink the love potion, but the assumption that they can never be united leads them severally to renounce happiness. Isolde says farewell to all joy in life and resolves to devote herself to charitable enterprises and to living with Mark in sisterly solicitude. Tristan, for his part, determines to put his life in the service of the church, to risk it fighting the heathen in the holy land, for only in this way, he feels, can he do recompense for his great sin in uniting Isolde and Mark. After the confession of love, the realization that they still cannot be united leads them to renounce life entirely, that is to say, they decide to commit suicide. This is prevented by Brangane who is willing to substitute for Isolde on the wedding-night. The rather decorous discovery scene in Immermann's work leads to Isolde's demand for the ordeal by fire which she then, apparently successfully, undergoes. But after this ambiguous oath—which incidentally is made possible only by the *chance* meeting with Tristan in disguise on the way to the place of ordeal—Isolde herself banishes Tristan from her presence. She feels herself now sanctified and no longer able to maintain their relationship. Tristan must go away and may send for her only in the hour of his death.

The latter part of the work is available only in a prose outline and interpretation is therefore a little difficult, but the difference between it and the first part is nevertheless

4. Karl Lebrecht Immermann, *Tristan und Isolde* (Dusseldorf, 1841).

remarkable. Whereas earlier Isolde had been prepared romantically to sacrifice everything for the sake of passion, for a passion which raised them above others and rendered them free of the world—"frei da vor Sonne, Licht und Meer, frei da vor Gott dem höchsten Seher" (p. 356)—she now adopts an attitude which indicates a desire to maintain public morality. Whereas in Gottfried the oath had enabled the lovers to continue their relationship, in Immermann, Isolde accepts it as a sign of grace and determines henceforth to live a pure life in conformity with moral precepts. Immermann would therefore seem to be an example of the ambivalent attitude prevalent in the early nineteenth century: although he proclaims the divinity of passion, he feels called upon to uphold the sanctity of the moral code.

The only really successful version of the Tristan theme in the nineteenth century was of course the opera by Wagner,[5] for the plot of which he is largely indebted to Immermann and which is too familiar to require summarizing. In this work the relationship between love and death, which was so often stressed by the Romantics and which played also an important role in Immermann, assumes a position of primary importance. The love potion is thought by Tristan and Isolde to be poison which they willingly drink, but it is in fact not poison and they are not released from their suffering which is due to repressed passion. On the other hand the love potion which Brangane has given them is not the source of their love, since they have long loved in secret; but it does give them release in that they are able in the moment of expected death to confess their feelings. Having passed then as it were through death, they are able subsequently to look on life with different eyes, to see it as an illusion. After the confession of love they still long for death, but for a different kind of death. Their suicide pact had been wrong; it had been negative in aspect since their desire had only been to escape from this world. Having discovered the world and its values as illusory, they renounce it and abandon all desire. Through love they are led to a state of utter self-negation, to non-

5. First published Leipzig, 1859; first performed in Munich in 1865.

will: "Mußte er [der Tod] uns das eine Thor verschließen, zu der rechten Tür, die uns Minne erkor, hat sie den Weg nun gewiesen."[6] The ultimate goal remains death, not suicide, however, but the passive love death through which they will again become one with the universal will, Wagner's nirvana, the realm of night and love, the home of perfect because unindividuated love.

This version by Wagner is obviously far removed from the views of his contemporaries, but is it also as far from Gottfried's belief? Wagner does return to an analysis of the existential problem of the lovers and he concentrates like Gottfried on their spiritual development and on the esoteric nature of their experience. But whilst Gottfried's lovers achieve their ultimate experience in this life, in the union of body and spirit, in the mystic revelation of the grotto episode, Wagner transfers this experience to the life hereafter. Gottfried's lovers are separated after their experience and are presumably only symbolically united at death. Wagner's lovers remain separated in life by their corporeality and are fully united only in death, which brings the ultimate experience.

Apart from the early verse romance by Immermann and the opera by Wagner, there were several attempts in the course of the latter part of the nineteenth century at new versions of the Tristan theme, all of them, curiously enough, in dramatic form.[7] The use of this particular form certainly contributes in no small degree to the lack of success of these works, since—at least in the nineteenth century—it presupposes a plot or series of plots with a development in action and so forth. Since also the dramatists were faced with the problem of making the love potion, the wedding-night substitution, and other such details credible or palatable, the result was inevitably a series of complicated plots

6. *Gesammelte Schriften und Dichtungen*, vol. VII (Leipzig, 3rd ed. 1898), 49.

7. Josef Weilen, *Tristan* (Breslau, 1860); Ludwig Schneegans, *Tristan* (Leipzig, 1865); Albert Gehrke, *Isolde* (Berlin, 1869); A. Bessell, *Tristan und Isolde* (Kiel, 1895); Friedrich Roeber, *Tristan und Isolde* (Leipzig, 1898)—includes also the earlier version of 1838; Albert Geiger, *Tristan* (Karlsruhe, 1906).

in which the main question, the relationship of Tristan and Isolde, was lost from sight.

But the plot structures are also symptomatic of the attitude of the authors, for their interest clearly lay less in the personal problem of the lovers and much more in the conflict of their love with the social order, which conflict could only be manifested in a series of actions. Whilst the passion is depicted as irresistible, there is also an implicit, even explicit, assumption that the social order, the law, is immovable, and on this basis the tragedy develops. In a way this recalls the attitude of Hans Sachs, for whom love had been somehow worthwhile even though it had to be condemned. But in the nineteenth-century plays the value of love is stressed very highly and viewed almost as a religious experience. On the other hand the laws of society have by now become so rigid that the writers cannot conceive even of them being broken and the individual dramatists display a wealth of ingenuity in order, for example, to remove from Isolde any taint of adultery. The law then prevails. Society is of course guilty in that it upholds these laws—and there is an element of social criticism in some of these works—and the tragedy of Tristan and Isolde therefore lies in their living and loving in a time which does not accept the divine right of such love.

Twentieth-century versions of the Tristan theme show a very great variety and in the early part of the century particularly reflect changes in attitude toward sexual relationships under the influence of Freudian psychology. The love theme rather than the socio-legalistic conflict comes again to the forefront and in a specifically contemporary manner. As examples of this we may look briefly at the plays by Georg Kaiser[8] and Ernst Hardt.[9] In Kaiser's version Mark is extremely old, and it is immediately obvious that he, unable to possess Isolde, feels the relationship between Tristan and his wife and takes a vicarious pleasure in it. He is warming himself as it were with the heat of their love and does not wish the relationship disturbed. The only thing which does disturb him is something that he has overheard concerning Isolde. When she welcomed

8. *König Hahnrei* (Potsdam, 1913).

9. *Tantris der Narr* (Leipzig, 1920).

Tristan in Ireland, she picked up her six year old brother, stood him on her lap and hugged and kissed him. The thought of this embrace—which is evidence of her desire to embrace Tristan—torments Mark who feels that this child may have felt sexual desire for Isolde; he feels himself as though cheated of his vicarious possession of Isolde by this child which had possessed her, perhaps even incestuously, earlier. It is lsolde's refusal to answer Mark on this score which provokes him to banish the lovers, but he soon realizes that he has deprived himself more than them and they are therefore recalled. The return of the lovers solves nothing, however, since they have now become aware of his knowledge of their relationship, and Mark's encouragement of their love has the opposite of the desired effect. Their love, which had already weakened, now dies. Commanded to embrace, they can only feel revulsion.

The psychological complications of the three-sided relationship, are analysed from a different point of view by Ernst Hardt who takes as the subject for his drama a single episode, namely Tristan's visit to Isolde in the disguise of a fool, and on the basis of this makes a study of the complexity of the love-hate relationship. The plot is too complicated for analysis here, but it concerns Tristan's reappearance after banishment. Someone, who is apparently Tristan, has fled when challenged by one of the king's men, and Isolde feels that she has been betrayed by Tristan, since by fleeing he has betrayed her as a knight, whilst by his very presence in the country her life is forfeit under the terms of the agreement at the time of his banishment. The king, however, is also in doubt since Tristan has apparently been seen elsewhere at the same time, but when Isolde repeats in passionate tones the original ambiguous oath—which the king has never really believed—he condemns her in a fit of rage to be cast among the lepers. From this fate Isolde is saved by Tristan, but she either can not or will not recognize him in the short space of time before he has to make his escape. The king is forced, however, to take Isolde back, and into the tense and uneasy situation which now prevails, Tristan comes in the disguise of a fool. Despite his admission of detailed knowledge of the relationship between Tristan and Isolde (he even calls himself Tantris) the truth is not believed, but what he says is

taken to be fiction, fool's licence. When the fool is later able to see Isolde alone—even after she had learned that the knight who had earlier fled from the king's men had not been Tristan—she still fails to recognize him. Only Tristan's dog welcomes his master and with the dog at his side the fool leaves the palace without a backward glance at Isolde, who realizes too late that it really was Tristan.

In this work the lovers are deeply enmeshed in the web of deceit which they have woven in order to protect themselves; they are unable to extricate themselves and to see the truth. And in this atmosphere of doubt and deception every relationship is poisoned. The love-hate which the king bears toward Isolde, drives him to desire her, but to order her to be turned over to the lepers. Similarly Denovalin, one of the king's men, in love with Isolde, wavers between his desire to protect and betray her or her lover. The love of Tristan and Isolde is so poisoned by the double-dealing in which they have involved themselves that each doubts the love of the other, unable to cut through the tangle of deceit to the truth; and the result is the failure of their love.

The problem of passionate love, according to Denis de Rougemont,[10] was given expression in western culture by the legend of Tristan and Isolde. The smouldering crisis in European thought is seen by him as being the continuing conflict between passionate love, *eros*, as exemplified in this myth, and the Christian *agape*. In so far as the sacrament of marriage represents the union of two souls in *agape*, de Rougemont's thesis can be adapted to our purpose. The innate belief in the goodness of passionate or romantic love can be traced throughout the history of literature. This belief conflicted with the bourgeois ethic as early as the sixteenth century, while by the nineteenth century, society had become so rigid in its attitude toward love and marriage that the Tristan and Isolde legend could only be seen as a socio-legalistic conflict leading to tragedy. Passion may be good but the law is the law. But the legend had never been a tragedy, and the only person to appreciate this—although

10. *L'amour et l'occident* (1939), rev. ed. trans. by M. Belgion under the title *Passion and Society* (London, 1956).

diverging greatly from Gottfried—was the atheistically inclined Wagner. The relaxation of social strictures and diminution, if not abolition, of sexual taboos which began in the early twentieth century, led to a revival of interest in the Tristan theme as love story, but the equation of love with sex, not marriage, led to a preoccupation with sexual and psychological problems and not to a renewed interest in the love relationship *per se*. Despite the breaking down of taboos, a proper study of the love relationship and its problem was not forthcoming.

One of the chief elements in the depiction of romantic love has, however, always been the delay in fulfilment, the element of negation or impediment. In the case of Tristan and Isolde the impediment is Mark, the husband, but it may take various forms: the jealousy of others, difference in rank, separation, even the deliberate self-imposition of inaccessibility practised by some minnesinger who would love an unknown woman. Perhaps the simplest form is the fairy-tale situation: the princess in the clutches of a wicked giant (standing, probably for her father), whose rescue must precede erotic fulfilment. But what if there is no ogre, no jealous husband; what if there are no sexual taboos and we consequently admit to true love no impediment? In a recent essay de Rougemont[11] suggests that only two such taboos remain in modern life, namely the love of an older man for a child—what he calls nymphet love, citing Lolita as an example— and incestuous love. Whatever the merits or demerits of this theory, it is certainly true to judge from the treatment of the Tristan theme in modern literature that the positive portrayal of love, the overcoming of whatever difficulty may hinder fulfilment and the achievement of a genuine relationship is scarcely possible, for clearly, a love which is unhindered except by material problems is from a literary point of view lacking in interest. But is it really true that a modern Tristan and Isolde face no existential problem? Is this what Berthold Möncken, the "hero" of Nossack's novel *Spätestens im November* means when he says: "Es ist zu bezweifeln, ob es uns Heutigen noch erlaubt

11. *Love Declared, Essays on the Myths of Love*, trans. R. Howard (Boston, 1963).

ist, Liebende darzustellen"?[12] Berthold, himself a writer, composes a play not around Paolo and Francesca, but the figure of the husband Malatesta. Yet in this novel he himself plays the role of Tristan and exemplifies the statement quoted earlier from Cocteau to the effect that myths are relived at all periods unknown to those involved. The question therefore arises: has Nossack in this work produced a contemporary and valid recreation of the Tristan theme? Or has he too not been permitted to portray a genuine love relationship?

The outline of the story—convincingly transposed to modern times is as follows: Berthold meets Marianne, the wife of Max Helldegen, at a cocktail party given on the occasion of his accepting a literary prize. They immediately fall in love and, after a brief scene with Max, leave the same evening. After an idyllic interlude in the country they settle in a small town, but soon become estranged. Marianne returns to Max. Later Berthold's new play is given its premiere performance in Marianne's city. On this occasion Berthold comes to the house and they leave together, this time clearly for good. They are killed when their car crashes in the outskirts of the city.

The impediment to fulfilment for Berthold and Marianne is not Max, the husband, since in contemporary society the husband is no longer a dominant factor. Unlike Gottfried's lovers Berthold and Marianne can therefore set themselves above the conventions of society. And yet their love is not without its problem. Is it the same problem as in Gottfried? Berthold and Marianne are, like Tristan and Isolde, set apart from the rest of the world, but their otherness is of a different quality. They are individually aware of the illusory nature of the material and materialistic world and they reject it. But their withdrawal is not, as in Gottfried's work, into the sphere of love. Rather it is a preparation, a preparedness for the possible experience of another realm of existence altogether. The hallmark of the protagonists of Nossack's novels is in fact always this awareness of another level of being, a form of existence at once infinitely

12. First published 1955; edition used: Munich, 1963 (p. 175).

more meaningful and yet totally inexplicable.[13] In order not to destroy the faith of the world in itself, Berthold and Marianne—like other characters in Nossack's works—play out their role in life, prepared at any time to abandon one occupation for another, to cut themselves off completely from the past, prepared always for what Nossack has called the "Ausbruch ins Unversicherbare."

The problem of preserving and concealing this esoteric knowledge of another realm of existence at the same time as carrying on a form of life in the conventional world, the problem, that is, of maintaining this precariously balanced relationship, is for such people an individual problem. Over and above this, Berthold and Marianne are faced with the problem of reconciling this experience with their love relationship. This relationship they do not have to conceal and their elopement is not therefore, as it would have been with Gottfried, a break with the world. The problem does not lie here. The problem for them is to find a satisfactory mutual relationship which is based on an individual, but now common, rejection of the world. Their failure at first to achieve a harmonious state is due, it would seem, to their inability to maintain their relationship without the incursion of materialistic motives, to preserve the delicate balance of their life. They become in fact infected by worldly attitudes, Berthold by taking himself and his writing seriously, Marianne by reverting to a possessive attitude toward Berthold.

The details of this "relapse" are not, however, so important: important is rather the change in emphasis. Nossack applies the Tristan myth and portrays the existential problem of two contemporary characters in the Tristan and Isolde situation, but the actual problem has changed. The otherness of the lovers, both in Gottfried and Nossack, depends on their awareness of something superior to the material world, an awareness which they must conceal. But whereas for Tristan and Isolde this sphere is love itself and the problem is their balance between it and the world, for Berthold and Marianne their knowledge is of another

13. The most detailed discussion of this matter is in Nossack's *Unmögliche Beweisaufnahme* (Berlin, 1959).

realm of existence altogether and their problem is to reconcile their love with this.

Nossack's novel is then a love story; moreover, it is one within a positive context, even though the death of the lovers follows immediately on their final decision, for, as in Gottfried's work, the fulfilment precedes death, and the time and manner of death are largely irrelevant. This is of course in contrast to Wagner for whom death is really the beginning, and to the other nineteenth-century writers for whom death was the tragic conclusion to unfulfillable love. There is therefore a correlation between the mediaeval version of Tristan and Isolde represented by Gottfried and the contemporary version by Nossack. In both cases the lovers are fully conscious of their otherness, conscious that they possess a special knowledge, conscious, too, that they must cherish and protect this. But the difference between the concepts of these two authors is nevertheless significant. Gottfried establishes a religion of love at a time when the conflict between Christianity and the dualistic heresies had broken out with full violence, heresies in which the nature of the love experience played an important role. Whether or not Gottfried was directly involved in these heresies is immaterial, for there can be no doubt that he was very much *au courant* with religious and philosophic trends and in sympathy with the new theories of love. Any detailed discussion of the contemporary attitude toward love is clearly beyond the scope of this essay; we must simply accept the fact that Gottfried was writing at a time when the erotic passion had not yet been confined within the terms of the conjugal contract. But we also have to accept that for Gottfried no other order than the Christian *ordo*, by which is understood the providential ordering of the sum total of the universe in all its parts, could possibly exist; he envisaged no other form of existence. His refusal to allow religion a part in his work is not atheism, but a desire to insist upon the unfettered expression of human experience in love, since this was man's divinity in life.

If we turn to the contemporary scene we find a situation which is somewhat similar. Now the love relationship is again freed, or is being freed, from the restrictions of religion, and if the equation "love equals marriage" has not been entirely

abandoned, nevertheless marriage itself has become a sufficiently loose bond to place it closer to the twelfth century situation. But the contemporary situation is not based on any belief in order; on the contrary it is the result of widespread disbelief and the destruction of those social patterns which underlay the interpretation of the Tristan and Isolde myth from the thirteenth to the twentieth century. The elemental problem for the lovers has become not love and its relationship to life but life itself. The difference between "love" in the materialistic world and true love still exists and it is obviously the modern materialistic view of love, the preoccupation with sexual, social, and economic factors, which Berthold Möncken has in mind in the quotation above. The sexual union of materialistically motivated individuals is akin to the "käufliche Liebe" castigated by Gottfried in his famous excursus (lines 12,183 ff.). True love can still exist but only between those who are aware of the *meaninglessness* of this life; a meaninglessness which persists even in the face of this love. What is worth living for is therefore not love but the hope of another and altogether more meaningful realm of existence. What this realm is, Nossack does not and clearly cannot say, and it is therefore not possible to say whether death for the lovers means the end or the apotheosis of their love. All we can say is that the Tristan and Isolde myth, which has been re-interpreted at almost every stage of the culture of western Europe since its first startling appearance in the twelfth century, has become the vehicle for a radically contemporary and, I think, very significant appraisal of the problem of romantic love in our society.